NOTHING IF NOT CRITICAL
SELECTED ESSAYS ON ART AND ARTISTS

"For the last decade or more, Mr Hughes has been writing the best art criticism for popular consumption in the English language"
BRYAN ROBERTSON, *Spectator*

"May well be the best reviewer writing in English" *Observer*

"Hughes has a sixth sense for how people are feeling about contemporary cultural life" JED PERL, *Modern Painters*

"Hugely stimulating ... He conveys enthusiasm with infectious relish – as well as proving that his critical insights rest on a firm foundation of art-historical knowledge" RICHARD CORK, *Listener*

"Robert Hughes is illuminating and compelling on whatever subject he touches . . . Writes not only neatly but on occasion with a seductive beauty"
LAWRENCE GOWING, *Times Literary Supplement*

"The world's most influential art critic"
ANDREW GRAHAM-DIXON, *Vogue*

"He is a master of the English language, his prose a delight to read ... His latest book confirms his reputation as the best art critic this country has produced" *Sydney Sun-Herald*

"Hughes has the rare ability to popularise art without trivialising it ... One of the most significant anthologies of art criticism to have been published in the past decade"
SASHA GRISHIN, *Canberra Times*

"Honest, informed, unpretentious and with a gift for communicating directly and personally"
PAUL MCGILLICK, *Australian Financial Review*

"Written in passion and rumbling with humour" *Sunday Age*

"Few critics can be both honest and eloquent; nobody does it in such fine style as Hughes"
JOHN MCDONALD, *Sydney Morning Herald*

Robert Hughes, art critic of *Time* magazine and twice winner of the American College Art Association's F.J.Mather award for distinguished criticism, is author of *The Shock of the New*, of *Heaven and Hell in Western Art*, and most recently of the internationally bestselling history of the transportation of convicts to Australia, *The Fatal Shore*. This was described by *The Times* as "a unique phantasmagoria of crime and punishment, which combines the shadowy terrors of Goya with the tumescent life of Dickens", and by the *Washington Post* as "popular history in the best sense, its attention to human detail and its commanding prose call to mind the best work of Barbara Tuchman". *The Fatal Shore* won the W.H.Smith Literary Award, the Duff Cooper Memorial Prize and the *Melbourne Age* Prize. Robert Hughes was born and educated in Sydney and now lives in New York.

Robert Hughes

NOTHING IF NOT CRITICAL

Selected Essays on Art and Artists

Harvill
An Imprint of HarperCollins*Publishers*

First published in Great Britain by Collins Harvill and
in the United States by Alfred A. Knopf, Inc., 1990

This edition first published in 1991 by Harvill,
an imprint of HarperCollins Publishers,
77/85 Fulham Palace Road,
Hammersmith, London W6 8JB

9 8 7 6 5 4 3 2

BRITISH LIBRARY CATALOGUING IN PUBLICATION DATA

Hughes, Robert 1938-
Nothing if not critical
1. Visual arts
I. title
700

ISBN 0-00-272162-7

Two essays from this collection were originally
published in *The New Republic*.

Grateful acknowledgment is made to the following for permission
to reprint previously published material:
The New York Review of Books: Seven essays by Robert Hughes.
Copyright © 1978, 1979, 1982, 1984, 1989 by Nyrev Inc.
Reprinted by permission of *The New York Review of Books*.
The Time Inc. Magazine Company: All pre-1989 essays from *Time* Magazine
by Robert Hughes copyright Time Warner Inc.;
all 1989 essays from *Time* Magazine by Robert Hughes
copyright The Time Inc. Magazine Company.
Reprinted by permission.

Printed and bound in Great Britain by
Hartnolls Limited, Bodmin, Cornwall

FOR HENRY GRUNWALD,
WHO BROUGHT ME TO
AMERICA, AND FOR
CHRISTOPHER PORTERFIELD
AND ROBERT SILVERS,
WHO EDITED MOST OF
THESE PIECES

DESDEMONA. What wouldst thou write of me,
 if thou shouldst praise me?
IAGO. O gentle lady, do not put me to 't,
 For I am nothing if not critical.
DESDEMONA. Come on, assay.

<div align="right">—Othello</div>

Contents

Nothing If Not Critical

Introduction: The Decline of
the City of Mahagonny

I

In the early 1960s, when I was a baby critic in Australia, it seemed that faraway New York had become a truly imperial culture, heir to Rome and Paris, setting the norms of discourse for the rest of the world's art. This sense of imperial role (and the nervousness it induced in the provinces) would much later be summed up by Irving Sandler in the title of his fine book on Abstract Expressionism, *The Triumph of American Painting*.

Between 1945 and 1970, the quarter-century that saw the rise and flowering of the New York School, three generations of remarkable painters and sculptors seemed to have taken centrality away from Europe. First there had been the Abstract Expressionists: Pollock, de Kooning, Rothko, Newman, David Smith, Gorky, Guston, Krasner and Motherwell. Then there were the slightly younger painters whom Clement Greenberg and his school had nominated as the continuers of art history, the ones on whom the future of painting as a high art was alleged (wrongly, as it turned out) to depend: Noland, Olitski, Frankenthaler and especially Louis. And then the younger men and a few women who rose at the beginning of the 1960s, Johns and Rauschenberg, followed by Oldenburg, Lichtenstein, Rosenquist, Warhol, Kelly, Stella, Judd, Smithson, Morris, di Suvero, Serra; from there one could make up one's own list, which by the end of the 1970s might well have included painters such as Susan Rothenberg and Brice Marden and sculptors such as Joel Shapiro. And of course, Philip Guston again—reborn, since 1968, as a figurative artist of extraordinary power.

It would be foolish to claim that 1945–70 in New York rivaled 1870–1914 in Paris. America has never produced an artist to rival Picasso or

Matisse, or an art movement with the immense resonance of Cubism. But marvelous work was done there nevertheless. And it can certainly be said of the New York School that its artists often showed those "native" qualities listed by Frederick Jackson Turner in his history of the American frontier, qualities that seem inseparable from a younger America and are looked back on with nostalgia by Americans now: "that coarseness and strength combined with acuteness and inquisitiveness, that practical, inventive turn of mind, quick to find expedients . . . that restless, nervous energy, that dominant individualism . . . and withal that buoyancy and exuberance."

One saw this triumph from afar, going down Fifty-seventh Street with its tramping legions and subjugated Gauls, its gold and purple and apotropaic cries. In Australia one's response to it came out as a sigh—resignation to one's own cultural irrelevance. We were already used to that, since for most of the two-hundred-year history of white Australia the colonial experience had bitten deeply into us and caused a reflex known as the Cultural Cringe.

The Cultural Cringe is the assumption that whatever you do in the field of writing, painting, sculpture, architecture, film, dance or theater is of unknown value until it is judged by people outside your own society. It is the reflex of the kid with low self-esteem hoping that his work will please the implacable father but secretly despairing that it can. The essence of cultural colonialism is that you demand of yourself that your work measure up to standards that cannot be shared or debated where you live. By the manipulation of such standards almost anything can be seen to fail, no matter what sense of finesse, awareness and delight it may produce in its actual setting.

There is no tyranny like the tyranny of the unseen masterpiece. That was our predicament. In Australia we had art schools teaching people how to make Cézannes, but our museums had no real Cézanne to show us. The seen and fully experienced masterpiece tends to liberate. Great art is seldom repressive. But reproduction is to aesthetic awareness what telephone sex is to sex: in Australia, without knowing it, we were anticipating that worthless "freedom" from the original art object, the sense of floating among its media clones, which would be so lauded in 1980s New York as part of the postmodernist experience. It was stifling to independent judgment. There have been fine painters in Australia, at least since the rise of its Impressionist school in the 1880s. One can very well imagine an "alternative history" of twentieth-century art with some Australian artists in it, Arthur Boyd, for instance, or Fred Williams. But we Australians tended to be afraid to claim our own qualities, for fear of looking gauche—not

just to others but to ourselves as well. Much the same thing had happened earlier in the United States, of course. Few people today would dispute that Thomas Eakins and Winslow Homer were among the greatest of nineteenth-century realists. Very few Americans wanted to believe that thirty years ago, for fear of being judged provincial by other, Francophile Americans. In Australia, for fear of seeming unsophisticated, we kept wondering: Is this up to international standards? And we had no answer, because we could not articulate these "standards" for ourselves. In this we may not have been so different from most American artists living out of easy reach of New York in the fifties and sixties.

Thirty years ago, Abstract Expressionism was pretty well a mandatory world style. We in Australia looked at it with awe. The bottle in which its messages washed up on our shores (since the paintings themselves did not cross the Pacific) was the magazine *ARTnews*. Its hagiographic tone was clear. Except for the titans of the history books, whose work we hadn't seen either—from Michelangelo and Leonardo down to Picasso and Matisse—we had never read the kinds of claims made for *any* artist that Harold Rosenberg or Thomas Hess made for figures such as Barnett Newman and Willem de Kooning. They were grand enough to stifle aesthetic dissent. Only contact with the originals could have tested them, and we could not see the originals. Thus, although we did not know it, we were in the situation of many *American* artists outside New York in 1960—flat on our backs, waiting for the missionary.

The copy of *ARTnews* would arrive and we would dissect it, cutting out the black-and-white reproductions and pinning them on the studio wall. One was, say, a Newman. You had just read one of Tom Hess's discourses on how Newman's vertical zip was Adam, or the primal act of division of light from darkness, or the figure of the unnamable Yahweh himself. How could you disagree? On what could you base your trivial act of colonial dissent? A mere reproduction, two inches by three? But Yahweh doesn't show his face in reproductions. He shows it only in paintings. And if you got to see the paintings, what if you still didn't see it? Did that mean that his terrible and sublime visage was not there either? Of course not; it meant only that you had a bad eye; or that Yahweh doesn't show himself to goyim from the South Pacific. And since it is difficult for the young or otherwise uninitiated to avoid, still less be skeptical about, the language in which peak experiences are offered to them, you were apt to assume that it was your own unpreparedness or sheer obtuseness that prevented you from seeing the deity that lurked within Newman's zip or Rothko's fuzzy rectangle.

This act of unwonted humility was made by thousands of people

concerned with the making, distribution, teaching and judgment of art, not only in places like Australia but throughout Europe and—not incidentally—in America in the mid-1960s. They resigned themselves to an imperial situation. Imperialism creates provincialism: it standardizes things, straightens out the edges. The periphery yearns for the reassurance of the center—to submerge its fragile and only partly definable identity in something manifestly strong. Just as late imperial Roman sculpture looks much the same all around the Mediterranean, and statues of Lenin vary little from the Finland Station to Tashkent (although the god's features get more Asiatic the farther east they travel), so the modernist image tends toward standardization from the centers out. The difference today is that instead of an imperialism of place we have an imperialism of the market, operating internationally. From Basel to Canberra, from Minneapolis to Venice, late-modern collections are bought from essentially the same *menu touristique;* if Antarctica had a museum of modern art, the penguins would get to contemplate an Ellsworth Kelly, a mock-Tantric watercolor by Francesco Clemente, a straw-and-mudscape by Anselm Kiefer and a nice lump of frozen fat by Joseph Beuys. So what has this done to the vision of Imperial Manhattan, at the end of what probably has been the worst decade in the history of American art?

II

In America, nostalgia for things is apt to set in before they go. Perhaps some people already feel stirrings of nostalgia for the eighties. If so, their feelings are premature.

If cultural cycles did not have their own momentum and life span, neither to be measured in decades, one would now murmur a small prayer of gratitude for release and reach for the Maalox. But we will not be out of the eighties for years, because few of the social conditions that fostered the decade's cultural traits have changed or seem ready to. The decade may be officially dead, but it won't lie down just yet.

In the eighties the scale of cultural feeding became gross, and its aliment coarse; bulimia, that neurotic cycle of gorge and puke, the driven consumption and regurgitation of images and reputations, became our main cultural metaphor. Never had there been so many artists, so much art vying for attention, so many collectors, so many inflated claims and so little sense of measure.

The inflation of the market, the victory of promotion over connois-

seurship, the manufacture of art-related glamour, the poverty of art training, the embattled state of museums—these will not vanish, as at the touch of a wand, now that 1990 is here. But at the same time, few people outside the United States continue to believe in the New York imperium; Europe has risen again, and with a vengeance. There is much to suggest that in the 1980s New York not only lost its primacy as an art center but also began to go the way of its predecessors, Paris in the 1950s and Rome in the 1670s—over the hill, into decline. The point is not that New York has been replaced by some other city as center. It has not been, and will not be. Rather, the idea of the single art center is now on the verge of disappearing. New York's decline is only a prelude to that situation.

This sense of loss, which was rather more than a mere faltering of creative momentum, was not confined to New York. It may be that Picasso's death in 1973 marked the end of a period in Western art as emphatically as the deaths of Sophocles and Euripides in the same year, 406 B.C., marked the end of high tragic drama in Greece. Tragedies continued to be written in Greek, and some quite good ones too; but the age of tragedies was past and that of the histories had begun. We are all conditioned by the art market and the decadent myth of modernist progress into thinking that there is no such thing as a slump in cultural history. But slumps do happen, and we are in one now.

When Americans in the fifties and sixties eagerly claimed that their art had superseded that of Europe, their eagerness was itself a period phenomenon.

The American Revolution had held, deep in its heart, the vision of a corrupt Europe, a Europe whose hold was long and tenacious but which could be demystified by showing its moral obsoleteness. The idea that Europe was culturally exhausted was an important ingredient of American self-esteem. Its ancient craftiness, its subtlety, its strata of memory, its persistent embrace of elitist against "democratic" cultural values: these, in American eyes, were grounds for suspicion and even hostility. And if an artist openly espoused them or seemed for a moment lost in admiration of them—Robert Motherwell, for instance—then he must acquit himself of charges of self-indulgence, as though he were claiming experiences that were not truly his. Europe must be transcended, outdone. Thus the power of Bernard Berenson's appeal to the plutocrats of Chicago, New York and Boston at the turn of the century—just as, under his guidance, the art of the Italian Renaissance came pouring into America at the start of its museum age—was his promise of a new American Renaissance which would outdo the old, whose paintings and sculpture would nevertheless

furnish indispensable refinement to the new. It may be that, as an American, Berenson actually believed this: one cannot be sure. But his audiences certainly did. It was a desire that none too subliminally shaped the program of history presented by the most influential of all American museums, the Museum of Modern Art in New York: the passing of the torch from failing Europe to vigorous America.

But the "American Century" whose arrival was eagerly proclaimed after 1945 is now at an end. It finished ignobly amid the glitzy triumphalism of Reagan's presidency, and its squandered resources cannot simply be willed back into being. New York's loss of vitality as an art center runs parallel to events in the larger culture of politics, economics and mass media. It is part of a general aging of the United States: its stagnation, its willing surrender to ephemeral media images and unargued persuasion. It is connected, not causally but by analogy, to the extraordinary decay of American public life. But it has also been caused by a loss of talent to painting and sculpture, itself connected to a general decline in educational standards. The idea of the hegemony of American art in the fifties and sixties—the belief that it was the mission of New York to set cultural standards for Europe and the Western cultures of the Pacific, including Australia—sprang from the narcissistic assumption that people everywhere *aspired* to the condition of Americans, so that aesthetic issues that filled the New York horizon could be transferred anywhere else, regardless of local traditions, imagery, preoccupations. This reflected the larger political assumptions Americans made at the time: their belief in their country's moral leadership in a Manichaean world, clearly divided between disinterested American light and devouring Russian darkness; the conviction of some of its leaders that, in Henry Luce's words, "no nation in history, except ancient Israel, was so obviously designed for some special phase of God's eternal purpose." Nobody of any intelligence believes this kind of fustian today in politics, and in the visual arts, where New York lives in a state of continuous hype but diminished expectation, it is merely the echo of a lost time: an echo Americans still eagerly listen to, in their nostalgia for a time when their country seemed young and powerful and capable of producing anything at will.

Nothing comes around again. Who could possibly compare the efforts of our fin de siècle in the visual arts with those of a hundred years ago? Merely to invite the comparison seems so unfairly loaded against the scale of our cultural expectations as to be, well, impolite.

The nineteenth century went out in a blaze of glory. The period 1885–1905 was one of striking cultural energy and confidence, not a decline

and not by any means a mere prelude to modernism. Europe then had, among others, Cézanne, Monet, Seurat, Degas, Matisse, van Gogh, Gauguin, Munch, Rodin; we, the pessimist might say, have network television and the pallid ghost of Andy Warhol.

The more hopeful, or less dismissive, could readily name twenty or so painters and sculptors of real merit who are at work today, some in Britain, some in Europe, some in New York: from senior figures such as Richard Diebenkorn, Robert Motherwell, Antoni Tapiès, Jasper Johns, Cy Twombly, Arthur Boyd, Lucian Freud and Francis Bacon, through the middle generation (Ilya Kabakov in Moscow; Avigdor Arikha in Paris; sculptors Magdalena Abakanowicz, Nancy Graves, William Tucker and Joel Shapiro; in England, Frank Auerbach, Howard Hodgkin and R. B. Kitaj), to such younger artists as Anselm Kiefer, Susan Rothenberg, Neil Jenney, Sean Scully, Elizabeth Murray, Martin Puryear, Tony Cragg, and maybe one or two hopeful group events such as the collaboration of Tim Rollins and K.O.S. (Kids of Survival). Nevertheless, although the eye of the future will find artists to respect when it looks back on our time, they are not likely to seem as consequential as those of a century ago. And the good ones will look like raisins bedded, very far apart, in the swollen duff of mediocrity that constitutes most late-twentieth-century art. Whether the bad museum art of our own day—David Salle, Gilbert & George, and other *deliciae*—is better or worse than its late-nineteenth-century equivalents, the stuff that Cézanne and van Gogh had to slog their way past, is no longer an open question; because of the overpopulation of the art world there is far more of it, and thanks to the lack of discrimination on the market-museum axis it is, if anything, somewhat worse.

The future cannot be relied on to value what is most fashionable in one's own day, and the remembered figures in 2090 may not be those popular in 1989. Who, in 1890, would have predicted that the obscure and clumsy Cézanne would cause a revolution in values that would oust the masterly, "impeccable" diction of Bouguereau from the history books? (But then, who in 1960 would have bet on Bouguereau's return to our museums in the eclectic revivalism of the 1980s?) The most famous painter in Northern Europe in the 1890s was not Gustave Klimt, Egon Schiele or even Edvard Munch, but an Austrian named Hans Makart. His studio in Vienna, a huge hangar of a place full of antlers, Persian rugs and palms, was a shrine of pilgrimage for collectors from all over Europe. In it he hung his enormous paintings—battle scenes, varied with bits of mythology for gentlemen who preferred nymphs. Journalists hung on his table talk. Public belief in Makart's genius was second only to his own. Senti-

mental and bombastic, he was the Julian Schnabel of the Ringstrasse, with the difference that Makart could draw. And today he is almost wholly forgotten—except in Vienna, where he remains a cultural curiosity of its Belle Époque.

The last fin de siècle, the period between 1885 and 1905, was greeted by the middle classes of Western Europe and America as a time of inordinate hope, although its hopes were not the ones we have today.

Imperial thinking—French, German, British and, in the form of a belief in "manifest destiny," American—was at its peak. The presiding metaphor was one of conquest and development: of oceans, air, mineral strata, jungles and foreign peoples—Kipling's "lesser breeds without the Law." No limit to the promise of technological development was apparent to the men who ran this world, and the idea that the globe was itself a finite resource would have struck them as absurd—largely because they did not have the industrial capacity, as we do, to exploit it to the limit, or the range of markets to support such an exploitation. Their world was much less crowded than ours. It was not on the very edge of being used up. We think of preservation, they thought of expansion.

But if established power was hopeful, so was radical dissent. A hundred years ago the promise of radicalism was young and, before its ruin at the hands of Lenin, Stalin and their heirs in this most murderous of all centuries, relatively innocent. For instance, the political relations of some French artists and writers with the radical left—first Courbet with his friend Proudhon, then such figures as Paul Signac, Félix Fénéon, Stéphane Mallarmé and the editors of *La Revue Blanche* with anarchists of the 1880s and 1890s—went on in a spirit, however naive, of hope for betterment of the world through universal brotherhood. They may have been wrong, but at least they were decently wrong. They did not have the flippant, reamed-out cynicism that passes for "radicality" in the art industry's embrace of Jean Baudrillard. And no politically inclined artist then faced what his modern counterpart must contend with, and in a mass-media environment lose to: the draining away of art's power as a witness.

In the visual arts, the confidence of the last fin de siècle had its echoes. They showed themselves (as it were) subliminally, in the belief that Nature was still an unfailing regulator of thought and an inexhaustible storehouse of forms for the artist or the architect, while "exotic" cultural traditions—Japanese for van Gogh, Whistler or Monet; Breton or Polynesian for Gauguin; African for the young Picasso—could be raided at will. (The desire to be primitive was very much a function of fin-de-siècle imperialism; it appealed to strong egos and domineering minds.)

Moreover, the excellence of fin-de-siècle painting and sculpture rested on a firm belief in the artist's ability to consult and use the past traditions of his own culture, freely and without prophylactic irony—as summarized in Cézanne's belief that "the way to Nature lies through the Louvre, and the way to the Louvre through Nature." Michelangelo was *available* to Auguste Rodin in a way that he may be to no sculptor now. No living architect anywhere in the West today can bring to inherited motifs and crafts the sublime freedom with which Luis Domenech y Montaner deployed his Catalan traditions of ironwork, glass and ceramics in the Palau de la Música Catalana (1905–08) in Barcelona.

This was so partly because no myth of cultural repudiation (as enshrined in Futurism, Dada and Surrealism) had yet arisen, although there was certainly an emphasis on the *renewal* of art's language, and partly because the training of artists had changed little, in its essential emphases, since the sixteenth century. Thus the Belle Époque's legacy to later artists, Miró, Picasso and Matisse, for example, was fecund and continuous. If Jacopo Pontormo had walked into the life class of one of the big teaching ateliers of Paris in 1890 he would have seen immediately what was going on; if the same time machine were to deposit him in Walt Disney's Academy for the Briefly New, the California Institute of the Arts, in 1990, he might not recognize it as an art school at all: and who could blame him?

For nearly a quarter of a century, late-modernist art teaching (especially in America) has increasingly succumbed to the fiction that the values of the so-called academy—meaning, in essence, the transmission of disciplined skills based on drawing from the live model and the natural motif—were hostile to "creativity."

This fiction enabled Americans to ignore the inconvenient fact that virtually all artists who created and extended the modernist enterprise between 1890 and 1950, Beckmann no less than Picasso, Miró and de Kooning as well as Degas or Matisse, were formed by the atelier system and could no more have done without the particular skills it inculcated than an aircraft can fly without an airstrip. The philosophical beauty of Mondrian's squares and grids begins with the empirical beauty of his apple trees. Whereas thanks to America's tedious obsession with the therapeutic, its art schools in the 1960s and 1970s tended to become crèches, whose aim was less to transmit the difficult skills of painting and sculpture than to produce "fulfilled" personalities. At this no one could fail. Besides, it was easier on the teachers if they left their students to do their own thing. It meant they could do *their* own thing, and not teach—especially since so many of them could not draw either. A few schools, such as the Pennsyl-

vania Academy of the Fine Arts, held out against this and tried to give their students a solid grounding. But they were very few.

Other factors contributed to the decay of the fine-arts tradition in American schools in the sixties and seventies. One was the increased attachment of art teaching to universities, which meant that theory tended to be raised above practice and making. Thinking deep thoughts about histories and strategies was more noble than handwork, and it produced an exaggerated drift toward the conceptual. This interlocked in a peculiarly damaging way with reliance on reproduction of works of art instead of direct contact with the originals.

Few people now remember a time when the thirty-five-millimeter color slide was *not* the main fodder of art teaching, both for artists and for art historians. For the last quarter-century slides and not originals have been the major source of most students' contact with art, and this has relentlessly nudged their experience toward the disembodied, the conceptual, the *not there*. The size and the number of art classes have made the didactic museum visit obsolete, and in any case most art schools are out of convenient reach of great museums.

As Cleve Gray recently pointed out in *Partisan Review*, slides and reproductions have reduced, and for some all but destroyed, the sense of uniqueness and particular scale of works of art, the physical presence Walter Benjamin called their "aura." One learns from the image flat in the book, cast oversize on the lighted screen, or glimpsed undersize in the slide viewer. Committees award prizes and fellowships on the basis of slides. Writers write from them. Collectors buy from them. But what is *there*? An image of an image. Not the thing, but a bright phantasm, a visual parody, whose relation to the original and actual work of art is that of a shrunken head to a real one.

In the slide or reproduction, no work of art appears in its true size or with its vital qualities of texture, color and the recorded movement of the shaping hand intact. A Klee, a Pollock or a lunette of the Sistine Chapel—all undergo the same abstraction, the same loss of presence. Impartially, they lose one of the essential factors of aesthetic experience, the size of the artwork relative to our sense of our own bodies: its scale.

There were, after all, reasons why Picasso painted *Three Women*, 1908, on a canvas six and a half by six feet, and *Still Life with Chair Caning*, 1912, on a surface one-fortieth that size. The former he meant to stand up before the eye sculpturally, like the Michelangelo *Slaves*, which are its distant ancestors, figures locked sleepily in their red stony space, their slow torsion speaking kinesthetically to one's own sense of bodily weight

and size; the latter accepts one's gaze more intimately, like a view through a little window.

But when both come out the same apparent size in a plate or a slide, the penumbra of meaning inherent in their actual scale as paintings cannot survive. Does this lie behind the peculiar confusion of size with scale that afflicted so much American painting in the eighties—the inflation of the artwork in its pursuit of a factitious "importance"?

A slide gives you the subject, the nominal image of the work, without conveying a true idea of its pictorial essence. You cannot think and feel your way back into the way something was made by looking at a slide: only by studying the real thing. And no tradition of making can be transmitted without such empathy. Did this foster the dull blatancy of so much recent American painting, all impact and no resonance? Have the falsifications of the reproduced image fed back into the new originals, cutting out those very qualities which, by their nature, cannot survive reproduction—subtleties of drawing, touch and brushwork, of color and tone, that slow up the eye and encourage, beyond the quick look, a slow absorption?

III

But the real disjuncture between the fins de siècle lies deeper than this. A hundred years ago, painting and sculpture were still socially dominant forms: they continued to supply, to an extent now all but lost to us, the visual codes by which one interpreted the world.

Mass media, except for print, did not exist. Photography had begun to fill the gap between fantasy and reality, reducing the effort of firsthand experience. But it was not yet a democratic medium: few could take their own pictures (that would begin in 1888, with George Eastman's preloaded cameras), and halftone reproduction, which put photographs on the pages of the daily press, was still uncommon.

Cinema was not quite born (Louis Lumière invented the cinematograph in 1894), and the vast popular reach of movies lay far in the future, outside social imagination. Not until 1925 would recognizable human features be transmitted by television. Nor would TV become a mass hypnotic in the United States until after 1945. Elsewhere in the West its advent would be even longer delayed; if you were born before 1940 in Australia you could reach college-graduate age without watching, let alone having, a television set.

Because mass visual media hardly existed in the world of our grand-

parents and great-grandparents, painting and sculpture carried more weight: the weight of tradition, dreams and social commemoration. The very idea of "radical" change in painting and sculpture gained its impetus from their traditional primacy and lost it when that primacy was lost. The political leader in 1890 might crave a bronze figure of himself in the square, but that kind of propaganda is now archaic—replaced by the forty-five-second attack commercial, as public oratory has been replaced by the sound bite and the managed press conference. When Parisian gallerygoers in the 1870s recoiled in horror from the "leprous" blue shadows in a Monet, it was because they felt an important contract had been broken— the agreement between painting, as a primary form of social discourse, and reality. No painting can offend anyone in this way today, because painting no longer has such primacy: it is not our index of the real.

Instead, photography enrages the moralist, as Americans saw with the recent imbroglio between Senator Jesse Helms and the National Endowment for the Arts over the work of Robert Mapplethorpe. If that overrated photographer, instead of sticking a bullwhip up his ass and pretending to be the devil in front of his own Hasselblad, had done it on network television, the fuss would have been even greater. But if the image had been painted, who would have much cared?

In 1989 the average American spent nearly half of his or her conscious life watching television. Two generations of Americans—including American artists—have now grown up in front of the TV set, their consciousness permeated by its shuttle of bright images, their attention span shrunken by its manipulative speed, their idea of success dictated by its collapse of fame into celebrity, their anxiety level (at least among the smarter ones, again including artists) raised by its sheer pervasive power.

This has not been a matter of choice, let alone fault. The power of television goes beyond anything the fine arts have ever wanted or achieved. Nothing like this Niagara of visual gabble had even been imagined a hundred years ago. American network television drains the world of meaning; it makes reality seem dull, slow and avoidable. It is our "floating world." It tends to abort the imagination by leaving kids nothing *to* imagine: every hero and demon is there, raucously explicit, precut—a world of stereotypes, too authoritative for imagination to develop or change. No wonder it has predisposed American artists toward similar stereotypes. It is stupidly compelling, in a way that painting and sculpture, even in their worst moments of propaganda or sentimentality, are not.

From Edgar Degas with his Kodak to Robert Rauschenberg with his silk screens, from Hanne Hoch with her clipped collages of news photos

to the use of TV and ads by the Fluxus group, modern artists have long been fascinated by the mass media. Rauschenberg or Lichtenstein could play with this fascination while still keeping their balance inside the fine-arts tradition. Warhol, a commercial artist to the core, took the step (gingerly, at first) outside it, in his acolyte's embrace of the value-free apparitions of the Tube. The next generation of American artists, Andy's children, followed him en masse. They could not imagine a fine-arts tradition that was not overshadowed by television. Accordingly, a peculiarly slack form of thinking (whose institutional site, in New York, was the Whitney Museum of American Art) arose about art and media. Nature is dead, culture is all, everything is mediated to the point where nothing can be seen in its true quality, representation determines all meaning, and the only way that "so-called high art" can engage with general perception is to step out of its old "elitist" traditions and follow the Yellow Brick Road of the "cutting edge" that leads through Deconstruction Flats and the Forest of Signs to Jeff Koons's porcelain pigs.

This trip turns out not to be worth taking. It has produced a clever novelty art of diminishing returns; far from affording artists continuous inspiration, mass-media sources for art have become a dead end. They have combined with the abstractness of institutional art teaching to produce a fine-arts culture given over to information and not experience. This faithfully echoes the general drain of concreteness from modern existence—the reign of mere unassimilated data instead of events that gain meaning by being absorbed into the fabric of imaginative life. The numbed eclecticism of eighties art, its fondness for pastiche and historical deck-shuffling, its vision of art history as a mere box of samples—these were the signs of a culture given over to surfaces, all style and no substance. Their imaginative drought reminds one of a sad Russian joke: Today you can order a steak by telephone—and get it by television.

There are extreme differences between the values of painting and sculpture, and those of mass media. Art requires the long look. It is a physical object, with its own scale and density as a thing in the world. Its images do not pass. They can be contemplated, returned to, examined in the light of their own history. The work of art is layered and webbed with references to the inner and outer worlds that are not merely iconic. It can acquire (although it does not automatically have) a spiritual aspect, which rises from its power to evoke contemplation. Fine art is infinitely more than an array of social signs awaiting deconstruction. Its social reach is smaller than that of the mass media, and it finds the grounds for its survival in being what the mass media are not. It now seems that if one opens "art"

to include more and more of the dominant media that have no relation to art, the alien goo takes over and the result is, at best, a hybrid form of short-impact conceptualism trying to be spectacle. Static, handmade visual art cannot furnish an answer to big media, or even an effective debunking of them. The working relation of most eighties artists to them has been that of a fairly tough fly to flypaper.

One saw this in Robert Longo's work in the early eighties—an over-size mélange of technical sophistication and sentimental blatancy, with more wallop than resonance. It came, in a different form, in Barbara Kruger's knockoffs of John Heartfield, with their smugly "challenging" slogans about manipulated identity. It was even purer and duller in Jenny Holzer's plaques and light-emitting-diode readouts (CHARISMA CAN BE FATAL, and so forth)—failed epigrams that would be unpublishable as poetry but that survived in the art context, their prim didacticism so reminiscent of the virtuous sentiments the daughters of a pre-electronic America used to embroider on samplers. The work that got into the American limelight after Neo-Expressionism prided itself on its political correctness, but most of its messages might as well have been sent by Western Union. Probably the only American artist of this generation who managed to introduce a real shudder of feeling into media-based work was Cindy Sherman, enacting her parade of gender caricatures, bad dreams and grotesqueries for the camera.

Not much of the art that really seems to matter is being made in New York today. There is a haunting parallel with Paris at the end of the fifties, when the French were busy persuading themselves that Soulages, Polia-koff, Hartung, Mathieu and other artists formed a generation that could eventually step into the shoes of the patriarchs of the Paris School, most of whom except Picasso and Braque were dead. Several important younger artists were alive and at work: Giacometti, Dubuffet, Balthus, Hélion. One could certainly believe that the tanks were not emptying. Yet today, for the first time in three hundred years, there is not one great artist at work in Paris. So it is with New York. The great city has gone on with frantic energy as a *market* center, an immense bourse on which every kind of art is traded for ever-escalating prices. But amid the growing swarm of new galleries, the premature canonizations and record bids and the con-version of much of its museum system into a promotional machine, its cultural vitality—its ability to inspire significant new art and foster it sanely—has been greatly reduced.

In part this was due to economic pressures, notably from the real estate market, which deprived younger artists—along with small theater

companies, dance groups and the rest—of working space in Manhattan.

Complaints about this are an old part of the texture of New York life, of course: even in the 1920s people were complaining that Greenwich Village bohemia was dying on its feet, made homeless by what later journalists would call gentrification.

But in the 1980s the supply of affordable workspace for artists in Manhattan finally ran out. The idea of the New York painter in a big white downtown loft—bohemia with industrial spaces—is about as real as the notion that French painters wear berets and live in high studios in Montparnasse. The working bohemia of New York artists made its last stand in the very early seventies, when SoHo had no name, two galleries (Paula Cooper and Max Hutchinson) and two bars, Fanelli's and the long-defunct Luizzi's. All the ground-floor spaces on West Broadway now occupied by fashion boutiques and art galleries then held small tenacious businesses—hardwood-flooring companies, knife grinders, plastic injection molders, fabric offcut warehouses: survivors of an industrial past that went back to the Civil War, whose pragmatism seemed to underwrite the kind of art that was being made by semilegal tenants with Murphy beds and industrial leases (no heat after 5:30) in the lofts above. The annals of this last American bohemia remain largely unwritten. But the loft on Prince Street that rented for $150 a month in 1971 and sold as a co-op floor for $25,000 in 1974 carried a price tag of $750,000 by 1987.

Such artists as live in SoHo got their places fifteen or twenty years ago. Today, any walkup space in the Lower East Side, complete with the crack dealers on the doorstep and a derelict pissing in his pants on the second-floor landing, rents for a dollar per square foot per month—say $1,000 for the reasonable minimum a painter needs to work. So artists cross the river to find workspace in Bayonne or Hoboken, and commute in to see the shows; at which point they may as well stop calling themselves "New York artists" at all, being part of no community. Where a young painter thinking of moving to Manhattan in 1970 might have armed herself for the struggle of life in New York, by the mid-1980s she was more likely to give up the idea altogether and stay in Chicago.

Thus, although Manhattan at the end of the 1980s is rivaled by no other American city as a monumental center and a culture market, its ability to draw in new talent and foster it in ways that make sense has almost gone. This is a poor omen. It was always the work of living artists, made in the belief that their work could grow best there and nowhere else, that fueled New York. The critical mass of talent emits the energies that proclaim the center; its gravitational field keeps drawing more talent in,

as in the combustion of a star, to sustain the reaction. The process is now dying. And the sense of entropy is compounded by the decay of New York civic life, not a problem in Paris. Up to a certain point, the grit, dirt and struggle of Manhattan were a stimulus to artists: all kinds of special poetries and particular looks arose from its aggressive materialism—until the late eighties, when the sheer inequality of New York became over-powering. Doubt now arose: Could a city with such extremes of Sardanapalian wealth and Calcutta-like misery foster a sane culture? Did it take more out of an artist than it put in? Why not stay in San Francisco or Chicago (or Barcelona, Berlin or Sydney), visit New York occasionally for its museums and galleries, but otherwise ignore its pull?

New York had never been paradise, and living there, below the kind of income level enjoyed by only one American in forty, had never been easy. (Those who complain about the street squalor of Manhattan as though it were something new should consult the chronicles of New York in the 1840s, when such garbage collection as existed on Broadway was done by packs of half-wild pigs.) But it was in New York that the essence of the Reagan years—private affluence and public squalor—cavorted in the limelight. Half of the public officials of the Koch administration seemed, like those of the Reagan administration in Washington, to be involved in some kind of criminal scam or shameless conflict of interest. Manhattan's middle class, the protein of urban life, felt squeezed between a small, repellently ostentatious crust of the newly rich and an increasingly demoralized mass of the hopelessly poor, and stepped up its rate of migration to the boroughs across the bridges. Television news and the tabloid press grew ever more debased. Reality shortage, induced by an inflated cult of promotion and celebrity, was acute. The sense of civic space began to collapse under the pressure of real estate greed, exacerbated racism, the fear of crime, the exploding drug market. And then there was AIDS.

Not one of these woes was confined to Sodom-on-the-Hudson, although New Yorkers (with their appetite for disaster scenarios) were apt to talk as though Manhattan were their special laboratory, a sort of Island of Dr. Moreau in which every kind of deformity was breeding. But social tensions, even plagues, do not in themselves guarantee the decline of a great art center. Delacroix's Paris was no Utopia either, except for the few, and many Londoners two hundred years ago experienced their city as New Yorkers do today: money-mad and dangerous to live in, threatened by a large "criminal class" and sapped by proletarian addiction. But the difference between then and now is that the pattern of world cultural activity has made the very idea of the single, imperial center obsolete. New

York, in other words, remains *a* center but not, as its art world used to imagine, *the* center. Moreover, its centrality is based mainly on the market, and the market has nothing to do with cultural vitality. A few years ago, a popular neo-Marxist argument (popular in academe, anyway) was that finesse of taste and connoisseurship were only masks for market activity— genteel ways in which a ravenous commercialism could spin euphemisms about itself. Anyone who believed that should look at the art market today and be corrected. It is now run almost entirely by finance manipulators, fashion victims and rich ignoramuses. The collector as connoisseur has been squeezed out of it. Connoisseurship is an impediment to its progress—mere dust on the road down which the inflationary march proceeds. Under the market's malignant sway, genuine expertise is virtually redundant and will soon be entirely so. The market's object is to erase all values that might impede anything at all from becoming a "masterpiece." In this situation, whose epicenter is New York, the role of the museum, like that of the critic, is attenuated. And because it has never paid more than lip service to the idea of state patronage of the arts, the United States has no dominant cultural institutions that are not tied into the market.

IV

In the eighties more paper wealth was generated in New York than in any other city, at any other time, in human history. Greenmail, junk bonds, leverage and the precarious liquidity of an overgeared credit economy transformed the art world into the Art Industry, turnover immense, regulations none. What was a picture worth? One bid below what someone would pay for it. And what would that person pay for it? Basically what he or she could borrow. And how much art could dance for how long on that particular pinhead? Nobody had, or has, the slightest idea. What is certain is that nobody foresaw the hyperinflation of the market; and that when the bubble bursts, or softly deflates, as bubbles do, nobody will have foreseen that either. Twenty years ago, the idea that any work of art made in the past century would sell for a million dollars seemed like science fiction to most people. In 1972, when the National Gallery of Canberra paid about $2 million for Jackson Pollock's *Blue Poles*, the price made world headlines and contributed, marginally, to the Australian public's acceptance of the fall of the Whitlam government soon afterward. Today, when someone pays five or ten million for a modern painting, the event rates no more than a sentence or two in the auction reports of *The New York Times*. We have come to take it for granted that art should be

alienatingly expensive: it seems normal that its price should violate our sense of decency.[1] Although art has always been a commodity, it loses its inherent value and its social use when it is treated only as such. To lock it into a market circus is to lock people out of contemplating it. This inexorable process tends to collapse the nuances of meaning and visual experience under the brute weight of price. It is not a compliment to the work. If there were only one copy of each book in the world, fought over by multimillionaires and investment trusts and then hidden in storage, what would happen to one's sense of literature—the tissue of its meanings that sustains a common discourse? "Where works of art are rare," young Goethe wrote on first visiting Naples, "rarity itself is a value; it is only when they are common . . . that one can learn their intrinsic worth." The truth of these words is very nearly lost to us, in a culture wrecked by its own commercialization. What strip-mining is to nature, the art market has become to culture.

At the end of the eighties there may have been five hundred people in the world who could pay more than $25 million for a work of art, and tens of thousands who could pay a million: a situation with no historical precedents at all. Never before have the impulses of art appreciation and collecting been so nakedly harnessed to gratuitous, philistine social display as in the late 1980s, and nowhere more so than in the United States, especially when the Japanese are buying. The new relations between "price" and "value" were epitomized at Sotheby's New York auction of Andy Warhol's collection in 1988, when necrophiles and relic hunters competed to pay $20,000 apiece for cookie jars that partook of the dead artist's aura. They were pushed from obscenity into farce in the spring of 1990, when one Japanese investor paid $160.2 million for a van Gogh and a Renoir.

Yet the game had losers as well as winners, and by the late eighties the losers, interestingly enough, were American: chiefly, American museums, and through the museums the American public. The art-market boom has been an unmitigated disaster for the public life of art. It has distorted the ground of people's reaction to painting and sculpture. Thirty

[1] Just how unforeseen the change has been may be sensed by consulting a later essay in this collection, "Art and Money," originally written for the University of Chicago's Harold Rosenberg Memorial Lecture in 1984. At that time I took $10 million as the "absurd" price that a work of art (notionally, a great Raphael) might some day attain. By 1989 no great Raphaels had come on the block, but $10 million seemed a commonplace figure in a market where a Jasper Johns had made $17.7 million, a Pontormo over $35 million, a small Picasso self-portrait $47 million, a large, mediocre and unfinished Picasso, *Les Noces de Pierrette*, $53.1 million, a van Gogh $53.9 million, and so on. Critics are lousy economic forecasters: none foresaw this inflation. But how many auctioneers and dealers did, in 1982?

or even twenty years ago anyone, amateur or expert, could spend an hour or two in a museum without wondering what this Tiepolo, this Rembrandt, this de Kooning might cost at auction. Thanks to the unrelenting propaganda of the art market this is no longer quite the case, and the imagery of money has been so crudely riveted onto the face of museum-quality art by events outside the museum that its unhappy confusion between price and value may never be resolved. It is like the bind in the fairy tale: At the bottom of the meadow a treasure lies buried. It can be dug up—under one condition: that while digging, you do not think of a white horse.

Moreover, there are many areas in which American museums can no longer buy. (British museums are worse off: as a result of the malignant cultural policies of Margaret Thatcher, they cannot repair their own roofs.) They voice a litany of complaints, a wrenching sense of disenfranchisement and weakness, as their once adequate annual buying budgets of two to five million dollars are turned to chickenfeed by art inflation. The symbol of the plight of the Metropolitan Museum of Art in New York is an annual booklet that used to be titled *Notable Acquisitions.* In 1986 it was renamed *Recent Acquisitions* because, as the museum's director wrote in its preface, the rise of art prices "has limited the quantity and quality of acquisitions to the point where we can no longer expect to match the standards of just a few years ago." And as the museum's buying power fades, public experience of art is impoverished, and the brain drain of gifted young people from curatorship into art dealing accelerates.

American museums have in fact been hit by a double whammy: art inflation and a punitive rewriting, in 1986, of U.S. tax laws, which destroyed most incentives for the rich to give art away. Tax exemption through donations was the basis on which American museums grew, and now it is all but gone, with predictably catastrophic results for the future. Thus, in a historic fit of legislative folly, the government began to starve its museums just at the moment when the art market began to paralyze them.

The inflated market is also eroding the other main function of museums: the loan exhibition. New York's position as art center of the West was based partly on the range, scholarship and aesthetic importance of its museum shows. And there is no question that the last fifteen years in the United States have been the golden age of the museum retrospective, bringing a sequence of remarkable and, for this generation of museums and the public, definitive exhibitions, done at the highest pitch of curatorial effort: late and early Cézanne, Picasso, Manet, van Gogh,

Monet, Degas, Watteau, Courbet, Goya, Velázquez, Poussin—and, in 1989, the greatest Cubist show ever held, "Picasso and Braque: Pioneering Cubism" at the Museum of Modern Art. Most of these transatlantic efforts, if not all, were seen in New York.

This type of serious and argued show must be distinguished from the blockbuster that was so much a feature of American cultural life in the seventies. Nobody—or nobody responsible, anyway—believes anymore that great works of past art should be sent around the world for frivolous or merely political reasons. The blockbuster, that curse of American museology, began with two events: André Malraux's loan of the Mona Lisa to the United States in 1963 (so that the world's two famous ladies, Mona and Jackie, could be in the same room at the same time) and the appearance of Michelangelo's Vatican *Pietà* at the World's Fair in Flushing Meadow in 1964, looking like a replica of itself done in margarine, the viewers carried past it on a moving walkway. It produced, at its height, frenetic events like Tut and clunkers like the Metropolitan Museum's 1983 Vatican show. It ended with that saturnalia of "heritage" nostalgia, "Treasure Houses of Great Britain," at the National Gallery of Art in Washington, D.C., in 1988. But the time of the blockbuster is gone; and it is no loss.

Yet the loss, or even the winding down, of the great monographic exhibitions will prove very serious: and that is what the art market threatens. It is difficult for museums even to contemplate large retrospectives now, and the 1991 Seurat exhibition arranged for Chicago, New York, London and Paris may be remembered—if it comes off—as one of the last of its kind. When the Metropolitan Museum of Art's "Van Gogh at Arles" was being planned in the early eighties, it was assigned a global insurance value of $1 billion. Today it would be $5 billion and the show could never be done. In the wake of the sale of *Irises*, every van Gogh owner wants to believe his or her painting is worth $50 million, and will not let it off the wall insured for less.

So circulation is slowing down and the chances are that museums will again have to rely, as they did forty years ago, much more on their permanent collections than on temporary shows—with the difference that these collections too will be relatively static. What effect this will have on the American museum audience, conditioned to expect the ever-changing stimulus of new art events, remains to be seen.

Certainly, the 1980s showed how the fear of contraction could lead institutions (notoriously, the Whitney Museum) to lower standards of curatorial judgment in the scramble for corporate underwriting and audience pull. The museum's immersion in the art world as a promotional

system reduces its independence of taste; it chooses to mirror "what's happening," for fear that it might seem obsolete. It must take its cues from the market, the main determinant of New York's visual culture in the eighties. But to invoke "what's happening," as though the museum were just a mirror, is an evasion. There are about 200,000 artists in the United States, each making (at a conservative guess) fifty or so objects a year. From the homeless proletariat of these 10 million works almost anything may be designated as "happening," but it is not likely to have any more significance in the long historical run than, say, Charles Jencks's classification of a previously uncatalogued subgroup of Japanese neo-Palladians does in architectural history. Trends can be condensed at will, and young artists, with careers such as those of Jean-Michel Basquiat or—parody of parodies—Jeff Koons held up before them, are less disposed to accept any ideal of slow maturation. This makes them vulnerable to fashion and prone to seize whatever eye-catching stylistic device they can, no matter how sterile it may be in the long run. The moral economy of the American art world has been so distorted by the hype and premature careerism of the 1980s that a serious artist in New York must face the same unreality and weightlessness as a serious actor in Los Angeles. The idea of the "cutting edge"—the phrase is still used by some curators—is likewise fatuous, a fossil relic of a belief in artistic "progress" that no one, at the agitated and directionless end of the twentieth century, will defend under its own name.

v

In thinking of centers, we remain fixed on the ancient Roman model of cultural imperium and so tend to overlook the possibility that things can work differently. But for centuries, they did—as in medieval and early Renaissance Italy. The slow growth of its city-states tended to emphasize what was native, local and patriotic. They fought wars, but none of them had the size, military reach or wealth to subjugate the rest. Hence no Italian state at the end of the quattrocento, not even Rome, had the gravitational field of an imperial culture center.

At the height of Donatello's career there were perhaps 65,000 people in Florence. There was a modest international art market. Artists did work in cities other than their own, as Leonardo did for the Sforzas in Milan. But travel was difficult, no image could be mechanically reproduced with accuracy, and museums did not yet exist; the idea of the traveling show was centuries away. Hence art tended to focus on specific acts of com-

memoration and propaganda—this fresco of the Last Judgment for our local church, this statue of the hired general who saved us from the baleful Pisans.

The results were regional in the best sense, the sense that matters. To this day the ancient cities of Italy, big ones such as Florence or little ones such as Todi, convey a satisfying sense of cultural wholeness—the full use of culture in the interest of local resources. Strictly speaking, this is a relic; they, like us, live in the late twentieth century and can only preserve what remains of the past without significantly adding to it. But at least one can still see the work there within the frame of the landscape, the vernacular architecture, the roots of its meaning.

What altered this regional ecology of the arts in Italy, and throughout Europe, was the rebirth of ancient Rome. The bones of the empire rose from the soil and reconstituted themselves as an aesthetic imperium. When Italian artists began to take a systematic interest in the relics of antiquity, the classical past was seen to contain whole systems of norms and forms for the present, of an authority not apparent in the Gothic.

Very soon the rediscovery of Vitruvius's writings and the digs in the Forum made the journey to Rome a necessary part of an artist's education. The Florentine, however much he felt that his city was the best of cities, could no longer believe that its aesthetic resources were going to give him all the language he could use. So he went to Rome—like Alberti, like Donatello, like Piero della Francesca, like Michelangelo. As soon as artists recognize that a place embodies cultural resources whose truth and efficacy exceed the merely local, no matter how fond they are of their own *paese,* the idea of the cultural capital is born. Once the stuff of this cultural stimulus is seen, then systems of interpretation will form around it—the academies, the art schools. Their monopoly of technique adds to the gravitational field of the capital. And so do the works the visitors leave. Michelangelo's Sistine and Paoline frescoes, Raphael's Stanze, become fused with the antique as part of the whole authoritative pattern that later artists come to Rome to experience. Only in the capital could schools of art and bodies of art theory make themselves felt. One of the great benefits of the center is centralized argument.

What could Michelangelo Merisi, growing up in the little northern town of Caravaggio, expect to learn about painting? He had to get to Rome; only Rome could open to him the scale of work and the technical proficiency that he sought. Capitals rejuvenate themselves by this gravitational pull. They draw their nourishment from the provinces. Caravaggio, Pietro da Cortona and the Carracci came to Rome more for its dead artists

than its uninspired living ones; most Roman painting in the early seventeenth century was as sunk in affectation as the much-touted *transavanguardia* in the early 1980s. But in the process they transformed Roman painting and added to the sense of the capital for centuries to come. They also changed the work of other foreigners in Rome, so that the Caravaggian style spread all over Europe.

Likewise, the careers of Nicolas Poussin and Peter Paul Rubens are unimaginable without their strong sense of the priorities of the capital. Poussin felt alienated from art in his native France: he craved the support of standards that only Rome could generate. "Were I to remain in this country for a long time," he wrote to his friend Cassiano del Pozzo from Paris in 1641, "I should be forced to become a *strappazzone* [hack] like all the other artists here. Studies and valuable observations from the antique and other sources are completely unknown."

Yet by 1670 Rome's decline as a center for living art had begun. It was still obligatory for a serious painter or sculptor to study in this great hive of time, and several more generations of foreigners, from Fragonard and Hubert Robert to the German Nazarenes, did so. But papal patronage slowed after the death of Urban VIII Barberini. There would be no more fresco cycles like Pietro da Cortona's ceilings for the Barberini Palace; no more architectural projects like Bernini's colonnades. Perhaps the outstanding work of visual art produced in Rome in the eighteenth century was the huge corpus of etchings by Venetian architect Giambattista Piranesi (1720–1778), whose obsessive subject is nostalgia: from the scale of those tiny figures picking their way over fallen pediments or dwarfed by the immense vaults of the *thermae*, we infer an acute sense of lost cultural potency.

When power declines and the center cannot hold, its works of art move into the eddy of the market and wash up where power is great, money is plentiful and order reigns. Although the image of Rome as cultural capital would go on for centuries, its reality would be enacted in Paris; this transfer was the work of Cardinal Mazarin, who took effective control of the French administration in the 1640s and began to move huge quantities of Italian art into France, thereby forming the basis of the state collections centralized in the Louvre. The aesthetic rise of Paris in the seventeenth century had the same epic quality as its political and military rebirth. Before long any cultivated Parisian could congratulate himself on living in a new Rome, a capital of the arts whose destiny was to be fed by whatever was best in the provinces—the talents of a magistrate's son from Rouen who became Pierre Corneille, or those of a boy from Valen-

ciennes named Antoine Watteau. This confidence in the uniqueness and supremacy of the capital would be reinforced by Napoleon and by the whole imagery and style of French neoclassicism. And it would continue to be ratified right through the nineteenth century, up to World War I.

The drift of economic history, and of population, fed it too. France was changing from a nation of countrymen to one of city-dwellers. By 1851 the urban population outnumbered the rural for the first time, in both France and England. By the 1860s this scheme of opposites—the superiority of the city to the provinces, the hostility of the provinces to the city—was set to become one of the axioms of the modernist creed, and hence of culture *as such*.

The idea of an avant-garde was born in the nineteenth century, in the ideas of men such as Baudelaire. And it was linked to city life. Cities inflicted rapid change on human life; the country stood for slow change, or none at all. The provinces, *la France profonde*, were inherently conservative; Paris, inherently radical. This image of the dynamic capital against the torpid provinces was tied into all the main cities of modernism— Moscow and Leningrad, Vienna and Berlin, Milan, Barcelona, New York. But Paris was the place where it was first seen as a great issue. "The interior is going to die," complained the diarist Edmond de Goncourt in 1891, looking at the demolition crews. "Life threatens to become public. I am a stranger to what is coming, to these new boulevards, implacable in their straight lines, which no longer evoke the world of Balzac, which make one think of some American Babylon of the future."

In this new Babylon, private life gets turned inside out by a new sense of public space. The café and the boulevard are stages that turn life into spectacle. Old social rankings weaken and new ones have to be named by artists—by Degas and Manet, for instance, tracing the fabric of slippages and pretensions, connoisseurs of the gesture and the passing moment. The art of the new Paris, capital of modernism, is fascinated by social ambiguity, with the freedom to make one's own life up.

So the idea of the capital city helped breed two of the most durable elements in the artistic avant-garde: the sense of not having a fixed self, of being free to invent; and the idea of the artist as subversive. These combined to raise two chief themes of modernist self-awareness in art: disconnection and loss on one hand—the loss of a secure social past, of a parental tradition; but on the other hand, artistic self-emancipation. Exchange of information was to the modernist capital what the contemplation of nature was to the eighteenth century. By the end of the 1920s the capital had become a machine designed to contemplate itself, to fill the world with images of itself.

Likewise, modern painting and sculpture were hugely affected by the crowding of resources in the great city. Art has to feed on art. The center would not send things to you—you had to go to it, like Picasso coming to Paris from Barcelona in 1900. The forms of fin-de-siècle Paris were to modernism what the marbles of Rome had been to classicism: think only of the Eiffel Tower, or of what Picasso and Braque, in their Cubist paintings, did with the texture of signs and reflections seen in the new Paris street, the billboards, ads, newspapers, all the mass-produced imagery of an industrial world. There was no such thing as rural Constructivism or pastoral Futurism. And Paris was the dream city of Surrealism too.

This fixation on the idea of the capital was carried over to New York City forty years ago. Manhattan was the capital of change—the Rome of instability. "Tomorrow's world—today!" The motto of the 1939 New York World's Fair was also that of America's growing new-culture industry. Europe with its more fixed orders might resist change, thereby creating one kind of avant-gardism, in opposition to authoritative culture. But America embraced the new, because its enshrined social and technological myth was one of progress. With a little prodding, it was willing to embrace almost any "radical" cultural change as therapeutic. Its cultural industry was announcing fresh, temporarily unnerving aesthetic changes and telescoping the future into the present. This being so, what American was really going to want an academy? Who was afraid of the future? In America the new was strong, tradition (relatively) weak.

Much European modernism, notably Constructivism, had taken its stand on millennarian hope. Abstract art was imagined as the final style, the end of history, in which all tensions and contradictions would be resolved—a religious fantasy at root, like Karl Marx's fantasy of the withering away of the state after the dictatorship of the proletariat. The tyranny of the past could be counteracted by an equal and opposite reign of the future—an avant-garde forever gazing ahead to utopian prospects which always recede.

But this was not congenial to Americans. Here, avant-gardism embraced a more businesslike model of novelty and diversity, the fast obsolescence of products, the conquest of new markets. In the overcrowded art scene of the eighties this would accelerate to the point of hysteria. In the fifties and sixties, when there were fewer artists, collectors and museums, the differences between New York's new-art environment and the "classical" European avant-garde, circa 1900–30, were perhaps not so obvious, although they certainly became so with Pop art. The American idea of avant-garde activity became competitive and inflationary, swollen with excess claims for itself.

It still is, but the claims are largely hollow and the reaction against them, once the false euphoria of the eighties wears off, will be harsh. In the main this was a low, dishonest decade for art, American art especially, and part of its dishonesty lay in the pretense that the idea of the "vanguard" still had some relation to aesthetic and ethical values. But perhaps one of its positive results will be finally to clear our minds of the cant of cultural empire and, with that, of nostalgia for the lost imperial center. Under the present circumstances a great artist could just as easily—and unexpectedly—emerge in Hungary or Australia as in New York. One may bet that in the nineties the necessary reconstruction work on the strip-mined sites of late modernism will be done in Britain and in Europe, rather than the United States. And even there, one should not expect too much, or expect it too soon.

I

Ancestors

Hans Holbein

That Hans Holbein the Younger (1497–1543) was one of the supreme portrait painters has never been in doubt. Anyone who has been to the National Gallery in London and seen his painting *The Ambassadors*—two wary young traders amid their clutter of emblematic objects, with an anamorphic blur of a skull floating across the inlaid floor—knows that at once. Together with his older contemporary, Albrecht Dürer, Holbein represents the point at which German painting shook clear of its Gothic past and its folk ties, entering and interpreting the Renaissance streams of power and trade, becoming a primary instrument of self-recognition for a new Europe.

At a time when most people lived and died within ten miles of their birthplace, when travel was arduous and news was the most expensive commodity in Europe, Holbein was a completely international man: he worked in Germany, France, Switzerland, Italy and, especially, England. His work, despite its integrity of style, was open to all kinds of influence: portrait prototypes ranging from Leonardo to Titian, the work of the Fontainebleau mannerists, Quentin Massys, English court miniaturists, Dürer and Matthias Grünewald. It seems to range backward and forward in time, a web of allusions that seldom rise to open quotation. Thus in drawing Cecily Heron, the youngest daughter of Sir Thomas More, Holbein selected the pose of another woman with the same first name, Cecilia Gallerani, the model for Leonardo's *Lady with an Ermine*. If one could not deduce from his work that Holbein's was one of the best minds of the Northern Renaissance, the names of his friends would suggest it: he was on familiar terms with such heroes of intellectual life as Erasmus and Sir Thomas More.

The surfaces of Holbein's paintings hide the machinery, as they were meant to do. For the first impulses, the slow probings and swift appraisals of a face, one must consult the drawings: something easier said than done in America until now. Although there are paintings by Holbein in U.S. collections, the body of his graphic work is in England and on the Continent. The most important part of it belongs to the British royal family and is housed at Windsor; it comprises the many sketches Holbein made of the nobility and gentry at the court of Henry VIII during his two sojourns in London, a short spell from 1526 to 1528 and a long one of eleven years that finished with his death, of the plague, in 1543. Much of this oeuvre is on view at the Pierpont Morgan Library in New York City, where it is amplified by material from the library's own collection—rare editions and manuscripts by and about Holbein's circle of patrons and friends, prints derived from his images, and so forth.

Nobody, one may morosely predict, will ever draw the human face as well as this again. The tradition is cut, the bow unstrung. But the drawings remain—abraded, retouched, sometimes (as in a study of the bony, intense face of Bishop John Fisher) vandalized by later hands, yet through it all, radiating their freshness of scrutiny. What strikes one first about them is their self-evident truth. Nobody else got the knobbly, mild face of English patrician power so aptly, or saw so clearly the reserves of cunning and toughness veiled by the pink mask. The idea that Holbein was criticizing his subjects is, of course, absurd; and yet his rapport with them was so acute that he could render their unease at the unfamiliar sensation of being limned. Young Sir John Godsalve, one of whose offices was resonantly called the Common Meter of Precious Tissue, is watching Holbein as Holbein watches him: calm and yet withdrawn to the fine edge of nervousness. It is the look people used to direct at cameras a hundred years ago, before everyone got used to the lens.

One knows these faces; better shaved, they populate the West End in London today. Even the women, as in Holbein's elegant full-face study of Mary Zouch, square-jawed and pale, are reborn among the Sloane Rangers outside Harrods. "Here is Derich himself; add voice and you might doubt if the painter or his father created him," runs an inscription on one of Holbein's portraits of a Hanseatic merchant in London, and for once the clichés about "speaking likeness" do indeed seem fresh. In drawing after drawing, the nervous mobility of the pencil or black chalk, linking blank spaces of paper together in casual but strict tensions between mark and void, creates a pictorial equivalent of the sitter's thought as well as the artist's. Hence the authority of Holbein's drawings of his friend Sir

Thomas More, which maintain the etiquette of distance and yet hint at the complexities of emotion such a face could display.

Holbein's formal resources were inexhaustible. His touch went all the way from emphatic black strokes to the subtlest frizzing and tonings of gray in a beard, and his sense of how to "tune" hard linear passages against evanescent transitions of tone seems never to have failed him. Sometimes he used technical aids: it is thought that some of the drawings were traced from the sitter's image on a transparent glass pane; this practice represents an early use of the principle of the camera obscura advocated by Dürer, and a forerunner of photo-derived painting. But the liveliness of touch is something no camera can give. Every hair in the scalp lives and has its place. The curve of a mouth or the arch of an eyelid is precisely weighted against the amount of blank space it must enliven. The intensity of detail shifts with marvelous fluency.

It is not certain how far Holbein wanted these drawings to be taken as finished works of art, but the fact that he did not discard them even when they had been developed into paintings suggests that he placed more than instrumental value on them. But whatever the cause of their preservation, one can be only grateful for it. No other group of Renaissance drawings offers so vivid a picture of a class. They are as fraught with human interest as any court memoir by Hervey or Saint-Simon.

Time, 1983

Caravaggio

"The Age of Caravaggio," the Metropolitan Museum of Art's big show this winter, may come to be remembered as a marker in the history of exhibitions. Not even the Met, this time, could get the loan of his greatest work. Owners and curators are getting more conservative, especially in Italy, and the days when uniquely important works of art could be flown around the world like greeting cards, even for scholarly purposes, are fading.

In 1951, when Italian scholar Roberto Longhi mounted the crucial show that brought Caravaggio out of three centuries of neglect and

obloquy, this was not a problem. But thirty-four years later, thanks to the enthusiasm generated by Longhi, probably more people go to, say, the Church of San Luigi dei Francesi in Rome to worship Caravaggio than to worship God.

There are splendid things in the Met's show: nobody could say that rooms holding Caravaggio's Uffizi *Bacchus* or the London *Supper at Emmaus* or the Thyssen *Saint Catherine* are underoxygenated. Moreover, the Met has done some good to scholarship by setting Caravaggio against what was painted in Italy, and especially in Rome, when he was alive. Other exhibitions have focused on how the artist influenced seventeenth-century painting all over Europe. This one shows the painting that influenced him when he was growing up—and the visual pedantry he had to contend with. Except for Lotto, Tintoretto and Bassano, and some beautiful works by Annibale Carracci, Adam Elsheimer and Guido Reni, most of this is deadwood and of interest mainly to specialists. Moreover, the climactic efforts of Caravaggio's career, such as *The Beheading of St. John the Baptist* in Malta (which must be the most concrete work of the tragic imagination painted between the death of Michelangelo and the maturity of Rembrandt), are not here. So it is best to treat the Met's show as a preparation for pilgrimage and to ignore the blatant copies, pastiches and restored wrecks, such as *The Magdalen in Ecstasy*, *The Toothpuller* and *The Martyrdom of St. Ursula*, with which its closing rooms are padded.

Today Caravaggio ranks almost with Rembrandt and Velázquez as the most popular of seventeenth-century artists. Mythmaking has something to do with this. We have a proto-Marxist Caravaggio, the painter of common people with dirty feet and ragged sleeves. There is also a homosexual Caravaggio, the painter of overripe bits of rough trade, with yearning mouths and hair like black ice cream. Most of all, there is Caravaggio the avant-gardist.

The late twentieth century loves "hot" romantics and geniuses with a curse on them. Caravaggio's short life and shorter temper fit this bill. He died of a fever in 1610, at age thirty-nine, in Porto Ercole, then a malarial Spanish enclave on the coast north of Rome. The last four years of his life were one long flight from police and assassins; on the run, working under pressure, he left altarpieces in Mediterranean seaports from Naples to Valletta to Palermo. He killed one man with a dagger in the groin during a ball game in Rome in 1606, and wounded several others, including a guard at Castel Sant'Angelo and a waiter whose face he cut open in a squabble about artichokes. He was sued for libel in Rome and mutilated in a tavern brawl in Naples. He was saturnine, coarse and queer. He thrashed about in the etiquette of early seicento cultivation like a shark in

a net. So where is the mini-series? When will some art-collecting shlockmeister of Beverly Hills produce *The Shadows and the Sodomy*, the 1980s answer to *The Agony and the Ecstasy*?

Popular in our time, unpopular in his. So runs the stereotype of rejected genius, which identifies Caravaggio as the first avant-garde artist. Our time, with its craving for rapid and unnerving change in the look of art, was bound to like Caravaggio. He was called an evil genius, an anti-Michelangelo; his work was compared to an overpeppered stew, and it became a favorite pretext for finger-wagging in the seventeenth century.

But if critics said one thing, the collectors said another, and this time the collectors were right. Caravaggio found influential patrons almost as soon as he arrived in Rome in 1592–93; they included Cardinal Francesco Maria del Monte, who owned eight of his paintings, and Vincenzo Giustiniani, who had thirteen. The Caravaggian cave of darkness was not invented yet. His early work tends to be bathed in a crisp, even, impartial light, recalling Lotto and (more distantly) Giorgione. Typical of this manner were *The Rest on the Flight into Egypt*, which is not in the show, and the Metropolitan's *Musicians* and the Uffizi *Bacchus*, which are. The *Bacchus* is detached, down to the last dirty fingernail on the figure's pudgy hand: not a god, but a pouting, weary-eyed model in costume, his crown of vine leaves rendered with sparkling exuberance, his flesh slack and tallowy, and half the fruit bruised or rotten.

No other Italian artist of the day had such mastery of gesture. Caravaggio was a minute observer of body language: how people move, slump, sit up, point and shrug; how they writhe in pain; how the dead sprawl. Hence the vividness of Abraham's gesture in *The Sacrifice of Isaac*, as he holds his wailing son down on a rock like a man about to gut a fish. In *The Supper at Emmaus*, the characters seem ready to come off the canvas, as Christ makes his sacramental gesture over the food. This insistence, this feeling of a world trying to burst from the canvas, is epitomized in one detail of the *Supper*—the basket of fruit, perched on the very brink of the painted table and ready to spill its contents at one's feet. Later, Caravaggio would learn how to combine poses seen in real life with those sanctified by tradition: hence the contrast achieved in the Louvre's *Death of the Virgin* between the onlookers, as grave and classical as any quoted from a sarcophagus, and the dead Mary, sprawled like a real corpse. He learned to run variations on the idea of decorum; to achieve stately effects and play them off against the "merely" documentary. His enemies thought this showed a taste for the banal. Today it suggests how little, in art, can be more radical than a hunger for the real.

Yet like many aesthetic radicals, Caravaggio had a conservative

streak. He had come from the northern provinces, in his early twenties, to an art world in recession. Rome in 1592 had a great past but a mincing present. The accepted style was a filleted kind of Late Mannerism, turned out by the frescoed acre by artists such as Caravaggio's early master, Giuseppe Cesari, alias the Cavaliere d'Arpino. Garrulous, overconceptualized and feverishly secondhand, Roman art in the 1590s was in some ways like New York art four centuries later.

Against that pedantry—the seicento equivalent, perhaps, of our "postmodern" cult of quotation—Caravaggio's work proposed a return to the tangible, the vernacular and the sincere. For all the theater in his work, Caravaggio had far more in common with the great solidifiers of the Renaissance, from Masaccio to Michelangelo, than with the euphuistic wreathings of Late Mannerism. He reclaimed the human figure, moving in deep space in all its pathos and grandeur, as the basic unit of art—the one that provokes the strongest plastic feelings by mobilizing our sense of our own bodies. He freed it from the musty envelope of allegory by putting it in common dress and lighting it "realistically," from outside the picture.

Above all, he brought to the human figure a renewed sense of design. Caravaggio's work moves from clutter toward simplicity: tracing their signs for energy and pathos in the dark, his bodies acquire a formidable power of structure. Sometimes it is very clear; the figure of David holding up the head of Goliath (the Goliath is a self-portrait, a striking rehabilitation of a "monster" as heroic victim) has the abruptness of an ideogram. Elsewhere it is subtler: the geometry of his *St. Catherine* consists of two triangles, one formed by the saint's gleaming upper body and dark skirt, the other by the attributes of her martyrdom: the sword tipped with a red reflection from the cushion, meeting the palm frond at an angle subtended by the arc of the broken wheel.

In one way Caravaggio's quest for strength and legibility reversed itself. He exaggerated the battle between light and dark to such a pitch that the late work became hard to read; its forms turned anxious and flickering. By then, this confusion had acquired its own expressive integrity as the handwriting of a painter more and more possessed by death. Caravaggio's sense of mortality was the thing his imitators found hardest to copy. But this did not stop the spread of Caravaggism. Within a decade of his death his followers had diffused his message all over Europe: Caracciolo and Ribera in Naples, Georges de La Tour and Valentin de Boulogne in France, Seghers and Honthorst in The Netherlands, and dozens of others inside and outside Italy.

Scratch almost any great seventeenth-century painter except Poussin, and traces of Caravaggio will appear. The vivid piety of his work after 1600 was fundamental to Baroque painting. Without his sense of humble, ordinary bodies lapped in darkness but transfigured by sacramental light, what would Rembrandt have done? Caravaggio was one of the hinges of art history: there was art before him and art after him, and they were not the same.

Time, 1985

France in the Golden Age

Some exhibitions can be done by great museums only at their full stretch. They alter the way art history is read, and "France in the Golden Age," at New York's Metropolitan Museum of Art, is one of these uncommon and persuasive events. It consists of 124 paintings by seventeenth-century French artists, all culled from American collections. Some are famous, like Nicolas Poussin or Georges de La Tour; others, such as Laurent de La Hire or the extraordinary still-life painter Sebastian Stoskopff, are familiar only to specialists. The show is the climax of long work on this period in French painting, done by scholars on both sides of the Atlantic. Its catalogue, by Pierre Rosenberg, conservator of paintings at the Louvre, is a model of scholarly enthusiasm—as is its long prefactory essay by Marc Fumaroli.

The French still call the seventeenth century *le grand siècle.* During it, French culture reinvented itself, regaining the strength (if not the spirituality) it had in the Middle Ages. From the centralization of state power to the design of gardens, from the cult of literary "genius" to the rationalization of economic policy, its social tissue dilated with confidence. France's idea of itself as a nation bound by collective myths and a shared destiny had been precarious: it was rent by feudal squabbles, foreign invasion and civil war. Culturally, Paris in 1600 was little more than a colony of Italy; the Frenchman traveling south was made painfully aware that he came from a second-class power. "We are indeed the laughingstock of everybody, and none will take pity on us," Poussin morosely

wrote from Rome in 1649. "We are compared to the Neapolitans and shall be treated as they were."

But the symbol and instrument of change was crowned at Reims five years later—the Sun King, Louis XIV, whose joining of a more than Roman *gravitas* to an insatiable desire for glory made him the central motif of French social myth and so of French culture. He was hailed as the new Caesar Augustus, the bringer of a literal golden age of peace and wealth. "The sun has its spots," exclaimed one of his courtiers on hearing a complaint about the king's financial management, "but it is still the sun." Not all Frenchmen of the lower orders, taxed hard to underwrite his wars and palaces, agreed. One of the irreverent epitaphs that circulated on his death, in 1715, sourly remarked that

> *Ci-gît au milieu de l'église*
> *Celui qui nous mit en chemise.*
> *Et s'il eut plus longtemps vécu*
> *Il nous eut fait montrer le cul.*

"Here lies, in the midst of the church, the man who had us down to our shirts; and if he had lived longer, he would have had us showing our arses." To celebrate this bewigged divinity, the right language was one of ideal form, majestic elocution and classical certainty: the diction of imperial Rome brought up to date. This did not, of course, develop overnight, for great artists who bring such language do not simply materialize like good waiters when a monarch snaps his fingers. But by any standards, the cultural efflorescence around Louis XIV was astounding—among dramatists, Corneille, Racine and Molière; among writers, La Rochefoucauld and La Fontaine; such architects as Mansart, Perrault and Le Vau; the garden designer Le Nôtre, whose monument is the parks and parterres of Versailles. Louis XIV's ministers also set about creating or strengthening the institutions of official French culture, meant to raise art, writing and thought to a new level of prestige: the French Academy for literature, the Comédie Française for drama, the Royal Academy for painters and sculptors, and the Academy of Sciences.

At the start of the seventeenth century, painting in France was not, on the whole, an instrument of state glory; it tended to be seen as a manual business, a craft. The story of French art in this period is very largely that of painting's struggle to be seen on a level with literature or philosophy. This entailed confronting the source of all great artistic prototypes, Rome, which supplied models both antique and modern. The chief modern one

was Caravaggio, who had died on a malarial Mediterranean beach at the start of the seventeenth century and left a legacy of influence all over Europe. To paint commonplace models in tavern settings or caves of gloom, to infuse biblical subjects with an exacting realism and directness, to drive the preciosity of Late Mannerism out of art—such were the aims of French Caravaggisti such as Valentin de Boulogne (1591–1632), whose *Fortune Teller* raises narrative to a pitch of ironic theater worthy of Caravaggio himself. It is a raffish image of tavern survival: the old circular comedy, as the gypsy woman bilks a credulous soldier while a man steals her chicken and a little girl lifts the thief's purse.

The best French painter to fall under Caravaggio's spell was, however, Georges de La Tour (1593–1652). His own *Fortune Teller* (the subject was perhaps bound to be popular in a country as worried about the future as early-seventeenth-century France) remains one of La Tour's masterpieces. Now that it is cleaned of grime and later repainting, its color is crisp and specific, like taffeta in spring sunshine; and to see it in a room with seven other La Tours, including the Wrightsman *Magdalen* and *The Musicians' Brawl*, is to realize how the traits of style cited against it by detractors—the theatrical "unreality" of costume; the clear, generalized volumes of cylindrical arm, of egg-shaped head—actually connect it to the rest of La Tour's oeuvre and help certify it as an autograph work.

La Tour probably never went to Rome; Nicolas Poussin, once he got there, rarely returned to France, although he was (in Pierre Rosenberg's words) "the greatest French painter of the seventeenth century"—perhaps even the greatest French painter in this show—and their cumulative effect has a Virgilian magnificence. *The Death of Germanicus*, 1626–28, in which the Roman general, allegedly poisoned by his adoptive father, Tiberius, is seen exhorting his friends to avenge his death, is one of the supreme images of civic virtue in French art, and Poussin's first success in the heroic mode. One can dissect its mechanics—the contrasts between the masculine and feminine groups; the cross-quotations of pose and gesture that link the two; the intelligent discretion with which Poussin used motifs from the antique—without losing touch with the deep emotions it conveys. Painterly language never strains against meaning: this is speech, not rhetoric. In the same way, Poussin's landscapes, as in the painting of St. John writing on Patmos, are grave and ample, the "Fair Champaign" of Milton's *Paradise Regained:*

Fertil of corn the glebe, of oyl and wine,
With herds the pastures throng'd, with flocks the hills,

Huge Cities and high tow'r'd, that well might seem
The seats of mightiest Monarchs, and so large
The Prospect was, that here and there was room
For barren desert . . .

Nothing trivial can happen in this landscape; nature is didactic, chance has no place. Poussin's strenuous organization of its space, the carefully marked planes ranked across the canvas with no sudden plunges or corridors for the eye, was to become one of the fundamental ways of seeing landscape. It looks antique, but it was potentially modern. Its not so remote descendant would be the stony, planar monumentality of Cézanne's views of Mont St.-Victoire. Three hundred years later, it seems to point toward the flatness of classical modernism. This may be an illusion, but it is hard to shake; in any case, painting of Poussin's order of greatness often seems to predict the future at the very moment of assimilating the past. If there were nothing but the Poussins in this show, one would still need to see it.

Time, 1982

Anthony Van Dyck

The peculiar achievement of Sir Anthony Van Dyck was to have invented the English gentleman—not the mild, knobbly creature one sees beneath its bowler in the street, but the now vanishing archetype of aristocracy, calm and straight as a Purdey gun barrel, with the look of arrogant security guaranteed to paralyze all lesser breeds from Calais to Peshawar. This invention began in 1632, when Van Dyck, an ex-assistant of the greatest court painter of his age, Peter Paul Rubens, arrived in London. It ended with his death at the age of forty-two, in 1641. In between came seven years of service to the court of Charles I and his wife, Queen Henrietta Maria, during which Van Dyck attained the kind of success that few artists of the time could imagine. Inundated with commissions, eulogized by poets, fluent and tireless, he helped set the cultural standards of the Caroline age.

Standing before Van Dyck's work, as a patron wrote to him, one felt "the Luck to be astonish'd in the righte Place." The current exhibition of Van Dyck's English portraits, organized by Oliver Millar at the National Portrait Gallery in London, shows how well Van Dyck's fluency has lasted. It is a delectable exhibition, though cramped and clumsily installed, and it makes one realize how far the tradition of formal portraiture has declined since the days when Van Dyck epitomized it.

Certainly, Van Dyck knew how to make his sitters look handsomer than they were. Any cosmetician can do that; it is part of the ordinary transaction that painting and photography have with reality. Before photography, when one's idea of a strange face had to be set up by painting, the disparity between the evidence of the eye and the speech of the brush could sometimes come as a shock. One of Prince Rupert's sisters, who knew Queen Henrietta Maria only through the portraits of Van Dyck, was dismayed to meet a short woman with crooked shoulders, spindly arms, and teeth that stuck out of her mouth "like guns from a fort."

Another of Van Dyck's clients, however, the Countess of Sussex, lamented that he had made her look "very ill-favourede," stout in the cheeks, like one of the winds huffing and blowing. "But truely," she conceded, "I thinke it tis lyke the originale." *Flattery* is not a word that can quickly be defined, at least in portraiture. How it is used, what it means depends on how the sitter feels about himself and how posterity will feel about the sitter. Our own bias, in a post-Freudian age, is toward portraits that show a "truth" about the sitter that the sitter was not willing to admit. But that is not how the portraitists of the sixteenth, seventeenth and eighteenth centuries saw their work.

Portraiture was a description of public roles, as well as a (necessarily discreet) essay on the private self. The unsparing vision of later Rembrandt self-portraits was the exception in Baroque art, not the rule. In Munch or van Gogh, portraiture resembles a siege laid to the Self by the Other. In Van Dyck or Reynolds, portraiture is diplomatic agreement between truth and etiquette, between private opinion and public mask. Since the Self is the sacred cow of today's culture we are apt to find this less "interesting" than fictions of interrogation and disclosure. But that is our problem, not Van Dyck's. It is also, of course, why we have no formal portraiture of any value.

In looking at portraits, we project ourselves on the past. We routinely call Velázquez's pictures of dwarfs "compassionate," not because we know what Velázquez felt about dwarfs but because we believe we ought to feel sorry for the deformed. We like to detect ferocious antimonarchical

satire in Goya's royal portraits, although the Spanish royal family was delighted with them and nobody at court thought them at all irreverent.

With Van Dyck, the question of flattery remains elusive, as it must with all great portraitists. Thus if one were to isolate the left-hand profile of Charles I from the triple portraits Van Dyck made to guide Bernini, a thousand miles away in Rome, in carving the bust of the monarch he had never seen, a Cromwellian might have much to say about it, starting with the sensuous coarseness of the nose, the air of shattered weakness suggested by the modeling of the mouth. Yet all that is questioned by the face-on portrait in the center, and refuted by the melancholy, angelic refinement of the King's three-quarter face on the right. If one wanted a king, one would want him to look like that. Perhaps no seventeenth-century portraits of exalted men (not even Rubens's) display a more intense awareness of the nuances of skin as it stretches over bone and sags, or is drawn into the hollows of the skull: mobile, labile, silken, it becomes a façade of extreme expressiveness. No wonder that this painting was acclaimed, "not only," as a contemporary put it, "for the exquisiteness of the worke but the likenesse and nere resemblance it had to the King's countenance."

Three kings within a king; a secular version, almost, of the Trinity, and implicitly a reminder of the divine right of kings. The grand military portraits are more straightforward; for example, the Earl of Strafford, lord lieutenant of a colonized Ireland, erect in dark glittering armor and soft boots, worshipped by a huge Irish wolfhound—a direct quote from Titian, but with local political undertones. In such works one sees Van Dyck, as a London reviewer has remarked, "take British art by the seat of its Tudor hose and pull it into the modern age," or at least the Baroque one. No portraitist had more influence on the way the English presented themselves to the gaze of others. Without Van Dyck there would have been no Reynolds or Gainsborough or Sargent: it is almost as simple as that.

Before Van Dyck, English portraiture was stiffer and simpler. The single figure was composed around its own central axis, body and head facing declaratively toward the spectator: Here I am, this is all. With Van Dyck, portraiture became a drama of self-presentation, whether rhetorical or inwardly nervous. Part of his skill was to convey the illusion that the sitters, not he, had invented their poses. Bodies twist, elbows are cocked, and the entire surface—cheek, lace, sword hilt, foliage, silk, the clenched hand and the soft quatrefoil of suede that rests on boots like a leather butterfly—is alive with touch.

Van Dyck's most memorable portraits, to a modern eye, are those that set up a feeling of subtle tension inside this play of delectable surfaces. Thus with the full-length image of the two golden sons of the Duke of Lennox, Lords John and Bernard Stuart. "Most gentle, courteous and affable," a memorialist called one of them, "and of a spirit and courage invincible." On one lével the portrait is an essay on rank, arrogance and the dauntlessness of youth. Lord John, on the left, proclaims his rights as elder brother by standing a step above Lord Bernard. But the rhythms of the design link them intricately together, and the indifferent gaze Lord Bernard throws over his shoulder has the security of a rare animal looking at another, less interesting species. A few years later, both were dead in the Civil War. As usual, only the portrait remains, a shadow, like the rest of Van Dyck's English work, of the most sophisticated court that England ever possessed.

Time, 1983

George Stubbs

Throughout his long life and for 150 years after his death, George Stubbs (1724–1806) was known as a horse painter. Never mind the Parthenon frieze, the Marcus Aurelius, the equestrian portraits of Verrocchio or Donatello, or any of the rest of the repertory of equine imagery in Western art: horse painting, like "sporting" art generally, tends to be seen as a minor style of aesthetic tailoring, shaped to reflect the blunt amusements of a class not much liked by connoisseurs. Painters such as Sir Alfred Munnings, who filled canvas after canvas with accurate replications of poised fetlocks and Lobb boots, are despised by art critics; and even in the eighteenth century, the age of the horse par excellence, Stubbs's attainments were looked down on by his fellow painters.

Today one sees him differently, not just as an *animalier* but as an artist of the whole rural scene, including its people. Stubbs had a haunted, driven side, and its combination with his visions of social tranquillity was like nothing else in eighteenth-century art. His anatomical studies of the horse, dense with thought and laden with death, rivaled Leonardo's anato-

mies and, like them, came from grueling years of dissection and observation. His variations on a favorite subject, the white horse neighing in anguish as it is mauled by a lion in the wilderness, are among the archetypes of Romantic imagination, comparable in intensity to Goya or Géricault. Finally, he was a minute and sympathetic watcher at the human theater of the English class system.

In sum, Stubbs was not just an interesting minor artist but a thoroughly absorbing one who often rose to greatness—as well as the best horse painter who ever lived. And since the exhibition of his work at London's Tate Gallery, which will go, with some substitutions and deletions, to the Yale Center for British Art in early 1985, American museumgoers will be able to test for themselves the feeling, now spreading in England, that Stubbs is to be ranked with Turner and Constable in English painting.

Stubbs lived at a time of intense curiosity about the animal world. Strange creatures and people from the corners of a growing empire drew crowds when they were put on show in rented London rooms; photography had not made all things familiar. The wonders of Africa, America and the Pacific glared peevishly back at the Georgian dilettanti from their wooden dens and dirty straw. "Just arrived from Botany-Bay," ran a newspaper advertisement in 1789, "three new live animals for the amusement of the public, with that singular animal the African Savage, a noble Lion and Lioness, a pair of beautiful Leopards, a Lynx, a Sangwin, the Arabian night-walker. . . . The Spotted Negro attends from eleven to seven in the evening."

Stubbs painted quite a few such marvels (although not, alas, the Arabian night-walker or the Spotted Negro). He portrayed lemurs, monkeys, a rhinoceros and several leopards, and foreign animals gave him the pretext for two of his greatest images. One of these was a painting of a cheetah that had been sent to London as a gift to George III from a former governor-general of Madras. It is a marvel of detached observation. In straightforwardness and dignity, unblemished by caricature, the heads of the animal's two Indian handlers rank with Rubens's famous studies of an African black. The evocation of substance, from the hair of the cheetah—done in a rippling amber pelt of short directional strokes interspersed with broader whiskery featherings—to the play of light on the white turbans and dhotis, is breathtaking.

The second exotic subject is more mysterious, almost surreal. It is of a zebra mare that had been brought from the Cape of Good Hope and given to Queen Charlotte in 1762. This "painted African ass," the first seen

in England, was installed in the royal menagerie at Buckingham Gate. When he came to paint it, Stubbs set it in an English wood, its black-and-white hide in contrast to the green tunnels of boscage and filtered shade that stretch behind it. It is as though one had taken a wrong turn in the Forest of Arden and encountered a mildly grazing apparition from another world.

Like all great artists, Stubbs was quite unsentimental, and his work reminds us what a recent invention the idea that "animals are only human" really is. His animals are always presented in the full "otherness" of their animal nature. He kept to this even when painting that traditional focus of woozy emotion, the dog. Stubbs rendered the lean ferocity of the staghound or the compact, questing efficiency of the foxhound with perfect respect for their actual being as creatures in their own world. Even when he did pets—as in *Fino and Tiny*, circa 1791, dominated by a rhythmical profile of the Prince of Wales's black-and-white spitz, Fino—he set down their complicated markings and puffs of newly washed hair with a measured, objective enthusiasm that transcended any hint of cuteness.

Of course, there is pathos in Stubbs's hunting scenes. His portrait of the Earl of Clarendon's gamekeeper about to cut a doe's throat in a darkening wood is a haunting mixture of the archaic and the matter-of-fact. Venison, to be eaten, must be killed, but the thickening shadows seem to enfold a more sacrificial rite than the mere stocking of a larder. This, like all Stubbs's paintings, must also be seen as a manifesto of the supreme ideology of late-eighteenth-century England: the celebration and defense of property. If the wrong person killed that doe, he would be transported or hanged.

It was the now vanished tone of eighteenth-century landed society— fenced about with deadly capital statutes, but also bound intimately together by chains of patronage running vertically through the classes—that enabled Stubbs to paint his varied theater of land work, from haymakers to grooms, trainers and jockeys, without the least sign of overt condescension. Across the Channel, patrons liked pictures of drunken, vomiting peasants in the Dutch manner: a class zoo. Not in England, where Stubbs painted the cult of the horse with rapt attention, as a ritual focus of many skills and several mutually dependent classes.

The horse was his chief image of social harmony: order on four legs. No wonder that, in such paintings as *Eclipse at Newmarket, with a Groom and a Jockey*, circa 1770, the plain rubbing-down houses on Newmarket Heath look like neo-Egyptian shrines, pyramids of the turf. They are, so to speak, the temples of Stubbs's Utopia, a place adjacent to Jonathan

Swift's imaginary country of the Houyhnhnms, those sagacious and moralizing horses.

Horses not only had ideal attributes in this scheme of things but also made plausible heroes. The great example is Stubbs's prosaically titled *Hambletonian, Rubbing Down,* 1800. Hambletonian, winner of both the St. Leger and the Doncaster gold cups in 1796, belonged to a rich and deep-gambling young baronet named Sir Henry Vane-Tempest. In 1799 Vane-Tempest put him up against Diamond, another star horse, for a purse of 3,000 guineas. (At the time, a farmer's laborer might have made five guineas a year.) The match drew the biggest crowd and the heaviest side-betting ever seen at Newmarket, and amid scenes of hysterical excitement Hambletonian won the four-mile race by half a neck. He finished "shockingly goaded," lathered in blood from whip and spur. To commemorate the victory, Vane-Tempest had the seventy-five-year-old Stubbs paint him life size.

The result was not only the largest canvas of Stubbs's career but the grandest in structure and, to modern eyes, the most suggestive. That immense, glossy brown frame of the horse, floating across one's whole field of vision, has the compulsive power of a dream image. In the interest of decorum, Stubbs left out the wounds and weals on Hambletonian's flanks, but his sympathies remained with the animal: white slaver flecks his mouth, the ears lie back flat, and the pink tongue lolls in the aftermath of exhaustion. The creature is attended, none too reverently, by brown pragmatic dwarfs. One cannot imagine that a more rhetorical horse—one of Rubens's baroque equine wardrobes, say, all flourishing hoofs and cascading mane—could possess the same intensity. Hambletonian may have been sired by a classical frieze, but his only foal would be the horse in *Guernica,* thrusting its outraged neck toward the indifferent sky of the twentieth century.

Time, 1984

Sir Joshua Reynolds

When Sir Joshua Reynolds died, wrote the man who most disliked him, the poet and engraver William Blake, "All Nature was degraded; / The King drop'd a tear into the Queen's Ear, / And all his Pictures faded."

The factual truth of this can be assessed by anyone who visits the Reynolds retrospective at London's Royal Academy. Reynolds's paintings have long since faded, mimicking his reputation. "Sir Sploshua," as others called him for his handling of wet paint surfaces, had an imp of fakery lodged in his breast. He was determined to produce, for his clientele of the great, the tone and mellowed appearance of European seicento art. To this end he would whip up weird mayonnaises of wax, turps, asphaltum, eggs, resin and oil. "Varnished three times with different varnishes, and egged twice, oiled twice, and waxed twice, and sized— perhaps in twenty-four hours," exclaimed a fellow artist, Benjamin Haydon.

It was not unknown for the face to fall off a Reynolds portrait if it was shaken. Obsessed with technique, he was said to have scraped patches off his own Titian and Rubens, and was known to have destroyed a Watteau, in search of the "secrets" of the old masters. But his own paintings cooked themselves down to blistered wrecks within the lifetime of the sitters. An elderly Irish rake, the Earl of Drogheda, returned to his native land after thirty years abroad, with a shattered constitution. He found that his youthful portrait by Reynolds was even more poxed and wrinkled than he had become. One might say Joshua Reynolds, rather than Oscar Wilde, invented the portrait of Dorian Gray.

Yet Reynolds's achievement was very considerable. Not only did he change the look of English portraiture, but his career, which spanned most of the eighteenth century (he was born in 1723 and died, all but speechless from laudanum, in 1792), transformed the sociology of English art. Before him, most portraits of the noble and great were done by imported European masters, of whom the greatest was Sir Anthony Van Dyck. Reynolds was the first Englishman to practice the Grand Manner successfully, with the full range of reference to earlier art, from Roman portrait busts to Michelangelo, Titian and Rubens. Once his career got going, which happened almost as soon as he returned from a two-year sojourn in Italy and opened a studio in London in 1753, he was flooded with commissions. As a physiognomist of power, celebrity, rank and beauty, he was as celebrated in Georgian England as Rubens had been in Baroque Europe.

Everyone who was anyone, from George III to Omai (the first Tahitian to visit London, a genuine Noble Savage brought back from the South Seas by Captain James Cook), posed for Reynolds, as did a miscellany of less famous friends, actresses and risen whores. Some of them posed also for Gainsborough and Romney, but it was Reynolds who defined the role of official painter to the nobility, gentry and intelligentsia.

This role was summed up in his position as first president of the Royal Academy. Founded in 1768, the Academy grew out of the ambition of English painters and connoisseurs to shake off the air of menial trade that had always clung to painting on their side of the Channel. Under royal patronage, they would distinguish themselves from the mere mechanics of art—the etchers and engravers, the coach painters and vernacular artists. They would charge in guineas and implant the *gusto grande* in England: like European masters, they would be gentlemen. Above all, they would rise beyond mere pragmatism into theory. "The beauty of which we are in quest," declared Reynolds in one of his celebrated *Discourses* to the Academy's members and students, "is general and intellectual; it is an idea that subsists only in the mind; the sight never beheld it." What he sought was a platonic essence, part of a line of idealizations descended from Michelangelo and the Greeks, not something to be grasped by English terriers such as Hogarth. One did not find it in Gin Alley or Beer Lane. It would emanate from Burlington House, over whose courtyard Sir Joshua still presides with his bronze brush, bronze palette and bronze knee breeches, flicking at a "general and intellectual" canvas that hovers invisibly in the air of Piccadilly.

The first Reynolds retrospective ever held is a solid, if not uniformly impressive, affair: more than 160 paintings, drawings and prints, plus all manner of related material that ranges from ferocious contemporary satires on Reynolds and his sitters to the cast of a hanged and flayed smuggler. Its reception by English critics has been lukewarm. Sir Joshua remains hard to love—an exalted figure who was not quite exalted enough, whose output, like some of the English country houses it adorned, is a curious amalgam of grandeur and tattiness, of overwrought declamation and lovely episodes of truthful "natural" vision.

With Reynolds, the grandest is not necessarily the best at all, and this is especially true of his attempts at history and myth: the most ambitious of these, a poached and blackened pastiche of Rembrandt depicting the infant Hercules throttling a snake, was thought highly sublime by Reynolds's contemporaries but looks like dreadful fustian today. It seems not wholly unfair that the stout baby should have been used by a Victorian advertiser to promote something called Woodward's Gripe Water.

When Reynolds depicted high literary tragedy, as in his scene from Dante *Count Hugolino and His Children in the Dungeon*, he produced bathos. The count, realizing that he must eat his offspring or starve, wears the peevish look of one who would have preferred fettuccine. And despite a cast-iron skill of conception and many felicities of touch, Reynolds's big

official portraits, seen en masse, have something tedious about them. One would cheerfully exchange a wall or two of this stilted and fluent presentation of the social mask for a few square feet of Gainsborough.

Still, there are exceptions. The finest of them is a monumental portrait of the Marlborough family, exhibited for the first time since 1888, which locks eight figures and three dogs together in an arrangement as varied yet coherent as anything in portraiture since sixteenth-century Venice: a composition webbed by subtly arranged linkages of expression, gesture and pose. Due respect is given to both parental power and childish playfulness; it is, in short, a painting of people and not just a genealogical diagram.

Today one is apt to like Reynolds less for his formal declamations than for the intimate portraits of people in his London circle. Reynolds's appetite for grandeur was savagely guyed by English cartoonists of the day; there is a hilarious coda to the exhibit, showing how the vipers of popular prints treated the Royal Academy, its patrons and the values they claimed to embody. But how agreeable he was with his coat off. Sir Joshua's heads and half-lengths of writers and actors did for the cultural life of Georgian London what Nadar's photographs, a century later, would do for Paris.

Reynolds made the canonical likenesses of James Boswell, pink and observant; of David Garrick, the actor-manager, and his star tragic actress, Sarah Siddons; of Laurence Sterne, the Irish prebendary who wrote *Tristram Shandy,* smiling like a quizzical fox; of Samuel Johnson in profile at sixty, like a Roman sage struggling to articulate some weighty trope, and of the same great bear in old age a decade later. (Johnson, for his part, paid Reynolds a mighty compliment, referring to him as the man "whom, if he should quarrel with him, he should find the most difficulty how to abuse.")

All these portraits display a degree of sympathy with character that is attenuated, if not wholly lacking, in the huge social performances. Then, of course, Reynolds painted himself: grandly, as president of the Royal Academy, alone with a bust of Michelangelo (presumably after Rembrandt's *Aristotle Contemplating the Bust of Homer*), but also in a fresh, direct way, as in the oval *Self-Portrait in Doctoral Robes.* The latter, done in the space of a few hours, captured his shrewd potato face, with the hair disordered and lips just parted in speech, above the pink and vermilion of an academic gown.

Once off the pedestal, Reynolds could create memorable types. Nowhere in English art is there a sweeter, tougher demimondaine than his

Mrs. Abington, reflectively sucking her thumb while sizing up the audience with a level look annealed by years of prostitution before her stardom as a comic actress. And it would be difficult to imagine a more sympathetic portrait of a minor writer than his study of Giuseppe Baretti, shortsightedly scrutinizing a book inches from his eyes with the greed of a man devouring an orange. In Reynolds's intimate portraits, the aura of classical make-believe becomes an ironical virtue (it is, after all, hard to take altogether seriously a title such as *Lady Sarah Bunbury Sacrificing to the Graces*).

Here is little Cupid as a London linkboy, sporting demonic bat wings and an immense phallic torch to remind those in the know of the proclivities of a certain patron, recalling the lines of Lord Rochester:

> Nor should our love-fits, Chloris, be forgot,
> When each the well-look'd link-boy strove t'enjoy,
> And the best kiss was the deciding lot
> Whether the boy fuck'd you, or I the boy.

And here are Reynolds's friends in the Society of Dilettanti, arguing about antiquities and knocking back the vintage claret, while Sir William Hamilton points to an engraving of one of his own Greek vases and Mr. John Taylor holds up a lady's garter. Peering into this lost world—reprehensible, no doubt, for its elitism, sexism, amateurism and other social vices, yet not without its allure—one realizes what Sir Sploshua's friend Sir George Beaumont meant when he swept aside the doubts of an uncertain client: "No matter, take the chance; even a faded picture from Reynolds will be the finest thing you can have."

Time, 1986

Goya

I think most of us would agree that the Goya exhibition at New York's Metropolitan Museum of Art is the most powerful show in town. We can say this even though it doesn't give us the whole Goya. We can feel it

because he speaks to us with an urgency that no artist of our time can muster. We see his long-dead face pressed against the glass of our terrible century, Goya looking in at a time worse than his.

You can make a protomodernist out of Goya, just as the nineteenth century made him a proto-Romantic and then a proto-Realist. His dismembered carcasses in the *Disasters of War* directly inspired Géricault's. Manet assiduously imitated him—his Parisiennes on the balcony are Goya's *majas* transposed to Paris, his bullfight is a direct homage to Goya's *Tauromaquías*. Dali constantly invoked him, and from *L'Age d'Or* to *The Exterminating Angel*, Luis Buñuel's films elliptically refer to Goya and constitute a cinematic parallel to his eighty prints about the sexual and social follies of Madrid, the *Caprichos*.

Picasso, of course, meditated on Goya from first to last and was always scared of the comparison. Among Americans, to name only a couple, Goya surfaces dramatically in the late works of Philip Guston (so many of which seem homages to the *Caprichos*) and in the tragic blacks and humped profiles of Robert Motherwell's *Elegies to the Spanish Republic*.

But you cannot make Goya into a proto-*post*modernist. He is never trivial enough for that. It is the wholeness of his fiction, its unremitting earnestness, its desire to know and tell the truth, that our art has lost.

This is what used to be meant when a great artist was called "universal": you can't take the term literally—there is no imaginable Goya who could mean as much to a Chinese as to a European—but it does suggest the power of such artists to keep appealing through their imagery to very different people along the strand of a common cultural descent, so that even when beliefs have lost their fervency, when both the oppressors and the oppressed are dead, when the references of religion and popular culture have changed, as they certainly have between Madrid in 1809 and New York in 1989, still we venture to claim Goya as our own. Our ability to describe ourselves is *somewhat* inflected by this man's paintings, drawings and prints.

You could not claim this for any of his Spanish contemporaries. It doesn't entirely rest on his greatness as an artist either, since other great painters of the eighteenth and early nineteenth centuries don't have Goya's ability to project their images from their time into ours. No matter how much we love Watteau, his sense of society is closed to us forever; we will never be able to imagine ourselves taking part in those rituals on the shaved lawns of the paradise-garden. But Goya is a different matter.

Consider two paintings that are not in this show. (Their absence is

one of the reasons why nobody should call it a Goya retrospective, an event that now will never take place.) The works commemorate a rising that touched off Spain's War of Independence against France. On May 2, 1808, in the Puerta del Sol in the very heart of Madrid, a crowd of citizens turned into what authority calls a mob and attacked a detachment of Mameluke cavalry led by the French general Murat. Goya's *Dos de Mayo* records this moment. Its companion piece, the *Tres de Mayo*, commemorates the next night's reprisals, in which about forty *madrileños* found with weapons were summarily shot by French firing squads behind the hill of Principe Pio, outside Madrid.

The Second of May is a fine painting but not a great one, renovated Baron Gros with its heroic rocking horse but without the French etiquette of violence, and more abandoned in expression. *The Third of May* is not renovated anything. It is truly modern and its newness seems to have ensured that, although it was a state commission, it remained in storage for the first forty years of its life. The surface is ragged, for Goya is suppressing his fluency in the interests of a harsher address to the eye. Occasionally the signs of that fluency break through; one is the saber and sheath of the French soldier closest to us—a mere scribble, but *what* a scribble, of burnt umber, lightened by a swipe of yellow that begins in a round splotch at the tip of the sheath and swings right up the form. Elsewhere the improvised bluntness of his painting is tragically expressive, even—or perhaps especially—down to the blood on the ground, which is a dark alizarin crimson put on thick and then scraped back with a palette knife, so that its sinking into the grain of the canvas mimics the drying of blood itself: it looks crusty, dull and scratchy, just like real blood smeared on a surface by the involuntary twitches of a dying body. The wounds that disfigure the face of the man on the ground can't be deciphered fully as wounds, but as signs of trauma embodied in paint they are inexpressibly shocking: their imprecision conveys the sense of something too painful to look at, of the aversion of one's own eyes.

Signs of past art are there: I suspect that the array of French barrels and bayonets carries a small, sharp echo of a more triumphal and chivalrous military piece, well known to Goya: the palisade of lances in Velázquez's *Surrender at Breda*. Above all, there is the man about to be shot, whom we saw dragging the Mameluke backward off his horse on May 2. There he now stands, facing martyrdom in his clean white shirt, throwing out his arms in a gesture that irresistibly recalls the Crucifixion. It is a gesture of indescribable power: it takes the spread arms of the passive crucified victim and makes them active, a flinging out of life in despair and

defiance. Indeed, he has a face—coarse, swarthy, dilated in its last moment of vitality. All his fellow victims have faces too. By rendering them as notional portraits—the faces of the *pueblo*, the Spanish people—Goya grants the living their individuality right up to the edge of the mass grave. The landscape, however, is featureless: a bare hill and bare rocks. And so are the soldiers, whose row of backs still strikes you as the first truly modern image of war because it is the first to register the anonymity, the machinelike efficiency of oppression. Nothing personal.

We see only backs, braced forward into the recoil of those big 70-caliber flintlocks. And without knowing it, Goya piercingly anticipates our sense of modern documentary with that lantern: the minimal cube with its objective white light, presently to be repeated, in homage to Goya, by Picasso in *Guernica*. In sum, this painting is as unlike all previous war paintings as Wilfred Owen's writings from the trenches are unlike all Georgian and Victorian war poetry. And the difference is that Goya speaks for the victims: not only for those killed in French reprisals in Madrid, but for all the millions of individuals destroyed, before and since, in the name of The People. *The Third of May* is not a piece of reporting—any more than the *Disasters of War* will be. Goya didn't see this scene; he almost certainly wasn't there, although he was in Madrid. In any case it can't have looked like this. But we can't forget what he didn't see.

I have dwelt on this painting because it exemplifies what is somewhat underplayed in this show. The idea of Goya as a man of the Enlightenment stops far short of explaining why his work has such a purchase on our imagination. The light of this lantern is not the light shed by Rousseau's assumptions about the goodness of mankind, or by the hopes of the Spanish reformers that Goya saw crushed at the very moment in 1814 when he was painting *The Third of May*, when that parody of kingship Ferdinand VII entered Madrid and, instead of restoring the rights of the Spanish people that Napoleon and the war had taken away, abolished the Constitution of 1812 and reinstated the Inquisition. To employ Milton's stunning phrase about the illumination of Hell, it is "no light, but rather darkness visible." Because *The Third of May* excites our pity and terror as no other painting of war has done—or, I suppose, will ever do—we incline to suppose that it does so in the name of liberal ideology.

But here our emphasis may be wrong. Perhaps in claiming Goya as a liberal we are only repeating the process by which successive moments of taste have appropriated him. There have been quite a few Goyas in the two hundred years since his birth. There was Goya the Romantic, the creation of writers such as Théophile Gautier. We have had Goya the

Man of the People, critic of established power and French imperialism, whose work argues for an immutable bedrock of his culture, the *ser autentico.*

His offspring is Goya the Incipient Marxist, in whose work the class struggle is set forth and predicted from the eyeline of the workers. This view is based partly on his own humble birth, but it ignores some of Goya's opinions of the common people and creates problems when it comes to explaining his social climbing and canny self-interest.

Then there is Goya the Surrealist, whose uncensored access to his own worst dreams would not be approached until the 1930s, with the anxious maturity of Picasso—and will certainly never be equaled.

There are a few other Goyas too—Goya the Existentialist, for instance, about whom André Malraux wrote—and in each one a culture later than his own strives to locate itself, its own dreams, its own self-image. They are all partly true, and none of them wholly excludes the rest. For Goya's personality was one of the richest and most various that an artist ever had: a remarkable blend of introspection, opportunism and relentless curiosity, gluttonously drawn to the social framework but always alone among his fantasies.

He turns in the dark space of Bourbon history like a ball with mirrored facets, immediately casting back whatever pencil of light the specialist directs on him. He demands interpretation, he absorbs it and always seems to want more, because his work is so rich and so variegated.

The latest Goya—the one this show invokes and to some degree invents—is Goya the Liberal. The use of the term *liberal* in its political sense began in Spain in his time, to distinguish reformers from the *serviles*, the conservatives who wanted no change in social ranking and the power of the Church and the Inquisition. That use of the word came into English only around 1830. Maybe the Spanish today want to stress Goya's liberalism because they see their present king fulfilling the liberal promise of his ancestor, Charles III, in Goya's time—and because Goya was too often claimed as "quintessentially Spanish" during the long Franco years. Maybe we like to hear it because American liberalism has taken such a beating from political speechwriters and TV preachers. That they could so easily turn America's noblest tradition of political thought into the "L word" is obscene, and maybe it's natural that survivors of this linguistic massacre should want to claim Goya as an ancestor for their own opinions about human freedom and rights. And there is a good deal of evidence for this in his work, especially the *Caprichos,* brilliantly explicated by Eleanor Sayre in the catalogue. But it is not the whole story.

Goya's liberalism is bound up with his class ambitions. In the late eighteenth century, which also saw the first phase of Goya's career, Madrid had a thin veneer of *ilustrados,* whose influence was largely dependent on royal approval—which they got in plenty from Charles III. Their liberalism was safeguarded not by popular movements, but by the direct sympathy of the monarch. Like many of the aristocrats who supported the French Revolution in its pre-Jacobin years, they perceived their King as the caretaker of liberal reform.

But the *pueblo,* the common people and artisans from whose ranks Goya had risen, was far more conservative. There was an immense chasm between popular and elite culture in Bourbon Spain. To the *majo* on the street, the *ilustrado* in the salon with his Frenchified ideas was virtually a foreigner. People rarely like the humanitarian plans of their social superiors. The culture of the Madrid *pueblo* had nothing to do with Beccaria or Diderot—or with Goya's court portraits, for that matter. It was immersed in folktales, superstitions and ferociously dirty jokes. It clung to the bullfight, to flamenco singers and hellfire preachers, to the grotesque pantomimes known as *tonadillas,* to phantasmagorias full of witches and demons, to crude woodcuts and a popular theater whose heroes were bandits, smugglers and other enemies of authority, and to the codes of brash, laconic dandyism and male bonding that were signified by the word *majismo.* At forty-six, Goya painted himself as a *majo*—a costume which for an established court painter in the 1790s was roughly equivalent to black leather and jeans among New York artists in the 1960s. Populism stood for liberty—of a rough, conservative, intensely xenophobic kind, sentimental and hard-eyed by turns. And it was indissolubly linked to old Spain, black Spain, the Spain the *ilustrados* hoped to cure with their judicious enemas of liberal ideology. What they really thought of their would-be doctors and their medicine came brutally clear to Goya (and everyone else) after the Peninsular War broke out. They thought liberals were French quislings. The title of one plate from the *Disasters of War* is *Popolacho,* meaning "rabble" or "mob"—definitely not "people"; the victim on the ground is a liberal defrocked, and the instrument whose sharp end he would be about to experience if he were alive is a *media luna,* a tool with a half-moon cutter used to hamstring bulls.

The taproot of Goya's imagination was fixed deep in this world, and its imagery pervades his work. It is in some ways its deepest source. Yet his late work moves beyond purely Spanish concerns, although its dress is Spanish, and its encyclopedic despair and skepticism are just as much about his disillusionment at the failure of French revolutionary promises

as about his loathing of the return of Spanish absolutism after the Peninsular War. He had watched the liberal blossoming of 1789 and the Paris bloodbath of the 1790s. He was the first great artist to bear witness to the atrocities committed by ideologues in the name of liberty. This was the Gorgon's head of modern history. David could not look at it. But Goya could. And still he chose to spend his last years in France, and to die there. The developing drama of his work unfolds from his efforts to move between these two mental worlds of the *ilustrados* and the *pueblo*, even as political events in Spain were tearing them apart. But the view he took of those events was deeply colored by his memories of the French Revolution, which is why no simple view of Goya as either a liberal or a man of the people fits the late work.

When I first saw the show in Boston I wanted to accept the Enlightenment view of Goya wholeheartedly, because it promised a way out of earlier stereotypes of the artist. It enables us to reread many of his images, even the most famous, such as the title leaf of the *Caprichos, El Sueño de la Razón,* "The sleep of reason (brings forth monsters)." The figure of the artist dozing over the midnight oil and beset by foul imaginings is rooted in both the present and the past. In the present, because it seems to repeat the pose in which, in 1798, he painted the economist, writer and educational reformer Gaspar Melchor de Jovellanos, whose *Informe,* a report on agrarian law, was the bureaucratic cornerstone of the Spanish Enlightenment, and who was made minister of culture and justice by Charles III's successor, Charles IV, for a brief nine months in 1789–90 and was then banished to a long and frustrating exile for his liberal views. Goya paints this intellectual meditating on the cares of office in the splendors of the palace, symbolically blessed by Minerva, goddess of wisdom.

In the etching, as Sayre shows, Minerva's role is filled by a protective lynx, the symbol of alertness and skepticism—these big cats have night vision and can pierce the gloom of ignorance. The owl is a perversion of Minerva's emblem: it is offering the sleeper a pen with which to record error and superstition. And there is no doubt about the meaning of the bats, cats and other critters that swarm through the sky to take over the man's dreams. Goya's owls on the sleeper's back—one with its wings spread, the others staring at you—come from a similar cluster of owls on a ruined inscribed tomb slab that is the opening plate of the *Scherzi* by Giambattista Tiepolo, who died in Madrid in 1770.

And then one recalls other, older images that Goya knew from the royal collections, such as those of Hieronymus Bosch, that favorite of the gloomy Philip II: in particular the theme of St. Anthony tempted by

devils, of which the Escorial had no less than four versions. Sayre points out that Goya didn't want to paint "a dreaming artist surrounded by a wild phantasmagoria of bizarre, Bosch-like beings." Certainly these hellish little androids scuttling around the saint and his pig are fantastic in a way that Goya's owls and cats are not. And yet I find it hard to suppose that Goya's image is not a recycling of *The Temptation of St. Anthony*, and harder still to believe that this was not a partly deliberate choice, signaling his own rootedness in a tradition that predated the Enlightenment by centuries. Indeed, until Goya's own moment, it would be difficult to name a denser landscape of hysteria than northern Europe between 1480 and 1550, with its pogroms and religious wars, its flagellants and messiahs proclaiming the imminent arrival of the Millennium—like the Middle East today, with priests instead of imams and right-wing rabbis. Bosch's importance to Goya can hardly be overestimated. Because of the influence Surrealism has had on us, and the extreme difficulty of decoding the actual meaning of Bosch's images—as well as the opacity of some of Goya's—we are apt to get this slightly skewed. But it seems likely that Goya was drawn to Bosch not only by the unmatched power of the long-dead painter's fantasy but by his reputation as a moral allegorist. Here is Brother José de Siguenca, an early-seventeenth-century monk attached to the Escorial, defending his king's favorite painter against the charges of frivolity and heresy: "I should like to point out that these paintings are by no means farces, but books of great wisdom and art, and if foolish actions are shown in them they are our follies, not his: and, let us admit it, they are a painted satire on the sins and fickleness of men. . . . Others try as often as possible to paint man as he looks from the outside, while this man has the courage to paint him as he is inwardly." This is very close to Goya's own blurb for the *Caprichos:* "The author," he writes, "is convinced that censoring human errors and vices—though it seems the preserve of poetry and oratory—may also be a worthy object of painting. As subjects appropriate to his work, he has selected from the multitude of errors and stupidities common to every civil society, and from the ordinary obfuscations and lies condoned by custom, ignorance or self-interest, those he has deemed most fit to furnish material for ridicule." A full study of Goya's debt to Bosch and to later demonological painters has yet to be made, and when it is done it will connect with Goya's delight in demotic and populist fantasy, and unlock more of him than we now have.

Relying on direct observation, fixed by incessant note-taking, his genius was to make this symbolism of the body concrete, rather than schematic, so that you are always left feeling that such monsters *may* be

chatting to one another, in darkness or sunlight, just around the corner. It was a thought that occurred to him when he was preparing to publish the *Caprichos*. "He who would catch a group of goblins in their den," Goya wrote, "and show them in a cage at ten o'clock in the morning on the Puerta del Sol, would not need any rights of primogeniture to an entailed estate." It was a joke: he meant that they'd be such curiosities that their owner would get rich. But it wasn't a joke: to cage these goblins, these *duendecitos*, in the white sunlight of the printed page was to have power over them, more power than mere birth could give you; it was to have dominion over your own fears, and society's as well.

Some geniuses find their true voice almost indecently early, for instance Mozart or Masaccio. Others are late developers, and Goya was one. If he had died at forty—a common fate in the eighteenth century—we would not remember him as a great painter.

He was born in the Aragonese village of Fuentetodos, two days by mule from Saragossa, deep in the provinces, in 1746. His father was an artisan, a master gilder. In the 1750s Goya went to school in Saragossa. In 1760 he was apprenticed to the painter José Luzán. In 1763, aged seventeen, he went to Madrid for the first time, and he moved up to studying under Francisco Bayeu, a court painter whose sister Josefa he eventually married.

In 1770, at twenty-four, he went to Italy to study; he stayed more than a year. Much romantic nonsense has been written about his Italian visit; we can be fairly sure that he did not go there as a toreador with a bullfighting troupe, as was claimed after his death. But he stayed in Rome and Naples and probably Milan.

The frustrating thing about this period of his life, which must have mattered immensely to his later growth—as the pilgrimage to Rome did with any artist—is that we know so little about it.

It seems likely that (apart from the great obligatory menu of Raphael, Michelangelo and the Carracci) he would have seen work by Magnasco and stored those voluptuously menacing dungeon and inquisition scenes away for future use. But they pale into agitated theatricality beside Goya's own laconic images of suffering under the Inquisition: "For having been born elsewhere"; "For discovering the movement of the earth"; "For marrying as she wished." In fact the furies of the Spanish Inquisition had calmed down somewhat in the Bourbon period, but for Goya it was still an archsymbol of tyranny which had to be erased. Goya's carceral imagery

vividly reminds us that eighteenth-century prisons and bedlams in Spain no less than in England had nothing to do with the enlightened idea of the prison as reformatory or the madhouse as hospital. They were simply dumps, holes in the social surface, where anything anomalous could be thrown and forgotten. He must have looked at Piranesi too, because the imagery of perpetual confinement in endlessly replicated, overscaled spaces that haunts you in Piranesi's *Carceri d'Invenzione* is present, in a terser form, in Goya—the figures crushed into solipsistic despair by the sheer weight of stone walls and arches.

But these come later. What Goya actually painted under Italian influence, what commended him to Anton Rafael Mengs, the friend of Winckelmann who ruled the Madrid painters' roost under Charles III, was a fairly routine kind of neoclassicism in which nothing of the eventual Goya could be seen. The Met show has a *Sacrifice to Priapus* of this kind, done when he was twenty-five. Once back in Madrid, he began the scramble up the greasy social pole. There were rebuffs. The Academy wouldn't accept him. In 1779 Mengs died and Goya applied for his job as *pintor de cámara* but was refused. Then in 1786 he was able to report to his friend, the lawyer Zapater, that he was at last Painter to the King, with a salary of 15,000 reales—not much in money, but precious in terms of access. As Goya moved upward to become First Painter to the King, a post he finally secured in 1799, he stuck a "de" in front of his name to suggest aristocratic kinship; he kept crowing loudly about his fees, his new English coach, his posh friends. He had absolutely no qualms about fawning to the great—you had to, if you were to succeed, and above all he was fixed on success.

The tone is set in his 1783 portrait of the Conde de Floridablanca, the minister of state, magnificent in his red suit and blue sash, surrounded by the emblems of administration and plans for public works. His king's oval portrait smiles down on this physiocrat like a god from a cloud, and in front of him is Goya, holding up a picture for the count's approval—the artist as artisan, Figaro in front of Count Almaviva, you'd like to think, except that nowhere in Goya's court portraits to come would there be a trace of the rebelliousness of the little barber whom Beaumarchais would place onstage to the scandal and delight of Paris the very next year.

Through the 1780s and into the next decade, Goya's portraits became a small anthology of socially responsible aristocrats who took an interest in practical, prudent, bureaucratic enlightenment, partly no doubt because he liked their ideas, but mainly because they were the people favored by the monarch. There was Francisco de Cabarrús, the founder of Spain's central bank, a strong believer in equal education for all classes and the

right to divorce, both scandalous propositions in their day; then Jovellanos, whose report on agrarian law was the cornerstone text of the Spanish Enlightenment; and the Duques de Osuna, great supporters of progress in economics, science, technology, writing and art, in whose salon Goya expanded his friendships with writers such as Leandro Moratín and the art critic Ceán Bermúdez.

Such people had copies of Diderot's banned encyclopedia; they had read *El Teatro Crítico Universal*, the massive compilation of superstitions and follies by the Benedictine monk Benito Feijóo, which ran into fifteen editions by 1780 and kept dozens of conservatives writing attacks on it, all in vain. They enjoyed the social and political cartoons that the *serviles* hated on principle, especially English ones by Gillray, Rowlandson and others. They subscribed to skeptical papers such as *El Pensador,* modeled on Addison's *Spectator,* and to radical ones such as *El Censor,* whose corrosive satires were the closest thing in words to the values Goya would express in the *Caprichos.*

We don't know how much of this liberal material Goya actually read—perhaps not as much as scholars would like to believe. But there is no doubt that the *ilustrado* circle in Madrid fed his art, gave him ways of dealing with social subjects, fostered his career and directed his thought. With his tapestry designs of the 1770s and 1780s he became, in a sense, its decorator, under the influence of Giambattista Tiepolo. The hopeful convention is to see these as evidence of Goya's eye for the common people, but the social is just what is suppressed in them: all these peasants, workers, *majas* and folk are seen from the eyeline of patronage, and even *The Wounded Mason* is meant more as a compliment to the new safety regulations Charles III clapped on the construction industry than as a gesture of identification with the suffering worker. Goya was adaptable. He understood the skill without which the career of a court artist or a social portraitist is bound to fizzle—the ability to tailor the image to the cloth of the patron's ideas or the sitter's self-esteem. That is why, admiration aside, you tend to trust Goya the portraitist most when he does the formal likeness of someone he was close to, for instance the marvelously frank and direct image of Sebastián Martínez, a wine merchant and collector from Cádiz who was also a self-made man and whose friendship with Goya is inscribed on the paper he is holding. Or of a colleague, such as Bartolomé Sureda, who taught Goya some of his printing techniques and went on to head the royal porcelain factory in Madrid.

But we get into problems if we try to project the internal Goya, the creator of the *Caprichos,* back on the external and public Goya, the por-

traitist and allegorist. We'd like to think our hero viewed those in power with a cold eye, and that his portraits of them have an undercurrent of satire; but they didn't think so and and they were neither foolish nor lacking in vanity.

We may wish to see his great Madrid portrait of the family of King Charles IV as a parade of lumpish buffoons in costume, but there is no evidence that Goya did so, and in fact the lyrical enthusiasm with which he swathed his royal personages in exquisite tissues of light and color suggests quite the opposite. It may even be that Charles and María Luisa were so much uglier in real life that Goya's portraits of them are a positive act of charity. Goya could fill his portrait of General José de Palafox, the popular hero of the defense of Saragossa, with quite unironic enthusiasm. But he did the same with one of his most regular patrons, who was also among the nastiest pieces of work ever to hold power in Spain: María Luisa's minister, lover and so-called Prince of Peace, Don Manuel Godoy, whose pretensions to military virtue were, as everyone in the army knew, a joke—although not one you could laugh at publicly. He may look to us like the prototype of every Latin dictator who ever diverted foreign aid from Washington to a numbered account in Switzerland, but there is no mistaking Goya's obsequiousness. On the other hand, he was wonderfully sympathetic to Godoy's unhappy wife, the Condesa de Chinchón, bewildered and fragile in her cloud of sprigged muslin. It is perhaps fitting in view of Goya's practical indifference to the politics of his sitters that in the late 1930s when Franco was looking for a present for his friend Adolf Hitler he was only narrowly dissuaded from giving him Goya's portrait of the Marquesa de Santa Cruz: he thought the Führer would like the swastika on her lyre.

Goya's readiness to maneuver ought to make us wary about the political content of his work. The catalogue of this show presents one huge and, for Goya, rather simpleminded picture as the *Allegory on the Adoption of the Constitution of 1812*, but as Jonathan Brown argues in an excellent review of the show in *The New Republic*, it may be nothing of the kind. The painting bears no date, it is a reworking of a much earlier allegory, *Truth and Time*, and it could just as plausibly have been commissioned by the French to celebrate the Napoleonic Constitution of 1808, which many of the *ilustrados* welcomed with open arms: they wanted to collaborate with Joseph Bonaparte, hoping that he would produce the radical reforms of church and state Spain so badly needed.

But unofficial allegory was a different thing. Goya in 1793 fell ill from an infection—it may have been a form of polio—that disoriented him,

rocked his self-confidence and left him permanently deaf. Deafness meant less sociability, and through the 1790s you see the second, the private, the deeper Goya pushing to the surface, first in genre scenes that look like Rococo pastorales in which something has gone hideously wrong—he won't suppress the ugly sprawl of the dead or the shoe that's come off the foot. Having hallucinated and heard noises in his head, he thinks of madhouses. He nourishes himself with drawings whose content is very far from the polite discourse of court art. These drawings of the 1790s are the protein of his later work. They form the basis of the *Caprichos*. They parallel a sudden mood of reaction that swept the Spanish government. In 1790 Floridablanca banned the import of French writings; in 1791 he suspended most Spanish newspapers; in 1792 Godoy took power, ruling Spain through María Luisa and her complaisant husband. Goya was shocked by this and disillusioned by the seesawing of influence between liberals and conservatives that would end, after 1800, with total liberal defeat. His response was one of sardonic, oblique protest. Through the nineties there was a growing split between the public and the private Goya. After 1800 he still did official commissions and negotiated his way through the centers of patronage, but more and more of his drive went into his private visions, whose first complete manifesto was the *Caprichos*, sent to press in 1799, when he was fifty-three.

You can decode the *Caprichos* because they are meant, explicitly, as social speech—satires on reaction, privilege, stupidity, exploitation and social vulgarity, a manifesto of liberal dislikes. He attacks the clergy for overglossing the Bible and trying to ban its vernacular editions. He satirizes the irrational rise and fall of favorites at court in an image that may very obliquely refer to Godoy as a risen Lucifer, and that derives from the medieval figure of the turning of Fortune's wheel. On the rituals of commercial love and commercial marriage, he is wonderful: "They say yes"; "Even this close, he can't make her out." He draws prostitutes plucking their clients and shooing the poor little chickens out the door; but he also shows the victimization of helpless whores by the respectable— "How they pluck out her feathers!" the caption reads. He guys the aristocrat's pride in his family tree—a donkey showing off its asinine lineage— and rebukes the people for putting up with their indolent masters. And he goes much deeper into the fears of the *pueblo*, down to the crossroads of the demonic and the sexual, protesting against the sexual abuse of children in *Sopla*, an image whose details shock us even today.

The catalogue of the show tends to treat the *Caprichos* and Goya's later and altogether weirder etchings, the *Disparates*, as though they were

continuous. Nothing could be further from the truth. The *Disparates* resist all interpretation; they are hermetic even when they are most appalling; they weren't even published until Goya was dead, and he said nothing about them. One of them, showing French soldiers stumbling in panic away from the enormous specter, can be decoded as a political allegory. But another, with the rearing Leonardine horse carrying an ecstatic woman in its mouth—what does it mean? You sense it viscerally: on some level the plate is about orgasm; but these dark sexual images, so intensely vivid in their presentation and yet so elusive in their literal meaning, are among the most mysterious components of European Romanticism and they invert the rationalist pretensions of the Englightenment. And how did Goya get from the *Caprichos* to this point beyond satire? Through experience of political disillusionment and terminal violence; through the extinction of liberal hope and the reign of unreason; in short, through what is set forth in the *Disasters of War*. For the last third of his immensely long working life he found himself less and less able to sustain an optimistic belief in the power of reason to organize a just world. The message of his later work—the *Disasters of War*, the *Disparates* and the black paintings with which he adorned the dining room of his villa outside Madrid, the Quinta del Sordo—is one of cumulative despair. Hysteria, evil, cruelty and irrationality are not just the absence of wisdom, any more than black in Goya's paintings is merely the absence of color. Education will not stop these Fates from spinning and snipping the thread of life. Culture will not exorcise them. They are continuous presences, and the world is thick with them. They are pervasive, as demons were to the medieval mind: *y no hai remedio*, as he engraved below one of the massacres in the *Disasters of War*—and there is no remedy. The painting in the show that best expresses this is the tiny *Witches in the Air*, done around 1798, when he was working on the *Caprichos*. Three half-stripped men in the long conical hats that heretics were forced to wear in their ritual humiliation by the Inquisition are floating in the air. There is nothing airy about them. Their bodies are concrete, dense and muscular—businesslike, almost, as they gobble like owls at the flesh of the victim they carry. The arms and legs sticking out of the core of bodies make an extraordinary burst of light in this thick darkness. And the men on the ground do not want to know about it. One lies down and covers his ears. The other makes a sign to ward off evil and tries to hurry on by. Part of the subliminal power of this image for a Spanish Catholic in the late eighteenth century would have been as a reminder of a Christian image, the Resurrection of Christ, which it morally inverts. But the schema is essentially the same: the manifestation

rising from the ground, the failed witnesses—the Roman soldiers around Christ's tomb, or the stricken travelers on the Goya—not seeing what is really there.

The liberal message was that human nature is naturally good but is deformed by corrupt laws and bad customs. Man is born free, but he is everywhere in chains. Goya's message, late in his life, is different. The chains are attached to something deep inside human nature: they are forged from the substance of what, since Freud, we have called the id. They are not the "mind-forged manacles" of which William Blake wrote; they are not a social artifact that can be legislated away or struck off by the liberating intellect; *they are what we are.* In the end, there is only the violated emptiness of acceptance of our fallen nature: the pining of the philosophical dog, whose master is as absent from him as God is from Goya; the two last men in the world, Cain and Abel at the end as at the beginning, flailing at one another with their shillelaghs as they sink in the marsh; the corpse at the conclusion of the *Disasters of War,* pointing to the one word of wisdom it can show us from the jaws of death—*Nada,* Nothing. We can claim an affinity between Goya and Rousseau only if we are prepared, at the same time, to admit there is also one between Goya and Rousseau's antitype, the Marquis de Sade—and that Goya's unflagging modernity lies somewhere between the two.

The New York Review of Books, 1989

Zurbarán

The Metropolitan Museum of Art has gotten its new season off with that doctrinaire mystic of the Spanish Baroque, Francisco de Zurbarán (1598–1664). After Velázquez, El Greco and Ribera, Zurbarán was the best painter the so-called golden age of Spanish painting produced, but his work has never been seen in depth in America; now, in one of those big transatlantic double acts the Met does in cahoots with the Grand Palais in Paris, this is changed. From its panoramic exposure a new Zurbarán emerges: both stronger and weaker, more intense and yet more prone to hackwork, than one had imagined.

Our idea of Zurbarán, as the art historian Yves Bottineau points out in the catalogue, was fixed more than a century ago by the Romantics: "a somber and tragic rigidity." His paintings of cowled monks and saints in meditation seemed to connect with spectacular areas of Romantic fantasy: its obsession with trance, death, and the link between faith and cruelty— the dungeon beneath the cloister, the Grand Inquisitor's icy hand on the red-hot iron. This Zurbarán was more or less written into cultural existence by Théophile Gautier in 1844, on a visit to Seville:

> *Monks of Zurbarán, white-robed Carthusians who, in the shadows,*
> *Pass silently over the stones of the dead,*
> *Whispering Paters and Aves without end,*
> *What crime do you expiate with such remorse?*

What indeed? It was no small irony that Zurbarán, an artist of devout Catholic faith, whose entire career was spent illustrating the most rigid dogmas of the monastic orders he worked for (Dominicans, Franciscans, Shod and Barefoot Mercedarians, Trinitarians, Hieronymites, Carthusians, Carmelites) became a favorite of French anticlericals two centuries and more after his death. Even the Surrealists, who hated the Church on principle, liked him—and indeed there are Zurbaráns whose pure literalness might strike a modern eye as surrealistic, such as his figure of the Sicilian martyr St. Agatha daintily bearing on a platter her breasts (which had been cut off by a wicked Roman prefect, causing Mount Etna to erupt) looking like two pale pink, heavenly scoops of *gelato.*

But as a result, Zurbarán is known today by a tiny part of his output, maybe half a dozen "typical" paintings—single images of great power and reductive concentration: a Paschal Lamb, the Agnus Dei, lying in darkness mutely trussed for sacrifice, or a *bodegón* (still life) of clay vessels as dense and grand as architecture, ritually arranged as though on an altar. Perhaps the most remarkable of all is the life-size kneeling figure of *St. Francis in Ecstasy,* painted at the height of his career, in the late 1630s, from the National Gallery in London. This is not the St. Francis of earlier legend, warbling to the birds of Assisi about Brother Sun and Sister Moon. Spanish Catholicism in the sixteenth and seventeenth centuries invented a new St. Francis, a death-haunted monk whose images would force the faithful to think about their own dissolution. Zurbarán's version comes right from the heart of the Counter-Reformation: admonitory and raw. It seems real in every detail, from the coarse weave of the woolen habit (with a frayed hole at the elbow, emblematic of poverty, brilliantly accentuated

with a few impasto flicks of white light on the dangling threads to give
a hint of contrast to the massive carving of the rest of its forms) to the
shrouded face whose eyes Zurbarán loses in darkness to suggest the her-
metic nature of the saint's vision. The saint's gaping mouth is doubled in
the eye sockets of the skull he clutches. The eyeline is set low, so that the
saint towers over you even as he kneels. The light snatches the forms out
of an eroding darkness; the shadows suck them back in again. It gathers
up all the ecstatic and theatrical resources of Caravaggio's lighting and
impacts them into one single figure. Zurbarán, living in Seville, never
went to Italy and probably never saw an original Caravaggio in Spain,
although he probably knew the copy of Caravaggio's *Crucifixion of St.
Peter* that had been praised by his teacher in Seville, Francisco Pacheco.
The crucified Peter who materializes upside down in a reddish visionary
fog to the entranced St. Peter Nolasco in one of Zurbarán's weirder
paintings—an astonishing prophecy of late Dalí, as well as an echo of
Caravaggio—must have been inspired by that copy.

Zurbarán's work embodies the paradox of what the Spanish Counter-
Reformation expected in church painting: that extreme "spirituality" lay
in extreme realism. "Sometimes you might find a good painting lacking
beauty and delicacy," Pacheco wrote in his *Art of Painting*. "But if it
possesses force and plastic power and seems like a solid object and lifelike
and deceives the eye as if it were coming out of the picture frame, the lack
of them is forgiven." The real image made Christ or a saint real, ready to
speak to you from the wall. What we read as signs of El Greco's "spiritual-
ity"—the elongations, twistings and weird flickering light of his late
work—struck Pacheco as mannered and distracting. True, he had a
grudge against Zurbarán too and did not mention his ex-pupil in his book:
but Pacheco was a dry, insipid painter, and Zurbarán's slightly awkward
fierceness must have been disturbing to a man whose chief pride lay in
being the father-in-law of Velázquez. Zurbarán could not master the sense
of secular decorum, the discreet and far-reaching rhetorical power of
Velázquez's far greater art. He did not try to, since he was painting mainly
for monks not connoisseurs. He and Velázquez studied together and were
born within a year of one another, but their characters as artists were
utterly different: one was a chamberlain, the other a preacher and limner.
Velázquez makes Zurbarán look primitive. One senses this even in the
latter's most ambitious work, the immense altarpiece he did in 1638–40 for
the monastery of Nuestra Señora de la Defensión in Jerez, whose surviv-
ing parts—scattered long ago among museums in America, Spain, France
and Scotland—have been reunited for the first time by the Met for this

show. Its most beautiful panels, the *Adoration* and *Circumcision*, are crowded with static figures and seem to come out of the old world of Titian and Veronese; but when it came to mobilizing figures in action in deep space, in the centerpiece of a battle between Christians and Moors, Zurbarán could only quote from Velázquez's *Surrender at Breda* without achieving anything like its seamless integration. When a composition with many figures worked for Zurbarán, it was almost always arranged in friezes parallel to the picture surface, producing a solemn, stiff effect (sometimes hieratic, more often creakingly earnest), as in his paintings of St. Hugh and the Virgin of Mercy for the Carthusians at Las Cuevas. This archaic, almost Gothic patterning—inside which his genius for simplified form could produce ravishing episodes of detail, such as the folds and loopings of the monks' white habits in *The Virgin of Mercy*—was one of the things that commended Zurbarán to modernist taste. But to Velázquez's circle it cannot have looked very sophisticated. For all his formal solidity, moreover, the perimeter of Zurbarán's world often seems a tissue, ready to collapse under the pressure of revelation—and sometimes it literally does, as when the back wall of the otherwise "normal" domestic scene of *The Virgin and Christ in the House of Nazareth* dissolves in clouds and fulgid light as the young Jesus, foreseeing his Passion, pricks his finger on a thorn.

Zurbarán's Caravaggian intensity started to drop out of favor after 1650: what the Spanish Church wanted was the sweetness and emotional flexibility of Murillo, and Zurbarán turned to producing devotional paintings by the score for the provincial market in Latin America. Some of the late Madonnas in which he tried to rival Murillo's sentimental grace are sugary beyond belief, and the swarms of putti that infest them are among the ugliest in Spanish art. But the "feminine" late Zurbarán, with his fluid daylight effects and graceful, slightly stilted coloring, although less congenial to modern taste was not a painter to ignore. In any case, one now sees him whole for the first time.

Time, 1987

Nicolas Poussin

Nicolas Poussin (1594–1665) was the greatest French artist of the seventeenth century, the founder of his country's classical school. With him,

French painting shook off its provinciality and became a European affair, mirroring the power of its *grand siècle,* the age of Louis XIV. After Poussin, Rome could no longer condescend to Paris. But without Rome there would have been no Poussin: Rome formed and trained him, gave him his conception of professional life, his myths, his essential subjects, his sensuality and measure—in short, his pictorial ethos.

He first went there in 1624, and stayed sixteen years. What did he see? What did he do? No American museum until now has tried to tell us: there has never been a Poussin retrospective in this country. But now the gap has been filled by a show at the Kimbell Art Museum in Fort Worth, "Poussin: The Early Years in Rome: The Origins of French Classicism." It comes with a detailed, argumentative and altogether excellent catalogue by art historian Konrad Oberhuber, who has carried Poussin studies well beyond the point at which they were left by the death of Anthony Blunt. And it is bound to correct whatever stereotypes one may have about Poussin the cold, the correct, the theoretician of mode and decorum.

To the seventeenth century the classical world was the locus of Ideal Beauty, but how did a Frenchman enter it? A writer could read Virgil without leaving Paris, but a painter had to go to Rome. There, ancient sculpture and architecture abounded; from them, antiquity could be reimagined; and it was the strength of the reimagining, not just its archaeological correctness, that counted. Poussin's main regular job during his Roman years was drawing records of ancient sculpture for a rich antiquarian named Cassiano del Pozzo. This gave Poussin excellent access to collections, and the time to develop the repertoire of figures that would fill his work in years to come. Rome was not just a boneyard of suggestive antiques: it was full of living art whose plasticity, color and narrative richness surpassed anything you could see in France—Caravaggio, Pietro da Cortona, the Carracci. But del Pozzo's main gift to Poussin was the intellectual background that enabled a melancholy, impetuous young Frenchman to become the chief *peintre-philosophe* of his age.

"This young man has the inner fire of a devil," wrote one of Poussin's Roman acquaintances. And in fact Poussin's vitality, reconceiving the antique, is the clue to his art. His renderings of classical myths struck back to the root. Poussin was more of a sensualist than people think. You want to roll on his grass, sprawl under the shot-silk blue and honey-colored sky that unfurls over his Roman *campagna.* His goddesses and nymphs grow up out of the earth; they have not dropped from Olympus. They carry their archaism like a bloom. There is more sexual tension between the white goddess and the kneeling shepherd in *Diana and Endymion,* 1628,

than in a hundred Renoirs. This, for him, is part of classicism. "The beautiful girls you will have seen at Nîmes," he wrote to a friend in 1642, "will not, I am certain, delight your spirits less than the sight of the beautiful columns of the Maison Carrée, since the latter are only ancient copies of the former."

But antiquity mattered to him for other reasons. It was Law. Deprived of its magisterial influence, a painter could go off the rails and become a fribbling hack, "a *strappazzone,*" he wrote in Paris, "like all the others who are here." For him, the one thing that truly sustained creation was the inseminating authority of the past.

Poussin was to art what his contemporary Pierre Corneille became to drama. As La Bruyère said of Corneille, he "paints men as they ought to be." The world of Corneille's great tragedies of the 1640s, *Rodogune* or *Horace,* is prefigured in Poussin: not just the reflection of classical drama, but its heightening into a schematic grandeur where will, pride and logic are displayed as they rarely are in real life, and exemplary self-sacrifice resolves the conflict between duty and passion.

The manifesto of this in Poussin's early work is *The Death of Germanicus,* 1626–28.

Germanicus Julius Caesar, conqueror of Germany, was sent to command Rome's eastern provinces and died in Antioch in A.D. 18, poisoned— so it was believed—by a jealous Roman governor. He soon became an archetype of the Betrayed Hero.

Poussin turns this incident into a tremendous oration on duty and continuity, overlaid with Christian allusions to the entombment of Jesus, whose life that of Germanicus overlapped. The hero lies dying beneath the frame of a blue curtain, which suggests both a temple pediment and a military tent. On the right are his wife, women servants and little sons; on the left, his soldiers and officers. The common soldier on the far left weeps inarticulately, his grandly modeled back turned toward us. Next to him, a centurion in a billowing red cloak starts forward: grief galvanized to action in the present. Then a gold-armored pillar of a general in a blue cloak (adapted from an antique bas-relief) projects grief forward into the future by swearing an oath of revenge; Poussin hides the man's face to suggest that this is not a personal matter but one of History itself. The target of this socially ascending wave of resolution is not only Germanicus himself—whose exhausted head on the pillow vividly predicts the style of Géricault nearly two hundred years later—but his little son, whose blue cloak matches the general's; the women suffer, but the boy learns, remembers and will act.

The more *Germanicus* unfolds, the more one realizes why Bernini, on his visit to Louis XIV in Paris, declared Poussin the only French artist who really mattered: *il grande favoleggiatore*, "the great storyteller." For the means of the painting match its narrative. Its pictorial structure, with the blues, reds and golds pealing like single strokes of a gong in the warm internal light, is irreducibly taut. Poussin's ancient Romans are not the insipid denizens of lesser classical art but men and women of vivid presence; their gestures have dramatic coherence and intensity. If one had to pick one image to sum up the best qualities of Baroque painting *all'antica*, this would be it.

Later in life Poussin would complain of the pressure of commissions. "Monsieur, these are not things that can be done at the crack of a whip," he wrote to his friend and patron Chantelou in 1645, "like your Parisian painters who make a sport of turning out a picture in twenty-four hours." But in his Roman youth, he could and did turn them out, and it would be idle to pretend that all early Poussin is on the same level. Some paintings are much less "finished" than others; a few are hackwork (such as a *Hannibal Crossing the Alps*, done for del Pozzo, who had a thing about elephants); and one painting from San Francisco's de Young Museum, *The Adoration of the Golden Calf*, does not survive comparison; it is clearly not by Poussin at all, although it shows how fanatically others imitated him. But the unevenness is part of Poussin's development: an artist in the real world, discovering the true tone of his ideas. Young Poussin did not paint plaster gods, and he was not one himself.

Time, 1988

Guido Reni

Anyone who thinks art reputations stick once they are made should think again—about Guido Reni (1575–1642), whose show, the first glimpse of him in ages, is now at the Kimbell Art Museum in Fort Worth. Reni was the leading Bolognese artist of the seventeenth century. For nearly two hundred years after his death, connoisseurs and tourists held him to have been angelically inspired, the greatest painter of his age: as famous, in his

own way, as Michelangelo, Leonardo, van Gogh or Picasso. Shelley thought that, if some cataclysm destroyed Rome, the loss of Raphael and Guido Reni would "be alone regretted."

But the scaly truth is that taste changes; and an anthology of writings on Guido Reni at the end of the catalogue charts his fall. You see the first puff of feathers detach itself from the wing of the Angelic Limner in 1846, when John Ruskin lets fly in *Modern Painters:* "A taint and stain, and jarring discord . . . marked sensuality and impurity." In 1895 Romain Rolland downed him: "He was able to deceive two entire generations. . . . Guido's laborious conscientiousness is void of thought and true feeling." Two years later, Bernard Berenson wrung his neck: "We turn away from Guido Reni with disgust unspeakable." And it was downhill from there; in 1910 his *Bacchus and Ariadne* sold at Christie's for just under ten pounds, or about a fifth (in real money) of its auction price sixty years before. The nadir was in the late fifties, when you could get a ten-foot Guido Reni (if you wanted it, which few did) for under $300 at auction. Reni's posthumous career is not one that the heroes of the Late-Modernist Art Industry can contemplate with equanimity.

What did him in? For the Victorians, the growing belief that his piety was hypocritical. More seriously, Guido's frequent combination of tepid high-mindedness and relentless self-repetition looked insincere to early-twentieth-century eyes. The classicism of his languidly yearning saints, rolling their eyeballs to the light of heaven, seemed trite and formulaic.

Much of it still does. Reni did not make things easy for himself. Apart from being superstitious (he kept seeing a phantom light over his bed) and timid to the point of paranoia (he refused any food not prepared in his house, lest it be poisoned), he was a compulsive gambler. It was his only vice—his sex life should certainly have appealed to prudish Ruskin, for it did not exist: he shunned women in the fear that they might be witches. But gambling led him to churn out hack paintings, with predictable results for his reputation.

Still, an artist deserves to be judged on his best work, and the idea that Reni was just a painter of saccharine devotional figures does not stand up. He will never get back on the pedestal he occupied in the seventeenth and eighteenth centuries, alongside Raphael. But there were qualities in Reni which his sometimes irksome professional smoothness served; and they are still perceptible today.

This show is the first in a generation to restore Guido Reni: the last one, in his native Bologna, was in 1954. And to a great extent it succeeds. When the various phases of Reni's work are assembled, he comes across

as a more diverse and interesting painter than one ever expected. Some of his key paintings, such as the Prado's extraordinary *Atalanta and Hippomenes,* in which he achieved a grand synthesis of Caravaggism and classical diction, are missing from Fort Worth. But it is quite clear from a work such as *Joseph and Potiphar's Wife* that Reni could endow human figures with a Caravaggian density and passion while pointing out the way for a classicism still to come: the figure of Joseph, moving away in its sandals and serene quadrant of ocher cloak, might be striding toward his eventual home in one of Poussin's paintings. His image of the young Baptist, modeled to the nth degree of sensitivity, warm against the cold blues and dark greens of the framing landscape, seems about to speak; and to look at the landscape background is to realize what English artists a century later, particularly Gainsborough, would gain from Reni. He had an inspired sense of the mechanics of composition, as *Nessus and Dejanira* proves: an airy ballet on the theme of rape, in which every billow and facet of the drapery seems to operate as form. Partly because he worked from sketches, engravings or memories of sculpture, Reni's heroic male nudes—the *Samson Victorious,* or the various figures of Hercules done for the Gonzagas in Mantua—possess a sculptural intensity that blots out the rest of the painting. One remembers only the imposing structure turning, as it were, before the eye, displaying its stresses and bulges—straining for embodiment and yet defeating it with its own supercharged mannerism. More than any other artist of his time, Reni adumbrated the abstractness of the neoclassical figure, along with its faint overtones of camp.

That is why, however incongruously, some Renis call to mind "classical" Picasso in the early twenties: both are parodies, Guido's part-subliminal and Pablo's wholly deliberate, of the same antique fantasy of ideal beings on the Mediterranean shore. The point is made by Reni's *Bacchus and Ariadne,* with its enameled colors, its air of travesty—one doesn't believe for a second in jilted Ariadne's grief, but one does wonder what her right hand is about to do to the hero's diminutive genitals—and its iron-butterfly stylishness. This is an idyll that makes no bones about its own artificiality. Brilliance is all, and it is just enough.

Time, 1989

Inigo Jones

Tucked away in downtown Manhattan, far off the museum track, the nonprofit Drawing Center has been quietly at work since 1977. Along the way it has become one of the few necessary art institutions to be born in the USA in the last fifteen years. "Necessary" because, unlike the muddle of private and semiprivate vanity museums full of outsize contemporary art foisted on the American public in the late eighties, The Drawing Center really does stand for quality—as against what is only "spectacular" or "relevant." It has never done a less than interesting show. Its new one, "Inigo Jones: Complete Architectural Drawings," curated by English art historian John Harris, is one of its best.

Inigo Jones, court architect and masque-maker to the Stuarts, was undoubtedly a genius; but except by name he is not a well-known genius in America, since he built nothing outside England and no attempt, until now, has been made to gather a full exhibition of his drawings. But he was the great English all-rounder of the seventeenth century—designer, painter, mathematician, masque-maker, engineer and antiquarian.

His career was long. Not many Englishmen lived to push eighty. Born in 1573, he grew up in Elizabethan England, collaborated on a masque with Ben Jonson and probably knew Shakespeare. He lived on into the time of Cromwell and suffered the humiliation of being dragged out of the sack of Basing Castle by Roundhead soldiers at the age of seventy-two, bundled up in a blanket. He died seven years later, in 1652. He cannot have been wholly sorry to leave a world that had killed his king and friend, Charles I. For Jones was the greatest royal architect England ever produced. During his quarter-century of service as Surveyor of Works to the Crown (from 1615 to 1625 under James I, and from 1625 to 1641 under Charles I) he acquired an authority like Bernini's. Through the example of his most famous buildings, such as the Queen's House in Greenwich and the Banqueting Hall in Whitehall—which, with its ceiling paintings by Rubens, is one of the grandest collaborations of talent in the seventeenth century—Inigo Jones guided English architecture out of its Elizabethan mannerism. He led it into an Italian amplitude, based on Roman

and Venetian models but with its own distinctive qualities—"solid," as he wrote himself, "proportionable according to the rules, masculine and unaffected." Moreover, he was adaptable. When it came to designing the piazza of Covent Garden with its integrated Church of St. Paul, Lord Bedford (who was paying for it) told Jones that he wanted this church to be "not much better than a barn." "Well, then! You shall have the handsomest barn in England," Jones answered, and produced it. He never delegated a design or failed to transform what he copied. He thought—and drew—in terms of large volumes, generous spaces, exalted plainness relieved by lucid, ingenious detailing. Later, Georgian architects would owe him an immense debt. He was the father of English classicism.

Curiously enough, not much is known about his life. Jones was a clothworker's son and began his career as a journeyman painter. Quite early on, in his mid-twenties, he went in a ducal retinue through France and Germany, and then to Italy, where he spent five years. How he afforded that stay is a mystery; one theory holds that Jones, who never married and may have been homosexual, was kept by one or another of the powerful exquisites of the Elizabethan court, the Earl of Essex or the Earl of Southampton. But whatever his arrangements, his taste for European travel and study would change the face of English culture. As Harris points out, Jones was first in what would be a long line of English "intellectual travelers," bringing lessons back from the Continent—especially on his second European trip, in 1613–14, this time with the Earl of Arundel, who would tap their mutually acquired learning to assemble the greatest private collection in England, while Jones himself was able to make use of the cameos, medals, sculpture and precious archives of drawings by Palladio and Scamozzi. Everything Jones drew breathes an air of sophistication quite new to English art. This includes his stage designs, for he revolutionized the English theater by giving it, for the first time, the elaborate scenery with backdrops, revolving stages and sliding wings that had been used in Italy but never on the Shakespearean stage. The confidence of his fantasies was striking and even a costume sketch like that for the "fiery spirit," a torchbearer for one of his court masques, shakes its red plumage with Italianate brio. And although his inventiveness is best seen in the stone and brick of his finished buildings, one marvels at its evidence in the drawings—the variations he would run, for instance, on designs for ceremonial doorways, now grave and severe, now bursting with free uses for acquired Italian motifs. Drawing mattered a great deal to Inigo Jones: more, probably, than it had to any English architect before him. It was the vehicle of imitation, on which his talent was explicitly

based. He was not content to direct work with rough perspective sketches and leave details to the inherited skills of artisans. During his Italian journeys he had collected some 250 sheets by his paragon, Palladio. From these he learned the conventions of drawing to a fixed scale, combining them with a fluent pen-and-wash technique to give a truthful, not just impressionistic, account of the future building. One sees his formidable skill as both a technical and a pictorial draftsman growing right through the show. *"Altro diletto che Imparar non trovo,"* he scribbled in his notebook in Rome, on his visit with Arundel in 1614: "I find no pleasure other than learning." That pleasure stayed with him throughout his life and is almost palpable in the drawings he left behind.

Time, 1989

Jean-Siméon Chardin

By general consent, Jean-Siméon Chardin was one of the supreme artists of the eighteenth century and probably the greatest master of still life in the history of painting. Yet there has never been a full-dress retrospective of his work, and to mark the 200th anniversary of his death, at the age of eighty in 1779, a huge Chardin show has opened in Paris. Organized by Pierre Rosenberg of the Louvre, it is the kind of exhibit that assigns the Tuts and Pompeiis to the category of show-biz trivia where they belong.

To see Chardin's work en masse, in the midst of a period stuffed with every kind of jerky innovation, narcissistic blurting and trashy "relevance," is to be reminded that lucidity, deliberation, probity and calm are still the chief virtues of the art of painting. Chardin has long been a painter's painter, studied—and when his work was cheap, collected—by other artists. He deeply affected at least three of the founders of modern art, Cézanne, Matisse and Braque. Van Gogh compared his depth to Rembrandt's. What seized them in his work was not the humility of his subject matter so much as its ambition as pure painting. The mediation between the eye and the world that Chardin's canvases propose is inexhaustible.

Were he judged merely as a social recorder, he would not have a

special place in art history. One does not need to be a historian to know how narrow his field of social vision was. He ignored the public ostentation of his time, as well as the private misery. Most of his paintings are condensed sonnets in praise of the middle path, idealizing the sober life of the Parisian petite bourgeoisie as embodied in his own household. He is said to have had a chirpy sense of humor, and there is certainly a sly irony in his *singeries,* or monkey paintings, in which hairy little parodies of man play at being painters and connoisseurs.

But of social criticism there is no trace. The nurse in *Meal for a Convalescent,* who stands opening a boiled egg in a kind of reverential silence like a secular descendant of Georges de La Tour's saints, is not a representative of the class war; the efforts of some historians to see Chardin's servants as emblems of an oppressed proletariat on the eve of the French Revolution are simply beside the point. A sense of social precariousness is the last thing one could expect to meet in a Chardin. Indeed, one can hardly imagine him working without the conviction that his way of life was immutable—that there would always be nurses to make beef tea, scullions to bargain for chickens, and governesses to scold the children; that the kitchen skimmers and casseroles and spice pots that he so often painted were in some important sense as durable as the Maison Carrée or the Colosseum.

He did not travel for nourishment. Apart from trips to Versailles, Chardin may not have left Paris once in his life. He was entirely a metropolitan man, and this fact seems oddly at variance with his paintings, since, as Pierre Rosenberg remarks, "one would like to imagine Chardin a solitary individual, a provincial."

Chardin's prolonged meditation on brown crockery and the matted fur of dead hares took place in the midst of an efflorescence of luxury art—pink bodies, swirling fronds of gold ornament, rinsed allegorical skies: the Rococo style in all its Gallic glory. It pervaded his milieu, and he did not despise it, but it was quite alien to his temperament. What he craved was neither luxury nor the high rhetoric of history painting, but apprehensible truth, visible, familiar, open to touch and repetition. The truth about an onion could be tested again and again. The truth about a Versailles shepherdess was, to put it mildly, more labile.

His love of truth and nature endeared him to advanced thinkers in France, the *encyclopédistes* in Denis Diderot's circle. Detecting a moral value in Chardin that was lacking in Boucher, Diderot became his chief intellectual supporter. "It is the business of art," he argued in 1765, "to touch and to move, and to do this by getting close to nature." Chardin

epitomized that ambition at work: "Welcome back, great magician, with your mute compositions! How eloquently they speak to the artist! How much they tell him about the representation of Nature, the science of color and harmony! How freely the air flows around these objects!"

Few painters have ever had such a press as the one that, interrupted by a few decades of posthumous neglect, greeted Chardin from Diderot, the Goncourt brothers, Gide, Proust and dozens of others. And what is rarer, their praise was deserved. Chardin had two remarkable gifts. The first was his ability to absorb himself in the visual to the point of self-effacement. Now and again, as in his *Basket of Wild Strawberries*—a glowing red cone, compressing the effulgence of a volcano onto the kitchen table, balanced by two white carnations and the cold, silvery transparencies of a water glass—the sense of rapture is delivered almost before the painting is grasped.

But the fervor of this image, almost literally a contrast of fire and ice, is comparatively rare in Chardin's output. Generally his still lifes declare themselves more slowly. One needs to savor his *Jar of Apricots*, for instance, before discovering its resonances, which are not only visual but tactile: how the tambour lid of the round box accords with the oval shape of the canvas itself and is echoed by the drumlike tightness of the paper tied over the apricot jar; how the horizontal axis of the table is played upon by the stuttering line of red—wineglass, fruit, painted fruit on the coffee cups; how the slab of bread repeats the rectangular form of the packet on the right, with its cunningly placed strings; and how all these rhymes of shape and format are reinforced by the subtle interchange of color and reflection among the objects, the warm paste of Chardin's paint holding an infinite series of correspondences.

It is as though Chardin extended his ideal of the family to include groups of objects as well as people. The props of his still lifes, which were also the normal appurtenances of his home life, become like familiar faces: the patriarchal mass of his copper water-urn, raised on a squat tripod; a white teapot with a rakish finial; the painted china that signified his growing prosperity; and so on down to the last stoneware *daubière*, all signifying a world into which the eye could move without alienation or strain.

This patient construction, this sense of the intrinsic worth of seeing, combines with Chardin's second gift: his feeling for the poetic moments of human gesture (rather than the didactic ones, as in Greuze). It permeates his genre scenes and portraits, especially the portraits of children; the gentle muteness Diderot perceived turns into a noble ineloquence, as

though Piero della Francesca were visiting the house. Chardin's absorption in the act of painting paralleled the absorption of children in their games, which he painted. One has only to look at the figure in his portrait *Little Girl with Shuttlecock*—the expressionless face and white shoulders sitting on the stiff bodice like ice cream on its cone; the sequence of forms pinned together by accents of blue on her cap, her dress, her scissors ribbon and the feathers of her shuttlecock—to realize the truth of Rosenberg's insight: "The world that Chardin imposes on his figures is a closed world, a stopped world . . . a world at rest, a world of 'infinite duration.' " Rarely, in painting after Chardin, would one find this blend of intimacy and decorum.

Time, 1979

John Constable

John Constable (1776–1837) remains the great example of the Englishness of English art. In his work even God is an Englishman. What other deity could have created those ripe interfolding fields, that mildly blowing air, that dewy sparkle on the face of a static world? Constable did to the perception of landscape in paint what William Wordsworth did to it in verse: he threw out the allegorical fauna that had infested it since Milton and the Rococo—nymphs, satyrs, dryads, Virgilian shepherds and Ovidian spring deities—and substituted Natural Vision for the Pathetic Fallacy.

Between them, Constable and J. M. W. Turner define the supreme achievements of landscape painting in Europe in the first half of the nineteenth century, but Constable was by temperament incapable of reaching for Turner's ever-changing rhetoric of sublime effects. His work was more staid, more modest, less conspicuously "inventive." Painting, he considered, was "a branch of natural philosophy, of which my pictures are but the experiments." From Nicholas Hilliard's Elizabethan miniatures through Rupert Brooke's pastoral poetry, a deep love of the particulars of landscape, nose thrust in the hedgerow, has always been central to English culture. No wonder, then, that Constable's following is large and loyal.

His landscape is just what the English feel nostalgic for as they dodge trucks on the bypass amid the billboards and concrete goosenecks. It is conservatism writ in leaves and wheat.

Constable has always had an American following too, but the present show of sixty-four of his paintings and oil sketches at the Metropolitan Museum of Art in New York City is his first in the United States for thirty years. It is, necessarily, a modest affair compared with the immense Constable show at the Tate Gallery in 1976. Many favorites are not here, starting with *The Hay Wain*, the most reproduced landscape in English painting—a sort of vegetative Mona Lisa. But the show was curated by the world's leading Constable specialist, Graham Reynolds, formerly of London's Victoria and Albert Museum, and it serves as a refresher course for those who know Constable and a delightful introduction for those who do not.

Peace, security, the untroubled enjoyment of unproblematic Nature: such is the main motif of Constable's work. One might suppose that it would have made him popular in his lifetime, but English connoisseurs were far more receptive to Turner, the Romantic with wider moods and more liberal feelings. An archconservative who longed for institutional acceptance but was denied it most of his life—he was not elected to the Royal Academy until age fifty-two, and even then he had the humiliation of seeing his first entry as a member to its annual show rejected by his colleagues—Constable did not have the knack of getting on with clients or fellow artists. He was timid, prickly, and complacent and sardonic by turns. "Why, this is not drawing, but *inspiration*!" exclaimed William Blake over one of his tree studies. "I never knew it before," Constable snapped. "I meant it for drawing."

At times, in his copious letters, one senses the veerings and fragile boastfulness of a manic-depressive. He was not a sociable painter, which at least saved him from being a society artist; he disliked painting people, though he turned out quite a few routine portraits of country seats. In his emotional uncertainty and fear of change, he was the stuff of which rank-and-file Tories are made. He did not so much idealize stability as worship it, and as a result his entire view of rural England presents Arcadia in a new guise. One could never imagine, looking at his paintings of Dedham Vale and the River Stour, that the placid shires of the 1820s and 1830s looked very different to the writer and reformer William Cobbett, that they were full of rick burners, machine breakers, hanging judges and posses of brutal yeomanry.

The most Arcadian picture in this show is *Wivenhoe Park, Essex*, 1816,

almost the last word on Eden-as-Property. The enameled lawns and bulky cows, the relaxed zigzag of planes leading the eye toward the pink villa, the swans and fishermen riding on a serene sheet of water stitched with silver light: this is the epitome of civilized landscape. Like the best work of Jacob van Ruisdael, the seventeenth-century Dutchman whom Constable considered a master of "natural" vision, *Wivenhoe Park* manages to be both real and ideal; it is a powerful (though subdued) instrument of fantasy as well as an exact rendition of General Rebow's family seat.

Constable was a painter of substance, not fantasy; but imagination rises through the substance. His earliest childhood memories, the elements of his genetic code as a painter, were all about the weight and noise and feel of things he grew up with as a well-off son of a water-mill owner in Suffolk, on the River Stour. "The sound of water escaping from Mill dams . . . willows, Old rotten Banks, slimy posts, and brickwork. I love such things," he wrote to a friend. "They made me a painter (and I am grateful). . . . I had often thought of pictures of them before I had ever touched a pencil."

No wonder that, in a painter with so pronounced a taste for the specific, there was a constant argument between stereotypes and things seen. Constable loved his masters: Claude Lorrain, Ruisdael, Gaspard Poussin. Some of his most delectable paintings, such as *The Cornfield*, 1826, rely on the Claudean use of dark *repoussoir* trees framing a view of bright space at the center, and this can make them too charming to a modern eye. Constable himself remarked that *The Cornfield* "has certainly got a little more eye-salve than I usually condescend to give." But the great fact of nature, as Benjamin West had pointed out to Constable, was change. Shadows, vapors, clouds, the dewiness of grass in the morning, the dryness of leaves in the evening: nothing is fixed in a schema. Constable became convinced that he must overcome the stasis that convention and idealism produce in art: his project would then be, as he put it, "to arrest the more abrupt and transient appearances of the Chiaroscuro in Nature . . . lasting and sober existence."

Hence the hundreds of studies of clouds and sky and rain squalls, the sifting of light down on Hampstead Heath, the endless particularizations (never meant to be exhibited as final pictures) of small divisions of time, no two of which were the same. And hence, above all, the quality of Constable's mature work that seems so puzzlingly modern, a prediction of Impressionism: the thick paint. By his late years he was piling it on with a palette knife in higher and higher tones, all the way up to pure flake white, in an effort to render the broken luminosity he saw in nature. There

are moments when one feels the subject needs disinterring from the mass of pigment, but the expressive gains were sometimes enormous.

Never more so than in *Hadleigh Castle,* 1829. Constable brought to his view of the castle (which overlooks the Thames estuary) a pressure of melancholy: he was painting this desolate shore from memory, and his beloved wife, Maria, had just died of consumption. The paint is crusted, layer over layer, like mortar; even the grass and mallows in the foreground seem fossilized, and the broken tower—taller in art than in life—has an Ossianic misery to it. Then one's eye escapes to the horizon, glittering with scumbled white light, like a promise of resurrection. The whole image is as intense as anything in Turner: "melancholy grandeur," as Constable put it, the very essence of Romanticism and thus one of the key images of the English imagination.

Time, 1983

Antoine Watteau

There are exhibitions that, in their sympathy and scholarly energy, redefine the image of a dead artist for a generation. The presentation of paintings and drawings of Antoine Watteau that opened last month at the National Gallery in Washington, D.C., and will be seen at the Grand Palais in Paris and in Berlin through the spring of 1985, is such an event. So much of the work is fragile, and loans are so difficult to negotiate, that this, the first international loan exhibition of Watteau, may also be the last.

Its curators, Margaret Morgan Grasselli and Pierre Rosenberg, with the help of Nicole Parmantier and other art historians, have condensed the existing scholarship on Watteau, together with a great deal of their own, into a catalogue that now becomes a standard work. It shows no trace of the puffy garnish of superlatives considered obligatory for blockbuster shows in U.S. museums. The authors discriminate severely: "The execution lacks energy and seems pasty," runs the note on one painting from the Hermitage in Leningrad. "The figures are unsteady, the faces have no character or charm."

There are only about sixty Watteau paintings on whose authenticity

all experts agree, and his life is obscure. Since the Renaissance there have been few great artists about whom less is known than Watteau. He is almost as much of an enigma as Vermeer. He was born in Valenciennes in 1684, the son of a Flemish roof tiler. Until a few years before, Valenciennes was part of Flanders, not France; and Watteau's Flemish origins may have had more than a casual meaning to him, since the main influence on his work was Rubens. Nothing is known about his political views, family affections or sexual life. He had no fixed address; yet once he reached Paris, he rarely left its gate. His only recorded trip outside France was to England, where he went in the hope of a cure for the tuberculosis that killed him, when he was not yet thirty-seven, in 1721.

No scandals attach to Watteau's name, although he was said to have burned a few paintings he considered obscene a few days before he died. If they were as exquisite as *The Intimate Toilette*, the little panel that is shown for the first time in this exhibition, the loss must be considered heavy. He never married. He kept no journal, and no undisputed letters by him survive. The only writings in his hand are a few banal jottings on the back of drawings. They do not contain a word about the theory of painting; perhaps he had none.

His circle of friends in Paris included some of the most cultivated men of the day, such as the financier Pierre Crozat (whose collection of old master drawings was said to have completed young Watteau's aesthetic education) and the Flemish artist Nicolas Vleughels. But their memoirs of Watteau tend to be short and sometimes contradictory; they blur when the traits of his possibly rather feckless, prickly character present themselves. He seems to have been solitary and misanthropic, but with flashes of antic gaiety: "A good friend but a difficult one," the dealer Edmé-François Gersaint unhelpfully put it. Naturally one would like to know more; probably we never shall.

There were, of course, great differences between Rubens and his hierophant Watteau. One painted big, the other small; the tone of Watteau's paintings is always unofficial and intimate, very unlike the grand elocution of Rubens. Watteau managed to skim off Rubens's lustrous surface and endow it with a still greater sense of nuance, while leaving his master's tyrannous physicality behind. To look at his *fêtes champêtres*—those felicitously idealized gatherings of young lovers planted on the unchanging lawn of a social Eden—is to think of pollen and silk, not flesh. Watteau was a great painter of the naked body, but his nudes tend to privacy and reflection. They are completely unlike Rubens's magniloquent blonde wardrobes. He seems, for this reason, the more erotic artist.

Because his scenes were bathed in an aura of privilege, many people still think of him as a court painter. Nothing could be further from the truth. After he died, Watteau's work appealed irresistibly to the high and mighty of Europe: Frederick the Great of Prussia had no fewer than eighty-nine paintings by or in the manner of Watteau in his palaces at Potsdam, Sans Souci and Charlottenburg. Alive, Watteau had no time for courts, and little access to them anyway. He sensibly preferred the theater, whose troupes and characters he painted so often, shifting them from the stage to "real" landscapes (which are themselves stages, only of a subtler kind), that it is still hard to disentangle his allegories from his theater pieces.

His heirs—Boucher, Pater, Lancret—would embody Rococo. But Watteau died in 1721, just over a year before Louis XV was crowned. Thus the artist whose feathery trees and pastoral scenes of gallantry seem the very essence of Rococo sensibility reached only the edge of the Rococo. His time was that of Louis XIV, the Sun King. If the intimacy of his art seems so far from the bemusing pomp of Versailles, it is partly because his imitators lagged; it took time to convert the scenography of Watteau's fugitive, shadowed mind into a system of decor suitable for the Pompadour.

One learns nothing about real history from these paintings. Outside the gilt frames, hysteria and massacre ruled. France was continuously at war for most of Watteau's life. In the winter of 1709, men ate corpses in the streets of Paris; the French economy was wrecked by a wave of delirious speculation whipped up by a Scottish financier, John Law. But on canvas, the Cytherean games never end. Men need paradises, however fictive, in times of trouble, and art is a poor conductor of historical events. One thinks of the Impressionists constructing their scenes of pleasure through the days of the Commune of 1871 and the Franco-Prussian War.

But there is another reason to connect Watteau with Impressionism: the colloquial, almost chatty strand of improvisation that purls along the surface of his art without distracting from its depths. As with Renoir, his models were his friends. He drew them incessantly, in fine-pointed chalks—a red, a white and a black, the famous *trois crayons*—whose use he had learned from Rubens. Their faces and poses, rendered in that wiry, atmospheric line, became a collection of types, single figures such as the Seated Woman that he would combine for his finished compositions.

Thus, even when the subject is purely imaginary, his figures have a lot of descriptive reality. Their expressions take us away from the explicit theater of Baroque art, where each gesture stands for a set emotion. They

are more complex than that. The face is a surface in change: it does not compose itself formally as an index of traits. It suggests that personality is labile, and this insight was part of Watteau's appeal to modern artists. The supreme example, in his portraiture, was the face of the clown Gilles rising centered and alone in his baggy white costume—the Louvre's male Mona Lisa, the Pierrot adopted as a symbol by Picasso, Stravinsky and Cocteau.

Critics have always spoken of Watteau's "musicality." But what does it mean? His paintings are full of people playing instruments, and Watteau obviously understood their techniques and disciplines. He loved music; sometimes he was comic about it too, as in *Mezzetin*, whose soft operatic expression is mocked by the figure's sinewy hands and the high twangling of the guitar he plays. But Watteau's musicality is more rarefied than this: it lives in pauses, silences between events. He was a connoisseur of the unplucked string, the immobility before the dance, the moment that falls between departure and nostalgia. In *Prelude to a Concert*, the central musician is tuning but not playing his theorbo or chitarrone, a long business that slightly frays the patience of his fellow musicians. A girl riffles through a score, a child plays with a spaniel, nothing happens. But the stance of the player is commanding; it enjoins attention, and in the protracted pause one sees the pictorial magic of the painting: its ruffled and sliding light, its sense of intimate structure expressed by the crinklings of taffeta in the dress of the standing woman on the left, her back half turned to us.

Great artists invent things that sound banal. Watteau invented the draped human back. This sounds simple, a matter of mere observation; it was not. In his hands the human back, preferably of a young woman, became as expressive as a face—a pyramid or wedge of subdued, lustrous substance, played on by light, divided into delicately articulated folds and crannies that betoken silence and concentration.

Nowhere is it more subtly used than in his largest and perhaps greatest painting, *Gersaint's Shop-sign*, which was actually, though briefly, used as a sign above the dealer's premises on a Paris bridge. We are looking into a gallery that sells paintings and mirrors. The paintings are dimly legible; the mirrors are black, reflecting little. Three backs are turned: a pink cascading dress on the left, a lady and a gentleman scrutinizing a painting on the right. The sense of absorption—of a painter spying on people looking at art—is extreme; and so is the feeling for material substance, quiet, glowing, meticulously wrought. On the far left, a portrait of Louis XIV is being lowered into its crate for shipment. This refers to

the name of Gersaint's shop, Au Grand Monarque, but also to the death and burial of the Sun King himself. The shop sign is at once an elegy, a work of art criticism (for no painting on the walls is there by accident) and an inspired essay of social observation. It begins what Watteau would have done with his maturity. But a few months later his lungs were gone, and he was dead.

Time, 1984

II / *Nineteenth Century*

German Romanticism

The exhibition "German Masters of the Nineteenth Century," now on view at the Metropolitan Museum of Art in New York City, is about thirty-five years late in coming to Manhattan; but in this case, better late than never. No such comprehensive view of German art has ever been set before an American public; from the romantic visions and esoteric metaphors of painters such as Philipp Otto Runge and Caspar David Friedrich in the first decades of the nineteenth century, to the robust dash and splash of Lovis Corinth at its end, there are 150 works by thirty artists, and they help fill a gap in our sense of the actual patterns of European culture. The fact, to put it simply, is that German art was left out of American taste on nineteenth-century matters—a taste formed and dominated by Paris, from Impressionism onward. Ten years ago, not one art course in America would have suggested that Friedrich was a painter of comparable importance to Géricault, or that the work of Wilhelm Leibl or Hans Thoma might be anything better than an able but provincial reaction to that of Gustave Courbet. It was not always so; in the last century, Munich influenced American artists even more than Paris. There are plenty of parallels, if not exact concordances, between the longings expressed in German Romantic art and the sense of pantheistic immanence, God-over-the-Hudson, that ran through American nature painting in the mid–nineteenth century. But since World War II, for obvious reasons, the links were broken and discarded—especially by those blind savants who fell in with the idea that Nazism could, by some train of coarse free association, be traced back to German transcendentalism. So this show, in all its variety and unfamiliarity, cannot help instructing its audience. Its range

is wide (and ably discussed in the catalogue by Gert Schiff and Stephan Waetzoldt).

"One might come closest to a definition of their aspirations," writes Schiff in his catalogue essay on early-nineteenth-century artists such as Friedrich, Runge and Carl Gustav Carus, "by stating that 'longing' (*Sehnen*) was the first and almost the last word of German romanticism." These painters were men of exceptional seriousness, their sense of mission verged on the priestly, and they saw art as a powerful means of philosophic speech. As Schiff remarks, one dictum of writer Friedrich von Schlegel appears to summarize their hopes: "Only he can be an artist who has a religion of his own, an original view of the infinite."

Where did the infinite show itself? In nature, and all individual mythologies must be deduced from a philosophy of nature, through contemplation of the universe. One saw God in what he had made, a diffuse and vast presence behind the screen of natural facts. Thus one of the master images of Romantic contemplation was Friedrich's *Moonrise on the Sea*, 1822, three figures on a rock, silhouetted in a loneliness as absolute (though not as flamboyant) as Manfred's, Childe Harold's or Young Werther's, gazing in immobility at the slow unfolding of light on the darkened, violet-tinged flatness of sea and sky. Like most of Friedrich's paintings, it is soaked in allegory—the moon representing Christ, the ships serving as emblems of the voyage of life, and so on—but the recent revival of Friedrich's reputation has more to do with his ancestral relationship to more modern artists: to Edvard Munch, in particular, and Mark Rothko, whose rectangular "landscape" forms and transcendentalist pessimism now seem to preserve, with striking intensity, the Romantic desire for that "original view of the infinite."

The exhibition offers that desire in all its facets. It shows itself to spectacular effect in the obsessed, lyrical mysticism of Runge, a painter who was perhaps the closest equivalent to William Blake that Germany produced. In Runge the world is imagined in extreme detail, near and far, as a sort of metaphysical machine, a generator of intricate meanings about the life of the universe: birth, death, renewal, metamorphosis. His ambition (never fulfilled) was to do a cycle of religious murals, *The Four Times of Day;* they would be installed in a special chapel and would form, Runge hoped, the nucleus of a new religious cult. The surviving studies for them, for instance *Morning,* 1803, are remarkably hard to decipher as doctrine. Yet that blue world of twining blossoms—Runge's amaryllises and lilies are the ancestors of Art Nouveau—of genii and weird, pale cherubs is rendered with such pantheistic conviction that it attains the force of

religious art. The spiritualist urge lasted far into the nineteenth century. Its last major bearer was Arnold Böcklin—a Swiss, but included in this show by adoption, as it were. Böcklin's painting *The Island of the Dead*, 1880, had every reason to survive: theatrical it may be, but that spectacle of a white-wrapped priest, borne silently on the coffin-bearing barge toward the screen of cypresses in the unnatural raking light, remains one of the canonical images of death in art.

The image and myth of Italy presides over this show, as it must over any account of nineteenth-century German culture. The reasons are many, but they grow from one stem: Italy offered German artists both sensuous discipline—as it had, centuries earlier, to their national hero Albrecht Dürer. The luxury lay in nature, the stringency in culture. Goethe's "land where lemons flower" provided northern enthusiasts with an inexhaustible supply of prototypes and themes, marmoreal fragments of the Roman past and painted lessons from the Renaissance.

No French or English admirers of the antique would surpass Johann Winckelmann's rapturous descants on the Apollo Belvedere, and it would be hard to find any other nineteenth-century painting that showed more adoration for cincquecento Rome than Peter Cornelius's *The Wise and the Foolish Virgins*. With its fresco-pale, linear style, its hard outlines à la Signorelli and its copious quotations from Raphael, it is the kind of picture that could be produced only by a man infatuated with his sources.

Such paintings remind us that there is no simple definition of Romanticism, especially in Germany. The luminous, tightly rendered religious icons done by German artists in Rome after 1810—Cornelius, Johann Overbeck, Franz Pforr and Julius Schnorr von Carolsfeld—are just as much a product of the Romantic impulse toward fundamentalist spirituality as Friedrich's but they approach it in a different way, through a doctrinal channel. Faith, not philosophy: these Nazarenes, as the Italians nicknamed the long-haired German idealists in the Roman artists' colony, believed it was their mission to bring back the direct and ardent Roman Catholic faith of old Germany. They would be medieval guildsmen, reborn—a fantasy that runs through German art history and, incidentally, gave the Bauhaus a good deal of its impetus. Reacting against a "modern" Germany they saw as spiritually depleted, they tried to return art to the "primitive" vitality of the Renaissance, to the purity of vision they attributed to all presecular, biblically addressed painting. In fact, their best work—which once looked merely quaint to Francocentric taste—now seems to have acquired a peculiar dignity with the years. In its queer, pedantic way, it is more than pious pastiche of Botticelli or Raphael. It

has the integrity of absolute conviction, although the hopes and moral assumptions behind it—like so much of the spiritual fabric that formed Romanticism itself—now seem lost, a matter of cultural archaeology, as remote as the moon over Friedrich's flat sea.

Time, 1981

Edgar Degas

The Metropolitan Museum of Art's huge Degas show (more than three hundred works) proves once more that—whatever else may be wrong with the art industry—we are still in the golden age of the retrospective exhibition. In the last ten years almost all the great nineteenth-century artists, with a few conspicuous exceptions such as Seurat and Delacroix, have been done at their full stretch by French and American museums: Cézanne, Manet, Courbet, van Gogh, Gauguin and now this. Such shows will not be repeated. (Can one imagine the Art Institute of Chicago lending *La Grande Jatte* to a Seurat retrospective in London or, conversely, the London National Gallery permitting its *Bathers at Asnières* to go to America? Only with difficulty, and before long such a project will seem inconceivable.)

As the last examples of a kind of museum discourse that will be extinct in the twenty-first century, such shows ought not be missed. One may deplore the crowds, the souvenir-selling, the Met's social circus and its Teletron tickets at $7.00 apiece, an outrageous tax on knowledge. Earplugs—preferably not attached to Acoustiguide gadgets—and yogic detachment will be needed. There are, as crusty old Degas once said, some kinds of success that are indistinguishable from panic.

But there has not been a major Degas retrospective in fifty years, and probably never again will so many of his paintings, drawings, prints and sculptures, with such a massive scholarly effort (literally: the catalogue, weighs slightly over six pounds), be brought together. And now, we see the man whole at last.

It is curious that it should have taken so long. There was not even a full-scale biography of Degas until Roy McMullen's in 1984. Aspects of

Degas's work—mainly, his ballet paintings from the 1880s—have long been popular with a broad audience; too much so for their own good. But he has never been a "popular" artist like the wholly inferior Auguste Renoir, whose Paris–Boston retrospective in 1985 beguiled the crowds and bored everyone else. Degas was much harder to take, with his spiny intelligence (never Renoir's problem), his puzzling mixtures of categories, his unconventional cropping and, above all, his "coldness"—that icy, precise objectivity which was one of the masks of his unrelenting power of aesthetic deliberation. Besides, the long continuities of his work have not always been obvious. The figure you think he skimmed from the street like a Kodak turns out to have been there already, in Ingres or Watteau or some half-forgotten seventeenth-century draftsman who suited his purposes. Degas was the most modern of artists, but his kind of modernity, which entailed a passionate working relationship with the remote as well as the recent past, hardly exists today. How we would have bored him, with our feeble jabber of postmodernist "appropriation"!

In his late years Hilaire-Germain-Edgar Degas was chatting in his studio with one of his few friends and many admirers, English painter Walter Richard Sickert. They decided to visit a café. Young Sickert got ready to summon a fiacre, a horse-drawn cab. Degas objected. "Personally, I don't like cabs. You don't see anyone. That's why I love to ride on the omnibus—you can look at people. We were created to look at one another, weren't we?"

No passing remark could take you closer to the heart of nineteenth-century Realism: the idea of the artist as an engine for looking, a being whose destiny was to study what Balzac, in a title that declared its rebellion from the theological order of Dante's *Divine Comedy,* called *La Comédie Humaine.*

The idea that the goal of creative effort lay outside the field of allegory and moral precept was quite new in the 1860s, when Degas was coming to maturity as a painter. The highest art was still history painting, in which France had reigned supreme; but since 1855 practically the whole generation of history painters on whom this elevation depended—Paul Delaroche, Ary Scheffer, Horace Vernet and, above all, Eugène Delacroix and Jean-Auguste-Dominique Ingres—had died, and no one seemed fit to replace them. French critics and artists alike, and conservative ones in particular, felt a tremor of crisis, as others would a century later as the masters of modernism died off. After them, what could sustain the momentum of culture? "His presence among us was a guarantee, his life a safeguard," ran Ingres's obituary in the *Gazette des Beaux-Arts* in 1867.

And yet beyond the ruins of the temple, something else was stirring: a sense of the century as unique in itself, full of what Charles Baudelaire called the "heroism of modern life." Its chief bearers, in painting, were to be Édouard Manet and Edgar Degas.

Born in 1834 into a rich Franco-Italian banking family with branches in Paris, Naples and New Orleans, Degas was never short of money and never doubted his vocation as a painter, in which his family encouraged him. He was a shy, insecure, aloof young man—if one did not know this from the testimony of his friends, one would gather it from his early self-portraits, with their veiled look of mannerist inwardness acquired from Pontormo—and, it seems, unusually devoid of narcissism: unlike almost every nineteenth-century painter one has heard of, he gave up painting his own face at thirty-one. It was the Other that fascinated him: all faces except his own.

In time he would construct a formidable "character" to mask his shyness: Degas the solitary, the feared aphorist, the Great Bear of Paris. He never married—"I would have been in mortal misery all my life for fear my wife might say, 'That's a pretty little thing,' after I had finished a picture." Certainly he was not homosexual. The more likely guess is that he was impotent. If so, all the luckier for art: his libido and curiosity were channeled through his eyes.

He had a reputation for misogyny, mainly because he rejected the hypocrisy about formal beauty embedded in the depilated Salon nudes of Bouguereau and Cabanel—ideal wax with little rosy nipples. "Why do you paint women so ugly, Monsieur Degas?" some hostess unwisely asked him. *"Parce que la femme en général est laide, madame,"* growled the old terror: "Because, madam, women in general are ugly."

This was a *blague.* To find Degas's true feelings about women, one should consult the pastels and oil paintings of nudes that he made, at the height of his powers, in the 1880s and 1890s. Some critics still find them "clinical," because they seem to be done from a point outside the model's awareness, as though she did not know he was there and were not, actually, posing. "I want to look through the keyhole," Degas said. The bathers were "like cats licking themselves." Their bodies are radiant, worked and reworked almost to a thick crust of pastel, mat and blooming with myriad strokes within their tough winding contours. But they are also mechanisms of flesh and bone, all joints, protuberances, hollows, neither "personalities" nor pinups. (One sees why Duchamp, inventor of the mechanical bride, adored and copied Degas.) Not even *Nude Woman Having Her Hair Combed*, 1886–88, the most refined and classical of these nudes, seems in the least Renoiresque, although nothing could be more

consummately appealing than that pink, slightly blockish body against the gold couch and the regulating white planes of peignoir and apron. It was a subject to which Degas brought special, almost fetishistic feeling, and a later version of the same theme, *The Coiffure*, 1896, shows what a vehicle for innovation it could be: by now the contours of the woman and her maid are roughed out with an almost Fauvist abruptness, and they emerge from a continuous orange-russet field that seems to predict Matisse's *Red Studio*—in fact Matisse once owned this painting, although he bought it from Degas's studio sale in 1918, long after his *Red Studio* was finished.

Looking back from old age, Degas reflected that "perhaps I have thought about women as animals too much," but he had not—although he was certainly reproached for doing so. His "keyhole" bathers provoked the crisis of the Ideal Nude, whose last great exponent had been the man Degas most revered, Ingres. Yet their exquisite clarity of profile could not have been achieved without Ingres's example. In them, the great synthesis between two approaches that, thirty years before, had been considered the opposed poles of French art—Ingres's classical line, Delacroix's Romantic color—is achieved. There is no clearer instance of the way in which true innovators, such as Degas, do not "destroy" the past (as the mythology of avant-gardism insisted): they amplify it.

In their novel *Manette Salomon* (1867) the Goncourts had Coriolis, an artist, reflect on "the feeling, the intuition for the contemporary, for the scene that rubs shoulders with you, for the present in which you sense the trembling of your emotions. . . . There must be found a line that would precisely render life, embrace from close at hand the individual, the particular—a living, human, inward line—a drawing truer than all drawing."

Degas thinly disguised, you would think. But at the time, the Goncourts did not know Degas; they would come to meet him later. Neither, strangely enough, did Degas meet his literary parallel, Gustave Flaubert, whose *Madame Bovary* had made its scandalous and prosecuted debut in 1856—although he had certainly read him. Flaubert's objectivity, his impassioned belief in "scientific" description as the instrument of social fiction, his acute sensitivity to class, his sardonic humor—all find their counterpart in Degas. And so does his attitude to the past as source and example, the springboard for invention in the present. "There must be no more archaisms, clichés," Flaubert wrote about the difficulty of prose. "Contemporary ideas must be expressed using the appropriate crude terms; everything must be as clear as Voltaire, as abrim with substance as Montaigne . . . and always streaming with color." Read Ingres and Delacroix for Voltaire and Montaigne, and you have Degas in a nutshell.

Nothing escaped his prehensile eye for the texture of life and the

myriad gestures that reveal class and work. He made art from things that no painter had fully used before: the way a discarded dress, still warm from the now naked body, keeps some of the shape of its wearer; the unconcern of a dancer scratching her back between practice sessions (*The Dance Class*, 1873–76); the tension in a relationship between a man and a woman (*Sulking*, 1875–76) or the undercurrent of violence and domination in an affair (*Interior*, sometimes known as *The Rape*, 1868–69); a laundress's yawn, the stoned heaviness of an absinthe drinker's posture before the dull green phosphorescence of her glass, the exact port of a dandy's cane, the scrawny professional absorption of the *petits rats* of the ballet corps, the look in a whore's eye as she sizes up her client, the revealing clutter on a writer's desk. Even when painting themes from the Bible or from ancient history, as he often did in his early years, there were, as Henri Loyrette points out in the catalogue, "contemporary concerns beneath a thin archaeological veneer." His *Scene of War in the Middle Ages*, 1863–5, whose erotically charged women victims prefigure his bathers, refer to the brutality inflicted on women in New Orleans (where all his maternal family lived) by Union troops in the Civil War.

Degas did not suddenly "become" a Realist. That was a myth propagated by his friends in the Impressionist circle at Batignolles, especially Édouard Manet, who implicitly claimed the credit for his conversion. What happened was more subtle: gradually this quintessential young bourgeois discovered what was to be seen from the eyeline of the bourgeoisie, but he raised his theater of social observation on the foundations of strict academic training in the mold of Ingres, whose precision he never lost. His eye for the instant gesture and socially revealing incident went with a lifelong habit of recycling poses and motifs, patching them in. Thus he can be very deceptive: the image that seems the freshest product of observation turns out to have been used half a dozen times before. Degas copied everything from Mantegna to Moghul miniatures, and even the work of lesser painters than himself; an artist, he said, should not be allowed to draw so much as a radish from life without the constant habit of drawing from the old masters. (By the same token, he was an avid collector of both old and new art: in his sixties he purchased two Gauguins, and when pushing eighty he remarked with some admiration of Cubism that "it seems even more difficult than painting." Allegory, in his early work, went with the desire to see freshly—and it would return in strange forms in his old age, as in the painting of a fallen jockey whose horse is clearly one of the steeds of the Apocalypse, or *Russian Dancers*, three women in clumping boots, locked together in a straining mass like

Goya's witches. Both are present in his first real masterpiece, done in 1858 after he got back to Paris: *The Bellelli Family*, that marvelously observed group portrait of his neurotic aunt Laura, her lazy and distracted husband, Gennaro, and their two daughters. For although it is a tour de force of Realist observation—how much more concrete and present the Bellellis seem to us, surrounded by the furniture and other stuff of their lives, than the people on the neutral brown grounds Manet borrowed from Velázquez!——it is also an allegory, of family continuity under stress: the drawing on the wall behind Laura Bellelli is of Degas's grandfather Hilaire, and she is pregnant, so that four generations, not two, are present in the picture. And you cannot fail to associate this with Degas's own working methods, the sense of filiation and descent that would breathe through his work for the rest of his life, the past feeding into the present and then out into the future. Degas, the synthesizer of Ingres and Delacroix, would point—through the wild color-fields and direct manual touch of his later years—to a modernism that was not yet born.

Time, 1988

Courbet in Brooklyn

Gustave Courbet (1819–77) has been seen, for most of this century, as the patriarch of the avant-garde ideal—a man both embodying his time and at odds with it, working in defiance of "repressive" bourgeois taste: in short, a hero.

He is born the son of a farmer; he lives a socialist; his paintings deemed unexhibitable in France on political grounds, he dies in exile in Switzerland, financially crushed by a judgment imposed on him by the French government of more than 300 million francs—the cost of re-erecting the Vendôme Column, the imperial symbol for whose toppling, during the Paris Commune of 1871, Courbet was unjustly blamed.

All that, and a painter of unassailable (although uneven) greatness as well! Small wonder that Courbet has become one of the titans of radical nostalgia. There cannot be a political artist alive who does not dream of having Courbet's breadth of public address—a yearning frustrated by the

obscurity of late-modernist art discourse and neutralized by the rise of mass media.

"Courbet Reconsidered," the show of paintings and drawings organized by Sara Faunce and Linda Nochlin at the Brooklyn Museum is not, and could not have been, a "complete" show. But it is the first attempt by an American museum to show Courbet whole in nearly thirty years. Unlike the Courbet exhibition in Paris in 1977, it leaves out several of the most ambitious paintings with which he planted the Realist argument in the culture of the Second Empire: *Burial at Ornans, The Meeting, The Bathers*—with its "Hottentot Venus," as one of a score of hostile critics called her, that waddling wardrobe of a nude which became the scandal of the 1853 Salon—and, of course, the masterpiece over whose meaning so much art-historical ink has been spilled, Courbet's "real allegory," *The Artist's Studio.*

Such things can no longer be moved. Without them, can one have a Courbet retrospective that makes full sense? Emphatically, yes. The character of Courbet the painter is richly, indeed prodigally, distributed through his work, not just localized in its most famous images; and in any case, the curators have secured other and hardly less magisterial works from French museums, such as his great image of lesbian love, *Sleep,* and the *Young Ladies on the Banks of the Seine (Summer).*

Every aspect of his work is thoroughly set on view here—landscape, portraiture, animal painting, social commentary, erotica. And from them Courbet rises more vividly and intensely than he has done, at least in the United States, within living memory: this combative, ambitious, narcissistic and earthy man, crazy about women, convinced of his own historical mission and of his agonic stature as foe of the establishment, embedded in politics to the tip of his much-caricatured Assyrian beard, a blustering genius with plenty to bluster about.

Courbet thought he was *the* painter of his time, as some artists do today. But unlike them, he was—or at least could plausibly be argued to have been. His egotism still grates. What school did he belong to? "I am Courbetist, that's all. My painting is the only true one. I am the first and unique artist of the century; the others are students or drivelers. . . . I have made my synthesis. I laugh at one and all, without being disturbed by opinion any more than by the water passing under the Pont-Neuf. Above all I do what I have to do. I'm accused of vanity. I am indeed the proudest man on earth."

Without this battleship of an ego, Courbet would hardly have survived the attacks of the critics of his day—although he would probably not

have painted the images that provoked them either. What was Realism, to his enemies? Atheism, socialism, materialism, crudity: a denial of all decent control. An audience that doted on the Rococo peasant (as sensitive greenmailers, today, get gooey at the sight of the *misérables* of Picasso's Blue Period) had insuperable difficulties with Courbet's *Stonebreakers*, or with the frieze of worn faces and homespun black suits in *Burial at Ornans*. He painted, someone gibed, the way one waxed boots. He was seen not only as a dangerous socialist, but as a besmircher of the Ideal, a bucolic thug from the Franche-Comté trampling all over the classical tradition with his wooden clogs. And so forth.

What one sees today—and especially at the Brooklyn Museum—is a somewhat different Courbet, a painter immersed both in popular art, such as the *images d'Épinal,* and in the traditions of his medium (Caravaggio, the Le Nains, Corot), and refracting them with persistence through his own appetites: inventive, yes, but not in a burn-the-Louvre way. He was an empiricist (though not without sentimental moments), for whom the sense of touch preceded that of sight. What the vibration of light would be to Monet, the force of gravity was to Courbet. It is the physical law that insinuates itself into almost every one of his images, confirming their materiality and stressing their essential subject matter—the weighty body of the world. His disheveled girls on the banks of the Seine, in the painting that initiated a spate of such images among the Impressionists twenty years later, are drawn into the earth, their limbs and puffy faces asserting the heaviness of sleep. His trellised roses are inordinately fleshy; his apples, red and bruised—no perfect objects of oral desire here—are solid as stone. He painted hair, especially the thick curly tresses of Whistler's Irish mistress, Jo Heffernan, as though he were running his fingers through it.

This predisposition made him a great painter of the nude, though undoubtedly (as Linda Nochlin argues at length in the catalogue) a phallocratic one. One sees him at full stretch in *Sleep,* the painting of two life-size lesbians entwined on a bed—the redheaded one being Jo, *la belle Irlandaise*—that he did, on commission, for a lustful Turkish diplomat named Khalil Bey. It proves the impossibility of distinguishing, at a certain level, between "pornography" and "art." Needless to say, it has little to do with lesbian perceptions of sex: it is a seraglio scene, an enactment for men's eyes only. But despite the corniness of the flowers and pearls that allegorize luxury, the creamy rose of those bodies, shadowed with olive and held within the complicated machinery of the pose, is a breathtaking pictorial achievement. The surprise of the show is Courbet's *Origin of the World,* also done for Khalil Bey and by far the most "transgressive" image in

nineteenth-century painting. Long presumed lost, it turned up—appropriately enough—in the collection of French psychoanalyst Jacques Lacan. It is a frontal view of a woman's pubes, painted with vast enthusiasm: the symbolic climax, one might say, of the series of dark caverns Courbet painted in his native countryside, *The Source of the Loue.*

The objectivity of Courbet's work connotes a deep and sensuous love of whatever he painted. Sometimes his portraits of dead birds and animals—for instance the brilliant *Girl with Seagulls*—hark back to eighteenth-century prototypes such as Oudry, but their pressing reality comes from Courbet's own love of hunting. When he painted a landed trout strangling in air, he could put more death in its thick silvery body than most of his contemporaries could get in a whole battle piece—and, for a bonus, offhandedly use the "heroic diagonal" associated, in classical art, with dying warriors.

Time and again, in this show, one sees proleptic hints of art to come. The face of his young sister Juliette, with her minx mouth and big side-glancing eyes in a heart-shaped face, will become that of Balthus's nymphets. The limestone crags and ledges of the valleys of his home country, capped with dense dark green and anchored by thick clefts of shadow, have a solidity that young Cézanne will emulate, along with the pasty, almost mortared paint that evokes their surfaces. His rolling waves, marbled with foam as solidly as a steak is with fat, reappear on the other side of the Atlantic in Winslow Homer's sea pieces at Prout's Neck in Maine. Picasso will do versions of the sleeping girls on the banks of the Seine. In fact, Courbet has always been a painter's painter, because the scope of his appetite could show others how not to be afraid of their own "vulgarity." His career reminds us that great and idiotic artists have something in common—both are shameless.

Time, 1988

John Singer Sargent

Auguste Rodin called John Singer Sargent (1856–1925) the "Van Dyck of our times." Sargent was the unrivaled recorder of male power and female

beauty in a day that, like ours, paid obsessive court to both. He could make old money look dashing and paint the newest cotton-reel magnate as though he were descended from Bayard. Sixty years after his death, his "paughtraits" (as Sargent, who kept swearing he would give them up but never did, disparagingly called them) provoke unabashed nostalgia. In his Belle Époque sirens, in the mild, arrogant masks of his Edwardian gentry, are preserved the lineaments of a world soon to be buried like Pompeii, along with Sargent's own reputation, beneath the ash and rubble of World War I. Of course, he had to be revived. In Reagan's America, you cannot keep a good courtier down. Perhaps the rhinos and she-crocodiles whose gyrations between Mortimer's and East Hampton give us our vision of social eminence today are content to entrust their faces to Andy Warhol's mingily cosmetic Polaroiding, but one would bet they would rather go to Sargent. And the public that liked *Upstairs, Downstairs* is going to like him—this thought may not have been too far from the Whitney Museum of American Art's calculations when it planned its present retrospective of his work.

A word of caution is needed: Sargent's output was huge—more than eight hundred portraits and innumerable sketches of people and places— but its high points do stand out, and too many are missing here, from *El Jaleo*, 1882, the flamenco scene that is the masterpiece of his youth, or the Tate Gallery's portrait of Lord Ribblesdale, which, when exhibited in Paris before World War I, sent its public into raptures over *"ce grand diable de milord anglais."* This show says little about its subject that was not put more economically by the 1979 Sargent exhibition at the Detroit Institute of Arts but is still well worth seeing.

It may provoke a twinge of concern. Does Sargent signal a retreat from the standards the Whitney has battled for—the commitment to glitz that gave us the 1985 Biennial, the taste for inflated prettiness set forth in its Alex Katz retrospective, the reluctance to edit that made Eric Fischl's show such a letdown? True, director Tom Armstrong valiantly tries to establish a link by pointing, in a catalogue note, to Sargent's "highly expressive manner and his treatment of subject matter and narrative content, all of which are of great interest to contemporary artists." However, Sargent's "manner" was not that of a Neo-Expressionist but of a virtuoso; his drawing lacks the tenacity of an Eakins, let alone a Cézanne, yet it was drawing of a high order, heartless sometimes, but rarely less than dazzling in its fluency; and there is nothing like it in American art today. Sargent was certainly no modernist, but the fiercely competitive atelier system of figure drawing that formed his style when he studied with Carolus-Duran

in Paris also underpinned the high standards of early-modernist drafts-manship in Matisse, Picasso and Beckmann. Hence, although his relation to the avant-garde was nil, Sargent is no longer to be dismissed as a flashy bore. There is virtue in virtuosity, especially today, when it protects us from the tedious spectacle of ineptitude.

With James McNeill Whistler and Henry James, Sargent was the most vivid American presence on the Anglo-European cultural stage at the end of the nineteenth century. But even though he kept his twang, he was only notionally American. He had been born in Florence to expatriate parents—his father an introverted doctor from Philadelphia, his mother a perpetual tourist who wanted only to escape the crude continent of her birth and who used a succession of illnesses (some feigned) and pregnancies (all real) to stave off recrossing the Atlantic. Their son grew up at home everywhere and belonging nowhere, dragged (as Stanley Olson puts it in a sharp, sad and witty catalogue essay on Sargent's nationality problems) through the "purposeless shifting expatriate life glorified by Hawthorne and James": Paris, Munich, London, Rome, spring in the Tyrol, summer on the Rhine, winter in Nice, years of hotel rooms, rented villas and rentier chitchat. It bred in Sargent a case-hard-ened adaptability, a compliance with wherever he happened to be and a precocious sophistication that, refracted through his large pictorial talent, made him the stylist he was.

But he was a stylist without a natural subject, unlike such Americans as Homer or Eakins whose work was rooted in unmistakably American values and experiences. He spent most of his adult life in England but never gave up his American passport, even though Edward VII offered him a knighthood. Neither American nor English nor European, he was bored by politics, took little heed of current events and (like James) seems never to have had a real love affair: his sexual neutrality was a standing joke among his friends. Perhaps he was impotent, like Degas, or perhaps a deeply repressed homosexual. His real enthusiasms were work and social climbing.

If Sargent was the painter of his age, it was also because his talent suited a changed climate in England in the late nineteenth century—one in which John Ruskin's passionate social moralizing had dropped out of fashion. An unreflective spectator, Sargent saw the world as a string of motifs and rendered its surface with sparkling bravura. The best of his watercolors, which constitute the travel diary of his life, make a virtue of this; the ease and accuracy of judgment with which he could do the façade of Santa Maria della Salute in Venice or toss off an effect of sunlight on

the terrace of the Villa di Marlia in Lucca would be hard to beat, although they project no special intensity of feeling. Cézanne's remark on Monet applies even better to Sargent: "Nothing but an eye, but, my God, what an eye."

He was trained as a tonal painter, in a studio system whose guiding star was Velázquez. *In the Luxembourg Gardens,* 1879, is an uncanny performance for a twenty-three-year-old, with its suffusion of mauve twilight, its seamless recession of tones and the run of staccato red touches—flower beds, a patch on the promenading woman's fan, the end of her companion's cigarette—that stitches its way across the center. By 1880, when he headed for Venice, he had a prodigy's technique. *Venetian Glass Workers,* circa 1882, with its shadowy figures in a dark *bottega* sorting fans of glass rods, rests on one stunning visual trope: each sheaf of glass is done with a single swipe of the brush, so that each bristle mark defines a separate rod.

His fame as a social portraitist and his passage from France into the English upper crust that would reward him for it began at the Paris Salon of 1884 with the scandalous *Madame X.* This portrait of Virginie Gautreau, a huntress from New Orleans who had married a banker and become a monstrously affected social locomotive, cost Sargent some struggle, but in the end her strained, arrogant pose, plus her pale skin ("uniform lavender or blotting-paper color all over," Sargent wrote) rising like an arsenical lily from the low-cut black dress, caused a sensation. Madame X, and her author too, seemed to epitomize what the French disliked about Americans: their pushiness, their refusal to play themselves down as foreigners should. Worse still, the painting was associated with another bravura Sargent portrait: Dr. Pozzi, a society gynecologist resplendent in a red dressing gown, who was believed to be Madame Gautreau's lover. Confounded by the scandal, Sargent ducked and ran for London. His timing was impeccable. England had not had a first-rate society painter since Romney died. A new English plutocracy, mercantile and determined to outface the landed gentry, was on the rise. It sniffed suspiciously at the American, hesitated and then gobbled him up.

Over the years to come, Sargent's social and celebrity portraits became an indispensable record of their time and class, from Henry James ("I . . . am all large and luscious rotundity," the master remarked on viewing his image after ten sittings) to Eleonora Duse, who favored Sargent with her somberly direct gaze for fifty-five minutes and then abruptly left. But some of the greatest images are of people whose notability was merely social. At best, as in *Lady Agnew of Lochnaw,* circa 1892–93,

he could be as good as Van Dyck. He brought such excitement to his scrutiny of light and shade on a knotted lilac sash, of skin gleaming through voile, of delicate flesh so strongly modeled as to convince you that nothing else was more worth looking at. There is a perfect match among the decorous luxuriance of Lady Agnew's pose, the creaminess of the paint and the shadow of tension on her face. For that, one can forgive a lot of routine work. Sargent was the last of what had passed, not the first of what was to come; but he still looks impressive, and one realizes that his sense of decorum went deeper than the mere desire to curate the vanity of the rich.

Time, 1986

Augustus Saint-Gaudens

Since the end of the eighteenth century, America has produced any number of competent sculptors, even a few first-rate ones, but perhaps only two who brought authentic greatness to their own genres: David Smith and Augustus Saint-Gaudens. Smith's work was the climax of a tradition of open sheet-metal sculpture that began in 1912 with Picasso's tin guitar; Saint-Gaudens, at the end of the nineteenth century, epitomized the academic tradition of public speech through bronze casting, whose roots wound back to Donatello and Verrocchio.

The idea that one was as good as the other would have seemed absurd twenty years ago, when Saint-Gaudens's name was ignored by everyone except a few elderly loyalists and some young art historians with a revisionist glint in their eyes. He had been dropped from the list, in an act comparable to (though, happily, not as final as) the dismantling of that masterpiece of New York public architecture, McKim, Mead and White's Pennsylvania Station. However, work did survive, although unconsulted. Few visits were paid to his Shaw monument on Boston Common, the most intensely felt image of military commemoration ever made by an American; few Manhattanites bestowed more than a glance at his monuments to Admiral Farragut and General Sherman. Curators who, given the ticket, would cross the Atlantic to admire some steatopygous bauble by Niki de Saint-Phalle would hardly have crossed the street to see an

Augustus Saint-Gaudens. Even today his rehabilitation is incomplete. Sculpture provokes fewer fantasies than painting; not everyone is willing to give Saint-Gaudens the place accorded, as a matter of course, to Albert Bierstadt, Thomas Eakins or Winslow Homer. Hence the interest of the current exhibition "Augustus Saint-Gaudens: Master Sculptor," organized by art historian Kathryn Greenthal for New York's Metropolitan Museum of Art.

Between his professional flowering in the 1880s and his death in 1907, Saint-Gaudens was seen as proof that America could produce art—an ability that, his patrons felt, went hand in hand with the triumph of the industrial Northeast after the Civil War. He gave the crude, grabbing republic its lessons in symbolic deportment and visual elocution, and won its unstinted gratitude. If there was such a thing as the American Renaissance, then Saint-Gaudens embodied it in sculpture, as surely as the Roeblings did in engineering, Louis Comfort Tiffany in decor or McKim, Mead and White in architecture. Today portrait sculpture is dead, and the photo opportunity reigns. But Saint-Gaudens lived in an age when sculpture was thought the supreme mode of official commemoration, and the types he created are still very much with us. Our iconic sense of Abraham Lincoln as statesman, seamed, grave and erect, was created as much by Saint-Gaudens's bronzes as by Mathew Brady's photographs. Our image of the repressive, striding Puritan with Bible, cloak and conical hat owes much of its existence to the rhetoric of Saint-Gaudens's monument to Deacon Samuel Chapin in Springfield, Massachusetts. His only nude female figure, the gilded sheet-copper Diana that he made as a weather-vane figure for the top of Stanford White's original Madison Square Garden in 1891, slender as any Mannerist charmer from Fontainebleau, became in a literal way the Golden Girl of the 1890s in New York, as definitive a pinup as the Gibson Girl.

As an American, Saint-Gaudens had to make his relationship to the past from scratch, as his friend Henry Adams noted in *The Education of Henry Adams*: "In mind and person Saint-Gaudens was a survival of the 1500's; he bore the stamp of the Renaissance. . . . He writhed and cursed at his ignorance. . . . Saint-Gaudens was a child of Benvenuto Cellini, smothered in an American cradle." The fact that he was also the child of European immigrants was no help there. Saint-Gaudens pronounced his name in the American way, but his paternity was French; his father, a Pyrenean bootmaker, married a colleen, settled in Dublin (where the future sculptor was born, in 1848) and fled with his family across the Atlantic to escape the terrible potato famine.

The young sculptor's early training in New York was as a cameo-

cutter's apprentice (and this preparation laid the ground for his later mastery of concise depiction in shallow relief). There was not much sculpture to see in New York in the 1860s, and most of it was earnestly neoclassical—the Jeffersonian language of earlier official art. What gave Saint-Gaudens's career its peculiar spin was his departure for Paris in 1867, to study at the École des Beaux-Arts. For Saint-Gaudens was a competent carver, but his latent genius was for modeling: the buildup, lump by lump, pinch by pinch, touch after touch, of complex volumes out of clay or wax, later to be cast in bronze. Under the spell of the expressive, almost baroque forms that were in vogue in Paris, Saint-Gaudens learned to avoid the reductive fixity of the ideal antique. Besides, Beaux-Arts training was strong on collaboration—between architect and sculptor, sculptor and painter. The image of the Renaissance man was in the air. When Saint-Gaudens got back to New York in 1875, he met up with the men whose shared efforts would utterly transform the face of public art in America— the architects H. H. Richardson, Charles McKim and Stanford White, and the painter John La Farge. It seemed to all five that they held the makings of an American Renaissance.

Without question, Saint-Gaudens was one of the most fluent sculptors who ever lived, and his clients demanded fluency. He could and did turn his hand to anything, from a ten-foot-high stone profile on a pyramid in Wyoming to the design of the century's most beautiful coin, the gold 1907 double eagle. He could evoke any mood in a face, from the tremulous profile of an adolescent girl to the stormy jut of Farragut's jaw. But the main impression his works leave, when seen together, is not so much of a rigid technique turning out predictable results (which one learns to expect from official sculptors) as of an extreme responsiveness and delicacy, an adoring pursuit of the nuance, which coexists with his fondness for declamation. He had no embarrassment, of course, in quoting his quattrocento idols: that was the natural use of a heritage. He took from Pisanello, Laurana, Cellini and Desiderio da Settignano; the pose of Farragut is Donatello's St. George without a shield. Still, any academic hack can redo a prototype; Saint-Gaudens's peculiar gift was to shadow these massive and well-known shapes with the tiny subliminal events of a dreaming hand. In 1880 he could give Dr. Henry Shiff's bronze beard a labile, gratuitous beauty of texture akin to Monet; while, seen close up, the stubbled, worn face of Sherman is not a military mask but a psychological study as deep, in its way, as Rodin's *Balzac*. There are weak things in this show, and not a few florid ones; and by its nature, it cannot give Saint-Gaudens's monuments the coverage they need. But no matter: the illu-

sions it dispels make up for the works it omits—and fresh converts to Saint-Gaudens can seek those out for themselves.

Time, 1986

Winslow Homer

Some major artists create popular stereotypes that last for decades; others never reach into popular culture at all. Winslow Homer was a painter of the first kind. Even today, 150 years after his birth, one sees his echoes on half the magazine racks of America. Just as John James Audubon becomes, by dilution, the common duck stamp, so one detects the vestiges of Homer's watercolors in every outdoor-magazine cover that has a dead whitetail draped over a log or a largemouth bass, like an enraged Edward G. Robinson with fins, jumping from dark swamp water. Homer was not, of course, the first "sporting artist" in America, but he was the undisputed master of the genre, and he brought to it both intense observation and a sense of identification with the landscape—just at the cultural moment when the religious Wilderness of the nineteenth century, the church of nature, was shifting into the secular Outdoors, the theater of manly enjoyment. If you want to see Thoreau's America turning into Teddy Roosevelt's, Homer the watercolorist is the man to consult.

The Homer sesquicentennial (he was born in 1836 and died in 1910) is being celebrated with "Winslow Homer Watercolors," organized by Helen Cooper at the National Gallery of Art in Washington, D.C. Her catalogue is a landmark in Homer studies. It puts Homer in his true relationship to illustration, to other American art and to the European and English examples he followed, from Ruskin to Millet; its vivacity of argument matches that of the paintings. Cooper has brought together some two hundred watercolors—almost a third of Homer's known output. It is a wholly delectable show, and it makes clear why watercolor, in its special freshness and immediacy, gave Homer access to moments of vision he did not have in the weightier, slower diction of oils.

"You will see, in the future I will live by my watercolors," Homer once remarked, and he was almost right. He came to the medium late: he

was thirty-seven and a mature artist. A distinct air of the Salon, of the desire for a "major" utterance that leads to an overworked surface, clings to some of the early watercolors—in particular, the paintings of fisher folk he did during a twenty-month stay in the northern English coastal village of Cullercoats in 1881–82. Those robust girls, simple, natural, windbeaten and enduring, planted in big boots with arms akimbo against the planes of sea, rock and sky, are also images of a kind of moralizing earnestness that was common in French Salon art a century ago. Idealizations of the peasant, reflecting an anxiety that folk culture was being annihilated by the gravitational field of the city, were the stock of dozens of painters like Jules Breton, Jules Bastien-Lepage and Jean-François Millet. Homer's own America had its anxieties too—immense ones. Nothing in its cultural history is more striking than the virtual absence of any mention of the central American trauma of the nineteenth century, the Civil War, from painting. Its fratricidal miseries were left to writers (Walt Whitman, Stephen Crane) to explore, and to photographers. But painting served as a way of oblivion—of reconstructing an idealized innocence. Thus, as Cooper points out, Homer's 1870s watercolors of farm children and bucolic courtships try to memorialize the halcyon days of the 1850s; the children gazing raptly at the blue horizon in *Three Boys on the Shore,* their backs forming a shallow arch, are in a sense this lost America. None of this prevented Homer's contemporaries from seeing such works as unvarnished and in some ways disagreeable truth. "Barbarously simple," thought Henry James. "He has chosen the least pictorial features of the least pictorial range of scenery and civilization as if they were every inch as good as Capri or Tangier; and, to reward his audacity, he has incontestably succeeded."

Once into his forties, Homer rarely went anywhere without rag paper, sable brushes and little pans of color. He took his working vacations in places he knew would give him subjects—the New England coast, the Adirondacks, the tumultuous rivers of Quebec, the Florida Keys and the dark palmetto-fringed pools of Homosassa, the bays and whitewashed coral walls of the Bermudas.

Although Homer exhibitions up to now have tended to treat his watercolors as ancillary to his oils, mere preparations, it is clear at the National Gallery that Homer did not think the same way and that he did more than any other nineteenth-century American artist to establish watercolor as an important medium in this country. In structure and intensity, his best watercolors yield nothing to his larger paintings. Homer had great powers of visual analysis; he could hardly look at a scene without breaking it down and resolving it as structure, and some of his paintings

of the Adirondack woods, with their complicated shuttle of vertical trunks against a fluid background of deep autumnal shade, are demonstration pieces of sinewy design. He was able to isolate a motif in action, as though the watercolor were a pseudo-photograph. This sometimes looks false, but it was exactly the kind of falsity that appealed to popular taste, and Homer's watercolors of leaping trout and thrashing bass, the Big Fish dominating the foreground, are a curious conjunction of the merely illustrative and the frenetically decorative. In his sober moods he was rarely off-key. His Adirondack paintings have the astringent completeness of the Michigan woods in early Hemingway. Perhaps no painting has ever conveyed a hunter's anxiety better than *Hound and Hunter,* with its flustered boy in the dinghy trying to get a rope on a shot stag's antlers before its corpse sinks, lurching to and fro in a cave of forest darkness and disturbed silver ripples.

Watercolor is tricky stuff, an amateur's but really a virtuoso's medium. It is the most light-filled of all ways of painting, but its luminosity depends on the white of the paper shining through thin washes of pigment. One has to work from light to dark, not (as with oils) from dark to light. It is hospitable to accident (Homer's seas, skies and Adirondack hills are full of chance blots and free mergings of color) but disaster-prone as well. One slip, and the veil of atmosphere turns into a mud puddle, a garish swamp. The stuff favors broad effects; nothing proclaims the amateur more clearly than niggling and overcorrection. It can be violated (Homer sometimes did his highlights by tearing strips of paper away to show white below), but it also demands an exacting precision of the hand—and an eye that can translate solid into fluid in a wink. Homer understood and exploited all these needs of watercolor better than his contemporaries, and he applied them where they most belonged—to the recording of immediate experience. A painting like *Key West, Hauling Anchor,* 1903, has a sparkling directness hardly attainable in oil. It is so simple-looking—blue sea, white boat, a patch or two of red shirt, the red picked up again at the boat's waterline and in a jaunty lick or two of carmine reflection—that at first one does not mark the skill that went into it, the power of epigrammatic observation implicit in Homer's ability to convey the milky blue water over a Florida sand bottom in two washes of cerulean and cobalt. One knows how little time it took to see and how little to do; but one senses the years of self-critical practice behind it. No wonder Homer is the despair of every amateur.

Time, 1986

James Whistler

Among the thousands of nasty quips and barbed conceits that James Abbott McNeill Whistler sped at the world, the only one that everyone knows is perhaps apocryphal. Oscar Wilde, in admiration of some Whistlerian *mot:* "Jimmy, I wish I had said that." Whistler: "You will, Oscar, you will." In all his long career Whistler produced only one painting that enjoyed the same permanent celebrity as this riposte, and it, of course, is *Arrangement in Gray and Black, No. 1: Portrait of the Painter's Mother*, 1872, one of the half-dozen most famous pictures of the nineteenth century. The reasons for its fame are obscure and debatable, but the results are plain to see: "Whistler's Mother" swamped the rest of his output, turning him (at least in the eyes of the public after his death) into a one-painting man. A quip, and a portrait of an old lady from North Carolina: on such thin pedestals do legends rest.

There was much more to Whistler, as both man and artist, than this. He has never faded from view, yet he remains poised for rediscovery; and 1984, which marks the 150th anniversary of his birth, is the right year for it. The Hunterian Museum in Glasgow has put seventy-nine of its Whistler oils on view. In the United States the main Whistler event, which opened last month at the Freer Gallery in Washington, D.C., is a display of paintings, drawings and notes, more than three hundred in all, curated by David Clark Curry and assembled from the Freer's own collection, the world's largest source of Whistler material.

The Freer exhibition is fascinating, for its context as well as its contents. Charles Lang Freer, who made his millions in rolling stock in the boom railroad years of the late nineteenth century, was an impassioned Orientalist, a disciple of the "Boston bonzes," chiefly of Ernest Fenollosa. As Bernard Berenson fanned the ardor of the American rich for the Italian Renaissance, so Fenollosa was busy shaping American taste for Oriental art. He adored Whistler's work, calling him "the nodule, the universalizer, the interpreter of East to West." Freer concurred, and in the 1890s he became Whistler's chief patron—not always an easy role, since Whistler could go for the hand that fed him like a Doberman. Freer also consulted

Whistler about his Oriental purchases, so that in Washington one can see some informative parallels between Whistler's work and his taste in other art. There are, for instance, two majestic Satsuma-ware sake flasks, with a glaze the color and texture of old, cracked ivory, adorned with faint blue landscape paintings by Tangen, whose ghostly suggestiveness, mere scribbles wreathing out of the whiteness as though through fog, is exactly like Whistler's own images of twilit landscape.

Best of all, the Freer Gallery has the only interior by Whistler that survives: the Peacock Room, 1876–77, done in collaboration with the architect Thomas Jeckyll for the London house of shipping baron Frederick Leyland. This stupendous decorative work, in gold, silver and platinum on a turquoise ground—which was itself painted over ancient paneling of cordovan leather, reputedly salvaged from the Spanish Armada—caused a bitter crackup between Leyland and Whistler and provoked a ferocious letter from the patron: "Your vanity has completely blinded you to all the usages of civilized life, and your swaggering self-assertion has made you an unbearable nuisance to everyone who comes in contact with you. . . . [You have] degenerated into nothing but an artistic Barnum." But the Peacock Room has few if any rivals as the greatest decorated chamber of the late nineteenth century. All the irritable whiplash, elegance of Art Nouveau is latent in its plutocratic birds. No wonder Freer had to save it and bring it across the Atlantic.

Leyland was not altogether wrong about Whistler. The man was an egomaniac, a fop and a publicity-crazed liar—traits that perhaps should, but actually do not, prevent people from being serious artists. He lived most of his life as a string of fictions and adjustments. Born in Lowell, Massachusetts, the son of a former military engineer whom he hated with Oedipal intensity, Whistler "reconstructed" his childhood to focus on his doting southern mother. "I shall be born when and where I want," he piped in his high, waspish voice, "and I do not choose to be born in Lowell." Instead he became a self-made Tidewater gentleman, a southern cavalier who left it to others to figure out why when the Civil War came he did not fight in it. His military career consisted of a few years at West Point, from which he was expelled for academic incompetence.

Though a virulent racist, Whistler did not confine his obloquies to blacks and Jews. He was litigious, and that penchant contributed to his bankruptcy when he sued John Ruskin for libel, won token damages of a farthing but had to pay heavy legal costs and lost his house, his studio contents and his famous collection of blue-and-white porcelain. "There's

a combative artist named Whistler," ran a limerick by his Pre-Raphaelite friend Dante Gabriel Rossetti,

> *Who is, like his own hog's hair, a bristler:*
> *A tube of white lead*
> *And a punch on the head*
> *Offer varied attractions to Whistler.*

He was fixated on his mother and did not marry until he was fifty-four and she was dead. His mannerisms were effeminate, and when excited he pranced about like a peahen on hot bricks. "Whistler," Degas once cried as the American sailed into a Paris restaurant, "you've forgotten your muff." At sixty he had become a darting little creature of surfaces, more like a basilisk than the butterfly he used as his emblem. It took one dandy to see into another, and the novelist Joris-Karl Huysmans, author of *À Rebours,* picked out the practical, fussy American perched within the Whistlerian shell: "W. is always eating pickled cucumbers and butter. He is nice—almost simple in his highfalutin manner."

Yet he seems to have had no homosexual life. A stream of cocottes, demireps and actresses passed through his London and Paris studios, leaving their traces—pert, sly, lascivious—in images such as *Red and Pink: La Petite Méphisto,* circa 1880, with its wanton froth of tulle gleaming like a nocturnal peony from the sullen red room. He was the Watteau of the music halls, and his nude drawings are carried out with a tender, nervous line that, heightened with flicks of chalk, does recall that master. But his main inspiration for such work was Japanese *ukiyo-e* (pictures of the floating world), the scenes of the Edo print. Whistler loved these, and in *Caprice in Purple and Gold: The Golden Screen,* 1864, his red-haired Irish mistress, Jo Heffernan, dressed as a geisha, is seen studying what might be some Hiroshige woodblock prints.

If Whistler had been content with pieces of studio exotica and Japonaiserie, he would not have his place in art history. He wanted to go further, integrating the "Japanese aesthetic" into the texture of late-nineteenth-century European experience. Whistler was enraptured by the half-seen, the evanescent, the image that vanishes almost before it can be named. Hence his predilection for moments in the life of landscape that are about to slide into illegibility: the moody vistas like *Nocturne: Blue and Silver—Battersea Reach,* 1870–75, in which forms preserve the last vestiges of themselves—boat, horizon, crane, bridge—before they are lost in the blue darkness; the pearly chaos of his fog scenes, or the tiny seascape

sketches in which a mood is fixed with seeming instantaneity, each ribbon and bubble in the paint surface corresponding by inspired accident to a wavelet, a patch of foam or a pebble. With their elegant abstractions and syncopations of form, such paintings look back to the high decorative art of the Edo period, to Ogata Korin or Suzuki Kiitsu; but they also look forward, in their indeterminacy, to Monet's water lilies at Giverny.

Whistler loathed narrative and fervently espoused the idea of art for art's sake. Hence his abstract and musical titles—*Arrangement, Symphony* and the like. In France, where he had studied, this desire for an amoral, formalized art had been mooted forty years earlier by writers such as Théophile Gautier. But in London it was quite new (the time lag across the Channel was immense), and in making propaganda for it Whistler became a scandalous figure. When the dying industrial baron in Kipling's "The 'Mary Gloster' " (1894) speaks to his effeminate son, one knows he has Whistler's influence in mind:

> . . . *the things I knew was rotten you said was the way to live.*
> *For you muddled with books and pictures, an' china an' etchin's an' fans,*
> *And your rooms at college was beastly—more like a whore's than a man's.*

Such was the dread influence of the aesthetic movement, whose dragon Whistler became.

In the last years of his life (he died in 1903, just outliving Beardsley and Wilde, who owed so much to his ideas and style), Whistler was seen as an honored veteran and not an avant-garde figure; his paintings had lost whatever experimental look they once had, and were surpassed by Impressionism. Curiously, his biggest influence was on writing. Poets such as Stéphane Mallarmé found their own cult of the indeterminate, the penumbra of experience, confirmed in his work. The Whistlerian landscape of the Thames kept turning up in English poetry for another generation— not least in *The Waste Land*, with its "brown fog of a winter dawn" lying on London Bridge. Marcel Proust so adored him that he purloined one of his gloves, as a souvenir, at a reception. Meanwhile, the paintings have beautifully survived: strict in taste, limited in range, precise in key and never, ever, cloying.

Time, 1984

Pre-Raphaelites

The big spring exhibition at London's Tate Gallery, "The Pre-Raphaelites," has been a roaring popular success. In attendance it has been surpassed at the Tate only by exhibitions of John Constable and Salvador Dalí—fittingly, since it rivals the intense Englishness of the former while competing with the fulsome, more than photographic detail of the latter. The time is long past when hard-core modernists, secure in their belief that nearly everything England produced between the death of Turner and the arrival of Roger Fry was either hopelessly sentimental or irredeemably quaint, assigned the Pre-Raphaelite Brotherhood to the dustbin of history. Presumably it will not be long before some canvas by William Holman Hunt or John Everett Millais, the kind one might have gotten thirty years ago for 500 pounds, becomes the first Pre-Raphaelite picture to fetch a million in the auction room.

Yet Pre-Raphaelitism never quite went away. It acquired an armor-plated niche in the English imagination. Its present triumph, symbolized by the Tate show, has nothing to do with dubious cultural clichés such as "postmodernist irony." There is no irony in Pre-Raphaelitism. Everything there, from the pale, swooning damozels down to the last grass stem, is the product of unutterable sincerity. Those painters would rather have died of lockjaw than paint anything that was not direct, heartfelt and didactic.

The group was small: a secret society of seven artists, led by three men—Hunt, Millais and Dante Gabriel Rossetti—and followed, eventually, by a small trail of satellite painters. And it was self-consciously "revolutionary": the year was 1848, and a secret society of dangerous young subversives had become one of the special phantoms of the English mind. The P.R.B. wanted to reform English art, to drag it from the swamp of maudlin genre and low-grade history painting. They believed, with the ardent simplicity of young minds, that this decay had set in three centuries before, with Raphael. Hence they wanted to go back before Raphael, appealing to a moment in history—the Middle Ages on the cusp, as it were, of the Renaissance—when art seemed not to be entangled in false

ideals and academic systems. Their bywords were *purge, simplify, archaize*. Like all true cultural revolutionaries, they were conservatives at heart, and they were lucky in having as their megaphone and mentor the greatest art critic ever to use the English language: John Ruskin.

They needed whatever friends they had. The gnomic initials "P.R.B.," appended without explanation to their signatures in the 1850s, had the combined effect on many critics of a red flag and a leper's bell. "Monstrously perverse," was a typical comment. "Plainly revolting," was another. Charles Dickens, no less, saw "a hideous, wry-necked, blubbering, red-haired boy in a nightgown, who appears to have received a poke . . . and to be holding it up for the contemplation of a kneeling woman, so horrible in her ugliness, that she would stand out from the rest of the company as a monster." The painting in question was Millais's *Christ in the Carpenter's Shop*, 1849–50, whose image—little Jesus hurting his hand on a nail, in prefiguration of Golgotha—might strike a modern eye as lavishly sentimental and winsome but was overrealistic to Dickens.

Creatures of their time, the Pre-Raphaelites venerated those twin totems of Victorian thought: science and religion. Their objections to the popular English art of their time rested, in fact, on both. They were permeated with the belief that nature was the fingerprint of its creator and that studying it was the best way to acquaint oneself with his designs. Ruskin had inveighed against the "unhappy prettiness and sameness" of established English painting, "which cannot but be revolting to any man who has his eyes, even for a measure, open to the divinity of the immortal seal on the common features that he meets in the highways and hedges hourly and momentarily." He summed up his idea of landscape painting as "rejecting nothing, selecting nothing and scorning nothing."

God was in the details: in the petals of a cornflower or the veins of an elecampane leaf, in the grain of stone or the purling of a brook. That is why the details of Pre-Raphaelite landscape, ostensibly the fruit of candid observation, take on such a hortatory, didactic air. One knows, looking at Millais's portrait of Ruskin in his sober frock coat on the rocky verge of a Scots cascade, that every wrinkle of the gray gneissic crag he stands on is meant to speak of the geological span of the creation and to imply a sense of time at the opposite extreme to the rapid movement of the water, so that the life of man is presented as a kind of middle term between the geologically permanent and the merely transient.

The habit of medieval thought had been to explain the world of animals and plants as images of the virtues, the vices, God's nature and the events of the Bible. Nature presented itself as a web of moral symbols,

and the Pre-Raphaelites tried strenuously to revive this cast of mind. Every detail tells a story and wants to be decoded. It can be quite a tiring business "reading" a full-scale Pre-Raphaelite allegory, such as Hunt's *The Hireling Shepherd*, 1851–52. This sunny, pastoral scene of two rustics flirting was actually a warning against the reestablishment of the Roman Catholic Church in England. The girl in the red skirt refers to the scarlet woman of Rome; the lamb in her lap is about to sicken from the green apple of false knowledge it has bitten; the sheep, wandering unattended into the corn, are the strayed flock of the Anglican clergy, and so on.

This novelistic way of cramming a painting with narrative was not unusual with the Pre-Raphaelites, even when they had no religious intent. Ford Madox Brown's *The Last of England*, 1852–55—young middle-class emigrants to the Australian gold fields, sunk in melancholy as the white cliffs of their homeland recede—contains, as it were, paragraph on paragraph about Victorian class and diet. Although modern eyes are more likely to fasten on the peculiar, almost surreal shape of the wife's pink hat ribbon whipping in the Channel gale, Victorian ones were ravenous for those social details around the picture's rim.

The painters went to extremes of trouble in their pursuit of accuracy. Millais, having found a suitable country stream as the setting for his *Ophelia*, 1851–52, complained that swans kept gobbling the water-weeds as he painted them; his model for the drowned Shakespearean maiden, Elizabeth Siddal, had to spend session after session floating in a tub of water until she nearly caught her death of cold and was rescued by her irate father, threatening writs.

This process of observing more intently entailed finding a new kind of pictorial "look," very high and fresh, quite unlike the system of chiaroscuro taught in the academies. Generally, English artists had painted on dark canvas, bringing up highlights with opaque white. Millais and Hunt developed a fanatically elaborate technique of painting with transparent colors on a wet white ground, laid inch by inch, like fresco. It was meant to reproduce the dazzle of direct sunlight. Like the methods of the Impressionists a quarter-century later, it was a technical fiction, and it is startling to see how the same purpose—to convey the optical freshness of nature while working out of doors—could have produced two such different systems.

Not all Pre-Raphaelite painting, however, was about that kind of realism. The late work of Rossetti, when he was able to shake off his more oppressive pieties and stop doing his literary homages to Dante and Boccaccio, disclosed his intrinsic sensuality in a series of rosy, Titianesque

portraits of his cockney mistress Fanny Cornforth and his model Alexa Wilding. The sumptuous Wilding was Rossetti's "Venetian ideal of female beauty," and in *Monna Vanna*, 1866, he framed her passionate face in a lush swirl of gold-and-white sleeve, coral necklace, feathery fan and flowing hair. Nor could anybody call Edward Burne-Jones's strange, gray, airless and Michelangelesque figure compositions "realist." After 1860 this Symbolist phase of Pre-Raphaelite art was busy preparing the ground for William Morris and the arts-and-crafts movement, for Art Nouveau and thus, to some limited extent, for modernism itself. The fact is that nothing, not even the Pre-Raphaelite Brotherhood, is as isolated as its critics once believed. And in our time—haunted, like theirs, by thoughts of historical revival—the Pre-Raphaelites have much to reveal not only about the possibilities of refracting the past into the present but also about the limits of nostalgia.

Time, 1984

Camille Pissarro

Camille Pissarro (1830–1903) was the least spectacular of the Impressionists. An eye used to Monet (and Monet is what many people believe Impressionism was all about) will almost certainly find Pissarro conservative— more of a tonal painter, almost, than a colorist. There has long been a tendency to repeat, without checking it against the pictures, Gauguin's irritable verdict that Pissarro was a good second-rater, "always wanting to be on top of the latest trend. . . . He's lost any kind of personality, and his work lacks unity." So although there has been no lack of Degas shows, Monet retrospectives, homages to Cézanne and museum tributes to Bazille or Caillebotte, Pissarro has remained less known; this is ironic, since, with his peculiar steadfastness and probity, he was the linchpin of the Impressionist group. Now, at Boston's Museum of Fine Arts, the long process of rehabilitating Pissarro has begun with the first retrospective of his work ever held in the United States.

Pissarro was one of the avant-garde's oak-tree uncles: a man of enormous solidity and forthrightness, blunt in speech, loyal to his friends and

open to younger artists. He loved to organize, teach, argue and work with other painters, and the list of artists who owed him some part of their self-knowledge was long. Cézanne, nine years his junior, called him "a man to consult, and something like *le bon Dieu*"—meaning not the vengeful God of judgment but a kindly and paternal deity, the supervisor of hearths and gardens: in a word, the god of growth. Mary Cassatt remarked that "he could have taught stones to draw correctly."

Although he was immersed in the metropolitan culture of France, Pissarro lived at an angle to it. He was not only an immigrant—he had been born and raised on the Caribbean island of St. Thomas, the son of a well-off storekeeper—but a Jew as well. With the undercurrent of xenophobia and anti-Semitism that was to be encountered in ordinary French life, he was therefore twice a stranger in France, and his clan loyalty, his commitment to the tiny republic of the family, his probity and his political radicalism were connected, one may surmise, to his sense of outsidership. More than anything else, he loved painting. That was why he could continue to praise Degas, while in the wake of the Dreyfus affair, Degas, indurated anti-Semite that he was, brutally snubbed him. Painting could not heal everything, but it represented for Pissarro a corrected world, all relations manifest, all unities achieved, hopeful, measurable and decent.

A lengthy tradition of French landscape runs through Pissarro's work. He is a link between the weighty, materialist vision of Courbet and the molecular analyses of Impressionism, and the best of his landscapes possess an unremitting gravity of construction. Everything in a painting such as The *"Côte du Jallais," Pontoise,* 1867, is, so to speak, freighted with scruple, rendered dense by inspection—the blue air and clouds no less than the swatches of plowed and seeded field and the massed trees. Its low tones and construction by horizontal bands make one think of Corot, but its directness of handling points forward to the Impressionist "moment."

Through the 1870s, Pissarro's surfaces would become more agitated, broken and silky. In *The Climbing Path, L'Hermitage, Pontoise,* 1875, he gave a view of roofs through a dappled grid of tree trunks the sort of beautiful abstruseness one associates with Cézanne. But always there remained an Arcadian sense of order—a confidence in reasonable appetite, one of whose physical manifestations was the fruitful, vaporous and lovingly cultivated landscape of the Seine-et-Oise.

In the mid-1880s, Pissarro's work took a sharp turn toward pointillism, or "Neo-Impressionism," the dissection of light into swarms of tiny

colored dots, which had been developed by Georges Seurat and Paul Signac. So complete was his conversion and so short-lived—it lasted only five years—that it is hard to think of another artist of comparable talent and sincerity who was ever changed so sharply by men thirty years his junior. Certainly Pissarro was not scrambling onto a bandwagon: the growing vogue in Paris at the time was for occult imagery, Rosicrucianism, superstition, nuance—anything but the aim of pointillism, which was to state and quantify visual sensation as "objectively" as possible.

The work of "these chemists who pile up little dots," as Gauguin contemptuously named the pointillists, was to the 1890s what Constructivism would be to the 1920s: the house style of utopian politics. Pissarro was a fervent anarchist, and his dot-crusted scenes of idyllic rural labor (as stylized and unreal, in some ways, as any eighteenth-century pastoral) are attempts, not always successful, to convey an ideal vision of social dignity based on freely shared work. In this he was the heir of Millet as well—although he certainly did not know peasant life at first hand, as Millet had. But by the mid-1890s, with his bustling market scenes and views of Rouen cathedral rising from a choppy, tiled sea of roofs, he had returned to a less schematic form of painting.

Indeed, the view of cities as social condensers mattered greatly to Pissarro's way of imagining the world. He was not interested in rural life merely for its own sake, as a refuge or an idyll; he wanted to paint the relationships between country and town, the social fabric of France itself, epitomized at their point of meeting in the market square. He was also fascinated by townscape in itself: the hustle and bustle of Baudelaire's "ant-swarming city," with its shuttling traffic, its plunging perspectives, its bird's-eye views of impersonal transactions. Writing in 1898 of the view from his hotel window over place du Théâtre Français in Paris, he said: "Perhaps it is not aesthetic, but I am delighted to be able to paint these Paris streets that people have come to call ugly, but which are so silvery, so luminous and vital. This is completely modern."

Those who believe Impressionism viewed the world through rosy bourgeois lenses should ponder Pissarro's commitment to "our modern philosophy, which is absolutely social, antiauthoritarian and antimystical . . . a robust art based on sensation." Political decency does not, by itself, make good art. Yet one senses that in Pissarro, the man and the work were of whole cloth—and that their wholeness contributed to the honesty of his search and the vigor he displayed, especially as a draftsman, below the changing levels of style. Never too polished, never arbitrarily crude, Pissarro's plain visual speech now turns out to have been one of the real

achievements of French nineteenth-century painting—"the act," as his friend Émile Zola wrote, "of an honest man."

Time, 1981

Thomas Eakins

The Philadelphia Museum of Art is having a commemorative show of Thomas Eakins. It marks no particular date in the painter's own life. Eakins was born in 1844, and he died in 1916. But he passed his whole life, except for four years of European study, in Philadelphia, and his genius— hardly too strong a word, this time—is a proper thing to celebrate in that city's 300th-anniversary year.

Eakins was the greatest realist painter America has so far produced. He never successfully idealized a subject. When theatrical, which he rarely was, he tended to look silly. He was pragmatic, cussed, inquisitive, thorough and plain of pictorial speech: a Yankee to the last finger bone. He was so in love with the specific that one scholar managed to compute, from the sun's angle, the time and date of the scene depicted in one of his paintings of rowers training on the Schuylkill, *The Pair-Oared Shell*; they went under the bridge, give or take a few seconds, at 7:20 p.m. on either May 28 or July 27, 1872.

In order to fix the facts he loved—the blurred motion of a spoked wheel, the tilt of a catboat beating to windward, the awkward play of a naked boy's legs as he dives—Eakins produced a mass of preparatory work. Convinced that the camera was truth, he took photographs and worked from them; he was one of the first American artists to do so. He made drawing after drawing, from mere thumbnail sketches to elaborate perspective studies that include notes on such minutiae as eight cross-sections of an oar from loom to blade, or the reflection of a distant bush in a ripple of water. To get the muscles of horse and man right, he modeled them in wax.

All this output cannot go in one show; it would have been burden-some to even the most dedicated Eakins student. Instead, the exhibition's curator, Darrel Sewell, has intelligently chosen some 150 paintings, studies

and photographs to provide a thematic rather than a chronological approach. There are certain broad categories of imagery in Eakins. There are the rowing and sporting and sailing scenes. There are the paintings of medical and scientific inquiry. There are the horse pictures, the portraits and so on. By sampling each of these, Sewell hoped to build up a convincing picture of Eakins's main preoccupations, and of the growth of his style.

Eakins was no theorist, but he was by no means a bluff simpleton of the brush either. Right from the start, he had a clear idea of what he wanted painting to do. It was an idea that came out of his own experience and appetites and was enlarged by his contact with French Realism as practiced by his teacher, Jean-Léon Gérôme. As a student at the Pennsylvania Academy of the Fine Arts, he had disliked drawing from the plaster casts of antique statues. He was not interested in ideal beauty. Significantly, one of his earliest surviving drawings is of a mechanical lathe. Such things had no preexisting "aura"; they were not "artistic"; you either drew them right or drew them wrong. "In a big picture," Eakins wrote to his father from Paris, "you can see what o'clock it is, afternoon or morning, if it's hot or cold, winter or summer, and what kind of people are there, and what they are doing and why they are doing it."

But realism was not restricted to such facts. "The sentiments," Eakins added, "run beyond words. If a man makes a hot day he makes it like a hot day he once saw or is seeing; if a sweet face, a face he once saw or which he imagines from old memories or parts of memories and his knowledge, and he combines and combines . . ." Such was the essence of the realist enterprise. The act of painting negotiates an agreement between what we see and what we know—between memory and impulse, between the brush's gesture and the million other gestures that constitute the history of painting.

Eakins would never have echoed Christopher Isherwood's mendacious claim: "I am a camera." He was not passive. He painted what he saw—but he chose what to see. He had predilections about life, although to call him a moralist—a title many realist painters welcomed—is to invite misunderstandings. There are no Eakins paintings of wistful peasant goose girls, à la Gérôme. He was not a diagnostician or social protester; not, like Édouard Manet, a dissecting dandy. But he did stubbornly cling to two social themes, linked in the familiar Victorian cliché *Mens sana in corpore sano.* On one hand, the healthy body, absorbed, stringy and competent, straining at the oars or alert at bat or displaying itself, as an un-ideal figure in an American Arcadia, naked by a water hole. On the other, the

heroic mind, exemplified for Eakins in the forward stretch of scientific
inquiry and summed up in the paternal figure of the Didactic Doctor.

Such was the theme of his two most ambitious paintings, which the
Philadelphia show brings together in one room for the first time—*The
Gross Clinic*, which Eakins, a mere thirty years old, painted in 1875, and
The Agnew Clinic, done in a much higher and more even key fourteen
years later. In one obvious sense, *The Gross Clinic* was an homage to
Rembrandt's *Anatomy Lesson of Dr. Tulp*. It also contains traces of Ve-
lázquez, the hero of tonal painting in Paris ateliers of the 1870s: the shad-
owy figure silhouetted in the amphitheater entrance, hardly visible in
reproduction, seems to be a quotation from *Las Meninas*, which Eakins
had studied in the Prado.

The Gross Clinic was a consuming project, meant as a "masterpiece"
from the word go. Eakins did so many studies for it that Gross wished
him dead, but they paid off. The head of Dr. Gross, thought and tension
made flesh, is one of the supreme nineteenth-century portraits, and the
drama of contrast between the dense masses of black suits and gloomy tiers
of students, and the swooning white of the patient's thigh surrounded by
anxious straining hands and white cloth, reaches its apex in the fresh blood
on Gross's hand and the retracted lips of the wound. Such imagery
alarmed Philadelphia taste a century ago; *The Agnew Clinic* was rejected
from the Pennsylvania Academy's exhibition in 1891 because it depicted
a mastectomy for cancer and was "not cheerful for ladies to look at," an
understatement of the first order.

In his time Eakins was reproached for being too scientific, not artistic
enough, though "a builder on the bedrock of sincerity, and an all-sacrifi-
cing seeker after the truth." Their freedom from "poetic" conventions is,
of course, just what makes his best paintings so moving to a modern eye.
In them, system and nature rise to a close relationship. "The big artist,"
Eakins wrote, "keeps a sharp eye on Nature and steals her tools. . . . Then
he's got a canoe of his own, smaller than Nature's but big enough for every
purpose. . . . With this canoe he can sail parallel to Nature's sailing." To
spend time along the wall in the Philadelphia Museum of Art, where
Eakins's major paintings and drawings of rowers and shells are hung is,
eventually, to see what he meant. The perspective setups have the gratui-
tous complexity of Uccello and the modernity of Sol LeWitt; their geo-
metrical, measured web of lines turns, slowly and inevitably, into the
observed structure of water surfaces, the arrowing interpenetrations of
ripples, the striations, the delicate punctuation of water droplets in light.
"There is so much beauty in reflections," Eakins wrote, "that it is gener-

ally well worth while to try to get them right," and so he did, at the price of disciplined and laborious observation.

To construct was to see. He was never interested in conventional beauty. Sober, pinched, reflective, lined and melancholy, his portraits remind us of that. But how many American artists said more about the sense of being in the world? Eakins was that extreme rarity, an artist who refused to tell a lie even in the service of his own imagination.

Time, 1982

III

Into Modernism

Toulouse-Lautrec

A dwarfish cripple of exalted birth, absinthe-sodden and dead at thirty-seven, Henri de Toulouse-Lautrec was perhaps the most spectacular *peintre maudit* of the late nineteenth century: a doomed dog of early modernism, fit for Hollywood. No reputation can quite survive a movie like *Moulin Rouge*, and ever since its release in 1952 the popular image of Toulouse-Lautrec has been shaped by the sight of José Ferrer, legs bound, peering with lugubriously feigned interest up at the boilerplated buttocks of Zsa Zsa Gabor. Thus Toulouse-Lautrec became one of the few artists nearly everybody has heard of, a guarantee perhaps that his retrospective organized by Charles Stuckey for the Art Institute of Chicago will be so crammed as to render the work invisible.

One enters expecting the familiar recorder of a vanished culture, the café and boulevard life of the Belle Époque, the lowlife of the cabarets, the usual suspects—May Milton, Jane Avril, La Goulue. One leaves with an impression of precocious modernity, partly because Lautrec's caustic and tender view of the world speaks directly to our culture of narcissistic display. There is less space than you might think between Lautrec's absinthe drinkers and ether sniffers and the celebs snorting cocaine in the back room of Studio 54. Lautrec's art was about watching: as Stuckey observes, each figure spins in its own solitude in the midst of the schedules of lust and sociability: "In Lautrec's paintings glances are only seldom acknowledged or returned. Instead, he diagrams the routines of curiosity and anticipation he observed at public places." If the stream of life is divided into an infinity of fleeting moments, as it is by a culture based on photography, each looks like an actor's gesture, a pose—or a snapshot.

This disarticulation was what Lautrec attempted, and one still marvels at the speed and accuracy of his note-taking, whether it was real (in his sketch pads) or feigned (in the finished theatrical lithograph). The impression that his drawing of Jane Avril's kick or Yvette Guilbert's bow took as little time as the movement itself does not hold for long: one's admiration for Lautrec's craft, for the eggshell delicacy of spattered lithographic ink or the exact placement of a complementary color, overrides it. But it lasts just long enough to give a sense of different organization—that the image is based on a precarious grasp of the real, in contrast to the formal traditions of life drawing since the Renaissance. His poses were really seen, not inherited from the atelier tradition.

Lautrec was no expressionist. He did not revel in alienation and his most pathetic images have a measured distance and a focused sense of human absurdity. The painting that summed up his sense of what Baudelaire, another wounded argonaut of the boulevards, called the "heroism of modern life" was *At the Moulin Rouge*, 1892–95. It is a gathering of Lautrec's tribe, his best male friends and the cabaret women who were the main characters of his art. It also seems to be Lautrec's answer to the Parnassian pretensions of French artist circles in the 1890s—the kind of high-mindedness he had mocked as a student, ten years before, with an acrid parody of Puvis de Chavannes's *Sacred Grove*, into whose pallid scattering of Muses he introduced a line of stray moderns from a Paris street, including his stunted self, back turned, pissing on the turf of Parnassus. Lautrec thought the Timeless and the Eternal a boring joke, and in *At the Moulin Rouge* he offered the alternative: let the aesthetes dedicate themselves to Higher Thought, but he would stick with the gaslight and his fallen friends.

"Heads pass by in the crowd," wrote a Belgian painter describing the Moulin Rouge in 1893. "Oh, heads green, red, yellow, orange, violet. Vice up for auction. One could put on the door front: People, abandon all modesty here." This, as Stuckey points out, is almost a verbal postcard of Lautrec's painting, but anyone who read into its brilliant, sickly jolts of complementary color and its ravaged cast of characters the evidence of moral disapproval would not know his Lautrec. The sheer ingenuity of construction is astonishing: for instance, how the unstable colors within the group at the table, laced with patches and lines of burning red—the plaid lines of La Macarona's bodice, the serpentine fur trim of Jane Avril's coat—are stabilized by the four top-hatted heads of men receding to the upper left, all in profile, including Lautrec himself, like medallions. Nor is there a more startling apparition in early modern painting than the

green and yellow mask of May Milton, lit from below like a Halloween face in close-up, clashing with Jane Avril's puffy brioche of red hair. With this image, the stage is set for Ensor, van Dongen and the early Matisse. The effect of this show, in short, is to give us a Lautrec very different from the slumming *boulevardier* we are used to: it argues that he was one of the creators of modernism itself.

Time, 1979

Auguste Rodin

"Rodin Rediscovered"—an exhibition of some four hundred sculptures, drawings and photographs organized by Albert Elsen at Washington's National Gallery of Art—may be the most elaborate tribute an American museum has ever offered to a nineteenth-century sculptor. In effect, it is to sculpture what the Museum of Modern Art's 1977 Cézanne exhibition was to painting: a means of making us see afresh the processes and fantasies, the failures and successes of a very great artist whose work we assumed to be familiar. Who does not "know" Auguste Rodin, with reproductions of *The Kiss* and *The Thinker* the very furniture of cliché? But this exhibition shows us what we did not know. It brings forth not the debased Rodin of popular culture, or Rodin the herald of a modernism he did not live to see, but the actual artist, embedded in the nineteenth century, soaked in its values and yet struggling to extend them. It also clarifies, as never before, the taxing issue of what makes a Rodin "original." He did not work like a modern artist. He seldom carved his own marbles, never cast his bronzes, and he turned his models over to assistants so that they could be done in a gamut of sizes, Paperweight to Large Economy Monument. Yet his artistic control remained absolute.

Rodin had no successful followers because, as V. S. Naipaul once remarked of Charles Dickens, "the very magnitude of his vision, its absorption into myth, precluded so grand an attempt." There would, of course, be great sculptors after Rodin, but none of them, not even Henry Moore, was able to release such torrents of expressive power from the sole image of the human body. Pathos, energy, despair, exhaustion, orgasmic

pleasure: every shade of meaning, every sensation that the body can display, found its way into his oeuvre.

Rodin had very few inhibitions; flesh, both his own and others', was a source of inexhaustible fascination to him, and the erotic fury one often senses in his squeezing and manipulation of the clay was by no means a metaphor. One of his friends recorded a conversation with Rodin in his old age, as the sculptor talked about an antique copy of the *Venus de' Medici* that stood in his studio: "He spoke in a low voice, with the ardor of a devotee, bending before the marble as if he loved it. 'It is truly flesh!' he said, and beaming, he added: 'You would think it moulded by kisses and caresses!' Then, suddenly, laying his hands upon the statue: 'You almost expect, when you touch this body, to find it warm.' "

The myth of Pygmalion and Galatea (the sculptor falling in love with the figure he had carved) had vast resonance for Rodin; in his marble *Pygmalion and Galatea*, 1910, the girl emerging from the stone seems literally shaped by the carved sculptor's own passion, as though the contrasts between consciousness and dream, body and effigy, art and life, subject and object could all be packed into one erotic metaphor. No wonder that when he made his image of *The Sculptor and His Muse*, circa 1890, the muse's hand was laid encouragingly on the sculptor's genitals. Rodin was no ordinary phallocrat.

Perhaps we tend to see him as more isolated than he was. Rodin was never without gifted peers, and there were some formidable talents among his French contemporaries, particularly Jean-Baptiste Carpeaux. No great artist appears, as it were, from the desert as a person without a past: that is a messianic fancy peculiar to the popular myths, but not the realities, of early modernism. The point is made in the the first court of the exhibition, where representative works from the Salons of the 1870s are juxtaposed with Rodin's. This witty mélange serves to indicate what Rodin absorbed by way of themes, images and treatments from artists such as Jean-Paul Aubé, whose figure of Dante conversing with a damned soul may have helped start the train of thought that led to *The Gates of Hell*, or Alexandre Falguière, whose monument to Lamartine is distantly echoed in Rodin's bronze crag of literature, *Balzac*.

Rodin's career took off fairly slowly. Sculpture was not a medium in which precocity had much of a chance: there was too much, on the level of craft and technique and management, to learn before the work could publicly manifest itself. It was, after all, a quasi-industrial process and there were no shortcuts into it. But in this industry family position did not help, and in his case it could not have done so anyway. Rodin's father

was a small functionary, stuck in the French bureaucratic anthill. Rodin's school record was poor, and he failed three times to be accepted by the main art school in Paris, the École des Beaux-Arts. Until his early thirties, nothing he made was noted, and he simply contributed his anonymous efforts to the studios of other sculptors, patinating, chasing, designing decorative masks—the laborious but skilled hackwork of an age of architectural decoration and commemorative sculpture. He was in his late thirties before he managed to get a major sculpture on public exhibit in France *(The Age of Bronze).* If ever a great artist lived out the conventional trajectory from obscurity through unpopularity and thence to notoriety and patriarchal fame, it was Rodin.

In some way he seems such a modern artist. There is, to begin with, his relentless autophagy: the cannibalizing, part by part, of his own images in numerous variations, a self-reflexive mode of invention that one associates more with Picasso than anyone earlier. This point is brought home dramatically by the gallery of motifs from *The Gates of Hell,* from *The Thinker* itself (originally meant to be the central figure over the doorway, a Dante dreaming the whole Inferno) to the battalion of flying, crouching, writhing figures, bare forked animals all, that crowd the plinths. Then there is the refusal to submit to external schemes or narratives. *The Gates of Hell* cannot be read as a Renaissance fresco or a medieval Last Judgment, because it has no iconographic program: Rodin made up its meaning as he went along. It is less about divine doom than about the condition of secular despair, bad faith, the unrooting of the self—a vast and almost illegibly complex dirge that touches now and then on the original imagery of the *Inferno* but does not, in any consistent sense, illustrate it. Yet its formal properties—the sudden shifts of scale, the aggressive protrusions of figures from the bronze skin, the sense of strain and rupture—speak more eloquently of dislocation and frustration than any orthodox treatment could have hoped to do.

Then one must count his sexual frankness, overwhelming in its time, and his concomitant refusal to idealize the body's postures; Rodin's poses do not belong to earlier sculpture. Last, there is the fragmentation of the body itself as a sculptural object. Rodin's work was permeated by his fixation on Michelangelo and, specifically, on the expressive power of the *non finito,* the sculpture as unfinished block, as in the hacked pathos of the *Rondanini Pietà* or the *Slaves* half released from their matrix of stone. But his use of the "partial figure"—the headless striding man, or the spraddled, capering figure of *Iris, Messenger of the Gods*—went beyond such conventions as the broken antique fragment. It was a demonstration that the

expressive power of human form could be so concentrated in the body as to dispense with the need for its main signifier of emotion, the head. Released from its role as the head's pedestal, the body could speak more fully. This too looked back to Michelangelo. But it also predicted the fragmentation of later modernist sculpture, just as surely as Rodin's ideas about organic form clearly pointed forward to Arp and Moore. "The truth of my figures," he remarked, "instead of being merely superficial, seems to blossom from within to the outside, like life itself."

Those who found him inspiring were right. Those who find him inhibiting are also right, for Rodin was a man of nineteenth-century amplitude and not twentieth-century doubt. What sculptor today could one expect to possess such reserves of feeling, such an indifference to the errors of his own fecundity, or so unrestrained a tragic sense? There are no candidates. To compare him with Michelangelo is not, in the end, impertinent, for Rodin was one of the last artists to live and work in the belief that making sculpture—despite the potboilers and failures in his output—was a moral act, that it could express one's whole sense of being in the world and, by uttering it, make the self exemplary.

Time, 1981

Van Gogh and Cloisonnism

When did modern art begin? It is impossible to fix a date; the roots are too tangled in the subsoil of the nineteenth century. But one can point to some crucial events of its growth. One of them happened in France in the late 1880s, within a group of painters—some now familiar to us as secular saints or movie heroes, others still relatively ill known—who kept venturing out of Paris toward more "primitive" places. Paul Gauguin and Émile Bernard ranged among the megaliths, the cold heather and the gaunt folk Christs in Brittany. Vincent van Gogh pursued what he called "the gravity of great sunlight effects" in Arles. The pattern of these escapes was of great importance to modernism. It meant that artists, impelled by curiosity, were in a sense mimicking the colonial pattern of expansion and appropriation. They were becoming tourists in other ethnic realities, seizing on the distant world and its exotic contents as raw material. Arles in

1888, the year van Gogh began work there, was more foreign to a Parisian than Tunis is today.

As in travel, so in art: the painters looked to foreign sources, inside and outside France, for inspiration—Breton carvings, the crude popular woodcuts known as *images d'Épinal* and, above all, the Japanese woodblock prints that had been arriving in France in a steady trickle for the quarter of a century since Perry sailed into Tokyo Bay. What these influences produced, in the work of van Gogh, Gauguin and the various painters who were, at one moment or another during the late 1880s, linked to their work (among them, Maurice Denis, Louis Anquetin, Émile Bernard, Paul Sérusier and Toulouse-Lautrec) was a style known as cloisonnism. The French *cloison* means "division" or "partition," and the term was applied to a kind of enamelware whose patches of bright color were separated by fine metal lines. Largely because of van Gogh, cloisonnism became one of the key modernist styles, the sign of a new concern with the semantics of art (which were being explored in a totally different way by Cézanne in Aix-en-Provence and by Seurat with his light-filled dots), indicating a degree of aesthetic fundamentalism that had not been seen since Ingres's day.

The five seminal years of this style (1886–91) are the subject of "Vincent van Gogh and the Birth of Cloisonnism," at the Art Gallery of Ontario. The exhibition includes a large group by van Gogh, mostly from his time in Arles and St.-Rémy. They are backed up with some thirty Gauguins and many remarkable paintings by the "disciples"—including Bernard, who turns out, like Anquetin, to have been a painter of real originality who can now be seen without Gauguin's shadow across him. This ambitious curatorial effort is the work of Canadian art historian Bogomila Welsh-Ovcharov.

The van Goghs by themselves, of course, are worth the ticket to Toronto. Welsh-Ovoharov has assembled many of the best-known paintings, from the burning and writhing *Sunflowers* through the spiky lateen-rigged boats on the Camargue beach at Stes.-Maries-de-la-Mer; from the bedroom in the yellow house at Arles to the tiny, dense icon of the *The Sower*, a stubborn black lump distributing flakes of seed under the fire-wheel of the setting sun. Although these images have joined the noble clichés of art history, they can be seen afresh through their relationship with the work of other artists. The service this show does for van Gogh is to place him in a clear but somewhat unfamiliar cultural context, so that he is seen not as an inspired half-madman working out his obsessions in isolation, but as an artist in constant dialogue with his comrades.

Thus van Gogh's painting of the café terrace on place du Forum in

Arles, 1888, with its harsh contrasting color—deep nocturnal blue against yellow lamplight under the awning, streaks of orange opposing the absinthe green of the café tabletops—was both a direct act of natural vision and a tribute to Louis Anquetin's *Avenue de Clichy: Five O'Clock in the Evening*, 1887. Anquetin, drawing on childhood memories of seeing his parental garden through stained-glass lozenges in the front door, had suffused his view of a Paris street in a deep luminous blue, relieved only by the harsh yellow-orange flare of gaslamps on the charcutier's awning.

Such "radical" developments were underwritten by an appeal to older systems of art, not only to the Japanese printmakers, whose cutting into the wooden block provided the essence of division between line and patch, but also to French masters such as Ingres, with his steadfast differentiation between color and drawing. "Outline expresses that which is permanent, color that which is momentary," wrote the critic Édouard Dujardin, in the article that gave cloisonnism its name. "The work of the painter will be something like painting by compartments, analogous to cloisonné."

If Impressionism had banished the boundary line from art, Gauguin, van Gogh and their colleagues put it back with a vengeance. Their ambitions went beyond the formal, into the domain of symbolic meaning. This was particularly true of van Gogh and of Gauguin, who eventually went to Tahiti in order to paint huge allegories of human fate. One sees this interest already in his Brittany paintings, such as *Woman in the Hay*, an image drenched in anonymous sexuality, whose half-nude peasant woman sprawled on the hay is quoted directly from one of the female slaves in Delacroix's *Death of Sardanapalus*. These early modernists were not, after all, deeply concerned with the future, as the avant-garde would be thirty years later. They saw themselves as prophets—but obsessed, as prophets may be, with a past they wanted art to recover: a way of visual speech that was archaic, direct and sacramental. If some of the formal reductiveness of modern art begins with cloisonnism, so does its hope for "primitive" eloquence about the deepest appetites of the self. The achievement of this marvelous show is to suggest how the two were entwined.

Time, 1981

Édouard Manet

After Édouard Manet died of tertiary syphilis in 1883 at the age of fifty-one, Émile Zola and Claude Monet helped carry his coffin to the grave. In life, his milieu had included nearly every French artist of significance, along with writers of the stature of Charles Baudelaire and Stéphane Mallarmé; the latter called him "goat-footed, a virile innocence in beige overcoat, beard and thin blond hair, graying with wit." Dressed to the nines, Manet was celebrated as a dandy in that city of dandies, Paris. To read his friends and admirers, you would suppose that he never uttered a pompous word. His sense of measure, corrected by self-doubt, found expression in a sweet offhandedness. "Conciseness in art is a necessity and a grace," he told a younger painter. "Cultivate your memory; for nature will never give you more than information. . . . No set pieces! Please, no set pieces!"

He made no bones about hating the country. His life and work amount to a definition of urbanity. Paris is unthinkable without Manet; Manet unimaginable without Paris. Both were joined again last spring in a centenary exhibition at the Grand Palais. The retrospective was curated by two art historians, Françoise Cachin, of the Musée d'Orsay in Paris, and Charles Moffett, until recently curator of European paintings at the Metropolitan Museum of Art in New York City. Last week "Manet, 1832–1883" arrived at the Met. It has been shorn of two key paintings, the *Olympia* and the *Déjeuner sur l'Herbe*—a defensible loss, in view of their unique importance and the risks of transatlantic flight. This gap does not matter in the end. The Manet show is a triumph, a brilliant conjunction of scholarship and curatorial intelligence with the work of an exceptional artist.

An artist of this order has many profiles, not all of them visible at the same moment. Fifteen years ago, it was more or less obligatory for American critics to focus on the "radical" formal aspects of Manet's work and, in particular, on his use of flat (or at least shallow) pictorial space. Lone figures like those in *The Fifer* and *Matador Saluting* were posed against a background too flat to be a room, too brown to be outdoors; it was no more than a neutral backdrop, an exaggerated version of the depthless

space behind Velázquez's portraits and some of Goya's. This concern for silhouette and two-dimensional compression could be seen as the progressive missing link between illusion and the flatness of classical modernism. Thus it tended to monopolize discussions of Manet and, on the side, to exaggerate the importance of some of his "flatter" paintings, which are not always his best.

Today, surrounded by art that rejects formal grace in the interest of narrative, contradiction and hyperbole, we are conditioned to see a different Manet. In eyes that have viewed de Chirico's train stations, for instance, Manet's painting of a woman and a child at the Gare St.-Lazare acquires a strangeness that contradicts his intention of painting a peaceful urban scene. The grown woman stares at the painter, the little girl turns her back and gazes raptly through the iron bars into an industrial future, full of clamor and swift disjunction. For each phase of modernism there is a new Manet, but his greatness as a formal artist (and no other word for his achievement will do) is not to be predicated solely on the way his work anticipated the desires of later painters. The paintings, seen in themselves, do not look so very flat anyway. As Anne Coffin Hanson points out in one of the catalogue's searching essays, they reproduce flatter than they are. In reality, "surface qualities come into play. . . . It is as though the artist had discovered a means of simultaneously combining touch and sight."

Manet's sense of touch was extraordinary, but its bravura passages are in the details: how the generalized bagginess of a trouser leg, for instance, rendered in flat, thin paint and firmed up with swift daubs of darker tone in the folds, contrasts with the thick, creamy white directional brushstrokes that model the curve of a spat. The ceaseless, intelligent play of flat and round, thick and thin, "slow" and "fast" passages of paint is what gives Manet's surface its probing liveliness. There is nothing "miraculous" about it, but it was not the result of a mechanically acquired technique either. It is there because, in his best work, Manet's inquisitiveness never failed him; every inch of surface records an active desire to see and then find the proper translation of sight into mark.

Of *The Fifer*, 1866, Zola remarked that Manet did not shrink from "the abruptness of nature": "His whole being bids him to see in patches, in simple elements charged with energy." The same claims would be made by the Post-Impressionists—patch and discontinuity, "arrangement" as against continuous modeling. If *The Fifer* were a little more abstract, more "Japanese," it would almost be a van Gogh. At times, Manet's tact in balancing the decorative and the real almost passes belief, as in the black

stripe on the fifer's right leg—swelling and closing with negligent grace, extending the black of the tunic only to stop it an interval above the foot.

If Manet was not exactly a modernist, he was certainly not an Impressionist. He never exhibited with the Impressionist group; his aims were not compatible with theirs, much as they respected one another. Manet's firmly built structures of light and dark were mostly done indoors, after many preliminary studies; they have the formal diction of studio art, not the light, open qualities of plain-air painting. Atmosphere and local color were not his prime issues. And when he took what seems, on first glance, an "Impressionist" subject, he was apt to load it with ironies and contradictions until its straightforwardness evaporated.

The Balcony, 1868–69, is such a work. If this is a scene—well-off young people looking from a balcony into a street—it is a most peculiar one: a painting of a lapse in conversation. It is a setup (Manet was not floating in air above the street to look back on the balcony, but he had been looking at a Goya of an old *celestina* and a young *maja*). It is in fact a portrait of three of Manet's friends, including the painter Berthe Morisot on the left. Its friezelike stylization looks extreme to us and seemed absurd to critics 115 years ago. The color is almost a put-on, a *blague,* as such effronteries were called in the cafés of the day: the raucous, arsenical green of the shutters and iron balcony set so brusquely against the man's blue cravat and the tumbling white curds of the women's gowns. The formal rhymes within this gross dissonance seem deliberately mincing, as when the branches of the hydrangea on the left echo the angle of the balcony struts.

These are not the comments on Nature and Culture one expects a Monet or a Renoir to make, but disjuncture is part of the content of Manet's art. Time and again it brings a message, which he was among the first artists to deduce from the cultural compression of city life in the nineteenth century and which has become a shibboleth in the late twentieth: that the very unnaturalness of urban life is best resolved in high style and detachment. Manet's urbanity can be fully savored only in contrast with its opposite, the sentimental love of the pastoral that filled the breast of the average culture-consumer in his day. There is much in common between Flaubert, constructing the provincial mediocrity of Emma Bovary's life from a thousand icily observed details, and Manet, surrounding the blank-faced barmaid in *A Bar at the Folies-Bergère,* 1881–82, with a labyrinth of glitter, nuance and reflection. Detail contradicts sentiment. The orange glare of the tangerines, the bizarre rhyme between the green crème de menthe bottle on the counter and the green boots of an acrobat

whose legs make their tiny intrusion into the top left corner: such things maintain the surface and keep us from empathizing with the bored blonde.

Manet was no "social realist"; unlike Courbet, he was not on the lookout for allegories within reality. He paints a street singer, but she is his favorite model, Victorine Meurent (who posed for *Olympia*), and her taupe dress is far too fashionable ever to have been worn by a musical beggar, while her hat, a studio prop that recurs in the *Déjeuner sur l'Herbe*, is that of a male student in Paris. Or he renders her again in the preposterously unsuitable guise of an *espada*, a matador, posed in the bull ring: a transvestism, a play with notions of machismo, that insists on the artificiality of art.

The most famous example of Manet's contrariness is, of course, the *Déjeuner:* two women—one completely naked, the other nearly so—and two clothed men, occupying the foreground of a sketchily painted Arcadian landscape. We have been taught to see its allusions stick out like elbows (here an homage to Giorgione, there a quotation from Marcantonio Raimondi), but what infuriated the audience at the Salon des Refusés in 1863, and has caused so many gallons of ink to be spilled on it since, is its insolubility as narrative. An "uncouth riddle," one critic called it. What are those people doing? One modernist answer is that they are busy being in a painting. But, as Cachin shows in her catalogue note's meticulous and witty unskeining of the *Déjeuner,* there is far more to it than that.

The painting has the quality of farce, presented in the guise of a Second Empire pictorial machine. At the same time it is intensely serious (as farce can be), and one of the victims of its seriousness is the stereotype of the nude. Manet invariably painted women as equal beings, not as denatured objects of allure. Victorine, the model, is clearly a model doing a professional stint; the illusions of the Salon body, timelessness and glamour, are no longer properties of nakedness. Other artists painted nymphs as whores; it took Manet, in the *Olympia,* to paint a whore as her own person, staring back at the voyeurs, restricting the offer to a transaction. Here, as in paintings of women who were not models (such as Berthe Morisot, whose shadowed and inward-turning beauty Manet could portray as the index of thought), one sees him inventing the image of the "modern" woman. It was there to be seen; but that is true of any prophecy.

Time, 1983

Henri Rousseau

The Henri Rousseau show at New York City's Museum of Modern Art alters one's view of his work, as retrospectives are meant to—but slightly downward. It is, however, a delight to visit. One could write a little dictionary of received ideas about this engaging "primitive." It would begin with his nickname, the Douanier. (He was not, as MOMA's excellent catalogue stresses, a customs inspector, but a much lowlier form of bureaucratic life, a *gabelou*, or toll collector.) The dictionary would go through a whole list of legendary things that Rousseau did not do or see or say, things he cooked up himself (such as the innocent fiction that he had been to Mexico in the army of Napoleon III and had seen real jungles) or that were invented by friends (such as playwright Alfred Jarry's absurd story that he, a sort of Pygmalion, taught the old boy to paint). And it would finish with the belief that Rousseau (1844–1910) was one of the greatest protomodern artists.

This reputation rests, for Americans, almost wholly on one painting. It was no slight thing to have painted *The Sleeping Gypsy*, by now perhaps the most famous dream image in Western art. The silhouette of a sniffing lion, with one unwinking yellow eye and a tail stiffly outstretched, its tip erect as though charged with static electricity, quivering like Rousseau's own paintbrush; the swollen, white Méliès moon; the black nomad like a toppled statue, her feet with their pink toenails gravely sticking up; the djellaba, with its rippling stripes of coral, Naples yellow, cerulean; and the lute, like a pale lunar egg, hanging on the brown sand as the moon hangs in the blue night. Reproduced a millionfold, this oneiric image became the *Guernica* of the tots, the standard decor of upper-middle-class childhood. Such fame, decanted on a single picture, can distort an artist's entire reputation.

What we see in this enjoyable show is a painter whose high moments (two owned by Paris's Musée d'Orsay, *War* and *The Snake Charmer;* two by the Museum of Modern Art, *The Sleeping Gypsy* and *The Dream;* and one by a private collector, *The Hungry Lion*) must be weighed against a good deal of medium-rate work and potboiling. Enjoyment of the lesser

Rousseaus is usually tinged with condescension, although at least they are not cute or kitschy, like the truckloads of pseudo-naïf painting that would sprout from Montmartre to Haiti after his death. They have their period charm; you have to love his dirigibles and Wright biplanes creakily copied from postcards. But most of his city and country scenes are as platitudinous as Utrillo's.

Perhaps one should take Rousseau more on his own terms. The Paris modernists—Jarry, Apollinaire, Picasso, Robert Delaunay, Brancusi—hailed his work because of its fierce, astringent poetry, but also because it seemed to have predicted their own conscious concerns: the interest in popular art such as the prints known as *images d'Épinal*, the invented exoticism, the mode of composition in flat planes, but above all the ideal of the untutored eye unobstructed by academic culture, registering the world with the clarity, as the cliché used to run, "of a child or a savage." Rousseau's innocence might have been invented to refresh the culturally burdened. There you are, it declared: Late industrialism isn't so bad, it leaves little pockets with elves like me in them. The urban primitive has no style—or rather he has one that consists of absences: no correct drawing, no perspective, no knowledge of art history or cultural politics. He sings like a bird, without learning a score. Hence the Douanier, God's simpleton.

But Rousseau was very conscious of style and loved referring to other art. "I cannot now change my style, which I acquired, as you can imagine, by dint of stubborn labor," he wrote to a critic shortly before his death. He wanted his work to be a homemade replica of the values enshrined in the École des Beaux-Arts, as manifested in the big French Salon painters: Jean-Léon Gérôme, Adolphe-William Bouguereau, Felix-Auguste Clément. He loved their important subjects, their grasp of the colonial exotic, their professionalism and high finish. So when artists forty years his junior such as Picasso and Delaunay paid him their semireverent homages, he took them as his due without interesting himself much in their paintings. He patted the Young Turks on the head, telling Picasso, for instance, that the two of them were the greatest artists of their time, "You in the Egyptian style, I in the modern." This gnomic utterance can mean only that Rousseau identified "modernity" with the Salons: it was official speech, like the Eiffel Tower—about whose opening, incidentally, he wrote a lengthy theatrical skit satirizing the arrival of a Breton couple at the International Exposition of Paris in 1889.

Like many sweet old buffers, he admired authority. He painted the artists lining up for the Salon des Indépendants as an army of black-clad

troops, carrying paintings of identical size; it was a parody of the military metaphor of the avant-garde. Rousseau wanted honors, as his heroes had received. When the French government sent him a decoration by mistake he would not send it back, and he obstinately wore its violet rosette for the rest of his life. It was the Palmes Académiques—a serendipitous fluke, in view of his obsession with exotic scenes of distant jungles.

Among their leaves, he remained fixated on images of "natural" authority. Rousseau was less of a sweet fabulist than one is apt to suppose. His hero was Leo, king of the beasts, with vassals arranged in order of domination in their palm court. Some emblems of ferocity gave him trouble. The hero of *The Hungry Lion*, 1905, has a crescent of human dentures, and might be biting into a watermelon; the unhappy antelope, because of Rousseau's difficulty in drawing its head twisted at such an angle, is duckbilled; the eagle and owl, with their strips of meat, look stuffed. And yet the jungle—that lattice of leaves and fronds, each carefully turned toward the eye to display its full shape—is a majestic, formal green machine that fills its animal signs with utter conviction.

Facts merely impeded Rousseau. He needed fictions. Desperately poor most of his life, he could not travel. He had plenty of sources, untraceable today because ephemeral then. He used almanacs and magazines, engravings and photographs. He visited the exotic pavilions at the 1889 Exposition in Paris. He could walk in the Jardin des Plantes and hear the big cats roaring and coughing a few hundred yards away in their iron cages, jungle sounds floating to him through a screen of lush foliage. He "knew" what the Nile looked like, and the Niger, and the Amazon: muddier and steamier than the Seine, and lined with a frieze of swollen aspidistras. Out of this, on occasion, he could distill incantation. *The Snake Charmer*, 1907, condenses a huge popular imagery of the noble savage and the mysterious East. Its wonderful flora—light ocher blooms like hydrangeas or brains; green, yellow-fringed leaf spears; oversize blue foxgloves—look forward to Paul Klee. But the black woman with her glittering eyes, wreathed in obedient snakes, has to be the purest evocation of the colonial sublime in French painting—like a great Gauguin without the sex appeal. It makes one realize what distances separate the routine from the inspired, even among "innocent" visionaries.

Time, 1985

Vincent van Gogh, Part 1

If you once thought Vincent the Dutchman had been a trifle oversold, from Kirk Douglas gritting his mandibles in the loony bin at St.-Rémy to Greek zillionaires screwing his cypresses to the stateroom bulkheads of their yachts, you would be wrong. The process never ends. Its latest form is "Van Gogh in Arles," at New York City's Metropolitan Museum of Art. Viewed as a social phenomenon rather than as a group of paintings and drawings, this show epitomizes the Met's leanings to cultural Reaganism: private opulence, public squalor. Weeks of private viewings have led up to its actual public opening, this week. Rarely has the idea of artistic heroism been so conspicuously tied to the ascent of the social mountain. But now all this will change. The general public, one may predict, will see very little. Its members will struggle for a peek through a milling scrum of backs; will be swept at full contemplation speed (about thirty seconds per image) through the galleries; will find their hope to experience van Gogh's art in its true quality thwarted. Distanced from the work by crowds and railings, they may listen on their Acoustiguides to the Met's director, Philippe de Montebello, on the merits of the deceased. Then they will be decanted into the bazaar of postcards, date books, scarves—everything but limited-edition bronze ashtrays in the shape of the Holy Ear—that the Met provides as a coda. Finally, laden with souvenirs like visitors departing from Lourdes, they will go home. Vincent, we hardly knew ye.

There is little point, ninety-four years after his death, in trying to imagine what van Gogh would have made of all this. Neither the modern mass audience for art, nor the elevation of the artist as a secular saint, nor the undercurrent of faith in the expiatory powers of self-sacrificial genius, really existed in 1890. The insoluble paradox of museumgoing, which is that famous art gets blotted out by the size of its public, had not become an issue, and it was not thought "elitist" to express regrets about it. Yet one feels it matters more with van Gogh than with flabby events such as last year's Vatican show. For if there was ever an artist whose oeuvre wants to be seen carefully, whose images beg for the solitary and unhar-

ried eye to receive their energy, pathos and depth of conviction, that man was Vincent van Gogh—much of whose best work was done at Arles in the fifteen months between February 1888 and May 1889. This rhapsodic outpouring of creative energy produced some 200 paintings, more than 100 drawings and watercolors and 200 letters, written in Dutch, French and English. Of this mass of work, 68 drawings, 76 paintings and a few specimen letters are included in the present show, which has been intelligently organized by Ronald Pickvance around the proper armature—the strictly chronological unfolding of the painter's year.

Arles in 1888 was a torpid provincial town, as filthy and exotic—at least to a Parisian eye—as North Africa. Van Gogh's first reactions to it describe a foreign country. "The Zouaves, the brothels, the adorable little Arlesiennes going to their First Communion, the priest in his surplice, who looks like a dangerous rhinoceros, the people drinking absinthe, all seem to me creatures from another world." In fact, his stay there began the general pattern of migration southward that would be as obligatory for early modern French artists—Signac to St.-Tropez, Matisse to Nice, Derain to Collioure—as a stint among the marbles of Rome had been to their eighteenth-century forebears. Provence presented itself as a museum of the prototypes of strong sensation: blazing light, red earth, blue sea, mauve twilight, the flake of gold buried in the black depths of the cypress; archaic tastes of wine and olive; ancient smells of dust, goat dung and thyme; immemorial sounds of cicada and rustic flute—"O for a beaker full of the warm South." In such places, color might take on a primary, clarified role. Far from the veils and nuances of Paris fog and Dutch rain, it would resolve itself into tonic declaration—nouns that stood for well-being. Such, at least, was van Gogh's hope.

Vincent was ill when he arrived in Arles, jittery from booze, racked with smoker's cough. He had expected, curiously enough, that the place would look like one of the Japanese prints by Hokusai or Utamaro that had been circulating among avant-garde painters in Paris. In a way it did: the ground was covered with snow, like the top of Fuji. But soon it (and he) melted, and in his letters no less than in his paintings one sees the colors that sign his Arlesian period, the yellow, ultramarine and mauve. In the late spring, "the landscape gets tones of gold of various tints, green-gold, yellow-gold, pink-gold, and in the same way bronze, copper, in short starting from citron yellow all the way to a dull, dark yellow color like a heap of threshed corn. And this combined with the blue—from the deepest royal blue of the water to the blue of the forget-me-nots, cobalt." Some artists' letters are unrevealing about their work; others mythologize

it. Van Gogh's correspondence was unique: no painter has ever taken his readers through the processes of his art so thoroughly, so modestly, or with such descriptive power.

The forms of the Arlesian landscape, its patchwork of fields and tree-lined roads, were already embedded in his Dutch background—"It reminds one of Holland: everything is flat, only one thinks rather of the Holland of Ruisdael or Hobbema than of Holland as it is"—but the color was like nothing in van Gogh's previous life. Seeing his desire for "radical" color confirmed in the actual landscape gave him confidence. It affected even those paintings in which no landscape occurs, such as the self-portrait of Vincent with a shaved head, gazing not at but past the viewer with an intensity (conferred by the unearthly pale malachite background) that verges on the radioactive.

This, not the madman of legend, was the real and visionary van Gogh. The notion that his paintings were "mad" is the most idiotic of all impediments to understanding them. It was van Gogh's madness that prevented him from working; the paintings themselves are ineffably sane, if sanity is to be defined in terms of exact judgment of ends and means and the power of visual analysis. All the signs of extreme feeling in van Gogh were tempered by his longing for concision and grace. Those who imagine that he just sat down in cornfields and let the landscape write itself through him are refuted by the actual sequence of his drawings. Some of his most vivid and impassioned-looking sketches—the coiling, toppling surf; the silent explosion of wheat stooks; the sun grinding in the speckled sky above the road to Tarascon—are in fact copies he made after his own paintings and sent to his fellow painters Émile Bernard and John Russell to show them what he had been up to.

As a draftsman, van Gogh was obsessively interested in stylistic coherence. Just as one can see the very movements of his brush imitating the microforms of nature—the crawling striations of a gnarled olive trunk, the "Chinese" contortions of weathered limestone—so the drawings break down the pattern of landscape and reestablish it in terms of a varied, but still codified system of marks: dot, dash, stroke, slash. In his best drawings *sur le motif,* most of which belong to his second visit to Montmajour in July 1888, one sees how this open marking evokes light, heat, air and distance with an immediacy that "tonal" drawing could not. Space lies in the merest alteration of touch; light shines from the paper between the jabs and scratches.

And so van Gogh's Arlesian work offers one of the most moving narratives of development in Western art: a painter—and, needless to

repeat, a very great one—inventing a landscape as it invents him. The inevitable result is that one cannot visit Arles without seeing van Goghs everywhere. The fishing boats on the dark beach of Stes.-Maries-de-la-Mer have gone, and the fishermen's troglodytic cottages are now replaced by anthill apartment buildings. But to see an Arlesian orchard foaming into April bloom is to glimpse van Gogh rendering them ("absolutely clear . . . a frenzy of impastos of the faintest yellow and lilac on the original white mass"). Even his symbolism leaves its traces. One cannot see the purple underlights in plowed furrows against the sunset without thinking of the strange, dull mauve luminescence that pervades the earth in *The Sower* and helps suggest that this dark creature fecundating the soil under the citron disk of the declining sun is some kind of local deity, an agrestic harvest god. One apple tree will evoke the Japanese roots of van Gogh's spike line; another will suggest how Piet Mondrian's apple trees (and with them, his early sense of grids and twinkling interstices) relate to van Gogh; a third, resembling the veined canopy of a Tiffany lamp, may recall what the decorative arts of 1900 owed to the cloisonnism (decorative "inlaying" of the picture surface with outlines) of van Gogh and Gauguin. The Paris of the Cubists may have gone; but like the Umbria of Piero della Francesca, van Gogh's Provence manages to endure, both in and out of the frame.

Time, 1984

Vincent van Gogh, Part 2

Vincent is back. We left him at the Metropolitan Museum of Art in 1984, crop-eared and dazed in Arles: "Sometimes moods of indescribable anguish, sometimes moments when the veil of time and fatality of circumstances seemed to be torn apart for an instant." Two months after writing this, he voluntarily entered the lunatic asylum at St.-Rémy in Provence; and fifteen months after that, discharged but still plagued by unassuageable fits of melancholy, he shot himself to death in the rural village of Auvers, just north of Paris. Van Gogh was thirty-seven when he died—about the same age, it has often been noted, as Raphael, Caravaggio and Watteau, and with an oeuvre no less brilliant than theirs.

The Met's van Gogh exhibition in 1984 tracked the artist's career from his arrival in Arles to the spring of 1889. Its successor, "Van Gogh in Saint-Rémy and Auvers," completes the trajectory. The organizer of both shows, Ronald Pickvance, has brought together seventy paintings and nineteen drawings from this last phase of van Gogh's short life. Here we see the stuff of the most powerful legend of suffering and transcendence in modern art, and no superlatives seem apt to encompass its beauty and emotional range. It is a characteristic of great painting that no matter how many times it has been cloned, reproduced and postcarded, it can restore itself as an immediate utterance with the force of strangeness when seen in the original. Some of the van Goghs in this show, such as the Museum of Modern Art's *Starry Night,* with its oceanic rush of whorling energy through the dark sky, ought by now—if frequency of reproduction were as lethal as one sometimes thinks—to be one of the most corrupted clichés in art. But on the wall, among less familiar paintings (of which there are many in this show, thanks to the persistence with which Pickvance nailed down the loans), they are refreshed.

The longer van Gogh stayed in Provence the closer he thought he got to its "essence": its high tender color and sometimes violently modeled forms, its antiquity and, above all, its light. In Arles the initial shock of the landscape, impacted in citron and chrome yellows, had dominated his palette. But once inside the asylum at St.-Rémy, a different and more reflective way of looking at the landscape around him took over. "What I dream of in my best moments," he wrote, "is not so much striking color effects as once more the half-tones."

One may perhaps connect this yearning for stabilization with van Gogh's fear of his own ailment, whatever it was (epilepsy complicated by syphilis is a likely guess). It is as though the calmer color, the growing penchant for structuring his work as a process of sequential research into a given motif—a walled field near the asylum, the olive grove outside it, the pines in the asylum garden—had an apotropaic use for him, keeping at bay the demons of the unconscious. He wrote incessantly; his letters from the asylum, unmarred by a single note of self-pity, are among the most lucid and frank ever written by a painter. He categorized and catalogued his work, and art historians, wishing Cézanne had done the same, have long been grateful for this habit of his. In October 1889, he summed up the relation between his paintings and his illness in one piercing metaphor: "I am feeling well just now.... I am not strictly speaking mad, for my mind is absolutely normal in the intervals, and even more so than before. But during the attacks it is terrible—and then I lose consciousness

of everything. But that spurs me on to work and to seriousness, as a miner who is always in danger makes haste in what he does."

Work and seriousness: this, not the vulgar image of the madman issuing orgasmic squirts of yellow and blue at the dictation of his lunacy, is the real van Gogh of St.-Rémy and Auvers.

Quite often the works that seem most "expressionist," the clearest indexes of a mind approaching the end of its tether, are the most tenderly scrupulous in their treatment of fact. One has only to go to St.-Rémy and stand on the edge of the olive grove outside the asylum, looking south toward the chain of limestone hills called the Alpilles, to realize that van Gogh changed nothing essential in the view when painting *Olive Trees with the Alpilles in the Background* in the spring of 1889. The heaving stratification of the limestone, its caverns and holes, and the turbulent profile of Mont Gaussier to the west do look like that, just as the writhing strokes of his brush on the olive trunks are a direct pictorial equivalent to the real arabesques of ancient bark and wood. One might not often see a real cloud like van Gogh's—that strange fetal shape extruded into the blue sky—but it powerfully conveys the strength of the wind over the plains beyond Les Baux.

The idea that landscapes like this are fantasies, mere projections of psychosis on the mundane, is wrong and does no justice to van Gogh's exquisite sense of reality. The matter is more complicated than that. It is true that van Gogh applied the formal system he preferred to the Provençal landscape: the rapid, shifting notation of dots, speckles and slashes in the drawings, with the white paper burning like noon light behind the sepia ink; the characteristic spirals of the paintbrush, which link back to the decorative line work of Edo screens and point forward to the whiplash rhythms of Art Nouveau. But this handwriting was not mechanically stamped on the landscape, as the style marks of mere obsessives tend to be. On the contrary, it was infinitely responsive to the nuances of fact. Dealing with the "difficult bottle-green hue" of his famous motif, the cypress (of which the real landscape around St.-Rémy is now disappointingly short), he went to great trouble to set forth the realities inside its hairy, obelisk-like silhouette: the mauve cast of shadow on the trunk and branches, the sparks of almost pure chrome within the enfolding darkness of its leaves.

To watch him shifting gears in the portrait of the elderly head attendant of the asylum, Charles-Elzéard Trabuc, is to receive a vivid lesson in the adjustment of manner to motif. Trabuc's cotton jacket, with its emphatic parallel stripes of blackish blue, is as explicitly stylized as anything

by Klimt or, for that matter, Miró. Nevertheless this pattern is subordinated to volume, to the immobile self-containment of a man who, Vincent realized, "has seen an enormous amount of suffering and death." The chin and mouth are compressed, but the brow bulges irresistibly from its pale background, the relation between head and coat subtly maintained by the black strokes of hair and mustache and the unwavering darkness of Trabuc's eyes.

In such portraits, van Gogh attained the grave humane fullness of his model Rembrandt; but the landscapes are like nothing anyone had painted before. No wonder the little asylum, with its worn flagstone corridors and pine-shadowed garden, remains one of the sacred sites of modernist culture. Here, as in Manet's Paris and Cézanne's Aix-en-Provence, art turned on its pivot in the nineteenth century to face the twentieth. One does not see many exhibitions like this in a lifetime.

Time, 1986

Paul Gauguin

No great museum retrospective is just a matter of a "definitive" array of works, or of critical intelligence applied to them, or of a deep curiosity about the artist's life. It is a combination of all three, a vision of how they weave together—the museum's equivalent of George Painter on Marcel Proust, or Leon Edel on Henry James. Once you have digested it, neither you nor the artist will be quite the same. You have seen the record set straight. Such events cannot be replaced by fifty Helgas.

The Paul Gauguin retrospective at the National Gallery of Art in Washington, D.C., is of this kind. When the National Gallery, the Art Institute of Chicago and the Musée d'Orsay in Paris found they were all planning separate shows on different aspects of Gauguin—his prints, his Brittany paintings and his Tahitian work—it seemed obvious to merge the three; and the result is the most complete view of its subject ever offered by a museum. Gauguin's achievement has always been hard to assess because so much of his late work, done between his final departure from France in 1895 and his death on the tiny, remote island of Hivaoa in 1903,

was bought en bloc by Russian collectors, ended up in the Hermitage and the Pushkin Museum, and has not been seen in the West since 1906. The show contains eleven of these "Russian" Gauguins.

The 280 paintings, drawings, prints, sculptures and ceramics in this show are the outpouring of a protean talent who influenced the course of modern painting more than anyone except Cézanne. One may be half prepared for Gauguin's impact on younger artists after 1900, but to see it in the paint (and the wood) is another matter. Where does that peculiar, dense, purply-brown shading of Picasso's early work come from, but the bodies of Gauguin's Tahitians? Most early Matisse seems present in the twining lines and harsh dissonances of red, yellow and green with which Gauguin pictured himself fifteen years before in the sardonic *Self-Portrait with Halo*, 1889; one Gauguin bas-relief, *Be Mysterious*, 1890, was the source for a whole sequence of Matisse's relief sculptures of the human back, begun in 1908. Gauguin's sculpture and painting were basic to German Expressionism, and even Henri Rousseau seems to have based his *Sleeping Gypsy* on his goose-pimply image of erotic shame, *The Loss of Virginity*, 1890–91.

Gauguin is a "legendary" figure, with all the accretions that ambiguously beneficial state entails. His legend was helped by other people's fictions, although Gauguin's own existential posturings as hero, Christ-martyr, magus, savage and artist-criminal lay at its root. For many the hero of Somerset Maugham's *The Moon and Sixpence* is still the "real" Gauguin—a stockbroker and Sunday painter who cracks out of the bourgeois egg, dumps his wife, family and career, and hightails to Tahiti to "find himself" among the breasts and breadfruit. He is part brute and part escape artist, the Houdini of the avant-garde. Such an image of Gauguin, as the curators show by exhaustive research, is mostly moonshine. The "brute" of fiction was not only an intelligent painter but also a writer who left, as Richard Brettell points out, "the largest and most important body of texts, illustrated and otherwise, produced by any great artist in France since Delacroix. . . . That he has always been treated as a businessman-turned-artist rather than as an artist-turned-writer shows the extent to which his literary achievement has been undervalued."

As this show indicates, Gauguin was an artist of remarkable powers long before he sailed to the South Seas from Marseilles in 1891. By then, most of the basic themes of his work were in place: he had already "found himself" in Brittany, presiding over a small colony of lesser artists such as Maurice Denis and Meyer de Haan, amid the ritual dolmens and the stolid squinting peasants—an exotic tribe with its own language and

religious customs, an enclave that seemed closer to the earth than the rest of France.

The story of self-creation the early work tells is just as surprising as anything in his Tahitian years. By 1880 the Sunday painter in his late thirties had become a tardy Impressionist, imitating Camille Pissarro's landscapes and Mary Cassatt's moppets. Here and there one catches a glimpse, a hint, of the work to come. His brooding *Manao Tupapau* (*The Specter Watches Over Her*), 1892, with its uneasily dozing girl watched by a goblin, may hark back to Fuseli's *Nightmare*, but it also repeats a painting Gauguin did eleven years earlier of his daughter asleep with a sinister-looking Punchinello doll at the end of her cot.

Gauguin as Impressionist looks dull today, though Pissarro and Degas thought him good enough to show with them in the Fourth Impressionist exhibition in 1879, when Impressionism was in full decline. But after ten years of work in Paris and Brittany and with van Gogh in Arles, Gauguin was making his first real masterpieces, such as *The Ham*, a still life that pays homage to Cézanne and Manet while equaling both in its rigor and sensuousness, and *The Yellow Christ*, with its startling extremes of yellow and orange. This painting of peasants adoring a wayside crucifix was also, perhaps, an allegory of Gauguin's own opinion of himself: Christ's face is his schematic self-portrait, and the Breton women may stand for Gauguin's own followers in Pont-Aven. Always in the art world, as in a madhouse, there are bad painters who obstreperously claim to be prophets. Gauguin was that discomforting figure, an artist who made good on strident prophetic claims. He saw himself as both Christ and savage, both sacrificial lamb and initiator of cultural mayhem. The whole tangle of the "primitive," so basic to early modernism, begins with Gauguin—not in Tahiti, but in Brittany, "savage and primitive," he wrote, where "the flat sound of my wooden clogs on the cobblestones, deep, hollow and powerful, is the note I seek in my painting." The purpose of introducing it was to go beyond the eye, to endow painting with a symbolic resonance it had not possessed with Impressionism. "Atheist that I was," Gauguin's fellow Nabi Émile Bernard wrote of Brittany, "it made of me a saint. It was this Gothic Brittany that initiated me in art and God." Gauguin and his circle were not the only artists who painted Breton life as a form of pious, exalted symbolism: *folklorique* genre paintings of that sort were so common among now forgotten academics such as Émile Vernier and Alfred Guillou that the Salons were infested with nuns and provincial virgins in clogs. (The trend was neatly parodied in 1883 by a proto-Dada journalist named Alphonse Allais who exhibited a perfectly

white sheet of paper with the title *First Communion of Anemic Young Breton Girls in the Snow.*) However, the Nabis pushed it further than anyone else. Formalist history has tended to dwell on one part of their program—the emphasis on flatness, the rigidity and rectangularity of the picture plane—but not on another, which was at least as important: the desire for spiritually pregnant symbolism.

Gauguin's ambitions, in this regard, were quite Wagnerian. He thought in terms of large didactic and decorative cycles. He dreamed of making a "total" work of art subsuming architecture, painting and sculpture—hence the "Museum of the South Seas," which he set up in rue Vercingétorix in Paris after he got back from his first Pacific sojourn in 1893, and the "House of Pleasure," with its lewd carvings and mottoes, that he built in the Marquesas. Tahitian myth was as literal a gift from the gods to him as Valhalla had been to Wagner. Gauguin was no anthropologist, but a romantic looking for pity and terror among the vestiges of a lost golden age. Certainly his flight to the Marquesas was inspired by a wider reaction against Western cultural surfeit, against an industrial France fixated on money and "development." But the life he forged from his discontents, although not without moments of bathos, was deeply courageous. He tried what others in the Paris cafés only talked about. Gauguin was never the most limpid allegorist (one could not be, and remain attached to the weird mix of Symbolism and Rosicrucian mumbo jumbo that seized his imagination in France), and even his Breton work, for instance *Self-Portrait with Halo,* could be fairly inscrutable. But his fiercest intent was to go beyond mere pleasure in painting. How he would have despised the imagery of Club Med hedonism that so many people still expect in his work! The "optimism" of Gauguin's brilliant, moody color is a myth. His sensuality is shaded by transience and the fear of cultural extinction. The folkways of Tahiti were vanishing under French colonization long before Gauguin arrived. But Tahiti reinforced what he wanted to do in Brittany—to paint grand moral allegories that spoke of human fate and wove together the mundane and the mystical. Alas, the summation of these efforts, the 1897 mural portentously titled *Where Do We Come From? What Are We? Where Are We Going?,* could not be lent to this show from Boston.

He tried to create new myths out of the most eclectic elements— ironically, the kind of overview that only European colonialism, which he despised, makes possible: Buddhism, Hinduism, Oceanic legends, Christianity, Symbolist fancies, the nostalgia of Poussin and the despair of Poe. And his pictorial sources were just as varied. However much Gauguin

promoted himself as a man of instinct, his work is a cultural palimpsest. A high-born *vahine* displays herself in the pose of a Cranach nude; Manet's Olympia echoes through the Tahitian bodies; he copied poses from a large stock of photographs he took with him to the Pacific, and even from postcards he bought in Papeete. The figure in his *Exotic Eve* got her head from a photo of Gauguin's own mother in her youth, and her sinuous body from a temple sculpture at Borobudur in India. Some of his greatest Tahitian works are in part reflections on other paintings. *Te Rerioa (The Dream)*, 1896–97, with its silent meditative figures in the strange frieze-decorated room, is a distant reprise of Delacroix's *Women of Algiers*.

But that is also what lends Gauguin's Tahitian work its tension—the layering of cultural memory into ecstatic sight. A great artist's eye is never "innocent." If there is an absolute originality in Gauguin, it lies in his color, for which no amount of reproduction prepares you. It is saturated, infinitely subtle, full of stately assonances and risky contrasts; its range of emotional suggestion is large, from the dusky peaches and ochers of *Woman with a Fan*, 1902, to the slightly poisonous grandeur with which the yellow cushion intrudes among the dark creamy browns and blues of *Nevermore*. "I wished to suggest by means of a simple nude," Gauguin wrote to a friend about this painting, "a certain long-lost barbaric luxury. It is completely drowned in colors which are deliberately somber and sad; it is neither silk, nor velvet, nor muslin, nor gold that creates this luxury, but simply the material made rich by the artist." Colored mud, transcending itself. One may wonder if any painter in the last century put more meaning into his sense of color than Gauguin; and while one is under the spell of this show, it seems quite certain that none except van Gogh and Cézanne did.

Time, 1988

IV / Europeans

René Magritte

The large show of works by René Magritte—paintings, drawings and miscellaneous objects—that opened last month at the Centre Pompidou in Paris has been jammed with visitors ever since. It deserves its popularity: Magritte's strange paintings may have become exceedingly familiar to us (who does not know his image of the pubic face, *The Rape,* or the train rushing silently from the fireplace in the Tate Gallery?), but they are still the best way into the territory of the free mind that Surrealism called its own and named *le merveilleux.*

Magritte died in 1967, aged sixty-eight, but his work continues to appeal to its modern audience rather as the sultans of Victorian academic painting, the Friths and Poynters and Alma-Tademas, served theirs a century ago—as storytellers. Modern art was well supplied with myth-makers, from Picasso to Barnett Newman. But it had few masters of the narrative impulse, and Magritte, a stocky, taciturn Belgian, was its chief fabulist. His images were stories first, formal paintings second, but the stories were not narratives in the Victorian manner, or slices of life, or tableaux of history. They were snapshots of the impossible, rendered in the dullest and most literal way, vignettes of language and reality locked in mutual cancellation. As a master of puzzle painting Magritte had no equal and, although his influence on the formation of images (and how people decode them) has been wide, he has had no real successors.

The proper homage to his life and presence, as well as to his art, was the double-take. In the midst of a movement, Surrealism, which specialized in attention-getting stunts, political embroilments, sexual scandals and fervid half-religious crises, Magritte—next to Max Ernst and Salvador

Dalí, the best Surrealist painter—seemed to be all phlegm and stolidity. He lived in Brussels not Paris; he stayed married to the same woman, Georgette Berger, all his life; by the standards of Surrealist bohemia and Surrealist chic, he might as well have been a grocer.

It was curious that he had so little natural fluency or relish as an artist. Magritte's paintings from the early 1920s are painfully bad, illustrational Cubism—as awkward, in their way, as the Cubist exercises of another great ideas man of modernism, Marcel Duchamp. He had a poor sense of color and his drawing was mere tracing. The paint surface is as dead as an old fingernail. The low point of his career came in the 1940s, when he decided, in a mood of perversity, to abandon the precision he had cultivated with such effort and do "modern art"—pictures full of impressionist fuzz and expressionist slather. These woolly confections are, if anything, less digestible than Giorgio de Chirico's late "classical" paintings, and one doubts that even the growing sense of postmodernist revisionism will be able to rehabilitate them. If anything, they showed how far Magritte's real gifts lay from the orthodox processes of modernism. Nor did his first exercises in the Surrealist manner, done in 1925–26, indicate much about the artist to come; they are mostly grab bags of motifs from Ernst and de Chirico. A painting like *The Magician's Accomplices*, 1926, with its weak drawing and fumbled tones, is not the work of a "natural" talent. An idea is there but the hand does not yet know what to do with it.

Magritte's turning point was 1927, when he went to live in Paris. There, immersed in the Surrealist movement, he was no longer a provincial spectator. And he quickly realized where his contribution to it might lie: not in the exploitation of chance and random effects, as with Masson or Ernst, still less in exoticism and neurosis, as with Dalí, but in hallucinatory ordinariness. One of the obsessions of Surrealism was the way inexplicable events intruded into everyday life. With his dry, matter-of-fact technique, Magritte painted things so ordinary that they might have come from a phrase book: an apple, a comb, a derby hat, a cloud, a bird cage, a street of prim suburban houses, a businessman in a dark topcoat, a stolid nude. There was not much in this repertoire of images, taken one by one, that an average Belgian clerk might not have seen in the course of an average day in 1935. But Magritte's combinations were another thing entirely. His poetry was inconceivable without the banality it worked on and worked through: it subverted ordinary naming.

The glass in *The Heartstring*, 1960, is an ordinary glass, the cloud reposing in it an ordinary cloud; it is their encounter, in that blue, patiently rendered limpidity, that is so arresting. Magritte's best images seem

to have more to do with reporting than with fantasy, thanks to the commonplaceness of their ingredients. Would *The Human Condition,* one of his half-dozen most famous images—the painting shows an open window with an easel in front of it; the canvas on the easel bears a picture of the view through the window, and this picture exactly overlaps the view, so that the play between "image" and "reality" inside the fiction of Magritte's image asserts that the real world is merely a construction of mind—be any more jarring if its locale were exotic? Of course not; such paradoxes depend on the context of real life. This context included common media imagery as well; Magritte found rich sources in silent movies (the popular Fantômas series, whose athletic, mysterious hero anticipated American figures like Batman, was a great favorite of his), in pantomime, in waxwork displays at the Musée Grevin.

Magritte produced some of the most disturbing images of alienation and fear in the canon of modern art. There is no more chilling icon of the frustration of sexual communion than *The Lovers,* 1928, with two anonymous heads kissing through their gray cloth integuments. Nor are there many paintings that sum up the pathos of fetishism—the substitution of a symbolic part for the desired whole—more acutely than *In Memoriam Mack Sennett,* 1936, in which a woman's negligee, hanging on its own in the closet, has developed a forlornly luminous pair of breasts. And for panic, one need go no further than Magritte's *Hunters at the Night's Edge,* 1928, with its two stocky, armed and booted chasseurs writhing in apprehension at the sight of an empty horizon. We see their fear but, inexplicably, not what they are afraid of.

If Magritte's art had confined itself to administering shocks, it would have been as short-lived as other Surrealist ephemera. His concerns lay deeper. They were with language itself, the way that meanings are conveyed or frustrated by symbols. The manifesto of this was his famous painting of a pipe, inscribed: *"Ceci n'est pas une pipe"* ("This is not a pipe"). Just so: it is a painting, a work of art, a sign that denotes an object, but not the object itself. No painter had ever put this fundamental fact about art and its operations so clearly before. When Magritte, in *The Use of the Word,* 1928, labeled two virtually identical and amorphous blobs of paint "Mirror" and "Woman's Body," he was not making a joke about narcissism; he was showing the extreme tenuousness of the grip that language sometimes has on what it purports to describe. This sense of slippage between word and thing was one of the sources of modernist disquiet. In finding image after image for it, Magritte became one of the artists whose work is necessary to an understanding of modernist culture.

His visual booby traps set themselves and they go off, over and over again—"Gotcha!" we hear him whisper—because their trigger is thought itself.

Time, 1979

Vasily Kandinsky

The Russian artist Vasily Kandinsky (1866–1944) casts a long shadow over modern art. His career took him to most of its centers: Munich before World War I, Russia, next a long sojourn at the Bauhaus in Germany during the 1920s, then a last expatriation to Paris after the rise of Hitler. If ever a painter carried his culture in one portable labyrinth on his back, as if he were a rambling snail, it was Kandinsky. And while he did not invent abstract art on his own (as he and his admirers were given to claim), he certainly did more to promote the notion of ideal abstraction, in those distant years before World War I, than any other European artist.

Such a life, woven through so many cultural milieus, is not easily condensed into one retrospective show. The Guggenheim Museum in New York has set out to describe it in three parts, the first of which, "Kandinsky in Munich: 1896–1914," is now on view. It is focused, not exclusively on the text of Kandinsky's own paintings, but on their context as well. What did he see in Munich? What did he get from other artists' work? The exhibition, curated by Peg Weiss, is therefore largely about the Jugendstil, or "youth style"—the Art Nouveau porridge of medievalism, forest fantasies, greenery-yallery decor and arts-and-crafts utilitarianism that was cooking in the Munich studios when Kandinsky made his late start as a thirty-year-old art student there in 1896.

Later exhibitions will deal with Kandinsky at the Bauhaus and in Paris. By 1985, presumably, the Guggenheim Museum will have fulfilled its destiny as the St. Peter's of Kandinsky studies. That is fitting enough, since the museum is (so to speak) built over the ruins of a shrine that housed his cult in the 1940s. This was the Museum of Non-Objective Painting, set up and run by Baroness Hilla Rebay, who—in her dottily hierophantic devotion to the Great Artist, not to mention her Nazi sympa-

thies, which accorded strangely with her position as the mistress of Solomon Guggenheim, one of America's most eminent Jews—was for a time the Winifred Wagner of the New York art world. The Museum of Non-Objective Painting, complete with piped-in organ music, was devoted to the baroness's idea that Kandinsky was the Messiah, sent to save all culture, with Paul Klee as his attendant apostle.

The idea that such a transcendent being might eventually have to get along with the work of other artists would have been anathema to the baroness, but her collection became the core of the Guggenheim Museum. Meanwhile, the blazing torch of devotion has turned into a curatorial flashlight, poking abruptly here and there amid the somewhat musty recesses of the Jugendstil. Such are the sorrows of no longer believing that art and religion are the same thing.

To Kandinsky, of course, they were. His life's work was based on the belief that art, like religion, must disclose a new order of experience; both could describe exalted states and epiphanies of the *Geist,* the spirit. Anything less than that was not worth having. Being a Russian, Kandinsky had been formed by the tradition of the religious icon. But he was also a Theosophist, an ardent follower of one of the most influential spiritualist teachers of the day, Madame Blavatsky. The cultural centers of Europe, including Munich, were as full of parareligious cults then as California is now. It was Madame Blavatsky's opinion that before long the material world would vanish, leaving behind its "essence," a world of spirit. Elect souls, the survivors of this benign burnout, would communicate with one another in an immaterial manner whose proper art was abstract and ideal, composed of "thought forms."

Kandinsky spent his whole life believing this blither, waiting for the Theosophical heaven-on-earth and trying to work out its art language, in which colors would have the semantic exactness of words, and sounds the precision of things. The prospect of its imminent arrival was one of his favorite subjects as a painter: thus a pioneering near-abstract work such as *Small Pleasures,* 1913, is actually about the apocalyptic disappearance of the material world, the vanishing of the "mere" delights of body and landscape. As this show repeatedly makes clear, the fantasy of evolution from matter into spirit was shared by other Munich artists before 1914, most strikingly by Hermann Obrist, whose unbuilt project for a monument—figures ascending a spiral, hauled up on top by a winged angel—predicted the great unbuilt monument of the twentieth century, Tatlin's iron tower for the Third International in Russia.

But Kandinsky pressed all this to extremes, and such was the dog-

matic rigidity of his character that he managed to live through some of the worst catastrophes of European history without doubting the Theosophical fairy tale for a moment. No doubt he saw the wars and coups and mass murders of his age as signs that he was right after all—as preludes to the end of history itself, the Millennium. What distinguished him from other mystagogic nuts, however, was his talent as an artist. On the evidence of this show, he was far and away the most gifted painter of his generation in prewar Munich. Even his student drawings of the nude have a wiry and controlled strength in their ink-brushed line. Others might, and did, imitate Monet, or Beardsley, or Seurat, or the bright, flat patterns of "primitive" Austrian folk art; only Kandinsky could bring such diverse strands successfully together in the mysterious speckling and blooming of color over flat decorative shapes that light up a painting such as *Riding Couple*, 1907.

Perhaps the most striking early examples of Kandinsky's power of assimilation were the paintings he did at Murnau in 1909—his jumping-off point into abstraction. In *Landscape near Murnau with Locomotive*, the ballooning shapes of cloud and hill and tree, with the train pulling its scarf of smoke along the valley, are still recognizable, as is their debt to the Fauvist paintings of Matisse and Derain. Color is just on the point of unhitching itself from description, but the world is still ebulliently there. One touch the wrong way, and we would be in Austrian toyland, but Kandinsky had too much taste to allow his fictions of innocence to turn into kitsch.

It is the exalted and often rather confused polemical severity of the later, abstract paintings that a modern eye has difficulty with. For abstraction did not, in the end, become the universal system Kandinsky believed it would. The Guggenheim's future Kandinsky shows will no doubt have much to say about why, from the eyeline of the 1980s, abstract art did not fulfill the hopes its founders had for it three generations ago.

Time, 1982

Giorgio de Chirico

The case of Giorgio de Chirico is one of the most curious in art history. An Italian, born in 1888 and raised partly in Greece—where his father, an engineer, planned and built railroads—he led a productive life, almost

Picassoan in length; he died in 1978. He had studied in Munich, and in his early twenties, under the spell of the Symbolist painter Arnold Böcklin, he began to produce a series of strange, oneiric cityscapes. When they were seen in Paris after 1911, they were ecstatically hailed by painters and poets from Picasso to Paul Éluard; before long de Chirico became one of the heroes of Surrealism.

This phase of his work—the so-called *pittura metafisica*—lasted until about 1918. Thereafter, de Chirico changed. He wanted to become, and almost succeeded in becoming, a classicist. He imagined himself to be the heir of Titian. Rejected by the French avant-garde, he struck back with disputatious critiques of modernist degeneracy; for the next sixty years of his life, he remained an obdurate though not very skillful academic painter. He even took to signing his work *"Pictor Optimus"* ("the best painter"). The sheer scale of his failure—if that is the word for it—is almost as fascinating as the brilliance of his early talent. Naturally, a great deal of both has been hidden by the polemical dust, and last week New York's Museum of Modern Art unveiled its effort to stabilize and make sense of de Chirico's reputation with a show organized by William Rubin, the museum's director of painting and sculpture.

For the past seventy years, de Chirico's city has been one of the capitals of the modernist imagination. It is a fantasy town, a state of mind, signifying alienation, dreaming and loss. Its elements are so well known by now that they fall into place as soon as they are named, like jigsaw pieces worn by being assembled over and over again: the arcades, the tower, the piazza, the shadows, the statue, the train, the mannequin.

Many of its traits are drawn from real places in which de Chirico lived. Volos, the Greek town where he grew up, was bisected by a railway, and the glimpse of a train among the houses—which look so strange in de Chirico's paintings—must have been a fact of his childhood memory. But the richest sources of imagery were Turin, which de Chirico visited briefly as a young man, and Ferrara, where he lived from 1915 to 1918. Turin's towers, including the eccentric nineteenth-century Mole Antonelliana, regularly appear in his paintings. Another favorite site there, piazza Vittorio Veneto, is surrounded on three sides by plain, deep-shadowed arcades; these serried slots of darkness are the recurrent motif of de Chirico's cityscapes. He may have grasped their poetic opportunities through looking at Böcklin's paintings of Italian arcades, but no painter ever made an architectural feature more his own.

That de Chirico was a poet, and a great one, is not in dispute. He could condense voluminous feeling through metaphor and association. One can try to dissect these magical nodes of experience, yet not find what

makes them cohere. In *The Joy of Return*, 1915, de Chirico's train has once more entered the city; its black silhouette is plumb in the center of the looming gray façades; a bright ball of vapor hovers directly above its smokestack. Perhaps it comes from the train and is near us. Or possibly it is a cloud on the horizon, lit by the sun that never penetrates the buildings, in the last electric blue silence of dusk. It contracts the near and the far, enchanting one's sense of space. Early de Chiricos are full of such effects. *Et quid amabo nisi quod aenigma est?* ("What shall I love if not the enigma?")—this question, inscribed by the young artist on his self-portrait in 1911, is their subtext.

Morbid, introspective and peevish, de Chirico belonged to the company of the convalescents: Cavafy, Leopardi, Proust. The city was his sanatorium, and as a fabricator of images that spoke of frustration, tension and ritualized memory, he had no equal. No wonder the Surrealists adored his early work and adopted its strategies wholesale. The "illusionist" painters among them. Dalí, Ernst, Tanguy and Magritte all came out of early de Chirico, and in the 1920s George Grosz and other German painters used de Chirican motifs to express their vision of an estranged urban world.

But to treat de Chirico solely as a dream merchant, precursor of Surrealism, does his early work some injustice. The show's argument is that he survives as a painter within a specifically modernist framework, whose values and standards were generated in the thirty years before 1914 in Paris. That was "the city par excellence of art and the intellect," as de Chirico wrote, where "any man worthy of the name of artist must exact the recognition of his merit." Paris took young de Chirico, as it took young Chagall, and turned him from a naive provincial fabulist into a major painter. His "metaphysical" constructions, such as *The Jewish Angel*, 1916, certainly influenced Max Ernst. Just as certainly, they came out of the Cubist sculpture de Chirico saw all over Paris studios after 1912.

De Chirico is often said to have used Renaissance space in his pictures, but as Rubin points out, this is a myth. De Chirican perspective was not meant to set the viewer in a secure, measurable space. It was a means of distorting the view and disquieting the eye. Instead of one vanishing point in his architectonic masterpiece, *The Melancholy of Departure*, 1914, there are six, none "correct." This cloning of viewpoints acts in a way analogous to Cubism. It jams the sense of illusionary depth and delivers the surface to the rule of the flat shape, which was the quintessential modernist strategy. In color, in tonal structure and in its contradictory lighting, Rubin argues, de Chirico's style up to 1918 "was as alien to its

supposed classical, fifteenth-century models as it was dependent on the Parisian painting of its own moment."

This view of de Chirico as formalist fits the evidence and rids the artist of a great deal of accumulated "poetic" waffle. It also helps one distinguish, in a way that makes sense, between de Chirico's real achievements and the long slide into mediocrity after 1918. Authentic pre-1918 de Chiricos are few, and most of them are on the Museum of Modern Art's walls. On the other hand, copies and "later" versions—a euphemism for self-forgeries—are everywhere. (One of them, from the Cleveland Museum of Art, dubiously identified as a 1917 *Metaphysical Interior,* has crept into the show and should creep out.) Italian art dealers used to say the Maestro's bed was six feet off the ground, to hold all the "early work" he kept "discovering" beneath it. In a spirit of pardonable malice, Rubin reprints in the catalogue eighteen versions of *The Disquieting Muses,* 1917, all done between 1945 and 1962. Many of these facsimiles, backdated, were sold as original *pittura metafisica.*

What made him do it? In part, revenge; if modernist critics and the collectors they influenced were going to make capital from his youth while insulting his maturity, then let them eat fake. Why should he not profit from the fact that early de Chiricos fetched ten or twenty times the price of late ones? He believed he got better as he got older. He would have had to be a saint of humility not to think so. The worst insult you can offer an artist is to tell him how good he used to be. No wonder de Chirico rejected everything that was written about his early work and refused to agree that it had any fundamental connection with modernism. Only thus could he rationalize his belief that he was the same artist after 1918 as before: the difference between him and other members of that stupendous generation of the 1880s was that he alone had stepped out into the light of classicism, leaving Picasso and the rest behind in their "primitive" darkness and willful modernist regression.

A constant theme of de Chirico's early work is the loss of his father, the railroad engineer commemorated in those white statues, phallic smokestacks, cannons, towers and trains. Perhaps he consoled himself by embracing the most paternal of all styles—the ultimate authority of Greco-Roman archaeology as transmitted by the Renaissance, a classicism one could approach only from outside. Waking this sleeping father became another obsessive project: after 1920 de Chirico is always quoting classical models, allegories, iconographies. The one thing he could not do was paint with the measure and certainty appropriate to classical art. He could invoke, but never convincingly evoke, that great still frame of

agreement. Consequently his paintings after 1920 teeter on the edge of an absurd defensiveness; they mean less than they seem to. They are not about nostalgia, as the early work was. They are nostalgic, and flatly so.

Today, determined efforts are being made—though not by the Museum of Modern Art—to rehabilitate late de Chirico. Dealers need product, of course, but there is more to it than that. De Chirico's queer, starved relationship to the classical past closely resembles the way many young painters now look back on the prime energies of modern art; his "postclassicism," unconsciously camp, is uncle to the pastiches of "postmodernism." Of course, that does not make the late paintings much more interesting; they are still not bad enough to look good. The Pictor Optimus could only stump about like a man at a masquerade, tangled in the mantle of Titian. The de Chirico this show gives back to us was so much less encumbered, so precise and knowing in his hard-won awkwardness.

Time, 1982

Julio Gonzalez

"The age of iron began many centuries ago," declared the Catalan sculptor Julio Gonzalez in the 1930s. "It is high time that this metal cease to be a murderer and the simple instrument of an overly mechanical science. Today the door is opened wide for this material to be—at last!—forged and hammered by the peaceful hands of artists." Prophetic words, and it was largely Gonzalez's own work that made them true. The great shift in sculptural history during this century, away from "closed" (solid) to "open" (constructed) form, became possible through the use of iron. Gonzalez's work, in particular his collaboration with Pablo Picasso more than half a century ago, was the clue to this shift. Without Gonzalez the story of modern sculpture would be wholly different, perhaps unrecognizable.

There has not been a proper retrospective exhibition of his work in either Europe or America since 1956. If not a forgotten man of sculpture, Gonzalez (1876–1942) is certainly a much-misunderstood one. But last month a show of almost three hundred of his sculptures, paintings and

drawings went on view at New York City's Guggenheim Museum. Organized by Margit Rowell, it shows us Gonzalez whole for the first time in more than a generation.

The surprising thing is that Gonzalez did not take up a full-time career in sculpture until he was past fifty. He was trained as a decorative-metal worker. Iron is everywhere in Barcelona, foaming along the balconies, standing out in rigid black swags and spikes from the corners of nineteenth-century buildings, lacing itself into intricate grilles and diapers and *chevaux-de-frise:* it is the bronze of Spain. The Gonzalez family had been forging it for at least three generations. Julio worked in the family firm; he went to art school and learned to draw, but at root he was thought of as a *forjador* and not a "fine" artist.

The Guggenheim show contains a fair sampling of his early metal-work: boxes and buckles, necklaces and rings, all made with perfect competence and a brisk sense of design, none of them markedly different from or technically better than the general run of high-quality craft metalwork that came out of Barcelona in the years of *modernisme,* as Catalans call Art Nouveau. After 1900, when Gonzalez moved to Paris, he and his sisters made a living by selling such things in a boutique. What with his metal ornaments and their laces and embroideries, the Gonzalez clan in Paris was closer to the fashion industry than to the centers of the art world. Gonzalez painted, mostly awkward imitations of Puvis de Chavannes. He drew, with ability. He turned his metalworker's hand to making hammered copper masks. This went on through the teens and twenties. In short, Gonzalez took longer to peck his way out of the egg than any modern artist of comparable stature, and what cracked the shell and released him was his relationship to a fellow Spaniard in Paris, Picasso.

Picasso had been working in sheet metal since 1912, the year he snipped and folded a piece of that material into a Cubist origami guitar, thus producing what was probably the first constructed (as distinct from modeled or carved) sculpture in the history of art. But he was not a skilled metalworker. He had never troubled to learn welding, forging or soldering. He therefore turned to Gonzalez for help, as other sculptors, such as the Spaniard Pablo Gargallo (1881–1933), had already done. Between 1928 and 1931, Gonzalez helped Picasso construct six sculptures of wire, rod and sheet metal. Gonzalez humbly asked Picasso for permission to "work in the same manner as himself," which, as Rowell points out, meant three things: using scrap metal as a medium in its own right; putting sculptures together like iron collages of existing parts; and translating "conventional subject matter [a nude, a face, a harlequin] into expressive ciphers or

signs." Apparently, Picasso was flattered to agree. For the next decade, until his death, Gonzalez went on to create a body of terse, harsh work that would inspire most iron sculpture to come.

There is no doubt that Picasso was the inventor of planar and then linear iron sculpture in the twentieth century. But through Gonzalez, this fundamental addition to the sculptor's repertory was given a syntax. The friction of Picasso's urgency made Gonzalez forget the need for "finish" in metalwork and thus endowed his iron sculptures in the 1930s with an extraordinary rawness, directness, vitality and self-sufficiency.

Gonzalez did not leap into abstraction, and at first his sculpture was permeated with Cubist devices acquired from Picasso. *Harlequin, Pierrot,* 1930–31, makes no attempt to conceal its borrowings from Picasso: the grille of lozenges quoting a harlequin's costume, the whimsical shield-mask of a face. Gradually these images were stripped and pared and stripped again. Inside the maker of Art Nouveau necklaces, a master of formal reduction was signaling to be let out. By the mid-1930s Gonzalez had gotten his sign for a human figure down to a mere gesture of forged bar-iron, surmounted by a spiky quiff of metal hair; a metal plate with two cuts and a couple of bends would both evoke a face and suggest a "primitive" African mask.

If his work touched Constructivism at one end, it encountered Surrealism at the other in its liking for metamorphosis. *Dancer,* circa 1935, belongs to the Surrealist vein of hallucinatory insect life—praying mantises, grasshoppers and the like—and its springing rods and vanes achieve a taut, predatory balance between grace and threat.

Yet although Gonzalez could invest his abstract use of iron with the deepest and most complex layers of formal sensation, he refused to become programmatic about abstraction; if meaning required it, he could turn back to the figure—and did, in *The Montserrat,* commissioned by the Spanish Republican government in 1937 for its exhibition pavilion in Paris. *The Montserrat* is the kind of sculpture that can no longer convincingly be done, or so it seems: images of the Enduring Peasant, sickle in one hand and baby on shoulder, are apt to look very condescending and nostalgic today. But to Gonzalez, a Catalan living half a century ago, this was a natural figure from experience. He was able to invest its stance—legs planted like olive trunks, lifted face scanning the sky—with an archaic alertness; *The Montserrat* also derives some of its meaning from the same history that provoked Picasso's *Guernica.* (The sickle is a weapon against Franco, an emblem of Communism, not just an agricultural tool.)

But what carries the image is Gonzalez's unerring sense of sculptural

form: the massive rotundities of the skirt and the baby's hood, the way the literal folding of the hammered sheet iron parallels the folds of the cloth it depicts, the difficult rendering of nuances in a stiff, intractable substance. That Gonzalez should have moved between this and abstraction is not proof of his indecisiveness. Rather, it shows what protean abilities lay beneath his work, when feeling was strong enough to roll back even the data of his own style.

Time, 1983

Max Beckmann

One thinks of Max Beckmann, whose centennial retrospective began in Munich in 1984 and is now at the Los Angeles County Museum of Art, as quintessentially "German." Yet his art had the same relationship (or lack of one) to German Expressionism as Édouard Manet's did to French Impressionism.

Beckmann was not interested in the transcendental ambitions of Expressionism—its yearnings for a higher world and bleatings about this lower one, its way of ducking into the "mystical" and the "primitive" as an escape from the politics of immediate experience. To him, as to the Dadaists in Berlin, this was for airheads. "My heart beats more for a raw, average vulgar art," he noted in one of his copious journals, "which doesn't live between sleepy fairy-tale moods and poetry but rather concedes a direct entrance to the fearful, commonplace, splendid and the average grotesque banality in life."

This was in 1909, when the young Leipzig painter was just a month shy of twenty-five. He was not far from such ambitious images of modern catastrophe as *The Sinking of the Titanic,* 1912. This enormous, early painting, nine by eleven feet, is a "journalistic" homage to Géricault's *Raft of the Medusa,* but the scores of figures dumbly raging for survival in the cold green water have nothing classical about them. Already one sees some of the main traits of mature Beckmann breaking through: especially the sense of packed humanity in tight spaces that somehow betoken worse things beyond their walls; the tilted, frontal picture plane; the voids that jostle as emphatically as the solids.

Beckmann aimed to be a psychological realist in a bad age: the Courbet of the cannibals. His work crystallized in the face of two major subjects, World War I (in which he served the German army as a volunteer medical orderly, until the unremitting chaos and death of trench fighting drove him into mental collapse in 1915) and the city. He was not the first artist to discover how the imminence of death can free the imagination, but he was utterly frank about it. "Since I have been under fire, I live through every shot again and have the wildest visions," he noted, having confessed the secret of how beautiful war can seem in the stops between its terrors: "The circular trembling aperture of the French and Belgian searchlights, like a transcendental airplane . . . the amazing apocalyptic sound of the giant cannon . . . a rider at full gallop in the dark . . . Poor pig that I am, I can live only in dreams." War went beyond art and burned out his fantasies. What it left behind was a hard, copious ash of realism, and an unassuageable will to describe what it was to be not just a German but a European, an inhabitant of the Berlin–Naples–Paris triangle. "Beckmann has been made ill," he sardonically remarked in 1924, "by his indestructible preference for the defective invention called Life."

Life precipitated in the city, the locus of modernism. His own cities were Leipzig, Frankfurt, Berlin, Paris and Florence up to the coming of Hitler; Paris and Amsterdam during World War II; and refuge, after it, in St. Louis and New York, where he died in 1950. But they tend to merge in his work into a single place. This city was the great human switchboard, the cruncher of experience, where people were forced together and the distances between them grew. It stood for oppression, strain, careful poses and unmediated confessions—above all, for the kind of blurting psychic truth under pressure that no villager could know.

It was also hell. In order to paint it, Beckmann developed a repertory of figures that seem literally imprisoned by the limits of the canvas. The sense of dislocation and implacable graphic firmness this involved, in works such as *The Dream*, 1921, were surpassed by no other artist. The amputee on a ladder with the fish slung around his neck, the war veteran blowing his tin trumpet, the catatonic blonde girl—in their density and strangeness, they seem like quotations from some permanent layer of German consciousness. All the more so because Beckmann thought very hard about his own cultural heritage. His figures, with their polelike limbs and mouths like gashes, their awkward eloquence of gesture (long on pathos and aggression, short on grace), step right out of late-medieval German sculpture, and so do the claustrophobic spaces they inhabit— shallow, pleated, shoving and butting against the four edges of the canvas.

The "naive" determination of fifteenth-century carvers to get a deep room and a whole Last Supper out of a slab of limewood not much thicker than a plank—with the result that everything stands up and out, as if in fright—was transferred to Beckmann's argument with the flat canvas. Even the gestures are religious. Thus the showing of outstretched palms, Beckmann's favorite sign for pathos and surrender, comes from the traditional figure of Christ as the Man of Sorrows, displaying his wounds.

Beckmann's imagery veered between the explicit and the hermetic. Usually both inhabit the same picture. As a symbolist he was heir to Gauguin, Ensor and de Chirico. Yet his cast of personages was far wider than the Frenchman's, his range of expression more sweeping than the Belgian's, and his mode of presentation less mannered and neurasthenic, denser in feeling, than the Italian's. But traits of all three are poured and crammed into the same Beckmann—Gauguin's liking for the portentous allegory, Ensor's vision of personality as a raw, lurid mask, de Chirico's urban claustrophobia.

Even the most straightforward Beckmanns, such as *Self-Portrait in Tuxedo*, 1927, retain a certain inaccessibility at their core; here the figure of the painter in the black-and-white court dress of the twentieth century glares at the viewer as intruder. Was Beckmann only celebrating the success of his early middle age by putting himself in black tie? Or was he citing, in paint, the sentiment he had already written down a few months before—"The worker should appear in tuxedo. . . . This should mean: We want a kind of aristocratic Bolshevism." If paintings as explicit as this present such problems of reading, his more allegorical ones (especially the late triptychs) can be as inscrutable as Hieronymus Bosch. What is one to make of these clowns and fish and blind Oedipuses, caged women and mutilated statues, tarty cigarette girls and Greek headsmen?

There is little question that Beckmann's *Temptation*, also known as *The Temptation of St. Anthony*, 1936–37, is, in plastic density and dark, hallucinatory power of feeling, one of the masterpieces of the twentieth century. Like Picasso jamming a Mithraic bull, newsprint and electricity together in *Guernica*, Beckmann collapses the new and the archaic on top of each other. The blonde she-warrior in the silvery green cuirass in the left panel (perhaps an image of Athena) is counterbalanced on the right by the invention, more edgily perverse and up to the minute than anything in Bertolt Brecht's *Mahagonny*, of a mean-looking page boy from the Hotel Kempinski in Berlin briskly delivering a golden crown on a salver while he leads a half-naked woman, bridled and crawling on all fours. The work is more about the problems of the artist than those of the

legendary saint; in fact, the Anthony is a painter fettered at his easel, passively adoring his model—who, by this reversal of the usual artist-model relationship, becomes a corpulent dominatrix.

The bare bone of Beckmann's message is that fame, money and the love of women are not all they are said to be, but the strange, staid-looking conviction with which Beckmann invests his personages carries his painting beyond moralizing to something like magical invocation, a raising of the worst noonday ghosts of the thirties. He was certainly one of the great fabulists of modern art. But unlike the Surrealists, he was not content with the effort to tap into a collective unconscious through the littered cellar of the individual self. And unlike lesser but more popular artists such as Marc Chagall, he did not permit himself a moment's slump into nostalgia. Always on the move, the exile with one packed bag under the bed, gazing at a future that was bound to be worse than the past, he retained an uncanny ability to go through his fears and find history on the other side of them. Beckmann's art was poised, so to speak, between the sleepwalk and the goose step; on its rigorous and masculine frame are nailed the private splendors and public horrors of the first half of the twentieth century.

Time, 1985

Henri Matisse in Nice

"The grand object of travelling," said Samuel Johnson, "is to see the shores of the Mediterranean." The maxim had a special force among artists from the early 1900s to the eve of World War II. It applied to the Côte d'Azur, that strip of Provence that runs from Nice to Hyères. If ever a shore was changed from a place to an idea by the efforts of painters, this one was it. Paul Cézanne, a Provençal rooted in the limestone and red clay of his native Aix, had made backcountry Provence around Mont Ste.-Victoire one of the themes of the modernist imagination. Pablo Picasso, Henri Matisse and Pierre Bonnard would do the same for the coast.

The image of the paradisiacal Mediterranean that still haunts our imagination—despite its present-day reality of gridlocked campers frying

in the sun at the tepid edge of a half-dead sea—was created by these painters and their followers. Their relations with this place, or more properly their invention of it, gave modernism its one practical utopia of the senses, a bourgeois Eden whose roots wound back through a coastal peasant culture (still unhurt by tourism in the 1920s) to the Greco-Roman past. Instead of the pie in the sky offered by Constructivism, they contemplated the langoustes on the table, bringing their sensuous embodiment to a pitch of imaginative precision in which mere fantasy had no role.

The maestro of this process was Matisse. He was a mature painter of forty-eight when he started his first working sojourn in Nice after 1916. Just as Gauguin had carried his style preformed with him to Tahiti, so Matisse took his to the Côte d'Azur. One would logically expect that with the tremendous efforts of abstraction and integration that had gone into his work from his Fauvist paintings of 1905–06 to *The Moroccans* of 1916, nothing he did thereafter would seem trivial to art historians. Yet such was not the case. Most accounts of Matisse's life treat his first fifteen years on the Mediterranean (however much the public liked the results) as a slackening, almost a betrayal of his talent; he would not entirely recover, this version insists, until he began a new phase of abstraction in the early 1930s, one that would culminate fifteen years later with the pure color silhouettes of his paper cutouts. Museums, up to now, have not shown us much of Matisse the Niçois. Of the gaps in our experience of any twentieth-century artist, this was surely one of the biggest.

Now the National Gallery of Art in Washington, D.C., has filled it with a show of 171 paintings done by Matisse in his early Nice years, assembled by Jack Cowart and Dominique Fourcade. It should dispel any lingering suspicion that between 1916 and 1930 even average Matisses got as complacent as most Renoirs. Indeed, some of Matisse's greatest work was done in those years. Why was this acknowledged so grudgingly, or not at all? For "ideological reasons," cocurator Fourcade argues, springing from a "modernist obsession" with Matisse's largely posthumous role as prophet of Paris–New York abstraction. If you assume that art history culminates in abstract art, then you may feel betrayed if your hero's work goes from flatness to depth, from a space built from blocks of color to one evoked by the illusion of light, from schematic drawing to fuller modeling.

Matisse, though, made no such assumptions. He was not an abstract artist but a painter of bodies and spaces. The specific did not just "interest" him; it was close to an obsession, for all the apparent generalizations of his style. Even in paintings of calm and predictable subjects, for example *The Black Table*, 1919, which shows a girl seated by a vase of flowers, one

sees his hand evoking the most difficult conjunctions of sight and imagination—in the way the transparent Turkish blouse is rendered by a few strokes of white over the flesh, for instance, or in the sliding knot of green and black shapes that defines the leg of the armchair. When Matisse saw the glitter of light on a band of water, he wanted to get it right, along with the curlicues of wrought iron between his eye and the Baie des Anges, and the Moorish dome of a pier pavilion, and the curl of a dressing mirror frame, and the flat black cover of a notebook on the vanity, and the way a scrim curtain hung and stirred in the faint breeze—and all the rest.

Scanning Matisse's rooms is like reading a reticent autobiography, written before the days when authors were expected to spill all the beans. The calm they radiate is not an expression of complacency but a ploy against anxiety. Nice enabled Matisse to stabilize things, to remain in the same frame of mind for days on end. "After a half-century of hard work and reflection the wall is still there," he wrote to a friend. "Nature—or rather, my nature—remains mysterious. Meanwhile I believe I have put a little order in my chaos. . . . I am not intelligent." Of course, Matisse painted his share of perfunctory images in Nice. But the overwhelming impression is of struggle and synthesis, of a mature artist who, having achieved a monumental diction before 1916, set out to reinvest it with immediate impressions before it congealed.

His instrument for this was color, betokening light. Nice gave him a different light from that in Paris—a high, constant effulgence with little gray in it, flooding broadly across sea, city and hills, producing luminous shadows and clear tonal structures. It encouraged Matisse to think of space (in particular, the space of the hôtel rooms where he worked, overlooking the promenade des Anglais) as a light-filled box, full of reflections, transparencies and openings. Shutters filter the light, and their bars are echoed in the stripes of awnings or rugs; light is doubled by mirrors that break open the space of the room, and discreetly splintered in the gleam from silk, pewter or furniture.

All this is some way from the flat pre-1916 Matisses, and one of the governing impulses was the artist's desire to measure himself not only against the visual stimuli of the Côte d'Azur but against the heritage of the nineteenth century. Its masters speak both to and from his Niçois canvases. The hushed green density of *Large Landscape, Mont Alban*, 1918, is an amalgam of Courbet and Corot, although the slow, wristy drawing that drives the eye around the curve of the road and follows the slant of the windblown pines is entirely Matisse's own. The modulation of silvery grays (jug of water, belly of sole) with a few touches of red within the ambient darkness of *Still Life, Fish and Lemons*, 1921, accentuates a lesson

Matisse had learned from Manet: that black, far from signifying the absence of color, can read as a suave and powerful hue. Matisse's work, seen in this concentration, proves once more that in painting, innovation means nothing without a vital sense of the past. "I have simply wished to assert," he used to tell his students, echoing Courbet, "the reasoned and independent feeling of my own individuality within a total knowledge of tradition."

Because of, never despite, such affinities, Matisse's originality is always clear. It lay in his gift of pure color. He possessed to the nth degree the power of making a flat disk of yellow or a slice of viridian turn into a lemon or a leaf, bathed in sunlit air. Sixty years have done little to blunt the impact of the flat-out chromatic intensity of some Matisses from the 1920s, such as *Anemones in an Earthenware Vase*, 1924. The structure of the painting is as lucid as a theorem, with its pattern of rectangular hangings, panels and tabletop and the surging diagonal of the flowers in the vase, but the color—pinks, carmines, chromes, lilacs and an orange that glows like a red-hot cannonball laid casually on the table—would be disorienting if the harmony Matisse imposed on it did not persuade you that it is real.

The strain between the all-over pattern and the real motifs gives his Nice paintings their special vitality. But the strain was real, and in extreme cases, such as *Decorative Figure on an Ornamental Ground*, 1925–26, it induces an almost palpable discomfort. The sheer congestion of pattern— rococo mirror, painted wallpaper, overlapping rugs, Ming blue planter— dismays the eye while seducing it, and the architectonic forms of the nude halt the whirling of color like a massive log brusquely jammed in the gears of a machine. This is the creation not of a complacent man but of an artist at the height of his powers and willing to gamble deeply. By putting such paintings alongside others that are less well known, the National Gallery has given us, if not an entirely new Matisse, then at least a refreshed one—no mean feat, considering the amount of writing and scholarship devoted to his career in the thirty years since his death.

Time, 1986

Futurism

No city stood higher on their hit list than Venice. "We repudiate the Venice of the foreigners, market of antiquarian fakers, magnet of universal

snobbishness and stupidity. . . . We want to prepare the birth of an industrial and military Venice. Let us fill the stinking little canals with the rubble of the tottering, infected old palaces! Let us burn the gondolas, rocking chairs for idiots." Thus Filippo Tommaso Marinetti and his friends, the Futurist painters, in a manifesto from 1910. It is a delicious irony that the most important exhibition in Europe this summer should be a giant display of Futurist paintings, sculpture, books, pamphlets, posters and memorabilia in a palace, no longer tottering, on the Grand Canal. Titled "Futurismo & Futurismi" ("Futurism and Its Offshoots," more or less), the exhibition marks the opening of Palazzo Grassi as a museum, redesigned by Gae Aulenti, run by Pontus Hulten and lavishly funded by Fiat.

The show has art and a good deal else, including such totems of Futurist affection as a 1911 Blériot monoplane and a World War I SPAD hanging from the *cortile* roof, and a vintage Bugatti by the canal entrance, to remind one of Marinetti's belligerent and much-quoted dictum that "a roaring motorcar that seems to run on shrapnel is more beautiful than the Victory of Samothrace." But no exhibition has ever made a stronger case for the quality of Futurist art or gone into more detail about its roots. Futurism was the most influential art movement Italy produced in the early twentieth century. Indeed, the very word *futurist* became synonymous with modernity itself to people in America, England and Russia until around 1925. The movement took an aggressively internationalist stance, looking to a future world unified by technology. Yet its rhetoric was bedded deep in Italian life. The core of the Futurist group, which coalesced in the early 1900s, was made up of the painters Umberto Boccioni, Carlo Carrà, Giacomo Balla, Luigi Russolo and Gino Severini, the architect Antonio Sant'Elia and a few writers clustered around the figure of Marinetti, poet, dandy, ringmaster, publicist and red-hot explainer to the global village—"the caffeine of Europe," as he called himself. They were all Italian; to be Italian then was to inherit a culture dominated by the weight of the Tuscan and Roman past and by a technologically backward economy based largely on agriculture and craft.

Such weights evoke violent reactions. The Futurists set out to create the image of an Italy that did not yet exist, a utopia of tension and transformation whose god was the machine. Its architecture would not be the old cellular stone hill-town but the dream environment conjured up by Sant'Elia: all girders and concrete cliffs, with glass elevators zipping up the exterior walls. Its painting would try to encompass not just sight but noise, heat and smell; above all, it would depict movement. To fix this

industrial mode in Italian (and European) culture, the pastoral mode had to be slaughtered. "Kill the moonlight!" one Futurist manifesto exclaimed. Whatever lingered from the 1890s—Symbolism, Impressionism, the cults of nuance and nostalgia, of the Arcadian countryside or the introverted personality—was the enemy of Futurism.

Could the world be made new in this way? Of course not: art is invention, but also remembering. It is never in a real artist's interest to "abolish" the past, which is impossible anyway. Boccioni, in particular, kept paying it homage: his striding bronze figure in space alludes to the same Victory of Samothrace that Marinetti thought less beautiful than a car; the figures who scurry frantically about the two battling women in the Milan Galleria in Boccioni's *Riot at the Gallery*, 1910, look like the ghostly crowds in the background of Tintorettos. What the Futurists opposed was not so much the past itself as the mind-set they called passéism—the cult of nostalgic or obsolete cultural attitudes. Their problem was framing a pictorial language to describe rapid stimulus and movement in space on a flat, static surface. They came up with an amalgam of pointillism, Cubism and photography. Picasso and Braque had built Cubism on the scrutiny of a single object from multiple viewpoints: the table stood still, the eye moved. In Futurism, the eye is fixed and the object moves, but it is still the basic vocabulary of Cubism—fragmented and overlapping planes—that tells us so. Carrà, Boccioni and, above all, Balla prized the photographs of sequential movement taken by Eadweard Muybridge and Étienne-Jules Marey. Some of Balla's own paintings, such as the famous *Dynamism of a Dog on a Leash*, 1912, are virtually straight renderings of multiple-exposure photographs. But in his series of paintings inspired by a Fiat speeding down via Veneto, the game gets more complex. Nearly all this series is assembled at Palazzo Grassi, culminating in Balla's *Abstract Speed*, 1913, one of the few large Futurist paintings that can be called a pictorial masterpiece, a thundering black Doppler-effect image in which the shapes of wheel, mudguard and driver dissolve in and out of the shuttling buildings.

To go through this show is to realize how close Futurism is to us in its cultural postures, even though its machine worship is dead. Anticipating punk-rockers, Marinetti urged nightclub singers to dye their hair green and their breasts sky blue. The worst mannerisms of late nouvelle cuisine were foreshadowed by his *cucina futurista*, with its "completely new, absurd combinations" of ingredients, its sauces of chocolate, red pepper, pistachio and eau de cologne. But above all, it is the Futurists' genius for scandal and hype that makes them seem so modern, or rather,

postmodern. As a provocateur, not as a poet, Marinetti turned himself into one of the key figures of twentieth-century culture. He was the prototype of avant-gardist promoters. For how do you create interest in something as utterly marginal to the public as new art? By turning it into fresh copy. The Futurists, unlike the Cubists, realized that the newspapers wanted to run sensational stories about weirdos, not virtuously tolerant reviews of the avant-garde. Marinetti brilliantly used this appetite by trumpeting an art movement as a broad "revolution" in living that aims to change life itself, embracing everything from architecture to athletics, politics and sex.

The Futurist word spread far and wide, taking hold especially in Russia, whose primitive state of industrialization, like Italy's, favored exalted myths of machine progress among intellectuals. The Futurist influence on the Russian avant-garde before the Bolshevik revolution was immense, and the show traces it through the works of such artists as Vladimir Tatlin, Natalia Gontcharova and Kasimir Malevich. Futurism linked up with a similar movement in England, named Vorticism by its leader, the painter-critic Wyndham Lewis. Lewis, however, was critical of Marinetti's operatic cant about war as the hygiene of civilization (unlike Marinetti, he had seen combat in the trenches) and highly skeptical about paintings that illustrated movement. His own wartime masterpiece, *A Battery Shelled*, 1919, turns whatever is mobile, even smoke, into a stiff-plated fossil of itself.

In their zeal, the curators of the Venice show have tracked Futurist cells and influences to the most unlikely haunts, even Mexico and Japan. The result is a very full show, except in one area: relations with Fascism. Here the treatment suddenly becomes quite bland. Most of the Futurists licked Mussolini's jackboots with their eloquent tongues, from the march on Rome through the end of World War II. Fascism and Futurism were not identical, but Marinetti's praise of the metallization of the human body, of speed, war and domination represented, as Walter Benjamin put it, "the consummation of art for art's sake," a rampant aestheticization of war. To say, as the catalogue does, that "Marinetti and Futurism were never supported by the Fascist regime, but merely tolerated" is to miss the point. A glance at the catalogue of the 1933 "Exhibition of the Fascist Revolution" in Rome, jammed with reproductions of Futurist-style murals, montages and sculpture in praise of the regime, would have put such sophistries in perspective: "The artists had from Il Duce a clear and precise order: to make something MODERN, full of daring." Just so. But this document is not in the show.

The centenary of Marinetti's birth was all but ignored in Italy in 1976; at that time no cultural institution wanted to touch the hot potato of Futurism and Fascism. This show fumbles it by exhaustively displaying one and scanting the other. The reason probably lies in the facts of patronage. Palazzo Grassi is Fiat's gift to Venice; Fiat built cars, trucks and aircraft for Mussolini. It was the chief corporate patron, if one may so put it, of the Futurist idea of war as ultimate artwork. Rarely has the tact of art historians about the messy history of the real world seemed more strained. That, but that alone, prevents this show from being definitive.

Time, 1986

English Art in the Twentieth Century

It would be hard to think of a more overdue subject for an exhibition than "British Art in the 20th Century," the panorama of 310 works by some seventy artists at the Royal Academy in London. Our fin de siècle is the natural time for summing up, and the subject of modern British art has never been tried in depth by an American museum. No matter what quibbles and demurrals one may have about the choice of this work or that name, no one with half an eye could spend a couple of hours in Burlington House and leave without asking why the cumulative achievements of British painters and sculptors—as distinct from the popularity of a few individuals, such as Henry Moore, Francis Bacon and David Hockney—have been so scanted by the official and mainly American annals of modernism.

Unfortunately, American views of British art tend to echo the Chinese court scribe who is said to have remarked, in a letter to George III, that his emperor was not unmindful of the "remoteness of your tiny barbarian island, cut off as it is from the world by so many wastes of sea." Modern British art, that is to say, tended toward the provincial, the marginal, the literary and the cute; it cultivated nuance and eccentricity at the expense of broader and grander pictorial concerns; it was anecdotal and too much tied to a fascination with human society—little-island art, not really comparable to the utterances of those Hectors of the prairie and

Ajaxes of the long white loft who, in New York City, were busy using up all the air in art history's room.

So why do so many of the lesser-known things in this show—the dense and acerbic paintings of Degas's friend Walter Richard Sickert; Matthew Smith's responses to Fauvism; the work of the Vorticists around 1914 (Wyndham Lewis, William Roberts, Henri Gaudier-Brzeska); that of individuals such as Stanley Spencer, David Bomberg, Jacob Epstein, Paul Nash and so on through contemporaries such as Lucian Freud, Leon Kossoff, Frank Auerbach, R. B. Kitaj, Howard Hodgkin—now strike us as not just a footnote to, but an essential part of, the visual culture of the past eighty years: neither "provincial" nor "minor," but singular and grand? What muffled this recognition? Partly, the English themselves: a nation always mingy in valuing its own artists.

The most durable form of English hostility came not from the Royal Academy, whose fogies died off, but from the enlightened purlieus of Bloomsbury, where the critic Roger Fry, who had organized the first Post-Impressionist show at the Grafton Galleries in 1910, and his truculent fugleman Clive Bell, inventor of the catch-phrase "significant form," made it just fine to despise new English art in the name of the French avant-garde. With their belief in an imperial France whose seigneurs were Cézanne, Matisse and Gaugin, Fry and Bell preferred any imitation of the École de Paris, however pallid, to anything else, however strong. They both disliked Vorticism, the remarkable English movement that combined elements of Cubism, Futurism and Dada and centered on the belligerent genius of Wyndham Lewis, painter, soldier, novelist, critic and editor of *Blast*. In 1917 Bell sneered at the "new spirit in the little backwater, called English Vorticism, which already gives signs of being as insipid as any other puddle of provincialism," and thereafter the Bloomsberries rarely missed a chance to put Lewis down.

Hence, one of the early pleasures of this show is its vindication of Lewis and his colleagues: to walk from the gallery that contains the weak pastiches of Matisse by Duncan Grant, Vanessa Bell and other Bloomsbury-approved painters into the one dedicated to Britain's avant-garde at the time of World War I is to move from cozy provincialism to formidable energy. Its monument (or perhaps, its idol) is the only large marble carving that Henri Gaudier-Brzeska was able to complete before his death in an infantry charge, at the age of twenty-three, in 1915. This is the *Hieratic Head of Ezra Pound*, 1914, and hieratic it is; the face, with its wedge of a nose, embrasurelike eyes and triangular goatee, is as powerful as a royal Assyrian portrait, possessed of an awful gravity that the outrageous phallic pun of the poet's hair fails to reduce.

The war, which evoked so little from French artists, inspired some English ones to their best work; Paul Nash's *A Night Bombardment*, 1919–20, a view of the sea of cratered mud and dead trees at the front, is both formally rigorous and filled—though not a figure appears in it—with the most intense pathos, an elegy for the pastoral mode itself. Facing a mechanized world whose origins lay in England's Industrial Revolution, Lewis argued, the English should be peculiarly fitted to make art of it: "They are the inventors of this bareness and hardness, and should be the great enemies of Romance." The pleated, diagonally stressed, armored precision of Lewis's paintings, as grand in their own way as Fernand Léger's, testifies to this—in *A Battery Shelled*, 1919, even the smoke is metal. "I look upon *Nature*, while I live in a *steel city*," exclaimed David Bomberg in 1914, and the terse machinelike signs he found for briskly moving figures in *The Mud Bath*, his early masterpiece of 1912–13, have a tonic decisiveness that is only magnified by the simple color scheme of red, white and blue.

The most unexpected things could happen in British art. A few years ago, just when people thought they had Walter Sickert pegged as a narrative-minded and garrulous Edwardian follower of Degas, they were faced with an exhibition of his extraordinary late paintings, which had largely been ignored by his admirers and appeared to contain the first "appropriations" of narrative mass-media sources by any artist: thus Sickert's huge but obviously unofficial 1936 portrait of Edward VIII stepping from a car and about to don his busby was based, like Warhol's Jackie thirty years later, on a news photograph. (No wonder that the long arm of Sickert would have such an effect on the best history painter of our time, R. B. Kitaj.) Time and again, especially between the wars, England produced artists to whose work there was no Continental parallel, and who thus came to be seen as "eccentric."

The greatest of them, Stanley Spencer, might appear to an unsympathetic eye to have the very qualities—a deep religious vision, abhorring art theory and centered on the landscape and populace of his native village of Cookham in Berkshire—that are supposed to make for parochial art. Certainly, if anyone inherited the Pre-Raphaelite mantle, it was Spencer. Yet his work was also rooted in earlier traditions of European painting; one might not immediately notice, for instance, that the watchers by the bed in *The Centurion's Servant*, 1914, are quoted from the mourning angels in the sky of Giotto's *Crucifixion* in the Arena Chapel in Padua. Spencer's anxiety, especially the sexual anxiety his paintings record, was also intensely "modern": the almost desperate frankness that made his self-portrait with the naked body of his disagreeable future wife, Patricia Preece, unexhibitable in its day, and durably startling in ours, belongs to a whole

subhistory of the crisis of the ideal nude, beginning with Degas's pastels and continued by the unconsoling candor of Lucian Freud, Sigmund's grandson.

The show has no shortage of art that fits the history of avant-gardism as normally constructed; from Ben Nicholson in the 1930s to Anthony Caro, Roger Hilton and Bridget Riley in the 1960s, Britain has had its share of distinguished abstract artists, and the fundamental ideas about mass culture that lie behind Pop art were first explored there by Richard Hamilton and Eduardo Paolozzi. But the significance of the impulse to make art about other media is seen to gutter out in the last gallery, amid the pederastic banalities of Gilbert & George, and one is left with the conviction that the real pictorial genius of English art has everything to do with the peculiar stress and intensity of natural vision. There are no equivalents in American figurative painting to such painters as Freud, Kossoff and Auerbach. Their deep scrutiny of the motif and their ability to render its raw truth within the hard-won diction of their respective styles seem unique in the 1980s—as in fact they were, although less noticed, for decades before. What myopia, that no American museum had the sense to bring it across the Atlantic!

Time, 1987

Oskar Kokoschka

The initials "OK," like a brusque mark of approval, are scrawled in the corners of a few of the best paintings of our century. They belonged to Oskar Kokoschka (1886–1980), the visionary Austrian painter whose career spanned seven decades and not a few places of exile. Born in the world of the Emperor Franz Josef, he died in that of Reagan and Thatcher, just before the Expressionist revival of the 1980s took hold. Recent years have seen major shows of such Expressionist masters as Ludwig Kirchner and Max Beckmann, and now the hundredth anniversary of O.K.'s birth is marked by a retrospective at London's Tate Gallery. The man it reveals, in his waxing and waning powers, seems one of the most absorbing creatures of old modernism.

Some artists know how to create from a succession of scandals; Kokoschka certainly did. Almost from the moment he left art school he assumed center stage in the Viennese avant-garde, enacting its fixations on love and death, abandonment and deviancy. Painting apart, he worked hard to earn his nickname *der Tolle* ("the crazy man"). George Grosz remembered him at a ball in Berlin, gnawing on the fresh and bloody bone of an ox. He sometimes hid among the waxworks of criminals in the chamber of horrors of the Berlin Panoptikum, and sprang out with a howl to frighten the visitors. These early "happenings" (artist as cannibal, artist as criminal) were subtexts to the main theme of artist as primitive, untrammeled by conventions of any kind. O.K.'s letters were full of nostalgia for the innocence and vitality he felt had been lost to Europe under the crust of bourgeois sublimation. As an Expressionist, he was one of the last children of Rousseau, and he idealized the noble savage within himself.

That this "savage" was the cultural artifact of the middle classes whose values he longed to escape was no mean irony. Kokoschka's shenanigans failed to throw the burghers into the turmoil he hoped for, but they made an indelible impression on his friends, a circle that included the satirist Karl Kraus, the architect Adolf Loos and a galaxy of painters from Gustav Klimt to Vasily Kandinsky. His most eccentric episode was that of the doll. In the spring of 1912 he fell violently in love with Alma Mahler, widow of the composer and a pretentious man-eater. Their affair lasted three years, and she dumped him in favor of the architect Walter Gropius soon after Kokoschka enlisted in the imperial dragoons to fight in World War I. This, combined with the horrors of the trenches and the shock of being shot and bayoneted nearly to death, drove O.K. over the brink. He had a Munich dollmaker construct a soft, life-size red-haired effigy of his former lover, fetishistically complete in every anatomical detail. The doll shared his bed, and during the day he would dress it up and take it out. In *Self-Portrait with Doll*, 1920–21, Kokoschka is seen pointing with a woebegone expression at its sexual parts, presumably to indicate a cooling of the one-sided affair. Eventually, after he and some friends got drunk, he "murdered" the doll and flung it on a garbage truck in Dresden: the dumper dumped.

In point of fact, the image of Kokoschka as a prophet martyred by the middle-class audience of Vienna and Berlin was far from the truth, despite the zeal with which he curated it. Kokoschka could rarely miss an opportunity to present himself in heroic silhouette on the barricades of culture. Thus, as Peter Vergo and Yvonne Modlin show in their catalogue essay on O.K.'s work as a playwright, his own story of the first perform-

ance of his Expressionist drama *Murderer, Hope of Women* in Vienna in 1909 was fiction. In his 1971 memoirs he described a screaming audience, "foot-stamping, brawling and chair-brandishing," an impending fire, a riot of Balkan soldiers, his own near arrest and a chorus of savage reviews. Actually, the Viennese newspapers of the day reported that amused theatergoers took the play "as a piece of fun, with sympathetic good humor."

It is unlikely, however, that his Austrian sitters took their portraits the same way. There is still something disquieting about their effigies, pinned on the dark canvas in those peculiar scratchy tones, the flesh iridescent and yet as musty as a dead moth's wing, the fingers crooked like sickly vine prunings. Apart from a few ferrety, etiolated aristocrats with names like Joseph de Montesquiou-Fezensac, most of the people who were prepared to undergo the ratcheting of what Kokoschka called his "psychological tin opener" were fellow artists and intellectuals. These "black portraits" have perhaps been overpraised. They are irresolute in form and full of devices from Ensor, Schiele, Redon and van Gogh. At their occasional best, as in O.K.'s portrait of Loos, van Gogh's influence predominates, and the sticky coils of paint develop a high psychic pressure: Loos, riddled with syphilis, all twisting hands and hunted glare, seems ready to implode. But Kokoschka's ability to draw with paint, to sustain a rhythm of marks across the whole surface instead of niggling at patches, came out on the eve of the war in portraits such as the brilliantly energetic one of Franz Hauer, 1914.

This intensity entered his work when Alma Mahler entered his life. In the 1913 *Two Nudes* (*The Lovers*), O.K. and Alma embrace naked, full length, like arrested waltzers. In the enigmatic *Knight Errant*, 1914–15, with its creamy paint and cold prismatic colors, the artist is seen lying down exhausted in knight's armor, a pilgrim's scallop shell at his side, abandoned in a wilderness vaguely reminiscent of Altdorfer's high alpine views, while an angel extends a martyr's palm and Alma lurks siren-naked in the middle distance. Here all the emotional threads are rolled together: Kokoschka's fear of the war, his sense of displacement and exile, his self-pity and his amorous miseries.

The knight-errant was the right figure for him. Kokoschka had to work in Germany because the decorative traditions of Vienna could not, in the end, contain the intensity he wanted to project into painting. And just as surely, he had to leave Germany because of Hitler. In 1937 he painted a big-jawed self-portrait, titled *Portrait of a "Degenerate Artist,"* which commemorated his inclusion in the Nazi exhibition of "Degenerate Art." A figure among the trees, in the background on the left, sketchily

furnishes the key: it is the Adam from Masaccio's *Expulsion from Paradise*. Kokoschka was being driven from his European paradise. He went to England, where he remained throughout the war. There he painted a number of obscure political allegories, inspired by the cartoons of Gillray and other Georgian caricaturists, and supported himself by teaching and portraiture.

In the postwar years, during which Kokoschka cast himself as a maestro appointed to pull the great European figurative tradition out of the grip of abstraction, his art declined in vitality. One soon wearies, for instance, of the view-from-the-boardroom cityscapes of Berlin, London and New York that he turned out in some profusion for Axel Springer and other bigwigs of the postwar boom years. But to say that his talent collapsed like Chagall's is quite untrue. Chagall painted nothing but cloying ethnic kitsch for the last thirty years of his life. But in some of Kokoschka's last paintings there is the real sense of an old man's rage and an old man's freedom—the sort of deliberate clumsiness by a highly gifted draftsman, the sense of the ludicrous posture, the gross energy of the old satyr, that fires up our responses when we look at a good late Picasso. Nowhere does this come out better than in *Theseus and Antiope*, the huge canvas Kokoschka began in 1958, worked on intermittently for sixteen years and left unfinished at the time of his death. If one can speak of Neo-Expressionism by an original Expressionist, this painting is it. Everything about it, from the violently suffused colors to the lumpish drawing of the Amazon queen's feet, runs close to satire. Never, one suspects, has classical myth been rendered with such homely, indeed suburban, protagonists. But for the burning temples in the background one might suppose the scene was a Baltic beach in August. And yet it has a strange, mocking intensity: despite his official position, the old dog could still bite when left to his own subjects, far from the civic view and the official portrait, in his own studio.

Time, 1986

Giorgio Morandi

When Giorgio Morandi died at the age of seventy-three in 1964, he was, from the view of modern art that revolves around "movements" and

historical groupings, a kind of seraphic misfit. He was not a joiner, moved nowhere, did a little teaching and spent most of the last forty-five years of his life in a slightly musty flat in Bologna, the red-brick provincial city whose reluctant cultural ornament he had become. In all his life he stepped out of Italy only to cross the border for a few brief trips into nearby parts of Switzerland. *Il monaco,* one critic nicknamed him, "the monk": a big heavy man, gray on gray, shuffling between the dark outmoded tallboys, painting little groups of bottles and cans, or a vase with one paper rose stuck in it.

Throughout his career, Italian culture buzzed with manifestos, claims and counterclaims. Before World War I, the Futurists tried to marshal art into a relentless machine-age spectacle. In the twenties and thirties, Mussolini and his cultural gang strove to coopt Italian modernism into Fascist propaganda—dynamism, simplification. By the late forties and fifties, socialist realism (especially in Bologna, which took pride in its worker traditions) was trying, amid clouds of Stalinist polemic, to become the house style of Italian art. All through this, Morandi stayed where he was, looking at his plain table of dusty bottles.

No other major modern painter has less to tell us about the tensions of history and the facts of the twentieth century than Giorgio Morandi; none, except Matisse, retired more completely from the cultural role expected of the avant-garde. Today Morandi's renunciation of the art world as a system seems noble and perhaps inimitable. He disdained all ambitions that could not be internalized, as pictorial language, within his art. This earned him the reputation in some quarters of a *petit-maître:* a man who, although he said it very well, had only one limited thing to say. The untruth of this verdict can readily be seen at New York's Guggenheim Museum, where the first American retrospective of Morandi's work is on view.

"Here are most of my paintings," Morandi said to a reporter in the mid-fifties, pointing to a thick dried crust of waste pigment that had accumulated through years of his wiping palette knives on the crossbar of his easel. Morandi scraped off many more paintings than he finished; his self-editing was relentless—a fact that should give pause to anyone who supposes there might not have been much difference between one still life and the next. But the differences, like the nature of his work itself, are hard to catch in words. One can easily say what the paintings are not. They do not tell stories. They do not point to any kind of action "out there." They tell us nothing (or nothing immediate) about Morandi the man. They are not dramatic, colorful or "modernist" in any doctrinaire way.

And although they are saturated in historical awareness, they are unlike most still lifes that were done before them.

The typical still life of earlier days—the seventeenth-century Dutch table, say, cascading with parrot tulips and gold beakers, fur, fruit, fish, feather and dewdrops—was a symbol of appropriation. It declared the owner's power to seize and keep the real stuff of the world. Even the still lifes of that master of reflective vision, Chardin, tend to retain this emblematic quality; it was written into his social background. In Morandi, things are otherwise.

The sense of display is abolished. The objects are inorganic and dateless: milky long-necked bottles and squat flasks, a biscuit tin, a fluted bowl, some long-beaked metal pitchers. They carry no marks, patterns or brand names. One thinks of them not as manufactured objects but as elements in a hesitantly ideal architectural scheme. Sometimes the slender bottle necks, leaning together, vaguely recall the towers of Bologna or San Gimignano. They look fragile and contingent, but they endure for decades, through picture after picture. (To make quite sure that nothing disturbed the precise relationships he put them in, Morandi drew chalk circles around the the bases of his "models" on the surface of the table.) Occasionally their groups, bound together by some mutual gravitation of shape, might remind one of people insecurely huddled on the edge of Morandi's small flat earth, the tabletop.

The way they are painted looks awkward at first, ill defined—but only because it makes no concessions to haste. Morandi used no shortcuts. He eschewed the sharply abbreviated shapes, high contrasts of tone and grabby oppositions of color that can make an image "memorable" on first sight. Instead, the things in his paintings seep deliberately into one's attention. They start vaguely, as little more than silhouettes, a vibration of one low color against another. Gradually they "develop" on the eye, and one begins to grasp their internal relationships: how articulate the subtle sequence of tones may be, in a form that once looked flat and light brown; how many colors may be contained, as dusty hints and pearly afterimages of themselves, in what seemed to be a sequence of gray patches. If the straight side of a bottle seems to waver, it does so only to remind us how mutable and hard to fix the act of seeing really is. And if the shapes look simple, their simplicity is extremely deceptive; one recognizes in it the distillation of an intensely pure sensibility, under whose gaze the size of the painting, the silence of the motif and the inwardness of the vision are as one.

As Kenneth Baker points out in the catalogue, Morandi chose an art

that could not frighten or persuade, as the mass-media imagery of Italy was intent on doing; his struggle was "to purge representation of its manipulative potential so that painting . . . might be carried on without cynicism or apology." Modestly, insistently, Morandi's images try to slow the eye, asking it to give up its inattention, its restless scanning, and to give full weight to something small. When Japanese aesthetes spoke of the quality called *wabi*, they had in mind something like this: the clarity of ordinary substance seen for itself, in its true quality. Chardin had this most of the time, and Vermeer nearly all the time; Manet and Braque, in very different ways, understood it; and Morandi's entire life was predicated on the prolonged search for it. That is why the Guggenheim's show provides such a lesson in seeing.

Time, 1981

Late Picasso

That Pablo Picasso (1881–1973) was the most prodigally gifted artist of the twentieth century can hardly be in doubt, even among those who can make the effort to see him with a measure of skepticism or detachment. But his last years have always posed a problem. When the Palace of the Popes in Avignon was filled with Picasso's last paintings in the summer of 1973, they caused as much disappointment as surprise. Picasso appeared to have spent his dotage at a costume party in a whorehouse. The walls were covered with seventeenth-century dwarfs and musketeers, puffing on pipes and goggling at pudenda. They were painted coarse and quick, with what seemed to be a kind of narcissistic perfunctoriness, as though the old man had become so obsessed with filling out his Don Giovanni catalogue that he could not stop long enough to finish the last entries. The paintings seemed, in the art jargon of the seventies, more process than product, but none the more palatable for that. Nor did the market like them much; collectors who saw the late work as much more than the repetitive spoutings of an old man raging against death were few and far between. Lear *à l'espagnole,* no doubt, but one need not queue for tickets.

Because of this indifference, it is only now, eleven years since

Picasso's death, that a properly done museum show of his last decade can be seen in New York City. It nearly foundered on the way: organized by Gert Schiff for New York University's Grey Art Gallery, it was first canceled for lack of funds, and then revived by the Guggenheim Museum. A show like this cannot pretend to contain all the evidence; apart from a huge output of drawings and prints, Picasso made perhaps four hundred paintings in the last three years of his life. And yet it draws the profile as it had not been drawn before. Not even the most hard-bitten viewer can contemplate this oeuvre without a degree of awe—a sensation not always identical with aesthetic pleasure. No doubt about it, Picasso painted many bad and some flatly absurd pictures at the end of his life. But the good ones are so good, and in such a weird way, that they utterly transfix the eye, while the drawings (and some of the vast outflow of etchings) possess an assurance, a sensuous ferocity that no other living artist could approach, let alone rival.

Schiff's catalogue essay does an excellent job of dissecting and analyzing the themes of late Picasso, but there are moments when he goes right off the edge. The last period, he declares, "is not a 'swan song,' but the apotheosis of his career." A ten-dollar word: it means "transformation into a god." It is what mad Nero dreamed of; and now, on the theological authority vested in the Guggenheim Museum and its trustees, it has come to Ol' Cojones.

Why the hyperbole? Because of inflation. Now that every squawking Neo-Expressionist turkey is treated as an eagle, Picasso, whose angry, abbreviated late style is grandfather to the mode of the early eighties, has to be deified, and never mind the language. (One wonders what Schiff would say about late Titian or the old age of Michelangelo.) Actually, Picasso's last decade contains little that can compare with his work in the thirty years after 1907, when his transformation not only of modernist style but of the very possibilities of painting was so vast in scope, deep in feeling and authoritative in its intensity. Then as now he was influencing Pabloids, but the earlier ones had better material to work with.

The drawings and prints are the most accessible part of the late work. A large enough part too: even without the famous *Suite 347* etchings of 1968, they run into the thousands and probably have not all been counted even yet. Picasso drew with an immediacy that, in most of us, is reserved only for daydreaming, and anyone who supposes that the rough, wobbly-looking handling of the late paintings is due to the shaky fist of age should look at the drawings, whose linear control is absolute. They make up a theater of characters, some familiar and others not: nudes from the imagi-

nary seraglios of Delacroix and the real brothels of Degas, comic in their pillowy availability; inhabitants of Picasso's Hesiodic arcadia, little whop-straw gods, satyrs, nymphs; musketeers and *majas*, dwarfs and Velázquez aristocrats. Then there are his own inventions of years before, pulled in for a final bow—the women from *Les Demoiselles d'Avignon*, for instance. Picasso was saying good-bye to sex and could never see enough of its emblems; so his *scènes galantes* are imbued with a heavy, nostalgic, un-deceived randiness.

The paintings are a somewhat different matter. There, despite the apparent outwardness of his vehemence, Picasso was almost crazily her-metic. Later and younger artists could mimic the expressive urgency but not earn the reasons for it. He was an old, ravening man in a world without resistances. He had always been preoccupied with the spectacle of himself as Primitive Man: a fiction, but (as worked out across the long panorama of Picasso's oeuvre) a consoling and sustaining one. He wanted to go a step further: to paint something that, in defiance of the secular, spiritually exorcised conditions of modern life, would not just challenge but actually invest the viewer with its iconic power—the lost power of the mask. As André Malraux recounted in his memoir of Picasso, *La Tête d'Obsidienne,* Picasso was obsessed by this project in old age: "I must absolutely find the mask."

Except for a few intense and contorted still lifes, all the paintings in this show are of the human figure, usually centered glaring outward with the dilated mania of the eye that first transfixed its audience in the prepara-tory paintings for *Les Demoiselles d'Avignon* three generations before. No exhibition in memory has been so full of eyes (or of anuses and genitals, his other fetish objects). The late work attacks and reattacks art-history themes, figures by Rembrandt, Poussin, Manet, Delacroix, Rousseau. It is culturally saturated, as well as drenched in his macaronic, theatrical and self-mocking sexuality. And yet its obsessive project is to so generalize the image of the figure as to remove it from the sphere of "culture." Picasso hardly ever used models; every figure comes out of the head, and each face (despite the occasionally recognizable features of his last wife, Jacqueline Roque) aspires to the conceptual impact of the "primitive." As paintings, they do not necessarily get better as they get more masklike.

The picture that may be destined to become the most famous late Picasso (his supposed last self-portrait, green and mauve, stubble on the withered, tight ape flesh) is merely banal in its theatricality. But when, as in *The Artist and His Model,* 1964, the grinding contradictions of his formal system lock at last, when the haste and incompletion of the surface are

overcome by the tensions of their massive underpinning, late Picasso has great visceral power—if not, necessarily, the magical efficacy he sought. Even in travesty, he knew the tragic; and although these late paintings are not the best of Picasso (let alone Schiff's "apotheosis"), they are to be valued as fragments of the kind of talent that comes, at most, once in a century.

Time, 1984

V / Americans

Thomas Hart Benton

If ever an American artist had seemed dead and buried a decade ago, along with the movement he had led, that man was surely Thomas Hart Benton (1889–1975). True, his huge murals writhing with buckskinned, blue-jeaned and gingham-clad Americans were still to be seen in situ in the Missouri State Capitol, Jefferson City, and the Truman Library in Independence; his name might still be invoked in Kansas City, where his latter years were spent; and most students of American art history knew that he had been the teacher (and to no small extent, the substitute father) of Jackson Pollock at the Art Students League in New York. But actual interest in the Michelangelo of Neosho was fairly low, and this lack of interest mirrored the poor esteem into which American Regionalism, that populist art movement which in the thirties had tried to assuage the miseries of the Depression, had slumped. From the late forties onward, Regionalism had come to look cornball, and its project, which was to rescue American art from the supposed corruptions of Europe and New York, almost comically dated. But nostalgia and a market boom bring most things back, eventually. In 1983 the Whitney Museum revived Benton's old co-Regionalist, Grant Wood, with a retrospective. Six years later it is Benton's turn, with a show of some ninety works at the Nelson-Atkins Museum in Kansas City, Missouri, curated by Henry Adams.

The show confirms what one had already suspected. It is bound to be a hit, because Benton was a dreadful artist most of the time. He was not vulgar in the tasteful, closeted way of an Andrew Wyeth. He was flat-out, lapel-grabbing vulgar, incapable of touching a pictorial sensation without pumping and tarting it up to the point where the eye wants to cry uncle.

Yet Benton's is a curious case because, despite all the hollering he and his admirers produced about down-home values and art for the common man, he was no kind of a naïf. He had studied in Paris before World War I, and was closely tied into the expatriate avant-garde there, especially with Stanton Macdonald-Wright, whose "Synchromist" abstractions (developed out of František Kupka and Robert Delaunay) were among the most advanced experiments being done by any American painter. Back in New York in the early twenties, Benton dressed (as one of his friends would remark) like "the antithesis of everything American," and had a peripheral relationship to Alfred Stieglitz and the circle of his "291" gallery. Benton's own abstract paintings may not have been quite up to the level of Macdonald-Wright's or Morgan Russell's, still less of Patrick Henry Bruce's—although it is difficult to judge them fairly, since he destroyed so much of his own early work "to get all that modernist dirt out of my system." But it was abstraction that underwrote the system of Benton's later figurative paintings—an abstraction based, as his *Three Figures* of 1916 reveals, on bulging serpentine figures derived from Michelangelo. From him, and Mannerist sources such as Luca Cambiaso's block figures and El Greco's twisty saints, Benton assembled the theory of kinetic composition that would eventually alter the walls of the Midwest. Indeed, it would alter abstract painting itself, since Benton's preoccupation with surge and flow got across to Pollock and, much etherealized, led to his invention of "all-over" abstraction.

In Benton's own paintings, however, what it mainly produced was rhetoric. His ideas about "bulge and hollow," the rhythmical distortion of bone and muscular structure, made his human figures weirdly overdetermined, like lanky dummies with cartoon faces. Benton's trains lean forward like Walt Disney's as they steam along; the very clouds in his landscapes flex their biceps. His color is tawdrily emphatic and he has no sense of surface at all—paint, in Benton's work, is just dry stuff for conveying a message. His nudes are pinups, and even when this quality seems a deliberate quotation from popular art of the day—his *Persephone*, 1939, spied on by a libidinous old Pluto in blue denim, is basically a Petty girl—it grates against Benton's habit of Renaissance quotation. One might make a case for him as a pre-postmodernist, a sort of American de Chirico without the sophisticated melancholy, full of nostalgic "appropriations" and thinly veiled fetish-images. But it would not play in Peoria.

Benton left New York for good in 1935, returning to the heartland, to Kansas. By then, the Regionalist movement had formed around his "heroic" pastoral vision, and he felt obliged to repudiate the city, whose

art world was, he announced, a veritable Sodom of fanatics like Stieglitz and "precious fairies" who "wear women's underclothes." He would return to the Eden of honest work and stiff wrists, where the Missouri and the Wabash Cannonball rolled by.

Yet an odd thing about Regionalism, as Adams shows in amusing detail, was that it became the only art movement ever launched by a mass-circulation magazine. Its promoter was a small-time art dealer from Kansas named Maynard Walker, who sensed that the resentments of America, battered by the Depression and bitterly suspicious of the East, could be harnessed in the field of art. Cultural populism would sell, if it were shown welling up from the undefiled American heartland. The bubble of European modernism, he wrote in *Art Digest* in 1933, had popped with the Crash of '29. No more drug addicts, foreigners (code for "Jews") and ear-cutters. Now it was time to return to the deep pragmatic values of what George Bush's speechwriters, in years to come, would call "a kinder, gentler America." The artists who embodied these values best were three: Benton, John Steuart Curry and Grant Wood. They hardly knew one another. Grant Wood, a mild and timid homosexual, painted most of his scenes of midwestern life in his Connecticut studio, and could only with difficulty be persuaded to revisit the acreage of his birth; now and again he would don a pair of bib overalls and lean against a tree or a porch for what one would now call a photo opportunity. But it happened that Henry Luce was looking for an uplifting, patriotic circulation-builder for the Christmas 1934 issue of *Time*. Maynard Walker was duly interviewed, Thomas Hart Benton's self-portrait went on the cover, and American Regionalism was born. "A play was written and a stage erected for us," Benton would later remark. "Grant Wood became the typical Iowa small towner, John Curry the typical Kansas farmer, and I just an Ozark hillbilly. We accepted our roles."

The further irony was that Regionalism, supposed to be the expression of American democracy, was in its pictorial essence the kissing cousin of the official art of 1930s Russia. If socialist realism meant sanitized images of collective rural production, green acres, new tractors, bonny children and muscular workers, so did the capitalist realism proposed by Benton and Wood. Both were arts of idealization and propaganda. In aesthetic terms, little Benton painted for the next forty years would have seemed altogether out of place on the ceilings of the Moscow subway. By the same token, although today one looks with disbelief and disgust at Nazi caricatures of Jews, they were no worse than Benton's hymns of hate to the Japanese such as *Exterminate!*, 1941, with its cackling GI bayoneting an

obese, snaggle-toothed Tojo who has chains for intestines. Apart from this outburst of hysteria, the whole matter of Benton's racism is still up in the air. His paintings of blacks look condescending because he never figured out how patronizing his desire to "ennoble" them was, but at least he was equally hard on whites, those gangling hayseeds and pudgy politicos. In any case, he could hardly draw anything without caricaturing it. That was part of the reason for his popularity—as it is with an artist such as Red Grooms today. You can't help liking Benton for his lack of cant, his energy, his cussedness and independence. But as his work proves, these qualities, although admirable in themselves, do not guarantee major art.

Time, 1989

Deco and Fins

The Brooklyn Museum's entrance hall is a period room of the recently lost future, haunted by a peculiar American dream from the days when model-airplane kits were still mostly balsa. A 1929 high-wing monoplane, bravely lacquered in sky blue and wasp yellow, hangs from the ceiling, almost low enough for the grown visitor to touch its spats. Nearby sits the Chrysler Airflow—not, alas, the classic 1934 model with the "water-fall" radiator, but still modernity on wheels, squinty windshield, fairings and all. Between them are such icons as the 1936 Sears, Roebuck Water Witch outboard, offering its owner some whiff of the thrill associated with Henry Dreyfuss's bullet-nosed locomotives or Norman Bel Geddes's flying wings. Your trousers shorten as you look.

Was it only fifty years ago? How touching our grandfathers' faith in the future seems, in our day of acid rain, exploding shuttles, decaying inner cities and general creeping dystopia. The mood is epitomized in objects like the male of the future dreamed up for *Vogue*—a bearded figure in an immaculate white jumpsuit wearing a circular antenna as a halo on his head, Jesus among the insulators. Everything is streamlined, even objects that are screwed down and cannot move, so that America's breathless rush toward utopia is clearly signified by things like a 1933 Raymond Loewy metal teardrop desk-mounted pencil sharpener. In the twelve

years between the Wall Street Crash and Pearl Harbor, the American imagination seems to have oscillated between two images, the streamline and the breadline—the former promising relief from the latter. And in the maxim of the 1939 New York World's Fair, "See tomorrow—now," lay the siren syllables of undeferred gratification that would abolish the constraints of Puritan America while preserving its millennarian fantasies.

A plethora of dreams flowed from America in the 1920s and 1930s; and although, at least on the face of it, we have ceased to share them, they lend a deep and sometimes rather scary poignancy to the remarkable exhibition organized by art historians Richard Guy Wilson and Dianne H. Pilgrim, titled "The Machine Age in America, 1918–1941."

It was in the twenties and thirties, and in America, that a cultural fascination with machinery that had been growing since the early nineteenth century reached its apogee. One is used to reading, in prattle such as Tom Wolfe's 1981 book *From Bauhaus to Our House,* that the American affair with machine culture during those years—functionalism, steel-and-glass buildings and so forth—had been imported, as intellectual fashion, from Europe. Nothing could be further from the truth. The concise and mighty industry-based forms of American building, conceived by architects from James Bogardus in the 1850s to Louis Sullivan in the 1890s and by the engineers of a technology whose emblematic climax was John and Washington Roebling's Brooklyn Bridge, were among the prototypes of European avant-garde thinking before and after World War I. Even to the Russian Constructivists, "Americanism" was something infinitely desirable: it stood for electricity, progress, a society knit together and made transparent by fast communication.

In Europe, World War I—history's first fully mechanized conflict, a production line of death—had given climactic form to the image of the bad machine, a Moloch bent on destruction and alienation, that had haunted the imagination of artists and writers through the nineteenth century. No one was going to see the machine as an unqualified good. But America's role in that distant war had been small, its trauma of human loss slight. With industry booming, Americans found it not just easy but almost obligatory to believe in machine-created utopias. Their country, wrote photographer Paul Strand in 1922, was the "supreme altar of the new God," a trinity formed by "God the Machine, Materialistic Empiricism the Son, and Science the Holy Ghost." Its factories, thought Strand's colleague Charles Sheeler, "are our substitutes for religious expression."

The machine, with its stripped and logical forms, its imagery of power, change and fast communication, would make concrete what Walt

Whitman had dreamed of: "The expression of the American poet is to be transcendent and new." Farewell to Henry Adams's Virgin, to the Renaissance and Gothic nostalgia that had assuaged the cultural elites of New York and Boston at the end of the nineteenth century; welcome to the dynamo, the total plan, the slick shell housing, the fins and flanges, the didactic sheen of stainless steel, the Aztec-style bracelet of imperishable Bakelite. Good-bye, Hell's Kitchen; hello, skyscraper.

The traditional American frontier of horizontal space was receding into memory by 1920. In its place grew a new myth that supplied one of the core images of American Art Deco: the conquest of the air, by buildings and machines—the taming of vertical space. The aircraft, with its fairings and streamlines, became the formal metaphor for a host of products from milk-shake machines to staplers. Fantasy piled on fantasy: Bel Geddes, one of the master industrial designers of the period, looked at airfoils and fish and came up with the finned, monocoque body of his Motor Car Number 9, 1933, which was never built but which launched a thousand period spaceships into the popular epic of the future.

Meanwhile, as static conquest of the air, the skyscraper multiplied the site, extruding a patch of earth into a stack of pure property: the abstract, universal sign of capitalism. The standardization of its floors invoked the image of the machine, just as in the use of bodies as mechanical parts in Busby Berkeley's choreography or the precisely drilled production-line kicks of the Rockettes. Its soaring shafts, tapering setbacks and elaborate stacking (for this was the age of Rockefeller Center, not of the banal glass box) hinted at vastly oversize Mayan temples; the contrast between glittering surface and deep wells and slots of shadow suggested exuberance and secrecy conjoined, the "metropolitan style" of Big Business. Instead of quoting Gothic or Renaissance detail as an indirect sign of quality, the whole tower changed into a business logo, architecture as advertisement— the archexample being William Van Alen's Chrysler Building, 1928–31, with friezes of hubcaps and wheels, gargantuan winged chrome radiator ornaments and stainless-steel finial.

The imagery of this "architecture of joy" is one of clean impaction and ecstatic reaching toward the light; not even the court of Louis XIV, the Sun King, made as much of solar disks, sunrays and other bursts of radiance as Deco America. As the utopian form to end all others, the skyscraper manifested itself as chair backs, bookcases, table lamps, cocktail shakers and, of course, refrigerators. That these things were not tall mattered no more than the fact that most streamlined objects did not budge. It was the image that counted.

Drawing on public and private collections across America, but especially in New York, the curators of this show have done a wonderful job of bringing all this, and more, together. At last one can see, in full detail, how the mass-produced, democratic nature of American machine-based design gave it a quite different flavor from that of French Art Deco, which was less a response to the myth of modernity than a continuation, by souped-up means, of the high-luxury tradition of *ébéniste* furniture. The work of painters and sculptors was far less important to this process than that of photographers, engineers, architects and designers. What epitomized the machine age better: a gas pump quoted in a painting by Stuart Davis or a DC-3? John Marin's watercolors of the New York skyline or the Empire State Building itself, surging upward before the astonished eyes of Gotham at the rate of one floor a day? A relief sculpture by Charles Biederman or the prodigious steel catenaries of Othmar H. Ammann's design for the George Washington Bridge?

There are some delightful "pure" works of art in this show, such as Alexander Calder's little maquette for a huge motorized sculpture at the 1939 New York World's Fair—a small, sharp orrery with strong cosmological overtones. There are also some rarities by lesser-known artists, notably the huge Cubist-derived portrait of the workings of a watch by Gerald Murphy, the American expatriate on whom Scott Fitzgerald was to base his character of Dick Diver. But compared with the knockout confidence of the work of engineers and designers represented in this show, the machine-aesthetic painting of twenties and thirties America was mostly feeble, decent and derivative—an appendage to a larger cultural framework.

No American sculptor who tried to make metaphors of technology, not even Calder, came up with an object as striking as Walter Teague's Bluebird radio, 1937–40, whose integration of a spartan Constructivist design ethic into an American sense of technology as spectacle—the big blue glass disk suggesting the ether from which broadcast signals were gathered—shows how little truth there is in the idea that design is condemned to lag behind "high" art in expressive clarity. We certainly need more shows as thorough and intelligent as this one, to counteract the vulgar mania for "art stars" and remind us of the real continuities of visual culture.

Time, 1986

Morris Louis

It is advisable, when visiting the Morris Louis retrospective now on view at New York City's Museum of Modern Art, to recall the claims made for this painter ten or fifteen years ago. In such work, the art historian Michael Fried once wrote, "what is nakedly and explicitly at stake . . . is nothing less than the continued existence of painting as a high art." It contained "unimagined possibilities for the future of painting." One chews on this, moving from one sweetly august canvas to the next, enjoying the floods and diaphanous veils of color, the sheaves of burning stripes, the technical control, and marvels once more at the mutability of cultural reputation. Whatever painting may be argued to depend on today, it is not the lyric disembodied stain. Its possibilities for the future turned out to be not just "unimagined" but nonexistent. History, fickle jade, balked at this fence and took a turn. One cannot imagine future painters mining Louis's work for motifs and ideas, the way Jackson Pollock's was mined by Louis and other artists of his generation. Here is the beautiful impasse, the last exhalation of symbolist nuance in America, the eloquent sigh of transparent color that was soon to be a period style.

Louis was only forty-nine when he died of lung cancer in 1962. He owes a large part of his reputation to the critic Clement Greenberg, who was also his coach. It is not really true, as has often been said, that Greenberg told Louis what to paint, although he probably had more influence over this lonely, gifted and insecure man than any American critic has had over any other artist. After Louis died, Greenberg edited his work, deciding where to cut off the stripes. (This habit of intrusion was to get him in some trouble when the critic took it upon himself to remove the paint from a number of David Smith sculptures and have them refinished a uniform brown, on the grounds that Smith was not an important colorist.) Nevertheless, Louis's instinct for light as the primal theme of painting, and his desire to find a syntax for it, winds back beyond his encounters with Greenberg to the fact that he spent his time as a student in Washington, D.C., looking at the Bonnards in the Phillips Collection rather than the Picassos at the Museum of Modern Art.

Bonnard's light and Matisse's luxe, run through Greenberg's reduction mill and then filtered by Louis's own proclivity for the ethereal, came out in a curiously attenuated form. But it supported—and after Louis's death was in turn supported by—the argument that after Pollock painting had only one way to go. No more figures, organic symbolism or utopian geometry; no more gestural surfaces, tonal structure or Cubist layering of space. In future, art would hang onto the spread-out, expansive quality of Pollock's work while refreshing it with a new intensity of color, inspired by Matisse. At the end of the purge you would have a clipped but radiant discourse of pure hue, fixed by an exaggerated pictorial flatness, done in thinned translucent washes that became the surface. Louis's direct inspiration for this was an early canvas by Helen Frankenthaler, *Mountains and Sea*, 1952, whose liquid blotches and airy sense of light struck him, in one of the few quotable phrases he left behind, as a "bridge between Pollock and what was possible."

Thus emerged the chief form of American museum art in the early sixties: The Watercolor That Ate the Art World. Of course, one could hardly come right out with it and say the works of Helen Frankenthaler, Kenneth Noland and Morris Louis (not to mention the thousands of yards of lyric acrylic on unprimed duck done by their associates and imitators) were basically huge watercolors. But there was little in the soak-stain methods of color-field painting that did not seek and repeat watercolor effects. The only difference lay in the size, the curtness and (sometimes) the grandeur of the image, and in the scrutiny it received from Greenberg's disciples, rocking and muttering over the last grain of pigment in the weave of these canvases, like students of the Talmud disputing a text, before issuing their communiqués about the Inevitable Course of Art History to the readers of *Artforum*.

When Louis's work is unwrapped from its exegetical package, quite a lot is still left. These paintings are among the most purely optical ever made in America. Some look like mere swatches, but many do retain the mystery of a tour de force: you can see how they are painted but not imagine doing it yourself, even when Louis's own technique is made clear. He eschewed the usual signs of intervention with the flow of color, the hooking and squiggling of the brush. Instead, Louis sought a language of impersonal nuances. He found his hands-off technique in a complicated process of pleating the canvas and flooding it with runnels of diluted color, wash after wash, never a brush mark in sight. He "drew" his shapes by manipulating the effects of gravity on liquid. This eliminated the traces of the expressive hand and gave his surfaces a sweet, frictionless clarity.

It was also chancy in the extreme, since it courted the possibility of turning the image into a decorative Rorschach blot. But Louis destroyed much of his own work, editing heavily, and the sense of risk in the surviving paintings gave them an intriguing tension, as though their radiance had been snatched from the very jaws of entropy. His best works, such as *Beth Gimel,* 1958, or *Beth Chaf,* 1959, touch on the exalted otherness of nature (one might almost be looking at a rendering of an aurora borealis or a butte), and their concentration on broad effect of light and color, coupled with the impersonality of their technique, seems to connect back through Georgia O'Keeffe's watercolors to nineteenth-century American Luminism. (To visit Washington in the spring and see its broad avenues framed in V perspectives of flowering plums and cherries is perhaps to sense a connection with Louis's late *Unfurleds* of 1960–61.) Yet despite his expertise, precision of feeling and taste, Morris Louis does not come out of this show looking like a great painter. What is left? A perfume; a visual buzz unlike any other—and the persistent impression of medium-size pictorial ideas writ large. But for what it is, the work can still offer intense pleasure to the eye while inadvertently reminding you that beauty, in art, is not necessarily enough.

Time, 1986

Diego Rivera

Throughout his life, which was flushed with publicity, Diego Rivera was often photographed. He filled the frame—a three-hundred-pound Silenus in suspenders and open-neck shirt, the liquid eyes bulging at the rival lens. One image shows him feigning sleep. He lies mountainously in the garden of his house in Coyoacán, his head pillowed on the side of an eroded pre-Columbian head. He is pretending to be a big baby dozing by his mother, the Mexican past, touching the root of contentment. No other photo so pungently expresses Rivera's idea of his own history, as an artist born to link the old Mexico with a new, postcolonial one.

Diego Rivera was born a hundred years ago, in 1886, and he died of cancer in 1957: seventy-one years, not a long life by Picassoan standards,

but a staggeringly exuberant and productive one. All his attributes as an artist, including his vulgarity, were cast in a large mold. He became a symbol, the key figure in cultural transactions between North and Central America in the first half of the twentieth century. He played his role for Mexico, part ambassador and part *genius loci*, to the hilt. He covered many acres of wall in Mexico and the United States with his murals and left behind a huge output of easel paintings, drawings and prints. Few twentieth-century artists have been as popular in their own societies. None is more relevant to the debate over "indigenous," or "national," art language as against "international style." A Marxist who read little Marx, he found a deep well of pictorial eloquence in the traditions and miseries of the *campesino*. "For the first time in the history of art," Rivera claimed, "Mexican mural painting made the masses the hero of monumental art."

Yet gringo capitalists wanted him too. In 1930, when he did his enormous fresco cycle of Mexican history in the Palacio de Cortes at Cuernavaca, a work that made no bones about his Communist sympathies, his $12,000 fee was paid by Dwight W. Morrow, then U.S. ambassador to Mexico. In 1931 Abby Aldrich Rockefeller bought Rivera's sketchbook of the 1928 May Day parade in Moscow.

Although such pairings were tailor-made for satire, nothing suggests that his American patrons were masochists. They wanted the best public art they could get, and believed, with reason, that Rivera could supply it. They thought him a cross between Whitman and Picasso.

To display such sympathies in the Depression made management look benign. When Edsel Ford wanted to celebrate the Rouge complex and the auto industry, he got Rivera to paint a mural cycle in Detroit; it attracted 86,000 visitors in its first month. Rivera had no problems in casting American engineers as the heroes of a new age. Encouraged by this, John D. Rockefeller in 1932 commissioned a Rivera mural, *Man at the Crossroads Looking with Hope and High Vision to the Choosing of a New and Better Future*, for the RCA Building in Rockefeller Center. (Can one even imagine a title like that being used without wincing irony today?) Rivera put in a head of Lenin and refused to take it out, although he offered to balance it with some portraits of Lincoln and other Americans whom he supposed to be Lenin's moral equivalents. The result of this Mexican standoff was that the Rockefellers effaced the mural, while the Communist Party denounced Rivera for "opportunism." This finished Rivera's career as the conflicted Michelangelo of American capitalism, and he went back to Mexico to become the wholehearted Tintoretto of the peons.

Clearly, no artist who habitually worked on Rivera's scale can be

shoehorned into the dimensions of a museum retrospective. But to mark Rivera's centenary, the Detroit Institute of Arts, where his Detroit Industry frescoes for the Fords are preserved, has organized a large exhibition. In part it was prompted by the 1978–79 discovery of a mass of unpublished Rivera material—photographs, letters and, forgotten in a dim storage room, the full-scale cartoons for the Detroit frescoes.

The fact that no such exhibition has been attempted in the United States for fifty-five years tells us something, of course. Rivera since his death has been shoved into a special category—"Mexican muralist"—set somewhat apart from the official version of modern art history. A merit of this show is the clarity with which it explains the roots of Rivera's art. It suggests how organically his mature, Mexican style from the twenties onward grew from his early attachment to Ingres, El Greco and the quattrocento. It also proves that Rivera in Paris (where he lived, on and off, from 1909 to 1921) was no provincial but a gifted and alert man immersed in the currents of the avant-garde. Once this is grasped, one sees his mature work, in all its placid monumentality, with its strange fusions of mechanical shape with archaic pre-Columbian effigies, in a different light.

At art school in Mexico City, he had learned to draw from Santiago Rebull, a former pupil of Ingres's. The French master's smooth, continuous modeling, his stress on linear profile and formal gesture continued to be the root of Rivera's art. There are pencil drawings from the 1910s—portraits and still lifes—of the most exquisite and silvery precision, as exacting in their beauty as anything by Juan Gris. Young Rivera was interested in *campesino* subjects, not because he had ever shared the life of peons but because another teacher, José María Velasco, had encouraged him to paint them.

In Paris, one sees him chewing through Seurat, Mondrian, Robert Delaunay, Gris and, above all, Cézanne. He loved mathematical construction and the golden section, and his obsession with "secret" geometry was to be of great help when he turned to the problem of making huge, static, formally coherent frescoes. Nowhere does the essential solidity of his early skill show more clearly than in his 1913 portrait of a foppish Mexican artist, Adolfo Best Maugard, adjusting his glove on a terrace, while a great Ferris wheel rises over the skyline behind him. The figure owes something to El Greco, the cityscape a lot to Delaunay's Eiffel Towers, but the dramatic centering of the wheel on Maugard's hand, as though the man were a juggler twirling its flickering spokes, is entirely Rivera's own. His big-hearted assurance prefigures the rougher, more arbitrary diction of his Cubist paintings.

Rivera became a Cubist after 1913, but he was no mere follower. Large and often fiercely colored (not the brown and gray of Braque), his Cubist canvases strike their own medium between boldness and indecipherability, making the work of minor French Cubists such as Gleizes or Metzinger seem wispy and ladylike by comparison. The extreme case was *Zapatista Landscape—The Guerrilla*, Rivera's masterpiece of 1915. It has everything in it from a rifle and pistol holster to a serape, a sombrero and the snow-capped Mexican cordillera. Yet despite all the detail, the figure of the Zapatista is hard to find; some analogy between Cubist hide-and-seek and a real guerrilla's elusiveness got Rivera thinking about camouflage and disappearance.

But by 1920 he had also been thinking long and hard about public art, which Cubism never pretended to be. He was already a celebrity in Mexico. When Álvaro Obregón swept into office as president, Rivera found he had an enthusiast in the minister of education, José Vasconcelos, who invited him back to Mexico to take part in a huge program of public painting. In Mexico and Russia, as was not the case in most of the early-twentieth-century world, a fresco could still be counted on for political impact. Mexico had a huge illiterate population, used to learning Church doctrine by looking at images. Painting had little or no competition from other media. It could be as direct a form of social speech as it had once been in the city-states of the Renaissance. Characteristically, Rivera mythologized the impact of Mexico on his work after he returned in 1921—and yet, in a way, he was telling the truth: "Gone was the doubt and inner conflict that had tormented me in Europe. I painted as naturally as I breathed, spoke or perspired. My style was born as children are born, in a moment . . . after a torturous pregnancy of thirty-five years." His idea of public art, though secular and materialist, turned out to possess a sacerdotal gravity: it could stand in for religious icons. Even a relatively small easel painting such as *Flower Day*, 1925, is consciously hieratic in its symmetry, the stillness of its squat figures, the blazing color and the clear identification of the Indian flower-bearer, bowed under his load of calla lilies, with a priest bowing before celebrants. And although many a cheap tourist cliché would come from Rivera's fusion of the thick crankshaft rhythms of pre-Columbian sculpture with the observed faces and bodies of Mexican peasants, there can be no doubt that in his hands, at least, it was a powerful union.

By its nature, this show can give only a faint impression of Rivera's achievements as a muralist. But his strength as a draftsman on the large scale can easily be sensed from the cartoons for the Detroit Industry frescoes. The drawing *Figure Representing the Black Race* has a formal

strength to match its chthonic allegorical power; it makes you realize what graphic sophistication lay beneath the populist surface. Such is Rivera at his best, but even at his worst the man's kitsch and bad taste have an orotund wholeheartedness that seems endearing. His mock-surrealist landscapes of the 1940s, together with some of his more contrived social portraits, are rubbish, but they do not spoil the cumulative effect of the show.

Perhaps it is time to amend the familiar high-modernist view of Rivera as a gifted painter deformed by the needs of propaganda. Sometimes his work was too openly didactic and coarse-grained, too attached to populist stereotypes of love, comradeship, struggle and work. It offended the etiquette of alienation. Too bad—he was still an extraordinary painter, a lighthouse of vitality. Nobody could say Rivera kept a steady political line, but at least he was no ideologue; his socialism was instinctive and antitotalitarian, like Picasso's, but much deeper. Rivera gave Leon Trotsky asylum from Stalinist assassins (including the painter David Alfaro Siqueiros) in his own house at Coyoacán, but two years later Trotsky moved out, complaining that he no longer felt "moral solidarity" with Rivera's "anarchistic" views. In 1940 Rivera denounced Stalin as "the undertaker of the Revolution," the betrayer of Spain; by 1952 he was painting a saintly Uncle Joe with a peace dove on one hand and the Stockholm peace petition in the other. Rivera's political life had as many twists and turns as the feathered serpent Quetzalcoatl. It inflated his personal myth but obscured his achievement as a formal artist—by which, as the political characters in his murals fade into historical remoteness, he must be judged. This show has set the process in motion.

Time, 1986

David Smith, Sculptures

The exhibition of the work of David Smith at the National Gallery of Art in Washington, D.C., is the most important show by an American sculptor in years. Smith died in 1965, when his pickup truck spun off a country road near Bennington, Vermont. He was fifty-eight and in the prime of

his sculptural career. Only Jackson Pollock's fatal car crash nine years earlier subtracted so much, so soon, from American art. No sculptor of similar talent has appeared in America since. If one measures a man's achievement by emotional range, formal vitality, material energy and historical ambition—the often derided "phallic" virtues of ambitious art— then Smith was the Melville of his chosen medium, and his shadow lies, perhaps unfairly long, across most of the steel sculpture that has been made in the United States since 1960.

Smith was an extremely fecund artist. One array of steel parts pushed around on the floor of his studio could set off a train of associations that led with Picassoan abruptness to a whole group of pieces. For this reason the show, curated by E. A. Carmean, concentrates on the role of series in Smith's work, on how sculptural sets arose out of the opportunities suggested by particular types of steel forms (such as boiler ends), and how, in general, material determined imagery. The National Gallery's East Wing, with its choppy transitions of level, is a confusing place for large sculpture; the background is always getting in the way. But Smith's ponderous iron wagons, bright stainless-steel portals and gesturing arabesques of rusty or painted metal survive against it in all their magnificent variety. This is not a complete retrospective. It concentrates on the years of Smith's maturity as a sculptor, starting in 1951 with the *Agricola* series— "drawings in air" made, as often as not, from abandoned farm implements he collected around Bolton Landing, the isolated little town in the Adirondacks where he had his studio—and finishing with the *Cubi*s, a series incomplete at his death. In those fourteen years, one may say without exaggeration, Smith explored the possibilities of metal sculpture more fully than any artist before or since—more, even, than Picasso or Julio Gonzalez, from whom he first got the idea of using iron. But his work reminds one that there the history of twentieth-century iron and steel sculpture, which sometimes gets treated as continuous, is actually branched. There was, on one side, the artisan-based, forged-iron tradition that came out of Catalunya, where Gonzalez had worked, and continues to this day in artists such as Eduardo Chillida and Alain Kirili. Because it included forging shapes from blocks of metal, it was closer to the monolith. And then there is the industrial strain, based on assembling plates and bars: the main line of Constructivism. Smith was a welder, not a forger.

Iron was in his name, of course, and in his family history and social environment as well. He was born in Decatur, Indiana, in 1906, the descendant of a nineteenth-century blacksmith, and his sculptural lan-

guage flowed with perfect naturalness out of a childhood in the part-mechanized heart of America. "We used to play on trains and around factories," he recalled. "I played there just like I played in nature, on hills and creeks." Thousands of youngsters, no doubt, could say the same; but art grows out of other art, and what opened the sluices and let Smith's childhood associations flow into a career as a sculptor was seeing photographs, not the originals, of the metal sculpture of Picasso and his fellow Spaniard Gonzalez in an art magazine published in the early thirties. Smith had been a painting student in New York City. Working iron, he saw, might have the directness of painting. It was an intrinsically modern material, which had, as he said, "little art history. What associations it possesses are those of this century: power, structure, movement, progress, suspension, destruction, brutality." Smith was not one of those artists, common enough in America, who felt alienated from the machine age.

He was a gargantuan *bricoleur,* a user-up of discarded things, a collagist in three dimensions. His work touched base with the fundamental modernist movements, seizing and transforming something from each of them. From Cubism and Constructivism came the planar organization of form and the abstract language; from Surrealism, the sense of encounter with a "personage," as basic to his work as it was to Miró's. Given enough found metal, he could launch into runs of astonishing inventiveness, like a jazz virtuoso improvising on a phrase. This happened most notably in 1962, when he was invited to make a sculpture for the Spoleto Festival in Italy. On going there he found, in the nearby town of Voltri, five deserted steel mills, littered with offcuts, sheets, bars and, best of all, a mass of abandoned tools, from calipers and wry-necked tongs to the ponderous, archaic-looking iron wagons and barrows used to run hot forgings from one part of the work floor to another. From these he made twenty-seven sculptures in one month; and then had the leftovers shipped back to the United States to complete the Voltri–Bolton series.

Smith's energy made people talk about him as a "monumental" sculptor. They still do, but today *monumental* is a husk of a word. In the past ten years, it has decayed to mean nothing more than "very big." American cities are now generously speckled with abstract ironmongery: sculpture that means nothing but is part of the perfunctory etiquette of urban development, most of it larger than it needs to be. Locked in a losing battle with the big-city environment, it manages to look both arrogant and depleted.

Smith never went in for such parodies of the monument, and not one of his major works was the result of a commission. Consequently, his

pieces all look as if they were made to the scale of one man. This fact bears on the alertness with which his work addresses the spectator. "Most of my sculpture is personal, needs response in close proximity and the human ratio," he said. Smith wanted to focus the image, make it speak to one pair of eyes, one mind at a time, as precisely and, there being no other word for the moral undercurrent of his work, as earnestly as possible. Hardly any Smith is more than ten feet high or wide. All the work responds willingly to nature. The stainless-steel planes of the *Cubi*s, scribbled with stuttery, glittering lines by the rapid "drawing" of a power grinder, respond better to sunlight or starshine than to the static lighting of a museum. The high color and splashy textures with which he sometimes painted the steel were certainly meant to be seen against the colors of tree, snow and autumn grass.

But under museum conditions, the human scale of Smith's vision remains. Even the biggest pieces, such as the disquieting *Wagon I* (a personage consisting of a rectangular helm set on a swollen belly made of two tank ends welded together, all balancing on a huge forged chassis), suggest a sense of the figure and accordingly evoke responses from one's own body. They convey forceful impressions of posture, gesture and attitude. Smith was not in the business of making large iron dolls, and it may be, as various critics have pointed out, that the usual verticality of his sculptures encourages one to read them too readily as effigies of the figure. The same object, horizontal, would not be seen as a recumbent personage or sentinel. But in the end, the body messages of Smith's sculpture do not depend on whether the pieces have "heads" or "legs," as quite a few of them do. They flow from the internal relationships of the forms and from the metaphorical suggestions of tension, flexibility, alertness and so forth that their vivid and deliberate "drawing" evokes.

Steel, as a sculptural material, is imperfectly expressive. It has never been fully able to suggest the pathetic. But it is a marvelous substance for embodying optimistic energy, the direct flow of feeling into untormented substance. All of Smith's best sculpture is an object lesson in what scale means, in the relationship between the sculptured object and the body of the viewer. And it was in his ability to create large steel equivalents for the sensations of the body, unclouded by apparent doubt or fear, that Smith's monumentality as a sculptor lay.

If his conception of sculpture was "heroic," it was because Smith really saw those totems and sentinels, *Cubi*s and sacrificial altars, gateways and chariots, not just as emblems of art history but as things to be rein-vented. They were a proof of the self's limitless powers to project itself

upon the world. In other words, he possessed a belief in the possibilities of sculpture that has now vanished from Western art. "Oh, David," wrote his best friend Robert Motherwell, in one of the most moving valedictions ever offered to a dead artist by a live one, "you were as delicate as Vivaldi and as strong as a Mack truck." And so he was.

Time, 1983

David Smith, Drawings

As a draftsman, David Smith was prolific to the point of garrulity and very uneven. In front of many drawings in this show (at New York's Whitney Museum of American Art, curated by Paul Cummings), one is made to feel that, had they not been created by one of the leading modernist sculptors, they would not sail on their own aesthetic merits. Most of the work from the thirties and forties is pastiche of one kind or another: a heavy line, by turns dogmatic and uncertain, grinding across the paper, paying its digestive homages to Picasso, Gonzalez, Constructivism generally and the bonelike figures of Henry Moore. The last is surprising only because Smith has been used for so long by American critics as a club with which to bash Moore's reputation. But in practice, artists do recognize one another. One of Smith's earliest drawings is a hole-in-the-head figure clearly derived from Moore, whose own interest in totems would presently be assimilated, with different results, into Smith's work.

An artist of stronger political feelings than most of the Abstract Expressionists, Smith tried his hand at propaganda with a set of *Medals for Dishonor* inspired by the Spanish Civil War, and later with a number of drawings that tried, in effect, to do a Brueghel on Fascism. Their desolate landscapes, populated by knotty women copulating with cannon, are post-Surrealist clichés—although they make clear Smith's erotic feelings about steel. Even so, they are full of the harsh graphic intensity that would soon burst forth in his sculpture.

Smith's identity and achievement in sculpture were bound up with the Constructivist mode of cut-and-build assembly: planes welded to planes and, instead of closed mass, open intersection. "I would prefer," he said in 1951, in a splendid phrase, "my assemblages to be the savage idols

of basic patterns." He was fascinated by metamorphosis, by the unfolding sequences of identity that Picasso could produce out of one given shape": bone into tooth into penis into head into harp. This sense of the breeding of images was borne out at all levels of Smith's work. He drew, not to produce "well-made" drawings, but to keep his pipes clear. The special value of his drawings was not in their finish, but in their evidence of process—how he thought and felt, how he arrived at the decisions about imagery, content and shape that found their eventual expression in the cut and welded metal. He jotted, made notes, abandoned them and got the half-usable ideas out of his system before they could waste steel. And so the drawings exhibit the sometimes incoherent grounds of imagery from which his sculpture was refined. "What are your influences?" he was repeatedly asked, and sometime in the fifties he came up with a rambling free-verse answer that ran, in part:

> *From the way booms sling*
> *From the ropes and pegs of tent tabernacles*
> *and side shows at county fairs in Ohio*
> *from the bare footed memory of unit relationships on locomotives sidling*
> *through Indiana,*
> *from hopping freights, from putting them together and*
> *working on their parts in Schenectady*
> *from everything that happens to circles*
> *and from the cultured forms of woman and the free growth*
> *of mountain flowers*

Such lines are not, of course, a description of any particular Smith sculpture. But they poignantly evoke the spirit of his work, rooted in the broadest recapitulation of memory, physical feeling and hard manual work. In the same way the drawings establish a harmony parallel to the sculptures. Sometimes they deal directly with the formal problem of cutting sheet metal, and you can imagine their flat shapes being used as templates. But more often they transpose and extend the kind of line work present in Smith's sculpture into the less physical and more speculative realm of drawn calligraphy. Not many of his best drawings could be used as blueprints for sculpture, but one sees in the spatter and twist of their knotted, scrubby lines an open curiosity about how a drawn motif might be turned into welded plate and rod. They are dream sculptures, on the boundary that divides drawing with ink on paper from drawing with steel in space.

Lee Krasner

At seventy-five, Lee Krasner is finally getting her due, and the power of received ideas in American taste is so strong that not too many people sense what the due is. Everyone, of course, has heard of her late husband, Jackson Pollock, the mythic hero (one still reads such inflationary phrases) of Abstract Expressionism. But Krasner's painting is less well known, the proof being that she is only now getting her first American retrospective, at the Houston Museum of Fine Arts, curated by Barbara Rose. Anyone who thinks that all the major American artists have been locked into their historical profile should see it, and repent. Krasner has never been a trivial painter, and sometimes her work has been touched with real grandeur.

So what hid her? The vicissitudes of life with Pollock, whom she married in 1945, do not explain that. It was a match easily caricatured: the growing fame of the male painter overwhelms the more vulnerable mate, his penumbra dims her light, his demands blot out her needs. This scenario is a fiction. Pollock's talent did not use up all the oxygen in the room. If he had married someone with a less acerbic and combative temper than Krasner's, his demands, his egotism and his fondness for the bottle might have done her in. Yet they did not do Krasner in, and the marriage turned into a remarkable working partnership that was truncated only by the car wreck on Long Island in 1956 that killed him. Pollock respected Krasner's work, and episodically tried to promote it. But the art world was not listening.

Women artists through the forties and into the fifties in New York City were the victims of a sort of cultural apartheid, and the ruling assumptions about the inherent weakness, derivativeness and silly femininity of women painters were almost unbelievably phallocentric. Thus Peggy Guggenheim, the first major collector of Pollock's work, seems to have been so jealous of Krasner's place in his life that she refused to acknowledge her as an artist. And a poll in the Cedar Bar or any other watering place of the New York avant-garde would simply have echoed Picasso's dictum that women were always "goddesses or doormats," never painters. Add to this Krasner's prickly contempt for diplomacy with

critics, and one can see why for most of her life her work was scanted as "minor," an appendage to Pollock's. Yet although she had to contend with bigotry, her dislike of groups always stopped her from presenting herself as a "feminist artist." Hence by the seventies there was no lack of denigrators on both sides of the sex war tacitly writing her off as an art widow first, a painter second. Certainly, Krasner has earned the irony with which she now looks back on the past forty years of American art.

Living with Pollock slowed her development, which had been precocious before they met. Krasner had a very full art education: in fact, no American could have had a better one in the thirties. First, rigorous academic grounding under the atelier system at the Art Students League in New York; then large-scale practical experience on the WPA murals in the thirties; finally, three years (1937–40) under the great émigré teacher Hans Hofmann, who knew the fabled phoenixes of Europe (Matisse, Kandinsky, Mondrian) and could transmit their ideas to his students. As a disciplined draftsman, Krasner was nearly the equal of de Kooning and better than Rothko or Still. Her perspective on the culture of modernism was more intellectual than Pollock's. So their matching was not that of a passive muse to a moody genius, but of one demanding eye to another that was more voracious and (at first) less sophisticated. Krasner had to carry two loads of self-doubt: his and hers. Most of the time, Pollock had only his. No wonder that Krasner's full powers as an artist did not start to show until the late fifties.

But when they came, their blossoming was remarkable. In fact, "blossoming" is hardly the word, for it suggests a soft, floral, ethereal event; one would not pick these adjectives for the tough paintings, often full of barely controlled anger, that she was to produce after 1960. Krasner's Cubist background had given her a strong sense of how to manage her pictorial field as a whole, rather than preserve, in abstraction, the choice of "figure" and "background." In the best of her fifties work, for instance *Blue Level*, 1955, the play of raggy shapes and roughly sliced strips of burlap has an impacted pictorial density. She wanted to combine Picassoan drawing, gestural and probing, with Matissean color. There are direct homages to Matisse in the show, as in the lacy cut-paper silhouettes of *Blue and Black*, 1951–53; and the Picassoan body surfaces too, a fleshy phantom, as in *Visitation*, 1957, an allusion, it seems, to Picasso's *Girl Before a Mirror*.

Krasner always wanted to paint big pictures, ones that stretched arm and eye, surfaces that rose to the challenge of scale that was embedded in Abstract Expressionism. But she was able to find a way of rapid gestural

drawing that did not depend on the skeining and overlay of thrown paint from edge to edge that Pollock had perfected. It was the brush that counted for her, and when she did fling or dribble liquid pigment on the surface, it only looked like a mannerism. But her sense of drawing was so ingrained that she could cover a huge surface with notations that never palled: shifting tempo, direction, fatness of marks; she could (literally) paint up a storm. Works such as *Charred Landscape*, 1960, or *Cobalt Night*, 1962, raise echoes of romantic "spectaculars," from Tintoretto to Kokoschka. They take a field of subject matter that Pollock was generally thought to have sealed off as his own—atmospheric space, roiled with stress and strain—and return it from the impromptu drip (which no one after Pollock could manage anyway) to the more deliberate action of the brush. When she resorted to dream imagery, as in the vortex of eyes in *Night Watch*, 1960, Krasner did not let her private demons get the better of her formal instinct.

Is there a less "feminine" woman artist of her generation? Probably not. Even Krasner's favorite pink, a domineering fuchsia that raps hotly on the eyeball at fifty paces, is aggressive, confrontational; and when her line evokes eros, its grace is modified by a rough, improvisatory movement, a distrust of quick visual acceptance. Sometimes, as in *Green Fuse*, 1968, or *Rising Green*, 1972, she refers to the palm-court, winter-garden atmosphere of late Matisse; yet the shapes are too cutting to stand as undiluted emblems of luxury. Critical of the world, she is just as hard on herself, harder than most artists half her age. This is an intensely moving exhibition, and it will suggest to all but the most doctrinaire how many revisions of postwar American art history are still waiting to be made.

Time, 1983

Milton Avery

It may be that no major American artist has a thinner dossier than Milton Avery. A New York tanner's son, a mild, unassuming man who disliked publicity and made at best a bare living from his work, he joined no groups, signed no manifestos, was linked to no political causes and said

very little about himself; when asked for his theories about art, his usual reply was: "Why talk when you can paint?" It is not wholly a surprise that his family nickname was "Bunny." Avery's one apparent act of vanity was changing his birthdate from 1885 to 1893, so that he would not seem such an old fogy to the young art student, Sally Michel, whom he met in a rooming house in Gloucester, Massachusetts, in 1924, courted and married. He was a man of absolute dedication and conviction, a painter who did almost nothing but paint; the result was an enormous oeuvre, usually a painting a day until heart trouble slowed him down in 1949 and killed him, in his eightieth year, in 1965.

The retrospective of some 150 Avery oils and watercolors, organized by Barbara Haskell to open the Whitney Museum's fall season, can show only a fraction of this output. But it will provide plenty of grounds for reassessment. Nobody could call Avery a neglected painter, but he did work against the grain. In the thirties and forties his Matissean aesthetic and his refusal to paint "social" subjects, whether of the left, as Ben Shahn, or of the right, as Thomas Hart Benton, made him an outsider in the art world. Later he would be considered rather a fuddy-duddy compared with the Abstract Expressionists, a generation behind him. He was, in that way, a victim of orthodox modernist thinking—which tended to suppose that his art had not "evolved" beyond its representational purposes, toward abstraction. In the late 1950s, when Avery was in his seventies and at the peak of his talent, his prices were about one-tenth of Pollock's. (They still are, but Pollock's works now cost millions.)

Other painters, however, had no illusions about his merits. Mark Rothko treated him as a master—appropriately, since Rothko's glowing, blur-edged rectangles, now so prized as icons of American romanticism, were influenced by Avery's landscapes. Avery's effect on American abstract painting in the fifties and sixties, not only as a stylist but as a moral example of commitment and aesthetic ambition, was much greater than has usually been supposed. His way of filling a canvas with broad fields of color "tuned" by dispersed accumulations of detail (a cluster of rocks, a flurry of waves, a knot of seaweed, a post or two) had everything to do with the compositional procedures of color-field painting in the sixties. So did his liking for dilute, discreetly modulated washes of pure pigment that stained the canvas rather than sit on it.

But to regard Avery as a potentially abstract painter who could not quite summon up the courage to drop content was a mistake. Avery was uncompromisingly a figurative artist, like his mentors: Matisse and to some extent Picasso in Europe, and in America such painters as Ryder

(with his visionary seascapes) and Twachtman. What his best works offer is a very American sense of Arcadia, a hard-won paradise of the natural world reconstructed in terms of color. Shape is reduced to the minimum: some flat silhouettes, relatively little internal texture.

Avery was not good at maintaining a suavely impastoed surface, although sometimes he could bring one off with real subtlety: the bursting fan of foam over the rocks in *White Wave,* 1954, is like a Monet haystack made of water, not grass. But the major Averys, for example *Sea and Sand Dunes,* 1955, or *Speedboat's Wake,* 1959, are thin, taut, nearly as evanescent-looking as weather itself. Their pictorial construction is achieved almost entirely through color: the weight of a red, the brooding distension of a purplish sea against a blue headland. Nothing is subordinate in such paintings, and their dialogue between feeling and repression is like nothing else in American art.

One can deplore the injustice art fashion did to Avery without, however, going to the opposite extreme of making him into a Yankee Matisse, a painter (as Hilton Kramer wrote) comparable to late Turner and late Cézanne, displaying "the kind of archetypal grandeur and sweep that is to be found only among the masterworks of modern art." At no time did Avery approach such altitudes. Of his power as a colorist, there is no reasonable doubt. The only way not to feel it in the Whitney is to wear sunglasses. But Avery as draftsman? The color weaves a seamless fabric of pleasure; the drawing punches large puritan holes in it.

As a committed modernist *à la française,* Avery treated the figure as a strictly formal affair: patch for the dress or bathing suit, patch for face, no detail. In the process he often produced a curious scragginess. The parts of the bodies rarely connect well, and have *Noli me tangere* written all over them. Sometimes his lumpish ladies on the beach suggest the drawings of James Thurber. In Matisse, no matter how reduced the outline may be or how schematic the stroke of the crayon that says eye, breast or hip, one can almost always sense the live weight of a body, its organic relationship of part to part, its accessibility to touch. This ability to translate the presence of the physical object into abbreviated signs without sensuous loss is a precondition of good figure drawing, and Avery lacked it; his attitude was too distanced, his style too mannered and crotchety.

His figures are really ideograms, and they tell us as little about bodies as his small gray painting of a diving sea bird tells us about gulls. Its interest is focused wholly within the color—that rich "gray," actually a complicated melding of green, gray and dark rose, which pulsates with such airy serenity around the white patch of a bird. In the same way, the

human figure in Avery is a locus of color, something to carry a desired area of blue or pink. When he invested his figures with the same rhythmic sureness as the flat patches of his landscapes, as in *Two Figures by the Sea*, 1963, with its subtle relationships between the blues of the left figure, the dark plane of water and the putty-colored sand, the results were exquisite. But he did not always manage to; and that is why Avery, though one of America's finer artists, a stringent and eloquent sensibility, was in no way the equal of the European masters he revered.

Time, 1982

Jackson Pollock

In the field of modern art, the most eagerly awaited show this winter is certainly the Jackson Pollock retrospective, organized by Daniel Abadie for the Centre Pompidou in Paris. It is not a full retrospective, but the cream off the milk—just as well, perhaps, in view of the exhausting prolixity and often dilute quality at the lower end of Pollock's oeuvre. But it is a concentrated and moving show, probably the last of its kind to be seen in Europe or America. "Major" Pollocks are so expensive and fragile that their owners do not want to lend them, and museums find it hard to insure them.

It is superfluous to say that Pollock is one of the legends of modern art. American culture never got over its surprise at producing him; fairly or not, he remains the prototypical American modernist, the one who not only "broke the ice"—in the generous words of his colleague Willem de Kooning—but set a canon of intensity for generations to come. His work was mined and sifted by later artists as though he were a lesser Picasso; seen through this or that critical filter, it could mean almost anything. The basic données of color-field abstraction, which treated the canvas like an enormous watercolor dyed with mat pigment, were deduced by Helen Frankenthaler, Morris Louis and Kenneth Noland from the soakings and spatterings of Pollock's work. Along with that went the "theological" view of Pollock as an ideal abstractionist obsessed by flatness, which ignored the fact that there were only four years of his life (1947–51) when

he was not making symbolic paintings based on the totemic animal or human figure.

Still, if Claes Oldenburg dribbled sticky floods of enamel over his hamburgers and plaster cakes in the sixties, he did so in homage to Pollock. If Richard Serra made sculpture by throwing molten lead to splash in a corner, or Barry Le Va scattered ball bearings and metal slugs on the floor of the Whitney Museum, the source of their gestures was not hard to find. Distorted traces of Pollock lie like genes in art-world careers that, one might have thought, had nothing to do with his. Certainly Pollock scorned decor. He was not interested in painted hedonism; and yet his practice of painting "all over"—by covering an entire field with incidents that were not arranged in hierarchies of size or emphasis—became, in a banal way, the basis of the ornamental "pattern and decoration" mode that came out of SoHo in the late seventies.

If the work was so influential, the image of the man was too. The very idea of vocation in American art was profoundly altered by the way photography and magazines projected versions of Pollock on the public. He was the first American artist to become really famous. Millions of people who never set foot in a museum had heard of Jack the Dripper. Dying at forty-four, a mean and puffy drunk with two girls in a big car, he was seen as enacting the all-American *Heldentod*, the alienated hero's death that also, and at about the same time, lifted James Dean into undecaying orbit in the national psyche. Pollock became Vincent van Gogh from Wyoming, and his car crash—the American way of death par excellence—was elevated to symbolism, as though it meant something more than a hunk of uncontrolled Detroit metal hitting a tree on Long Island.

Pollock had been more photographed (by Rudy Burckhardt, Hans Namuth and Arnold Newman, among others) than any other artist in American history. These photos, Namuth's in particular, seemed to depict not his art but his "mythic" process of creating it: a man dancing around the borders of a canvas, an arena or sacred precinct laid flat on the floor, spattering it with gouts and sprays of paint. Pollock as seen by Namuth's lens, half athlete and half priest, seemed to confirm Harold Rosenberg's bizarre notion that Abstract Expressionism is not really painting at all, not paint on canvas, but a series of exemplary "acts." And so these images of him would have their effect on the aesthetic of the happening in the sixties and on avant-garde dance in the seventies.

But where is Jack the Dripper now, the harsh, barely articulate existentialist from the West, full of chaotic energy and anal aggression? This figment is not the creature whose work one sees on the walls of the

Centre Pompidou. It is as though the eruptive violence people used to see in Pollock's work twenty-five years ago had evaporated. Instead we see the work of an aesthete, tuned to the passing nuance. Many of the passages in his "heroic" paintings of 1947–51 remind one of Monet, or even of Whistler. Fog, vagueness, translucency, the scrutiny of tiny incidents pullulating in a large field—the title Pollock gave his most ravishingly atmospheric painting, *Lavender Mist,* 1950, about sums it up. In it one sees the delicacy—at a scale that reproduction cannot suggest—with which Pollock used the patterns caused by the separation and marbling of one enamel wet in another, the tiny black striations in the dusty pink, to produce an infinity of tones.

It is what his imitators could never do, and why there are no successful Pollock forgeries; they always end up looking like vomit, or onyx, or spaghetti, whereas Pollock—in his best work, at any rate—had an almost preternatural control over the total effect of those skeins and receding depths of paint. In them, the light is always right. Nor are they absolutely spontaneous: he would often retouch the drip with a brush. So one is obliged to speak of Pollock in terms of perfected visual taste, analogous to natural pitch in music—a far cry, indeed, from the familiar image of him as a violent expressionist. As William Rubin suggests in the catalogue to this show, his musical counterpart is not the romantic and moody Bartók: it is the interlaced, twinkling and silky surface of Debussy. No wonder that it took an enthusiasm for Pollock to provoke the reevaluation of Monet's *Water Lilies* among Americans, back in the sixties.

Yet Pollock's refinement is not the whole story. His best paintings (like all serious art) are triumphs of sublimation, but they leave no doubt of the strength of feeling he had to control. From the very first, when he was trying—in studies such as *Composition with Figures and Banners,* circa 1934–38—to find painted form for the violently energetic, twisting, flame-like movement of masses, Pollock was obsessed by energy. His great theme, one might say, was the dissolution of matter into energy under extreme stress. He did not approach this by some corny process of finding painted "equivalents" for Einstein, as did so many pseudo-artists of his time. Rather, he looked back into tradition, past his teacher Thomas Hart Benton, to El Greco and, with somewhat less understanding, to Michelangelo.

Pollock's early work is permeated by the forms of Mannerist contrapposto, the serpentine figures of sixteenth-century art, which he got from his studies under Benton; and there is more than just an echo of the strange excavated space of El Greco's paintings, simultaneously vast and womb-

like, in his work after 1947. Because of his aspirations to sublimity, it is difficult to assimilate Pollock—as some authorities have wished to do—to the traditions of the Paris School. The French painter he most admired, the Surrealist André Masson, was set against the preeminently French virtues of lucidity, calm and measure. Many strands are braided and involved in Pollock's work, from Indian sand painting to the theory of Jungian archetypes, from Zen calligraphy to El Greco, from American jazz and Western landscape to the doctrines of various occult religions.

These were woven around a sense of his own modernity as an American living in the mid-twentieth century, the heir but not the colonized admirer of Picasso and Miró. It seems now that Pollock was eager to wind so many elements together, not out of some empty eclecticism (which is what our "expressionists" give us today) but in the belief that cultural synthesis might redeem us all. How can one follow this show, from its first choked and turbulent exercises, through the grapplings with chosen masters (Picasso, Masson, Miró, Orozco) in the "totemic" and "archetypal" paintings of the 1940s, into the air and vastness of *Lavender Mist* or *Autumn Rhythm*, without seeing that Pollock's career was one of the few great models of integrating search that our fragmented culture can offer?

It does Pollock no service to idolize him. This point is that he grasped his limitations and refused to mannerize them. Thus he was by no means a natural draftsman, and his best paintings of the early forties, including *The She-Wolf* and *Male and Female*, are set down with earnestness but no graphic facility. When he set up a repeated frieze of drawn motifs, as in the mural he did for Peggy Guggenheim in 1943, the result—as drawing— was rather monotonous. But when he found he could throw lines of paint in the air, the laws of energy and fluid motion made up for the awkwardness of his fist, and from then on, there was no grace that he could not claim. Compared with his paintings, the myth of Pollock hardly matters.

Time, 1982

Arshile Gorky

In the summer of 1948, the painter Arshile Gorky entered his studio barn in Sherman, Connecticut, tied a noose in a rope, chalked a farewell message on a picture crate—"Goodbye, My Loveds," it read, in broken Eng-

lish—and hanged himself. He was forty-four years old, and he had been afflicted by most of the disasters that can befall a man: cancer, the destruction of many of his works in a fire, nagging poverty and the collapse of his family. His life had been a mass of insecurities right from his childhood in Armenia, where he barely escaped a Turkish pogrom in 1915. He was an immigrant, a nomad, a natural aristocrat condemned to anguish by his pride and fastidiousness. He was also, beyond question, one of the most gifted artists in New York City, where he had landed in 1920.

Gorky's career was of inestimable significance to modern art in America. It formed a sort of Bridge of Sighs between European modernism—in particular, Surrealism—and Abstract Expressionism. Nearly all the artists of the New York School, beginning with Willem de Kooning and Jackson Pollock, were to some extent liberated and inspired by his example. The measure of his work can be taken from "Arshile Gorky, 1904–1948: A Retrospective," curated by Diane Waldman for the Guggenheim Museum in New York.

Gorky's real name was Vosdanik Adoian. His father was a carpenter in Armenia, his mother a descendant of minor nobility and priests. He renamed himself as a defiant cosmetic gesture: *Arshile,* he explained, was the Russian form of *Achilles,* and the writer Maxim Gorky was one of the current heroes of the left. (Gorky was Maxim's pseudonym too; it means "the bitter one.") None of Arshile Gorky's friends really believed he was Russian, but the name gave him some purchase on fame. It tied up with his other harmless fibs—that he had studied under Kandinsky, for instance. Above all, it solidified the impression of a romantic outsider. Henceforth, Achilles the Bitter would be seen in New York (or so he naively hoped) as an Armenian Childe Harold, a creature of exalted but conjectural origins, with no baggage but the authority of his Europeanness, no passport but modernism itself.

As a student and then a teacher in the 1920s, Gorky was hard on himself. At the core of his discipline lay the belief that art history was continuous, that no fundamental break had occurred between the high traditions of European classicism (exemplified by Paolo Uccello in the fifteenth century and Ingres in the nineteenth, both of whom he worshipped) and the work of the founding fathers of modernism: Cézanne, Gauguin, Matisse and Picasso. To understand one, you had to work through the other. Gorky was under no illusions about how much time that would take; in fact, it would be almost twenty years before he found a pictorial syntax entirely his own. In order to approach it, he simply ignored the prevailing orthodoxies of American art: Regionalism and

"social commitment." The patriotism of artists such as Grant Wood—Arcadia with silos and furrowed hills—made little sense to this inward-facing survivor of the Turkish darkness. In a famous aside, Gorky dismissed the whole range of painting about social and political causes in the thirties as "poor art for poor people"; he had seen too much political horror as a child to imagine that canvas could interpose itself between history and its victims.

The god of Gorky's youth was Cézanne. It is interesting to see how some of the trials of his Cézannist homages recur as formal motifs, changed but still recognizable, in Gorky's mature paintings. His liking for "involutes" of clenched form, knots of gully or tree in a frontally presented landscape à la Cézanne, remains visible in the intestinal couplings and imbrications of the painting *The Liver Is the Cock's Comb,* 1944. A node, then space: the rhythm is of a fist opening and closing.

Two Spanish artists, Picasso and the Catalan Surrealist Joan Miró, preside over his work from about 1930 onward. After a brief Cubist phase in the late twenties, Gorky had become obsessed (it is hardly too strong a word) with the Surrealist promise of content in art. Surrealist metamorphosis—the sliding of identity, the merging of separate layers of experience in Picasso's threatening or rapturous eroticism of the early thirties, or in Miró's painted swarms of little Boschian monsters—was the ideal way for Gorky to convey his permeable sense of the world, drenched in childhood memory, skewed and shuffled by fantasy. "Dreams form the bristles of the artist's brush," he wrote to his sister Vartoosh in 1942. "In trying to probe beyond the ordinary and the known . . . I probe beyond the confines of the finite to create an infinity. Liver. Bone. Living rocks and living plants and animals. Living dreams . . . to this I owe my debt to our Armenian art. Its hybrids, its many opposites. The inventions of our folk imagination."

This strain of biological fantasy in Gorky was balanced by an intense regard for drawing in its classical sense: the precise elaboration of ideal forms. One sees its results in his self-portrait as a child, with his mother, two versions of which occupied him from 1926 to 1942. It was based on a photograph of his eight-year-old self, pigeon-toed, shy, holding a posy, standing beside his noble-looking mother. In the old photo, her face has a spectral pallor, like the moon, and the flowers her son grasps seem to have escaped from the rich floral embroidery on her apron. It is a suggestive photograph even to a stranger, and to Gorky it must have been unbearably poignant. In the painting, the details of pattern are suppressed for the sake of broad effects—the flat shapes of sleeve and bib, the blurred

hands, the rhythmically inflected boundary line. (They would surface later in the title of a 1944 painting, *How My Mother's Embroidered Apron Unfolds in My Life.*)

Gorky's sense of draftsmanship was bound up in the "speed" of a line, its whip and springiness, its ability to convey an edge and the volume behind the edge. His fondness in the thirties for Picassoan interlocks and kidney or palette shapes, where line served only to define closed forms, gradually gave way to a more autonomous, calligraphic sort of drawing that ushered in not only his mature work but de Kooning's as well.

A small example is *Painting,* 1938, with its excited rush of winglike shapes inside the pasty background field, dragged into forms incompletely described by the brush. With this and similar paintings, Gorky arrived at the characteristic space of his mature work—a sort of cave, a blank field with intimations of depth, on which his images of organic vitality disported themselves. They were allusive and squiggly, like Miró's bugs and beasts, and they combined in provocative ways.

One could make a small inventory of Gorky's pictorial tropes—the vulval slits and intestines and phalli, the mandibles, leaves, seeds, bracts, stamens, insect bodies, wings and so on—without touching their pictorial meanings. Gorky had a lyrical sense of natural life, expressed always as the close-up or interior view rather than the landscape with figures. Filled with a sweating, preconscious glow, images such as *The Liver Is the Cock's Comb* look inward to the body and not out from it. At the same time, the best Gorkys are delicate, almost hesitant, in their pictorial means (especially in the wayward slicing of that black line across the surface), which makes the theatricality of some of his surrealist contemporaries—Matta, for instance—seem coarse.

Sometimes Gorky used paint like watercolor, sponging and wiping it, letting it run in chancy dribbles, anticipating in the forties the stain techniques that later American artists (Helen Frankenthaler, Morris Louis, Kenneth Noland) would use in the sixties. Generally, these "watercolor" Gorkys are the least satisfactory of his canvases, congested and irresolute. But in the fully finished canvases, such as *Agony* or *The Orators,* 1947, one sees the work of a master of surface, who had absorbed everything there was to learn from Miró's use of line, stain, scumbling and impasto and released it in a lyrical form of visual rhetoric, where every touch answers to a specific pressure of feeling and there are no dead or incoherent patches.

Such paintings are in the minority, despite the catalogue's efforts to present everything Gorky touched as though it were a major statement.

Curator Waldman has tried to present Gorky's career as a continuous unfolding rather than a plagiarizing apprenticeship followed by a sudden "second birth" into originality. One is grateful to see the painter whole, but one wearies of such promotional rodomontade as: "The drawings are superb, yet the paintings that followed . . . are even more extraordinary." These canonizations of the Self-Martyred Master (an Armenian-American van Gogh, in effect) are rubbish. One senses that Gorky's hesitations and failures were as essential to the man's identity as his real successes. Nobody could expect that in so short and racked a life, Gorky could have resolved all the tensions and contradictions of his work. But in those tensions, part of the map of Abstract Expressionism was drawn.

Time, 1981

Joseph Cornell

Joseph Cornell (1903–72) was not just an American artist; he was extraordinarily American, and the condition showed itself—as it did with Edgar Allan Poe—in his fixation on a dream Europe that he could never bring himself to visit. He spent most of his life in a frame house on Utopia Parkway in Queens, which he shared with his mother and his brother Robert, who had been crippled in childhood by cerebral palsy. It was a distinct comedown from his earlier years, when his father (also Joseph), who died in 1917, supported his family in elegance by buying and designing textiles. From that suburban domestic seclusion, the gray and long-beaked man would sally forth on small voyages of discovery: to Central Park in the snow, to Times Square (in the days when it was a theater district and not the rats' alley of pimps and porn it has since become), to the now disappearing bric-a-brac shops and bookstalls that used to line Fourth Avenue from the Bowery to Union Square. There he would sort through boxes of old embrowned photos, pick over trays of shells or handless watches, haunt the penny arcades, gaze mildly through shop windows at working girls whom he would never dare approach—a *flaneur*, not of self-display but of urban reverie. Collected, resorted, combined and set, the results of Cornell's dreams are now on view at New

York's Museum of Modern Art, in a retrospective organized by Kynaston McShine. Having had four exhausting months of its Picasso retrospective, the Modern can now relax—after a fashion, since Cornell was by no means a consoling eccentric—with the last artist who believed in fairies and owls' grottoes.

If the French Surrealist Louis Aragon could call himself, in the title of one of his books, *Le Paysan de Paris,* Joseph Cornell was certainly the Peasant of New York, tilling its cultural deposits and suppressed memories. They presented themselves to him as an intriguing jumble of elements, waiting to be grafted onto one another, fitted together, mated and married. He once wrote about seeing a collection of compasses in the window of a shop: "I thought, everything can be used in a lifetime, can't it, and went on walking. I'd scarcely gone two blocks when I came on another shop window full of boxes. . . . Halfway home on the train that night, I thought of the compasses and the boxes, it occurred to me to put the two together."

The result of such an encounter (one cannot be sure it was the same one) was *Object (Rose des Vents)*, which Cornell began in 1942, tinkered with for years—as was his habit, there being few precise dates or prompt solutions in his work—and finished in 1953. Emblems of travels he never undertook, dwarfed mementos, a little box of mummified waves and shrunken coasts, peninsulas, planets, things set in compartments with an air of rigorous sentiment, each of the twenty-one compass needles insouciantly pointing in a different direction: it is the log of no ordinary voyage. (Even the map on the inside of the lid depicts an excessively remote coastline, that of the Great Australian Bight.) The earth is presented not as our daily habitat but as one strange planet among others, which to Cornell it was.

He had a most allusive imagination, forever unpicking its objects, forever recombining them. As Carter Ratcliff remarks in his catalogue essay on Cornell as puritan, he was "a virtuoso of fragments, a maestro of absences. Each of his objects . . . is the emblem of a presence too elusive or vast to be enclosed in a box." The best examples of this were Cornell's cosmogonies—the "Soap Bubble Sets," made in the forties and early fifties. The metaphor on which they rely is simple, even banal: a likeness between soap bubbles—quavering, iridescent, ephemeral—and the immutable orbits of the solar system, all things linked together by their ideal roundness. You cannot keep a soap bubble in a box, or fit the planets into one; but starting with two of the Dutch clay bubble pipes he acquired at the New York World's Fair in 1939, Cornell was able to construct a tone

poem of effigies and simulacra: an eighteenth-century French planetary map, two wineglasses (distantly recalling, perhaps, Dante's crystal heaven), a cork ball, a fossil ammonite unwinding its eternal spiral, and so on.

Some aspects of Cornell's imagery look fey or precious: the Christmas frosting, bats and moss and dingly dells. There is a treacherous line between sentiment and sentimentality, particularly in his evocations of his own Edwardian childhood. Yet often his most gothic fantasies and his most fussily reverential evocations of dead Victorian ballerinas—Taglioni being a special favorite—are plucked back from the edge by Cornell's rigor as a formal artist. A box contains: that is what it is for. Cornell enhanced the sense of enclosure and limitation with the spare, strict proportions of his compartments: not without reason did he call himself a "constructivist." What one sees in the boxes is not simply memory but the exact disposition of memory, an entrancingly just division of one's attention between thought and material, metaphor and substance.

Cornell had many modes, and they ran from the white abstract grids of his "Dovecotes," filled with one repeated geometrical motif—balls, wooden cubes—to his lush, romantic tree-grottoes with birds. But to see him as a reclusive American eccentric, a man working out of private fantasy alone, is to miss one major point of his art: its reference to the work of other artists, not only the Renaissance and Mannerist painters such as Bronzino whose images he selectively filched, but those of the twentieth century.

His early collages of the thirties are indebted to Max Ernst's *Femme 100 Têtes*, and there are more subtle references—as in a conversation between equals—to Marcel Duchamp in the boxes; sometimes Cornell would crack the glass pane that protected his images, in homage to the cracks in Duchamp's *Large Glass*. But the effect was more violent, since the cracks in Cornell's glass suggested the rupture of a sanctuary, an attack on Eden. The glass pane of Cornell's boxes, the "fourth wall" of his miniature theater, is also the diaphragm between two contrasting worlds. Outside, chaos, accident and libido; inside, sublimation, memory and peace.

Cornell's modernity as an artist expressed itself in other ways too, as in his use of secondary, filtered material from print, reproduction and photography. Some of the future of Pop art nestles quietly in these boxes, and even Andy Warhol's use of the same image over and over was predicted, ten or twenty years before, by Cornell in his repeated cells. In his rustling, fiddly way, he was a more inventive artist than one sometimes thinks.

But in the end it is Cornell the poet, the provoker of reverie, who engages one's attention. Nowhere in Surrealism is there an imagery quite like his. Cornell had no interest in the revolutionary fantasies of Surrealism, in its inheritances from Sade or its dandified notions of overthrowing the bourgeois state. His work has no sexual content, no *amour fou.* He wanted his art to turn its viewers to a state of sexless contemplation. If this was childhood, it was one no child has ever known—an infancy without rage or desire. Yet what artist of his generation, which was also the generation of Surrealism, could inject more evocative intensity into his work, or fix it with such concise images?

There was nothing foolish or pulpy about Cornell's pursuit of innocence. As Ratcliff argues in his catalogue essay, it had to do with the need for redemption. That need could not be satisfied: no guilt, no culture. Cornell was a wholly urban artist, cultivated to his fingertips, and the peace he sought was not a pastorale. It was a sense of cultural tranquillity, where all images are equally artificial and thus equally lucid, permeable to the slightest breath of poetic association, linking memory and reality in its web: Heaven in a box.

Time, 1980

Edward Hopper

The Whitney Museum of American Art's retrospective of Edward Hopper, curated by Gail Levin, may be the only incontestably great museum exhibition of work by an American artist in the last ten years. The word *great* is debased today, crippled by contemporary hype, and perhaps it only clouds what it seeks to praise; yet the qualities it suggests—patient, lucid development; the transcendence of mere talent; richness and density of meaning; and a deep sense of moral dignity in the artist's refraction of his own culture—are so evident in Hopper that no other word will really do.

Hopper was eighty-four when he died in 1967, and to the end of his life he remained a somewhat misunderstood figure. The problem was not lack of fame or acceptance; he had plenty of both, at least in the United States, and even abstract painters (whose work he felt a bit threatened by)

respected his exceptional formal gifts. What people got wrong was Hopper's Americanness.

Hopper belonged to the first generation of American artists whose work voted for secession from Paris. In 1927 he stated his belief that "now or in the near future"—the caution was typical of the man—"American art should be weaned from its French mother." But by the end of the thirties his rigorous vision of American social isolation, the vacant brownstone windows and blowing curtains, the solitary coffee drinkers, the aloof houses robed in chalky light against the sky, had been incorporated (much against his will) into something much coarser: the kill-Paris chauvinism of the American Scene painters. To inattentive critics, it seemed all wrapped in the same ideological package.

"The thing that makes me so mad is the 'American Scene' business," Hopper told an interviewer in 1964. "I never tried to do the American scene as Benton and Curry and the Midwestern painters did. I think the American Scene painters caricatured America. I always wanted to do myself." Yet the idea that he was a cultural nationalist lingers on, and one still reads in current histories of American art such remarks as: "For Hopper, contact with European art meant little, even though he visited Paris three times between 1906 and 1910."

In fact, contact with Europe meant everything to this diffident, strictly raised, beanpole son of a dry-goods merchant from Nyack. Paris formed his work and gave him the analytical confidence to deal with his American motifs. By no stretch of fancy could Hopper have been called an avant-gardist. Nothing in his work suggests the influence of Cubism, let alone of abstract art, although one might be able to detect some remote Fauve echo—perhaps through Albert Marquet, a much-underrated painter whose work he had seen in Paris—in Hopper's fondness for relieving a low-toned background with a sudden distant poke of primary color: a coat, a flag or the red side of a brick chimney.

Yet if the poetic consistency of Hopper's vision now seems far more interesting than the timid vanguardism of most "advanced" American painting in the twenties and thirties, that is partly because it was grounded in nineteenth-century France, especially in Manet, whose work Hopper studied and copied. The sober painterliness of Hopper's style, its reliance on the single brush mark to enunciate form, came ultimately from Manet; so did his meticulous regard for truth of tone; and so, especially, did the "emptiness" of his compositions, with their emphatic blocks of shadow, their wide, flat planes of wall, sky or road, and their unfussy, reverberant light.

There were other influences too: Daumier for the dense impacted drawing, a touch of caricaturists such as Théophile Steinlen for the faces, Symbolist poetry for the emblematic moodiness of some of the scenes. Nor should one discount the theater, whose staging and lighting Hopper often invoked. His rooms and landscapes have a constant air of expectancy. When empty, they seem to have been just vacated by actors; when peopled, the figures are posed and lit as though by a director, and their casual "ordinariness," their lack of ostentatious drama, is itself a charade. (Levin interestingly suggests that one of Hopper's best-known images, the row of blank-windowed shops raked by horizontal light in *Early Sunday Morning*, 1930, was derived from a Broadway theater set by Jo Mielziner.)

But to inventory Hopper's presumed sources does not explain either the quality of his paintings or their grip on the viewer. In part, these come from his sense of place and his unsparing, discreet eye for the truth of a scene. Anyone who has spent time at sea knows that nothing, in terms of observation, is lacking from his images of Truro on Cape Cod, for instance *The Martha McKean of Wellfleet*, 1944. From the humping blue wave into which the hull lifts to the mild sun on the belly of the gaff-rigged sail, it is all there, fragile but immemorial, as permanent as the way the gulls on the sandspit face into the light.

For the same reasons, his great city images such as *Nighthawks*, 1942, are by now as solid a fixture of the American imagination as the novels of Raymond Chandler. Hopper's European contemporaries, especially in Weimar Germany, had also dealt with this theme—the city as condenser of loneliness. But none of them did it with the same etiquette of feeling. Hopper had no expressionist instincts. He sensed, but did not agonize over, a profound solitude, a leaning toward Thanatos that lay below American optimism. He too had lived through the Depression. Although he was the first American painter to deal with this, the natural text for his city paintings had been written by Herman Melville in the opening pages of *Moby-Dick*: "Posted like silent sentinels all around the town, stand thousands upon thousands of mortal men fixed in ocean reveries. . . . But these are all landsmen; of week days pent up in lath and plaster—tied to counters, nailed to benches, clinched to desks. How then is this? Are the green fields gone?"

Time and again, Hopper's work insists in its characteristically modest way that the green fields have indeed gone or, at least, are going; that having run out of external frontiers, Americans were faced by an impassable frontier within the self, so that the man of action had been replaced by the watcher, or voyeur, or nostalgist, whose act of watching included

the creative functions or "eye" of the artist. One's company, two's a crowd: such is the implied motto. This may be why one senses such a bond between Hopper and his seemingly aloof, disconnected human subjects. The distance between the self and the other was bridged by an acute feeling of common predicament—a much more valuable thing than the production of "heroic" or "tragic" worker figures required of American social-realist painting in the thirties.

Hopper never lost his grasp of the poetic possibilities of such utterances. It stayed with him right to the end and produced some wonderfully concise images, notably the figure of his aging wife, Jo, in *A Woman in the Sun*, 1961, standing like a caryatid on a plinth of golden light in the bare Hopperian room, wearing nothing but a cigarette. In the painting, the distances between wall and wall, window and sky, or the lit edge of the curtain and the worn radiant torso, take on something of the strangeness of the space in a good de Chirico, but they are also suffused with human meaning, an inalienable sense of the here and now. The body is enfolded by its own distances from the world, while planted solidly in a real bedroom. By the same token, the realism of the scene is also a subliminal appeal to art history: Jo facing the August light of Truro recalls any number of quattrocento Annunciations.

Hopper, one learns from Levin's catalogue, used to carry a worn quotation from Goethe everywhere with him, in his wallet. As well he might have done, for his paintings are (in the words of Goethe's title *Dichtung und Wahrheit*, poetry and truth, the dignified utterances of a man whose modest attachment to the commonplace freed him from triviality but not from doubt.

Time, 1980

Norman Rockwell

Norman Normal, such was his image: the Rembrandt of Punkin Crick, as one critic rather sourly called him, the folksy poet of a way of American life that slipped away even as he set it down. "I do ordinary people in everyday situations," Norman Rockwell once declared, "and that's about

all I do." From the day in 1916 when he walked apprehensively into the offices of *The Saturday Evening Post*—already a behemoth of the media, circulating 2 million copies a week—carrying a velvet-wrapped bundle of artwork to show to its editor, George Lorimer, Rockwell was greeted by nothing but recognition. He began his career as a professional artist at a time when large-scale magazine color illustration, thanks to improved printing technology, had become an essential element in mass culture— the television, one might say, of pre-electronic America. It was the illustrators' moment; born into it, Rockwell kept climbing. By 1920 he was the *Post*'s star draftsman. By 1925 he was a national name, and by the end of the Depression an American institution. It is unprovable, but likely, that Rockwell's work did more to bolster the insulted values of American middle-class life after the Crash than all the politicians' speeches lumped together.

When he died last week at eighty-four, at his home in Stockbridge, Massachusetts, Norman Rockwell shared with Walt Disney the astonishing distinction of being one of the two artists familiar to nearly everyone in America, rich or poor, black or white, museumgoer or not, illiterate or Ph.D. To a tiny minority of these people, Rockwell was a kitschmeister whose work it was obligatory to despise, as he turned out relentlessly sentimental icons of midcult virtue—family, kids, dogs and chickens, apple pie, Main Street and the flag—in the corniest of retardataire styles. But to most of them, Rockwell was a master: sane (unlike van Gogh), comprehensible (unlike Picasso) and perfectly attuned to what they wanted in a picture.

A *picture*, not a painting. Practically none of his audience ever saw an original Rockwell. His reputation was not made by museums and could not have been. He lived at a time when museum art tended to intimidate or bore the American audience. His work addressed its vast public through reproduction. It was seen, not as painting, but as windows opening onto slices of life. Its images had no surface. Its minute verisimilitude—as well as the exaggeration of every wink, scowl, smirk or pout on the faces of its characters—was designed to be transposed into a mass medium, to survive the passage into ink compressed but unharmed. Rockwell's best illustrations tend to have the depthless narrative clarity of a TV image, which is also the clarity of popular art. His design has a coarse, efficient impact on the eye, but what gripped his audience was his ravenous appetite for detail. Every hair of every mutt got its share of picturesque completeness. So his work acquired the same kind of relationship (or lack of it) to modern art that scale modeling has to sculpture. The shapes may

not have much aesthetic interest, but the level of effort was unstinting. Besides, the pictures were funny and corny. Nothing ironic, no bitterness, a mild poking of fun at human foibles, never subversive nuance or the flick of indignation. What you got was what you saw. Rockwell took care to ensure authenticity of detail—costumes, furniture, every object just right for period and wear; and no other artist in America had his knack of making a chicken stand still to be painted. (You rocked it back and forth, he explained, for a minute or two, and that hypnotized it for five minutes.)

This patient work served to describe a dream world of small-town America. His paintings offer Arcadia. In Rockwell's America, old people were not thrust like palsied, incontinent vegetables into nursing homes by their indifferent offspring; they stayed basking in respect on the porch, apple-cheeked and immortally spry. Kids did not snort angel dust and get one another pregnant; they stole apples and swam in forbidden water holes but said grace before meals. All soldiers were nice boys from next door; all politicians were benevolent or harmlessly bumbling (although Rockwell, faced with the distasteful chore of committing Spiro Agnew's face to canvas for the cover of *TV Guide,* once allowed that the disgraced veep was not quite his type). The great social fact was family continuity, generation on generation. It was a world unmarked by doubt, violence or greed. The mountainous Thanksgiving turkey that appears in *Freedom from Want,* one of the paintings of the Four Freedoms he made in 1943, is an image of virtuous abundance rather than extravagance, a puritan tone confirmed by the glasses of plain water on the table.

Propagated through 317 *Saturday Evening Post* covers and countless other illustrations, these consoling fictions made Rockwell into a reticent monument of Americanism. In 1976 more than 10,000 spectators and 2,000 participants turned out for a Rockwell parade during the Bicentennial in Stockbridge, where he lived with his third wife, Molly Punderson; for an hour and a half, float after float passed by, each bearing tableaux representing his most popular images—the Four Freedoms, the Boy Scouts, the doctor solemnly examining a child's broken doll, the returning GI. Corny, certainly; but no American artist had ever received such an affecting tribute. By then Rockwell had outlived his subject matter, and his fundamental decency did not permit him to ignore this fact. "I really believed," he said six years earlier, "that the war against Hitler would bring the Four Freedoms to everyone. But I couldn't paint that today. I just don't believe it. I was doing this best-possible-world, Santa-down-the-chimney, lovely-kids-adoring-their-kindly-grandpa sort of thing. And I liked it, but now I'm sick of it." In the sixties, glimpses of a less Arcadian society surfaced

in his work—most memorably, an illustration of U.S. marshals escorting a small black girl to school in Little Rock. But these did not represent the essential Rockwell as far as his public was concerned. What they wanted was a friendly world, far from the calamities of history, shielded from doubt and fear, set down in detail, painted as an honest grocer weighs ham, slice by slice, nothing skimped; and Norman Rockwell gave it to them for sixty years. He never made an impression on the history of art, and never will. But on the history of mass communication—and on the popular self-image of America—his mark was deep, and will remain indelible.

Time, 1978

Mark Rothko in Babylon

On the morning of February 25, 1970, Mark Rothko's body was found in his studio in New York. He had done a thorough job of killing himself the night before, like Seneca but without the bath; first gulping down an overdose of barbiturates and then hacking through his elbow veins with a razor. He lay, fat and exsanguinated, clad in long underwear and black socks, in the middle of a lake of blood; and this miserable death not only cast a lurid glare of publicity over his work but seemed to write the colophon to a period of American art, marking the end of Abstract Expressionism. Now most of its major figures except Willem de Kooning, Robert Motherwell and Lee Krasner were dead, whether by their own hand (Arshile Gorky) or violent accident (Jackson Pollock, David Smith) or booze, old age, the usual debilities.

Less than two years later, Rothko's children sued the painter's trustees—an art-world accountant named Bernard Reis, the painter Theodoros Stamos and Morton Levine, a professor of anthropology—for malpractice, claiming that they had conspired with Marlborough Gallery to "waste the assets" of Rothko's estate and defraud them of their proper share. The assets were 798 paintings, on which the plaintiffs set a value of $32 million—by far the largest estate valuation ever claimed for the work of an American artist. The plaintiffs contended that Reis, Stamos and Levine

had conspired to sell Rothkos to Marlborough at far less than their true market value—one parcel of 100 paintings went into the gallery's hands at a round sum of $1.8 million, or $18,000 per picture.

Thus began the "Rothko case," the main entertainment and font of gossip for the New York art world in the early 1970s. It was a Victorian melodrama of the fruitiest sort, and its characters could not convincingly be duplicated in modern fiction. Two Wronged Orphans (Kate Rothko was twenty when the writs went in, and her brother, Christopher, only eight), a trio of Wicked Trustees, the ghost of a Great Artist, a Good Judge, a revolving cast of art dealers, lawyers, critics, experts for the prosecution, other experts for the defense—and, most picturesque of all, the Foreign Plutocrat, seen by a delighted public as a combination of Fu Manchu and Goldfinger, Frank Lloyd: resident of Nassau; boss and founder of Marlborough Fine Art in London and its branches in Rome, Tokyo, Toronto and New York; holder of mysterious brass plates in Liechtenstein engraved with names such as Kunst und Finanz A.G.: not the richest dealer in the world, but one of the richest, and a copywriter's dream. There he sat in his financial control booth, ticker tapes streaming through his fingers as the spotlights and writs sought him out: *"come il Basilisco,"* as Machiavelli remarked of Cesare Borgia, *"soavamente fischiando nella sua caverna,"* like the basilisk whistling softly in its cave.

After four years of hearings and litigation, the Orphans won. The court issued a crushing verdict. The executors were thrown out for "improvidence and waste verging upon gross negligence." Reis and Stamos were found to have been in conflict of interest; as executors they could not bargain honestly with Marlborough, since the company had Reis as its salaried employee and Stamos under contract to it as an artist. All contracts between Marlborough and the Rothko estate were voided. The judge assessed fines and damages of more than $9 million against Frank Lloyd, Marlborough and the executors. Then there were the legal fees. No art dealer had ever suffered such catastrophic punishment at the hands of the law.

Lloyd went back to Nassau and immersed himself in Caribbean real estate deals, not to be seen in New York again until the court was satisfied. Bernard Reis sank into bankruptcy; Stamos, his career a wreck, returned to Greece. Marlborough Gallery is still in business, of course, but it lost more artists than Rothko; Lee Krasner, for instance, broke off relations with it and took with her the estate of her dead husband, Jackson Pollock. The winner, apart from the Orphans, was the Pace Gallery, which got the rights to the Rothko estate.

The only journalist who followed the whole labyrinthine course of the trial, Lee Seldes, wrote a detailed book on it. The paintings behaved as they were expected to, whatever the verdict: they doubled in price, and doubled again, so that by 1978 a large "prime" Rothko from the fifties would routinely fetch anything between $150,000 and $250,000. The market does not think the only good artist is a dead artist; but it knows that the best sort of artist is a dead good artist. Corpses do not paint; and as Arnold Glimcher, the director of the Pace Gallery, delicately put it during his two days of rather sanctimonious testimony for the prosecution, death creates "a finite commodity, where there once existed an open-ended one." At present, quite a lot of the finite commodity—a retrospective of Rothko's work—is to be seen at the Guggenheim Museum in New York, accompanied by a monograph written by the museum's curator of exhibitions, Diane Waldman.

In all its initial secrecy, mazy wanderings and unpleasant moral implications, the Rothko affair was frequently compared to Watergate. As Tristan Tzara observed, the politics of art are only a diminutive parody of the politics of real power. Just as the fall of Nixon filled the press with sanguine hopes of an end to corruption on the banks of the Potomac, so it was widely imagined that the Orphans' victory might provoke an appearance of a new morality in the art world. A cleansing wave would scour it, dealers and executors would become, in a collective ecstasy of self-criticism, as scrupulous as gynecologists, and a new age of ethical candor would dawn over SoHo and Fifty-seventh Street.

Of course, nothing of the sort happened. The Rothko affair was no Watergate. Rather it resembled the Profumo scandal that so entertained England fifteen years ago. After the execrations heaped on Lloyd, Reis, Stamos, Levine and the staff of Marlborough; after the evidence, opinions, moral judgments and ritual denials ejaculated by the art world at large, everyone went back to doing exactly what he or she had done before, though perhaps (for a time) a little more cautiously: just as the British parliamentarians and Beaverbrook hacks, having nailed the guilty Profumo for whoring and lying, went back to their own lying and whoring with the gusto of those who have just enjoyed a cleansing sauna.

For despite the peculiarly American illusion, enshrined in museum practice and art education, that contact with works of art is good for the morals as well as pleasurable and interesting, the ethical level of the art world is no higher than that of the fashion industry. The problem is not that some dealers are crooks or that most are unabashed opportunists; the same could be said of lawyers. It is that the whole system of the sale,

distribution and promotion of works of art is a *terrain vague*. Art dealing aspires to the status of a profession, without professional responsibilities; and it is against this background that the sins of Marlborough must be seen.

Professions are, in essence, self-regulating. They have strict codes of conduct and ethics. Their willingness to stick by these codes, enforce them on errant members and expel impenitent ones is what distinguishes professions from trades. But there is no agreement in the American art world on how critics, museum curators or dealers should behave. What are the limits of cupidity and influence-peddling? How far do they mask themselves as normal? The question of where self-dealing and conflict of interest begin is very rarely asked: the boat must not be rocked. In the 1950s, if a critic such as, say, Thomas B. Hess owned not one or two but a dozen paintings by Willem de Kooning and wrote lyrically in support of his work while giving him as much prominence as possible in *ARTnews*, the magazine Hess edited, nobody minded; it was assumed that since the works were worth only a few hundred to a few thousand dollars apiece, their value could have no bearing, not even a subliminal influence, on a man's opinions of their worth. Obviously, since the price of de Koonings has since multiplied by a factor of 1,000, to amass the same collection today and still write about the artist would have presented a later critic with grave conflict-of-interest problems.

The flight of speculative capital to the art market has done more to alter and distort the way we experience painting and sculpture in the last twenty years than any style, movement or polemic. It has shifted the ground rules of museumgoing: what was once a tomb becomes a bank vault, as every kind of art object is converted into actual or potential bullion. (Strangely enough, this phenomenon has not yet found its Walter Benjamin, although the subversion of aesthetic experience by monetary value is by now as pervasive and visible as the alteration of unique objects by mass reproduction.) Colossal sums of money are exchanged, every day, on the art market. But the market remains wholly unregulated, and almost uninspected. It is the last refuge of nineteenth-century laissez-faire capitalism, in all its self-sufficiency and arrogance. If the units of value traded in the world's galleries were debentures or commodity futures, the Securities and Exchange Commission would be watching; but there is no regulation of the American art market, nor is there likely to be. One of the reasons dealers are so resistant to the idea of outside inspection lies in the inherent irrationality of art prices. No work of art has an intrinsic value, as does a brick or a car. Its price cannot, of course, be discussed in terms

of the labor theory of value. The price of a work of art is an index of pure, irrational desire; and nothing is more manipulable than desire. It is no accident that the immense fetishism that sustains the art market should have reached its present level—a delirium whose only historical parallel was the Dutch tulip mania of the seventeenth century—just at the time when the old purposes of art, the manifestation of myth and the articulation of social meaning, have largely been taken away from painting and sculpture by film, television and photography. Only when an object is truly useless, it seems, can capitalism see it as truly priceless. The desire for all commodities and hence their price are affected in greater or lesser degrees by manipulation—apart from diamonds, art is the only commodity whose price is purely and intrinsically manipulative and has no objective relationship to any social machinery except that of "rarity" and promotion.

That is why Frank Lloyd could buy a Rothko for $18,000 and, two years later, offer it to an acquaintance of mine in Paris, Minda de Gunzburg, for $350,000: in art, a fair price is what you think you can get. Every dealer observes this rule, since there is no other; but Marlborough was caught pushing it too far. The idea that Marlborough violated some natural ethical code, let alone an accepted and shared professional standard of the art market in the 1970s, however, is an illusion. Naturally, it was also an illusion that every other major dealer in American or European contemporary art was anxious to propagate.

Lee Seldes's book adopts the posture of a hanging judge. It is a thoroughly researched and closely observed account of the trial, the evidence and the twisting and turnings of an extremely turgid case. There are, it is true, moments of laziness—where on earth did she get the idea that Henri Matisse, who died in 1954, sent a telegram of congratulation (by planchette board, no doubt) for the opening of the Rothko Chapel in Houston in 1971?—but when functioning as a court reporter she does well. As a sociologist of the art world, alas, she is quite inept. Her view of Rothko's role in the sixties is very simplistic: she presents him as a culture hero, a sort of Fisher King, ritually sacrificed by ignoble acolytes for the good of the market. She rightly points out the secretive and unregulated nature of the art market, but presumes that it is an immense hive of conspiracy—a Mafia. In fact, it is not a Mafia, merely a throwback to the days of Andrew Carnegie.

In one thoroughly discreditable chapter, she even manages to suggest that Rothko did not commit suicide at all. She quotes painter Agnes Martin, who was not even in New York at the time of his death, as saying

Rothko was murdered: "I wish you could publish," Martin informed *ARTnews* from her remote fastness in the Southwest, "that I don't believe for a minute that Rothko committed suicide. Nobody in that state of mind could. He was done in, obviously . . . by the people who have profited or have tried to profit." Seldes quotes this bit of confused gossip without producing any support for it, as though it had some evidential value in itself; and she even manages to imply, without coming out and openly saying so, that one of the trustees was the hit man. One would need to be obtuse not to grasp her drift: Marlborough, by some unspecified means, assassinated one of its most profitable artists, presumably to create that "finite commodity." Paranoid styles of journalism could hardly go further in brutal unfairness.

It is true that Rothko was a victim of the system, as some other artists are. But he was also, in every sense but the posthumously financial, his own victim. Rothko's terminal act was the climax of his long, troubled preparation for a failure that eluded him. He believed he was misunderstood. He thought the art world was out to get him. The more he railed against the misunderstandings to which he thought he was subject, the more he voiced his distrust of the art world as system, the more praise and money were decanted on him. He could deal with the praise but not with the money.

"Li medici," Leonardo opaquely scribbled in the margin of one of his manuscripts, *"mi creorono & distrussono"*: "The Medici [or "The doctors"—since the initial is lowercase, the phrase must remain ambiguous] created me and destroyed me." This lugubrious remark could well be the epigraph to Rothko's entire management of two subjects that obsessed him, patronage and health.

He managed neither well. Rothko was physically infirm, and his temperament unstable: sweetness, benevolence and a desire to please those close to him would alternate with fits of irritability and paranoia. (He especially feared younger artists and, unlike Barnett Newman, who enjoyed the role of avuncular sage to younger Minimalists, could be crushingly rude to them.) He was not a happy drunk, and toward the end of his life he drank most of the time. He therefore lived surrounded by those modern New York equivalents of the comic and dangerous clyster-wielders of seventeenth-century farce: a retinue of doctors and shrinks who listened to his self-pity, took their fees and prescribed in relays various combinations of upper and downer, Elavil, Librium, Equanil, Sinequan, capsules to make him sleep, pills to get him up, boluses to fix his ruined digestion and stop his accusing old friends of imaginary slights. There was

very little contact between Rothko's mind and his body. "He" treated "it" as though it were an appendage.

In the studio, Rothko was a man of resolution: one of the last artists in America to believe, with his entire being, that painting could carry the load of major meanings and possess the same comprehensive seriousness as the art of fresco in the sixteenth century or the novel in nineteenth-century Russia. Outside its door, he dithered. The least eddy on the surface of the day, a misplaced phone call or a mislaid bank statement, could drop him into the Black Hole. Thanks to his inability to deal with anything except his art, Rothko's last years were a tragedy of infantilism. Other than the central burden of his painting, there was no responsibility he would not delegate to someone else: and one of the things he most feared and could least cope with was money.

The Abstract Expressionists, those *quarante-huitards* of American art, had conditioned themselves never to expect wealth. Until about 1950, the idea that more than a few dozen people could ever constitute an audience for their work was inconceivable to most of them: painters, in any case, did not get rich unless, like Salvador Dalí, they sold out and betrayed their own talent. Their sense of their own worth as artists, even of their human authenticity, was deeply entangled with this distrust of material success. Rothko's, in particular, was predicated on it. Money seems to have retained for him its primitive symbolism as feces. It was a taboo substance and the idea of "handling" it alarmed him. Consequently, when the sluice gate began to open in the late fifties, as the market for modern American art began to rise and Rothko found himself potentially rich, he panicked.

Bernard Reis, the worldly old fox who understood the mysteries of money, therefore struck Rothko as a savior—the man who would relieve him of the odious task of even thinking about the stuff. So Reis did, to his own profit and Marlborough's. But one may well suppose, without attempting any excuse for Reis's delinquency as an executor, that he drifted into the habit of considering his friend Rothko as a dependent (Rothko invited this relationship), as a kind of legal minor in a world of financially adult minds, a person with the attenuated rights of a child, subject to parental control. Run along and play with your paints, sonny.

Because he could not resolve the contradiction he felt between the exalted aims of his painting and his material success, Rothko exaggerated his own sense of outsidership. This cannot have been easy to do, because from the mid-fifties onward practically no serious American critic had much doubt about the quality of Rothko's talent. It was one of the few

matters on which American critics generally agreed—so much so that Rothko, when he felt impelled to name his "persecutors," could come up with no bogey more substantial than Emily Genauer, a newspaper critic whose work is virtually forgotten today and exerted little influence even then. He had no Ruskin sermonizing against him. What generally greeted his work, especially from the art magazines, was a stream of transcendentalist rhetoric, of which this extract of Peter Selz's catalogue essay for Rothko's retrospective at the Museum of Modern Art in the sixties is a fair example: "Unlike the doors of the dead which were meant to shut out the living from the place of absolute might, even of patrician death, these paintings—open sarcophagi—moodily dare, and thus invite the spectator to enter their orifices. Indeed the whole series of these murals brings to mind an Orphic cycle; their subject might be death and resurrection in classical not Christian mythology; the artist descending to Hades to find the Eurydice of his vision. The door to the tomb opens for the artist in search of his muse."

And so on: reams of that, for years. Stuck in these "orifices," burbling its muffled threnodies to the ineffable, the higher criticism may not have served Rothko very well: but it certainly was not his foe. Indeed, it faithfully echoed the statements Rothko made about his own art, in all their exalted ambition and frequent cloudiness. The effect was to set up a screen of Malraux-like incantation around his work. "I can call spirits from the vasty deep." "Why, so can I, and so can any man; but will they come when you do call for them?" Shakespeare's eminently practical question was not asked. The frame of language around Rothko saved his work from the kind of analysis that might have argued that Rothko, far from being Yahweh's official stenographer (a role not entirely monopolized by Barnett Newman, despite his vigorous efforts), was a *painter*, a maker of visual fictions—better than most, but still prone to repetition and quite able to succumb to his own formulas and reflexive clichés. He got the same treatment as his old friend Clyfford Still. Everything Still produced, like everything Rothko produced, was widely assumed to contain the seeds of Infinity and the rudiments of Paradise: so that even Still's worst paintings, as vulgar in their thumping *Sturm und Drang* as the "Night on Bald Mountain" sequence in Disney's *Fantasia*, tended to be assigned a spiritual value (reflected in price) which went far beyond the limits of ordinary modern art.

Rothko never went in for Still's brand of romantic melodrama. He was an aesthete to the fingertips, the American prolongation of a line drawn from Mallarmé to late Monet. Kenneth Clark once remarked that

Fuseli's goal was to render the grandest scenes of Shakespeare in the language of Michelangelo: the ambition was also the problem. In the same way, Rothko's dilemma was that he wanted to employ the vocabulary of Symbolism—the palpitating, indeterminate space, the excruciatingly refined, sensuous color, the obsession with nuance, the presence of Mallarmé's "negated object"—to render the patriarchal despair and elevation of the Old Testament.

There was a deeply rabbinical streak in Rothko's character: he was a Russian Jew who wanted to be a great religious artist. "We assert," ran one of his formal statements in the 1940s, "that the subject matter is crucial and only that subject matter is valid which is tragic and timeless." In effect, he wanted to recapitulate the sense of awe, dread or numinous presence that had been associated with the human figure in art (and lost, he thought, in the Renaissance); but to do it in an abstract manner. "Without monsters and gods, art cannot enact our drama; art's most profound moments express this frustration. . . . For me the great achievements of the centuries in which the artist accepted the probable and familiar as his subjects were the pictures of the single human figure—alone in a moment of utter immobility."

The "frustration" of which Rothko spoke was real, and it lay at the core of his art, lending it an exemplary air of cultural impossibility, a brave bet against loaded odds. His painting accumulated resonance by appealing to myth; but the myths were in decline and could only nominally be revived by painting. In this way Rothko's art became more self-referential than a genuine religious art could ever be. The pathos of his late work is often that of failure: the most ambitious example being the large chapel filled with gloomy, near-monochrome canvas he did on commission for Jean and Dominique de Menil in Houston. The emptiness of this work is not the deliberate, polemic emptiness of Minimalism, but a sort of yearning vacancy, a sense of waiting for an epiphany that never comes. In its desire to raise the condition of modernist doubt to a mythic level, Rothko's work could be (and still is) very moving. In an age of iconography, he might have become a religious artist (if he had been able to overcome his severe limitations as a draftsman). He did not live in such an age.

Consequently, most of the vital relationships among myth, dogma, symbol and personal inspiration that gave religious artists from Cimabue to Blake their essential subjects were denied to Rothko. Claud Cockburn, in one of his volumes of autobiography, recounts how as a reporter in the thirties he had gone to interview a big American hot-gospeler who had

crossed the Atlantic to convert England. Cockburn pressed this mild and hearty soul for a description of God. What was his ideated form of the deity? The evangelist allowed that he never imagined God as an old man with a beard in the sky. "My conception of Him," he told the reporter, "is something like a great, oblong, luminous blur."

That was all Rothko had, by way of religious imagery. In anguish, the blur was dark; in repose and happiness, suffused with the peachiest and most delicately tuned colors. In their similarity to landscape, the august blurs stacked up the canvas often connect Rothko's work to an older American tradition, that of Luminist painters such as Kensett and Heade: horizon, mountain and light seen as God's handiwork, the Great Church of Nature.

His format, which he hit on in 1949 and repeated with minor variations for the next twenty years, gave him an excellent matrix in which to experiment with color. In effect, it abolished practically everything but color. One does not read Rothko's tiers and veils of paint primarily as form: they are vehicles for color sensation, exquisitely set forth in a technique that descends from Rothko's watercolors of the 1940s—wash upon wash of thinned pigment soaked into the surface, filtering the light. There is a rhapsodic airiness to the best of Rothko's paintings in the fifties; something almost voluptuous in their wholehearted abandonment to feeling. On that score alone, Rothko was a major though uneven painter. But we are not talking about an artist on the level of Picasso, or Mondrian, or even Jackson Pollock. One may doubt if his achievement, impressive as it was and sustained against such crippling emotional debility, was quite enough to sustain the orphic prating of relentlessly sublime performance, of continuous production of awe, which serves to accredit Rothko's work in museums and the marketplace.

Diane Waldman, however, is in no doubt about the matter. Her book supplies useful source material on Rothko's life and his stylistic relationships with other artists; but when it comes to interpretation, out come the violins, the woodwinds, the kettledrums, everything. Rothko's Houston murals "create a total environment, a unified atmosphere of all-encompassing, awe-inspiring spirituality." By the end of his life, the tragic hero of her text "had attained a harmony, an equilibrium, a wholeness in the Jungian sense, that enabled him to express universal truths in his breakthrough works, fusing the conscious with the unconscious, the finite and the infinite, the equivocal and the unequivocal, the sensuous and the spiritual." (No wonder that her essay, apparently in homage to Lesley Blanch's *The Wilder Shores of Love*, is entitled "The Farther Shore of Art.")

If one feels impatient with such bombast, it is not merely as a result of a dislike of vagueness. The language of Rothko appreciation tends to be coercive, because of a deep uncertainty about the nature of his art. Sublime, sublime, sublime, sublime: the reflexes go clickety-clack, all the way down the Guggenheim ramp. What role does cultural nationalism— America's illusion that it is the unchallengeable center of cultural events— play in the persistent desire to treat Rothko as though he were an American blend of Turner and Michelangelo? How far are such responses dictated by the uneasy feeling that if verbose obeisances to the Ineffable stopped, the work might suffer? To what extent did Rothko's suicide confer a profundity on the paintings that, had he lived, they might not quite have had? But how can one dare think such things, in the presence of blue-chip masterpieces?

The New York Review of Books, 1978

Andy Warhol

To say that Andy Warhol is a famous artist is to utter the merest commonplace. But what kind of fame does he enjoy? If the most famous artist in America is Andrew Wyeth, and the second most famous is LeRoy Neiman (Hugh Hefner's court painter, inventor of the *Playboy* femlin, and drawer of football stars for CBS), then Warhol is the third. Wyeth, because his work suggests a frugal, bare-bones rectitude, glazed by nostalgia but incarnated in real objects, which millions of people look back upon as the lost marrow of American history. Neiman, because millions of people watch sports programs, read *Playboy* and will take any amount of glib Ab-Ex slather as long as it adorns a recognizable and pert pair of jugs. But Warhol? What size of public likes his work, or even knows it at first hand? Big: and growing bigger: but not as big as Wyeth's or Neiman's.

To most of the people who have heard of him, he is a name handed down from a distant museum culture, stuck to a memorable face: a cashiered Latin teacher in a pale fiber wig, the guy who paints soup cans and knows all the movie stars. To a smaller but international public, he is the last of the truly successful social portraitists, climbing from face to face in a silent delirium of snobbery, a man so interested in elites that he has his

own society magazine. But Warhol has never been a popular artist in the sense that Andrew Wyeth is or Sir Edwin Landseer was. That kind of popularity entails being seen as a normal (and hence, exemplary) person from whom extraordinary things emerge.

Warhol's public character for the last twenty years has been the opposite: an abnormal figure (silent, homosexual, withdrawn, eminently visible but opaque, and a bit malevolent) who praises banality. He fulfills Stuart Davis's definition of the new American artist, "a cool Spectator-Reporter at an Arena of Hot Events." But no mass public has ever felt at ease with Warhol's work. Surely, people feel, there must be something empty about a man who expresses no strong leanings, who greets every-thing with the same "Uh, gee, great." Art's other Andy, the Wyeth, would not do that. Nor would the midcult heroes of *The Agony and the Ecstasy* and *Lust for Life*. Vinnie and Mike would discriminate between experiences, as artists are meant to do for us.

Warhol has long seemed to hanker after the immediate visibility and popularity that "real" stars such as Liz Taylor have, and sometimes he is induced to behave as though he really had it. When he did ads endorsing Puerto Rican rum or Pioneer radios, the art world groaned with secret envy: what artist would not like to be in a position to be offered big money for endorsements, if only for the higher pleasure of refusing it? But his image sold little rum and few radios. After two decades as voyeur in chief to the marginal and then the rich, Warhol was still insufficiently loved by the world at large; all people saw was that weird, remote guy in the wig. Meanwhile, the gesture of actually being in an ad contradicted the basis of Warhol's fame within the art world. To the extent that his work was subversive at all (and in the sixties it was, slightly), it became so through its harsh, cold parody of ad-mass appeal—the repetition of brand images such as Campbell's soup or Brillo or Marilyn Monroe (a star being a human brand-image) to the point that a void is seen to yawn beneath the discourse of promotion.

The tension this set up depended on the assumption, still in force in the sixties, that there was a qualitative difference between the perceptions of high art and the million daily diversions and instructions issued by popular culture. Since then, Warhol has probably done more than any other living artist to wear that distinction down; but while doing so, he has worn away the edge of his work. At the same time, he has difficulty moving toward that empyrean of absolute popularity where LeRoy Nei-man sits, robed in sky-blue polyester. To do that, he must make himself accessible. But to be accessible is to lose magic.

The depth of this quandary, or perhaps its relative lack of shallowness, may be gauged from a peculiar exhibition mounted by the Los Angeles Institute of Contemporary Art: a show of portraits of sports stars, half by Neiman and half by Warhol, underwritten by Playboy Enterprises. It was a promotional stunt (LAICA needs money, and exhibitions of West Coast conceptualists do not make the turnstiles rattle), but to give it a veneer of respectability the Institute felt obliged to present it as a critique of art-world pecking orders. Look, it said in effect: Neiman is an arbitrarily rejected artist, whose work has much to recommend it to the serious eye (although what, exactly, was left vague); we will show he is up there with Warhol. This effort backfired, raising the unintended possibility that Warhol was down there with Neiman. The Warhol of yore would not have let himself in for such a fiasco as the LAICA show. But then he was not so ostentatiously interested in being liked by a mass public. This may be why his output for the last decade or so has floundered—he had no real subjects left; why *Interview,* his magazine, is not so much a periodical as a public-relations sheet for the people in the fashion and film industries whose attention Warhol craves; and why books like *Exposures* and *POPism* get written.

Between them, *POPism: The Warhol Sixties* and *Exposures* give a fairly good picture of Warhol's concerns before and after 1968, the year he was shot. Neither book has any literary merit, and the writing is chatty with occasional flicks of diminuendo irony—just what the package promises. *POPism* is mostly surface chat, *Exposures* entirely so. For a man whose life is subtended by obsessive gossip, Warhol comes across as peculiarly impervious to character. "I never knew what to think of Eric," he says of one of his circle in the sixties, a scatterbrained lad with blond ringlets whose body, a postscript tells us, was found in the middle of Hudson Street, unceremoniously dumped there, according to "rumors," by fellow partygoers after he overdosed on heroin. "He could come out with comments that were so insightful and creative, and then the next thing out of his mouth would be something so dumb. A lot of the kids were that way, but Eric was the most fascinating to me because he was the most extreme case—you absolutely couldn't tell if he was a genius or a retard."

Of course, poor Eric Emerson—like nearly everyone else around the Factory, as Warhol's studio came to be known—was neither. They were all cultural space-debris, drifting fragments from a variety of sixties subcultures (transvestite, drug, S&M, rock, Poor Little Rich, criminal, street and all their permutations); talent was thin and scattered in this tiny universe. It surfaced in music, with figures such as Lou Reed and John

Cale; various punk groups in the seventies were the offspring of Warhol's Velvet Underground. But people who wanted to get on with their own work avoided the Factory, while the freaks and groupies and curiosity-seekers who filled it left nothing behind them.

Its silver-papered walls were a toy theater in which one aspect of the sixties in America, the infantile hope of imposing oneself on the world by terminal self-revelation, was played out. It had a nasty edge, which forced the paranoia of marginal souls into some semblance of style, a reminiscence of art. If Warhol's "Superstars," as he called them, had possessed talent, discipline or stamina, they would not have needed him. But then, he would not have needed them. They gave him his ghostly aura of power. If he withdrew his gaze, his carefully allotted permissions and recognitions, they would cease to exist; the poor ones would melt back into the sludgy undifferentiated chaos of the street, the rich ones end up in some suitable clinic. That was why Valerie Solanas, who shot him, said Warhol had too much control over her life.

Those whose parents accused them of being out of their tree, who had unfulfilled desires and undesirable ambitions, and who felt guilty about it all, therefore gravitated to Warhol. He offered them absolution, the gaze of the blank mirror that refuses all judgment. In this, the camera (when he made his films) deputized for him, collecting hour upon hour of tantrum, misery, sexual spasm, campery and nose-picking trivia. It too was an instrument of power—not over the audience, for whom Warhol's films were usually boring and alienating, but over the actors.

In this way the Factory resembled a sect, a parody of Catholicism enacted (not accidentally) by people who were or had been Catholic, from Warhol and Gerard Malanga on down. In it, the rituals of dandyism could speed up to gibberish and show what they had become—a hunger for approval and forgiveness. These came in a familiar form, perhaps the only form American capitalism knows how to offer: publicity.

Warhol was the first American artist to whose career publicity was truly intrinsic. Publicity had not been an issue with artists in the forties and fifties. It might come as a bolt from the philistine blue, as when *Life* made Jackson Pollock famous; but such events were rare enough to be freakish, not merely unusual. By today's standards, the art world was virginally naive about the mass media and what they could do. Television and the press, in return, were indifferent to what could still be called the avant-garde. Nobody wanted to publish wads of copy about the life-styles, decorating schemes, marriages and opinions of artists, let alone their price levels, which were uninterestingly low. Publicity meant a notice in *The*

New York Times, a paragraph or two long, followed eventually by an article in *ARTnews,* which perhaps five thousand people would read. Anything else was regarded as extrinsic to the work—something to view with suspicion, at best an accident, at worst a gratuitous distraction. One might woo a critic, but not a fashion correspondent, a TV producer or the editor of *Vogue.* To be one's own PR outfit was, in the eyes of the New York artists of the forties or fifties, nearly unthinkable—hence the contempt they felt for Salvador Dalí. But in the 1960s all that began to change, as the art world shed its idealist prejudices and its sense of outsidership and began to turn into the American Art Industry.

Warhol became the emblem and thus, to no small extent, the instrument of this change. Inspired by the example of Truman Capote, he went after publicity with the voracious singlemindedness of a feeding bluefish. And he got it in abundance, because the sixties in New York reshuffled and stacked the social deck: press and television, in their pervasiveness, constructed a kind of parallel universe in which the hierarchical orders of American society—vestiges, it was thought, but strong ones, and based on inherited wealth—were replaced by the new tyranny of the "interesting." Its rule had to do with the rapid shift of style and image, with the assumption that all civilized life was discontinuous and worth only a short attention span: better to be Baby Jane Holzer than the Duchesse de Guermantes.

To enter this turbulence, one might need only be born—as Warhol noted in his lasting quip: "In the future, everyone will be famous for fifteen minutes." But to remain in it, to stay drenched in the glittering spray of promotional culture, you needed other qualities. One was an air of detachment; the dandy must not look into the lens. Another was an acute sense of nuance, an eye for the eddies and trends of fashion, which would regulate the other senses and appetites and so give detachment its point.

Diligent and frigid, Warhol had both to a striking degree. He was not a "hot" artist, a man mastered by a particular vision and anxious to impose it on the world. Jackson Pollock had declared that he wanted to be Nature. Warhol, by contrast, wished to be Culture—and Culture only: "I want to be a machine." Many of the American artists who rose to fame after Abstract Expressionism, among them Jasper Johns and Robert Rauschenberg, had worked in commercial art to stay alive, and other Pop artists besides Warhol, of course, drew freely on the vast reservoir of American ad-mass imagery. But Warhol was the only one who embodied a culture of promotion as such. He had enjoyed a striking success as a commercial

artist, doing everything from shoe ads to recipe illustrations in a blotted, perky line derived from Ben Shahn. He understood the tough little world, not yet an "aristocracy" but trying to become one, where the machinery of fashion, gossip, image-bending and narcissistic chic tapped out its agile pizzicato. He knew packaging and could teach it to others.

Warhol's social visibility thus bloomed in an art world that, during the sixties, became more and more concerned with the desire for and pursuit of publicity. Not surprisingly, many of its figures in those days— crass though genuinely art-loving social climbers such as the Sculls, popinjays such as Henry Geldzahler, and the legion of insubstantial careerists who leave nothing but press cuttings to mark their passage— tended to get their strategies from Warhol's example.

Above all, the working-class kid who had spent so many thousands of hours gazing into the blue, anesthetizing glare of the TV screen, like Narcissus into his pool, realized that the cultural moment of the mid-sixties favored a walking void. Television was producing an affectless culture. Warhol set out to become its affectless culture hero. It was no longer necessary for an artist to act crazy, like Salvador Dalí. The old style of hot dandyism was on its way out. Other people could act crazy for you: that was what Warhol's Factory was all about. By the end of the sixties craziness was becoming normal, and half of America seemed to be immersed in some tedious and noisy form of self-expression. Craziness no longer suggested uniqueness. Warhol's bland translucency, as of frosted glass, was much more intriguing.

Like Chauncey Gardiner, the hero of Jerzy Kosinski's *Being There*, he came to be credited with sibylline wisdom because he was an absence conspicuous by its presence—intangible, like a TV set whose switch nobody could find. Disjointed public images—the Campbell's soup cans, the Elvises and Lizzes and Marilyns, the electric chairs and car crashes, and the jerky, shapeless pornography of his movies—would stutter across this screen, would pour from it in a gratuitous flood. But the circuitry behind it, the works, remained mysterious. (Had he made a point of going to the shrink, as did other New York artists, he would have seemed rather less interesting to his public.) "If you want to know all about Andy Warhol," he told an interviewer in those days, "just look at the surface of my paintings and films and me, and there I am. There's nothing behind it." This kind of coyness looked, at the time, faintly threatening. For without doubt, there was something strange about so firm an adherence to the surface. It seemed to go against the grain of high art as such. What had become of the belief, so dear to modernism, that the power and cathartic necessity of art flowed from the unconscious, through the knot-

work of dream, memory and desire, into the realized image? No trace of it; the paintings were all superficies, no symbol. Their blankness seemed eerie.

They did not share the reforming hopes of modernism. Neither Dada's caustic anxiety, nor the utopian dreams of the Constructivists; no politics, no transcendentalism. Occasionally there would be a slender, learned spoof, as when Warhol did black-and-white paintings of dance-step diagrams in parody of Mondrian's black-and-white *Fox Trot*, 1930. But in general, his only subject was detachment: the condition of being a spectator, dealing hands-off with the world through the filter of photography.

Thus his paintings, tremendously stylish in their rough silk-screening, full of slips, mimicked the dissociation of gaze and empathy induced by the mass media: the banal punch of tabloid newsprint, the visual jabber and bright sleazy color of TV, the sense of glut and anesthesia caused by both. Three dozen Elvises are better than one; and one Marilyn, patched like a gaudy stamp on a ground of gold leaf (the favorite color of Byzantium, but of drag queens too), could become a sly and grotesque parody of the Madonna fixations of Warhol's own Catholic childhood, of the pretentious enlargement of media stars by a secular culture, and of the similarities between both. The rapid negligence of Warhol's images parodied the way mass media replace the act of reading with that of scanning, a state of affairs anticipated by Ronald Firbank's line in *The Flower Beneath the Foot:* "She reads at such a pace . . . and when I asked her where she had learnt to read so quickly she replied, 'On the screens of Cinemas.' "

Certainly, Warhol had one piercing insight about mass media. He would not have had it without his background in commercial art and his obsession with the stylish. But it was not an aperçu that could be developed: lacking the prehensile relationship to experience of a Claes Oldenburg (let alone a Picasso), Warhol was left without much material. It is as though, after his near death in 1968, Warhol's lines of feeling were finally cut; he could not appropriate the world in such a way that the results meant much as art, although they became a focus of ever-increasing gossip, speculation and promotional hooha. However, his shooting reflected back on his earlier paintings—the prole death in the car crashes, the electric chair with the sign enjoining SILENCE in the chamber of death, the taxidermic portraits of the dead Marilyn—lending them a fictive glamour as emblems of fate. Much breathless prose was therefore expended on Andy, the Silver Angel of Death, and similar conceits.

Partly because of this gratuitous aura, the idea that Warhol was a

major interpreter of the American scene dies hard—at least in some quarters of the art world. "Has there ever been an artist," asked Peter Schjeldahl at the end of a panegyric on Warhol's fatuous show of society portraits at New York's Whitney Museum of American Art two years ago, "who so coolly and faithfully, with such awful intimacy and candor, registered important changes in a society?" (Well, maybe a couple, starting with Goya.) Critics bring forth such borborygms when they are hypnotized by old radical credentials. Barbara Rose once compared his portraits, quite favorably and with a straight face, to Goya's. John Coplans, former editor of *Artforum,* wrote that his work "almost by choice of imagery, it seems, forces us to squarely face the existential edge of our existence."

In 1971 an American Marxist named Peter Gidal, later to make films as numbing as Warhol's own, declared that "unlike Chagall, Picasso, Rauschenberg, Hamilton, Stella, most of the Cubists, Impressionists, Expressionists, Warhol never gets negatively boring"—only, it was implied, positively so, and in an ideologically bracing way. If the idea that Warhol could be the most interesting artist in modern history, as Gidal seemed to be saying, now looks a trifle *voulu,* it has often been declared on the left—especially in West Germany, where, by one of those exquisite contortions of social logic in which the Bundesrepublik seems to specialize, Warhol's status as a blue chip was largely underwritten by critics praising his "radical" and "subversive" credentials.

Thus critic Rainer Crone, in 1970, claimed that Warhol was "the first to create something more than traditional 'fine art' for the edification of a few." By mass-producing his images of mass production, to the point that the question of who actually made some of his output in the sixties has had to be diplomatically skirted by dealers ever since (much of it, and not just the prints that exist in uncontrolled editions, was run off by assistants and merely signed by Warhol), the pallid maestro had entered a permanent state of "anesthetic revolutionary practice"—delicious phrase! In this way the "elitist" forms of middle-class idealism, so obstructive to art experience yet so necessary to the art market, had been short-circuited. Here, apparently, was something akin to the "art of five kopecks" Anatoly Lunacharsky had called on the Russian avant-garde to produce after 1917. Not only that: the People could immediately see and grasp what Warhol was painting. Let them eat soup! They were used to movie stars and Coke bottles. To make such bottles in a factory in Atlanta and sell them in Abu Dhabi was a capitalist evil; to paint them in a Factory in New York and sell them in Düsseldorf, an act of cultural criticism.

These efforts to assimilate Warhol to a "radical" aesthetic now have a musty air. The question is no longer whether such utterances were true or false—Warhol's later career made them absurd anyway. The real question is: How could otherwise informed people in the sixties and seventies imagine that the man who would end up running a gossip magazine and cranking out portraits of Sao Schlumberger for a living was really a cultural subversive? The answer probably lies in the change that was coming over their own milieu, the art world itself.

Warhol did his best work at a time (1962–68) when the avant-garde, as an idea and a cultural reality, still seemed to be alive, if not well. In fact it was collapsing from within, undermined by the encroaching art market and the total conversion of the middle-class audience; but few people could see this at the time. The ideal of a radical, "outsider" art of wide social effect had not yet been acknowledged as fantasy. The death of the avant-garde has since become such a commonplace that the very word has an embarrassing aura. In the late seventies, only dealers used it; today, not even they do, except in SoHo. But in the late sixties and early seventies, avant-garde status was still thought to be a necessary part of a new work's credentials. And with the political atmosphere of the time, it was mandatory to claim some degree of "radical" political power for any nominally avant-garde work.

Thus Warhol's silence became a Rorschach blot, onto which critics who admired the idea of political art—but would not have been seen dead within a hundred paces of a realist painting—could project their expectations. As the work of someone such as Agam is abstract art for those who hate abstraction, so Warhol became realist art for those who despised representation as "retrograde." If the artist, blinking and candid, denied that he was in any way a "revolutionary" artist, his admirers knew better; the white mole of Union Square was just dissimulating. If he declared that he was interested only in getting rich and famous, as was everyone else, he could not be telling the truth; instead, he was parodying America's obsession with celebrity, the better to deflate it. From the recesses of this exegetical knot, anything Warhol did could be taken seriously. In a review of *Exposures,* critic Carter Ratcliff solemnly asserted that Warhol "is secretly the vehicle of artistic intentions so complex that he would probably cease to function if he didn't dilute them with nightly doses of the inane." But for the safety valve of Studio 54, he would presumably blow off like the plant at Three Mile Island, scattering the culture with unimagined radiations.

One wonders what these "artistic intentions" may be, since Warhol's

output for the last decade has been concerned more with the smooth development of product than with any discernible insights. As Harold Rosenberg remarked, "In demonstrating that art today is a commodity of the art market, comparable to the commodities of other specialized markets, Warhol has liquidated the century-old tension between the serious artist and the majority culture." It scarcely matters what Warhol paints; for his clientele, only the signature is fully visible. The factory runs, its stream of products is not interrupted, the market dictates its logic. What the clients want is *a Warhol*, a recognizable product bearing his stamp. Hence any marked deviation from the norm, such as an imaginative connection with the world might produce, would in fact seem freakish and unpleasant: a renunciation of earlier products. Warhol's sales pitch is to soothe the client by repetition while preserving the fiction of uniqueness. Style, considered the authentic residue of experience, becomes its commercial-art cousin, styling.

Warhol has never deceived himself about this: "It's so boring painting the same picture over and over," he complained in the late sixties. So he must introduce small variations into the package, to render the last product a little obsolete (and to limit its proliferation, thus assuring its rarity), for if all Warhols were exactly the same there would be no market for new ones. Such is his parody of invention, which now looks normal in a market-dominated art world. Its industrial nature requires an equally industrial kind of facture: this consists of making silk screens from photos, usually Polaroids, bleeding out a good deal of the information from the image by reducing it to monochrome, and then printing it over a fudgy background of decorative color, applied with a wide loaded brush to give the impression of verve. Only rarely is there even the least formal relationship between the image and its background.

This formula gave Warhol several advantages, particularly as a portraitist. He could always flatter the client by selecting the nicest photo. The lady in Texas or Paris would not be subjected to the fatigue of long scrutiny; in fact she would feel rather like a *Vogue* model, whether she looked like one or not, while Andy did his stuff with the Polaroid. As social amenity, it was an adroit solution; and it still left room for people who should know better, for instance art historian Robert Rosenblum, in his catalogue essay to Warhol's portrait show at the Whitney in 1979, to embrace it: "If it is instantly clear that Warhol has revived the visual crackle, glitter, and chic of older traditions of society portraiture, it may be less obvious that despite his legendary indifference to human faces, he has also captured an incredible range of psychological insights among

his sitters." Legendary, incredible, glitter, insight: stuffing to match the turkey.

The perfunctory and industrial nature of Warhol's peculiar talent, and the robotic character of the praise awarded it, appear most baldly of all around his prints, which were recently given a retrospective at Castelli Graphics in New York and a catalogue raisonné by one of his German enthusiasts. "More than any other artist of our age," it gushes, "Andy Warhol is intensively preoccupied with concepts of time"; quite the little Proust, in fact. "His prints above all reveal Andy Warhol as a universal artist whose works show him to be thoroughly aware of the great European traditions and who is a particular admirer of the glorious French *Dixneuvième,* which inspired him to experience and to apply the immanent qualities of 'pure' peinture." No doubt something was lost in translation, but it is difficult to believe that the author even looked at the prints he speaks of. Nothing could be flatter or more perfunctory, or have less to do with those "immanent qualities of 'pure' peinture," than Warhol's recent graphic efforts. Their most discernible quality is their transparent cynicism and their Franklin Mint approach to subject matter. What other "serious" artist, for instance, would contemplate doing a series entitled *Ten Portraits of Jews of the Twentieth Century,* featuring Kafka, Buber, Einstein, Gertrude Stein and Sarah Bernhardt? But then, in the moral climate of today's art world, why not treat Jews as a special-interest subject like any other? There is a big market for bird prints, dog prints, racing prints, hunting prints, yachting prints; why not Jew prints?

Yet whatever merits these mementos may lack, nobody could rebuke their author for inconsistency. The Jew as Celebrity: it is of a piece with the ruling passion of Warhol's career, the object of his fixated attention— the state of being well known for well-knownness. That was all *Exposures* was about—a photograph album of film stars, rock idols, politicians' wives, cocottes, catamites and assorted bits of International White Trash baring their teeth to the socially emulgent glare of the flash bulb: I am flashed, therefore I am. It is also the sole subject of Warhol's house organ, *Interview.*

Interview began as a poor relative of *Photoplay,* subtitled "Andy Warhol's Movie Magazine." But by the mid-seventies it had purged itself of the residue of the "old" Factory and become a feuilleton aimed largely at the fashion trade—and this was a natural step, if we consider Warhol's background. With the opening of Studio 54 in 1977, the magazine found its "new" Factory, its spiritual home. It then became a kind of marionette theater in print: exactly the same figures, month after month, would cavort

in its tiny proscenium, do a few turns, suck or snort something and tittup off again—Bianca, Margaret Trudeau, Marisa, Halston and the rest of the fictive stars who replaced the discarded Superstars of the Factory days.

Because the magazine is primarily a social-climbing device for its owner and staff, its actual gossip content is quite bland. Many stones lie unturned but no breech is left unkissed. As a rule the interviews, taped and transcribed, sound as though a valet were asking the questions, especially when the subject is a regular advertiser in the magazine. Sometimes the level of gush exceeds the wildest inventions of S. J. Perelman. "I have felt since I first met you," one interviewer, archaeologist Iris Love, exclaims to Diane von Furstenberg, "that there was something extraordinary about you, that you have the mystic sense and quality of a pagan soul. And here you are about to introduce a new perfume, calling it by an instinctive, but perfect name." And later:

> Q. I have always known of your wonderful relationship with your children. By this, I think you symbolize a kind of fidelity. Why did you bring back these geese from Bali?
> A. I don't know.
> Q. You did it instinctively.
> A. Yes, it just seemed right. One thing after the other . . . It's wild.
> Q. There's something about you that reminds me of Aphrodite.
> A. Well, she had a good time.

Later, Aphrodite von F. declares that "I don't want to be pretentious, [but] I was just in Java and it has about 350 active volcanoes. I'll end up throwing myself into one. I think that would be very glamorous."

In politics *Interview* has one main object of veneration: the Reagans, around whose elderly flame the magazine flutters like a moth, waggling its little thorax at Jerry Zipkin, hoping for invitations to White House dinners or, even better, an official portrait commission for Warhol. Moving toward that day, it is careful to run flattering exchanges with anyone remotely connected with White House protocol and PR. It even went so far as to appoint Doria Reagan, a daughter-in-law, as a "contributing editor." To its editor Robert Colacello, Reagan is Caesar Augustus Americanus and Nancy a blend of Evita and the Virgin Mary, though in red.

Warhol seems to share this view, although he did not always do so. For most of the seventies he was in some nominal way a liberal Democrat, like the rest of the art world—doing a campaign poster for McGovern,

trying to get near Teddy Kennedy. Nixon, who thought culture was for Jews, would never have let him near the White House. When Warhol declared that Gerald Ford's son Jack was the only Republican he knew, he was telling some kind of truth. However, two things changed this in the seventies: the Shah and the Carter administration.

One of the odder aspects of the late Shah's regime was its wish to buy modern Western art, so as to seem "liberal" and "advanced." Seurat in the parlor, SAVAK in the basement. The former Shahbanou, Farah Diba, spent millions of dollars exercising this fantasy. Nothing pulls the art world into line faster than the sight of an imperial checkbook. There was a slump in the market at the time, and shrewd figures including Leo Castelli thought that the creation of an oil-rich modern-art museum run at the will of the art-loving wife of a despot in Tehran might reinflate the system, singlehandedly pumping demand back into it. Not since the death of Tamerlane had there been so much kissing of Persian arse. The conversion of the remnants of the American avant-garde into ardent fans of the Pahlavis was one of the richer social absurdities of the period. Dealers started learning Farsi, Iranian fine-arts exchange students who happened to be the sons or daughters of the Tehran *gratin* acquired a sudden cachet as research assistants, and invitations to the Iranian embassy—not the hottest tickets in town before 1972—were now much coveted.

The main beneficiary of this was Warhol, who became the semiofficial portraitist to the Peacock Throne. When the *Interview* crowd were not at the tub of caviar in the consulate like pigeons around a birdbath, they were on an Air Iran jet somewhere between Kennedy Airport and Tehran. All power is delightful, as Kenneth Tynan once observed, and absolute power is absolutely delightful. The fall of the Shah left a hole in *Interview*'s world: to whom could it toady now? Certainly the Carter administration was no substitute. Those southern Baptists in poly-cotton suits lacked the finesse to know when they were being flattered. They had the social grace of car salesmen, drinking amaretto and making coarse jests about pyramids. They gave dull parties and talked about human rights. ("How can you go to a tyranny like that?" some English journalist is said to have asked a member of Warhol's entourage, who had stopped off in London on the way to Tehran. "By jet," was the succinct reply.) The landslide election of Reagan was therefore providential. The familiar combination of private opulence and public squalor was back in the saddle; there would be no end of parties and patrons and portraits. The Wounded Horseman might allot $90 million for military brass bands while planning to dismantle the National Endowment for the Arts; who cared? Not

Warhol, certainly, whose work never ceases to prove its merits in the only place where merit really shows, the market.

Great leaders, it is said, bring forth the praise of great artists. How can one doubt that Warhol was delivered by Fate to be the Rubens of this administration, to play Bernini to Reagan's Urban VIII? On the one hand, the shrewd old movie actor, void of ideas but expert at manipulation, projected into high office by the insuperable power of mass imagery and secondhand perception. On the other, the shallow painter who understood more about the mechanisms of celebrity than any of his colleagues, whose entire sense of reality was shaped, like Reagan's sense of power, by the television tube. Each, in his way, coming on like Huck Finn; both obsessed with serving the interests of privilege. Together, they signify a new moment: the age of supply-side aesthetics.

The New York Review of Books, 1982

VI / *Contemporaries*

Saul Steinberg

The life of the creative man is led, directed and controlled by
boredom. Avoiding boredom is one of our most important pur-
poses. It is also one of the most difficult, because the amusement
always has to be newer and on a higher level. So we are on a
kind of spiral. The higher you go, the narrower the circle. As
you go ahead the field of choice becomes more meager, in terms
of self-entertainment. In the end, working is good because it is
the last refuge of the man who wants to be amused. Not every-
thing that amused me in the past amuses me so much any more.
　　　　　　　　　　　　　　　　　　　　　　—SAUL STEINBERG

Saul Steinberg is sixty-four this year: a solid, wary man, rabbinically
delicate in gesture and as immobile in repose as a large tabby cat. For
decades, he has been regarded as the best cartoonist in America. Publish-
ing mainly in *The New Yorker*—for which, to date, he has done fifty-six
cover designs and innumerable drawings and dinkuses—Steinberg
erected standards of precision and graphic intelligence that had not been
imagined in American illustration before him. "After nearly forty years
of looking at his work," remarks the magazine's present editor, William
Shawn, "I am still dazzled and astounded by it. His playfulness and
elegance are of a sublime order." In the United States, Steinberg typifies
the cosmopolitan Jewish exile, a refugee, a man of masks, languages and
doctored identities, through whom the world's multiplicity is refracted as
by a prism. He is both outsider and insider: only he could have dreamed
up the poster, now a best-seller, that summarizes the Manhattanite's pro-
vincial view of America: Eighth and Ninth Avenues wide in the fore-

ground, a strip of Hudson River, a smaller strip of New Jersey, and in the far background two or three inconsiderable dots marking Los Angeles, Australia and Japan.

But if he is the doyen of cartoonists, Steinberg is also—to a growing number of his colleagues—a "serious" artist of the first rank. "In linking art to the modern consciousness," declares art critic Harold Rosenberg, "no artist is more relevant than Steinberg. That he remains an art-world outsider is a problem that critical thinking in art must compel itself to confront. . . . Steinberg is the only major artist in the United States who is not associated with any art movement or style, past or present." The man has always been a loner; but the long embargo, it seems, is being lifted now. This week, an exhibition of drawings, watercolors, paintings and assemblages by Steinberg opens at New York's Whitney Museum of American Art, accompanied by a book with an excellent, pugnacious critical appraisal of the artist by Rosenberg. The crowds will, one may predict, come to laugh but stay to think: for this show sets before us one of the most intriguing intelligences in the field of culture today.

Steinberg counts himself lucky to have been born in Rumania. In 1914 it was "a corridor, a marginal place"—a palimpsest on which various neighbors and colonial powers (Russia, Greece, Turkey, France) had left their traces. To this day, Steinberg confesses himself to be "a culturally born Levantine—my sort of country goes from a little east of Milan, all the way to Afghanistan." He grew up in the capital, Bucharest, then a city of about a million people—the right size, neither cramped village nor crushing megalopolis. In childhood he spoke three tongues, Rumanian, French and "the secret language of my parents," Yiddish. "Childhood," he recalls, "was very strong. It stayed like a territory, like a nation: not in terms of space, but of time. In my childhood the days were extremely long. I was high all the time without realizing it: extremely high on elementary things, like the luminosity of the day and the smell of everything—mud, earth, humidity; the delicious smells of cellars and mold; grocers' shops. . . . A few years ago I gave up smoking after years of two or three packs a day. With this came a beautiful bonanza: my nose rejuvenated. I had the pleasure of childhood again. When man was a dog, the nose was supreme."

His father, Moritz, was a printer, bookbinder and box maker. The infant Saul had the run of his workshop, which was filled with embossed paper, stamps, colored cardboard, reproductions of "museum" Madonnas (literally, chocolate-box art) and type blocks. These were his toys. "I had from the beginning the large, wooden type used for posters; so if later I

made, for instance, a drawing of a man holding up a question-mark by the ball, it's not such a great invention—it was something known to me." And so letters, from the outset, presented themselves to Steinberg as things, and he has "always had a theory that things represent themselves. The nature of the question-mark is questionable: you always wonder how come the upper part of the question-mark is always passively following the ball, whereas the top half of an exclamation point is so rigid, so arrogant and egotistical."

In adolescence he felt rather a misfit, as gifted children do. He went to high school in Bucharest—a school photo shows him at thirteen, the liquid brown eyes and budding prow of a nose beneath a military cap—but, as Steinberg remembers it, "my education, my reassurance, my comportment came out of reading literature. I found my real world, and my real friends, in books." At ten, "much too early," he read Maxim Gorky; by twelve he was devouring *Crime and Punishment*; from France, there were heavy doses of Zola and Anatole France, and "I had a complete anaesthesia with Jules Verne." The biggest impression was made by Gorky. His short story "Alone in the World" was "an excellent metaphor for how I felt. One must consider the idea of the artist as orphan, an orphaned prodigy, whose parents find him somewhere—the bulrushes, perhaps. To pretend to be an orphan, alone, is a form of narcissism. I suppose all children have this disgusting form of self-pity: but more so the artist, who is Robinson Crusoe. He must invent his stories, his pleasures; he succeeded in reconstructing a parody of civilization, from scratch. He *makes* himself by education, by survival, by constantly paying attention to himself, but also by creating a world around himself that hadn't existed before. The corollary of this is the desire not to end childhood. Which in turn makes for a desire not to stop growing."

Steinberg graduated from high school and enrolled as a philosophy student at the University of Bucharest. A year later, in 1933, he made the first of his many expatriations—to Italy, where he settled in Milan to study architecture at the Polytechnic. "It was clear to me that I could never become an architect, because of the horror of dealing with people that architecture involves. I knew it from the beginning, but I went on with it. One learned elementary things. How to sharpen a pencil. You learn that when an eraser falls off the table, you don't jump after it. You keep cool! You follow it with the eye, because it keeps jumping until it rests in the most unlikely place. The fact was that most of my colleagues went to architecture the way I went, as a decoy or an alibi." In fact the influence went a good deal deeper than that, for Steinberg's later drawings would

display an exceedingly refined sense of architectural convention, of the parodies of style learned by precision rendering: the sharp, etched shadows and intricately reasoned-out façades of his dream skyscrapers on the American horizon could have been drawn only by an architecture dropout gazing with irony on his past. "You learn all the clichés of your time. My time was late Cubism, late Bauhaus: our clouds came straight out of Arp, complete with a hole in the middle; even our trees were influenced by the mania for the kidney shape."

In Milan, his career as a cartoonist began. "I succeeded right away; I published my first drawing, and the magazine paid me for it." Living off his cartoons for *Bertoldo,* a satirical fortnightly, Steinberg in his early twenties could afford a reasonable facsimile of the *boulevardier* life he had read about, as a child, in Anatole France: buying new neckties in the Galleria, lounging in the restaurant Biffi. "I had the rare, beautiful pleasure of making money out of something I enjoyed doing and then spending it as soon as I made it. As I lunched, I knew that this was my cat—I mean my *drawing* of a cat—that I was consuming; followed by a tree, the moon, and so forth."

But whatever the pleasures of Milan in the late thirties, the countervailing fact was that Steinberg, a Jew—and a foreign Jew at that—was living under a Fascist regime that grew more anti-Semitic by the week. He graduated as a *dottore in architettura* in 1940, and on his diploma, awarded in the name of Victor Emmanuel III, King of Italy, King of Albania and (thanks to Mussolini and his bombers) Emperor of Ethiopia, was written: *"Saul Steinberg, di razza Ebraica."* "It was some kind of safeguard for the future, meaning that although I was a *Dottore* I could be boycotted from practicing, since I am a Jew. The beauty for me is that this diploma was given by the King: but he is no longer King of Italy. He is no more King of Albania. He is not even the Emperor of Ethiopia. And I am no architect. The only thing that remains is *razza Ebraica!*"

It was time to go. In 1941 Steinberg left Italy for a neutral country, Portugal, and after some altercations with the authorities there he managed to get on a boat to the United States, armed with a "slightly fake" passport, which he had doctored with his own rubber stamp. It got him to, but not past, Ellis Island. The quota for Rumanian immigrants was minuscule and Steinberg exceeded it. While a relative in New York tried, at short notice, to persuade *The New Yorker* (whose art editor, James Geraghty, had bought his cartoons before) to sponsor him, Steinberg spent a sweltering Fourth of July on Ellis Island and was deported to Santo Domingo on a cargo boat. After a year, his visa came through:

Geraghty had finally convinced his stubborn and rather unvisual editor, Harold Ross, to like Steinberg's work and sponsor him. In July 1942, Steinberg landed in Miami and caught a bus to New York, enjoying the "noble view, as from horseback," of America as it rolled by. He had come home to his definitive expatriation.

With a steady outlet for his drawings in *The New Yorker* and *PM*, Steinberg almost at once set out to see the United States, coast to coast, by train. "Driving is no substitute for the view from the sleeping compartment. The window is like a screen; the most unexpected things are projected on it. To arrive at a whistle-stop in Arizona and see Indians at the station, even though they don't have feathers—how expected!" It was, in part, a ballet of fables and stereotypes. Steinberg's America, as confirmed by this trip, proved to be a mythic and precarious place, as much an invention as it was in Brecht's *Mahagonny:* flat horizons broken by mesas or isolated, rococo-Deco movie palaces; the tubular, metallic faces of midwestern entrepreneurs and their massive but wizened spouses, glazing blankly through their horn-rims; blazing signs the size of provincial churches; all-leg girls and cowboys teetering on their long heels like human stilts. The drawings testify to the country's unutterable strangeness in the eyes of a young European who could not, as yet, speak English. "Individuals unmasking themselves only to reveal other masks," Rosenberg percipiently notes in his catalogue essay, "verbal clichés masquerading as things, a countryside that is an amalgam of all imported styles, an outlook that is at once conventional and futuristic—America was made to order for Steinberg."

The next year, 1943, he enlisted in the Navy and became a U.S. citizen. By an administrative quirk that Joseph Heller might have envied, he was at once drafted into Intelligence: the Navy had the wrong Steinberg. He was posted successively to Ceylon, Calcutta and then, masquerading as a "weather observer" with the 14th Air Force (his knowledge of meteorology being slight), Kunming, in China. His task was to act as a go-between with friendly Chinese guerrillas. Since he spoke little English and even less Chinese, he drew pictures for them. What effect this small metaphor of future Sino-American incomprehensions had on the course of the war in Asia, none can say.

When the war was over, Steinberg returned to his favorite occupation: drawing and traveling, the one nourishing the other. He did not work en route, which is one reason Steinberg's drawings of places all look equally exotic: their abnormality is a refraction of memory, whether of Paris, Los Angeles, Istanbul, Tashkent, Palermo or Samarkand (whose

single telephone directory, stolen in 1956 and listing a hundred subscribers, is one of Steinberg's more cherished souvenirs). Provoked by "a geographical snobbism," he and his wife, artist Hedda Sterne—they were married in 1942, and fondly separated without divorcing twenty-four years later—became epicures of travel. "I loved to arrive in a new place and face the new situations, like one newly born who sees life for the first time, when it still has the air of fiction. It lasts one day." The late forties and the fifties were perhaps the last time when, in Europe, travel was travel, unfiltered and not homogenized by mass tourism. It must have appealed to Steinberg as a form of controlled exile—the mask of expatriation. In the meantime, his books and albums accumulated: *All in Line*, his wartime drawings, in 1945; *Passport* in 1954; *The Labyrinth* in 1960. As they did so, his reputation steadily grew, and he began to enter that choppy strait, much roiled by the currents of American aesthetic puritanism, where the "illustrator" or "cartoonist" finds his reputation crossing to that of "artist."

That Steinberg made the passage, few of his colleagues doubt. But he is one of the very few American graphic artists to have done so: not even the big popular illustrators of earlier years, N. C. Wyeth or Maxfield Parrish, Norman Rockwell or Charles Dana Gibson, can quite bear that claim. Milton Glaser sees Steinberg as a cartoonist who "by some extraordinary series of shifts became a major artist. . . . It is very hard to truthfully understand what happened to him on the way, not only in terms of self-transformation but in terms of how the audience saw that transformation—so that he could keep working as a literary and social critic through drawing, and still be a unique American painter. He is the only one that I know who has been able to achieve both at once."

Steinberg, on the other hand, dismisses (or refuses to pin down) the idea of such a transition. What marks the difference between his work and that of the easel painter, in his view, has always been more a question of medium than of aesthetic fullness. "I think of myself as being a professional. My strength comes out of doing work which is liked for itself, and is successful by itself, even though it is not always perfectly accessible. I have never depended on art historians or the benedictions of museums and critics. That came later. Besides, I like work to be on the page. I never like to sell the object. I enjoy selling the rights of reproduction. In that way I consider myself to be doing the work of a poet who prints the words but keeps the manuscript. I keep most of my original drawings. I believe every artist in the world would like to sell only the rights of reproduction. Except for the ones who make giant paintings—they are very happy to get rid of them. And sculptors: there is nothing more tragic than the

unsuccessful sculptor, faced constantly by his large, reproachful objects. *Comment s'en débarrasser?"* Steinberg's desire to keep a life's work together, compact in size and under the hand, like a portable collection of stamps, is perhaps another quirk of the watchful émigré behind his eyes. But it is bent on one of the most remarkable oeuvres in art today: the product of an intelligence so finely drawn, restless, ironic, insinuating and (at times) sadistic, so refracted in its own seemingly innocent maze of linguistic mirrors, as to suggest no ready parallels. The best of Steinberg presents you with a master: but a master of what?

The short answer is: of *writing*.

Every major artist finds his scale—the size of gesture proper to the image and medium he uses. "The scale of the drawing," Steinberg points out, "is given to you by the instrument you use," and pen drawings, being governed by the radius of the hand, cannot be very large. "The nib has an elasticity meant for writing, and that is why I have always used pen and ink: it is a form of writing. But unlike writing, drawing makes up its own syntax as it goes along. The line can't be reasoned in the mind. It can only be reasoned on paper." Steinberg's drawing is a form of thought. It is all "reasoning."

"Ogni dipintore dipinge se," a Renaissance maxim ran: Every painter paints himself. Steinberg's peculiar achievement has been to render this literally as a subject of art, pruned of all expressionist content. What obsessively concerns him is the idea that each drawing remakes its author: it is a mask, a card of identity, but also a proof of existence. The self-made artist is one of his favorite motifs, and certainly his most famous: a little man grasping the pen that draws him. In this "self-portrait," artist and motif are fused, locked in a permanent logical impossibility which is also an ambition of poetry: *Myself I will remake.* As Rosenberg writes, "In the mid–twentieth century the artist is obliged to invent the self who will paint his pictures—and who may constitute their subject-matter." Steinberg's work is always signaling that there are more interesting matters, in art, than "authenticity" in the expressionist sense. It looks beyond the man to the mask, and finds there an extraordinary variety of personae, by turns bland, urbane, comic, ridiculous and distinctly threatening. The first mask of all is style itself. "I want the minimum of performance in my work," says Steinberg, a virtuoso if ever there was one. "Performance bores me. What interests me is the invention. I like to make a parody of bravura. You have to think of a lot of my work as some sort of parody of talent. Of course, parody is not an attack; you cannot parody anything you can't love. But I wish to create a fiction of skill in the same sense [that] my

writing is an *imitation* of calligraphy: fine flourishes that can't be deci-
phered, official stamps no-one can read." And so Steinberg can fill a sheet
with figures, each of them drawn in a different style—Cubist, pointillist,
child art, hatched shading, mock sculptural, hairy scribble, Léger boiler-
plate, Art Deco—and display a wide, ironic complicity with art history
while making no final commitment to a "way" of drawing. The drawing
works because he so obviously possesses each style. It is imitation without
flattery. As a fully paid-up modernist, Steinberg has transformed eclecti-
cism into a distinctive sort of originality. As dandy, he owns all the hats
in his wardrobe. A Cubist still life is not a "Cubist-type" drawing, a thing
done in homage to Braque and Picasso. It is rather a drawing *about*
Cubism, seen as one stylistic mannerism among others in the art-historical
supermarket. In short, it is an act of criticism. So is the decision to paint
a watercolor palette in watercolor. His "postcards"—melancholy vistas of
flatland and horizon, with blotty little figures gazing at some manifestation
of Nature or Culture, a pyramid or a rubber stamp masquerading as the
moon—are philosophical landscapes. They are parodies of scenery and the
picturesque.

The elusive self keeps peeping through, like the rabbit Steinberg once
drew peering out of a man's eyes. Even his cats have large meditative noses
and Jewish whiskers. The tone of his work is comic; but one's guffaw,
once provoked, is checked by Steinberg's unsparing precision about how
the self may be allowed to materialize. The artist seeks complicity with
the audience, but he does it (so to speak) from the driver's seat. There are
simple drawings in Steinberg's oeuvre, but very few simple situations. He
delights in apparently simple ones: the conflict between a hero and a
dragon, for instance. But then we find the fight is rigged. The hero and
the monster are actually partners; they have a deal; without a dragon, what
can a hero do? One drawing makes this point with particular elegance: a
new kind of adversary, a man with a cannon, is drawing a bead on the
dragon. The hero is about to save his enemy by attacking the gunman
from the rear. In another drawing, the monster has become an enormous
furry rabbit. "The rabbit is as armored as the dragon," Steinberg points
out. "It has the impenetrable armor of fat fluff. It is invincibly sweet.
There are, you see, two sorts of danger. One is being hit by a giant
boulder: the direct assault of the world. The other is being overcome
by a mountain of fluff, or molasses. The softness is as dreadful as the
hardness."

One does not expect social optimism from a man of Steinberg's
background—and one does not get it either. The America that rises from
some of his drawings in the 1970s is an edgy, nasty place, a theater of

disaster populated by grotesques. The white paper takes on the look of Forty-second Street at midday in summer, bombed out by glare. Whores, bums, flint-faced Irish cops, frazzled black pimps, rats, crocodiles up from some imagined sewer, sirens emitting Technicolor laser-blasts of sound, bulbous cars farting their exhaust smoke, an S&M homunculus encased in glittering leather with the motto VIVAN LAS CADENAS ("Long live chains") worked in studs on its back—this, in Steinberg's ironic eye, is the American dream-street (our equivalent of the de Chirico piazza, repository of all unspoken fantasy) brought up to date from its origin in the Wild West movie. One of his most cutting inventions—or adaptations—is the Urban Guerrilla seen as Mickey Mouse. In *Six Terrorists*, 1971, a file of them struts across the page, in aviator jackets and miniskirts, equipped with flick-knife and carbine: young bourgeois clones of affectless violence, Blackshirts, SLA or Brigate Rosse. It is an uncannily predictive drawing. "The Mickey Mouse face," Steinberg remarks, "is sexless, neither black nor white, without character or age: for me it represents the junk-food people, the TV children, the spoilt young ones who have all their experiences, inferior as they are, handed to them on a plate."

An encyclopedic disgust pervades these drawings. But it is not a common emotion in Steinberg's work. In general he is a paragon of detachment: he is, as the title of one of his books announces, the Inspector, imperturbable, restless and nosy. This applies to his own career, in a sense. "As far as I could ever see," recalls Hedda Sterne, "Saul never did anything to bring about his success. It just fell into his lap. All he ever did was draw, and the rest came by itself. People have theories about artists: they must have great experiences, much suffering; or else they must plot and connive to be successful. I have been a witness that Saul never did anything like that. He just made drawings." Steinberg himself views the Whitney exhibition and the glare of attention with a carefully nurtured indifference. "I would like," he says opaquely, "to retrospect the retrospective." But the fact of being in the major leagues is, he allows, "one of the major satisfactions of my life. I am a follower of baseball. At night, I often identify myself with the pitcher who pitches a perfect game. Before falling asleep I strike out a side, then in the next inning I initiate a triple play, then I go ahead at bat and hit a homer. All these fantasies, based on the true glory of baseball! And why? Because a major league player has to be special; he must have a certain lyrical quickness and luck that belong more to the poetic than to the athletic part of life. Baseball is nearer to art because of the expert solitude of the player."

Time, 1978

James Turrell

The most interesting museum show by a living artist to be seen in New York City at present is at the Whitney Museum of American Art: "Light and Space," by the thirty-seven-year-old Californian James Turrell. A spare-time pilot and full-time sculptor, Turrell has filled an entire floor of the Whitney with almost nothing: some walls, some tungsten and fluorescent lamps, and the reactions between them. To say that he has posed some ingenious visual conundrums on an ambitious scale is true, but insufficient. Turrell has also contrived an exquisite poetry out of near emptiness.

The most compelling illusion in the show seems at first to be a big flat rectangle pasted to a white wall, dark gray in color with perhaps a greenish cast: undifferentiated, banal. But as you approach it, corners appear within its surface, as though reflecting the gallery in which you stand; perhaps this is a dark, smoky sheet of mirror? Not at all. "This" does not exist; it is nothing more than a hole in the wall, giving onto another room, which seems to be filled with a gray-green mist. The surprise of this dissolution of substance into absence is so intense, and yet so subtly realized, that it becomes magical; a trick enters the domain of the aesthetic.

Ever since the ancient Greek painter Zeuxis astonished his audience, and created a durable legend, by painting a bunch of grapes so "real" that birds tried to eat them, the problems of illusion have been central to our sense of culture: How does one conjure up the presence of something that is not really there, and once that is done, how do we know the exact limits of image and reality? We see the dog in the corner or the Vermeer on the wall only by mentally reassembling and interpreting the stupendous variety of light waves reflected from them, but these light waves are not a dog or a Vermeer. Can one make art by eliminating the middle term and just having light?

That is what Turrell has tried to do—and with brilliant success, leading us to question our sense of substance, presence and absence while looking at his work. A wall floats and fogs out in a blue hypnotic glow; a tract of colored light takes on the apparent density of a screen or a boundary. These are not cheap hall-of-illusion effects.

Turrell's work has a restrained, elevated air, hushed and deliberate; one thinks of Mark Rothko's paintings, translated into three dimensions and actual conditions of light. And just as Rothko's paintings were once accused of "emptiness"—there being nothing for the casual eye to engage, beyond a couple of fuzzy colored rectangles—so Turrell's installations may be thought, by some, not full enough. But after a while the question of fullness versus emptiness turns on itself; in contemplating these peaceful and august light chambers, one is confronted—perhaps more vividly than by any current painting—with the reflection of one's own mind creating its illusions and orientations, and this becomes the "subject" of the work. The art, it transpires, is not in front of your eyes. It is behind them.

Time, 1981

R. B. Kitaj

With his retrospective of 102 paintings and drawings at the Hirshhorn Museum in Washington, D.C., the American artist R. B. Kitaj, expatriate in England, has come home in force. For the past fifteen years, Kitaj has been one of the most visible figures in European painting. His images, edgy and literary, full of sexual belligerence and failed political hopes, powerfully convey what poet John Ashbery's catalogue essay calls "an era's bad breath." If Kitaj is not, in fact, the Auden of modern painting, he is quite often discussed as though he were, especially by English critics. Of late, he has also emerged (along with such Englishmen as Lucian Freud and Frank Auerbach) as one of the few real masters of the art of depictive figure drawing now alive.

The Kitaj show begins with Weimar modernism, reflecting on the strains, dislocations and terrible urgencies of a time that Kitaj, born in 1933, is too young to have lived through—Europe in the twenties and thirties. Gangsters and politicians, clowns and whores, drifting intellectuals and their pale café groupies, the doomed, the uprooted, the crushed, the demented—such is the cast of characters, presided over by a figure with whom Kitaj clearly identifies, the Wandering Jew, emblem of the diaspora as a pervasive state of mind. They are imagined and mixed by a mind

saturated not only in literature but in fantasies about reading, straying and witnessing. Kitaj's works from the sixties, such as *The Ohio Gang*, set forth dramatic mélanges, Bertolt Brecht plus Constructivism plus Al Capone—irresistibly nasty stuff, Neue Sachlichkeit run through a fragmented lens. The words *history painter* suggest an august mummification of fact: Wolfe nobly expiring at Quebec, Washington becoming his own statue in the boat on the Delaware. If Kitaj can be called a painter of modern history, he is not of that sort. Rather, he has a close instinct for the disconnected emblems of a moment—the faces glimpsed in smeared newsprint, the sense of not having the whole story that comes from living close up to traumatic events.

Other critics have found Kitaj's wide allusions both obscure and pretentious. So they can be, but not very often. A peculiar case in point is *After Rodin*, a recent pastel drawing of a nude woman sprawled on her back, rosy, firm and decapitated. To what does this repugnant, though not very gory, piece of sadism owe its title? Apparently to Rodin's habit of sculpting fragmentary figures, headless torsos, isolated arms or legs. But then one recalls that this, in Rodin's own day, was much guyed by satirists as *literal* mutilation, as though there had been a whole sculpture that Rodin chopped up; during the Turkish atrocities in Armenia, a French cartoonist drew some observers in front of a hut festooned with severed limbs, exclaiming, "What fine models for Rodin!" Presumably, this lopsided equation of the fictive violence of art with real violence is meant to hover, in quotation marks, above Kitaj's nude; but it seems contrived.

The images that work best are those in which Kitaj spins a web of congruent allusions without ever getting too literal, where the art-history and real-history footnotes balance and bear one another out. A remarkable one is *If Not, Not*, 1975–76, his meditation on T. S. Eliot's *The Waste Land.* One could hardly call it an illustration of the poem, although Eliot seems to make an appearance as a clerkish figure with spectacles and hearing aid in the lower left corner, an irritable St. Anthony dreaming the horrors of history and tempted by a naked demoness, in the manner of Bosch or Pieter Brueghel. *The Waste Land*'s familiar cast of characters—Phlebas the Phoenician, the homosexual Mr. Eugenides, the Fisher King and the rest—do not appear. But there is an early-Eliot tone of dissociation, alienation and decay; and it is grafted onto an ambitious composition not unlike the burning phantasmagorias of Brueghel. The poet Eliot (if it is he) functions, in the picture, as the figure of Mad Meg in Brueghel's *Dulle Griet*, striding through the landscape and inventing it as she goes. The building on the distant hill, with its gaping mouth, recalls the hell mouths

in Brueghel (it is copied from a photograph of the guardhouse gate at Auschwitz). The figures, lying dead or crawling about in unidentifiable uniforms, recall both the swarms of damned souls in sixteenth-century Flemish paintings and Eliot's vision of the crowd crossing London Bridge, itself a quote from Dante: "I had not thought Death had undone so many."

These allegorical allusions are made more digestible by the dry and exact pleasure with which Kitaj's paint covers the surface, its luminosity, even its neatness. Kitaj is very aware of himself, but that awareness (or wariness) presses him toward a detached way of painting grounded in tradition. "There are some people who don't like museums because they think of them as tombs, or something negative," he remarked in an interview recently. "I've always loved them. They are to me lighthouses of utopianism and social well-being." Why utopianism? Because the museum does nothing if it does not strive toward some ideal of visual literacy. Its mission begins from the belief that learning to see is as important as learning to read, and that seeing is not the property of one class.

This literacy—a sense of the thickness of art's layer over an insufficiently named world, a knowledge of what alternative images it contains—is part of Kitaj's essential subject matter. It explains his passion for homage, his contempt for theories of progress in art and his dislike of spontaneity. Few people today believe art "evolves," moving from lower states to higher, but ten years ago, Kitaj was scorned in some circles for not believing it and saying he did not. "In the terms of my own life and its present needs, the Mona Lisa is more profound, more 'real,' more timely, less dated . . . than almost any picture I can think of since Cézanne put his brushes down in 1906." That is Kitaj practicing with the crust (if not the mantle) of his curmudgeonly hero, Degas.

Kitaj's recent drawings, particularly his pastels, are of marvelous density. The firm boundary line, probing and circumscribing, pays its respects to Degas, as does the broken, emphatic texture of the pastel, sometimes built up to a thick coat of peacock-hued dust. There is nothing theoretical about these drawings, no "as if"—such as one might expect from an artist turning, at mid-career, away from modernist fragmentation. *Solid, chunky, driven, greedy:* these adjectives apply to Kitaj's appropriation of the world—particularly the bodies of women—with line. Sometimes his egotism goes out of control or his taste fails him, or both, as in an absurdly paranoid self-portrait that looks like Jack Nicholson fried on acid. But when confronted with the posed model, as in *The Waitress* or his various nude studies, Kitaj draws better than almost anyone else alive,

taking on all the expressive and factual responsibilities of depiction. His drawing convinces you of the integrity of his search, whatever the occasional obscurities of his imagery.

Time, 1981

Roy Lichtenstein

Roy Lichtenstein was always the most cerebral of the Pop artists. Yet his images in the 1960s, taken from comic strips and ads—"I know how you must feel, Brad!" whispers the enormous girl's mouth to its exclusively art-world audience—were once rebuked for their dumbness, their lack of "real" art content. To mimic the processes of commercial art, to take a common image and replicate it on canvas, much larger, with hard-edged line and stenciled arrays of benday dots in primary colors for shading: could this be art? Is the pope Catholic?

A good deal of the popularity of Pop art, as Harold Rosenberg pointed out some years ago, partook of "the astonishment of Molière's character on learning that he has been speaking prose" all his life. Suddenly, there was the commercial vernacular of America, that amniotic fluid in which every collector had been nurtured, right there on the museum wall. And the curious paradox was that, in Lichtenstein's case, the fluid—those cartoon images of teenagers and Korean War jets—was transparent. After a while the imagery hardly got in the way at all, and Lichtenstein could be treated as a formalist much more readily than, say, Claes Oldenburg, with his gross impurities and gargantuan appetite for metaphor. A lot of Pop art owed something to Surrealism. Lichtenstein's never did.

In the early 1970s, Lichtenstein was fond of quoting Matisse, that supreme artificer of calm and luxurious reverie. Run through Lichtenstein's mill, however, the images lost this aura entirely, becoming stark, neutral or even disagreeable. The three fish in *Still Life with Goldfish*, 1972, a broad transcription from one of Matisse's still lifes of sixty years before, wear dyspeptic expressions and seem not at all pleased with the painting of a giant Lichtenstein golf ball on the wall behind them.

Enough time in the museum can wash almost any art clean, but Lichtenstein's work, always restrained, has by now reached what amounts to a trance of near-mechanical decorum. It scarcely trespasses on the world of feeling or lived experience. If the word *academic* means anything in relation to art today, it must apply to Lichtenstein's output: an oeuvre committed to the play of a given set of pictorial mannerisms, faultlessly sustained, often funny and always dryly intelligent, all of them directed toward reducing art to a sequence of predictable signs. Anything can be turned into a Lichtenstein by the application of those hard outlines, benday dots and primary colors—not only comic strips, but Greek temples, mirrors, entablatures, still lifes and other people's paintings.

A good sense of the march of this all-American mannerist's stylizations can be had from a large exhibition of the work from his post-Pop years, "Roy Lichtenstein, 1970–80," organized by art historian Jack Cowart and now at the St. Louis Art Museum. It provides a deftly culturebound experience. Lichtenstein is nothing if not erudite, and to see him parodying established modern masterpieces (Matisse's *Red Studio,* or the Cubist work of Picasso and Juan Gris, or Carlo Carrà's *Red Horseman*) is to see a very informed mind at work, particularly at obscure levels of parody. How, for instance, does one render the odd ambiguities and shifts of Cubist or Futurist painting in terms of this rigidly determinate dot-and-line style? Of course, it is not painting but reproductions that Lichtenstein parodies; reproduction itself reduces art to dots, and by increasing the scale of that convention Lichtenstein exposes it, reminding us that most of our experience of art is vicarious and based on print. Whether this point is worth making over and over again, at such length and at great expense to collectors, seems moot—though not to Cowart, who detects in Lichtenstein's ability to apply his method an almost Picassoan energy. "Tomorrow he could take Renaissance, Classical or other known subjects or, on the other hand, quickly invent a new vocabulary of images," Cowart writes in the catalogue. Perhaps, but how much would it matter? Like Andy Warhol, Lichtenstein is a paragon of the American *industrial* artist, a man diligently turning out a steady stream of product whose purpose is less to reflect on, and with difficulty articulate, the complexities of experience from image to image than to supply an expanding market with eucharistic emblems of his own fame and desirability: "a Lichtenstein." He is by now perfectly tooled up for this, in temperament and visual manner. What one misses in a large proportion of the work on view in St. Louis is, simply, the sense of necessity—an engagement deeper than style.

Sometimes, rather surprisingly, it is there. In particular it seems to lurk in the imagined depths of the *Mirrors*, a series of paintings Lichtenstein completed between 1970 and 1972. With their silvery surfaces, reflection lines, bevels and breaks in the light, which manage to function equally as pattern and as illusion (the mirror, in art, being one of the arenas in which both can live side by side), these paintings possess a ravishing formal elegance.

They are also more plainly invented than the works derived from printed sources. We do not think of mirror reflections as being suffused with style, and in that sense Lichtenstein's mirror paintings sidle closer to unmediated experience, and so indirectly to nature, than his other work. They are the closest thing to the only kind of life drawing one can imagine Lichtenstein doing, an image of a blank white page. They acquire poignancy from the fact that they are empty. One gazes at them frontally, as at a real mirror, but nothing shows up in their superficial depths. The spectator is a phantom. These icy, imperturbable tondos and ovals may say more about the nature of Lichtenstein's imagination than anything he has painted since. What could convey better than a blank mirror his belief that exhibitions of the self are hateful in painting?

Of late Lichtenstein has been preoccupied not merely with parody but with parodies of parody—paintings based on the cartoonist's view of modern art. There was a "pop" view of Surrealism, loosely derived from Dalí and Arp and epitomized in the 1940s in such verses as:

> On the pale yellow sands
> There's a pair of clasped hands
> And an eyeball entangled with string,
> And a plate of raw meat,
> And a bicycle seat,
> And a Thing that is hardly a thing.

This is the caricature of Surrealist kitsch Lichtenstein invokes in paintings such as *Reclining Nude*, 1977: one figure sporting Swiss-cheese holes in the manner of Arp, another in a stiff suit like a Magritte businessman, a Kandinsky-style wiggle here, a Tanguy pebble there.

In parodying these caricatures of Surrealism, Lichtenstein is certainly showing a postmodernist turn of mind—recycling the already recycled; but what else is going on? Not much, in truth, beyond the production of more Lichtensteins *en série;* to call these paintings "visionary," as Cowart does in the catalogue, is to overrate them. They are grounded on a rather

smug familiarity with the power of cliché. They remind us that mass art education has now created its own pictorial equivalents of the fake leather–bound, hand-tooled Great Books of the Western World. In effect, the show asks us to have the cake and eat it too—to see Lichtenstein's work as part of a "heroic" historical continuum while deriding the platitudes to which that continuum is being worn down. But this cannot allay the feeling that, for all his abilities as wit and as designer, his own art has become repetitious.

Time, 1981

Nam June Paik

Mention video to some people and watch their faces fall. If the cliché of "modern sculpture" used to be a piece of stone chewing-gum with a hole in it, and that of "modern painting" was a canvasful of drips, then the cliché of "video art" is a grainy close-up of some UCLA graduate rubbing a cockroach to pulp on his left nipple for sixteen minutes while the sound track plays amplified tape-hiss, backward. Video art has not yet shaken off its reputation as clumsy, narcissistic and obscure.

Of course, video has no monopoly on that; most art of any kind, in this overloaded art world, is clumsy, narcissistic and obscure. Still, even video does not have to be, and some of it is not. An indication of this may now be seen at the Whitney Museum. The Whitney has long been conscientious about video art, showing it in regular programs through the 1970s when other museums would hardly condescend to touch it. Now it becomes the first American museum to give a retrospective show to a video artist. He is Nam June Paik, a Korean, who lives in New York City.

At fifty, Paik is the sage and antic father of video as an art form—"the George Washington of the movement," as another experimental artist, Frank Gillette, dubbed him at the end of the sixties. He began by emigrating from his native Seoul in the fifties, first to Tokyo and then to West Germany, to study music. In Germany he met composer John Cage, that perennially controversial guru of the avant-garde, and he was soon busily involved in the multimedia "events" and benignly neo-Dadaist actions of

a European artists' group that called itself, for its commitment to change, Fluxus.

Fluxus was less a defined art movement than a loose anarchist confederacy, given to ritual gestures of protest against "high" culture. Paik, who was to move to New York in 1964, would play a piano and then topple it over onstage; he would cut a pianist's shirttails to shreds with scissors, or stage a little musical "event" by dragging a violin along the sidewalk on a string, like a scraped and protesting pet. A cellist, Charlotte Moorman, would appear for Paik at a concert and play her instrument with tiny TV sets rigged over her breasts; or, to the scandal and amusement of the New York art world in 1967, she would perform topless.

Such occasions pass, marked only by photographs. Some of Paik's pieces were more permanent, for instance a TV set with the screen removed and a candle burning in the empty cabinet—a neat comment on the votive, shrinelike role played by television in the home—or a closed-loop setup titled *TV Buddha*, in which a stone effigy of the Buddha sits with a camera pointed at it, ceaselessly contemplating its own immobile image in a small monitor.

Paik was interested in technology, of course—but in a lax, low-tech way. The rise of kinetic and programmed-systems art in the sixties brought with it the hope that some electronic Leonardo might emerge from all the squeaking and twinkling: a new figure of the artist as cybernetic technocrat, a Tatlin with a 64K chip. No such figure emerged, and Paik in no way resembled him. His machines were crude, funny, aleatory gremlins, held together by string and Scotch tape; one of them, a robot named K-456, is preserved in the show. Controlled (in a vague way) by a model-aircraft radio transmitter souped up to send commands on twenty channels, this frail creature did manage to perform in West Germany and even in Washington Square Park in New York City, where it walked, spoke, waved its arms and excreted a stream of beans.

Paik's television pieces tend toward disciplined confusion; ends stick out everywhere. They have no narrative structure. Can one speak of decorative TV? If so, Paik makes it. The keynote of the Whitney show is struck, as soon as one gets out of the elevator, in the first installation on view: a row of goldfish tanks. Behind each tank is a TV screen silently emitting its bright electronic collage through the water; live fish swim in front of magnified images of themselves; there is a glimpse of sky underwater, a figure, a swirl of interference pattern. In *Fish Flies on Sky*, 1975, several dozen TV sets are hung from the ceiling and one lies on one's back and looks upward, as the staccato montages of fish, dancers and a World

War II monoplane cavort and twirl. In *TV Garden*, the sets are dispersed through a peculiarly unconvincing grove of indoor plants, glowing and babbling like discarded electronic detritus left in an artificial jungle.

The effect of such pieces—particularly *Fish Flies on Sky*—is curiously soothing; once urgent images, struggling to claim one's attention through the set, are multiplied and dispersed into pretty electronic wallpaper, and one's distance from the screens makes them look almost floral. It is low-fidelity television, short on information, long on suggestion; Paik has more than once compared his work with that of Monet, whose lyrical blurs and water reflections were at the opposite extreme of pictorial strategy from the precise definition of an Ingres. "As collage technique replaced oil paint," Paik declared almost twenty years ago, "the cathode ray tube will replace the canvas." Of course, collage never replaced paint, and the idea that everything that canvas and paint can do may be better done by manipulating a stream of electrons was one of the harmless delusions of the sixties.

But the direction of Paik's aim is clear enough: rather than compete with the informational power of "real" television, he wants to alter the box into a form of pure play, electronic finger-painting. It is his solution—and a very adroit one—to the fact that the TV screen, small and intimate as it is, can never acquire the grand declamatory power of film or canvas. There is no such thing as a physically impressive videotape. The scale is not there. But the tape can involve you and even promote an occasional sense of mystery; and this, if not always profoundly, is what Nam June Paik's installations do.

Time, 1982

Richard Diebenkorn

Richard Diebenkorn, fifty-nine, is by fairly general consent the dean of California painters. A former Marine who began his career in the San Francisco Bay area, Diebenkorn started as a representational artist in the 1940s, became an abstract painter, returned to the theme of figure-in-landscape in the 1950s and then, from 1967 onward, gradually began to

make himself a world reputation with a sequence of essentially abstract canvases that he christened the *Ocean Park* series, after the section of Santa Monica where he now lives. Yet there was nothing veering or arbitrary about the changes in his approach. Diebenkorn has always been a man of tenacity, deeply conscious of the tradition he works in and the homages to other art that it entails, and he does nothing lightly. When his work shifts, the shift means something. One sees this happening in the show of Diebenkorn's drawings, mostly in gouache and crayon, at Knoedler & Company in New York City.

The show marks both a departure and a continuation. Diebenkorn's recent drawings (all are paintings on paper, in a restricted color range keyed to blue) develop, with some diffidence, out of the quasi-abstract *Ocean Parks*. Those works may be the most refined images of the abstract bones of landscape (in the best sense of refinement, which excludes prettiness and weakness) done by an American artist of his generation. Pale-blue Pacific air, cuts and slices of gable, white posts by the sea, sudden drop-offs of hill or thruway—these images of the California coast have found their way into his works, but in a condensed and fully digested idiom whose sources, far back in the early twentieth century, are Henri Matisse and Piet Mondrian.

Landscape is still a presence in the new Diebenkorn; it is not hard, for instance, to see ocean in the tract of blue that fills the lower two-thirds of *Untitled #50*, 1981, or horizon and the vestige of a grass strip in its ruled bars of white and green. The same handwriting pervades them, a sunken geometry of lines scumbled over and hazed with paint, as though bathed in light and vapor. There is a kind of light on Diebenkorn's stretch of coastline—mild, high and ineffably clear, descending like a benediction on the ticky-tack slopes just before the fleeting sunset drops over Malibu— that is all but unique in North America, and Diebenkorn's paintings always appear to be done in terms of it. It is part of their signature, whether they suggest actual landscape or not.

From most of the drawings at Knoedler, the image of landscape has receded. It is displaced—though not wholly abolished—by a curious motif Diebenkorn refers to as his "ace of spades," and which does resemble the black pip on that card pushed and pulled out of shape. It is Diebenkorn's way of breaking up the remote geometry of the *Ocean Parks*; one no longer sees a distant "view" of a whole terrain but moves closer, toward this lobed and writhing emblem which suggests either body or still life: the curves of a thigh, a buttock or a breast, the petals of a flower rising on its stalk, or—in some of the drawings—the black propped lid of a grand

piano. The body image is confirmed particularly in a *Untitled #45*, which is haunted by the swollen, vegetative forms of 1930s Picasso rather than 1914 Matisse. Of course, the drawings also seem more intimate than the previous *Ocean Park*s simply because they are drawings—smaller and more provisional, the receptacles of experiment.

Yet they retain a distinctive intensity, quiet and mannered, that goes with their aloof and somewhat ambiguous degree of abstraction. When Diebenkorn wants to set a curve flowing across the paper, its rhythm acquires a detached mellowness, a quality of reverie; this wandering of the hand is constantly checked and inflected by the vestiges of a grid, the angled cuts of straight drawing that survive from the *Ocean Park*s and are, in fact, a permanent feature of his style. Consequently, the Knoedler exhibition as a whole presents a display of control rare in current painting.

Diebenkorn can be clumsy sometimes, and there is a direct link between the dumpy off-centeredness of some of his "ace" emblems and the awkward postures of sunstruck California figures in his paintings from twenty-five years ago. But that comes from consistency. Part of Diebenkorn's essential tone has always been the way his first pictorial impulses survive in the written-over manuscript of his work. His mastery of his own long-considered syntax has never led him to smooth out the quirks. Diebenkorn is a great stylist, and what gives life to style is a certain disequilibrium. These modest drawings clearly signal an interesting turn in his work. Will a series of paintings on the scale and quality of the *Ocean Park*s eventually come out of them? One would be rash to bet against it.

Time, 1982

Komar and Melamid

Iosif Vissarionovich Dzhugashvili (1879–1953) lives again! Pink, incorruptible and smelling only a little of mold, the Maximum Leader and Supreme Baby-Kisser of the Soviet Peoples has come back to greet us. Who would ever have supposed that the most immediately memorable show in New York City's SoHo, at the start of the 1982 art season, would be a gallery full of mock Stalinist socialist realism, done in the correct borscht-and-

gravy colors of official Soviet art thirty years ago? But there is nothing that pluralism will not give us; and so it is with the exhibition by Vitaly Komar (his last name, in Russian, means "mosquito") and Aleksandr Melamid, which grandly fills the Ronald Feldman gallery all this month.

Komar, thirty-nine, and Melamid, thirty-seven, henceforth denoted as K&M, are both "dissident" Russian artists, who started exhibiting their peculiar team form of Pop conceptual art in the USSR in 1972; in the fall of 1974, they took part in the still notorious "unofficial" art show on a vacant lot in Belijaevo, a suburb of Moscow, which was flattened by police bulldozers. Soon after that, they were able to arrange their departure for the USA, where all art is ipso facto harmless. Do you long for the days when the old left was new? Then head for K&M, who will fix you up. This is the funniest exhibition to be seen in New York in quite a while, although that, unfortunately, is not saying much, with the low quotient of wit in the American art world.

In essence, K&M's work is of the same kidney as Aleksandr Zinoviev's *The Yawning Heights:* a prolonged satire that is bureaucratically realistic; a machine that recycles its own absurdity; above all, a meditation on the entropy of rhetoric, the way clichés wear down and finally deflate one another. K&M's work is obliged to resemble what they poke fun at: anyone can caricature an official Russian political picture, but only Russians can do it effectively. This involves a steady sequence of double-takes: Just how serious are these guys, anyway? One can imagine some good apparatchik responding without irony to K&M's appalling *View of the Kremlin in a Romantic Landscape,* its gold onion domes and pink ramparts and red star floating on a sea like the isle of Cythera itself, framed by a "classical" Poussinesque clutter of arching trees, fallen columns and pediments and other bric-a-brac. It has the deeply sincere vulgarity of a holy card: an alliance between Aleksandr Gerasimov, Stalin's favorite artist, and Walt Disney.

Perhaps other Russian painters, unknown to the West, are busy boring and clicking like so many deathwatch beetles within the façade of idealist kitsch known as socialist realism. But it is hard to see how they could ruin it more thoroughly. K&M's paintings are not merely banal, but excruciatingly so, oily and inert, varnished so heavily that three-quarters of the surface is glare; the eye gropes for the clichés that lie embedded in them. The accretion becomes a kind of conceptual art, holding everything in quotation marks.

Sometimes a weird sort of yearning intrudes. As a child, Melamid lived on the Moscow street that Stalin's staff car reputedly took on its way

from the Kremlin to his country dacha: If you look carefully, his elders told him, you might see him in the back of the car. Melamid never did, but a yearning for the ogre is commemorated in *I Saw Stalin Once When I Was a Child:* the red curtain in the rear window slides back, revealing the fleshy nose, the twinkling eye of the Dreadful Father. "To us," Melamid points out, "Stalin is a mythical figure. We are not trying to do a political show. This is nostalgia."

Well, up to a point. To suppose the work is only a satire on an obsolete propagandist style is to miss its deadlier thrust. What K&M are getting at is not just totalitarian art, but official art as such. *Stalin and the Muses*—showing Clio, muse of history, presenting a volume for revision to the mustachioed god in his transcendent white military greatcoat—is "objectively" a hilarious spoof, done in clumsily tight parody of the seventeenth-century Grand Manner. But then, if these sleek pictorial tropes are so absurd when lavished on Stalin, why should they be any less so when used on Louis XIV, Peter the Great or any other enlightened despot?

Seldom has a tyrant been so absolute or cruel that he could not find some major artist, a Rubens or a Titian, a Velázquez or a Bernini, to fawn on him for a suitable fee. It is the nature of carnivores to get power and then, having disposed of their enemies, to deploy the emollient powers of Great Art to make themselves look like herbivores. Stalinist socialist realism was merely the end of this process, carried out by hacks. After it, the more intelligent of the Beloved Leaders would want radio and television, not painting, as their cosmeticians. We must thank Melamid and Komar for reminding us what heights of awfulness the great lost tradition could reach in pre-electronic days.

Time, 1982

Howard Hodgkin

The main event of the past two or three years, as far as the New York art world is concerned, has been the "rebirth" of European art—mainly young, German and Italian, expressionist in mode and flirtatiously eclectic in tone. The spectrum of achievement runs from mere operators like

Salomé to deeply serious artists of the caliber of Anselm Kiefer. The fact that an American audience is paying attention to European painting once more comes as a relief, but before attention gets wholly stylized as fashion, it is worth remembering that England is part of Europe and that some English painters have more to offer than other, more loudly promoted figures of the day. One of them is Howard Hodgkin, whose exhibition is now at Knoedler & Company.

Hodgkin is fifty this year: a diffident man with a tough, discursive mind and a long background in art history, collecting and teaching. His work comes directly out of the French tradition known as Intimism, which coincides with the rise of middle-class life as the cultural norm and runs (roughly) from Chardin in the eighteenth century to Bonnard, Vuillard and Matisse in the early twentieth. It assumes that the ordinary, day-to-day relationships of an artist's domestic life—his family, his parlor, his cook, his cat, the almond tree that can be seen in flower if you crane your neck a little bit to the left of the studio window on this particular day in early May—is deeply interesting as a subject for painting. Not because it is lent grandeur by being part of the stage of an artist's life—that kind of egotistical silliness is quite alien to the Intimist tradition—but rather, because it shows that life obliquely, in its ordinary quality, just like yours or mine, and then slightly transcends its commonplaceness, thus giving us hope of meaning, by analogy, in our own lives.

Hence, Intimism shuns the grandiose. It argues, without getting polemical about it, that painting can reasonably leave the demands of public declamation—the world of David or Géricault's *Raft of the Medusa*, of Ingres's *Apotheosis of Homer* or Picasso's *Guernica* or, in our day, the reflections of Kiefer on German romanticism and German guilt—out of the picture. It has no need for allegory or moralizing. It wants to get one thing right at a time. The subjects of the artist are all around him, in his private life. Quite a small corner of that life can be enough. The scale is rarely big because you don't need bombast—in the Intimist context all heroics look forced and the merits are closeness of feeling, modesty of scale, and a witty accuracy about place and character. Intimism likes the interior view. It is apt to see the world from inside the house, through a window—a frame within the frame. Objects tend to take on the role of characters, which appear over and over again: the dusty bottles and rustling bouquets of paper flowers in Morandi's studio, the striped wallpaper in Vuillard's sitting room, Matisse's curly black iron balcony, the funny little dachshund on his mat in Bonnard's bathroom. By the same token, people have the permanence of objects: Bonnard's wife, Vuillard's invalid

aunt. Intimism is sociable art. But it does not take off from society at large.

Now all these characteristics are part of Howard Hodgkin's work. Its special aura is an intimacy that verges on voyeurism, whose details are somewhat muffled by abstractness and generalizing, but whose sense of place and even social ambience comes through quite clearly once you have grasped the general drift of the work. Hodgkin grew up in libraries and gardens. His family was related on one hand to the intellectual clan of the Huxleys, and on the other to Roger Fry, the great English critic who gave Post-Impressionism its name when holding the first English show of Cézanne, Matisse, van Gogh and others at the Grafton Galleries in London in 1910. One of Hodgkin's most vivid childhood experiences was being taken to visit Fry's sister Margery, whose house was full of brightly painted furniture from the Omega Workshop: this had a deep effect on the tablets of painted wood that constitute Hodgkin's grown-up work. His grandfather was a medical scientist after whom Hodgkin's disease is named. His father was a garden designer. In dealing with Hodgkin we are not dealing with a naïf, a painter with a self-made culture, but rather with a highly sophisticated man in whom the pastoral and the empirical mingle in sometimes rather unpredictable ways. And a literary background led him to think visually in terms of a certain scale: the page of a book. For Hodgkin a very big picture is three feet square. There is not a more educated painter alive, and it would be hard to think of one whose erudition was more exactly placed at the disposal of feeling. His paintings look abstract but are full of echoes of figures, rooms, sociable encounters; they are small, "unheroic" but exquisitely phrased. The space they evoke is closed, artificial, without horizon or other legible reference to landscape. One seems to be looking into a box full of colored flats and wings—a marionette stage, behind whose proscenium the blobs and cylinders of color glow with shivering, theatrical ebullience. "Curious," as English art historian Lawrence Gowing remarked in a recent essay on Hodgkin's work, "that no one has recognized in Hodgkin a God-given stage designer, a man with a mission to the theater of enrichment and augmentation."

Because Hodgkin's type of abstract flatness admits the eye some way into the picture and identifies the surface as an imaginary opening, it has nothing to do with the idealized flatness of sixties American color-field painting. It hovers on the edge of scenic recognition, tricking the viewer into the thought that just one more clue might disclose a particular room or restaurant, a familiar scene. Sometimes it will. The most spectacular painting in the current show, *In the Bay of Naples*, 1980–82, presents itself

as a soft hive of colored blobs, blooming and twinkling in rows, against a dark ground. Lit windows? Strings of restaurant lights? A view from a terrace? Then more specific things appear: a pinkish vertical, another stage flat, turns into a stucco wall; a cobalt patch at the center, where the vanishing point would be if there were any perspective, resolves itself as a glimpse of sea; the S of creamy green paint that lights the whole painting with its contradictory glare, leaping against the more tentative and modulated speckling of the rest of the surface, is the wake of a speedboat, tracing its phosphorescent gesture on the night water.

There is a strongly private, autobiographical element in Hodgkin's work; it refers to friendships one does not know about, to conversations in rooms long since quitted. But it resists transmission as anecdote. "The picture," Hodgkin says firmly, "is *instead* of what happened. We don't need to know the story; generally the story's trivial anyway. The more people want to know the story, the less they'll look at the picture." Likewise, the paintings are full of references to other art, usually of a rather arcane sort. But they seem casually, even inattentively deployed, coming out not as formal homages to this or that master but as a function of temperament. Like Bonnard, whose work he reveres, Hodgkin is a fidgety peeper into secular paradises and controllable realms of pleasure. But as befits a painter who makes no bones about his belief in the continuity of past and present, part of the pleasure lies in the conversation between his work and its sources.

One of the main sources (a parallel text, as it were) is Indian miniature painting, of which he has long been a collector. The jeweled colors and flattened space of the court miniature, the way all natural detail is filtered by artifice, and above all the sense it provides of looking past the edge of the ordinary world into a privileged domain—all this is echoed and modified in his own small paintings.

But such influences are melded into a wholly modernist idiom. Hodgkin does to the Indian miniature what Matisse did to Islamic decoration; the source is not simply quoted but also transformed. The miniaturist's precision of edge and line is replaced by a fuzzy, affable kind of formal system—nursery-toy versions, almost, of the sphere, cube and cylinder, those intimidating platonic solids of programmatic modernism. His pigment, however, has an extraordinary range of effect. His work sports in the transparency, density and sweet pastiness that only oil paint can give. Surfeited by color, twinkling with fields of dots (like enlarged details of a Seurat, betokening light), its casual surface can look clumsy; but that is only Hodgkin playing with the idea of clumsiness, extracting an educated

pleasure from the babyish joys of daubing. In fact, his taste rarely fails, and his talent as a colorist is unsurpassed among living painters. Both place his paintings squarely in the tradition whose praises they modestly sing.

Time, 1982

Louise Bourgeois

Louise Bourgeois is certainly the least-known artist ever to get a retrospective at New York's Museum of Modern Art, an honor usually reserved for the Picassos or at least the Frank Stellas of this world. She is almost seventy-one, French, a resident of New York City since 1938, and a mature sculptor by any conceivable definition of the word. Until quite recently not many people wanted to look at her work, and her recognition was slight, at least compared with the fame that surrounded that implacably durable queen bee of the art world, Louise Nevelson. Bourgeois belonged to no groups and was a complete loner; her work appeared to have a queer troglodytic quality, like something pale under a log, the vulnerable product of obsession but with a sting in its tail.

That quality remains; but in the meantime, two things changed its status in the art world. One was the collapse of the idea that art had only one way, the abstract track, forward into history. This made Bourgeois's idiosyncratic kind of late surrealism well worth examining. The second, which made it look more interesting still, was feminism. The field to which Bourgeois's work constantly returns is female experience, located in the body, sensed from within. "I try," she told an interviewer, with regard to one work, "to give a representation of a woman who is pregnant. She tries to be frightening but she is frightened. She's afraid someone is going to invade her privacy and that she won't be able to defend what she is responsible for."

This kind of subject is a long way from the normal concerns of sculpture, which impose themselves in a "masculine" manner on culture. What Bourgeois sets up is a totemic, surrealistic imagery of weak threats, defenses, lairs, wombs, almost inchoate groupings of form. Her work is by turns aggressive and pathetic, sexually charged and physically awk-

ward, tense and shapeless. It employs an imagery of encounter to render concrete an almost inescapable sense of solitude. In short, it is physically, if not always formally, rich stuff, and one may be glad that the Museum of Modern Art and its associate curator Deborah Wye have set it forth in such a detailed exhibition.

Bourgeois's most stringent and satisfactory works tend to be those based on either "primitive" totems or natural forms: coral polyps, breasts, buds and palps. The totemic pieces cluster sociably together in crowds, tall and etiolated, often made up of worn chips and fragments of wood threaded on a central armature, like shashlik on a skewer, and then painted. Bourgeois likes repetition with small variations: some of her larger pieces, like *Number Seventy-two* (*The No March*), 1972, are composed of hundreds of marble cylinders, their tops lopped and slanted at different angles, clustered on a platform. They give an impression of preconscious liveliness—nature on the march. Their aura becomes a little more sinister in a large carving, *Femme-Maison '81*, done in black marble: waving tubular shapes, frondlike rather than phallic, rustling and jostling against one another with a peculiar, irresistible energy, that rear up around a plateau on which reposes a small schematically carved shed.

At the same time, Bourgeois's imagination has a nasty side, as real acts of exorcism must. The fantasies her art expels into the chaste gallery space have as much to do with incest and cannibalism as with the more usual aesthetic satisfactions of MOMA. The most vivid of them, and the crudest, is a sort of grotto full of pendulous brown stalactites, lumpy and breastlike. A banal red light plays over them; in the middle is a table, perhaps a sacrificial altar, and the whole cave is strewn with what seem to be mummified joints of meat. These are not identifiably human; if anything, they resemble small legs of lamb. But they suggest the dread cave of the Cyclops Polyphemus in *The Odyssey*, strewn with fragments of unspeakable meals. The title is *The Destruction of the Father*, 1974.

"It is a very murderous piece," Bourgeois points out in the catalogue, with some understatement, "an impulse that comes when one is under too much stress and one turns against those one loves the most." The same imagery recurs, in a slightly more distanced way, in her big room environment, *Confrontation*, 1978. Here the viewer is excluded from the central table, which is strewn with breasts, remnants of latex-covered food and other morsels, by a ring of white wooden boxes. These taper toward the top and, like versions of the dolmens in archaic ritual sites, press to be read as abstracted effigies of the human figure: a ring of watchers, backs shutting out the audience, absorbed in an obscure ritual.

Some may find such imagery not merely archaic but quite old-fashioned; invocations of the chthonic and the primitive have been common modernist fare for three-quarters of a century, since Picasso's *Demoiselles d'Avignon*. But Bourgeois uses her primitive quoting to get her past the conventional categories of modern art history—the litter of isms that tells us so little about the real meanings of art—and to rummage painfully between the layers of her own psyche. What images can art find for depicting femaleness from within, as distinct from the familiar man-powered conventions of looking at it from outside, from the eyeline of another gender? What can sculpture say about inwardness, fecundity, vulnerability, repression or resentment? How can it propagate different meanings for the body? It is to such questions that Bourgeois's work turns, not always with equal success, but with a striking intensity. Some of it looks "unheroic," deficient in fully realized form, even incoherent: but these are by-products of her effort to describe, by surrealist means, experiences that tend to be left out of heroic art. For such an effort "Bourgeois" may be the wrong surname, but it is good to see such an artist getting her due at last.

Time, 1982

Philip Pearlstein

The Philip Pearlstein retrospective now at the Brooklyn Museum, curated by Russell Bowman, is a dense and satisfying show. Pearlstein's work has not lost its episodic power of surprise: one tends to feel more familiar with it than one is. What is so new about a nude in a room, done over and over again? Quite a lot, in fact. Pearlstein is by now a fixture of the museums and art history books. He is fifty-nine this year, and probably did more to "break the ice" for realist painting in America than any other artist of his generation. What is on the walls in Brooklyn embodies a struggle with convention as tenacious as any in modern American painting.

As Irving Sandler remarks in his catalogue essay, Pearlstein "resumed what an avant-garde some three-quarters of a century earlier had proclaimed to be academic"—modeled painting of the naked human body.

The studio nude, posed, had been the very protein (or, to its detractors, the basic starch) of Salon painting from Ingres to Bouguereau. It was thrust into eclipse by Impressionism because it carried an aura of the posed, the stagy, the allegorical, and Post-Impressionism finished it off. The nude became a casualty of the means painters chose to assert their pictorial honesty: the near-religious cult of flatness. The intricate bumps and hollows, bosses and knots and smooth rotundities of the body's landscape were generalized down to patches. By the start of Pearlstein's career, in the ebb tide of Abstract Expressionism, the very idea of rendering the posed body in a room seemed absurd; it required the most taboo act known to late modernism, making a spatial illusion, turning the flat plane into a window.

Taboos are made to be broken; one sees today why Pearlstein was interested in an artist so totally unlike himself, the Dadaist Francis Picabia, who conceived his work as a constant affront to received taste. Painting the studio nude, Pearlstein declared allegiances very different from those common in the New York art world of the late fifties. In neither hedonism nor irony nor self-expression, he wanted to go back and start from Gustave Courbet, painting the naked body in a spirit of detached, colloquial reportage, as though all the proscriptions against figure painting had lost their magic. To suppose this was not a radical act, one would need to know very little about the pressure of ideology and convention in the New York art world of the time. Realist figurative painting was as unpopular then as abstract art is now.

Pearlstein's "look," with its tallowy *largesse*, its peculiar blend of remoteness and intimacy, did not appear overnight. In the early fifties his paint was as roiled and heavy as any young abstract painter's: his interest in Picabia's machine-body images shows in a 1950 painting of a scrawny nude being attacked by a bathroom shower, and there is even a sign of Pop imagery to come, in a 1952 painting of Superman, blue-chinned as a mafioso and bulgy as the *Laocoön* (to which his pose refers), flying over the pinnacles of Metropolis. But by the mid-fifties Pearlstein had begun to concentrate on landscape, and the basic motifs of his later work were beginning to emerge. There are studies of rocks and cliffs in this show, plain mineral matter pushed against the eye, whose closeness and rotundity, cracks and fissures uncannily predict the nude bodies Pearlstein would be scrutinizing twenty years later. But, he later remarked, he chose them because they looked like Abstract Expressionist compositions. For a while he stayed with landscape, painting it in Italy—the sun-inflamed bricks of Roman ruins, the cliffs at Positano running like wax in a con-

trolled chaos of juicy brush marks—paying the necessary homages to de Kooning and, further back, to Soutine's landscapes at Céret. Then, on his return to New York City in 1959, he concentrated on the human figure and, with a few exceptions (paintings of the Canyon de Chelly in Arizona, done in 1975, a few cityscapes of lower Manhattan from a Greenwich Village high-rise, among others), ignored the outdoors thereafter. What he wanted was something perfectly controllable, a situation rigged by choice, a setup: a hired anonymous figure under floodlights, in a room.

For Pearlstein's idea of realism had nothing to do with the conventional picture: an artist plants his easel before a scene and transcribes it as best he can. On the contrary, he wanted the rules of the game to be apparent. This meant declaring the artifice of pose, cropping, lighting and visual angle, as conscious elements of subject. Nothing about the final image would seem "found"; if a leg cut the corner of the canvas at forty-five degrees, that was because Pearlstein wanted it to, not because the model happened to sit that way. He said he wanted his art to look "strongly conditioned by procedures," and thus it came to seem—perversely at first, then inevitably—aligned with "systematic" art in the seventies, even with Minimalism. Pearlstein's mature pictures do not suggest that you have walked into a room and come across people sitting or standing there. The framing and angles are too conscious for that. The eyeline jumps up to seven feet above the ground; the top of the canvas slices off the model's head. Sometimes, particularly in recent works such as *Two Models in Bamboo Chairs with Mirrors*, 1981, the relationship among body, furniture, patterned cloth and their mirrored reflections takes on an almost conundrumlike air. Pearlstein's space is so transparent that one cannot at first tell the body from its reflection. The eye sorts through the rhymes, counterparts and fragments, reassembling the scene against the resistance of the pattern, its responses dominated by the strong, smooth ovals of the bamboo chair arms. He gives inanimate pattern—baseboard moldings, a kilim rug, the herringbone parquet of a floor or the florid Deco geometries of a wrap—a pictorial importance equal to that of the sallow flesh. And yet it is not true that everything gets reduced to pattern. Pearlstein's eye is harsh and factual, and it takes in the conditions of pose without eliding them. One knows that his models are tired, their faces sag in boredom, their muscles are barely awake. The mechanics of the studio are acknowledged too. If the edge of an easel casts two shadows because two floodlights are aimed at it, they end up in the painting.

This collusion between the formal, procedural side of Pearlstein's work and its ungeneralized directness of observation is what gives his

paintings their "cold," unsettling look. And something else: for there is no painter today who rejects, more tellingly, the idealist distinction between the "naked" and the "nude." There is a blunt sexuality in Pearlstein's work that the conspicuous formal devices frame rather than abolish. This formality is not voyeuristic, cute, Playboyish or "earthy"; it offers nothing and does not even try to be inviting. It arises from Pearlstein's fascination with the strangeness of flesh, the otherness of bodies not his own. In other words, his style isolates that quality in nakedness that the conventions of the pinup and the titillations of high-art nudes seek to cover: the fact that the skin is a frontier as well as a surface. Most of the objections to Pearlstein's frigidity seem to connect to this fact without acknowledging it, and yet it is one of the chief insights of his work, very much a part of its growing claim on our attention. Realism, we learn once more, is neither a simple nor an easy matter.

Time, 1983

Robert Motherwell

One does not usually think of art shows in terms of seasons, but the Robert Motherwell retrospective that opened last week at the Albright-Knox Art Gallery in Buffalo is certainly autumnal: a life's work fully matured, all its lights, smokes and fermentations distinct, its promises ripely fulfilled. The show, organized by Douglas Schultz, is not a huge affair in proportion to the size of Motherwell's output. There are, in all, ninety-three paintings and collages to represent a man whose oeuvre must be ten or even twenty times that.

Motherwell is sixty-eight, the youngest member of the group whose name he coined: the New York School, or as the history books say, the Abstract Expressionists. Pollock, Rothko, Still, Newman, Baziotes, Gorky, Smith and Kline are all dead; only de Kooning, Krasner and Motherwell are still at work. In the meantime the achievements of the Abstract Expressionists have become so encased in legend, fetishized by the market and picked over by scholarship that their work, in the eyes of younger generations, has assumed a somewhat fabled air. Like grizzled

bison in a diorama, they suggest a lost age of American pioneering. The sheer weight of the cultural appetites their work helped set in motion has turned them into monuments against their will.

This process has proved particularly unfair to Motherwell, because his full maturity as an artist came after the Abstract Expressionist "period"—in fact, after 1960—and his career illustrates the perils of generalizing about decades, groups or movements. Of course there are expressionist elements in Motherwell, and strong ones at that. But the rhythm of this show obliges one to discard the hearty cliché of the Abstract Expressionist as a kind of existential romantic, flinging pots of paint in the eyes of fate.

What we see is not what legend tells us to see. For Motherwell is a painter of superb though admittedly fitful balance who has managed to raise a magisterial syntax of form over an undrainable pond of anxiety, and the apparent fluctuation of his art between the "expressive" and the "classical" really depends on how much of that water is showing around its foundations. He is not a great sublimator, like Matisse or Braque. Yet in its breadth, grace, discipline and lucidity, as in the standards of self-criticism that are embedded in its patrician rhetoric, his art is genuinely Apollonian. Even its disorder speaks of a nostalgia for order.

That such traits are strengths seems obvious today. But it was not always so. Twenty years ago, Motherwell's reflective temper, his unabashed reverence for the Parisian past and, above all, his wish to bring modernist writing from Mallarmé to Joyce into the ambit of his art made critics uneasy. Surely this was all a trifle historicist, a bit too stylish?

Motherwell never dissembled about his sources. Not only was a sign for the human body such as *Figure in Black*, 1947, with its mask's eyes staring from the bent trapezoid of a head, clearly derived from Picasso, but Motherwell would also write more knowledgeably about Picasso than most of his contemporaries, critics included. If the rectangular opening that kept appearing, as a promise of space beyond the picture plane, in painting after painting from the early forties to the *Open* series of the late sixties and early seventies derived its authority from Matisse's *Blue Window* or from the 1916 *Studio: View of Notre-Dame* in the Phillips Collection in Washington, D.C., Motherwell would be the last to deny it: he was preoccupied with continuity and saw modernism as a tradition.

He meant to claim the same kind of filial attachment to Matisse that Delacroix (another household god) had to Rubens. To those whose idea of modernism was modeled on Oedipal battle, that was not enough. Hence the feeling, not yet dispelled in all quarters of the art world, that Motherwell was too French, too fluent, not hard enough on himself or his

viewers. Unlike such Nietzschean contemporaries as Pollock and Still, he was (dreaded word!) "elegant," and the fact that the blackness, raggedness and restrained violence of many of his paintings invoked the tragic only made matters worse.

Today these objections sound like dated cavils. All art is fiction, and the more complex the fiction, the better the art is apt to be. Motherwell's elegance is not a matter of style. It comes from deeper wells: mainly from his highly critical and intelligent sense of the accumulated language of modernism and of the way in which his own pictorial impulses relate to that language. It is the elegance of realized thought.

One needs to be fairly naive these days to believe that artists can literally function as shamans or magicians. Certainly Motherwell does not think so. But he fervently believes in the efficacy of signs, the ability of quite simple configurations to carry and release powerful associative cargo. The blue triangle of paint above the ocher and earth-red bars of *Summertime in Italy, No. 28*, 1962, offers all the sense of being in a landscape: light and wind stream from the blue, heat radiates from the brown. Motherwell's *Elegies to the Spanish Republic*, a lengthy series that lasted some thirty years and ended after the death of Franco and the restoration of parliamentary democracy in Spain, are best seen as an American pendant to Picasso's *Guernica*, although with different imagery. Black in the hands of some painters—a Manet, a Goya, a Matisse—is a color, not an absence of light; and *el negro Motherwell*, as Spanish poet Rafael Alberti called it, sometimes acquires a walloping chromatic power.

The basic shapes that make up the *Elegies*, held between bars or strung like meat on a skewer across the canvas, could hardly be simpler: black ovals or ragged beam-shaped forms that bear a resemblance to bullfighter's hats, black frames that evoke the deep shadow of doors in lightstruck village walls. But out of these signs Motherwell has fashioned a resonant and funereal sequence of images that, despite its repetitions (when in doubt, paint an *Elegy*), is one of the few sustained tragic utterances in post-Picasso art. He has always been faithful to the Abstract Expressionist dictum (which he helped formulate) that subject matter is crucial.

The colors of the *Elegies* are, as he put it, "an equivalence of the ferocity of the whole encounter." This is perhaps what Mallarmé refers to in his famous phrase about describing not the object itself but the effect it produces. To speak of "Motherwell black" or "Motherwell blue" is not to identify a particular hue—there are many blacks in his work and a near-infinite range of blues, from creamy cerulean to wine-dark—but

rather to evoke the way these colors work, as stable characters in a plot of sensation.

This is especially true of the *Open* paintings, which consist of broad fields of color whose only additional feature is an incomplete rectangle or trapezoid, formed by three or four lines of charcoal or black paint. These lines seem to give access to a field behind the field. The enclosure may be strict-edged or fuzzily tremulous, but it always conveys the impression of architectural form—a window or a door, a passage from inside to outside. The painting *Summer Open with Mediterranean Blue*, 1974, creates a strikingly concise yet opulent impression of landscape by these pared means. The passages of tone in the paint, the variations of blue depth, drench the eye in sea light without offering a glimpse of horizon; it is as though a part of nature had been taken down to its barest essence—discarding the thing but leaving the nuances—and then contrasted with an equally reduced emblem of culture: three lines, the platonic ghost of a building, humanizing the blue and saving the eye from getting lost in it.

But Motherwell's color is never descriptive. Even the more recent arrivals on his palette, for instance the soft greens and grayed browns of "Irish" paintings including *Riverrun*, 1972, an homage to Joyce's meditations on Dublin's river, the Liffey, soon acquire this fixed quality. Color in Motherwell is not an adjective but a noun.

It is the collages that most clearly represent the "French" aspect of his work. Motherwell put this explicitly in the title of an early one, *The French Line*, 1960. Its main element is the top of a diet-toast package torn into a shape vaguely suggestive of a liner seen bow-on. Its stripes suggest deck chairs and awnings, and they convey one into the atmosphere of luxury and fine-tuned bodies that was part of the fantasy raised by the SS *France*, and first-class ocean travel in general, two decades ago. The diet wafers, the label tells us, are "the faithful friends of your *ligne*"—the last word means "figure," but also "shipping line" and, of course, "line," as in drawing. This elegant triple-entendre is meant to be read as a pledge of Parisian allegiance.

Motherwell has never used collage as a means of surrealist shock treatment. His work sits squarely in the formal tradition of early Braque, not in the poetic irrationality of Ernst. But its play between form and meaning is no accident. The "found" element in *Unglückliche Liebe* (Unhappy Love), 1974, is a fragment of sheet music whose words apostrophize the miseries of passions: "Begone, begone, ye children of Melancholy!" But set on its dark ground, with a rectangle of slaty blue and a marvelous, soaring shape of white paper—Mallarmé's swan, making a personal ap-

pearance—its stilted sentiment turns into a concise image of sorrow and relief.

Motherwell's collages amount to a definition of their medium. It is the nature of glued paper to look flat, frontal and spreading; to build its image in planes; to set up counterpoints between word and shape; to make one focus on texture and edge. In pieces such as *In Memoriam: The Wittenborn Collage,* 1975, Motherwell draws by tearing, and the implied violence of the torn edge (which looks and feels very different from the clean-cut edges of Braque's newsprint or Matisse's scissored paper) plays, in collage, the same role as the ejaculatory splattering of paint in his paintings. It is chance, fixed: no one can say how a piece of paper will go when it is torn. This combination of violence and reflection, along with the easel size of the images, is Motherwell's basic addition to the art of collage. In making it, he became the only artist since Matisse in the fifties to alter significantly the syntax of this quintessentially modernist medium.

Motherwell's collage invokes social encounter. It uses the flotsam of everyday life—cigarette packets, labels, brown paper—to pass us through abstraction and back to common experience. His painting is natural or mythic encounter; one traverses its condensations and gestures to arrive, on the other side, among the ochers of Italy and California, the blues of Nice and Provincetown. In moving between these two poles, Motherwell has become for some people the greatest abstract painter alive, and for others not an abstract artist at all.

Time, 1983

Sandro Chia

At the age of thirty-seven, Sandro Chia, whose show of paintings and bronzes is at the Leo Castelli Gallery in SoHo, is one of the more promising of the artists who have recently floated from Italy to New York City like putti on roseate, gaseous clouds of hype. Because they share the same last-name initial and transplanted nationality, Chia, Enzo Cucchi, thirty-two, and Francesco Clemente, thirty-one, tend to be bracketed together as the "Three Cs." In fact they are very different painters. Chia's light-

operatic gifts have little in common with Cucchi's mucky, doom-laden earnestness: apopletic chickens and mud slides in the cemetery, done in umber and black two inches thick. Nor does he seem a forced talent like Clemente, a glib draftsman whose "expressive" pictorial rhetoric is stretched fairly thin to cover a paucity of formal skills.

Along with an assortment of German Neo-Expressionists and many others besides, the three Italians were packaged in a sonorous phrase by a Roman critic: *la transavanguardia*, or "the trans-avant-garde." This clot of art jargon, like "postmodernism," means nothing definable. It merely points to a mood of eclectic revivalism, the assumption being that since progress in art is a myth, painting must perforce go crabwise, with many nostalgic glances backward. Under such a vague rubric, Chia looks a very apposite painter. Granted, neither he nor his fellow *transavanguardisti* get anywhere near the best German art of this generation, epitomized by the grim, formidable visions of Anselm Kiefer, thirty-eight. Yet it is better to lack the tragic sense than to fake it. If an artist such as Kiefer can uncover the sublimated debris of Nazism, one such as Chia can do history as comedy, positing his style on the mannerisms of Italian art in the Fascist period. He has an acutely caricatural sense of conventions and some sophistication about how to create a surface. Neither is fully at work in his present show.

Chia's originality is more notional than real. It depends on the unfamiliarity of the sources he adroitly quotes. How many people in America have heard of, let alone seen, the work of Ottone Rosai (1895–1957), a Florentine painter whose roly-poly figures were part of a conservative reaction against Italian Futurism in the 1920s? Chia has, and his rotund bodies—thighs like boiled ham, buttocks like blimps, coal-heaver arms—are straight out of Rosai, although bigger and endowed with a crustier decorative surface.

In the same way, Chia alludes to de Chirico (not the early master of strange, oneiric cityscapes, but the de Chirico of the 1930s, with his kitschy antique pretensions) and, more recondite ly, to the paintings of de Chirico's brother, who took the name Alberto Savinio. With tongue in cheek, Chia has assembled a whole secondhand wardrobe of classical nostalgia: the painting *Figures with Flag and Flute*, 1983, with its bearded sage listening to the pipings of a young musician amid the rubble of some temple, thus manages to be both knowing and undemanding. It evokes complicity; artist and viewer share their camp enjoyment of a dead language.

One of the reasons for Chia's popularity may be that he persuades his

viewers that they are just a bit erudite without taxing them with art-historical demands. If those padded boys and dropsical nymphs, dreamily enacting their parodies of Arcadian life, were to meet the demands of real classical art, it would seem a breach of etiquette. If the absurd athlete without genitals in *Young Man with Red Arm*, 1983, a descendant of Mussolinian strength-through-joy nudes and post office murals from Turin to Ladispoli, were to become credible, he would be threatening. But no such things happen. Chia has figured out how to take authoritarian images and render them cuddly, defusing their latent political content. All heroes are organ-grinders. Everything looks so ebullient, juicy, operatic and harmless that non-Italians consider it "typically Italian," like a painted cart or a singing gondolier. Nothing menaces. When Chia paints a crocodile, you suspect that the model was a handbag.

There are times when his work transcends this innate cuteness, when the pressure of quotation builds up into poetry, or when some underlying theme of his preoccupations (usually the conflict between paternal authority and lunky adolescent waywardness) catches fire. At his best he is capable of flights of lyrical painting: *Melancholic Camping*, 1982, a strange and complicated vista of de Chirican tents pressing in on a tiny figure with rabbit ears, was one of the surprises of the past year in SoHo.

No work of that quality is in this show. Castelli's huge white walls seem to cause painters to inflate like blowfish under stress. Chia ends up painting so big that his parodies of "heroic" figure paintings cease to be parody. They look stodgy and overblown. The drawing is sometimes woebegone, particularly when he does "homages" to Tintoretto in the form of a pair of walruslike nudes adrift in a sea of greeny-blue wiggles. The sculpture, fussy in surface and ponderously lumpy in volume, is a waste of bronze. In short, it is time to retrench; if this show turns out not to be a passing phase, a minor artist will be in major difficulty.

Time, 1983

Malcolm Morley

One of the largely unnoticed facts about current art is that despite the hoopla made over some national groups of painters—mainly German and Italian—a great deal of the most inventive and solid painting in the eight-

ies keeps being done by the English. One thinks immediately of Frank Auerbach, Howard Hodgkin or half a dozen others. And among them, prominently, one thinks of Malcolm Morley. Morley is fifty-two. His first retrospective, curated by Nicholas Serota, has been touring Europe for the last year and is now at its last stop, the Brooklyn Museum. It spans less than twenty years, from 1965 to 1982: a highly edited affair that says nothing about Morley's background as an abstract painter but a great deal about his foreground as a figurative one.

In this case, the foreground counts most. It is a simplification, but not a gross one, to say that Morley and the late Philip Guston were the twin unlatchers of "new figuration," at least in America. Morley was an expressionist artist when most of the current crop of Neo-Expressionists were still, aesthetically speaking, in diapers. His mix of mass-media cliché with intimate confession, his abrupt shifts of gear in imagery and format, and his therapeutic desire to shovel his whole life—traumas, lusts, memories, hopes—onto the canvas, struck many younger painters as a fresh model of artistic character. In the past few years, aping this or that aspect of his work has almost become a cottage industry; West Broadway is full of painters solemnly brandishing fragments of Morley as their own, like leaf-cutting ants.

Then too his character must be reckoned in. Morley's reputation as the last wild man of the art world gives collectors a delicious frisson. Stories about him proliferate and are often true: a jail sentence in Wormwood Scrubs as a young man, the rages in his broken-up studio, the destruction of work. One German collector gave Morley $40,000 for a painting and was nonplused to see the artist slash his canvas to ribbons before handing the check back. Such gestures establish a profile. But it is the work that matters.

One can plunge into Morley's peculiar oeuvre with a painting that presents his dislocations at full stretch: *Age of Catastrophe*, 1976. It shows an accident that never happened. A liner on the Atlantic run is warping out of port. Its hull is literally "warped," the perspective skewed and twisty. An airliner seems to have crashed on it, an old Pan Am Constellation of the sort that went out of service decades ago. But the scale is all wrong: the plane is too big for the boat, and it looks more like an effigy stuck to the painting. In fact, Morley did paint it from a tin airplane, picked from his vast collection of models and toys. A U-boat, suspended beneath the painted sea on painted sticks, is also done from a toy. As a document of catastrophe, the scene is far from believable, but its curious power as an image comes partly from the sheer blatancy of its fiction. The

fact that the plane, the liner and the sub are so toylike carries one back to the mock battles of the nursery, to the child's delight in constructing harmless miniature wrecks that discharge the aggressions of childhood. "As flies to wanton boys, are we to the gods; / They kill us for their sport." So the real subject of Morley's painting is not so much the death of people or the destruction of machinery as the general, ineradicable ground of adult violence in the infant psyche.

The paint on the canvas looks sluggish and frozen, like cake icing. (In the early sixties, Morley did put the pigment on with icing nozzles.) Its dull turbulence parodies the violence implicit in expressionist paint-handling. The heavy brushstroke is no longer an index of earnestness; it quotes strong feeling without necessarily endorsing it. Morley's blend of coolness and violence has some of the impact of early Warhol. But it is far more complicated and nuanced, and free from chic.

Instead of accepting the glossy impact and impersonality of mass media at face value, Morley rants against them. That is the main difference between him and the Pop artists with whom he was associated in the 1960s. It was not obvious at once. When he first emerged as a painter, it was with images that looked utterly deadpan: paintings of ocean liners, enlarged from postcards and publicity brochures. But their method was peculiarly systematic, a parody of system, in fact. Squaring the postcard image up to canvas size, Morley would work on it patch by patch, sometimes upside down, stippling away so that each bit of water or hull looked abstract to him, as patterns do when they are isolated and magnified. What counted was not so much the liner as the labor of painting it. In reproduction, of course, the paintings become postcards again. But on canvas they have a disconcerting air; above their anonymous imagery the paint is beginning to assert itself, its texture and weight anxiously at odds with the bland scenes of middle-class pleasure they describe.

By the early seventies Morley's painting was largely about violence happening to a spuriously calm surface. In *Los Angeles Yellow Pages*, 1971, a jagged rip appears in a Los Angeles phone-directory cover, thus eerily predicting the city's real 1971 earthquake. A postcard scene of *Piccadilly Circus*, 1973, is incoherently violated by blurts and blobs of paint; they include a quantity of gray that has leaked from a bunch of bags hanging from the top of the canvas. Morley invited some friends to shoot arrows into them and release the paint, and the arrows remain stuck in the picture, thus supplying a missing figure: Eros, the god of love, with his bow, who stands on the fountain at the middle of the actual Piccadilly Circus. The image is a memorial to Morley's marriage, which had collapsed in bitter disarray a short time before.

More recently, the work has become, if not exactly more amiable, less wrenched by signs of aggression. It preserves its haunting collisions of imagery; who knows what the elephant is doing beside the field-hospital tent in *M.A.S.H.*, 1978, or why the white figure is on its head—an effigy of his father, according to Morley—or why they are all in the Florida greenery? His paintings hop between memory and desire; infantile recollection, fragments of autobiography, references to historical art all get crushed together. In the process he will quote anyone from Pollaiuolo (in *La Plage*, 1980) to the ineffable LeRoy Neiman.

When Morley is spinning his fables around a core of imagery that the viewer cannot quite grasp, his real successes occur. The painting *Underneath the Lemon Tree*, 1981, cannot be fully read. One knows it is about aggression: Morley's toy soldiers again, two ancient Egyptians and a modern member of the Horse Guards, plus a scrawled, emblematic castle. But what are they doing in the green space that is Morley's sign for paradise? The probable answer is that they are there because they are in the artist; the combinations of aggro-and-bother with glimpses of lush relaxation and childhood escape epitomize his own conflicts. When painting "straight" landscape, Morley is less convincing, producing huge pictures of wobbly livestock under a crude Constable sky. At such moments he reminds one that there are not only good art and bad art but bad "bad painting" and good "bad painting." Fortunately, most of Morley falls in the first and the last of these four categories.

Time, 1984

Julian Schnabel

Six months ago I took myself out of Julian Schnabel's memoirs. When Random House was circulating its manuscript in the hope of selling serial rights, an extract came my way from a friendly editor:

> At the beginning of the 8os things are hazy in my mind. . . . I remember some guy coming up to me, I think his name was Richie or Robbie Huge.

This essay first appeared as a review of Julian Schnabel's *CVJ: Nicknames of Maître D's & Other Excerpts from Life* (New York: Random House, 1987).

I noticed he was wearing . . . a bow tie with a black leather jacket, although the tie was almost obscured by his triple chin. He whispered in my ear, "Could we go somewhere alone? Maybe to the wine bar and talk about you—I mean your work? I've always intended to write about it." I said, "Sure, let's talk." After some introductory flattery, his voice dropped down a tone. He whispered, "Will you chain me up?" I said, "I'm sorry Robbie, I'm not into that sort of stuff." His reaction was one of shame inflected with hate. In his sort of cockney accent, he said you'll pay for this one day. Reading his antisemetic [sic] babbling and personal attacks on me in Space magazine I found out he is a man of his word.

For Space, read *Time*.

Never having met Julian Schnabel, I began to wonder from what elements he had concocted this "memory." I once had a black leather jacket, but in 1973 my motorcycle was stolen from a sidewalk in SoHo and I gave the now useless garment to an art historian in Worcester, Massachusetts. (Fourteen years later an old photo of me wearing it on my lost hog appeared in *New York* magazine, where Schnabel presumably saw it.) To be called anti-Semitic by a man who couldn't spell the word was weird enough, but what about those chains? I puzzled over them for days until a friend, a scarred veteran of the psychoanalytic couch, pointed out that this mystifying passage could only record Schnabel's own desire to "chain up"—that is, silence—any skeptic who doubts his genius. I called the publisher. There was a sound of foreheads being clutched. The paragraph was cut. Thus *CVJ* lost its one and only spicy bit, although perhaps not its only fictional one.

The unexamined life, said Socrates, is not worth living. The memoirs of Julian Schnabel, such as they are, remind one that the converse is also true. The unlived life is not worth examining. Writing them at thirty-five, he has set some kind of a record for premature retrospection, at least among artists. No wonder he needs to invent.

"It's sort of a cross between Charles Dickens and Gertrude Stein," he told one reporter. For Julian Schnabel is nothing if not a celebrity—a minor one by the standards of the mass media, but quite a big fish in the art pond. If he is not a household name like Pablo Picasso, Jackson Pollock or Andy Warhol, that is not for lack of trying; indeed, through the last years of his life Andy had Schnabel at his feet, looking up, missing nothing. "The hall of Fame," wrote a nineteenth-century wag,

> . . . *is high and wide,*
> *The waiting-room is full,*

And some go in through the door marked Push,
And some through the door marked Pull.

As a true self-constructed American, Schnabel chose the former. His entry
was propelled by a megalomaniac, painfully sincere belief in his own
present genius and future historical importance. Between writers and
readers this kind of lapel-grabbing has dubious value as a promotional
tactic, and in any case it never works for long. (After their second books,
what will persuade the discriminating reader that something worthwhile
will come out of Bret Easton Ellis or Tama Janowitz, the Bright Young
Things of lower Manhattan whose media-struck careers in the mid-eight-
ies seem so close to Schnabel's? But the American art system is more
plagued by inflation and vitiated by fashion than the literary world be-
cause while a book confers no status on its owner, a painting may. There
is a crack of doubt in the soul of every collector. In it lurks the basilisk
whose gaze paralyzes taste: the fear that today's klutz may turn out to be
tomorrow's Picasso, so that nothing except the manifestly out-of-date may
be rejected with impunity. This hardy little reptile was particularly active
at the moment Schnabel came on the scene, because in the first half of the
eighties the demand for hot, young, new, exciting contemporary art shot
through the ceiling. All of a sudden scores and then hundreds of the very
new rich (arbs, developers, soap opera producers, agents, admen and all
manner of important folk whose uncertainty in cultural matters matched
their professional vanity) decided that, being amply entitled to Total
Everything Now, they would also become "major" art collectors.

This wave had been rearing up, far out on the horizon, for a long
time. The prescient could see it coming with the Scull auction in 1973. But
it hit the beach in 1982. The emblematic moment was, to be precise, on
August 13, 1982, the day the Dow jumped forty points and the bull market
started its five-year run. This surge transformed the contemporary art
market beyond recognition. (It is too early to know what the bears will
do to it; the price of van Gogh or even Jasper Johns is not a guide to the
market stability of reputations made yesterday.) Most of the aspiring
collectors, some of whom would duly end up on museum boards, or even
with their own private museums, could not have told you the difference
between a Cézanne watercolor and a drawing by Parmigianino. Their
historical memory went back as far as early Warhol, where it tended to
stop. Their sense of the long continuities of art was, to put it tactfully,
attenuated. Insofar as they thought about the matter, they were apt to see
twentieth-century art history as a series of neatly packaged attacks

launched at the frowning ramparts of "tradition"—first the Fauves, then the Cubists, then the Expressionists, then the Constructivists and so on to Abstract Expressionism and Pop. This reflex, applied to the present, meant they all bought essentially the same paintings by the same artists—a herd instinct that explains the monotony to which one is condemned when passing from one new collection to the next in Beverly Hills.

By the time this new class of rich fashion victims irrupted into the market, the old scenario of avant-garde confrontation had already collapsed in America, whose entire cultural life was based on models of diversity and novelty. The struggles of the avant-garde—as enacted, say, in Max Beckmann's Berlin or Wyndham Lewis's London—had dissolved in the sixties and seventies into something much more rationally American, more suited to a middlebrow culture that had come to believe in the therapeutic and educative powers of art. "Modernism" was telescoped into "newness," and newness was promoted as a value in itself. The art market embraced the aesthetics of Detroit: a new model with styling changes every year and *radical* restyling every five or so. We see this in 1987, as hot Neo-Expressionism is gradually nudged off the showroom floor by the hotter, because cooler, footnotes to Minimal art and the Duchampian readymade which, for want of any "movement" name, go under the essentially meaningless label of "Neo-Geo."

In the early eighties, however, the action lay with recycled Expressionism; this was where Schnabel came in. New collectors had been raised on folk myths of the totally expressive artist as scapegoat or hero—van Gogh and his ear, Pollock and his booze, Rothko slitting his wrists, Joseph Beuys wrapped in felt and fat beside his crashed Stuka. After the *cuisine minceur* of the seventies, a time of small pebbles on floors and sheets of typing paper on gallery walls, they were aching for something hot and heavy. They got it in abundance from Schnabel's Gaudí-derived plates and Beuys-derived antlers, his heavy surfaces of horsehide and velvet choked with slimy pigment, and his incoherent layering of "mythic" imagery. The art looked radical without being so; it was merely novel, and that quality soon outwears itself. However, in 1980 the uncertainty of new-market taste was such that if someone stood up to assert loudly and repeatedly that he was a genius, there was a chance he would be believed. This was the strategy of Schnabel and his first dealers, Mary Boone and Leo Castelli, and it worked brilliantly. Everyone wanted a genius, and in Schnabel our time of insecure self-congratulation and bulimic vulgarity got the genius it deserved. There was a more than accidental correspondence between Schnabel's success in meeting the nostalgia for big macho

art in the early eighties, and Sylvester Stallone's restoration of American *virtù* through the character of Rambo.

Indeed, Schnabel's work is to painting what Stallone's is to acting—a lurching display of oily pectorals—except that Schnabel makes bigger public claims for himself. Grace Glueck interviewed him for *The New York Times* and recorded his solemn opinion that his "peers" were "Duccio, Giotto and van Gogh." One might suppose that such displays of invulnerable conceit would have turned Schnabel into a figure of fun overnight. In England, where his work has never acquired a following among critics, artists or the public, they did—and Schnabel, in a recent interview with the editors of *Flash Art*, sagaciously attributed this reaction to "a history of philistinism in England from Shakespeare to George Bernard Shaw and Evelyn Waugh." But the American art world, despite its recent fixations on the idea of irony, does not have much sense of humor: too much is at stake to entertain the thought that a hero might be a buffoon. Like the political analysts who, only a year ago, supposed Reagan's image would never succumb to the real results of his dimwittedness, some critics persist in treating Schnabel as though his fame were a given cultural fact, which no perception of the ineptitude of his work can alter. "No one expected him," pants Thomas McEvilley in his catalogue essay to the Schnabel retrospective that opened at the Whitney Museum of American Art in New York this month. "No one knew they wanted him. Yet somehow the age demanded him. . . . There is nothing anyone can do about it." The notion that the man is an emanation of the zeitgeist no doubt matches the artist's fantasies about himself. It even has a small truth, since only a culture as sodden with hype as America's in the early eighties could possibly have underwritten his success.

Yet there is a problem built into the nature of the American system: its volatility and short memory. Given its mass-market conditions, the art world of the eighties closely resembled the fashion industry. Things, as it developed, went down as well as up. Careers rose like the shuttle, amid roars of acclamation and pillars of smoke—and then, like *Challenger*, detonated. Who now remembers graffiti, the hot ticket of '83? Or the East Village scene in general? Out to limbo, to the land of Nod, to that elephants' graveyard of the formerly new that one imagines existing somewhere in the marshes of New Jersey, to join the second-generation acrylic-on-duck paintings of the seventies and the talking refrigerators of the sixties: permanently remaindered.

To escape (or at least, stave off) this fate, which looms larger as the market becomes jammed with a teeming proletariat of emergent artists—a

mass from which trends can be condensed more or less at will—a painter's work must quickly scale the museum system and hammer in its pitons: the lavishly illustrated book, the traveling retrospective. Hence the steady pressure bearing from the market on museums to hold full-dress "retrospective" exhibitions of work by artists still in their thirties. This practice would have struck an earlier generation of American museum staff as absurd, if not macabre. The whole point of a retrospective used to be (a) that it was an unusual honor, setting a long-meditated and hard-won vision into the disinterested historical matrix the museum was meant to supply, so (b) that a life's work could be seen whole. Today you can be ten years out of art school, like David Salle, and still get your retrospective at the Whitney—or, in Schnabel's case, at the Whitechapel Gallery in London, the Centre Pompidou in Paris, the Houston Museum of Fine Arts and the San Francisco Museum of Modern Art as well. The tinkle of his broken plates—which have lately developed the irksome habit of falling off the paintings, so that he now has a factotum who flies about America gluing them back on—is heard from sea to shining sea.

A rum business, this end of the contemporary art market; to properly tease out its strands of idealism, ambition, sanctimony, folly, generous enthusiasm and nervous bluff, to describe its machinery and the characters who tend it would challenge the powers of Balzac or Trollope. If Schnabel, in writing his memoirs, had tried to take the reader down to the engine room, if he had written about process rather than product, he might have produced a text of some documentary interest. Alas, nothing of the kind occurred. *CVJ* is a celebrity bio of the most banal sort, and its writing is little more than a gray grout around the big color reproductions of his pictures.

Schnabel's style of discourse has points of resemblance with his painting: a stew of mixed metaphors and rhetorical hiccups, thickened with unparsable gibberish that would break the point of any editorial pencil— "The disparity between the reflectiveness of the plates and the paint were in disagreement with each other." *CVJ* (the initials are supposed to stand for a private term of endearment between Schnabel and his wife, a rich Belgian girl) has no beginning and no end, only a disjointed middle, a string of maundering art-world anecdotes, stilted attempts at aphorism and peevish attacks on much better painters such as Eric Fischl. (David Salle, with whom Schnabel used always to be bracketed, is not mentioned at all; when the titans of the early eighties fall out, they pout but do not speak.)

Schnabel writes about great art (van Gogh's, Vermeer's, Goya's and

of course his own) in solemn terms of unconscious parody. His aesthetic responses are remarkably meager. Most of the time, art is a pretext for striking attitudes. Looking at a Vermeer "is like when you go to the movies and the lights go out and you become invisible before the film goes on. . . . This affords you the luxury of dying with a grin on your face"— like Bogey, presumably, up there on the Sierra Madre. On the other hand, the sight of a van Gogh drawing

> made me feel like I was standing on Houston Street in late November, when the temperature has just changed; I don't have a scarf, and a friend has cancelled a dinner appointment with me. I have nowhere to go. I feel the air go through me. I have a sense of my own twilight.

Götterdämmerung indeed. Poor Vincent, who labored so that this Texas culture-starlet, a hundred years later, might feel he has forgotten his scarf and, worse, been stood up for dinner! Schnabel may feel the air go through him, but we must listen to it, flatulent self-congratulation mingled with affectless chitchat about other artists. He does not like many of them much. Clement Greenberg, "one of the most destructive, inane, positivistic, and stifling forces against the growth of art in this country," makes a cameo appearance in the Los Angeles airport (mercifully, not in black leather) so that Schnabel can preen himself on flying first-class while the wicked old guru, who seems not to like his work at all, flies coach. Schnabel has no good stories because, one suspects, he is so self-absorbed that nobody else seems altogether real. "Good conversation is scarce," he complains, "and there are so few people who know how to make art." Indeed; and one less than he thinks.

Thus his narrative tends toward farce, a mooning, callow replay of the Outsider:

> I took a train to a public swimming-pool in the suburbs of Madrid. I watched teenagers making dates for later that night. I watched families watching each other. There was no way to enter into their lives. I went to the movies a lot. I saw *Last Tango in Paris* three times in the same day. In those three days I had finished a bottle of Valium and in almost a week hadn't spoken to anyone.

"No way to enter into their lives"—what did he expect the *madrileños* to do? Drop their babies, drag him inside and ply him with roast suckling pig? But at least his self-pity is less inauthentic than his claims to tragic elevation. He describes his plate paintings in terms of "parents screaming

on *Kristallnacht*, as their voices are lost as they are being dragged down the streets of Berlin while pieces of shattered glass glistened in the moonlight; or after some great violent act, whether it be human against human or human against nature. The plates seemed to have a sound, the sound of every violent human tragedy. . . . All of this was happening before I even started to paint the painting." One does not need to be a Jew to feel repelled by Schnabel's facile appropriation of a tragic historical event— one that happened twenty years before his birth—in the hope that it will lend resonance to his plate paintings. If broken plates really did "mean" Kristallnacht, how could he bear to use them in his coarse society portraits of Texas millionairesses and Beverly Hills producers? But of course, they don't mean anything of the sort. They are just bombastic texture.

Naturally, the book contains advice to the young, so much of it that its author seems unsure whether he is Picasso or Polonius. He inveighs against what he calls "signaturization," reliance on a brand-image—this, from the plate man!—and even speaks harshly of careerism, at least in others. Older artists, we learn, pose special problems. The young painter may give his seniors the benefit of his freshness, but he must shun their influence, lest it sully the miraculous originality of his vision. "Never listen to anybody. . . . It's a mistake for young artists to want to please older ones. They're going to make you take out of your paintings the very things that most characterize them as yours. . . . You can't listen to them because nobody knows better than you what you need to do. Most older artists are going to try to get you to conform to the standards that you are out to destroy anyway."

That, in a nutshell, is why Schnabel has never learned to draw: his growth was smothered by his impregnable self-esteem, through whose rhetoric one glimpses a mangled form of popular modernist cliché—the artist as thaumaturgic hero, as the driven Outsider locked in Oedipal battle with the hostile past.

If you want to know what went wrong with the education provided by many an American art school in the seventies, Schnabel's career is instructive. With scarcely an exception, every significant artist of the last hundred years, from Seurat to Matisse, from Picasso to Mondrian, from Beckmann to de Kooning, was drilled (or drilled himself) in "academic" drawing—the long tussle with the unforgiving and real motif which, in the end, proved to be the only basis on which the great formal achievements of modernism could be raised. Only in this way was the right to radical distortion within a continuous tradition earned, and its results raised above the level of improvisory play. This kind of rigor had been

leached out of American art schools by the 1970s, when Schnabel went to one in Houston, and it is quite plain from his student efforts (which are not in the retrospective now at the Whitney, of course) that he never had the smallest formal capabilities as a draftsman: the weak lumpish silhouettes, the kitsch-expressionist faces with their poached-egg eyes, the clumsy line and the fumbling inability to relate a form to the space around it by the energy of its contour were all there from the beginning. In short, because there was never a time when he could draw, there has not been a moment at which he could be said to have jettisoned this skill in the interest of some fiction of "rawness" or "primitive" intensity. The cackhandedness is not feigned, but real. Even when he has an original to copy, as in the Caravaggio youth with a fruit basket quoted in *Exile*, 1980, it is done with such paint-by-numbers awkwardness as to be embarrassing. The only paintings that carry any kind of conviction are those in which Schnabel makes no attempt to draw a figure or a motif, but contents himself with a murky, nostalgic sort of Abstract Expressionist splashing; the best of these (not in the show) is *Rest*, 1982, a brusquely painted board supported like a retable on a T-beam of wooden balks, in the Saatchi Collection in London.

Schnabel is a most eclectic artist; what you see in his paintings is what he was looking at last. It is bad luck that a show by Michael Tracy, an older Texas painter with whom he was associated in the seventies, should have opened in New York at the same time as Schnabel's retrospective, for in Tracy's lush hortatory imagery—always on the edge of religious hysteria, choked with ex votos, riven by knives, pierced with bronze nails and suffused by sadomasochistic references to the *penitente* cults of the Southwest, where he lives—one sees the real condition of emotional overload that Schnabel's work mimics but cannot make formal sense of. Likewise, his recent letterings on tarpaulin, such as the cruciform *St. Ignatius Loyola*, 1986, are little more than replays of the work of Salvatore Scarpitta. A list of Schnabel's "sources" would be long, as would a catalogue of the images he has appropriated in his magpie search for the stuff of major statements. Perhaps, with the art industry needing dissertations that amplify the hum of myth, Thomas McEvilley's catalogue introduction will not be the last piece of incantatory prose devoted to the exegesis of Schnabel's pictorial blather: "The brown biomorph wandering like a melon vine or a cancerous tumour across the page of the children's book is the sign of involvement in natural process, of the endless growth and change of things that will not stand still for human objects." Enough, already. The strongest symbol embedded in this conjuncture of show and book is their timing.

Did the Whitney Museum and Random House really mean to celebrate Thanksgiving by serving up this turkey?

The New Republic, 1987

Jean-Michel Basquiat:
Requiem for a Featherweight

If any artist may be said to have parodied, not just illustrated, the contemporary-art boom of the eighties, he was Jean-Michel Basquiat, who died of a heroin overdose in New York last August at the age of twenty-seven.

A few years ago, an art teacher at Cooper Union in New York showed me the computerized results of a survey designed to find which artists the incoming class of freshmen had heard of. They did not have to describe a work, let alone discuss it; only to name names. Picasso, as one might expect, topped the list with 61 mentions. Right under him were Michelangelo and van Gogh (54), Rembrandt (53) and Monet (50).

The curiosities began lower down. Andy Warhol scored 33, Watteau 1. And Jean-Michel Basquiat, not much older than the freshmen, was recognized by as many of them as were Tintoretto and Giacometti, and by five times as many as recognized Nicolas Poussin or William Blake. To them, Basquiat was living proof that one could make it straight out of the egg—no waiting.

One marveled at such innocence, for the truth about this prodigy was rather less edifying. It was a tale of a small untrained talent caught in the buzz saw of art-world promotion, absurdly overrated by dealers, collectors, critics and, not least, himself. This was partly because Basquiat was black; the otherwise monochrome Late American Art Industry felt a need to refresh itself with a touch of the "primitive." Far better black artists than Basquiat, such as the sculptor Martin Puryear, did not have to contend with this kind of boom-and-bust success. Its very nature forced Basquiat to repeat himself without a chance of development.

Jean-Michel Basquiat first appeared around 1980 as half of a two-man street-artist team who left gnomic graffiti in neat block letters around

lower Manhattan under the tag SAMO, shorthand for "Same Old Shit." (The message on my building on Prince Street read: "SAMO as an antidote to nouveau-wavo bullshit"—a claim not without its retrospective ironies.) You couldn't call Samo a master of aphorism, but his stuff read a little more snappily than most of the spraying and paint-pissing on downtown walls: needling, discontented and detached.

Likewise, Basquiat's paintings—when they appeared in 1981 at P.S. 1, in a sprawling survey called "New York / New Wave"—were clearly better than the common run of graffiti art: although he had dropped out of high school and scarcely set foot in art school, Basquiat had an instinct for putting things—words, masks, marks, disconnected phrases—on canvas with space between them (rather than just scribbling and void-filling, edge to edge, as most of his street colleagues did). This, coupled with his coarse but zappy line, suggested an unformed talent. His use of color was rudimentary and schematic. He had looked, however desultorily, at some museum art—mainly Dubuffets and Picassos, from which his "primitive" conventions were gleaned.

In a saner culture than this, the twenty-year-old Basquiat might have gone off to four years of boot camp in art school, learned some real drawing abilities (as distinct from the pseudo-convulsive notation that was his trademark) and, in general, acquired some of the disciplines and skills without which good art cannot be made. But these were the eighties; instead he became a star.

Graffiti were in fashion in the early eighties, and collectors were ready for a Wild Child, a curiosity, an urban noble savage—art's answer, perhaps, to the Wolf Boy of Aveyron. Basquiat played the role to the hilt. He had enough distance from it to carry it convincingly, for a time: far from being a street kid, he was in fact an upper-middle-class, private-school boy of Haitian parentage, whose father owned a four-story brownstone in Brooklyn and drove a Mercedes. By 1985, the peak of his career, when he made the cover of *The New York Times Magazine,* his larger paintings were going for $25,000 in the galleries and sometimes more at auction.

Deeply wounded by a rift with his father, Basquiat seems to have fixed on celebrity as a substitute for parental esteem; indeed, for the last few years of his life, his mentor was Andy Warhol. He made worthless "collaborative" paintings with Warhol, lived in Warhol's spare studio on Great Jones Street in downtown Manhattan and seems to have accepted Warhol as a surrogate father—along with the pale rider's own values about art, money and fame. Not the best of incubators for an infant artist;

but Warhol's friendship certainly kept him going for a while. What finished him off was drugs.

Like most junkies, Basquiat thought he was invulnerable. To feed the monkey, he had to crank out paintings by the hundred. Once wired up he lost whatever capacity for aesthetic reflection he might have had. The result was a run of slapdash pictorial formulas, whose much-discussed "spontaneity" and "energy" were mostly feigned. Thus, far from being the Charlie Parker of SoHo (as his promoters claimed) he became its Jessica Savitch.

Basquiat was not ideally lucky in his choice of representatives. His social groom was Henry "Freebie" Geldzahler, who had failed long before as a writer, curator and historian, but still wielded great influence as a tipster, at least among new collectors. Basquiat's first dealer, Annina Nosei, kept him in the basement of her gallery turning out canvases—now esteemed as "early Basquiats," to distinguish them from the less sought-after "late Basquiats" of three years later—which she sold before they were dry and sometimes before they were finished. Her successor, for a time, was a disturbed Iranian sleazeball named Tony Shafrazi, who a decade or so earlier had vandalized Picasso's *Guernica* in the Museum of Modern Art by spraying the words KILL LIES ALL across it in red. (For some reason the trustees of MOMA did not prosecute Shafrazi; he soon reemerged as a prosperous dealer in graffiti art, in a dazzling act of chutzpah.) A West Coast dealer is said to have maintained Basquiat in a Los Angeles studio for the few weeks he needed to crank out a show, thrusting pot, cocaine and heroin through the pantry door whenever the nostrils of genius began to twitch. But Basquiat's unreliability and his need for drug money prevented him from staying long with anyone—certainly not long enough to rig a safety net. In the end, about thirty-five dealers were left holding a stake in him.

Basquiat's career appealed to a cluster of toxic vulgarities. First, the racist idea of the black as naïf or rhythmic innocent, and of the black artist as "instinctual," outside mainstream culture and therefore not to be judged by it: a wild pet for the recently cultivated white. Second, a fetish about the infallible freshness of youth, blooming amid the clubs of the downtown scene. Third, an obsession with novelty—the husk of what used to be called the avant-garde, now serving only the need for new ephemeral models each year to stoke the market. Fourth, the slide of art criticism into promotion, and of art into fashion. Fifth, art investment mania, which abolished the time for reflection on a hot artist's actual merits—never were critics and collectors more scared of missing the bus

than in the early eighties. And sixth, the audience's goggling appetite for self-destructive talent: Pollock, Montgomery Clift. All this gunk rolled into a sticky ball around Basquiat's tiny talent and produced a reputation.

It may survive, or it may not. If it does, it will show only once more—as if further proof were needed—that a perch in the pantheon of the eighties does not necessarily depend on merit. Basquiat's stardom was waning badly when he died, because the fashion that had raised him up was already tired of him. The urban graffiti movement that Basquiat had used as a conduit in 1981–83 had no fans left among collectors five years later. Moreover, the "adventurous" collectors who had bought his work in the beginning were now into Neo-Geo: the hot young artist with his dreadlocks had been thrust aside by the cool one with his paperback Baudrillard.

Hence we now have a gush of posthumous hype—a codicil, as it were, to the media overkill that surrounded the auction of his mentor Warhol's chairs and cookie jars last spring. There are so many Basquiats floating out there that the only possible strategy is to romanticize their author while loudly claiming him as a potentially "major" artist, a genius cut off in his first flower.

The New York Times, as one might expect, festooned his bier in column-inches. "Martyr Without a Cause," ran Peter Schjeldahl's head-line in 7 *Days,* treating Basquiat as a veritable St. Sebastian, bristling with syringes flung by the cruel zeitgeist. Comparing him to "a soft young African prince, imperious and wistful," Schjeldahl invoked Cy Twombly and Franz Kline, claimed that like them Basquiat "seemed incapable of moving his hand in a way that was uninteresting," and called for "a proper retrospective of his work." Perhaps he will get his wish, what with the Whitney Museum's loss of intellectual fiber and the number of people holding Basquiats whose price would be advanced by that "proper retro-spective." Then the Museum of Contemporary Art in Los Angeles might do it too, because its trustees own lots of Basquiats as well. This is known as Postmodernist Museum Ethics and it's how short-run art history gets made.

In *Vanity Fair,* Anthony Haden-Guest got breathless about "the brilliant, intense life of a most remarkable artist—America's first truly important black painter," as though Jacob Lawrence and others whose brushes Basquiat was scarcely qualified to clean had never lived. Phoebe Hoban, in *New York* magazine, weighed in with nine full pages of heavy breathing on Basquiat. It was stuffed with exequies, mainly from dealers, although relieved by such flashes of comedy as a cameo appearance by

René Ricard of *Artforum*. "Ricard is hysterical. . . . He says the bottle of champagne he planned to pour on Basquiat's grave has exploded. 'Jean-Michel was touched by God,' Ricard raves. 'He was a black saint. There was Martin Luther King, Hagar, Muhammad Ali, and Jean-Michel.'" There spoke the voice of critical detachment, eighties style.

Confronted by such puffery, the cynic might conclude that if the *système de la mode* likes anything better than a hot new young artist, it is a dead hot new young artist. But the only thing that brought Basquiat back into the spotlight was his death. Schjeldahl waxed indignant at some unnamed shrugger who wondered "What else could he have done?" The remark was itself an appropriation of the famous line about Elvis Presley's death: a shrewd career move. Both, however, have a disagreeable core of truth. The difference is that, whereas rock 'n' roll would be immeasurably the poorer without Elvis, Basquiat never looked as if he would turn into a painter of real quality. His "importance" was merely that of a symptom: it signifies little more than the mania for instant reputation that so grotesquely afflicts American taste. His admirers resemble right-to-lifers, adoring the fetus and rhapsodizing about what a great man it might have become if only it had lived. Apparently Neo-Expressionism has at last found its Thomas Chatterton—Wordsworth's "marvellous boy," a fame-struck baby poetaster whose name, thanks to his suicide at seventeen, lives on while his work remains wholly unread. In an auction soon after his death, one of Basquiat's paintings fetched $300,000. It will be interesting to see what it makes the next time around, when the hysteria has cooled a little.

The New Republic, 1988

Willem de Kooning

Willem de Kooning will be eighty this year. To have reached such an age, still bravely painting, is to have outlived all one's enemies and most of one's friends; by now his reputation can hardly be diminished, which may be why the Whitney Museum of American Art has had no choice but to enlarge it a little more. If de Kooning is not quite an American Picasso,

at least he has been in every art history book, and in the mind of many artists, for the past thirty years. His career started late—he did not even have a one-man show until he was forty-three—but it proved durable. So although the exhibition of more than 250 of his paintings, drawings and bronzes at the Whitney is the largest de Kooning retrospective ever held, it is still a provisional report. And, it must be said, a woefully incomplete one.

Quite a lot of his best work is absent. The Art Institute of Chicago refused to lend *Excavation*, 1950, the biggest and most ambitious of de Kooning's biomorphic abstractions, while from the celebrated *Women* series of the early fifties, those shark-grinning popsies before whose dumpy and threatening torsos so much critical rhapsody has been laid, three of the main paintings (owned by Australia, Iran and the Museum of Modern Art in New York) are missing. Nor do we get to see *Police Gazette*, 1954–55, or *Gotham News*, 1955–56, the impacted city paintings that initiated de Kooning's bravura landscapes of the late fifties. With these and other gaps, one gets a less than full picture of the artist at his best, up to his sixtieth year. By the time the show gets to Europe and other early works have dropped out, it will be patchier still; this will frustrate any hopes that the show will revise art history with a bang, installing de Kooning in Pollock's place as the central hero of Abstract Expressionism.

Jorn Merkert's catalogue essay asserts that de Kooning "played perhaps the decisive role" in the development of Abstract Expressionism (notwithstanding de Kooning's own generous tribute to Pollock as the one who "broke the ice"). The purpose of canonization is well in hand; once again—although one must except Paul Cummings's measured and enlightening essay on de Kooning's drawings—the work of a distinguished artist becomes a pedestal for the display of swollen claims. Perhaps it is not in the holiday spirit to feel that this oeuvre has any faults or limitations at all.

But it does; what serious painter's does not? Their nature can be assessed by comparing the "early" with the "late" de Kooning. When the slight, pale Dutch youth smuggled himself into the United States without proper papers in 1926, he brought with him something that very few of his colleagues in the New York School of the forties and fifties would turn out to have: a thorough, guild-based art training that centered on formal drawing of the figure. His early portraits—whether in pencil, as is the exquisite study of Elaine de Kooning, *Portrait of Elaine*, circa 1940–41, or in oil—thus tended to consolidate an unerring density of structure beneath their tentative-looking, close-toned surfaces; all nuance and doubt

on top (often de Kooning, like Arshile Gorky, could not bring himself to give the final form to a hand or the side of a face, leaving it a worried blur), they were iron below. It was de Kooning's draftsmanship that enabled him to fix his parings from other artists—from Gorky, John Graham and, above all, Picasso—to a firm core. One can cite the Picassoan acquisitions in *Seated Woman*, circa 1940 (the hair from Dora Maar, the breasts and calves from Marie-Thérèse Walter), but the drawing, the rhythm, the sense of interval and structure are already de Kooning's own, and they have a strong classical bias, fixed by a long study of Ingres. (The shoulders of Ingres's women, rising in sublime lunar complacency from their Empire decolletages or, naked, from the Turkish tiles, had much to do with de Kooning's syntax then.)

The result was that the very paintings that secured de Kooning's reputation as a key figure in Abstract Expressionism, a painter hardly less "radical" than Pollock, were grounded in classical prototype and practice: if his paintings of the decade 1945–55 looked a mile forward, they also looked two miles back. Their inherent structure had nothing to do with German or any other kind of modernist Expressionism. It was closer to Cubism, but with the turning and flickering of Cubist shape given a jostling density, almost literally made flesh: a shallow grid torn and reconstituted by the wristy, virile, probing action of de Kooning's line. His two near-monochrome abstractions at the end of the decade, *Attic*, 1949, and *Excavation*, invoke the body without depicting it. They seem packed with elbows, thighs and groins, but these images—which, in the hands of a mere surrealist-minded painter, could have turned the surface into a charnel house—are sublimated by de Kooning's classical instincts to a generalized sense of the body that matches, in a terse way, the muscular rakings of his brush.

If *Excavation* and *Attic* were perhaps the greatest paintings of de Kooning's long career, the best-known are certainly the *Women*. De Kooning has always been obsessed, as a painter, with the bodies of women, quoting them in whole and in detail, with a unique mingling of distance, intimacy, lust, humor and spite. In them, the billowy amplitude of Rubens's flesh is sometimes reborn, along with the sardonic affection Reginald Marsh felt for his Coney Island cuties. But the women of the early fifties are his canonical ones—part archaic Ishtar, part Amsterdam hooker and part Marilyn. Their most menacing attribute is their smile, originally cut from an ad in *Life* magazine and stuck on; in *Woman and Bicycle*, 1952–53, there are two smiles, one where it should be, the other arranged like a necklace of teeth around the throat. With such paintings de Koon-

ing brought off the near impossible joining of expressionist archaism with Pop-style fifties femininity. The *Women* may lack the formal rigor of the paintings that precede them, but they delve so far into American attitudes toward the beautiful and the banal that their vitality as signs has not abated in thirty years.

The big change in de Kooning's work came after 1960, when he left Manhattan for Long Island—that flat tongue of potato field, windmill and scrub, arched with dazzling air, that had already reminded generations of artists of his native Holland. His paintings became more candied and atmospheric; the scored, horny surfaces of the city images gave way to a spreading lushness; his syntax weakened as loose "expressive" effects of buttery, foamy pigment drowned the old rigor of his drawing. One constantly expects something "major" to emerge from their rhetoric: the intimations of erotic violence; the spraddled, froggy postures; the weird pull between cruel figuration and sweet sunny color.

Painted passage after passage reminds one that the old cunning of the hand remains, though often in abeyance—the "touch," like natural pitch in singers, for which de Kooning is justly famous and on which his sense of drawing is predicated. Sometimes a whole painting will recover the former lyrical intensity: one is *Pirate*, 1981, with its airy, pink-and-gold surface of flesh and cloud. But there is a lot of banality and self-parody, conscious or not, among such works, especially in the sculpture, which gets worked to a haptic frenzy of surface without conveying the least energy as form, its bonelessness mimicking the lack of structure in the paintings.

Naturally, the show's curators do not share this view. Argument about late de Kooning has always been influenced by weather reports, and its etiquette demands that the painter be treated as Hurricane Willem. Merkert's essay offers plenty of this sort of gibberish. "The creative force of eros has merged with the flux of a shapeless magma of light and unbound matter drifting toward congealment into form. Mists and gases obscure these happenings." Indeed they do, and the figure in this neo-Bayreuthian murk is *der fliegende Holländer* himself, scudding before the oratorical wind. It is myth that prompts such language, a myth now swollen to the point that one is expected to see de Kooning not just as a remarkable and even an occasionally great painter, but as a primal force of culture whose actions accumulate relevance with each passing day. Can it be only fifteen years since Hilton Kramer was assuring the readers of *The New York Times* that "the issue of Mr. de Kooning's influence is now a dead issue"?

What happened between, of course, was Neo-Expressionism. Just as his paintings of the fifties were imitated from Tenth Street to Sydney (and stomped by Minimalist and Greenbergian alike in the sixties and seventies), so his late work becomes the adopted parent of the "new Fauves." It will seem even more so when this show, shorn of most of the crucial de Koonings from before 1960, arrives in Berlin. Undoubtedly, this will give the late paintings a thicker rhetorical coating. But it will not make them any better than they are.

Time, 1984

Francis Bacon

All of a sudden, in a rush, the English know what they have. "Surely the greatest living painter," wrote Alan Bowness, director of London's Tate Gallery. "The greatest painter in the world," claimed Lord Gowrie, Britain's minister for the arts, "and the best this country has produced since Turner." The artist is Francis Bacon, and the occasion his second retrospective exhibition at the Tate (the first having taken place, to somewhat less acclaim, in 1962).

Some art is wallpaper. Bacon's is flypaper, and innumerable claims stick to it: over the past forty years it has attracted extremes of praise and calumniation. There are still plenty of people who see his work as icily mannered, sensationalist guignol. He is the sort of artist whose work generates admiration rather than fondness. The usual evolution of major artists in old age, whereby they become cozily grand paternal figures, patting their juniors on the back and reminiscing in autumnal mellowness about their dead coevals, has not happened to Bacon, who is apt to dismiss nearly everything painted in the twentieth century with bleak contempt. He has gone on record as admiring Giacometti and Picasso; for a few others, a few words of respect; beyond that, the sense of isolation is ferocious. The motto of an aristocratic French family declared: *"Roi ne puis, prince ne daigne, Rohan je suis"* ("King I cannot be, prince I do not deign to be, I am a Rohan"). Shift the context and you have the epitome of Bacon's own view of his place in twentieth-century art.

The lexicon of Bacon imagery is famous. Its most familiar component is the screaming pope, smearily rising from blackness like carnivorous ectoplasm, his throne indicated by a pair of gold finials, the whole enclosed in a sketchy cage—homage to an original that Bacon firmly denies having ever seen, the Velázquez portrait of Innocent X in the Doria Collection in Rome. (I can testify that, even if Bacon never saw it, my own first sight of it looked remarkably like a Bacon; not seen head-on, but reflected into the corner of my eye by the chance angle of the decrepit glazed rococo door of the cubicle in which it hung alone in the Galleria Doria Pamphili, distorted by the old handmade panes, ready to scream.) There are the Crucifixion motifs, reflections of Grünewald and the Cimabue Crucifixion in Santa Croce in Florence (partly destroyed by the 1966 flood), whose sinuous and near-boneless body Bacon once startlingly compared to "a worm crawling down the Cross." There are the humping, grappling figures on pallets or operating tables; the twisted, internalized portraits; the stabbings, the penetrations; the Aeschylean furies pinned against the windowpane; and the transformations of flesh into meat, nose into snout, jaw into mandible, and mouth into a kind of all-purpose orifice with deadly molars, all of which aspire, in the common view, to the condition of documents. Here, one has been told over and over again, is the outer limit of expressionism: these are the signs of the pessimistic alienation to which a history of extreme mass suffering has reduced the human image. The collective psyche has imploded, leaving only the blurred individual meat, hideously generalized. The paintings "reflect" horror. Their power is in their mirroring. They are narratives, although not always openly legible ones.

Bacon utterly rejects this view. He sees himself not as an expressionist but as a realist who nevertheless stakes the outcome of his art on an opposition between intelligence (ordering, remembering, exemplifying) and sensation. His paintings strive not to tell stories, but to clamp themselves on the viewer's nervous system and offer, as he puts it, "the sensation without the boredom of its conveyance." He once remarked: "An illustrational form tells you through the intelligence immediately what the form is about, whereas a nonillustrational form works first upon sensation and then slowly leaks back into the fact." The nub of the difference between Bacon's figures and those of expressionism is that his do not solicit pity. They are not pathetic and do not try to call you into their own space. Everything unwinds in silence, on the other side of the glass wall. (Maybe this is why Bacon insists on putting even his biggest canvases behind glass: it makes the separation literal, though sometimes too literal.

The glass becomes an element, even a kind of collage.) As art historian Dawn Ades acutely notes in her catalogue essay to the Tate show, there is a lot in common between Bacon's vision of human affairs and the neurasthenic, broken allusiveness of early T. S. Eliot—a cinematic, quick-cutting mixture of "nostalgia for classical mythology, the abruptness of modern manners, the threat of the unseen and the eruption of casual violence." Some lines from Eliot's "Sweeney Among the Nightingales" are quite Baconian:

> *The host with someone indistinct*
> *Converses at the door apart,*
> *The nightingales are singing near*
> *The Convent of the Sacred Heart,*
>
> *And sang within the bloody wood*
> *When Agamemnon cried aloud*
> *And let their liquid siftings fall*
> *To stain the stiff dishonoured shroud.*

That "someone indistinct" is, of course, a key figure in Bacon. The real peculiarity of his figurative style is that it manages to be both precise and ungraspable, for its distortions of face and limb bear little relationship to anything that painters have done to the human body since Cézanne. Forms are governed by slippage: they smear sideways, rotating, not like the succession of displayed facets and transparent planes in Cubism, but as though they had endured some terminal rearrangement by massage. Their shape retains an obstinate integrity, the precise result of a sudden move-ment. And by the early to middle sixties, the time of the great triptychs, when Bacon decisively abandoned the "spectral," scumbled evocations of the face used in his popes and caged businessmen, his figures had begun to embody an immense plastic power. Sometimes these creatures, knotted in contrapposto, seem desperately mannered; but there are other moments when the smearing and knotting of flesh, not so much depicted as recon-stituted in the fatty whorls and runs of paint, take on a tragic density closer to Michelangelo than to modernism. Among those artists who, in the past century, have tried to represent the inwardness of the body, Bacon holds a high place, along with Giacometti. He breaks the chain of pessimistic expectation by taking his prototypes beyond themselves into grandeur. In earlier art there was a repertoire of classical emblems of energy and pathos, beginning with the *Laocoön*, that painters could draw on for this opera-tion. Bacon's starting point is less authoritative: photographs of anony-

mous, hermetic white bodies in Eadweard Muybridge's *The Human Figure in Motion;* a snapshot of a baboon or a footballer in blurred motion, of a wicket-keeper whipping the ball across the stumps, of the bloodied face of the nursemaid on the Odessa steps in Eisenstein's *Battleship Potemkin,* squawking silently as the pram rolls away, her spectacles awry. These and other images begin as clues, holes in the social fabric, and are then worked up, gradually, into emblems. The elliptical lenses of the nursemaid's spectacles, for example, turn into bigger ellipses, without a face behind them; like punctuation marks commanding one to focus and look, they stud the painting of the seventies. Muybridge's wrestlers become Bacon's signs for sexual battle. But they shed their documentary purpose, and in doing so they open the way to another discourse of figures. When impelled by strong emotion—as in the *Triptych May–June 1973,* which commemorates the suicide of his lover, George Dyer, in a Paris hotel two years before— the "shocking" images in Bacon are raised to the order of grand lamentation: they take one back to the classical past, but to its sacrifices not its marbles.

None of this would be possible without Bacon's mastery of the physical side of painting. Much has been made of his reliance on chance, but it seems to have affected his life (he is an inveterate gambler, an addict of the green baize) more than his art. One could say the ejaculatory blurt of white paint in the painting *Two Studies for a Portrait of George Dyer,* 1968, is chancy, but that kind of chance is easily manipulated with practice, and it rhymes suspiciously well with other curves in the painting (such as the back of the chair in the picture-within-a-picture to the left). The truth is that the Bacon one sees this time at the Tate has much more in common with old masters than with contemporary painting. The paint acquires a wonderful plenitude in becoming flesh. One thinks of the coruscating light, the Venetian red interstitial drawing, in Tintoretto. This kind of paint surface is part of the work of delivering sensations not propositions, and it is neither idly sumptuous nor "ironically" sexy. But the one thing it cannot reliably do is fix the extreme disjuncture between Bacon's figures and their backgrounds. The contrast of the two—the intense plasticity of the figures, the flat staginess of the rooms and spaces in which they convulse themselves—is what gives rise to the charge of "illustration." It will not entirely go away, because Bacon only rarely manages to set up the whole field of the canvas as a coherent structure, every part exerting its necessary pressure on the next. One looks at the figures, not the ground. Hence the theatricality of his failures. But like his successes, these too are the work of an utterly compelling artist who will die without heirs.

No one could imitate Bacon without looking stupid. But to ignore him is equally absurd, for no other living painter has set forth with such pitiless clarity the tensions and paradoxes that surround all efforts to see, let alone paint, the human figure in an age of photography.

Time, 1985

Francesco Clemente

Three or four years ago, when the surprise of new figurative painting coming out of Europe was still fresh, when American critics were slapping the label "Neo-Expressionism" on everything that moved, there was a good deal of excitement in New York City over three young Italian painters nicknamed, whether for convenience or as a tribute to their common origin in the land of opera, the "Three Cs"—Sandro Chia, Francesco Clemente and Enzo Cucchi.

Cucchi made end-of-history folk art, full of skulls and torrents of lava, cemeteries and crowing cocks. Chia, in a mélange of twentieth-century styles ranging from early Mussolini to late Chagall, did ladylike coal-heavers expelling wind while floating in postures vaguely derived from classical statuary. And Clemente? Somewhat more elusive, various and parody-resistant: a survivor. The Three Cs are now reduced to two, if one can judge from the abysmal quality of Chia's New York show last winter—whimsies impacted into cliché by the stress of overproduction. This month Clemente is onstage, blanketing SoHo with paintings and drawings. He has three separate shows (one more than Cucchi had earlier in the season) at the Leo Castelli, Sperone Westwater and Mary Boone galleries.

At thirty-three, Clemente is a curiously polymorphous artist. He works, not always with the same assurance, in numerous media: fresco, watercolor, pastel, oil on canvas, sketchy washes over silver leaf. His work embraces a lot of art-book references, from the overripe Baroque of his native Naples to Tantric symbolism. It is full of occultism, tarot, necromancy, devils, Sabbats and pallid sexual grotesquerie. It always looks hasty. It is heavy on the orifices: eating, coupling, defecating; the mood

varies from *misterioso* rhetoric to voyeurism. One moment Clemente is quoting poses that run from Giulio Romano's illustrations of Aretino to Indian miniatures (he spends part of each year painting near Madras); the next, copying a spiral staircase out of Mario Praz's *Illustrated History of Furnishing;* and after that, doing a billboard-size head of Grace Jones with skulls for teeth.

Part of the secret of his success is that his eclecticism creates surface expectations of major art (complexity, depth, psychic intensity and so on) without meaning much. He wittily exploits the affinity between artist and charlatan. A symbolist with roller skates, he moves very quickly across a vast terrain of appropriated motifs, and the results are usually banal. Even in today's morass of worthless "personal" imagery, it would be hard to find a sillier painting than one in the Castelli show, of a green whirlpool à la Poe with a man and his separated genitals disappearing into it.

Now and then, however, Clemente comes up with a visual proposal so sweetly eccentric in its poetry that it compels assent. One, at Sperone Westwater, is his big canvas of beach rocks and pebbles, wetly reflecting a bluish light—a slice of nature into which, for no discernible reason, five red-spoked wheels of the kind one sees on a child's cart or tricycle have been introduced. It could almost be a real scene: anyone who has beach-combed knows what oddities accumulate at the sea's edge. Four identical wheels, or three, one would take for flotsam. But five? Wheels of fire occur in Ezekiel; in traditional Christian iconography, a superior grade of heav-enly being called a throne was represented by a red wheel. But whether Clemente's wheels are intended as grounded angels is anyone's guess. By the simplest means, one is shifted sideways into a parallel world of im-probabilities. At its best, and especially in the smaller work—the pas-tels and drawings at Mary Boone—Clemente's work lives a tremulous, only partly decipherable life at the juncture of eros and cultural memory. It is rarefied, intelligent and decadent, although its intelligence is more literary than plastic and its decadence never fails to make collectors want to cuddle it.

With his light and wide-ranging fancy, his educated touch in com-bining the lyrical with the hermetic, Clemente is an artist one would wish to admire more. But an affair like this three-gallery show presents obsta-cles. Why so large? The painter who insists on showing everything has a fool for an agent. Clemente is an overproducer, in a spirit of gauzy fecundity; and when he is light, he is very, very light.

Lurking somewhere in this inflated presentation is a leaner and better show, a quarter the size. It would include eight or ten of the smaller works

at Boone, only one of the paintings at Sperone Westwater (the pebbles) and maybe three from Castelli, carefully omitting a row of little portraits of friends on one wall, all but a couple of which radiate enough affectless chic and cosmetic anxiety to obscure whatever interest in the look and character of the human face may have prompted them in the first place. When Clemente draws a face, it is usually a mask, front-on, staring and strained in a conventionally "expressive" manner.

The enigma of Clemente's present career is his reputation in some quarters as a draftsman. In fact, he draws like a duffer and seems quite unable to make a mark that possesses much autonomous grace or power. Likewise, the bigger the work, the more strained its surface. Clemente uses pastel with verve and charm, but in his hands, oil paint becomes a scruffily pedantic coating. If he did not already have such a worldwide reputation, one would say that here is a young artist worth watching. As things are, one can hope only that the work eventually catches up with the fuss made over it.

Time, 1985

James Rosenquist

There are pure painters and there are American painters, and James Rosenquist, a survey of whose work since 1961 fills a floor of New York City's Whitney Museum this summer, is decidedly one of the latter. What other artist in the past twenty-five years has scanned the American scene more faithfully or brought such a compelling if fractured narrative out of its weird slippages and layerings of imagery? In the heyday of Pop art, there was more stress on Rosenquist's means and less on his ends. One saw the devices from advertising, the billboard manner; one felt affronted by its "vulgarity" and by the schematic thinness and neatness of the paint, so heartless-looking when compared with the thick, spontaneous and (it was assumed) emotionally stronger surface of late Abstract Expressionism. None of that seems a problem anymore. Rosenquist's ingenuities as a formal artist have floated to the top. And the subject is clearer: the vicissitudes of a certain kind of American dream.

Looking at a big Rosenquist (a small one is 10 feet wide, and *Star Thief*, 1980, the mural whose installation at Miami International Airport was successfully opposed by Frank Borman, then president of Eastern Airlines, is 17 by 46 feet) is a bit like seeing one of the lost panoramas that were so popular in nineteenth-century America scrolling creakily past, a journey re-created as spectacle, stripped of its pastoral imagery and re-tooled in terms of media glut. *Hey, look!* you hear the nasal voice of the artist saying: This is what the banks of the electronic Mississippi look like as they glide by. Here is a succession of odd dreams, bigger than life: a red fingernail the size of a mudguard, a slough of squirming orange spaghetti, a girl whose perfect, impersonal beauty has to advertise something other than herself, the black void of outer space, a paper clip, crinkled silver Mylar and bristling sheaves of fiber-optic cables and the Ford in your future.

Born in North Dakota in 1933, Rosenquist backed into being a painter through grass-roots advertising: he started painting Phillips 66 signs for a Minnesota paint contractor and gradually moved up to supporting himself as a billboard artist in New York City in the 1950s. Turning out these mammoth images high above the city streets had the most obvious connection to his later art: the problem of how to make something that looks perfectly realistic a quarter-mile away when you are close up against it and cannot see it as a whole. The huge fragmentary paintings of the sixties and seventies are imposing but not tactile, very big but oddly weightless, with none of the haptic intensity that is the gift of denser painting. They look hard to understand because they are easy to read. As Judith Goldman points out in her recent book on Rosenquist, most of his images are not just culled, collage-wise, from advertising; they are shards of personal experience, of memories scaled up and colloquially scrambled. Nevertheless, there was a certain tone of image that Rosenquist sought. He did not want to paint old things that provoked nostalgia. What he liked, as he put it, were images "common enough to pass without notice." Hence the fifties look of his paintings from the sixties, which, ironically, seem more nostalgic now than they did then. Unlike other Pop artists with whom he was classed, such as Andy Warhol or Claes Oldenburg, Rosenquist was not an ironist. "He rendered his blue-collar view of American things without mockery," writes Goldman, "with a deadpan literalness and a directness that suggested innocence."

It also suggested surrealism, and to a degree that Goldman perhaps underrates. Early Rosenquists from 1962—for instance *Noon, Capillary Action* or *Untitled (Blue Sky)*, with their small canvases that hover clear

of the surface while still carrying the sky or grass of the background—quote Magritte with an almost naive directness. True, Rosenquist could not be less interested in the literary and sexual side of surrealism, but the way disconnected images have always floated together in his work (the duck's head, tire tread and huge cropped face in *Silver Skies*, 1962; the immense rashers of bacon, their fat glistening among the stars, in *Star Thief*) does not come only from America.

Although he was never a "political artist" as such, a political current—generally of a milky, liberal kind—surfaces in Rosenquist's work. It produced a number of bland icons but one real masterpiece as well: *F-111*, 1965, the eighty-six-foot-long, multipanel anti–Vietnam War mural that caused a hullabaloo when the Metropolitan Museum of Art chose to exhibit it in the sixties. Unlike most political art of the time, it looks unpolemical at first, and that is the source of its power. It sums up Rosenquist's vision of America as an Eden compromised by its own violence. The impact of its neon colors and yowling discharge of images has slackened little in twenty years. Like a shark silently threading a reef, the sleek body of the bomber passes through a succession of signs denoting the good life and ways of defending it; a bubble of air from an Aqua-lung regulator mimics the burst of a nuclear cloud, over which is set an umbrella; the hole in a frosted ring-cake suggests a missile silo; a chillingly winsome little blonde muffin sits precociously under a hair dryer, whose gleaming cone evokes the nose of an ICBM; and so on.

F-111 may not be, as has sometimes been claimed, the *Guernica* of the sixties, but it has much in common with the apocalyptic tone that broke into popular culture at the time, through rock lyrics, and it affected people in a way few works of political art had done since the murals of Diego Rivera in the 1930s. It suited its time, just as Rosenquist's lusher paintings of the eighties, with their candied colors and peculiarly deceitful overlays of motif—the sumptuous presentation of dying fetishes of American culture, such as the space program—suit theirs. Rosenquist, in short, is one of the few former Pop artists whose work continues unabatedly to have something to say, however elliptical the mode of saying it turns out to be.

Time, 1986

Alex Katz

A taste for Alex Katz's work is easily acquired, but is it obligatory? After reading what has been written about the Katz retrospective that opened last month at New York City's Whitney Museum of American Art, one would think so. The reviews and catalogue essays thus far have favorably compared him with Édouard Manet, Edgar Degas, Jackson Pollock, Frederic Remington, Caspar David Friedrich, Cole Porter and Fred Astaire. "Katz's astonishing achievement," writes curator Richard Marshall in the catalogue, "is to have reconciled abstraction and realism in post–World War II America." If this means anything, it can be only that Katz's large flat paintings of figures and faces have qualities of abstract design; but there is no serious figurative artist of whose work this cannot be said, so it is hard to see why Katz should be credited with this supposed reconciliation, or why it should seem "astonishing."

There is no doubt that Katz, at fifty-eight, is one of the few painters who are equally popular with critics and public in America; he is, if one judges by the affection his work seems to evoke, the Norman Rockwell of the intelligentsia. To doubt the ultimate value of Katz might be construed as a vote against sunny lawns, clean, eager profiles, bright lakes, East Hampton parties, pretty women in lofts, long marital attachment and, above all, style—in short, against everything that makes the arts-and-leisure section of American life such a nice place to be.

Which heaven forfend! The stylishness and impact of Katz's work are not in doubt. Over the years he has come up with a way of doing quite a lot with limited plastic means. His sources are largely those of Pop art: the quickly seen, iconic, coercive imagery of mass media, which he then modifies and softens with high-art references. His main subject is the human face, close up and cropped by the frame, a pearly or tanned mask of flat paint with schematic shading, great swacking eyelashes and lipstick-colored lips: it is the face of advertising, the size of an image on a fifties highway billboard shifted into the context of domesticity. Much of the time the face belongs to his wife, Ada, whose liquid brown, slightly melancholy eyes and handsomely curved nose recur in image after image,

making her one of the most pervasive "presences" in American art since Marilyn Monroe. Ada makes an early appearance in a black sweater, with the characteristic level stare, in 1957; by 1972, in *Blue Umbrella No. 2*, she is a creature of formidable glamour, radiating a Monica Vitti–esque wistfulness in the rain (the slightly blurred expression is given by the three highlighted dots on each pupil), her pink and red scarf an homage to Bronzino, a raindrop neatly mimicking a tear on her cheek. Katz can also be very good at holding large areas of color in strict, hushed equilibrium (the "abstract" side of his work); two of the best paintings in this show are of birchbark canoes, their graceful forms doubled in reflection, riding on even fields of green and blue.

Granted the zippy registration of Katz's style and his constant ingenuity at fitting stacks of faces into difficult and mannered formats, given his bonhomie and sense of the social moment, the freshness of his color and the adroitness with which he makes his art-historical references—all this admitted, why does this show produce so unmistakable an aftertaste of satiation and déjà vu? Katz's admirers like to stress that his paintings are "deceptively simple," as though some mass of knotted thought lurked beneath their surfaces. But in fact, what you see is what you get, and his repertoire of compositional tricks, though effective, is not very wide. The hallmark of the minor artist is to be obsessed with style as an end in itself, and Katz has a near-Warholian indifference to meaning: "I'd like to have style take the place of content, or the style be the content. . . . I prefer it to be emptied of meaning, emptied of content." This is known as having your abstract cake and eating it too. The problem is not, as one sometimes hears, that Katz "paints the same thing over and over": everyone has his list of great artists who have done that, from Cézanne laboring at Mont Ste.-Victoire to Morandi with his dusty bottles. It is that Katz is a poor draftsman. He seems not to look at anything but the painting, and so he repeats the same stereotypes for the human face and body, for houses and dogs, steering wheels and tables, and everything else that he puts in his big, clean, Hopperish spaces. The idea of drawing as scrutiny of a subject, as a struggle with its strangeness and resistances, is quite alien to the pharaonic prettiness of his art. Of the structure, weight, pathos and energy of the human body he has no sense at all, and one result is his inability (shown in paintings such as *Behind the Back Pass*, 1979, with its wooden Frisbee-players on a lawn) to do a simple figure in movement. His colloquialisms let him down; arms become sticks, hands a mere bunch of squarish twigs, feet relate badly or not at all to the ground, while faces, most of the time, are little more than masks.

This show fails to suggest that Katz was ever interested in anything beyond the most generalized form of his human subjects. He may draw figures better than Milton Avery, but that is not saying much. The late-fifties portraits of Robert Rauschenberg, Paul Taylor and Norman Bluhm are, as portraiture, thin and perfunctory; for a quick check on what a first-rate American draftsman could do with the human face as a focus of inquisitorial attention, one could have done worse than visit West Fifty-seventh Street after leaving the Whitney to catch the show of Ellsworth Kelly's portrait drawings at the BlumHelman gallery. Perhaps only in America, where the cultural role of depictive drawing was so quashed and ghettoized by a quarter-century of "official" abstraction, could Katz be seen as a draftsman of any special quality. One would not wish to begrudge him the actual pleasures of his work with absurdly exalted claims of kinship with Degas or, for that matter, Fred Astaire.

Time, 1986

Susan Rothenberg

There are a few living American artists whose latest show one would always feel eager to see. Susan Rothenberg is high on the list. Her seriousness and talent are beyond dispute. At forty-two, she has survived the cultural gorge-and-puke of the early eighties, the manic starmaking and the pressure on immature talent. Her anxious but unhurried cast of mind grew stronger for the disagreeable experience of being in the pressure cooker. Rothenberg's current show at New York's Sperone Westwater gallery is in some ways her best yet.

Rothenberg first appeared in the mid-seventies—a time when figurative painting was still out—with, of all things, pictures of horses. These were more emblems than descriptions: bold, rather clunky equine silhouettes embedded in flat, abstract space with the totemic air of cave paintings. Their "primitive" look was, in fact, quotation; it was clear from her knowing use of close-valued color and her pasty, elegantly manipulated pigment that she was already an artist of considerable sophistication. What was not clear at all was where she could take this quasi-heraldic

imagery if she was going to hold on to her roots in pictorial Minimalism. One soon found out. Rothenberg clove to the human figure, presenting it as a collection of parts, signs and fragments: an open mouth, a lump of a head or a set of sequential images of a reaching arm that seemed to stutter across the canvas in a condition of terminal insecurity. The work looked muffled, ineloquent and infrangibly sincere. There was an intriguing contrast between the toughness of her pictorial means and the anxiety they suggested.

Since the early eighties Rothenberg has been grappling with two problems: how to put her fragments together, and how to do it in terms of color. She has never been a "natural" colorist (black, white, duns and a range of silvery grays, punctuated with the occasional splotch of crimson or ultramarine blue, came easiest to this tonal painter) and quite often her efforts to introject color into her work looked like mere tints imposed on a monochrome structure. From about 1980 onward Rothenberg took more to an open weaving with the brush, dabbing her pigment into a field of hatchings. There is so much overpainting and layering in her recent work that the paintings seem to have grown excruciatingly slowly. They carry a patina of doubt on every square inch of their surface. But they do breathe; light and air—of a rather claustral kind, but atmosphere just the same—bathe the bodies and unify them as objects in the world while threatening always to dissolve them as emblems of personality. The surfaces look as if they came via Philip Guston from Monet, picking up some of Giacomo Balla's Futurist dissections of light particles along the way—a sober flicker in which images flash and are gone like the sides of fish in dark weedy water.

The subjects of this show are mostly dancers and jugglers, manipulators of the fleeting instant in whose work Rothenberg detects a familiar cultural pathos, distantly related to Picasso's circus folk but less sentimental.

Most of them are in rapid movement, spinning, doing pliés and tossing eggs, and this contrasts oddly with the way they are painted. True, Rothenberg always liked to play on contradictions between the quick, snapshot nature of her chosen image (a galloping horse, a teetering bicyclist, Mondrian solemnly turning like a mantis on the dance floor) and the nuanced and obviously slow way it was presented. But in these paintings the incongruity gets extreme. None are done from life. And yet some figures have an undeniable veracity, the feeling of a life sketch that argues a lot of preliminary drawing; and an occasional awkwardness in the relation of figures within a given painting suggests that Rothenberg has been

fitting together drawings done on the spot. Over this lies the integument of broken atmosphere, a congealed version of Impressionist flicker. It is clear how much, subliminally or not, Giacometti has meant to Rothenberg. Her probing for form through a web, a mist of approximate lines, so that the never quite final shape becomes a palimpsest of recorded attempts to fix it, echoes Giacometti's own anxiety before his subjects. How can the artist be sure, and make you sure, what is there? For Rothenberg the problem worsens, because she chooses subjects in movement, the opposite of Giacometti's hieratic stillness. It does not always come off, but when it does you are made sharply aware of the breadth of Rothenberg's pictorial ambitions.

Now and again she comes up with an image of such quiet weirdness that it really shocks you—such as *Half and Half,* 1987, an interior with the top half of a body in the foreground, a head and shoulders staring mournfully out of the space—a resigned cousin of the figure in Munch's *The Scream;* for no clear reason the lower half of its body is left standing up behind it, like a pair of empty waders, in the bland spectral light of what appears to be an indoor swimming pool. At such moments Rothenberg's imagery delivers the jolt and reach of feeling one associates with the poetry of Sylvia Plath. She is one of the signal artists of our confused time.

Time, 1987

Anselm Kiefer

It seems from Anselm Kiefer's retrospective, organized by Mark Rosenthal and the late A. James Speyer for the Art Institute of Chicago, that at forty-two this German artist is the best painter of his generation on either side of the Atlantic. If we consider the mediocrity of most of the talent we have, this may not sound like much of a compliment. So what is the difference between his work and most Neo-Expressionism? The fact that he is one of the very few visual artists in the last decade to have shown an unmistakable grandeur of symbolic vision.

Kiefer's ambitions for painting range across myth and history, they cover an immense terrain of cultural reference and pictorial techniques,

and on the whole they do it without the pompous narcissism that fatally undermines the work of other artists to whom he is sometimes compared—Julian Schnabel, for instance. In the process, he has tried to shoulder the content of historical tragedy and redemptive hope that so much of the art of our fin de siècle has either trivialized or insulated itself against.

This is not to say (one should hastily add) that all his work is of equal value. Kiefer's reputation in the United States has benefited from the disillusion and even disgust with which visually literate people view the pictorial bombast of the 1980s. But this does not mean that his work has found a general level of "mastery" compatible with its reputation. Kiefer's limitations are inescapable: his drawing lacks fluency and clarity and his color is monotonous, although the former seems to reinforce the grinding earnestness of his style and the latter contributes to its lugubrious intensity. If you were to try to find a literary parallel for the merits of his work (its fearless attack on the large subject, its freedom of symbolic retrieval) and its defects (mainly, apocalyptic long-windedness), it could be a tome like Thomas Pynchon's V.

Kiefer's work is made (to list only the main substances other than paint) of tar, paper, staples, canvas, a rough foil formed by throwing a bucket of molten lead on the canvas and letting it cool there, sand, epoxy, gold leaf, copper wire, woodcuts and lumps of busted ceramic. It is highly unlikely that more than a few of these paintings will survive for another fifty, or even twenty-five, years—Kiefer carries a disregard for the permanence of his materials to such an extreme that the lead will not stay in place and the straw on some canvases is rotting already, although this does not seem to discourage collectors. The subjects of his art include Egyptian legends, alchemy, the Cabala, the Holocaust, the story of Exodus, Napoleon's occupation of Germany, Albert Speer's architecture, the mythic roots and Nazi uses of German Romantic imagery—dark woods, lonely travelers, ecstatic moral conversions in the face of Nature—and much more besides. Among its spiritual heroes—the *Deutschlands Geisteshelden* celebrated in one painting of that title, consisting of an empty log house with every timber knotted by the grain of growth lines and a row of flambeaux burning, each honoring a name written on the canvas—are Richard Wagner, Frederick II, Joseph Beuys, Arnold Böcklin, Robert Musil and Caspar David Friedrich. Kiefer is not an artist of ordinary ambitions. But his ambitions are not bound up in the cult of celebrity that riddled the art world in the eighties. He shuns publicity, will not be photographed and spends most of his time behind the locked gates of his studio in the unremarkable West German town of Buchen.

In this, of course, he is utterly different from his mentor, Joseph Beuys, who taught him at the Düsseldorf Academy. Lecturing, performing, always accessible to the young (and the press), Beuys was the Pied Piper of postwar German aesthetic renewal; one does not need to accept his message that everyone is some sort of artist to recognize his achievement in giving back to Kiefer's generation the vast fund of German imagery, the sense of the primordial, the ritual and the *völkisch* that had been corrupted, made almost radioactive, by Nazism. Thanks to Beuys, younger German artists were able to connect with their own history and think about it without illusion, and Kiefer's work is the fruit of that process. In some respects its "look" even resembles Beuys—he loves the same materials, the rusty iron fittings, the lead, the bathtubs, the magical body of a victimized world. But Kiefer's work is, in a sense, much more traditional than that of Beuys. He is the modern incarnation of the grand-scale *history painter*, producing didactic machines rather than the ephemeral and koanlike events (talking to a dead hare, sweeping a pavement) that were Beuys's specialty. Kiefer wants to involve his audience completely in the drama of the painting's construction: in that respect, he has learned a lot from the example of Pollock. As when deciphering the web of drips and mottlings in one of Pollock's "all-over" abstractions, the eye crawls its way across a Kiefer, mesmerized by detail: every square centimeter of those giant canvases is intended, somehow, to speak. What they were saying, particularly in the seventies and early eighties, was so literal that his German critics often got it quite wrong.

Some treat his reflections on Nazism not as a walk around the rim of the deepest spiritual crater in European history but as a modish and sinister nostalgia for Hitler. What other motives, the argument goes, can you assign to a painter who at twenty-four had himself photographed *sieg-heil*ing outside the Colosseum or on the edge of the sea, as though "occupying" these sites in the name of the dead Führer? Plenty, as it turned out (the shot of Kiefer saluting the Mediterranean is an acrid parody, the Nazi as Canute trying to raise himself to the level of a natural force)—but not if you want to think that the demons raised in Nazi Germany can be buried by mere denial, beneath the concrete of the postwar economic miracle.

The ghosts come out anyway; and it is Kiefer's project to lay them by showing their relations to the real cultural history of Germany, bitterly polluted by Nazi "appropriation." When Kiefer paints a Nazi monument, such as the long-destroyed Hall of Mosaics in Hitler's Chancellery in Berlin, he also evokes—by implication—the noble tradition of German

neoclassicism which Speer's architecture froze and vulgarized. His charred, plowed landscapes, their heavy paint mixed with straw, are real agricultural terrain; but they are also frontier, no-man's-land, graveyard and the biblical desert of Exodus.

What may be Kiefer's most humanly poignant cluster of images was provoked by "Death Fugue," a poem written in a German concentration camp by Paul Celan, which runs in part:

> *death is a master from Germany his eye is blue*
> *he strikes you with leaden bullets his aim is true*
> *a man lives in the house your golden hair Margarete*
> *he sets his hounds upon us he grants us a grave in the air*
> *he plays with the serpents and dreams death is a master*
> *from Germany*
>
> *your golden hair Margarete*
> *your ashen hair Shulamite*

Margarete, the blonde personification of "ideal" German womanhood, and Shulamite, the cremated Jewess who is also the archetypal beloved of the Song of Solomon, interweave in Kiefer's work in a haunting and oblique way. Neither is actually depicted as a figure—Margarete's presence is signaled, like a motif in music, by long wisps of golden straw, while Shulamite's emblem is charred substance and black shadow. Sometimes Shulamite is not there at all; she is absorbed in the landscape or the architecture, like the vapors of her burning into the sky. So with Kiefer's tragic image of *Shulamite,* 1983: a Piranesian perspective of a squat, fire-blackened crypt, the paint laid inches thick in an effort to convey the ruggedness of its masonry, whose architectural source (as Mark Rosenthal points out in his astute introduction to the difficulties of Kiefer's work) was a Nazi "Funeral Hall for the Great German Soldiers" built in Berlin in 1939. At the end of this claustrophobic dungeon-temple is a small fire on a raised altar, the Holocaust itself.

Not all Kiefer's allegories of German history, or the Jewish history with which it is so fatally entwined, work with such clarity. When Kiefer felt the urge to be didactic ten or so years ago, he could be remarkably opaque. *Ways of Worldly Wisdom,* 1976–77, attempts to create a whole genealogy of German nationalism starting with Arminius, "the undoubted liberator of Germany" according to Tacitus, who in A.D. 9 wrecked Augustus Caesar's policy of German occupation by destroying three Roman legions under Publius Varus in the Teutoburg Forest. Ar-

minius, or Hermann, may have given rise to the Siegfried legend. As a primal hero of German history he was a great Nazi favorite, but here Kiefer conflates him with awkward portraits of all manner of later German "descendants," including Gebhardt von Blücher, who fought against Napoleon, and Alfred von Schlieffen, whose strategy for the westward conquest of Europe was the basis of Hitler's blitzkrieg; Johann Fichte, the idealist philosopher whose rhetoric in *Speeches to the German Nation* (1814) helped raise patriotic ardor against the French occupation of Germany, and whose fantasy that a nation's history was nothing but the biography of its heroes would have such an appeal to Hitler; writers from Friedrich Klopstock to Rainer Maria Rilke; and so on. Lines signifying affiliation, as in a family tree (a whole family forest, in fact, this Teutoburg), ramble slackly between some of the characters. Pictorially, the result is a shambles, and one needs an instruction manual to decipher it at all.

Where Kiefer rises to eloquence is in his simpler and less conceptually turgid images, such as *The Book*, 1979–85, and *Osiris and Isis*, 1985–87. The former takes as its point of departure one of the canonical images of German Romanticism, Caspar David Friedrich's *Monk by the Sea*—a tiny figure contemplating infinity, culture lost before the magnitude of nature. In Kiefer's painting this is almost reversed; its main motif is a lead book without writing, its silvery pages full of light and as big as a medieval hymnal, an object as imposing as the seascape behind it. Is this the Book of Creation? Of Revelation? The unnamable form of God? Even more impressive is *Osiris and Isis*, the most recent painting in the show. According to Egyptian mythology, the god Osiris was murdered and dismembered by his brother Set. All the parts of his body (except the penis) were then reassembled for burial by his sister-wife Isis, so that he could have eternal life. An immense liturgy of transformation grew from this myth, and Kiefer uses it to connect the primal fertility rites involved with the Isis–Osiris legend to the no less awful mysteries of nuclear technology. The painting is filled by a gigantic step-pyramid, the site of Osiris's burial but also, by implication, a nuclear reactor. Osiris's body parts are ceramic fragments, scattered at the base, each wired by bright copper cable to his *ka*, or soul, at the summit of the mastaba, represented by a circuit board. Death and integration: fission and fusion. Through such metaphors, Kiefer sets forth images charged with warning and suffused with hope.

His work is a ringing and deeply engaged rebuke—clumsy sometimes, and bathetic when it fails, but usually as pictorially forceful as it is morally earnest—to the ingrained limitations of its time. It sets its face

against the sterile irony, the despair of saying anything authentic about history or memory in paint, and the general sense of trivial pursuit that infest our culture. It affirms the moral imagination.

Time, 1987

Elizabeth Murray

Followers of Elizabeth Murray's work will remember a time, only ten or twelve years ago, when the American art world decided that Painting Was Dead. Henceforth, the future would belong to videotapes, "propositions," "events" and bits of string on the gallery floor. The exequies over the body were as solemn as they were premature. Dust devils of argument spun through the art magazines, scattering its ashes. Although no prophecy could have proven less correct—for it is painting that has filled the horizon of American art in the eighties, almost to the point of monopoly—a young artist needed cussedness and conviction to reject the tribal wisdom at the end of the seventies. Luckily, Elizabeth Murray had both, and the sight of a dogged, idiosyncratic mind firmly engaged with its own experiences is what her retrospective show, or mid-career report, at New York's Whitney Museum has to offer. At forty-seven, Murray has developed without shortcuts into an articulate painter, one of the best of a generation that includes Susan Rothenberg, Neil Jenney and Brice Marden.

At a time when so much art is ironic, distanced and parasitically given to quoting the Big Media, Murray's work goes against the grain: it is sensuous, nominally abstract, a bit hard to read at first—until you are used to the shaping and layering of canvas planes in the paintings, and of separate sheets of paper in the drawings—but almost profligate in its flat-out appeal to the eye. The chrome yellows and leaf greens, cobalts, pinks, purples and deep reverberant blacks that proliferate in her work are the signs of a master colorist without inhibitions. Her drawing may be ponderous and whippy by turns, but it is rarely irresolute. The subtle friction of the yellow fingers and pink biomorphic shapes around the central void of *Keyhole*, 1982, has something of the quality of forties de Kooning, sexy and calligraphic at the same time: it is a way of evoking

the felt presence of the body as an obsessive subject, but obliquely. And there is a curious tension between the enormous size of Murray's canvases and their often domestic and maternal emblems that become their subject matter—tables and chairs, cups and spoons, an arm, a profile, a breast. Murray is not a "feminist artist" in any ideological sense, but her work, like that of Louise Bourgeois or Lee Krasner, gives a powerful sense of womanly experience: forms enfold one another, signaling an ambient sense of protection and sexual comfort—an imagery of nurture, plainly felt and directly expressed, whose totem is the Kleinian breast rather than the Freudian phallus. But this longed-for integration is always jolted by the fracture and splitting of the paintings, their discontinuous surfaces, their eccentric formats. There are times when Murray's shaping of the canvas gets too sculptural and becomes an awkward hybrid—the space her color evokes so well can be overstrained by so much twisting and jutting, although that never happens in the drawings. But the sense of controlled disorder does matter: "I want the panels to look as if they had been thrown against the wall and that's how they stuck together."

That sense of improvisation lets Murray make "abstract" art that includes experience of the body, filled with tender awkwardness—but in a colloquial way. False rhetoric is not one of her problems. She goes in for titles like *Yikes* and *Can You Hear Me*, and the shapes in her paintings have a cartoony flavor—there are speed lines and zap zigzags from the comics in several of them, and speech balloons too; one of her favorite forms, a swelling lobe pinched at the ends, looks like Popeye's bicep ready to take on the world after the transforming gulp of spinach; others look like rabbit ears and Pillsbury dough boys and, as she remarks in the catalogue, the silhouette of Tweety-bird. This fondness for the demotic shape has been with Murray since her childhood in Bloomington, Illinois, when she used to draw her own comic books and pass them around among her friends. But today the effect in no way resembles that of Pop quotation. Murray transforms these signs rather as Miró did those of Catalan folk culture; indeed, one of the presiding influences on her work clearly is Miró, for her art is about dreaming and free association, the goofy insecurity of objects that sidle through the looking glass of a tactile sensibility and peek out, transformed, on the other side. "It's like taking a line and using it as a word, something that fascinates me," she remarks about some of the squiggles in one painting—this is a Surrealist idea, of which Miró was the chief exponent.

The other artist one thinks of in connection with Murray is Juan Gris, the quiet master of Analytical Cubism, with his smooth Ingresque

planes and profiles of teacup, gueridon and spoon, their lights and darks fitting together like the notches of a key in the wards of a lock. But Murray's work is less composed, and its messages include the kind of direct psychological narrative, the contact with anxiety (including the anxieties of stylistic irresolution that must be faced with every new picture) that Gris's still lifes were designed to bury. You sense, when you look at her paintings, that a whole temperament is strenuously engaged in conveying what it is like to be in the world. The effort goes beyond pat categories of "abstract" and "figurative"; and it gives her work its sweet, rambunctious and very American life.

Time, 1987

David Hockney

No English artist has ever been as popular in his own time, with as many people, in as many places, as David Hockney. At fifty-one, an age at which J. M. W. Turner was hardly known in France and Henry Moore was only just beginning to enter collections outside Great Britain, Hockney has the kind of celebrity usually reserved for film stars but rarely visited on serious artists—Picasso and Warhol being the big exceptions. Merely to see his blond hair and round glasses across a crowded room, let alone hear his Yorkshire voice droning unstoppably on about Picasso, Cubism and his own photography, turns the knees of collectors to jelly. When Steve Martin pays $330,000 at auction for a medium-good, medium-size drawing of Andy Warhol by Hockney, as he did last month, one knows that some overriding program in the fame machinery has kicked in and will not soon be turned off.

No one has ever begrudged the artist his success. Hockney is that rarity, a painter of strong talent and indefatigable industry (*genius* being, however, too strong a word) who has never struck the wearisome pose of *il maestro* and has been grounded, throughout his career, in the bedrock of Yorkshire common sense. Self-mockery may not be his long suit, but Hockney is the least arrogant of men and his achievement, uneven though it looks, is a distinguished one. This can be assayed in his retrospective—

paintings, prints, drawings, photo collages, stage designs—at the Metropolitan Museum of Art in New York City.

To think of Hockney is to think of pictorial skill and a total indifference (in the work, at least) to the dark side of human experience. Does the latter make him a less serious painter? Of course not; no more than it trivialized the work of that still unfairly underrated artist Raoul Dufy. At root, he is popular because his work offers a window through which one's eye moves without strain or fuss into a wholly consistent world. It has its cast of recurrent characters, friends, lovers, family—Hockney's portraits of his aging parents, in particular, are full of an unabashed filial devotion, and through repeated drawings and paintings he has given the portly form of his friend and promoter Henry Geldzahler an abiding recognizability: one comes to know that stomach as one does the knob of Mont Ste.-Victoire. And then, inseparable from the skill and lack of pretension, there is Hockney's candor about sexual matters, which is no more titillating today than it was shocking in the early sixties: it is simply there, part of the work, like Bonnard's liking for peaches.

Hockney was not by any means the first English artist to make his homosexuality a theme of his art, but he was the first to do it in a garrulous, social way, treating his appetites as the most natural thing in the world and not, as in Francis Bacon, as a pretext for reflection on eros's power to maim and dominate. There were no haunted corners of the closet in his work and (surprisingly) no railing against English homophobia—even though sodomy was still a crime under English law when Hockney was an art student. Instead he produced a kind of coded teasing which soon became guilelessly straightforward. His code, in the early sixties, was graffiti. He was much influenced by Jean Dubuffet, whose flattened scrawly figures with sticks for limbs and blobs for heads influenced a whole set of images from 1960 to 1963—*Doll Boy, The Fourth Love Painting, The Most Beautiful Boy in the World* (a valentine to pop singer Cliff Richard, on whom the artist had an unrequited crush), *We Two Boys Together Clinging* (a line from Walt Whitman, who, with Mahatma Gandhi, was one of the heroes of Hockney's youth). The number 69 recurs often, along with the initials of idols and lovers in a schoolboy substitution code, where numbers stand for letters of the alphabet, so that "23.23" (W.W.) is Whitman and "4.8" Hockney himself.

The artist never appears as erotic hero. "I am 23 years old and wear glasses," he scratched beside one self-portrait. In his version of Hogarth's *A Rake's Progress*, the suite of etchings that commemorates Hockney's first trip to New York City, he is a scrawny, bemused spectator, the ninety-

eight-pound weakling who gazes longingly at muscular joggers in the park; he marries an "Old Maid," squanders his money and becomes a Clorox blond (as the real Hockney still is) because blonds have more fun. Conventions, sexual and pictorial alike, are there to be played with and outsmarted, not angrily broken.

This sport with convention was essential to Hockney's development in the 1960s. Often loosely called a Pop artist, he was only tangentially so. Hockney did not care deeply about mass imagery. What did delight him were the modalities of fine art, as they brushed against print and, later, photography. He loved formal impurity as long as it was clearly under-written by formal skill. In this respect he had quite a lot in common with another brilliant student at the Royal College in London, the American expatriate R. B. Kitaj, although he lacked Kitaj's political nostalgias and imagery of rootlessness.

He was in tune with some aspects of the sixties but not others. Being a working-class boy from Bradford he was not fooled for a second by the salon prattle about "cultural revolution" that rose from SW3 and NW1. He never doubted that art was (among other things) for pleasure, and he zeroed in to the point of fixation on issues of style. It was clear from the start that Hockney would have made an illustrator of genius, but he was much more than that. With his wiry line that defined shape while sublimi-nally conveying its depth and weight, with his unfailing instinct for placement, he knew just where the metallic fronds of a palm should pop up in empty space, just how much of a figure in a shower could be elided by white lines of water. His hero of virtuosity was Picasso, whose work, he said, showed him that "style is something you can use, and you can be like a magpie, taking what you want. The idea of the rigid style seemed to me then something you needn't concern yourself with, it would trap you."

These early Hockneys, flat, offhand and laden with tropes, hold up very well after twenty-five years. Were Kenneth Noland's targets, stained into canvas, treated as some "ultimate" form of abstraction in the early sixties? Then Hockney would slyly quote them for figurative ends, using them in *The First Marriage (A Marriage of Styles I)*, 1962, to represent the Egyptian sun, a pair of earrings and the breasts of a pharaonic princess. *Portrait Surrounded by Artistic Devices*, 1965, is a witty protest against Cézanne's peculiar remark, elevated into a tedious orthodoxy by art teach-ers, that in Nature one should look for geometry—the sphere, the cone, the cylinder. So Hockney paints his father behind a pile of cubes and cylinders, with more such patches ranged on a shelf above his head. These

"devices" are merely a pedantic clutter of spare parts without meaning; feeling, the portrait argues, matters more than pictorial formulae.

Hockney moved to Los Angeles, where he still lives, in 1964. It felt like paradise: fame, money, gaggles of beautiful boys, plus swimming pools and an escape from the constrictions of old niggling England. Before long it became apparent that Hockney's paintings of El Lay were inventing the city, giving it a promptly recognizable iconic form that no other painter had cottoned to. Just as, once you have seen their work, you cannot look at New York brownstones without Edward Hopper or at certain Paris locales without Édouard Manet, so Hockney's Los Angeles is quite indelible.

He did not always get the light right, but he fixed other things—those flat pastel planes, insouciant scraggy palms, blank panes of glass, and blue pools full of wreathing reflections and brown bodies. *A Bigger Splash,* 1967, remains the quintessential Los Angeles painting, taut but inviting, like a friendly, de-historicized de Chirico in which the melancholy drag of Then has turned into a radiant acceptance of Now—an eye-blink, picture-perfect. The splash itself, in its strands, hatchings and squiggles of white, is Hockney's masterpiece of stylization. Anything could have gone wrong but nothing did.

Hockney's LA paintings are not satires on urban blankness or social pretension, as one traditionally expects from visiting Englishmen. Like the architecture critic Reyner Banham, Hockney doted on the place. Sometimes he allowed himself a prod with the needle, though. *American Collectors (Fred and Marcia Wiseman),* 1968, takes its relationships of figures and architecture from the Italian quattrocento, the ideal proportional world of Piero della Francesca. But then one notices that Mrs. Wiseman's lopsided smile echoes the toothy grimace of the Northwest Indian totem, and that a dribble of paint has run down from her spouse's fist, as though he were crushing something small and warm to pulp.

Hockney's deepest interests as a painter lay with reaching an unforced calm beyond rhetoric, and in the late sixties and early seventies (as in the big affectionate double portrait of Christopher Isherwood and his lover, Don Bachardy, or the finely modulated *Still Life on a Glass Table,* 1971–72) he succeeded in doing so without a trace of pretension. Not all his later paintings have been as successful; his images of travel from Japan (flower arrangement in front of Mount Fuji, rain on pond) seem facile and touristy by comparison, and a coarse overdone glow began to seep into his portraiture. On the evidence of this show, Hockney was faltering somewhat by the late seventies.

He retrieved his momentum through photography and the theater. In photography, he took to reassembling a scene or a motif by taking hundreds of photographs of it, and then constructing a semi-Cubist patchwork out of these shifting, overlapping views. This, he believed, replicated for the viewer the actual process of scanning—and so it did, in a fairly schematic way. Hockney thinks that "lived time," not the frozen time of orthodox photography, inserts itself into these collages, set forth in the stutter of impressions they present to the eye. Like most artists who have made an invention of some kind, he tends to overplay the significance of his own and goes on about it as though it were a Rosetta stone, with whose help all representation can be rescued from one-eyed falsehood. A piece such as *The Desk* (*July 1st 1984*) does convey some of the feel of a Cubist painting by Picasso or Braque, the lettering, the wood grain, the breakup and shuttle of multiple perspectives, the reversal of "normal" recession; and its sharpness as design goes some way to make up for the fact that Hockney's camera process has little of the flexibility and mysterious ambiguity of real Cubism. Mostly, the collaged photographs seem on third or fourth viewing to do to Cubism what Hockney decried in art teachers for doing to Cézanne—reprogramming it into an "artistic device."

Cubism also linked up, in his mind, with the study of Chinese hand scrolls. Hockney enjoyed the sense of traversing an image, rolling through it, taking the eye on a journey. His most ambitious effort to mimic that feeling, the big buckling panorama of *Mulholland Drive: The Road to the Studio*, 1980, is quite gaudy and incoherent, but in *Nichols Canyon*, 1980, he did produce a soaring Dufyesque landscape of the Los Angeles hills (all Fauve orange and blue, viridian, chrome yellow and black) that wrought his color to a new freshness and intensity.

That, in turn, was useful in the theater. Hockney was and is a natural stage designer. The distanced attitude of his work, the sense of the image as a proscenium with flat figures moving in it like puppets, guaranteed that. Since 1966, when he designed a production of Alfred Jarry's farce *Ubu Roi* at the Royal Court in London, he has done a stream of designs for opera and ballet: Stravinsky's *The Rake's Progress*, Ravel, Poulenc, Satie and, most recently, Wagner's *Tristan und Isolde*, whose romantic sets with their plunging perspectives, sweeping sails and bombastically thickened architectural decor are lavishly represented at the Met show. Indeed, one may well prefer Hockney's stage work to the present phase of his painting, which consists mainly of devotional pastiches of 1930s Picasso in licorice-allsorts color, some of them very slack indeed. The wall space occupied by some of these should have been sacrificed for a better look at his prints

and graphics, which are among the great strengths of Hockney's work and, except for the *Rake's Progress* series, are not covered in the depth they deserve. Although parts of the show and its presentation disappoint, the whole does not: perhaps it is only because Hockney delights you so regularly that you feel vaguely cheated when, here and there, he fails to.

Time, 1988

Donald Sultan

The trouble with the show of Donald Sultan's work which opened at the Brooklyn Museum last week after a seven-month run in other American museums is its date. It should have begun in 1997. Then there would be a larger oeuvre to assess, a longer career to discuss and not just a bright reputation to inflect.

Sultan, born in Asheville, North Carolina, in 1951, is certainly among the more gifted American artists of his generation. But this show's catalogue hums with inflated comparisons and claims. "He seems formed in the Manet mold," writes one contributor, Ian Dunlop, adducing by way of proof that Sultan, just like the late great Édouard, is ambitious, paints images from modern life, looks at old master paintings, et cetera. Now it is true that Sultan does have a crush on Manet; a small still-life with asparagus pays homage to Manet's famous single asparagus stalk, and a little detail of masts and sails from Manet's *Moonlight over Boulogne Harbor*, 1869, is blown up to an eight-foot square in Sultan's *Harbor July 6 1984*. But there is, to put it mildly, a wee gap on the scale of talent between Sultan and his lucky predecessor. Another catalogue eulogist, noting Sultan's commitment to formal painting and his commendable lack of interest in grabbing quotations from visual mass media, winds up with the startling claim that "his works are meditations on the possibilities of transcendent meaning for an audience that has forgotten . . . how to believe." Aw, c'mon, lighten up. There is nothing "transcendent" about Sultan's work. It is decorative and materialistic. Most of its motifs come from photographs not direct observation; its style is distanced and gloomily elegant, enlivened by discreet erotic puns between, for instance, lemons and breasts.

Much of the character, and indeed the strength, of his paintings lies in their odd, slightly fetishistic technique. Sultan works on square plywood panels, faced with Masonite and then covered with ordinary vinyl tiles. Over these goes a thick coat of black glop—industrial Butyl rubber, used by roofers. Once this tarry skin is dry Sultan cuts and blowtorches his design into it, filling in white patches with plaster and enriching the whole with color. The seams of the tiles and the panels impose a grid on the image, a ghost memory of the Minimalist grids that pervaded American art in the seventies, when Sultan was a student.

This laborious process favors contour and flatness, light-and-dark contrast rather than color, and the single iconic shape. Sultan does decoratively what an older American artist, Robert Moskowitz, does grandly: by taking a familiar shape and rescaling it, mainly as profile—one still life of an egg and a pair of lemons on a plate is fully eight feet square—he slows up recognition and provokes, in the more successful paintings, a sense of strangeness. Along the way odd strands get pulled together; you would not expect a picture to remind you of both Ellsworth Kelly's works and Edward Steichen's massive still-life photographs, but a Sultan like *Lemons, April 9, 1984* rather unexpectedly does.

This scheme gets in the way when, instead of simple, flat images, he tackles scenes with a deeper space. In the painting *Battery May 5, 1986*—black smudgy figures on a promenade in lower Manhattan, a plunging perspective of lamps on the seawall, a livid yellow sky—the recession is brusquely contradicted by the surface grid of vinyl tiles; the image struggles to break back from the picture plane, but cannot—a self-canceling effect, but not interestingly perverse. In other paintings of fires, abandoned industrial plants and refineries belching out their pollutants under a Stygian sky, the emotive content of the image (industry as Pandemonium) is quite at odds with the stolid manner of its execution. Few techniques could be less suited to depicting what is fugitive and mobile, fire and smoke for instance, than cutting silhouettes from roofing tar. Sultan leans toward the mummified sublime. His stage effects of vapor and glare and rearing silhouette descend, remotely, from Turner. But he is so used to thinking in terms of figure and ground that he handles the transitions between them—the mid-tones, the modulations of light—clumsily at best.

The area of Sultan's work that seems unequivocally successful is his drawings—big, densely worked silhouettes of tulips and lemons, with so much charcoal ground into the paper over repeated layers of fixative that its blackness is velvety and palpable, with something of the richness of

Jasper Johns's encaustic or Richard Serra's oilstick drawings. Sultan is highly sensitive to the play of black and white, figure and ground, and he gives his shapes an admirable, embodied decisiveness: you sense that they have all been the subject of hard aesthetic argument. The tulip stems swoon like Margot Fonteyn's neck, the leaves fairly crackle with graphic energy, the big black lemons have the weight of millstones, and at times in the configuration of one of Sultan's flowers there is a sly reference to Matisse's odalisques. Sultan's instinct for pattern could have degenerated into a formula by now, especially with the market demand for his drawings, but it shows little sign of doing so—although the small still-life paintings are another matter. Within his limitations, he is an artist to watch.

Time, 1988

Leon Kossoff

The English painter Leon Kossoff, now sixty-two, is hardly known in the United States, and his show at the Robert Miller Gallery is his first in New York City. He is one of the two tortoises (the other, Frank Auerbach, also English) who cross the finish line just when so much of the short-winded art promoted in the eighties shows signs of flagging. When Neo-Expressionism arrived in the early eighties, it was as though an army of Bronze Age hectors had assembled, chanting hoarsely of Sex, Anxiety, Death and Egotism, leaving long tracks of slimy paint behind them in their progress toward the art centers of the world. The dull percussion of beaten chests lasted five years, from 1981 to 1986. Then, a dying fall. And who lasted? Not many, and not always the ones who were expected to. In West Germany, Anselm Kiefer; in the United States, Susan Rothenberg; and in England, Auerbach and Kossoff.

The son of a baker, Kossoff grew up in the tightly knit, poor Jewish community in London's East End. Upon being discharged from the army at the end of World War II, he studied under David Bomberg—once a prodigy of the Vorticist movement, but by 1947 a forgotten man, a failure, whose actual stature as a painter is only now being recognized. Bomberg

gave him two things: first, a training in the relations between modernism and tradition, based on unrelenting drawing from life, that has practically been wiped out of art training in the last twenty years; and second, patience—a sense of endurance.

As a result, Kossoff's work went naturally against the grain. A figurative painter when abstract art was the rage, his sin (so to speak) was *premature* Neo-Expressionism, back in the fifties and sixties. When painting was required to be thin, linear and efflorescent, Kossoff stuck to his delving into the scenes and people around him and the memories within. His work was permeated with the leveling vestiges of shtetl democracy, refusing any images of social grading: his scenes of public baths, markets and Underground entrances are packed with small figures, stuck in their close social matrix (and in Kossoff's dense pigment) as though in jam—a pictorial equivalent, as it were, to the double meaning of the Hebrew word *olam*, which means "world" but also "crowd" or "throng." There is nothing pretty about Kossoff's troglodytic figures; the old men look like weathered stumps, the women tend to have grave and stony masks, an archaic fixity heightened by the thickness and grain of his paint. A painting such as *A Street in Willesden*, 1985, with its isolated figures flattened into the brownness under the soft, exactly registered gray light of London, might in other hands have turned sentimental, an exercise in mere pathos—the Lonely Crowd. But Kossoff's inherent toughness, his impeccable sense of pictorial structure make sure that it does not. His work reminds one how pointless the stereotypes about English art have become. It is not anecdotal, witty, light or conversational. Rather the opposite. In it, an obdurate grandeur of intention is coupled to a deep sense of tradition: what other painter now alive can embed groups of figures in deep space with such conviction?

For Kossoff is, above all, a painter, obsessed with oily stuff. His paint is thick without being rhetorical. The surface develops by addition, sometimes over months, and contains an extraordinary range of nuances in both color and texture: tremulous depths of pinkish gray held within the sallow planes of a face; innumerable gradations of Venetian red and salmon pink in the body of a nude, rescued every time from mere allusiveness by the vehement drawing of shadow that gives Kossoff's work its tonal framework. Its solidity is relieved, almost involuntarily, by whipping skeins of pigment fallen directly from the brush, which work as a form of counter-drawing, lifting the thick surfaces from inertia. Sometimes it is crusty, sometimes of a jellylike delicacy whose tiny ripples quiver on the eye and reinforce the impression of light. For light counts

for a great deal in Kossoff's work. The density of the paint—which is such that the smaller canvases look like irregular plaques of pigment—is never opaque. It contains streaks and underglows of light, akin to the suppressed radiance in Rembrandt's mid-tones. And there is atmosphere too. One senses it particularly in a painting that makes literal Kossoff's desire for architectural grandeur—a view of Christchurch in Spitalfields (built 1729–30), by the English Baroque architect Nicholas Hawksmoor. This tall, slender building acquires a comatose power—the four columns of its portico look as thick and squat as those of Karnak, and they repeat the gravitational compression of Kossoff's nudes and heads—but it is the light one most remembers: a pale, almost chalky emanation from the grainy putty-whites and subtle grays that seems to bathe and lift the whole image. Substance *is* light. Such paintings and others, for instance *Here Comes the Diesel*, 1987 (a train passing through a cutting in north London), connect him back to late Constable, with their flickering impasto, their palpable joy in light and freshness embodied in substance. In his effort to squeeze so much from the world, Kossoff is a wholly traditional painter; only his anxiety about whether it can be done makes him a late-modern one.

Time, 1988

Eric Fischl

Eric Fischl, showing at the Mary Boone gallery in New York City, has become the painter laureate of American anxiety in the eighties. From the moment that he exhibited *Sleepwalker*, 1979, his image of a teenage boy resentfully jerking off in a suburban wading pool, Fischl has zeroed in on the discontents of the White Tribe whose territory stretches from Scarsdale to Anaheim: unreachable kids, grotesque parents, small convulsions of voyeurism and barely concealed incestuous longing.

This is the suburb as "failed Eden," as noted by three out of three American sociologists and not a few novelists. But Fischl's project is not to embroider clichés on it. Rather, he finds images that seem to trail a whole narrative history behind them, but obliquely—so that you, as viewer, are put at the threshold of a hidden life that may, if you look closer,

be yours. Fischl is a true American realist, but he works at a pitch of psychological truth (especially about adolescent sexuality) not known in American narrative art in the thirties.

When Fischl started out to paint, the odds were against the very idea of narrative painting based on the human figure. Born in New York City in 1948, he went to art school in 1970 at the California Institute for the Arts in Los Angeles—just at the height of the belief, then endemic in the American art world, that Painting was Dead. Cal Arts epitomized the frivolity of late-modernist art teaching—no drawing, just do your own thing and let Teacher get on with his. "Everybody was naked," Fischl recalled of one of these "life classes." "Half the people were covered with paint. . . . The two models were sitting in the corner absolutely still, bored to tears. Everyone else was throwing stuff around and had climbed up into the roof and jumped into buckets of paint. It was an absolute zoo. . . . They didn't teach technique at Cal Arts."

Art education that has repealed its own standards can destroy a tradition by not teaching its skills, and that was what happened to figure painting in the United States between 1960 and 1980. Fischl has been badly hampered by it, and the exaggerated demand for his work is also a function of it: very few collectors knew how to judge a figure painting, so that any attempt at figuration can slide by on its declared intensity of sentiment. Fischl can't draw as well as the average Beaux-Arts student in 1930, never mind 1880. He aspires to a mode of figuration that is tense, dramatic and full of body. He has managed to reconstruct at least some of his birthright; his figures, although they inhabit a different sexual and psychic world from that of late-nineteenth-century America, have a direct matter-of-factness that distantly recalls Winslow Homer. But the signs of loss do show.

Clearly, Fischl wants an overall look that is not too finished, that is consistently "imperfect," with an air of unconcern for its own pictorial mechanism—the creamy, dashed-off realism of a Manet oil sketch. But this requires a mastery over the detail and frequency of brushstrokes, and a certainty about the drawing embedded in them, which he cannot manage. He will slide from a passage of assured colloquialism to one of awkward smearing and prodding, and not fix—maybe not *see*—the difference. Because Cal Arts training, such as it was, starved his talent of skills, which ought to have become second nature, he must make everything up as he goes along—like someone who talks by consciously forming each syllable in turn. He tends to work as though he were afraid a single surface would look timid: hence his use of canvases butted against one another, overlaid,

leaning together, with the scene continued across them. This "collage" (which echoes the collage methods he uses to compose groups from photographs) suggests the overlay and dissolve of film images. But it is still a pedantic device, nostalgic for modernist "invention." And he uses it poorly. Big paintings such as *The Evacuation of Saigon* work despite it not because of it; and in *The Young Max B. in Kansas*, 1987, where an altar boy in a white surplice is standing behind a kitsch monument on a lawn in front of a tract house, the lawn ornament on its separate canvas looks like an afterthought even though its blue sphere, coarsely suggestive of infinity, is essential to the image. Fischl's work is stronger when it speaks directly from a single, continuous, rectangular plane, so that the argument among illusion and brushstroke and dramatic scenario is not cluttered by artsy shaped-canvas garnish.

The strangest image, and the simplest, is *Girl with Doll*, 1987. Wiry, squinting at the light and indefinably prole in her nakedness, she reminds you of one of Winslow Homer's Maine girls, deprived of innocence and brought up to date—the ones who, Henry James complained, reminded him of a homely dish of pie. But the beach toy she holds (a vinyl Bullwinkle) is like some comic-repulsive witch's familiar; it has her by the neck, and the pairing is so vivid that for the moment you ignore the formal lapses in Fischl's painting, such as the coarse modeling of the knees. It provokes comparisons with the pairings of monster and innocent in older art, and then slyly retracts them—Hey, lighten up, it's just a kid on a beach! This grotesque painting exemplifies Fischl's desire to turn the viewer into a voyeur, a reluctant and embarrassed witness. At such moments you realize that, whatever awkwardness his work harbors, he is up to something worthwhile—at least on the plane of psychic narrative.

Time, 1988

Sean Scully

A painting being so much more than its subject, you can't pin down an artist by naming his favorite motif. From Mondrian and the Russian Constructivists on, many an abstract artist has gone for the stripe in all

its apparent simplicity—the line that baldly, mysteriously, becomes a form in itself. Yet their paintings are not like one another: there is no confusing the precise black shimmer of a Bridget Riley with the effect of one of Barnett Newman's "zips," or the slightly blurred, funereal pinstriping of an early black Frank Stella. Today the stripe continues to linger in the wings of late modernism, and it is the adopted sign of one of the most toughly individual artists in the United States, Sean Scully. What, after so many other stripes, has he made of it? Not the emblem of a lost utopianism, but something fierce, concrete and obsessive, with a grandeur shaded by awkwardness: a stripe like no one else's.

Scully is forty-four, a pale knobbly-faced Irishman who was born in Dublin, studied in England and (since 1975) lives in New York. The show of his work at London's Whitechapel Gallery is not a retrospective; it covers his early maturity, from 1982 to 1988. But Scully has been fixed on the stripe since he was an art student in England. At first it was an optical shimmer, a weaving of color energy on the surface, in deference to the prevalent American art theory of the day and, in some degree, in homage to the English painter Bridget Riley. The work of Mark Rothko, which he had seen as a student in London, was a presiding influence: it had shown him how a neutral and even boring form, an imperfect rectangle, could accumulate reserves of feeling, cogitation, the life of the mind and its tentative decisions embodied—not just illustrated—in pigment. He also visited Morocco. There, Scully saw stripes dyed into awnings and djellabas and bolts of cloth, not a theoretical form but a motif embedded, as it were, in the landscape. When he moved to New York in 1975, as he puts it in the catalogue, he felt driven to paint "severe, invulnerable canvases, so I could be in this environment and not be exposed. I spent five years making my paintings fortress-like." He dropped the masking tape, let go of the clean edges and began to work thickly in oils.

The grid of Scully's paintings in the eighties speaks of two things: a desire for large order and a sense of impending slippage, as though the columns and lintels of paint had constantly to be tested, as though their pinning could come apart just as the painter turns his back. They look not smoothly designed but somewhat improvised, like the sides of large huts. They are very "New York" paintings, yet the Manhattan they evoke is not the foreigner's imagined grid of perfect planes but rather the gritty, heavy, slapped-together look of downtown, where Scully has his studio: the hoardings of warped plywood, the metal slabs patching the street. Nobody could take them for supergraphics. Their mood is, above all, reflective. They aspire to a rough, Doric calm. They do not move; or

when they do, it is by a slow pressure of grainy abutting edges or, in a work such as *No Neo,* 1984, by the slight bulging of stripes, like the entasis of a classical column, against their neighbors. (The title means something; Scully wanted his painting to resist the sense of recycling that pervaded the eighties, neo-this and neo-that. "The art that interests me," he says flatly, "is *heroic* art.")

The sense of internal pressure confers urgency on these big surfaces and turns them into something other, and more physically compelling, than flat pattern. It's not that Scully has any strong sculptural impulse—when he makes one slab of a painting project an inch or two above the adjoining surface, it is still not meant to be seen in the round or to suggest material weight. But he does want to give the image the distinctness of a body, asserting itself against your gaze.

The world keeps peeping in, especially in the color, which is richly organic and never blatant. Its tawny ochers and deep blues evoke landscape, though in a distant way. The whites in *Pale Fire,* 1988, are not flat white, but a subtle paste applied over a warm brown ground in rapidly varying touches, so that they have the visual elasticity of flesh. Scully is a conservative, measured colorist. His sense of art, the seemingly obsolete act of communicating meaning by smearing mud on cloth, is anchored in the past. He is always reaching back, though not in a spirit of inane citation. You can see the traces of his idols throughout the work: especially, in his liking for silvery grays, pinks and a constant regulating black, Velázquez, the greatest "impersonal" painter who ever lived. The paint goes on thickly but not with abandon. It respects the edges of the blocks and stripes without chiseling too closely along them. When its higher colors—white, ocher or bars of royal red—come up from their dark underpainting, the sense of darkness beneath gives each block a stabilized, brooding quality. The surface seems to store light, like stone. It is opaque; you can't see through it or even into it. It is not about space. Besides, the inlaid, modular, even puzzlelike surfaces of Scully's recent work prevent the eye from roaming them too freely: stray out of one box and you finish in another, not on a free horizon. Hence the density, the lack of spaces between things, which adds to the paintings' gravity. This has something to do with the largeness of architecture. But it is painting, all the way through.

Time, 1989

Christopher Wilmarth

When the sculptor Christopher Wilmarth committed suicide at the age of forty-four some eighteen months ago, there were no headlines. Wilmarth was not a star and so was spared the grotesque exequies accorded to Andy Warhol, not to mention the pathetic Jean-Michel Basquiat. Ignored by the mechanisms of art-world hype, Wilmarth's work was left to find its own level. It is now doing so. The time for a complete Wilmarth retrospective has not arrived, but New York's Museum of Modern Art has a small exhibition of some twenty-five of his sculptures, sensitively curated by Laura Rosenstock. Even from this limited evidence, it is clear that Wilmarth was by far the best American sculptor of his generation.

Bad popular artists come and go, but there is a degree of aesthetic literacy that cannot be faked. Wilmarth's originality was of the only kind that counts, born of long reflection on the past. He was a child of the museum, steeped in the "great tradition" the Museum of Modern Art originally stood for (which is why this small posthumous show seems so much like a homecoming). In poetry, Stéphane Mallarmé; in painting, Henri Matisse; in sculpture, Constantin Brancusi. Wilmarth was a man of wide visual curiosity, but of all modernist movements the one that interested him most was Symbolism, which reached its height around 1890 under Mallarmé's leadership and which, through its effect on Matisse, late Monet, Gauguin, van Gogh and others, lay at the very root of twentieth-century art.

For the Symbolists, art was a matter of evocation not description. Mallarmé had written of the "negated object," of a sense of reality— impalpable, uncertain, veiled in the clumsiness of language—that poetry must somehow approach. "To conjure up the negated object, with the help of allusive and always indirect words, which constantly efface themselves in a complementary silence . . . comes close to the act of creation." Paint, of course, in its vast suggestiveness, was superbly adapted to this conjuring. Wilmarth's singular project was to create the spirit of reverie that surrounded the "negated object," but in that most object-affirming of arts, sculpture—and to seek its unabashedly poetic effects in heavy indus-

trial materials, steel and glass. It was typical of Wilmarth—a Californian who spent most of his working life in New York—that one of his heroes should have been Manhattan's archconstructor John Roebling, the engineer of the Brooklyn Bridge.

For an artist of Wilmarth's age there was nothing "radical" about steel—it was the bronze of modernism, the normal substance of constructed sculpture for the past sixty years and more. What was unusual was his decision to combine it with glass and thus make transparency, as much as spatial enclosure, a part of the sculptural effect. Wilmarth loved light. It was his madeleine, the trigger of memory, as a particular sound or smell might be to others: "I associate the significant moments of my life with the character of light at the time." In fact, glass came before steel plate in his work of the early seventies, and some of his most beautiful pieces consist only of glass plate laced together with tension cable—flat, bent or subtly curved, as in *Tina Turner,* 1970–71, an astonishing tour de force for a sculptor still in his twenties. But it is the association of glass with steel that gives his work its peculiar evocative power. Wilmarth worked the glass, bending it (though only discreetly: he wanted dignified inflections of space, not pretzels) and also etching it with hydrofluoric acid. This frosted the panels and brought out their color, which varied from a cold ice-green to a soft, almost moonstone blue, diffused on the face but sometimes concentrated with sharp energy within the edges of the glass. The dark steel, seen through this translucency, lost its declarative character; it blurred and became a presence, or rather an immanence: something very much there yet hard to define. In large pieces such as *Nine Clearings for a Standing Man,* 1973, Wilmarth achieved the kind of discreet grandeur of light and pared-down form one associates with Rothko at his best, and something more: the sense of a figure not described but evoked by a flat vertical plane, behind the glass. Even in smaller ones such as *Is, Was (Chancing),* 1975, there is a fascinating exchange between dark and light, solidity and translucency, underwritten by the economic logic of its making—a single sheet of steel cut and folded, a single plate of glass. And the cables that hold such pieces together are not mere connectors: they are always conceived as drawing, an exact line whose tautness is both visual and structural. The ancestor they obliquely evoke is pre-1914 Matisse, whose linear, near-abstract views of Notre-Dame through the studio window had as much effect on Wilmarth's sculpture as they did on Richard Diebenkorn's *Ocean Park*s.

In Wilmarth's later work of the eighties the "hidden figure" becomes explicit. Wilmarth's sign for it was in part an homage to Brancusi: an

egg-shaped form, a glass sign for a head. Sometimes it appears on its own—in *Sigh*, 1979–80, for instance, with the "face" cut away and resting resignedly inside the egg, in an image of exquisite poignancy. Usually the head is attached to a metal plaque with edges and attachments that suggest a wall, a window frame and thus someone (the sculptor himself) looking out into our space. These pieces are darker and far less restrained. The smoothness of the glass gives way to textures of rust and even spattered lead—the silvery color of the lead functioning, like paint, as light. They are Giacomettian in their sense of endurance, remoteness and physical loss. But the phase of Wilmarth's work that they began was not to be completed. This was a vile subtraction.

Time, 1989

Bernard Berenson

"If small, lithe tigers could speak, they would have the voice and intelligence of this feline Pole. He has velvet paws and killer talons of steel. He's let his beard grow to cover up the fact that he is only half a man. His eyes are blue, the better to deceive. . . . His ambition, which is consuming, is to be recognized as the world's greatest expert on the Italian primitives; and he achieved his goal about three years ago. He is a dying man, but he'll go on for a long, long time. He doesn't do business or accept commissions, but he shares in the profits. 'Here are 25,000 francs, M. Berenson.' '*Merci*, Gimpel.' "

This entry from the 1918 diary of art dealer René Gimpel is the best thumbnail sketch of Bernard Berenson ever written. It was a curious fact of cultural life, and perhaps a tribute to the old serpent's powers of intimidation, that nobody else could deal with him in such terms, catching his epicene grace, deviousness, hypochondria, greed, relentless ambition and ophidian charm in a few lines. Berenson died twenty years ago, in 1959, and it seems longer, partly because of the fuzziness and piety of his memorialists, and partly because of his own remoteness from modernist culture. And yet he is still an extraordinarily interesting, even legendary creature. Berenson's success story was one of the most spectacular in the

history of art: the poor Jewish boy from a Lithuanian shtetl who became
a millionaire dictator of taste; the Harvard scholar who rose, by the end
of his life, to be regarded as a latter-day Goethe; the neurasthenic youth
who outlived nearly all his contemporaries and died at the patriarchal age
of ninety-four in the elaborately plain Tuscan villa where, for fifty years,
dealers, collectors, historians, nobility, princes, kings and politicians had
paid assiduous and often slavish court to him. Berenson was one of the
wiliest and yet most self-deluded men who ever lived, a great connoisseur,
but also a master of opportunism who came to believe in his own fictions.
He was, to put it mildly, a hard nut to crack, and a harder one to write
about.

Of all the pieces written on the Sage of I Tatti, as Berenson was
routinely called in his old age, few have biographical value and most are
silly. One need not count the articles that had become, by 1950, a subgenre
of American journalism all on their own, written by the hordes of Luce
staffers, moist Radcliffe girls and CIA spooks on holiday who, pink and
flustered, made the trek up the hill to Settignano and were rewarded by
the sight of Berenson, trundled out like a reliquary by Nicky Mariano,
with some rich kid being groomed for a future in the art world—Carter
Brown, William Mostyn-Owen—holding the lap robe. It was one of the
sights of Florence and, as was not the case with the view of the Duomo
from San Miniato, not everyone saw it, so that those who did felt both
humble and privileged. Berenson's *unsereiner* felt duty-bound to sustain
the legend and treat him as a secular saint, as though he had actually
become the modern Goethe he once aspired to be. Occasionally, as the
years went by, a chink would appear in the curtain, as when Kenneth
Clark in his unrevealing first volume of autobiography (*Another Part of the
Wood*, 1974) described him as sitting "on top of a mound of corruption."
The memoirs of Nicky Mariano (*Forty Years with Berenson*, 1966) are
wholly uncritical of him, as one might expect from a devoted companion
and protector who spent the last years of her life trying to make quite sure
no biographer would get access to any document that shed anything but
luster on Berenson's memory. And the only previous attempt at a full-
dress biography, Sylvia Sprigge's *Berenson* (1960), was less written than
poked into shape with a white stick by an author who had few responses
to art or art history, the sketchiest sense of aesthetic debate and a naive
view of relationships within the I Tatti circle.

But the twentieth anniversary of his death has brought two new
works about Berenson, both immeasurably superior to earlier biographical
attempts. They should be read together, since they approach their subject

from different angles. The more elaborate and scholarly of the two, Ernest Samuels's *Bernard Berenson: The Making of a Connoisseur*, is a winding, lucid and exhaustively researched account of less than half of Berenson's life, taking him through the years of his Lithuanian childhood, his emigration to America, his intellectual blossoming at Harvard, his return to Europe and self-discovery in connoisseurship; it leaves him in 1904, when, in his fortieth year, having blitzed American museums and collectors on a tour of the eastern states and set up his reputation there as the world's top eye on Italian Renaissance art, he made his final departure for Italy.

The second book, Meryl Secrest's *Being Bernard Berenson*, covers the whole life, so that we see the transubstantiation of Berenson the scholar into BB the culture hero. Its texture of detail is necessarily sparser. Samuels's book, from the point of view of I Tatti and its jealous ghosts, is the official biography: two years before she died in 1966, Nicky Mariano gave Samuels access to the Berenson archive, whereas her nephew—no relation to Berenson, but by some testamentary quirk the inheritor of his personal papers—refused the same courtesy to Secrest. Neither of the authors could read the all-important correspondence between Berenson and the dealer Lord Duveen, in which many bodies, presumably, lie buried. Berenson was Duveen's chief advisor for thirty years, and only their letters can finally resolve the highly vexed questions of his business morality and the disinterestedness of his attributions. Unfortunately, they are under seal in the Metropolitan Museum of Art in New York until the year 2003, by which time anyone who ever did business with either man will be unable to issue writs. Faced with this problem, Samuels took the conservative decision to leave Berenson a year before he started working for Duveen. Secrest, on the other hand, has tried to reconstruct Berenson's relation to the art market over those thirty years from other sources—and she appears to have interviewed almost everyone who knew Berenson and is still neither dead nor gaga. Nevertheless, until the Duveen archive is unsealed, this job cannot be done properly; which means, in turn, that there can be no truly definitive biography of Berenson until the twenty-first century. In the meantime, Secrest's narrative is the liveliest evocation of this strangely conflict-ridden man that has yet been written, a portrait with a ring of psychological truth.

Berenson was not, as Gimpel thought, a Pole; nor was he, as others at one time or another took him to be, English, French, Austrian, German or American. He was careful to veil his origins, because he was ashamed of them. He was a Jew, a child of the shtetl. He was born Bernhard Valvrojenski, the child of a well-read but poor lumber merchant in a now

extinct village named Butrimants, in the northern part of the Pale of Settlement, in 1865. He was an adored eldest boy, "the infant prince of a neolithic Lithuanian ghetto," as he noted eighty-five years later. When he was ten his family took him to America, and they settled in a small row house in the West End of Boston. From the beginning, his parents hoped that Bernhard would bring distinction on the family, transcend their poverty or perhaps become a great Talmudic scholar. What happened exceeded their hopes; but it could hardly have been predicted.

Berenson (the family name was changed, perhaps at his prompting, although that is unclear) lived in Boston for a dozen years, first at school and then at Harvard, from 1875 to 1887. In that time, pressed on by his father—a freethinker whose friends, according to Samuels, were given to eating ham sandwiches publicly, outside the synagogue on Yom Kippur—he remade himself. The pallid, bookish Litvak became, as Secrest puts it, "the very model of a proper Bostonian, circa 1885: polished, impeccably mannered, exquisitely educated, and fastidiously aesthetical." In the process, he had to submit to the judgments of his social superiors, most of whom were quietly anti-Semitic. Berenson missed the high tide of proper-Bostonian Jew-hating, which came after the great exodus of Jews to America in the late 1880s. Nevertheless, the prejudices he met in the society he aspired to join were of an almost Prussian nastiness, and they skewed his life.

He set out to cover his traces. Berenson had an almost pathological need to dissemble his own Jewishness, and Secrest quotes a remarkable passage from an essay that he sent to *The Andover Review*, when he was twenty-three:

> It is only by a study of Jewish institutions and literature that we shall begin to understand the puzzling character of the Jews. Begin to understand, I say, for comprehend them we never shall. Their character and interests are too vitally opposed to our own to permit the existence of that intelligent sympathy between us and them which is necessary for comprehension.

This drive to become a gentile at any cost, including schizophrenia, was the fruit of real desperation: young Berenson experienced his race and origins as a Medusa's head that could petrify his career at one glance. His social climbing, which looks so repellent and calculated, was inspired by the conviction that there was no way back. Proper Boston possessed the first culture he wanted to have; Jewishness was not a culture, only a point

of origin, something to transcend by means of any available fiction. In his old age, Berenson would make peace with his childhood, becoming almost rabbinical. But for the first fifty years of his life he fought to overcome and repress it, so that the gifted shtetl boy was ousted by a more literary specter—the pale exile of conjectural but high origins, bestowing his allegiance only on Culture: a Childe Harold of the salons and museums. His pedigree could not impress Boston, but his credentials of feeling could. Berenson went up to Harvard at a time when the cult of sensibility had swollen to unheard-of proportions, dominating all cultural discourse; as Samuels rightly observes, one of William James's effects on undergraduates in the 1880s was to make them as narcissistically busy with the flutterings of their conscious as their great-grandchildren would be with the promptings of their unconscious minds, so that "for young Americans of the *fin de siècle* imbibing the catechism of art for art's sake . . . the great world of politics and social strife was a world well lost." Berenson embraced the fetish of cultural refinement with an ardor that verged on religious ecstasy, and for the rest of his life it saved him from having to think seriously about social organization. Beyond routine fulminations against Fascism, which he opposed, and socialism, which he identified with mob rule, or as he put it, "ochlocracy," Berenson never had much to say about the political affairs of the world; and what he did say would have made sense only to a Boston Brahmin of the late 1880s who had forgotten the ambitions of making an ideal society that, up to the end of the 1840s, had given the intellectual life of Boston its unusual tone and vigor. For Berenson, as for George Santayana or Henry Adams, the sphere of culture was a refuge from such matters—a kind of New Jerusalem, a distant, golden, minutely organized refuge and reward for the Elect. In this heavenly city there could be no conflicts of class, only discussions about revealed truth; and the keepers of its keys lived at the top of the sublunary pyramid, on Beacon Hill. Berenson's growing sense of membership in the ultimate club enabled him to breathe a Harvard atmosphere which was, in the delicate phrase of his future brother-in-law, Logan Pearsall Smith, "richly colored by the sense of social differences"; it fortified him against the snubs of Charles Eliot Norton, who brushed him off as an intellectual arriviste with "more ambition than ability." Nevertheless, Norton's art lectures were of significance to Berenson, largely because they consolidated for him—as for polite Boston society, to which they had the same kind of appeal as Kenneth Clark's *Civilization* had to later audiences—the vision of the Renaissance as a heroic cultural saga, an art-historical Camelot fairly swarming with geniuses in silk doublets, who

all vanished like fairies after 1600 and, in passing, plunged Europe into the dark prelude to modernist chaos. The reinvention of the Renaissance by Jakob Burckhardt and his followers was one of the great facts of American cultural life in the 1880s, and when the millionaires and their wives began to identify with the *condottieri* and doges to the point of wanting to own the art they had commissioned four centuries earlier, Berenson's fortune would be made.

He did not set out to become a connoisseur-dealer. Berenson wanted to be a writer, but he imagined the act of writing as a means to a further end—not the mere extrusion of thought onto a page, but the demonstration of exemplary character, the writer as his final work of art. He wanted, in short, to become a literary presence, a model of pure cultivation. His prototype was Walter Pater, with whom Berenson, as a student, identified to the point of obsession. Pater is difficult to read today. The famous Gioconda passage, which moved a whole generation of undergraduates in Cambridge and Boston to tears and secret fantasies, has become period fustian: "She is older than the rocks among which she sits; like the vampire, she has been dead many times, and learned the secrets of the grave; and has been a diver in deep seas, and keeps their fallen day about her; and trafficked for strange webs with Eastern merchants." Nobody who read Pater's essays on the Italian Renaissance in the 1880s could approach the Mona Lisa without the sinuous Muzak of these cadences in his head. Pater furnished his readers with a model of young revolt. Against the materialism of the Victorian bourgeois father, and the arrogance of the landed "hearties," Pater's writings set forth a new shudder, a more refined snobbery of floating and pollination: the dandyist ideal of life lived as a procession of exquisitely shaped moments. This fantasy had been the common change of café society in France for twenty years or more, but it was alarming in Oxbridge and quite shocking in New England. "To burn always with this hard gem-like flame," Pater announced, "to maintain this ecstasy, is success in life." The manifesto of Pater's cult, which was to have profound effects on Wilde, Yeats and Roger Fry, as well as Berenson himself, was *Marius the Epicurean* (1885). This wispy and dilettantish tract became Berenson's gospel. Marius was a self-made child of feeling, who had arranged his life so that the structures and values of a florid, power-laden, parental Rome (for which read late-Victorian England or 1880s Boston) could not touch it at any point; and its highest morality—*the* highest morality, Pater insisted—was art for art's sake, a disinterested precision of feeling, a sense of minute discrimination elevated to the order of religion or science. Every moment contained some-

thing worthwhile hidden in superfluity, and success was to have "disengaged that virtue and noted it as a chemist notes some natural element." Here lay the root of the "scientific" ideal of connoisseurship that Berenson pursued throughout his life: a system of discrimination based not on any special power of argument, still less on the iconographical or social meanings of art, but on meticulous observation of detail, sensitivity to style, and exhaustive comparison based on a retentive visual memory. Berenson deserved the compliment Cézanne paid to Monet: *"Il n'est qu'un oeil, mais, mon Dieu, quel oeil!"*

The physical symbol of Pater's thought working on Berenson's life was to be I Tatti itself. As both Samuels and Secrest demonstrate, I Tatti was the realization of a fantasy that Berenson and Logan Pearsall Smith had shared in the 1890s—the dream of a contemplative order of men dedicated, like monks, to cultural perfection, and living together in a high-walled castle named Altamura. The plans for Altamura were drawn up at some length in *The Golden Urn*, a pretentious little magazine they brought out in 1898. It was to be a rentiers' lamasery, ineffably stylized, open to the sons of "wealth and disillusion" who would meditate on a different subject each month: pastoral beauty in August, entropy in November and so on. For Smith this was partly a sexual fantasy—a convent full of rich, sensitive boys—but for Berenson, who always rigorously sublimated whatever homosexual tendencies he may have had, rejecting the advances of Wilde, and failing to notice, when he met him, that there was anything odd about Montesquiou, the idea of *Marius* reborn as Altamuran monasticism had a different appeal. As a pseudo-religion it reinforced his idea of an alternative society, an elect of sensibility—*unsereiner*, in his word: Our Gang. I Tatti would be the proof that he had not only escaped his origins among the "Jews and other indecencies," as he called them, but transcended the iron social laws of Boston as well. It was his court, and there the great world came to him. "With horror I think what I might have become if I had lived the life of an ill-paid professor, or struggling writer," he wrote at the end of his life, "how rebellious, if I had not lived a life devoted to great art and the aristocratically pyramidal structure of society it serves, or worse still, if I had remained in the all but proletarian condition I lived in as a Jewish immigrant lad in Boston. . . . I keep hearing the Furies, and never forget them." And the only defense against them, the one missing component of the young Berenson's Altamuran hopes, was money.

It was therefore lucky for Berenson that on his first trip to Europe in 1887, underwritten by a group of Boston sponsors who included Isabella

Stewart Gardner, he quickly became disillusioned with the prospects of a literary career and moved toward that of the connoisseur and picture-attributor. "Conosching," as he and his wife, Mary Costelloe (whom he met in 1890 on that first *Wanderjahre*, which actually extended into seven years), jocularly called it, was a relatively new discipline; and its paragon, the man whose work gave Berenson the tools for constructing a method from the refined appetites Pater had stimulated in him, was Giovanni Morelli. Morelli's pioneering book, a brief study of Italian Renaissance paintings in the museums of Berlin, Dresden and Munich published in 1880, had fluttered the dovecotes by insisting on one fundamental law of evidence about attribution: that no matter what the documents said, the primary evidence on which one judged the authorship and date of a work of art was the work itself. Against this, no family tradition—"Grandfather always *told* us it was a Lotto"—or applied signature or letter could avail. But what form, exactly, did the primary evidence take? Anyone knows that the recognizable traits of a master's style are the easiest to do and thus the most often copied by students, shop hands or posthumous forgers. If every image with a Gioconda smile in it were a Leonardo, the walls of northern Italy would be papered with his autograph works—as, in the 1890s, they were thought to be: one luckless Frenchman named Eugène Müntz in 1898 published a study of Leonardo's drawings in which every single reproduced work was a school piece, a copy or a modern fake. While most connoisseurs did not achieve Müntz's perfect batting average, the study and attribution of Italian art was a swamp of misattribution, and Morelli believed the only way through it lay in studying and comparing those aspects of paintings which were *not* done at a high level of consciousness and so tended to be overlooked by imitators: namely, the small details of style, the drawing of an ear or a nostril, the disposition of vertebrae in a back or the curl of a toenail, the springiness of grass or the number of stamens in a lily. Since artists tended to develop standard forms of generalization for such things, their stylistic print on them was unmistakable. In short, what Morelli proposed was a system of fingerprinting, analogous to—and for obvious cultural reasons, contemporary with—the system of identification Alphonse Bertillon invented for criminals.

Berenson had read Morelli at Harvard, and was won over. This was the scientific system he craved, a mode of discrimination that raised Pater's ideal from the mere cultivation of pleasure to the "objective" life of the classifying, analytical mind. As Berenson's experience of painting grew by leaps and bounds in Europe, he came to feel that Morelli was not only the Winckelmann or Darwin of painting but a giant-slayer sent by providence

to strike down the authorities Berenson most detested, the German *Kunst-historiker,* whose chief—and Berenson's lifelong enemy—was Wilhelm von Bode of the Berlin Museums. Morellian comparison would be the means, as Berenson excitedly told his Florentine friend Enrico Costa one morning in 1889, of rewriting history: or more exactly, of writing it for the first time:

> Nobody before us has dedicated his entire activity, his entire life to connoisseurship. . . . We are the first to have no idea, no ambition, no expectation, no hope of reward. We shall give ourselves up to learning, to distinguish between the authentic works of an Italian painter of the fifteenth and sixteenth century, and those commonly ascribed to him. . . . We must not stop until we are sure that every Lotto is a Lotto, every Cariani a Cariani, every Santacroce a Santacroce."

No student of Renaissance art today can do more than imagine the obstacles that lay in Berenson's path of connoisseurship. In the age of art history, they have vanished, but their disappearance was very largely Berenson's doing. There were no reliable guidebooks or general histories of Renaissance art, although a start had been made by Crowe and Caval-caselle. The best available guide was the notoriously unreliable Vasari, who at least had the merit of being an eyewitness to some of the cultural events he described. Otherwise, the material was jumbled, inchoate, un-catalogued, unsifted or simply invisible. Provincial museums the length of Italy made no effort to coordinate their catalogues (when they existed) or to revise their attributions, which were jealously adhered to in a spirit of knee-jerk civic patriotism. Since the idea of accessible subcollections for study had not occurred to Italian museum men, vast deposits of paintings, terra-cottas and bronzes lay moldering in basements, coming to light only when filched by museum staff and sold to dealers. And in churches, particularly Tuscan and Umbrian provincial ones, an appalling neglect prevailed; when Berenson first saw Piero della Francesca's sublime fresco cycle of the Legend of the True Cross in the Church of San Francesco in Arezzo, for instance, the church had been turned into a military bar-racks and the frescoes were half hidden by dusty piles of ecclesiastical furniture, jammed higgledy-piggledy up the walls.

Berenson set out to cut his way through this mess and establish real canons of authentication for Italian Renaissance painting. Some people who love art have a short attention span; the effort of concentrated looking fatigues them. Berenson had the stamina of a chamois, and throughout his

life his ability to keep focused on the objects of his study was a wonder and a rebuke to other connoisseurs. It would never be used more energetically than in his early Italian years, between 1890 and 1895, when, poor as a church mouse and earning a small living by taking tourists around Florentine museums for a lira a head, he studied and sorted and filed and extrapolated, tramping for months across rural Italy and applying the Morellian system to everything he saw. The results of these years of patient, impeccably disinterested observation would eventually be summarized in Berenson's "Four Gospels," his four fundamental books with their accompanying lists of authentic paintings and their whereabouts: *The Venetian Painters of the Renaissance* (1894), *The Florentine Painters of the Renaissance* (1896), *The Central Italian Painters of the Renaissance* (1897) and *The North Italian Painters of the Renaissance* (1907), with, in between, his most exact and elegant work of scholarship, *Drawings of the Florentine Painters* (1903).

Throughout this he kept his eye on the main chance, the prospect of becoming an art pundit. Art, he wrote to his future wife, Mary Costelloe, in 1892, was the road to fame: "Once the public get the ring of this monosyllable, they will follow anyone who shouts it at them, you and me, if we shout loud enough." One ingredient of this future ruckus was their utter indifference to conflict of interest; it was Mary's regular practice, from 1894 onward, to set glowing notices of Bernard's work wherever she could place a review, sometimes under her own name, sometimes under assumed ones. But what Berenson most needed was an opportunity to carry out a public slaughter of established attributions. He got it in 1895, with an exhibition of Venetian painting from British collections at the New Gallery in London. When Berenson's essay on this show appeared, it transformed him at once into an enfant terrible: of thirty-three works attributed to Titian in British collections, for instance, he spared only one, the Mond Madonna, assigning the rest to copyists or to such minor figures as Polidoro Lanzani, Santacroce and Beccaruzzi; of seven "Mantegnas" he accepted two; and so on. Since nearly all the paintings in the show were owned by rich and titled Englishmen, Berenson's pamphlet stirred up a hornet's nest. It achieved its end, since if all earlier Renaissance attributions, in England as in Italy, could have doubt cast on them, whom could collectors trust? None but Berenson himself, the new authority. And so, amid envy from other critics and rancorous hostility from dealers whose swans he was degrading to ducks, Berenson—still the picture of scholarly detachment, the young *Aufklärer* with no visible allegiances to any established art-world interests—quite rapidly became what he would remain

for another fifty years: the filter through which most Renaissance art, entering the new-money collections of the New World, had to pass.

The critic who deals is a common spectacle, and not a noble one; the only way to keep your nose clean in the art world is not to deal or collect at all, and very few writers are prepared to do that. In Berenson's time it was simply assumed that art critics and art historians were up for sale and on the take, unless they were so rich as not to need the money. To the end of his life, Berenson was sensitive on this point, and he had every reason to be. One reads his lament, in his eighty-eighth year, about the comparative ease of his most famous protégé, Kenneth Clark: "K.C. not only inherited his fortune, but increases it. He buys and sells works of art, and that counts only as a gentleman 'exchanging' a good thing for a better one. If I sold any picture I should at once be put down as a 'dealer' because I started poor." The words "if I sold" betray no mean capacity for self-delusion, since Berenson spent as much time setting art up for sale, and selling it, as he did contemplating it. It was his means of support form 1895 until his death. His terms, as contracted with Lord Duveen in 1912, were simple: He got a quarter of the profits from the sale of any painting on whose authenticity he had been asked to pronounce. Since few American collectors were prepared to buy an Italian gold-ground predella fragment, let alone a full-dress portrait by Titian or Moroni, without a Berenson ticket on it, the volume of his business was immense. It is impossible to say, without access to the Berenson–Duveen correspondence, how many works of art (if any) Berenson upgraded to enhance their market value, but Secrest appends to the end of her text a long and interesting list of Berenson attributions that have gone down since his death, or jumped from school pieces to autograph works when they were in Duveen's hands. A spectacular case of this is a "Masaccio" acquired from Duveen by Andrew Mellon, *The Madonna of Humility*, a wreck with only a few square inches of genuine paint left on it. Berenson went so far as to publish it while it was still in Duveen's hands, writing that no painting of equal splendor had been seen "since the builders of the Pyramids and the sculptors of the Chefrens." It is now in storage in Washington, D.C.

Berenson likened his immersion in the art trade to Spinoza's lens-grinding: a way of getting by, of underwriting the mind. In fact, the scale of his business operations was such that the better analogy might have been the president of Zeiss dabbling in philosophy. This, Secrest argues (as Meyer Schapiro maintained twenty years ago), is why one cannot read Berenson's lamenting his wrong turnings with much sympathy; not once, in all the diary entries of his late years, could he bear to face the real reasons for what he considered his intellectual apostasy.

His first big client was Isabella Stewart Gardner, for whom he secured most of the major paintings still at Fenway Court. He came groveling after her like a heat-homing missile. "Whatever comes, I shall always worship you without exception as the most life-enhancing, the must utterly enviable person I have ever had the good fortune to know," he wrote to her in 1898, when she seemed to be going cold on further buying. And again, "You are really the most lovable person on earth, sunshine become flesh and blood. I know not how to describe you, but a miracle certainly, a goddess and I, your prophet." When "Mrs. Jack" bought the Darnley Titian, *The Rape of Europa*, through Berenson, its then astonishing price of $100,000 set a new plateau for Renaissance paintings and caused almost as great a sensation as the $2 million paid for Pollock's *Blue Poles* six years ago. From then on, Americans would pay ever-increasing prices for Italian art, and the one person who could guarantee the integrity of their investments was Berenson.

Thus in the winter of 1903 the Berensons let fall their triumphal blitzkrieg on America, and the accounts both Samuels and Secrest give of it make very funny reading—although it would take a Balzac to do full justice to the monstrous comedy of greed, insecurity and opportunism that unfolded as they hit the "squillionaires." The keynote of their trip was struck in Mary Berenson's diary entry, after dinner in Boston with James Loeb, banker and founder of the Loeb Classical Library—"a handsome, fat, prosperous, philistine Jew, classmate of Bernhard's," she noted. "It is astonishing how interesting and un-boring society becomes when you have something to get out of it." Thus the little fox and the Quaker tank cut their swath through the Wideners and Kresses, the Schiffs and Warburgs, the Potter Palmers and Freers and Gateses, deeply impressing everyone except, apparently, the wife of an Irish newspaper proprietor named Laffan, who later remarked of Mary to Roger Fry: "Oh, we women sink very low—to keep Berenson going, what a *métier*!"

Berenson would presently say, with understandable pride, that most of the major Renaissance paintings that entered the United States in the first half of our century did so "with [his] visa on them." He felt no compunction about prying them loose from Italy; the Italians had neglected their own heritage, and Berenson saw his own work for Duveen not as the cultural plunder it was, but as a work of preservation, which it also was. But there can be little doubt that his own dependence on art-dealing caused him to ossify as a critic and thinker. Berenson the attributor was much more interesting than Berenson the art critic, because he had so much territory to defend, and he saw that fief as an enclave of controllable sanity and ideal beauty—not to mention big money—in a

decaying culture. For Berenson was a nineteenth-century man who survived into the twentieth, and his main intellectual problem was, as Meyer Schapiro pointed out, that he failed to grow. Nowhere did this show itself more vividly than in his transactions (or lack of them) with the culture of his time, modernism. For an art writer to have lived through one of the supreme periods in Western art history, the forty years from 1890 to 1930, and not to have uttered one intelligent syllable about it is nothing to be proud of, but Berenson managed to do it. Often he seemed to have no idea of what was going on around him. He not only anathematized Pound, Joyce, Stein, Eliot and especially Freud. He actually managed to convince himself that Freud and Eliot had plagiarized him: "The stone I threw away as not to be used," he wrote in 1950, "they used as the cornerstone of their system."

In painting, little that tasted of modernist experience was allowed time in I Tatti. Late in life, Berenson would claim that he had "discovered" Cézanne by mentioning him in his *Central Italian Painters*. This mention was hardly more than a warbling palimpsest of incompatible names: "[A] real art of landscape," he wrote, will come "when some artists, modelling skies like Cézanne's . . . will have a feeling for space rivalling Perugino's or Raphael's." No one who imagined that Raphael's idea of space could be reconciled with Cézanne's heroic doubt and deep sense of relativity can be said to have looked much at Cézanne, and Schapiro was certainly right when he acerbically remarked that "the name of Cézanne served him, I suppose, as a piece of up-to-date dressing like the name of the fashionable Tissot." In any case, Cézanne was so well known to French artists by 1897 that any claim to have "discovered" him at that late date is absurd. All one can say is that Berenson had heard of him a little earlier than the squillionaires across the Atlantic.

Berenson did defend Matisse in 1908, in a letter to the New York *Nation*, but the terms now seem a trifle odd. Matisse, he suggested, was more draftsman than colorist. But after Matisse, from Cubism and Futurism onward, modern art was in his eyes an abomination, the work of madmen, dupes, Bolsheviks, poseurs, faggots and decadents, led by that archfiend and demagogue of chaos Pablo Picasso, whom Berenson rather startlingly compared to Huey Long.

It is unlikely that he saw much modern art, except in photographs, and in any case it might be asking too much of a man who was nearly fifty when the Armory Show opened to have a late conversion. But Berenson's asplike hostility to the culture of his own day ran deeper than ordinary fear of the unfamiliar. Berenson experienced modernism as a direct threat

to his own values, livelihood and well-being. He took its rhetoric of destruction, the stock-in-trade of Futurism, Dada and Surrealism, at face value. "Come on! Set fire to the library shelves! Turn aside the canals to flood the museums!" Marinetti had exclaimed in 1909, in the Futurist Manifesto. "Oh, the joy of seeing the glorious old canvases bobbing adrift on those waters, discolored and shredded!" Since Berenson had one of the grandest private libraries of the twentieth century, paid for by collecting twenty-five percent on the profits of every one of those same glorious canvases which, recolored and patched and restored, were sold by Lord Duveen, it would have been naive to expect him to sympathize with such outbursts. The energies of modernism therefore struck him as loathsome and satyrlike, certainly not "life-enhancing"; and he could not see the profound connections, direct or ironically masked, between modernism and its traditional sources. Besides, the confessional aims of Expressionism or Surrealism could not have been congenial to a man who believed so strongly in Pascal's dictum: *"Le moi est haïssible."*

But Berenson's defensiveness and his reluctance to face his own contradictions also tended to cut him off from developments within his own field: the study and criticism of Italian art of the distant past. In 1924, Duveen held a show of Berenson-attributed old masters, bought by American collectors, in his New York gallery. Some of these attributions were by then looking particularly optimistic. The art historian Richard Offner wrote an article for *The Arts* magazine, in which he mildly but firmly questioned a Cimabue, a Daddi, a Fra Angelico; it would be twenty years before Berenson spoke to Offner again. The art world is a nutrient broth for paranoid disputes and imagined slights, but even by its standards of conduct Berenson's was unusual. His ferocity may have been more closely connected with the nature of his thought than is generally supposed. In general, Berenson's perceptions about art were not easy to debate. Intuitions rarely are; they do not partake of the nature of argument, and Berenson staked his entire career on the superiority of his eye, backed up by that incomparable memory bank. Any questioning of his conclusions was therefore apt to be treated as a personal attack, and so he tended to see other art historians as barbarians shaking their billhooks and uttering hoarse dialectical threats below the walls of Altamura. The donnée of his work was that the value of painting lay in its ability to enhance self-consciousness, by means of intense increments of experience—flashes of vision and delight. These moments were to Berenson, as to anyone fortunate enough to have them, all but indescribable. Like his passionate delight in nature, they came close to mystical experience. They disclosed the

"It-ness" of which he often spoke—the irreducible, self-manifesting essence of reality.

Nevertheless, Berenson felt obliged to give this oceanic pleasure of the eye, the goal of the aesthete's quest, the trappings of a system. Hence the awkward formulations of his critical writing—"tactile values," "ideated sensations" and the rest. The idea of tactile values, as expounded by Berenson, sounded impressive but was merely a slogan: it was to illusion what the idea of "significant form" was to abstraction. It derived from a crude physiological notion of how the brain interprets space and passes that interpretation to the body. All it stood for, if analyzed, was a convincing impression of three-dimensionality. Nevertheless, Berenson insisted on applying this concept as a touchstone, quite mechanically, as though it were an arguable guide to quality in art. At the same time, he despised iconographical studies as mere groundwork at best and, at worst, a threat to his interests: hence his loathing of Erwin Panofsky. By the thirties, the famous pasquinade on an Oxford don applied with even more precision to Berenson's view of his colleagues:

> I am the great Professor Jowett
> Whatever there's to know, I know it.
> I am the Master of Balliol College:
> What I don't know, isn't knowledge.

What impressed Berenson's admirers, the court of I Tatti, was his formidable *certezza*. It is the very quality that now makes him seem such a period figure, so remote and in some ways so difficult to understand. He created the role of the waspish pontifex, and took it with him; few modern art historians would want to fill it again, and probably none have the devouring energy to do so. It costs too much to maintain, and the payment is not made in money but in suppleness of thought. In any case, the idea that any branch of the art market could have one single Sorting Demon presiding over it today, as Berenson did over his field half a century ago, is no longer conceivable. Berenson's writings—as distinct from his body of authentication, the Lists, which remain fundamental to the study of Italian art—have dated a great deal. It is unlikely that future generations will read them for the pleasure of good writing, as one reads Ruskin or the more sinewy areas of Pater. Certainly they are no longer read, as his contemporaries Wölfflin, Dvořák and Riegl still are, for their insights into the relations between art and history. Perhaps Berenson's main claim to survival is as the character Secrest so convincingly put before us: a man

who exemplified, more poignantly than anyone else in this century, the kind of Faustian deals the art market exacts on those who enter it with idealistic hopes of purity. It made him the big offer, and he could not make the *gran rifiuto.*

The New York Review of Books, 1979

Tom Wolfe: From Bauhaus to Our House

The past ten years have proved a weird time for architecture, and weirder still for its public. In the United States, vast numbers of new buildings go up. Whole malls and "living communities" rise overnight, like sprouting mushrooms in a time-lapse movie, each a semifaithful parody of something in last month's architectural press; status, constantly in flux, is one big slide area. Philip Johnson's AT&T building may be a scaleless monster smugly delighted with its own moderately clever quotes from Chippendale and Brunelleschi, but it has well and truly initiated a time—not, one hopes, a long time—in which the idea of style has mutated into that of styling. With the action goes an equal ferment of opinion. Classical modernism is defended as archaeology and derided as a failed utopia. In its place, though more visible on the drawing boards than the streets, there is something conveniently named "postmodernism." But is that a movement or just a journalistic label? The walls of the labyrinth, made of paper as much as brick, shift and recompose themselves erratically.

To systematize it all, to reconcile the buildings and the slogans, demands a degree of bravery verging on folly. Nobody would accuse Tom Wolfe of lacking either. And so, in he goes, promising to make sense of the past few decades of American architectural taste with a poor short book, *From Bauhaus to Our House.* The title, however strained, is better than the text. Wolfe has talent as a stirrer and, as you might expect, comes up with some funny parodical vignettes, but the opinions he vouchsafes on architecture bear out John Stuart Mill's remark that "the second-rate superior minds of a cultivated age . . . are usually in exaggerated opposition against its spirit."

This essay first appeared as a review of Tom Wolfe's *From Bauhaus to Our House* (New York: Farrar, Straus & Giroux, 1981).

Wolfe's argument is simple enough: dumbly simple. Before 1920 there was an *American* architecture, epitomized by Louis Sullivan and Frank Lloyd Wright. But in the thirties its heritage was traded off for a mess of ideological pottage, cooked up in the Bauhaus by various left-wing Germans and Mitteleuropeans under the sway of Walter Gropius and Mies van der Rohe. The raison d'être of this wholly alien style—monastic, severe, technology-obsessed and full of socialist notions, stinking in Wolfe's twitchily neoconservative nostrils of utopia and garlic—was worker housing. (This might have surprised Mies's European clients, who tended to be bankers and industrialists, such as the Tugendhat family in Czechoslovakia.) It was imported to the United States, a country (or so Wolfe argues in one of his more fatuous transports of sociological fancy) that had no need for blue-collar housing and was therefore ill fitted to use it.

Who did this? Pointy-headed elitists, that's who. Christened the International Style by Philip Johnson and Henry-Russell Hitchcock, the foreign manner was taken up by the Museum of Modern Art, shed its "real" aim (the promotion of socialism) and became the house style of American capitalism. Wolfe seems to think of Mies van der Rohe's arrival in America as a cultural parallel to Lenin's appearance from the sealed train on the platform of the Finland Station. Soon, America the Previously Beautiful was covered with glass boxes erected in helpless middle-class submission to intellectual fashion. Nobody liked these buildings then. Nobody wants them now. From sea to shining Seagram, it was a big waste of time. But the legacy is permanent, because the International Style created "Compounds," an entrenched dictatorship over taste centered in the eastern universities. These Compounds wanted to impose abstract dogmas on the real world of American desires and American fantasies. Nobody since has been able to get out of their ideological straitjacket.

Later architects, from Robert Venturi to Michael Graves, may seem to be coming out in favor of vernacular, complexity, decoration, memory and whatnot—the whole postmodernist bag of tricks, from Cape Cod shingles to Roman arches—but they are all abstractionists, clones of the Compound, still seeking to exalt the Word (theory and manifestos) over the Act (workable buildings). Real populist architecture has no chance. Within the academic taste centers, Wolfe says, "there was no way for an architect to gain prestige through an architecture that was wholly unique or specifically American in spirit." What was this spirit, this discarded and ignored zeitgeist? Tail fins and Empire: "the Hog-stomping Baroque exuberance of American civilization." Those who did continue to serve

it were banished as apostates, and become the heroes of Wolfe's narrative: John Portman, Morris Lapidus, Eero Saarinen and Edward Durell Stone.

That, stripped of the nudging, winking and stylistic razzle-dazzle that pad the book to length, is the gist of Wolfe's argument. It looks familiar, as travesties must. The dismantling of modernist dogma has been going on for ten years or more; it has been a prime staple of architectural criticism and practice throughout one of the most intense periods of building in American history. Everyone, including Wolfe, knows something about it. But he brings nothing new to the argument except, perhaps, a kind of supercilious rancor and a free-floating hostility toward the "intelligentsia." The late bird has gotten half the worm. *The Right Stuff,* his best book, sandwiched between his two weakest, *The Painted Word* and this one, showed how accurate an eye Wolfe has for manners, fantasies, customs and hype, and how he can rise to a kind of ravenous comic brilliance when engaged with a subject he respects and has really researched. There is no such feeling of engagement in *From Bauhaus to Our House,* no sense that he particularly cares about architecture at all, unless it can be shown up as the carapace of intellectual folly. This gives his argument a coarse and hasty air, and has produced a lazy book.

Nothing piques him more than the sight of Europe influencing America: the White Gods, Gropius and Mies, land among the prostrated natives and colonize them, as simply as that. But of course it was not that simple. What happened was not invasion, but long reciprocal exchange, intellectual barter, as it were. From about 1900 on, European modernism in architecture was imbued with American imagery, preoccupied with issues that became central to the International Style. The grid, the load-bearing frame and light skin of the new buildings, came to Europe from the Chicago School, whose leader was Louis Sullivan. The Bauhaus ideal of the open plan was transmitted to Germany by Frank Lloyd Wright. Adolf Loos's messianic rejection of ornament in the early 1900s, which became such a fetish with the International Stylists, came straight out of his infatuation with American machine culture. Le Corbusier derived a good deal of his architectural syntax from the "functional" shapes of American grain elevators, docks and airplanes. And when European modernists in the early twenties dreamed up their *Wolkenkratzer* ("cloud-scratcher"), the nearest the German language could come to the alien Yankee concept of a skyscraper, critics in Vienna and Paris accused the modernists of deserting their native traditions and caving in to transatlantic cultural imperialism.

And so what Wolfe's naive fable of White Gods and Silver Princes

ignores is a much more dramatic interchange than he can see. American architectural ideas, and fantasies about Yankee technology, were distilled and elaborated in Europe, where they contributed to a messianic style. It came back across the Atlantic in the thirties and forties, and then was academized. Without doubt, the reign of the curtain wall and the spread of a debased sort of rubber-stamp corporate modernism were helped by the factors Wolfe lists: fashion (but what architectural style is immune to that?), snobbery, herd instinct and the colonial cringe. Mainly, the glass box won because it was cheap to build. However, it might be that the American patrons of mainstream modernism were not as dumb or masochistic about their glass boxes as Wolfe thinks. What if they felt, on some instinctive level, that those cost-efficient termitaries with one marble foyer and a thousand Sheetrock cells disclosed some truth about power, conformism and social organization in American corporate life, a truth that the captains of industry and business embraced and wanted to perpetuate? What if the glass box *was* the all-American self-expression that Wolfe claims is not there? His book does not broach that possibility, yet it makes more sense of upper Sixth Avenue in New York City or downtown Houston than all his rattlings about the passivity of corporate clients. But then, there was probably no time to inspect the matter. He had a book to finish.

The text has some funny aperçus, such as the glimpse of reverent Yalies hand-washing the baby's diapers to pay for the pair of Mies Barcelona chairs, those comfortless icons of secular progress. But its flaw, apart from Wolfe's ignorance of architectural history, is that he looks with his ears. Architects tend to write manifestos when they are not being asked to build. Given the choice between what architects wrote about architecture and what they actually built, Wolfe believes the words every time. This leads him into some wondrous fluffs, such as the notion that Mies van der Rohe contrived the 1958 Seagram Building as "worker housing, utterly nonbourgeois." He should go inside it and have lunch at that well-known workers' canteen, The Four Seasons. If Wolfe cannot see what august luxury the grid as used by Mies contains, he literally does not know how to see architecture.

Most discriminations in *From Bauhaus to Our House* are dissolved in a hunt for conspiracies. Edward Durell Stone's late buildings such as the U.S. Embassy in New Delhi or the Kennedy Center in Washington, D.C., are, by any conceivable standard, maladroit and glitzy, but Wolfe will have none of that; he thinks the dread Compound laid Stone's name low not because he was a poor designer but for the crime of deviationism.

Alas, the politics of architecture were never so simple. They lie inextricably tangled up with aesthetics, money and ideas. But dealing with ideas, at least on the level this subject needs, is not Wolfe's forte. As in *The Painted Word*, he ends up doing what he accuses his bogies of: the meaning of the work is drowned in a spate of "theory," and each time the theory is undercut by Wolfe's stridently commonsensical attitudes. These, after a while, read like condescension, as a rigid adherence to the surface usually does. *Plus ça change, plus c'est la même pose.*

Time, 1981

Brideshead Redecorated

Now and then, a shadow of anxiety is seen to cross the broad, luminous face of American democracy. Was the Revolution a social mistake after all? Should Benjamin Franklin have gone to the French court in a wig instead of his own egalitarian hair? Was it really such a good idea to get rid of George III and Lord North? Given the uninflected worship of cash that marks the 1980s, it is no wonder that the spectacle of privilege enjoying its own toilette has become America's hottest cultural ticket. Thus Lord Marchmain of Brideshead becomes the Blake Carrington of the American upper-middle classes.

Museums have learned their part in this vicarious regilding. They supply a sense of history as spectacle. This seems to mesh particularly nicely, of course, with the English-heritage industry. Relatively few Americans can imagine themselves as King Tut, Rudolf II of Prague or Lorenzo de' Medici, but there is no shortage of people who feel that with the right decorator, their homes might become facsimiles of English landed estates, complete with an old red setter molting and farting on a new reproduction William Kent sofa.

An ideal museum show would therefore be a mating of *Brideshead Revisited* (the only vulgar novel Evelyn Waugh wrote) with *Architectural Digest*. It should borrow widely and set forth an impressive parade of authoritative objects, with special attention paid to furniture. It should

sketch a portrait of a vanished order without revisionist detail, thus pro-voking intense and pleasurable nostalgia for a past that none of its audi-ence has more than the sketchiest idea of. Its opening nights should be long, socially frantic and attended by as many titled lenders and assorted Chinless Wonders as can be flown across the Atlantic. Royalty should be present, enabling museum officials to fall, Bernini-wise, into swooning postures of gratification, one eye on the Princess of Wales and the other fixed on the box office. In short, it might not be unlike "The Treasure Houses of Britain: Five Hundred Years of Private Patronage and Art Collecting," which opened last week at the National Gallery of Art in Washington, D.C.

It is by far the most assiduously promoted exhibition to be seen in the United States in years. Its catalogue weighs as much as a fresh grilse (six and a half pounds) and is about as hard to carry. Although the National Gallery's director, J. Carter Brown, is accepting most of the credit for it, the main work of selection, cataloguing and arrangement was carried out by its English curator, Gervase Jackson-Stops, architectural advisor to the National Trust in London. He did the job with wide knowledge and, in the matings of some objects, a dry wit. One could be fatigued by the result but never bored, for Jackson-Stops is a dab-hand at fitting potted histories around incompressible works of art. One is firmly led through the mutations of English taste, as early Elizabethan patronage becomes the acquisitive connoisseurship of the late eighteenth century, and the tiny enameled world of Nicholas Hilliard opens to the spacious marmoreal one of the Grand Tour and Burlington House. Only after the 1930s, with the ethos of country-house patronage in full retreat before the incomprehensible twentieth century, does the show become a fatuous diminuendo of John Piper watercolors and Asprey-style silver humidors. The cutoff point should have been 1914.

The narrative is set forth in more than seven hundred remarkable objects. These run from Isaac Oliver's exquisitely realized miniature of three reflective siblings of the Montague family, clad in sober Catholic black, to an intimidating silver wine cooler half the size of a Jacuzzi; from Johan Zoffany's courteous but plainspoken portrait of a plump earl on the Grand Tour raising his hat to shield himself from the Florentine sun, to the boot-licking Edwardian rodomontade of John Singer Sargent's huge portrait of the Duke of Marlborough and Consuelo Vanderbilt; from a marble mock-Greek portrait by the sculptor Francis Chantrey of two woodcocks he had shot at Holkham Hall, to the Calke State Bed, a sumptuous four-poster whose hangings of gold-embroidered blue-and-

cream silk were recently found in their original box in Calke Abbey, as fresh as the day they left China nearly 250 years ago.

There are ideal juxtapositions, as with the Chippendale sideboard, wine cooler and pedestaled urns from Harewood House, whose rich tones of rosewood and satinwood are echoed and amplified in the glossy coats of the Stubbs horses hanging above them, borrowed from a different owner. The cast list of painters and sculptors, silversmiths, *ébénistes* and potters is immense, and although there are disappointments—Turner, for instance, is poorly represented—there are also some startling moments. It would be difficult to find a clearer or fresher Canaletto than his view of the Thames from Richmond House, for instance, or a more precocious early Rubens than his enormous, little-known portrait of the Marchesa Caterina Grimaldi from Kingston Lacy, or such a drop-dead showpiece of neoclassical metalwork as John Flaxman's silver-gilt *Shield of Achilles*, based on Homer's description of the "wonderful shield" wrought by Hephaestus in *The Iliad*.

The agenda of the show is plain, and who could object to it? It is a fund-raiser, aimed at drumming up more American support for that collectively unique, financially insecure, historically indispensable phenomenon, the Stately Home. These country houses, once the center of political power in a society where wealth was reckoned in acreage and rent rolls, make up an endangered species today. Everyone wants to look at them; in 1984 the historic houses of Britain received 45 million visitors. Four out of five were British, which shows a public loyalty to haunts of privilege that Engels might have found hard to explain. The truth is that neither English history nor English culture can be understood without these places; they matter far more as social evidence than most Italian palazzi or French châteaux. The ritual of public visits is not at all new. Some great houses have been open to curious strangers since the day they were built (even the First Duke of Marlborough was pestered by tourists in 1711 while building Blenheim).

But the problem, for the past hundred years, has been paying for them. As the landowning families of England were depleted by the long agricultural depression of the late nineteenth century, by the introduction of death duties and by the slaughter of their sons in World War I, so their houses declined. In the century from 1875 to 1975, over 1,100 were demolished, more than half since 1945.

Today, thanks partly to the English National Trust and partly to better tax arrangements—whereby families can give a house of major historical interest to the government in lieu of death duties but continue

to live in it as long as they keep it open to the public—the tempo of loss has slowed. But there are few estates that do not face their annual nightmare of rising damp, falling cornices, skyrocketing repair bills and shrinking rents. These shared threats induce the mood of solidarity fondly guyed by Noël Coward decades ago: "Though if the Van Dycks have to go / And we pawn the Bechstein Grand, / We'll stand / By the Stately Homes of England." As one should, for there is no parallel to the stubborn integrity of their collections among the stripped and much-looted palaces across the Channel.

The parade of valuables in Washington might suggest, to the uninitiated, that the British can easily afford to maintain them. Some mildew and burst upholstery would lend poignancy to the subliminal cry for help. In any case, a collection is not a house, and the catchpenny title "Treasure Houses"—suggesting Palladian Fort Knoxes inhabited by Volpones from Debrett's—does not convey the agreeably worn mixture of the grand and the scruffy that often defines their charm. The show embraces conventions of glamour (mainly about Georgian England) that few social historians would accept today. It rehearses the conventional picture of enlightened Augustan Whigs, adored by the whole inferior creation from their wives to their dogs and filling their rotundas with the works of Claude and Praxiteles. Surely by now an American museum can admit that a few of these paragons were educated brutes with Titians, like a few of their modern counterparts? Or that their ideology of cultural property was underwritten by their power to hang men for poaching a stag or breaking down an ornamental shrub? Or even that England, particularly from the Civil War to the rural riots of the 1830s, was by no means the serene garden of precedence and patronage suggested by the masterpieces of Gainsborough or Robert Adam?

The point about patronage is that it is not an extension of rights but a form of social control. The Benevolent Peer did, of course, exist. There were always English aristocrats willing to espouse liberal views, and they are commemorated in this show by Francis Wheatley's genre painting of John Howard, the pioneer of English carceral reform, visiting a prison in 1787. The work once belonged to the reforming, antislavery Tory, Lord Harrowby. But the show and its catalogue broadcast together on a narrow band of social meaning, emitting what is basically a fantasy about relationships among taste, property and justice. The show has certainly conveyed the opulence of its subject. But the other side of the coin is worth remembering, even as one gapes at this unabashed marriage of the fantasies of Reaganism with the opportunism of the English toff—a marriage made

in heaven, to be consummated on Chippendale sofas, with Carter Brown fluttering like an eager putto with many a coy sidelong glance between the withered participants.

Time, 1985

Jean Baudrillard: <u>America</u>

For seventy years after its Revolution, since French writers viewed America with hope and English ones viewed it with disgruntlement, some of the best observations on America were made by the French and most of the worst by the English. Eighteenth-century French visitors to America saw a self-emancipated people united in the world's first sizable republic: the forerunner of their own revolution. They noted the humiliation of *Albion perfide,* their own ancient enemy. What America was, in the eyes of Condorcet, Crèvecoeur and Volney, France might become: the natural home of democracy, if not of Hesiodic simplicity. France embraced Jefferson, Franklin and Washington as ideals of Republican Man long before the demolition of the Bastille, and with Chateaubriand's *Voyage en Amérique* (1827) the passion for seeking the meanings of democracy on the stage of the New World, within its epic spaces, moved into high rhetorical gear. The climax of French scrutiny was provoked after 1830 by the prospect of another French republic, and became by far the most perceptive book a foreigner ever wrote on American society and politics: Alexis de Tocqueville's *Democracy in America* (1835).

Englishmen, by contrast, either averted their eyes from America, or looked at it only to complain about the barbarity of their former colony, its people's lack of manners and art, their materialism. The Ur-work of malice was Captain Basil Hall's compilation of Tory rant, *Travels in North America in the Years 1827 and 1828.* It was followed by Frances Trollope's bitchy *Domestic Manners of the Americans* (1832). Ten years later Charles Dickens's *American Notes for General Consumption* was also a best-seller, being cut from the same cloth of condescension and snobbery. The last

This essay first appeared as a review of Jean Baudrillard's *America,* tr. Chris Turner (New York: Verso Press, 1989).

two at least were full of sharp vignettes, but neither showed much grasp
of how America actually worked. They served to persuade the reader that
America, though lost, had not really been worth keeping.

A century and a half later, what does one find? The reverse: that the
French have contributed little to the popular literature of American obser-
vation since Tocqueville, and even less since the end of World War II.
The Americans themselves, together with some English writers, have
done it all. Thus nothing in French about America in the twenties or
thirties approaches D. H. Lawrence on New Mexico, and there is no
French equivalent to the acute, modest-toned, undeceived reportage of
Alistair Cooke. No recent French writer has made an effort to get out into
the American landscape, deliver its look and feel, meet people, discover
how they talk and what they think about, evoke their histories; that is left
to English writers like Jonathan Raban, taking his skiff down the Missis-
sippi (*Old Glory*), or to V. S. Naipaul among the Good Ol' Boys (*A Turn
in the South*).

In the fifties, French intellectuals simply lost interest in getting
America right. Their imagination was seized by an altogether more lurid
and "interesting" America than the real one, the pow-zap-splat America
of the *bandes dessinées,* the alienated and sinister America of film noir, the
vengeful and paranoid America that let McCarthy ride and killed the
Rosenbergs, the booming paradisiacal America of tail fins and rock 'n' roll,
the megadeath America of the White Sands proving ground.

The stereotypes of this America had global reach; they could be
sampled and theorized about without leaving France. Their sheer power
canceled any obligation to experience the place itself, in all its size, com-
plexity and impurity, before writing about it. The real America was less
fascinating, which may be why the American notes of the few stars of the
postwar French intellectual firmament who bothered to go there—Si-
mone de Beauvoir, for instance—seem so flat and incurious.

As the fifties wore on, it became increasingly apparent that America
was merely a stage set for French left-wing bigotry about *l'Amérique.*
America was no longer an intriguing idea. It had withdrawn its original
offer of revolutionary transformation. Russia now did that; and then,
when the horrors of the Soviet utopia bulked too large for even Stalinists
to ignore, Cuba was supposed to. A dozen years later this reluctance to
look had become general. America, as all good *soixante-huitards* knew, was
a bellicose caricature, an imperialist Hulk, a crass *société de consommation*
nourishing itself on the flesh of the Third World. Its physical image had
dwindled to two vertical features (the skyscrapers of Manhattan and the

buttes of Monument Valley) and a horizontal one (the grid of superhigh-ways). It was populated by oppressed blacks, the ghosts of slaughtered Indians, rednecks in pickup trucks, hippies and Pentagon generals. Its culture was directed by mass media, and the only worthwhile things that came out of it were new rock and old movies. Once the revolutionary illusions of 1968 had gone down the pipe, French radicals—as Diana Pinto pointed out in 1982 in *Le Débat*—continued to comfort themselves with imagery drawn from what was left of American counterculture, so that "in each case, the 'interesting' America remained the one defined by its opposition to the Establishment." Curiously enough, even after intellectual fashions changed with Solzhenitsyn's visit to Paris and the rise of the *nouveaux philosophes,* the image of America in French eyes did not become much more concrete. Print and television journalists in France certainly came to realize that, whatever pressures the American media had to endure from capital and management, they were on the whole freer from constraint than the state-run, centralized French television system. But America remained a continent of abstractions whose main reality, eminently suited to France's own burgeoning consumer society, was the lightning-fast reassembly of American styles of promotion, marketing and entertainment techniques in Paris. No verification, no empirical reporting were needed to deal with such a place.

It is only against this background that Jean Baudrillard's new book, *America,* can be savored in all its remarkable silliness. Baudrillard, who taught sociology at Nanterre from 1966 to 1987, is regarded, as the jacket copy puts it, as "France's leading philosopher of post-modernism." As such, he has the badge of a distinctive jargon. Jargon, native or imported, is always with us; and in America, both academe and the art world prefer the French kind, a thick prophylactic against understanding. We are now surfeited with mini-Lacans and mock Foucaults. To write direct prose, lucid and open to comprehension, using common language, is to lose face. You do not make your mark unless you add something to the lake of jargon to whose marshy verge the bleating flocks of post-structuralists go each night to drink, whose waters (bottled for export to the States) well up between Nanterre and the Sorbonne. Language does not clarify; it intimidates. It subjects the reader to a rite of passage and extorts assent as the price of entry. For the savant's thought is so radically original that ordinary words will not do. Its newness requires neologism; it seeks rupture, overgeneralization, oracular pronouncements and a pervasive tone of apocalyptic hype. The result is to clear writing what the flowery blandishments of the valets to Gorgibus's daughters in Molière's *Les Pré-*

cieuses Ridicules were to the sincere expression of feeling: a parodical mask, a compound of snobbery and extravagant rhetoric.

And Baudrillard is not only the most *précieux* of all current *ridicules* but also the one who is quoted the most solemnly in Paris and New York, particularly among art dealers, collectors and critics. He has come up with a set of vogue words that are taken to evoke the state of Western culture in our fin de siècle: "simulacrum," "hyperrealism," "closure," "fascination," "facsimile," "transgression," "circulation" and the rest, along with "alienation," which may be defined as the state of metaconsciousness entered by the incautious reader who sets out to wade through Baudrillard's reflections. *America* makes much of this lingo, since it is mostly a rehash of ideas from his earlier essays, such as "The Precession of Simulacra" (1983).

His argument, in essence, runs as follows. Thanks to the proliferation of mass media we now have more signs than referents—more images than meanings that can be attached to them. The machinery of "communication" communicates little except itself. Baudrillard is something of a McLuhanite; not only is the medium the message, but the sheer amount of traffic has usurped meaning. "Culture"—he is fond of those snooty quotation marks—is consigned to the endless production of imagery that has no reference to the real world. There *is* no real world. Whether we go to Disneyland, or watch the Watergate hearings on TV, or follow highway signs while driving in the desert, or walk through Harlem, we are enclosed in a world of signs. The signs refer just to one another, combining in "simulacra" (Baudrillardese for "images") of reality to produce a permanent tension, an insatiable wanting, in the audience. This overload of desire in a disembodied, media-invented world is like pornography, abstract. Baudrillard calls it "obscenity."

Capitalism, the villain of the scene, must multiply desire by multiplying images ad infinitum. This, Baudrillard thinks, has led to "the disappearance of power" and "the collapse of the political," while everyone scurries about creating nostalgic effigies of power and politics. "Power is no longer present except to conceal that there is none." In time, he imagines, this will somehow undo capitalism itself: "*Undoubtedly this will even end up in socialism. . . . it is through the death of the social that socialism will emerge*—as it is through the death of God that religions emerge." But which religions? Which death of which god? "The death of the social"—what does such a phrase mean? What would these vaporings about the "disappearance" of power add up to in the White House, the Kremlin or the Élysée Palace? You can hardly read a page of Baudril-

lard without getting queasy from his pseudo-paradoxes, rhetorical exaggerations and begged questions.

Typical of these are his ideas about simulation versus reality. Like the famous map imagined by Jorge Luis Borges, so large and detailed that it would neatly cover the real territory it purports to describe, the grid of signs has become a complete simulacrum made up of smaller simulacra, all media-determined. The simulacrum is all we have and there is nothing below it. "Simulation envelops the whole edifice of representation as itself a simulacrum." Baudrillard is no friend of Occam's razor: he wants to multiply simulacra forever in order to push reality out of sight. It is like a sci-fi fantasy: we have been *taken over.* You may look, walk and talk like Captain Kirk but I, unlike everyone else on the ship, know that you are an alien, a simulacrum. Baudrillard's American fans revel in this, perhaps because his apocalyptic view of mass media excites a deep vein of snobbery in them while his oracular tone stirs memories of heroes of the sixties such as Marshall McLuhan and Buckminster Fuller.

This replacement of real things and actual relationships by their simulacra is what Baudrillard calls "hyperrealization." It lets him take a wonderfully lofty view of the relations between fact and illusion, for it denies the possibility of experiencing anything *except* illusion. In doing so it drifts away from sense, reminding one that Baudrillard's scheme is only a hypothesis and, despite the sweeping confidence with which he unfurls it, not a very convincing one at that. For instance, nobody would deny that Americans are immensely influenced by television. But it is by no means clear just how this influence works, whether it acts on everyone to the same degree or in the same way, whether the Box "substitutes" for reality when it is on, how far it mediates consciousness: in short, how passive the public is. Baudrillard seems to imagine it is completely so—no ifs, ands or buts.

On the other hand, it may be, *pace* Baudrillard, that millions of people are fairly sophisticated about the relations between reality and what they see on the Box; they are quite capable of sifting its truncated and overvivid exhortations, of blanking out the commercials and sorting through the trash. But since this would impede the march of his apocalyptic generalizations about the dictatorship of signs, Baudrillard will have none of it. Here we all are in America, 260 million of us, passively caught in the webs of electronic maya, as incapable of discrimination as of skepticism. No one is smart or willing enough to see past the image haze of Media. It's hard to say which is worse: Baudrillard's absolutism, his sophomoric nihilism or his disdain for empirical sense. It is like the argument of a flat-earther,

circular, oblivious to evidence or nuance, and shamelessly ready to say anything, no matter how contrary to common experience, to save its system.

Thus for Baudrillard in "The Precession of Simulacra," Disneyland—that Delphi or Shangri-La of the French intellectual in search of America—is more than tourists think: an amusing, cartoony panegyric on certain popular American icons such as Family, Innocence and the Future. In his view it's not that Disneyland is a metaphor of America, but that America is a metaphor of Disneyland:

> Disneyland is there to conceal the fact that it is the "real" country, all of "real" America, which *is* Disneyland. . . . Disneyland is presented as imaginary in order to make us believe that the rest is real, when in fact all of Los Angeles and the America surrounding it is no longer real, but of the order of the hyperreal and of simulation. It is no longer a question of the false representation of reality (ideology), but of concealing the fact that the real is no longer real, and thus of saving the reality principle. The Disneyland imaginary [*sic*] is neither true nor false; it is a deterrence machine set up in order to rejuvenate in reverse the fiction of the real.

Only two people in the world, it seems, have been privy to this electrifying fact about America—Uncle Walt and Jean Baudrillard; and it may be that Disney, *le grand simulateur*, didn't quite grasp what he was doing when he "set up" his "deterrence machine" full of ducks, pirates and Coca-Cola. The rest of us have been stumbling around America, bumping into those rejuvenated fictions from sea to simulated sea, mistaking them for the real thing. Silly us, we thought that political events might have substance, but Baudrillard puts us straight: they too are simulacra. Watergate was merely an "imaginary . . . scandal-effect," the "same scenario as Disneyland," for

> there is no difference between the facts and their denunciation (identical methods are employed by the CIA and the Washington Post journalists). . . . *Watergate is not a scandal:* this is what must be said at all cost, for this is what everyone is concerned to conceal, this dissimulation masking a strengthening of morality, a moral panic as we approach the primal (mise-en-) scene of capital: its instantaneous cruelty, its incomprehensible ferocity, its fundamental immorality—this is what is scandalous.

"Hyperrealization" not only dissolves the content of events but consigns the citizen to a state of dithering paranoia in which anything or its opposite can be true:

Is any given bombing in Italy the work of leftist extremists, or of extreme right-wing provocation, or staged by centrists to bring every terrorist regime into disrepute and to shore up its own failing power, or, again, is it a police-inspired scenario in order to appeal to public security? All this is equally true, and the search for proof, indeed the objectivity of the fact does not check this vertigo of interpretation. We are in a logic of simulation which has nothing to do with a logic of facts.

What Baudrillard calls a "vertigo of interpretation" is not vertigo at all, but complacency. He is saying, in effect, that since political events are mere bubbles on the surface of simulation and so not only inscrutable but also, on some basic level, not worth knowing about, the fastidious mind should not stoop to inquire about their nature and causes. He is mounting a none too surreptitious argument for indifference and moral anesthesia. The idea that four possible different reasons for a terrorist bombing can be "equally true" is not a "logic of simulation," but simply an abandonment of logic. It is as though, in Baudrillard's terms, thought's purchase on the world of human action was negligible, something to be impatiently brushed aside. Indeed, in *America* he gets rather peevish about a bad habit of *Homo americanus:* "Quite often he will confirm your analysis by facts, statistics or lived experience, thereby divesting it of all conceptual value."

Though punctuated with odd flashes of insight, his book on America is a slim *sottisier* in which facts have a nominal role. Reporting, it is not. There are signs that Baudrillard has decided to leaven the clogged mass of his jargon with bits of literary Americana; one detects, in the background, the hum of Henry Miller's *The Air-Conditioned Nightmare,* Thomas Pynchon's paranoid list-making and Norman Mailer's sermons against plastic and cancer, as well as echoes from the more chiliastic passages of J. G. Ballard's science fiction writing. The star of his own road movie, Baudrillard spends a great deal of time driving, for it is on the freeways—circulation again—that so much of the truth of America is to be found, or at any rate sought: "The speed of the screenplay, the indifferent reflex of television . . . the marvellously affectless succession of signs, images, faces, and ritual acts on the road." Highway signs are, to him, epiphanies. " 'Right lane must exit.' This 'must exit' has always struck me as a sign of destiny. I have got to go, to expel myself from this paradise, leave this providential highway which leads nowhere, but keeps me in touch with everyone. This is the only real society or warmth here . . . ," and so on, and so forth. No wonder he seldom gets out of the car. Baudrillard appears to meet nobody and hear nothing; the only voice in

America is his own, a heated and self-mythologizing flow of apostrophes and aphorisms. The only Americans mentioned by name in some 120 pages are Ronald Reagan and Walt Disney. He even disdains the academics he meets in Santa Barbara for their "monomaniacal passions for things French or Marxist," which seems a teensy bit ungrateful, since without those passions he might not have been invited there. Nowhere in his text is there the smallest evidence of a grasp of human realities in America: its world of work; its differences in race, ethos, ambition and cultural background; the flow of its past into its present; the friction of generations; the numberless tensions between greed and altruism, "progress" and conservatism; its variety of intellectual and moral climates. But no matter: Baudrillard is looking not for Americans but for something he calls "astral America," *l'Amérique sidérale*—"the lyrical nature of pure circulation. As against the melancholy of European analyses."

He has come to the States in 1986 on a lecture tour. "Aeronautic missionary of the silent majorities, I jump with cat-like tread from one airport to another." He pussyfoots to New England, New Hampshire, Wisconsin and then to Minneapolis, where he stares from his hotel window, high up. "But where are the ten thousand lakes, the utopian dream of a hellenistic city on the edge of the Rockies? Minneapolis, Minneapolis!" Alas, someone forgot to tell him that the "edge of the Rockies" is a thousand miles west of Minneapolis. But now the *philosophe* is off to New York, where he will look at clouds (which remind him of brains—and no wonder), at the sky (higher than in Paris), at people eating alone (who seem "dead"), at blacks and Puerto Ricans (whose skin colors, a "natural makeup," strike him as "sublime and animal"), at skyscrapers—all the sights. He also watches the New York Marathon on television, 17,000 runners in "an end-of-the-world show," "all seeking death," "bringing the message of a catastrophe for the human race . . . a form of demonstrative suicide, suicide as advertising." One gathers that this is not a *sportif* philosopher. But he is off to Salt Lake City and points west.

Yet the penny has dropped; he has his theme. On the way he was struck by a thought not uncommon in the ruminations of earlier visitors from France. America represents the future of Europe. It is modernism in its pure, extended state. It is an achieved utopia. "Mournful, monotonous and superficial though it may be, it is paradise. There is no other." (If Baudrillard can write with apparent conviction that "America has no identity problem," that "New York is no longer a political city," that "there are no cops in New York," and that "ethnic groups express themselves through festivals," it figures that he should think America is Utopia

too.) Having peeked through the gates of the American Eden he finds, like some anthropologist stumbling on a virgin tribe, "the only remaining primitive society . . . the primitive society of the future." Naturally, its members cannot know this. "Americans have no identity, but they have wonderful teeth"; with these, they chew things but cannot chew them over:

> America . . . is a hyperreality because it is a utopia which has behaved from the very beginning as though it were already achieved. . . . It may be that the truth of America can only be seen by a European, since he alone will discover here the perfect simulacrum. . . . The Americans, for their part, have no sense of simulation. They are themselves simulation in its most developed state, but they have no language in which to describe it, since they themselves are the model. . . . No more and no less in fact than were primitive societies in their day.

These simulated savages in their *jardin exotique* move Baudrillard to equally simulated transports of blissed-out tolerance. "For me there is no truth of America," he cries. "I ask of the Americans only that they be Americans. I do not ask that they be intelligent, sensible, original. I ask them only to populate a space incommensurate with my own, to be for me the highest astral point, the finest orbital space." Since Americans are primitives, Baudrillard thinks they lack one of the principal burdens of European consciousness. "They make no claim to what we call intelligence and they do not feel threatened by other people's." Consequently, "there is no culture [in America], no cultural discourse. No ministries, no commissions, no subsidies, no promotion . . . none of the sickly cultural pathos that the whole of France indulges in, that fetishism of the cultural heritage." Americans do not consume culture in a "sacramental mental space" or give it "special columns in the newspapers." How he latched onto this bizarre inversion of the truth is anyone's guess, but he won't let it go. "The cinema and TV are America's reality!" he exclaims a few pages later. "The freeways, the Safeways, the skylines, speed, and deserts—these are America, not the galleries, churches and culture." The thought that America might be both/and, not either/or, high and popular culture does not strike him. Then one realizes that he won't relinquish this patter about cinematic America because he brought it with him: it's the old comic-book French version of America from the sixties coming out. The most mystifying part of all is Baudrillard's unshakable belief that Americans are ahistoric beings. America, he writes, "ducks the question of origins; it

cultivates no origin or mythical authenticity; it has no past and no found-ing truth. Having known no primitive accumulation of time, it lives in a perpetual present." And again: "The mystery of American reality [is that of] a society which seeks to give itself neither meaning nor an identity, which indulges neither in transcendence nor in aesthetics."

It would be difficult to find utterances about American relations to history less true than these, falser in the whole or falser in their parts. They are sumptuous poppycock in the French manner, *de haut en bas*. The likeliest explanation must be that Baudrillard knows nothing of American history and so assumes that Americans are equally unaware of it; and that he has read little or no American literature, which, from the Puritan divines in the seventeenth century, through the Transcendentalists and Melville and Whitman and Henry James, has shown itself to be unremit-tingly obsessed with origins, "founding truths," transcendence and the past.

But none of this matters when you're behind the wheel in astral America. *L'Amérique sidérale* is all desert, freeways, lasers and circulating crowds of white, black and brown abstractions. Especially it is desert, since for Baudrillard the desert is the fundamental metaphor of American culture, the place where culture is not. Americans turn away from it "as the Greeks turned their backs on the sea" (?), but, Baudrillard says, "I get to know more about the concrete social life of America from the desert than I ever would from official or intellectual gatherings." Way out there, "caresses have no meaning, except from a woman who is herself of the desert, who has that instantaneous, superficial animality in which the fleshly is combined with dryness and disincarnation." Ouch. On he goes, scaring the armadillos, musing on the buttes from his car window. How they "designate human institutions as a metaphor of that emptiness and the work of man as the continuity of the desert, culture as a mirage and the perpetuity of the simulacrum"! On to Santa Barbara!

Santa Barbara is a bummer. Like the rest of domestic America, it is simply unreal. "Between the gardenias and the eucalyptus trees, among the profusion of plant genuses and monotony of the human species, lies the tragedy of a utopian dream made reality." Everything speaks of death, the grave, "fake serenity." "This soft, resort-style civilization irresistibly evokes the end of the world." And so on, for pages: a rerun of the sixties song about the little boxes made of ticky-tacky, inorganic America full of nowhere men (and women and children too). Does Baudrillard sense what a conventionalized version of America, what a bundle of stereotypes, he thinks he is seeing? To see this stuff refracted back from Paris is to be reminded of the tenacity of cliché.

Yet it may also help explain why he has an American following. In art circles especially, Baudrillard is doted on. This may seem odd, since he has written very little about the visual arts; he is interested in art only to the extent that it joins the rest of the signals that inundate us, and since its signals are weak and fairly exclusive compared to the inclusiveness of the big media, especially television, it has little part in his line of argument. His use to the art world is that of a talisman. He is a reassuring presence for artists who cannot imagine transcending the banal discourse of mass media. In the last ten years, the old irreverence and Dionysiac charm of Pop art have drained away; in its place there is an academic version, trivial and yet legitimized from birth by a runaway market, which plays its riffs on the sense of overload in mass culture—the feeling, caricatured by Baudrillard's taste for absolute prescriptions, that ad-mass imagery has floated free of its already tenuous grounding in reality. When one looks at David Salle's paintings, for instance, with their crudely drawn, emotionally congealed layering of unconnected images and their sour denial of the possibility of meaning, it helps (though not enough, perhaps) to have Baudrillard's theory of simulacra in mind. And it is rare to leaf through an article on the blandly commodified Young Turks of Neo-Geo (such as Jeff Koons, the starry-eyed opportunist par excellence, with his chrome rabbits, porcelain teddy bears and effigies of Michael Jackson) without getting splots of Baudrillardian jargon in your eye. Neo-Geo described itself as a "simulationist" movement, and with reason: it was in every way an artificial business, a pseudo-cooling of the pseudo-heat of early eighties Neo-Expressionism. Its postures about the "death of reality" are the obverse of other eighties postures about the unendurable, hysteric pressure of the real. The essays of Peter Halley, whose curiously intense yet visually inert paintings of square "cells" connected by linear "conduits" are literal illustrations of "circulation," take Baudrillard's ideas about simulation and hyperrealization so much on faith that he scarcely questions the dubious axiom that the model, in our perception of the world, has completely supplanted the real. "This is the end of art 'as we know it,'" Halley announces in his *Collected Essays: 1981–87:*

It is the end of urban art with its dialectical struggles. Today this simulated art takes place in cities that are also doubles of themselves, cities that only exist as nostalgic references to the idea of city and to the ideas of communication and social intercourse. These simulated cities are placed around the world more or less exactly where the old cities were, but they no longer fulfill the function of the old cities. They are no longer centers; they only serve to simulate the phenomenon of the center. And within

[handwritten margin notes: sophism — arguement intended to deceive / eschatology — doctrine of death, judgement, heaven, hell / sophos -wise (GK)]

these simulated centers, usually exactly at their very heart, is where this simulated art activity takes place, an activity itself nostalgic for the reality of activity in art.

Recast in terms of experience, of course, this is unconvincing: who actually feels such detachment on stepping into the streets of New York, Barcelona, Sydney, London or Moscow? It is a prosaic late spinoff of modernism's long-conventionalized image of the alienating metropolis (Eliot's "unreal city," Baudelaire's "ant-swarming city, city full of dreams"). Life goes on despite theory, and so does art. Through Baudrillard, Halley gets on to one fact—that a great deal of painting, sculpture and architecture in today's mannerist visual culture seems like a weakly motivated or merely cynical rerun of older prototypes—and inflates it into a blanket denial of all authenticity. *Finita la commedia:* all that is left is death, cloning, freezing, the zero degree of culture. This has a nice eschatological ring, but eschatology is a cultural construct too and this kind blandly skirts the possibility that art may have enough affirmative power to transcend such levels of sophomoric despair.

Baudrillard's other job in the art world has been to lend "radical" credentials to its inflated market. When he appeared at New York's Whitney Museum of American Art to lecture in March 1987, collectors, dealers and artists turned out in droves, as for the Messiah, and were not a bit deterred when Baudrillard declared that "relying on art has always seemed to me too easy, an undercommitment. . . . We should not be able to practice art, to enjoy the play of form and appearances, until all problems have been resolved." In other words, because Utopia has not been reached, there never has been and never could be a moment when art *could* legitimately be made! "Art," he added, "presupposes that all problems have been resolved," which might have been news to Goya (and Brueghel, and Daumier, and Picasso, and others too numerous to mention) but exemplifies Baudrillard's weird turn of overstatement. He was interested not in the history but in the "destiny" of art, which was to vanish. To show its dwindling he would refer to "very few" sources: Baudelaire, Walter Benjamin, McLuhan and "his electronic pragmatism," and "in his transcendental anti-esthetics of the euthanasia of art by itself," Andy Warhol. "What attracts me is the fact that the logic of production of values . . . converges with an inverse logic, that of the disappearance of art. The more esthetic values come into the marketplace, the less possibility there is for esthetic judgment of our pleasure." Since it is fairly clear that, whatever else art might be up to, it was not disappearing—indeed, that it was

growing, in hype, public prominence, institutional garnish and raw mass as the eighties wore on—one wonders what Baudrillard had in mind. But he came up with an ingenious cure for old-fashioned worries about the dominance of the art market. Extrapolating (so he claimed) from Baudelaire, he declared that the art object now had a way to defend itself against its corruption as merchandise, by becoming *absurdly* expensive. "It must go further into alienation. . . . Through reinforcing the formal and fetishized abstraction of merchandise, becoming more mercantile than merchandise itself . . . it becomes more object than the object; this gives it a fatal quality"; and so forth. Ludicrously high art prices, apparently, became subversive by showing the unreality of capitalism in "an ecstatic state of exchange."

One can see why Baudrillard's efforts to reconcile the fetishism of high price with the phantom of radicalism have made him so popular—the art dealer's intellectual, as it were. His effort to collapse all cultural meaning into mere simulacra lends credibility to the underlying assumption of the market, that art no longer has any purpose beyond its own promotion. If all signs are autonomous and refer only to one another, it must seem to follow that no image is "truer" or "deeper" than the next, and that the artist is absolved from his or her struggle for authenticity—an ideal proposition for dealers with a lot of recent product to shift and a clientele easily snowed by jargon. Hence Baudrillard has become the patron saint of those who wish to turn affectlessness into a commodity. He may be a patchy thinker and a poor travel writer, but he has his cultural uses.

The New York Review of Books, 1989

Art and Money

The twin figures of the art impresario and the art star, performing for a large audience, have been with us since the eighteenth century. It was in Georgian times that dealers started to matter—emerging as people who exerted a real force on taste, as distinct from mere antiquarians serving the existing taste of patrons. At the same time, English and American artists, envying the huge entrepreneurial success of men such as Rubens, craving

Given as the first Harold Rosenberg Memorial Lecture at the University of Chicago, 1984.

status, longing to be set free from the condition of mere craftsmen, began organizing themselves and their market: their instrument was the Royal Academy, led first by an Englishman, Sir Joshua Reynolds, and second by an American, Benjamin West. Today's relationships between art and money wind back to the time of Burlington House, and the north and south poles of an artist's attitude to the market were summed up in two eighteenth-century utterances. "Where any view of money exists," wrote William Blake, Sir Joshua's dogged but powerless enemy, "art cannot be carried on." On the other side, Samuel Johnson was just as categorical. "No man but a blockhead," he said, "ever wrote, except for money."

We would do well to seek the truth somewhere between these two utterances, perhaps more on the Johnsonian than the Blakean side. The fact is that art has always been carried on very nicely, thank you, where views of money exist. The idea that money, patronage and trade automatically corrupt the wells of imagination is a pious fiction, believed by some utopian lefties and a few people of genius such as Blake but flatly contradicted by history itself. The work of Titian and Bernini, Piero della Francesca and Poussin, Reisener and Chippendale would not exist unless someone paid for them, and paid well. Picasso was a millionaire at forty and that didn't harm him. On the other hand, some painters are millionaires at thirty and that can't help them. Against the art starlet one sees waddling about like a Strasbourg goose, his ego distended to gross proportion by the obsequies of the market, one has to weigh the many artists who have been stifled by indifference and the collapse of confidence it brings. On the whole, money does artists much more good than harm. The idea that one benefits from cold water, crusts and debt collectors is now almost extinct, like belief in the reformatory power of flogging.

So I will not rehearse the now familiar neoconservative complaint about unnecessarily pampered American talents living the life of Riley on giant grants from the National Endowments for the Arts and for the Humanities. Anyone who knows the realities of American culture knows also that this is about as real as Ronald Reagan's vision of the undeserving poor buying vodka with food stamps to carouse in their welfare Cadillacs. Of course the endowments waste money, since there is no known way of determining the cost-effectiveness of works of art; and some objects of their patronage are a minority taste, liked mainly by an elite. On the other hand, the NEA does not, so far as I know, charge the taxpayer $433.45 for a screwdriver, or $1,700 for a metal ladder, as does the Defense Department; and war itself, the sophist might add, is a minority taste, liked mainly by an elite. So my main quarry here is not how the relation of

money and art affects the artist, but how it bears on the public—a public that, necessarily, includes artists and other art professionals and has become enormously large in the last twenty-five years. More Americans go to museums than go to football games. Last year almost 4.5 million people went to the Metropolitan Museum of Art in New York City. Similar figures can be quoted for virtually every other major museum in the country.

The museum has very largely supplanted the church as the emblematic focus of the American city. It has become a low-rating mass medium in its own right. In doing so it has adopted, partly by osmosis and partly by design, the strategies of other mass media: emphasis on spectacle, cult of celebrity, the whole masterpiece-and-treasure syndrome. Only by these means can it retain the loyalty of its unprecedentedly large public, or so it thinks. In the meantime, that public—conditioned by its museums, by the art market and by the pervasive journalistic attitude that finds works of art interesting only if they are fabulously expensive or forgeries, or ideally both—has willed the glamour of big money onto art in a way that is, I believe, historically unique. And this transference doesn't happen in a vacuum. Americans have long been taught, and have believed, that the basic use of art is to provide oases in a fallen world. The residue of Transcendentalism teaches us that art refines, educates, makes people better. Such was the charter of American museums, at the dawn of the museum age in the late nineteenth century. They were meant to be not repositories of plunder but moralizing institutions. When these traditional assumptions meet the burgeoning commercialism of the real and over-populated art world, vortices start to spin.

Two million dollars for a Pollock; $4 million for a Zurbarán still life; $4.5 million for a bronze figure attributed to Lysippus; $5.5 million for a Velázquez; no decent Matisse available for less than a million, no major one for less than two. The late Lord Clark's late Turner seascape of Folkestone, for $7 million. Prices are creeping up, as we all know.

It should be fairly obvious that the whole of the relation of art to money in this culture does not hinge on million-dollar sales alone. But because seven-figure prices for art have such an emblematic power to so many people, we have to know if they are, in fact, historically unique; if so, why; and if not, whether previous ages made the immense fuss over the expensive artwork as cultural spectacle that we do.

Dealers tell us that the day of the $10 million painting is at hand. Probably it is, although I am not trying to guess which work of art the Messiah will be. So I'll take a painting that won't come on the market but

would certainly make $10 million if it did: Raphael's *Sistine Madonna*. I choose Raphael as an example because his reputation has fluctuated very little; it has always been high, partly because—questions of genius aside—he has appealed to the streak of sentimentality in every king and pope, no matter how ferocious, with the sweetness of his Madonnas and bambinos, while confirming the authoritarian bent of connoisseurs by his invention of the Grand Manner. A constant reputation gives us a clearer impression of relative price. Raphael did not suffer as did Vermeer, who was forgotten after his death—which is why Vermeer's prices have gone up by roughly 5 million percent in the last two centuries. Vermeer was still a minority taste when Proust had Bergotte suffer his fatal heart attack while contemplating the yellow patch of wall in the *View of Delft*. In the late eighteenth century Vermeer was a nobody. In 1813 his *Lacemaker* sold for 7 pounds; in 1870 the Louvre bought it for the equivalent of 51 pounds. His head of a girl, which the Wrightsmans bought for more than a million dollars in 1959 and which is worth several times that sum today, changed hands in Rotterdam in 1816 for three florins.

But Raphael's reputation was never of this kind; he was never obscure. In fact, two hundred years ago, the *Sistine Madonna* was the most expensive painting in the world and renowned as such. It had been sold, in 1754, by the monks of Piacenza to Augustus III, King of Poland and Saxony, for the unheard-of sum of 17,000 gold ducats—the equivalent of 8,500 pounds in the currency of George II.

Now if art prices were really keyed to the cost of living, and if the Raphael were really worth the same then as now, we would have to conclude that the pound of George II was worth more than 780 times the pound of Margaret Thatcher; and although inflation is bad, it isn't that bad.

When Augustus paid 8,500 pounds for his Raphael, Goldsmith's parson was considered to be "passing rich on forty pounds a year"—and although forty went further then than now, we can't multiply it by 780 and give rural clergy a yearly stipend of 31,200 pounds. English historian Roy Porter recently suggested that we multiply eighteenth-century prices by 40 to 60 to get modern equivalents. This works for low incomes and figures, but it doesn't apply to the expenditures of the rich—and rural laborers or ribbon vendors were not the ones who bought pictures in Hogarth's day.

The conversion rate inflates for the rich. In 1750 nobody could live like a gentleman for much less than 400 pounds untaxed income a year, the equivalent of about 100,060 pounds or $150,000, before taxes, in early 1984.

I will very tentatively suggest that to convert the rich man's spending money into its modern equivalent—the kind of discretionary income that is spent on art rather than meat and potatoes—one should multiply by about 100. Which gives us at the most an equivalent price of 850,000 Thatcher pounds, or 1,275,000 Reagan dollars, for the *Sistine Madonna*.

Much the same ratio would seem to apply to the work of extremely fashionable living artists, then and now.

In 1779 the Earl of Radnor commissioned a Holy Family from Sir Joshua Reynolds for 11,400 pounds, and in 1786 Catherine the Great paid him 1,575 pounds for a painting of the infant Hercules struggling with serpents. These prices were considered enormous: they were veritable wonders. But multiplied by 100 they scarcely compare at all with the half-million dollars or so that Leo Castelli was asking and apparently getting for new works by Jasper Johns last spring. On the other hand, the Reynoldses were subject pictures which, until the American mania for adopted ancestors took over in the 1920s, were ten times as expensive as his commissioned portraits. At the peak of Reynolds's career as president of the Royal Academy and arbiter of taste in English art, when he epitomized the Grand Manner and all it stood for, you could expect to pay 200 pounds for a full-length portrait—perhaps $30,000 in 1984 currency, only a little more than the standard fee for a portrait by Andy Warhol.

One must stress, once again, that these figures are very impressionistic: converting art prices between pounds and dollars across a gap of two hundred years is fraught with wild variables and may be no more accurate than the effort to convert wampum to lire.

Still, two aspects of the conversion interest me. The first is that some modern art prices are by no means as fantastic, when compared to the prices of the past, as we might casually think. But the second is that a discrepancy really does exist. A million and a quarter dollars or so for a Raphael is an imposing sum. But it would not buy any known painting by Raphael today, especially not one of comparable importance to the *Sistine Madonna*, the *Madonna della Sedia* or the little *Alba Madonna* in Washington, D.C., for which Andrew Mellon gave the Soviet government nearly a quarter of a million pounds, or about $1 million, at the height of the Great Depression in 1931. One and a quarter million dollars is not $10 million. There is still a big gap to be explained.

Its reasons lie in the greater liquidity of modern capital. There is far more cash in circulation today. Far more money is printed than was minted. Very large amounts of credit are available, and the highly abstract qualities of modern finance favor the swift conversion of assets into cash; most of all, our culture has been schooled to think of works of art as

investment commodities. These conditions did not apply in the eighteenth century. Most of them did not exist in the nineteenth either.

The great fortunes of preindustrial Europe were land-rich but relatively cash-poor. To raise large sums of money you had to sell acreage, and when fortunes were frozen in entailed lands that was hard to do; to do it for the sake of a few square feet of canvas would generally have been considered improvident lunacy.

Although the informed art audience was deeply interested in art prices, the idea of using art as a form of investment was unknown in the eighteenth century and barely even mooted, except among a few picture-dealers, in the nineteenth. One bought paintings for pleasure, for status, for commemoration or to cover a hole in the ancestral paneling. But one did not buy them in the expectation that they would make one richer.

Consequently the big historical prices looked somewhat gratuitous, even freakish—the gestures of potentates, signaling the vast dimensions of their surplus wealth. The most expensive pictures of the eighteenth century, after the King of Saxony's Raphael, were a pair of Claudes—the so-called Altieri Claudes, one depicting the landing of Aeneas and the other his sacrifice to Apollo. The dilettante William Beckford, who enjoyed a handsome income from his family's sugar plantations in the West Indies, bought these in 1799 for 6,825 pounds. Beckford was already famous for his extravagances: once, planning to sup at a country inn, he directed the landlord several weeks in advance to hang his bedroom with hand-painted French Réveillon wallpaper. Buying the Altieri Claudes confirmed his reputation as a financial madman. But as sometimes happens in the art market, this price created its own reality—at least for a time. Four years later, pressed for cash, Beckford sold them to a dealer for 10,500 pounds, and the dealer unloaded them for 12,600 within a few weeks. That is, nearly $2 million today. The sad coda to this story is that when the Altieri Claudes went on the block at Christie's in 1947 they made only 5,300 pounds, representing a drop in real-money value of more than 95 percent.

In those days when there were no art investors, and when nobody could get tax write-offs by giving their collections to museums—because there was no personal income tax and there weren't many museums either—people applauded the big price and the daring collector rather as they did the heroic rake, the deep gambler or the three-bottle man. The Georgians respected dandyism and eccentricity. High art prices could not readily be rationalized, defused as it were, by the claim of public benefit. Very few people sympathized with Lord Elgin's efforts to get money back from the British government after he had brought the educationally in-

comparable Parthenon marbles to London, even though he nearly bank-rupted himself doing so. Whereas, when the Metropolitan Museum of Art in New York paid more than $5.5 million over a decade ago for Ve-lázquez's portrait of his mulatto servant Juan de Pareja, it could invoke a host of justifications for this vast price apart from the arguable quality of the work—educational value, for instance, and solidarity with the black community. We may be quite sure that Augustus III felt no such obliga-tion: the costly painting disappeared into the regal or ducal collection as into a social tomb.

The idea of investing in a work of art did not begin to affect the art market until well into the nineteenth century, and it did so in a rather circuitous way. I mentioned the high prices Reynolds sometimes got on commission, but these were exceptional. Benjamin West, the American wunderkind who succeeded Reynolds as president of the Royal Academy, once—only once—got 3,000 pounds for a painting. This was in 1811, but between then and the arrival of the Pre-Raphaelites the magic barrier of 1,500 pounds was probably broken less than half a dozen times by living artists; not until 1885 would anyone pay a five-figure price for a Turner, and that person was Cornelius Vanderbilt.

Meanwhile, of course, the real value of money was declining, and so, with a few eddies and exceptions, was the old master market. A Botticelli cost a third as much as a Lord Leighton in the 1870s. In 1879 the National Gallery in London paid 9,000 pounds for Leonardo's *Virgin of the Rocks*, which compares well with the 10,000 pounds a newly arrived German financier straight out of Trollope, Albert Gottheimer, alias Baron Grant, gave a few years earlier for a large hunting scene by Sir Edwin Landseer. And meanwhile the ground was littered with major and minor Renais-sance paintings, from primitives and gold-ground icons of the trecento right through to the sixteenth century. These could be and were picked up for a few dollars, until Bernard Berenson and Lord Duveen completed their heavy task of reconditioning the cultural fantasies of the American rich.

Piero della Francesca's *Nativity* in London's National Gallery, which would certainly be a $10 million picture on today's market, cost less than 2,500 pounds in 1874, two-thirds the price of a gloomy landscape of a Hebridean bog by Sir John Millais. No cost-of-living multiplier will bring such prices into line with today's. The sum Isabella Stewart Gard-ner gave the Earl of Darnley in 1896, through Berenson, for the Titian *Rape of Europa* that is one of the glories of Boston may not seem big to us now: it was less than $100,000, about 21,000 pounds. But the last time

that picture had changed hands was only forty years before, and then it was bought for less than 2 percent of that price: 288 pounds, 10 shillings, at Christie's. That is what happens when Americans get into the act.

The second half of the nineteenth century was, for the art market, the great age of the living painter—at least of some living painters. Agnew's, the London dealers, paid 11,000 pounds for *The Shadow of Death,* by the Pre-Raphaelite William Holman Hunt; that sum, at the time, would have bought you the entire oeuvre of Manet, from *The Fifer* to *Olympia.* In 1892 a large watercolor by Meissonier—a copy of a battle scene already owned by Cornelius Vanderbilt—made the same price as the Titian *Rape of Europa,* perhaps the equivalent of 1.5 or 2 million in modern dollars. You could have had four or five autograph works by Velázquez for that. A Victorian nonentity named Edwin Long saw his works reach between 4,000 and 6,000 pounds in the 1880s, and 5,000 pounds—say, 25,000 old or 600,000 new American dollars—was a common price for the large Landseers that would be selling for $50 or $100 two generations later.

Such figures are always invoked by people who want to draw a parallel between today's inflated prices and those of a century ago. Look, the argument goes, the cost of the big Victorian guns was in preinflationary gold pounds and dollars and francs, and untaxed at that; you must multiply by at least 25, maybe 35, to get an equivalent today. Moral: Pictures may not be cheap now, but they are not *crazily* expensive.

I think this argument needs to be taken with a handful of salt. Most of the time, when you look at deals like Agnew's purchase of the Holman Hunt, you find that the figure included all reproduction rights to the picture. The ownership of these rights was of vast importance to the Victorian art market. It affected the price of popular pictures in exactly the same way that the market for film and television rights affects the price of popular novels today. In 1883, ten years after *The Shadow of Death* was sold, another Holman Hunt of comparable size, finish and popularity— *The Triumph of the Innocents*—sold for just a third of the price of the earlier painting because its reproduction rights were already signed away.

What transformed the popular market for living artists in the nineteenth century was the steel-faced engraving plate, which made it possible for just about everyone in England to have a three-shilling print of *The Light of the World* or *The Monarch of the Glen* on the parlor wall. And Gerald Reitlinger, whose book on the rise and fall of picture prices, *The Economics of Taste,* published nearly a quarter of a century ago, is by far the most thorough study of this subject, points out a curious detail that might elude many art historians: namely, that this print market couldn't

have come into existence in Victorian England without the repeal of the tax on glass, which reduced framing costs of works on paper to a level ordinary people could afford.

For an audience that valued exactly those features of the picture that could survive reproduction—the story, the moral, the iconographic detail, the close attention to nature—and didn't mind, as we do, missing out on the authentic, "expressive," incarnated touch of the artist, these engravings were real popular art, and had a far higher status than any photographic reproduction of a Pollock or a Picasso could have for us today. But this aspect of the Victorian art market is one of several that make it difficult to compare with today's. The price of a Picasso or a Bonnard is simply the price of an object: it does not give the owner entry to a profitable world of secondary rights. And if the Victorian story-picture had not engaged the public imagination—if it had not become mass-reproducible by its success in the Salon or the Royal Academy—then its relation to big money was not magical at all. We do not expect the cost of our star paintings to be underwritten by a plebiscite, but the Victorians did; in some ways they were culturally rather more democratic than we are.

Therefore I think we can say at the very least that the similarities between today's art market and those of previous centuries are more apparent than real. There is no historical precedent for the price structure of art in the late twentieth century. Never before have the visual arts been the subject—beneficiary or victim, whatever your view of the matter—of such extreme inflation and fetishization.

But I would go further. I think the whole relationship between art and money shifted so greatly after World War II—really, after 1960—that our way of perceiving art in its social relations (what we expect from it, how we approach it, what we think it is good for, how we use it) has been deeply, if not always consciously, changed. What we are seeing, in the last years of the twentieth century, is a kind of environmental breakdown in the art world. It is caused, as breakdowns customarily are, by a combination of shrinking resources and exploding population. And the cultural pressures it has set up have altered our relationship to all art in a way that our fathers or even our younger selves could not have imagined or predicted.

The art market we have today did not pop up overnight. It was created by the great liquidity of late-twentieth-century wealth. Sell a block of shares, shift the money elsewhere. But liquids do not flow where you want them to unless you dig channels, and this patient hydraulic effort has

been, since 1960 at least, one of the wonders of cultural engineering. The big project of the art market over the last twenty-five years has been to convince everyone that works of art, although they don't bear interest, offer such dramatic and consistent capital gains along with the intangible pleasures of ownership—what Berenson might have called "untactile values"—that they are worth investing large sums of money in.

This creation of confidence, I sometimes think, is *the* cultural artifact of the last half of the twentieth century, far more striking than any given painting or sculpture. Its origins lie in the mid-1960s, and although it is hard to assign a single starting point to a cultural movement so diffuse and international in scope, I think of it as beginning with a curious enterprise called the Times-Sotheby Art Indexes, which created much interest in London and afterward in New York around 1966. These indexes were the brainchild of a public-relations man who had been hired by Peter Wilson, the chairman of Sotheby's, to spruce up the somewhat fuddy-duddy image of his house; and what they purported to give was reliable statistics on the price movements of all manner of works of art—seicento Bolognese drawings, netsuke, old master prints, nineteenth-century *animalier* bronzes, Chinese porcelain—showing, in an extremely generalized way, how everything was going up by 25 to 200 percent per year. They were short, undetailed, memorable, and embellished with graphs.

Perhaps it was the graphs that did it. They gave these tendentious little essays the trustworthy look of the *Times* financial page. They objectified the hitherto dicey idea of art investment. They made it seem hardheaded and realistic to own art. From this modest beginning the idea ramified, and for the next ten years it was rare to open an airline magazine without finding yet another excited piece of hackwork pushing the idea of art investment. By 1980 the idea had become so familiar that it was no longer necessary to stress it, and the collector-as-investor dropped out of favor as a journalistic hero; even the dealers felt that such people should not be paraded too much, partly because it seemed a bit vulgar and partly, I would guess, because prices had already gone so high, and confidence in their continued ascent was so well implanted, that it was time to talk about eternal spiritual values again.

This confidence feeds and is fed by a huge and complicated root system in scholarship, criticism, journalism, PR, tax deductions and museum policy. And it cannot be allowed to falter or lapse, because of the inherently irrational nature of art as a commodity. Art prices are determined by the meeting of real or induced scarcity with pure, irrational desire, and nothing is more manipulable than desire.

The market is always converting works of art into passive fictions of eternity and immutability, of transcendent value for which no price may necessarily be too high. When the word *priceless* crops up, the haggling has only just begun. Hence the battered state of the word *masterpiece*, which used to mean a work that proved an artist's graduation into full professional skill, but now means an object whose aura and accumulated myth strike people blind temporarily and render their judgment timid. It refers more to myths of status than processes of comparison, and that kind of mythmaking is the seed of what New York dealer Ben Heller, in one of the great Freudian slips of recent art history, was heard to call "creative pricing."

It is the element of fantasy in the art market, the sense that art prices are so weakly tied to more mundane kinds of economic activity, and that there is something neurotic about them, that gives them their odd lability. The art market can be set pitching and rolling by a single act, which is why it is so notoriously vulnerable to manipulation. A ring of three or four promoters can bid up the price of a dubious young star painter at auction, and although the New York art world may know what's going on, the collectors in Akron, Ohio, are not so likely to—all they see is the price that was, after all, publicly bid and duly paid, and is henceforth true.

A large wine-dark painting by Mark Rothko was sold at Sotheby's some months ago to a Japanese collector at a record price for Rothkos— $1.6 million. It was not merely restored, but—according to a previous owner, William Rubin of the Museum of Modern Art—completely repainted, as a result of damage done to it by French handlers in a European loan show. Nearly a square meter of its original paint was gone, and it had spent many months being redone in a costly hospital for elderly, battered Abstract Expressionists run by a restorer on Long Island. At the time of the sale there were several Rothkos of equivalent quality and historical interest on the New York market, none of them damaged, all priced at around $400,000. If ever a record price was attained by ignorance, this was it. Yet nobody minded; the painting is now comfortably ensconced in some distant *tokonoma*, and the sale, instead of being seen as a freakish event concerning a compromised picture, doubled Rothko's prices overnight.

Something much more dramatic happened with Jackson Pollock's *Blue Poles*, which was sold to the Australian government for $2 million more than ten years ago. My fellow countrymen were rather proud of beating Ben Heller's creative asking price down from $3 million. Nobody had even thought of asking so much for a Pollock; but of course the market

gratefully rallied behind this heroic example and every Pollock in the world quintupled in price overnight, thus enabling the National Gallery of Australia to announce that *Blue Poles* was really cheap. The Australian press, in its skepticism, refused to buy this, and the resulting hullabaloo over the price of *Blue Poles* helped bring Gough Whitlam's Labor government down in 1973. But by that time the myth of price attached to *Blue Poles* was unstoppable. Around 1977 the Shah of Iran tried to buy it from Australia for $8 million; Australia refused, and the extravagant Shah had to find another way to fall. The moral of such events, the skeptic would say, is that the fair price of art defines itself reflexively. A fair price is the highest one a collector can be induced to pay. Once it is established it shows its fairness by reforming the level of the market.

The art market today takes its stand on two articles of faith. The first is the dogma of the Perpetual Resurrection of the Dead. It holds that everything old can be revived. The second concerns the Miracle of van Gogh's Ear, which teaches the unbeliever that nothing new may be rejected. To say that these propositions might contradict each other is impolite. They do, but it makes no practical difference. Their purpose is to ensure a heavy flow of product for the art market, despite the fact that the supply of good past art is dwindling and the supply of good present art is, to put it mildly, not getting that much more copious.

Consider the implications for historical art first.

One hundred years ago, old master prices were low—with all exceptions granted—because the supply exceeded the demand. From the attics of ducal homes in Kent to the crypts of churches in Umbria, Europe was crammed with unrecorded, uncleaned, unrestored, unstudied works of art, the raw material for another century of intensive dealing. The number of collectors then, as against today, was tiny. And the support system that we take for granted as a normal part of the landscape did not exist: few and unsystematic museums, fewer departments of art history. No museum had an income of $1 million a day, as the Getty now does. The *pensioni* of Florence were not full of anxious doctoral candidates swatting up for their dissertations on the size of the Christ Child's organ in a previously unrecorded predella fragment by the Master of the Bambino Vispo, and whether this holy member signified *ostentatio* or *pudicitia*.

It must have seemed, then, that the demand for old master paintings could never outstrip the supply. The historical deposit seemed as inexhaustible as the herds of elephants on the Serengeti Plain. In fact, it was as soon depleted. Our great-grandfathers could not have foreseen what the growth of the museum age would do. And as the major works entered

museums, there was more competition for the minor ones; and then the task of revival and reevaluation of schools and artists for whom our Victorian forebears had no time at all began in earnest. In due course there would be no schools or artists left to rescue from oblivion. There is no oblivion. Today, virtually everything that was made in the past is equally revived: there will be more argument about its meaning and its relative merits, but the universal resurrection of the formerly dead is pretty well an accomplished fact.

In this way the disinterested motives of the scholar go hand in hand with the intentions of the art market. To resurrect something, to study and endow it with a pedigree, is to make it salable. And what is not worth studying for aesthetic ends can generally be revived by an appeal to the sensibility of camp. Twenty years ago *antique* had an agreed-upon meaning: it denoted something not less than a hundred years old. Today it is used indiscriminately of anything made the day before yesterday, for instance 1940s nutmeg graters. For those objects that were too ephemeral, ugly, dumb or recent even to pass as modernist archaeology, the word *collectible* was invented.

But where the intellectual consequences of the depletion of available works of art were felt was not in the market for such trivia, but rather in the balance between aesthetic experience and the rhetoric of sales.

As the body is resurrected, it is gloriously transfigured. Theology teaches us this and art history confirms it. Minor works become major ones; major ones, masterpieces; and masterpieces are rendered almost invisible by the effulgent aura of their value. We have seen a perfect example of this coercive process in the market movements that followed the great work of scholarly reevaluation of eighteenth- and nineteenth-century American art carried out by a succession of historians from Lloyd Goodrich and John Bauer to John Wilmerding, Barbara Novak and Theodore Stebbins. Of course, it was long deserved, and it is right to give the best works of Kensett, Lane, Bierstadt and Church their place among the achievements of nineteenth-century culture as a whole, while patiently examining their special links to an American cultural and moral ethos. Some of their work is on the same exalted plane as Melville's or Whitman's, and the time for Americans to realize this was long due.

But market pressure has sent us into a sort of nationalist frenzy. There is no genre painting, however mawkish, of frontiersmen skinning the 'coon or strawberry-pink New England children dancing around the blueberry bush that does not find its way into some corporate collection in Tuscaloosa or San Diego at prices that would have seemed a bit steep

for Winslow Homer or George Caleb Bingham a few years ago. No grave of a provincial reputation remains unopened. There is gold in them thar holes.

Well, you may say, *caveat emptor.* The art market has always been the emblematic stronghold of laissez-faire economics—although like so much supposedly laissez-faire activity it benefits from a huge U.S. tax subsidy—and the buyer has always had to be on his or her toes. Quite true, but the difference today lies in the sheer number of people who are doing the buying and selling, and the porousness of the barrier that separates the language of disinterested evaluation from sales talk. What concerns me is the drift of hyperbole to places it does not belong: for instance, the museum.

At forty-five, I am among the last generation that conducted its basic art training in empty museums, without ever thinking about the cost of their contents. And although I am grateful for the volume of scholarly attention that the art market has helped to direct on art, I cannot help feeling a twinge of regret—not to say an occasional surge of nausea—at the way in which the monetary value of museum art has been moved to the forefront of people's experience. Twenty-five years ago it was easier to appreciate works of art in their true quality; what the masterpiece, laden with fetishistic value, has lost today is a certain freedom of access—a buoyancy, an availability to the eye and the mind. It has been invested with a spurious authority, like the façade of a bank.

This process began, for many of us, when the Metropolitan Museum of Art spent $2.3 million on Rembrandt's *Aristotle Contemplating the Bust of Homer* and put a red velvet rope in front of it to distinguish it from all other Rembrandts. Simultaneously, the painting was imposed on us as an authoritative object—money talks—and withdrawn as a communicative one. It was as though not only Rembrandt and his painting, but Homer as well, and Aristotle too, had been appropriated as passive icons of status. *Time,* for which I did not work then, unwittingly summed this up by putting a reproduction of the painting on the cover with a gold border around it instead of the customary red one—a gesture that helped to cement Americans' unconscious identification of art with treasure. Twenty years later, the two have fused to a disconcerting degree.

One of the great influences on the way the public thinks about art and money has been the masterpiece-and-treasure show. Such spectacles, loosely known as blockbusters, have been thick on the ground over the last decade. It used to be believed that, in order to get crowds, you had only to put on "The Search for the Gold of the Tomb of the Mummy of

Someone-or-Other" and in they would come. Now museums are not quite so certain, since it appears that the people who attend blockbusters show no more loyalty to the museum afterward than the people who saw *Raiders of the Lost Ark* have to the movie theater in which they saw it. However, this device—"The Treasures of the Vikings," "The Gold of the Gorgonzolas"—helped to reinforce the illusion that art was basically a kind of bullion. The difference between masterpieces and treasures was made clear. Treasures had gold in them, whereas masterpieces did not. For the new mass audience, this made the confusion between price and value only worse, especially since the size of the crowds guaranteed that nobody could look at anything for more than three seconds.

The members of the same mass art audience, in their role as collectors, have also transformed the conditions that surround the work of living artists. I do not think that anyone in 1945 could have predicted what the growth of American art education would do. Forty years ago it seemed an entirely marginal affair. Today, according to the best statistics I can find, 35,000 painters, sculptors, potters, art historians and so forth graduate from the art schools of America every year: this means that every two years this culture produces as many art-related professionals as there were people in Florence at the end of the quattrocento. Behind them are millions of people interested in art, as previously noted, and hundreds of thousands who collect it.

Does this mean that we have a new Renaissance? Of course not. It means that we have a severe unemployment problem at the bottom and an exaggerated star-system at the top of the artist population, while among the consumers we have a lot of free-floating anxiety that precipitates itself in fairly irrational ways and is more vulnerable to fashion than ever before. The art world now looks more like the fashion industry than like its former self. That is, its anxieties, which are real enough, are corporate; they tend to stem from the overriding need for a smooth flow of product. As the artist and critic Walter Darby Bannard recently remarked, the market pressure for accessible, undemanding, lavishly emotional art is now extreme. It has stepped up because the mass audience has to buy something. Despite those 35,000 people a year, the amount of good art being produced doesn't change much. The market must therefore figure out ways of selling mediocre-to-bad art at prices that are high enough to stifle aesthetic dissent. That, in a nutshell, is the market history of postmodernism so far. It is the story of van Gogh's Ear, without van Gogh himself. Nobody, and I least of all, would deny that there are admirable collectors and dealers:

people who really can and really do think and look, whose sense of responsibility is not inflated into pompousness, whose eyes have histories, and who buy from informed love rather than herd instinct. But they are rare, and they are not necessarily the ones on whom the contemporary art market, in its present form, depends.

The ones the market needs are the people whose apartments are shifting anthologies of the briefly new. They buy large quantities of art because they are infatuated with the art world as a system. For them it is glamorous and slightly alien, full of people—above all, young artists—who can be obsequious one moment and mysterious the next. It is, in short, Art World, the cultural equivalent to Disney World, full of rides and haunted houses and historical fictions; and they are tourists in it. Because they have been stuffed with propaganda about the increasingly vital role, the quiet power, of the collector, they mistake the events in this world for the real stuff of art history, not noticing the extent to which it is a public-relations project—an imaginary garden with a few real toads in it. They are rich. Sometimes the degree of their success and wealth is puzzling to them, and there is something a little expiatory about the way in which they buy. Most of the time they buy what other people buy. They move in great schools, like bluefish, all identical. There is safety in numbers. If one wants Schnabel, they all want Schnabel; if one buys a Keith Haring, two hundred Keith Harings will be sold.

Above all, their grasp of art history is only twenty years long and their connoisseurship is not quite a foot deep. Many of them seem to believe, quite sincerely, that Western art began with Andy Warhol. The others only behave as though it did. The idea of a present with continuous roots in history, where an artist's every action is judged by the unwearying tribunal of the dead, is as utterly alien to most of them as it is to the average American art student, raised like a battery chicken on a diet of slides. They want to believe that they are living, right now, in the middle of one of the great creative moments of Western art, something like Paris in the late nineteenth century. And in a sense they are right, because at no time since 1900 has the ground been so crusted with academic art—except that the academicism is not that of Cabanel or Bouguereau or Meissonier: it is the academicism of the spray can and the pat gesture of deep "expressive" involvement that signifies only routine picture-making, the academicism not of a depleted ideology but of a trivialized plurality. However, a Cézanne or a Seurat would have to struggle even harder to break through this crust today than he did a hundred years ago, because the mechanisms by which taste is handed down have improved.

The size of this sector of the new art audience, the gratifying uniformity of its taste, and its insecure obsession with mutually recognizable signs of status produce many consequences for artists. One of these is that the race is not necessarily to the swift, but more likely to the voluminous. The successful artist today must exhibit more widely than ever before. He or she is apt to get locked into a market structure that resembles, and parodies, that of the multinational corporation. Twenty or thirty years ago, dealers in New York used to struggle against dealers in Paris or London, each affirming the national superiority of their artists. These transatlantic squabbles are now extinct. What you have instead, on the multinational model, is associations of galleries selling the one product in New York, London, Düsseldorf, Paris, Milan. The tensions of national schools are dissolved. But this means that the successful artist must work on an industrial scale. How many pictures does Georg Baselitz, that sturdy German fountain of overwrought mediocrity, paint in a year? How many Pencks have been scribbled in the last five? The kind of market pressure we have now tends to encase artists in a formula, but it also makes it hard on the person who paints ten pictures a year: the conditions of maximum exposure demand two a week. That is why Frank Auerbach, to my mind incomparably the best, the most intense, the most self-critical expressionist artist at work today, an artist good enough to be mentioned in the same breath as Giacometti, has almost no reputation in the United States: he does not paint enough pictures to supersaturate the market. Whereas everyone has heard of rubbish by Salomé, Rainer Fetting or Luciano Castelli.

So it seems to me that today we are repeating one of the peculiarities of the Victorian art market, though on an industrial scale. By and large, historical art is better value than contemporary art; and contemporary art is overpriced. And this takes place against a background of considerable nervousness. Nobody of intelligence in the art world believes the boom can go on forever. There is a jittery feeling that we are heading for something like the slump that hit the once dominant French art market in the fifties, in the decline of the École de Paris. Except that instead of one Bernard Buffet, we have twenty. And except too that when the shakeout comes, it will be much more traumatic.

In the past the contemporary art market has always been sustained by the way in which the novelties of today turn into the museum art of tomorrow. There is no guarantee that they will keep doing so, especially with our present sense of innovational drift—the feeling that stylistic turnover gets more and more gratuitous. What is built on novelty perishes

by obsolescence, and it is likely that there will be no secondary market for some of the most fashionable art today. Does anyone really imagine that graffiti art, the vogue of 1983 and 1984, is going to keep passing and repassing through the auction houses for the next two decades, its price outstripping inflation? If you believe that, you will also believe in the tooth fairy.

Perhaps it is not the business of critics to predict, but I am going to try anyway. I don't have a date for a crash but I do have a story line. At present the contemporary-art market is very extended. It is so extended—meaning that so many pictures by newly fashionable names have been lodged with collectors who expect to realize on them one day—that the old processes of defending an artist's prices may no longer work. The traditional method, when a work by X came up in the salesroom and his dealer wanted to be sure it would not fall below the gallery price for X's work, was to bid it up. The auction room, as anyone knows, is an excellent medium for sustaining fictional price levels, because the public imagines that auction prices are necessarily real prices. However, it may be that a dealer, or a group of dealers, may not be able to defend the price levels of so much work. The slide will begin with graffiti and it will gather momentum from there. It will not affect every artist, because there are many reputations with the justifiable solidity that will enable them to survive such vicissitudes. But it will shake the confidence of the art market, and of the art world as a whole. It won't happen in 1985, or in 1986, but we shall see what has happened as the millennium crawls closer. Nor will all its effects be bad. One does not lament the pricking of the South Sea Bubble, or the sudden collapse of the Tulip Mania. At the very least, it may cure us of our habit of gazing raptly into the bottom of the barrel, in the belief that it contains the heights of Parnassus.

The New York Review of Books, 1984

The SoHoiad:

or,

The Masque of Art

A Satire in Heroic Couplets
Drawn from Life

by

Junius Secundus

NEW YORK, MCMLXXXIV.

Close by the Hudson, in MANHATTAN's town,
The iron palaces of Art glare down
On such as, wandering in the streets below,
Perambulate in glamorous SoHo,
A spot acclaimed by savant and by bard
As forcing-chamber of the *Avant-Garde.*
'Tis there, dread DULNESS dwells in sweats and glooms,
Gnaws her brown nails, and shakes her sable plumes;
FRIVOLITY extends her flittering hand
O'er the distracted, fashionable band,
And YOUTH sustains its present coalition
'Twixt vaulting Arrogance and blind Ambition,
Whilst rubbing shoulders with the newly-great,
Impartially selling *Smack* and *Real-Estate.*
Such is the spot for Apodictick Rhyme,
The Gadfly, yet the Mirror, of its time.

. . .

Now at thy hands, great CHAOS! are restored
The brief and foolish pleasures of the bored:
The pompous novelty, the well-hyp'd trick
Delivered in the merest *Augenblick.*
The patronage of younger talent there
(A favoured sport) is flinging Eggs in Air
To mark if they will fly; and when they fall,
As fall they do, it matters not at all:
The temper of the age decrees at once
That none may tell the Dancer from the Dunce.
Opinion bows and scrapes, to *Trade* defers,
As Disco-Owners turn to Connoisseurs;
Historians to the urinous subway fly
To scribble theses on "The Spraying Eye";
From Kutztown and the Bronx graffitists throng
To find, though Art is short, Reviews are long;
Our purblind *Virtuosi* now embrace
KEITH BORING, and JEAN-MICHEL BASKETCASE.
The spray-cans hiss, the ghetto-blaster shrieks,
Above the din, DOLORES GRUESOME speaks:
"My pa-in-law became a millionaire
From unguents to straighten *Negroes' hair:*
A generation later, I have come
To bring a new cosmetic to the slum.
In this fat piping time of cultural plenty
Art sheds its bloom when it is over 20:
Ripeness is staleness: Connoisseurs, behold
Th'apotheosis of the Twelve-Year-Old!
My *Noble Savages,* on sneakered feet,
Flock to the doors of Fifty-seventh Street;
The infant dauber, who MAYOR KOCH appalls,
Now sprays on *Belgian Flax* instead of walls;
The matrons twitter and the Cash-Bell rings,
I serve Hawaiian Punch and Chicken-Wings,
The fame of my invention spreads afar—
Part day-care center, part *Bateau-Lavoir.* "

With corybantic dance and Bacchic cry
Th'infatuate procession passes by:
And now the hybrid child of *Hubris* comes—

JULIAN SNORKEL, with his ten fat thumbs!
Ad Nauseam, he babbles, whines, and prates
Of Death and Life, Careers and Broken Plates
(The larger subjects for the smaller brain)
And as his victims doze, he rants again—
Poor SoHo's cynosure, the dealer's dream,
Much wind, slight talent, and vast self-esteem.

"Shall I compare me to Picasso? Yes!
Within me, VAN GOGH's vision, nothing less,
Is wedded to the genius of TITIAN
And mixed promiscuously, without permission,
With several of BOB RAUSCHENBERG's devices.
The market's fixed to underwrite my prices—
Compared to my achievement, JACKSON POLLOCK's
Is nothing but a load of *passé* bollocks;
My next show goes by *Concorde* to the Prado:
'Painter as Hero: Snorkel, Leonardo.'
Yet the comparison's a trifle spotty,
Since Leo says I'm heir to BUONARROTI.
Though those old *Guineas* knew a thing or three,
They'd certainly know more if they'd known *me.*"

Behind, a pliant and complaisant throng
Of Art-Reporters flatulates along
With tongues a-wag and wits made dull by rust,
Trustees who deal, and dealers none may trust,
Curators clutching freebies to their breasts,
The bureaucrats, the urgers, and the pests.
The *Critick* here expounds her fribbling law
That scarce an *Artists' Groupie* was before;
Now rise the squeals of diarist and bard,
Of WITLESS-PINKIE, of RENÉ RETARD,
Whilst PETER SHELLDUCK, of poetic mien,
Straps on his sandwich-board to puff the scene,
And bravely lays aside the critic's rod
To greet each *Neo* as the Son of G–D.

As they proceed beside the wat'ry deep,
B–LL R–B–N mutters "Pablo!" in his sleep

And BARBARA WOOZE, in descants loud and long,
Rends her fair locks, and chants her *Willow-Song*:
"O entropy! O misery! Oh Hell!
G–d's dead, Art's dead, and I am far from well!"
Yet KAKOPICTA, Muse of Transient Modes,
Sweeps her slack Lyre, and charms the list'ning Toads.
"Behold!" she cries. " 'Neath my indulgent wand
Fresh talents gather on Manhattan's strand;
Though void of sense and atrophied of muscle,
They are applauded by my friend JOHN RUSTLE
And (never care how hasty, botched, or patchy)
Are bought in loads by their *Maecaenas*, SAATCHI.
Thus is confirmed, before the sceptic's eyes,
The motto that *It Pays to Advertise*,
For if New York museums come too late,
We foist them on the trustees of the TATE:
What other Muse will hold to her so dear
The mannered charms of the Italian, CH––?
What other Goddess pour her horn of plenty
On psychobabbling doodles by CL–M–NT–,
Or bless young ENZO SPOOKY's murky flood
Of art, and feeling, thick as Umbrian mud?"

So saying, she ascends a little mound,
Shades her blear eyes, and gestures all around
At orts and fragments that bestrew the ground:
"As once the tourist, 'midst the ruins of *Rome*,
Cull'd from the earth the decor for his home,
A cornice here, a herm or statuä there,
To prink the prospect of the dull parterre,
Cumbering his house with false Etruscan urns,
Such is the custom of our *Post-Modernes*:
Post-Modernism long ago took note
That when Invention flags, we needs must *quote*:
And when the cobbled-up quotation drops
To semi-literates and earnest fops
(American collectors), the convention
Is to extol it as a new *Invention*.
Thus to advance, but likewise to retard,
Is purpos'd by the *Post-Trans-Avant-Garde*.

So in our world the energies are spent—
What few remember, dullards may invent."

What relics of the recent past remain
And in disorder, clutter up the plain?
A woollen cart-horse by DE CHIRICO!
Copy the nag, and hear the praises flow!
One late PICABIA, rendered willy-nilly,
Provides a whole career for DAVID SILLY.
The raucous pederast by the *Berlin Wall*
On KIRCHNER's figures may adroitly fall.
What if your style not fire the fickle town?
Then paint some lumpish *Fräulein*s upside-down,
Wielding your crayon with coal-heaver's mitts
After the manner of GEORG BUNGLEWITZ,
Whose strength makes *Virtuosi* reel and faint—
Thick wrists, thick neck, thick skull, and thicker paint.
In well-feigned homage to the Mantic Arts
Express yourself in spastic Fits and Farts,
Then sit and watch how HENRY GOLDBUG goes
Likening your drawing to divine WATTEAU's.
A generation past, *Abstraction*'s sway
Prevailed from Brooklyn to remote Bombay,
Extracting homage from the subtle *Jew*,
The coarse *Australian*, and the mild *Hindoo*—
And on repealing its presumptuous law
'Twas found that none remembered how to *draw*:
Yet this proved less a problem than a quibble,
Since none, it seemed, had quite forgot to *scribble*:
Thus from Academies in every nation
Arose the chant: EXPRESSIVE FIGURATION!

Who are the patrons whose indulgent glance
The painter craves, for whom the dealers dance?
Expunge, young Tyro, the excessive hope
Of gathering crumbs from *Humanist* or *Pope*:
No *Condottiere* holds his exigent sway
Like MONTEFELTRO upon West Broadway—
Instead, mild stock-brokers with blow-dried hair
Stroll through the *Soukh*, and passive snuff the air.

Who are the men for whom this culture burgeons?
Tanned regiments of well-shrunk *Dental Surgeons*,
With leather-swaddled spouses, minds obtuse,
And ALDO GUCCI's stirrups on their shoes,
Whose hope is to endow their own museum
With works of art, before they've learned to see 'em.
Yet count these dolts superior to the misers
Primping beneath the name of *Art Advisers*,
Dragging bewildered clients by the nose
Down Spring Street, through the lofts and studios.
In days gone by, ere art became a cult,
The task of Ignorance was, *to consult*;
But now, lest Vanity feel itself affronted,
Its expectation is, *to be consulted*.
The prattling, lacquered Divorcée makes haste
To deck herself in borrowed Weeds of Taste,
Gabble receiv'd Opinion, and flaunt
The blissful nescience of the *Soi-Disant*,
Combing the tyro's studio to start
Corporate collections of the latest art,
So that, in turn, each fashionable Matron
Perceives herself as Muse, as well as Patron,
And joins the scrabbling legion of the dull
Whose *Beau Idéal* was B–B and –TH–L SC–LL.

But lo! What sight divides the ambient air
And makes the Hierophantes turn and stare?
The authoritarian sound of muffled drums
Announces something *major* this way comes:
A chariot of iron, wreathed with flowers,
Shakes the wide streets, and o'er the pavement towers,
Such as the pagan *Balinese* prefer
In rites of Exequy and Sepulture,
Bearing the GOD OF MAMMON on its frame
Whilst on all sides, bells chime His sacral Name.
Dread EFFIGY! Eyes glazed with fiscal lust
And nostrils caked with prime *Peruvian Dust*—
Around it, acolytes and nautch-girls throng,
Roll the wild eye, and raise the choral song:
"When culture comes to cash, Less is a bore:

More is, and was, and ever shall be More."
Thus is arriv'd, as in the past foretold,
The gross *Saturnian* age of iron and gold.

The monstrous Ikon, decked in gold and blue
Rolls ponderously down the avenue,
Dragged by twin chains, dependent from its cage,
The first one drawn by Youth, the next by Age.
The former by the hands of MARY SPOON,
Part secretary, part goblin, part *Raccoon*,
Scribblers' fancy, opportunists' muse,
Her claim to taste, two hundred pairs of shoes.
The latter's harnessed to the wiry belly
Of SoHo's household word, LEO C–ST–LL–.
Arriving on Manhattan's primal scene
When half the Art World, and its art, was green,
He proved the City's proper go-between,
Flogging to Taxi-Lords and Corporate Dons
Encaustick canvases by JASPER JOHNS;
But in the Seventies, a decade drear,
He took to seeing mainly with his *Ear*,
And his advisers caused him to impart
His reputation to *Conceptual Art*.
Yet now he blooms again! A process which
Inspires him to extol pretentious *Kitsch*,
Attributing the genius of Proust
To Gallick rubbish like GERARD LANGOUSTE.
Let flattering daubers their C–ST–LL– paint
Rob'd as Philosopher, a Secular Saint—
He has become, throughout the noise and glory
A shrewd Italian *Imbollitore*,
A dancing-master of the passing rage,
The victim, not Petronius, of his age,
While, as collectors smirk and criticks gape,
He leads them as the *Organ* leads the *Ape*.

Perched like a *Syce* on this colossal bauble
Sits Leo's protégé, pale ANDY WARBLE,
Whose social lusts, like Chicken Little, grew
Into the world's worst journal, *Interview*.

Earth hath not anything to show more fair
Than *Andy*'s wig of silvery plastic hair:
With mild regard, forgiving, sweet, and dull,
He grins to shew the skin beneath the skull.
"Since *Leo*'s smile has authoriz'd my Muse,
Chaste be my conduct, and detached my views—
My life in Art is ever to confer
With Stars and Catamites, a keen *Voyeur*.
Thus my example helped this spot to grow
Into a *Stew* or sweaty *Bagnio*
Where rosy Artists posture in the steam
Soliciting trade; and their collective dream
Is that I use my certifying Power
To make them famous for *one-quarter-hour*.
If BARNEY NEWMAN showed them Laws of Moses,
Today, I show them *Aretino's Poses*:
Thus, though my painting long since came to naught,
I am the valet to this Juggernaut."

Yet hark! New sounds upon the eardrum fall
And ominously echo through the mall:
Proceeding from great MAMMON's gilt behind,
A susurration of escaping wind!
As Fame's posterior bugle softly blows,
What stench now fills the unsuspecting nose?
Pervasive, fruity, sulphurous, full, and ripe,
It is the odour of an *Art World Hype!*
The Statue shudders, and is proven soon
No solid monument, but a *Balloon!*
No child of bronze, but mere Inflation's son,
Sustained by fiscal dolts in Washington!
As all escapes, its poor and shrivelling skin
Proclaims the vast Vacuity within.
The revellers shriek, the priests draw close and mutter,
SHAFRAZI grovels in his place, the Gutter,
When random sparks, ascending from the road,
Ignite the gas, and make the God explode!
The vast percussion shudders on the air,
Galleries totter, boutiques are laid bare,
The fiery gust of driving wind contorts

Bald-headed mannequins in leather shorts;
Pâtés and pumpkins, *chèvre* and golden beets
Crash from DELUCA's window to the streets,
The crowd of celebrants is whirl'd from sight
As PHOEBUS disappears, and all is Night.
Thus to distracted Culture justly come
The punishments of Herculaneum.
The *Antipodean Shepherd* drops his gaze,
Brings to an end his Apopemptick Lays,
Resigns his Doric flute, and hopes for better days.

The New York Review of Books, 1984

Harvill Paperbacks are published by Harvill,
an Imprint of HarperCollins publishers